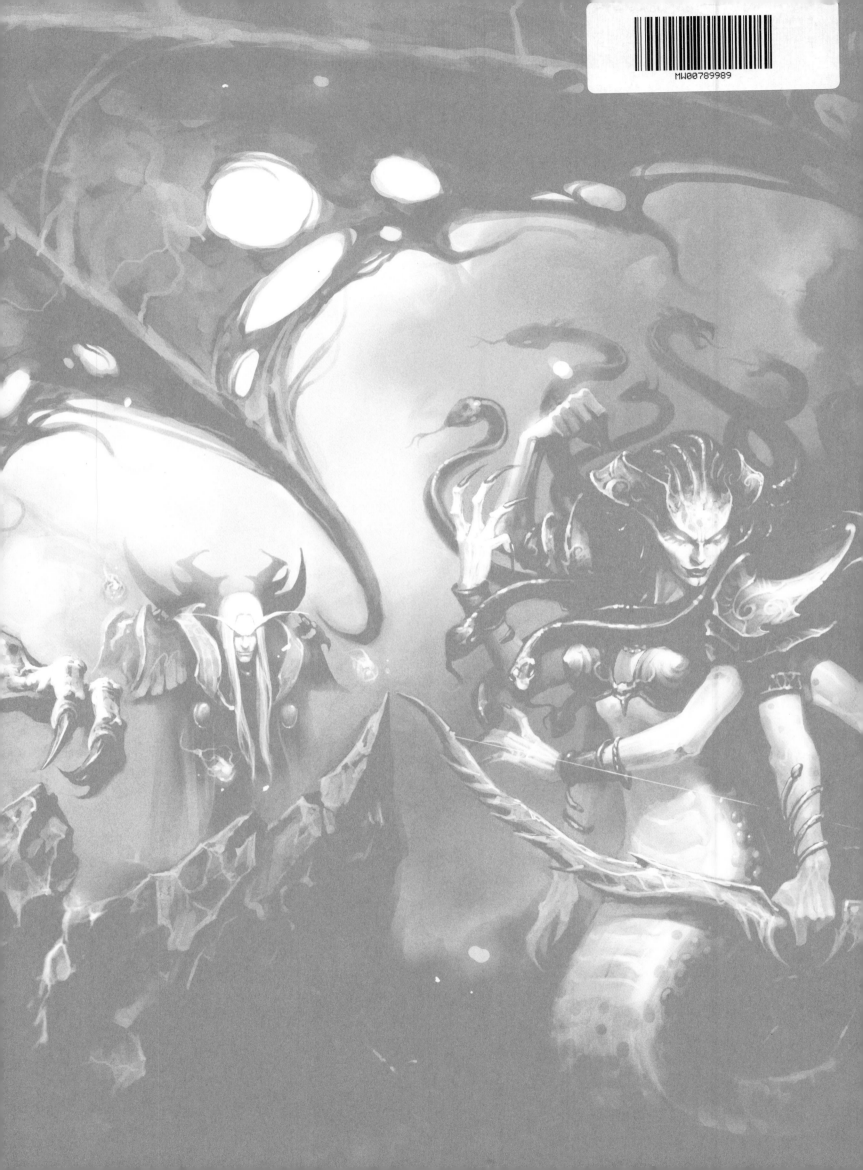

THE ART OF BLIZZARD

ENTERTAINMENT

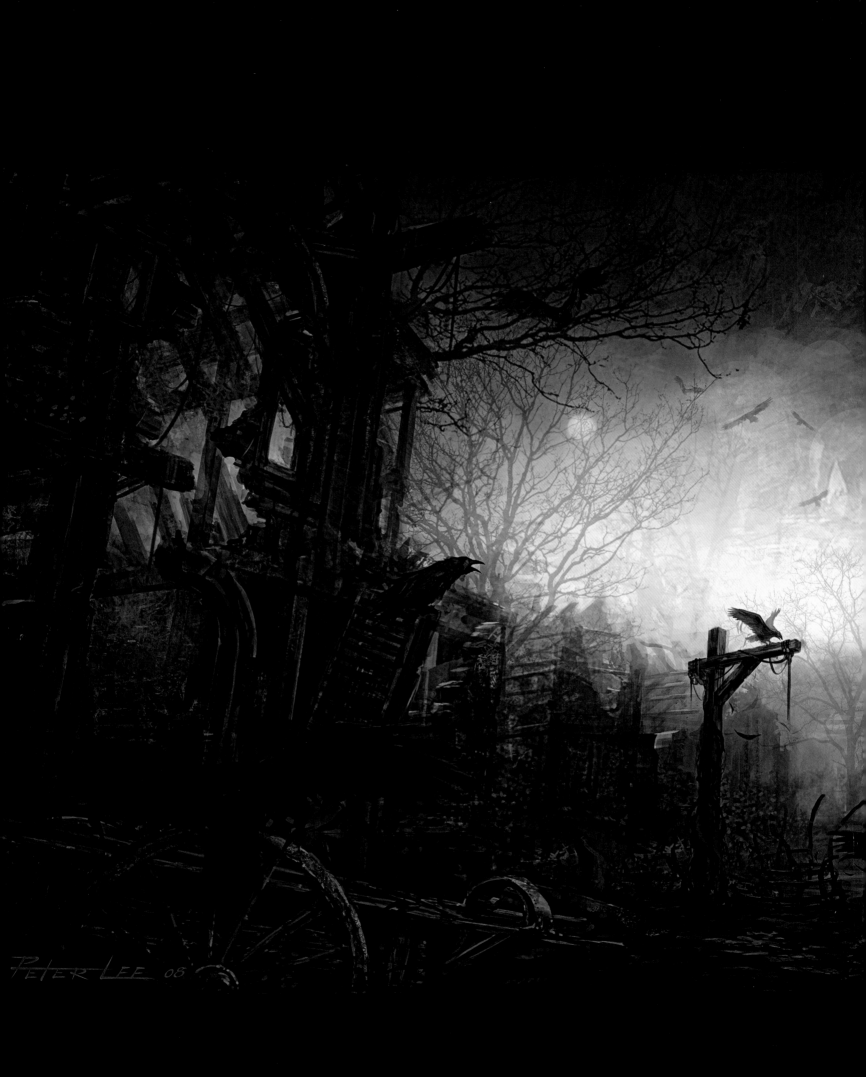

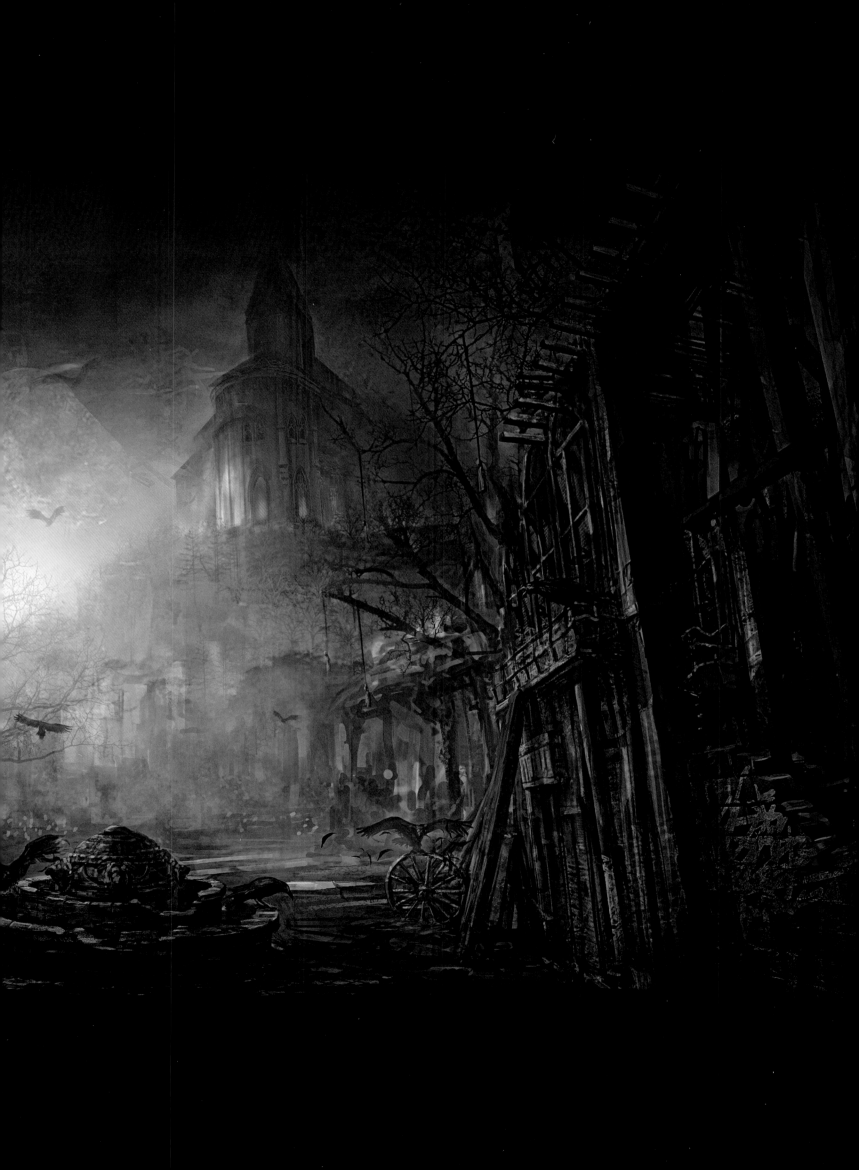

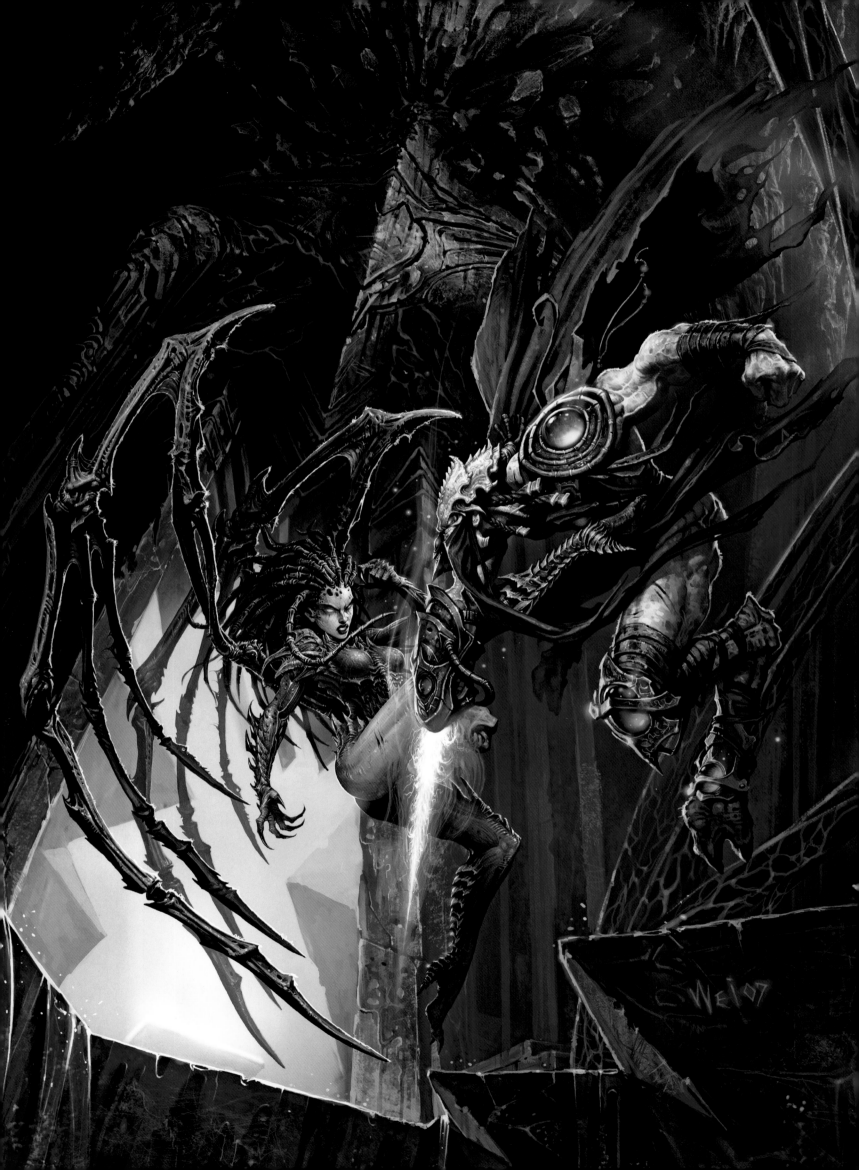

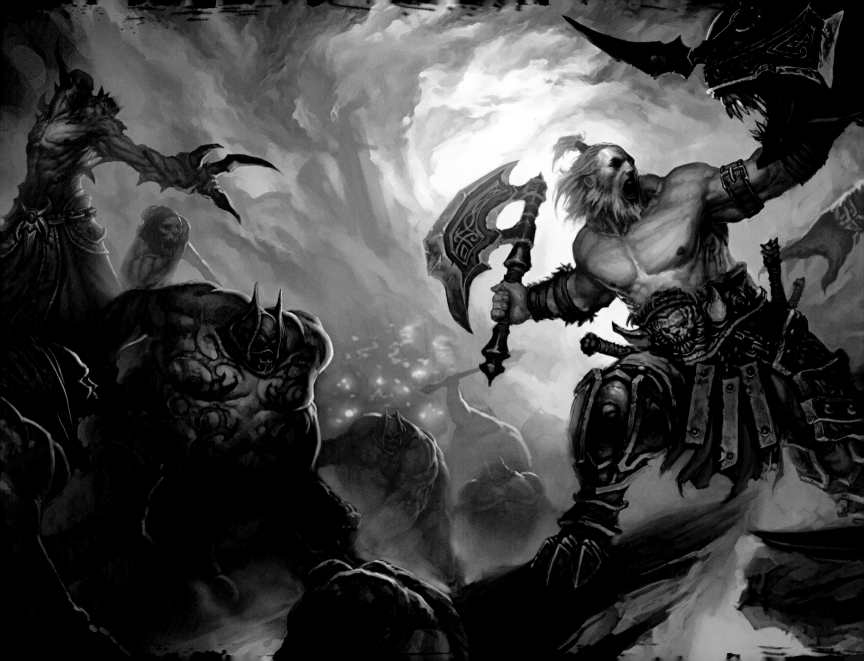

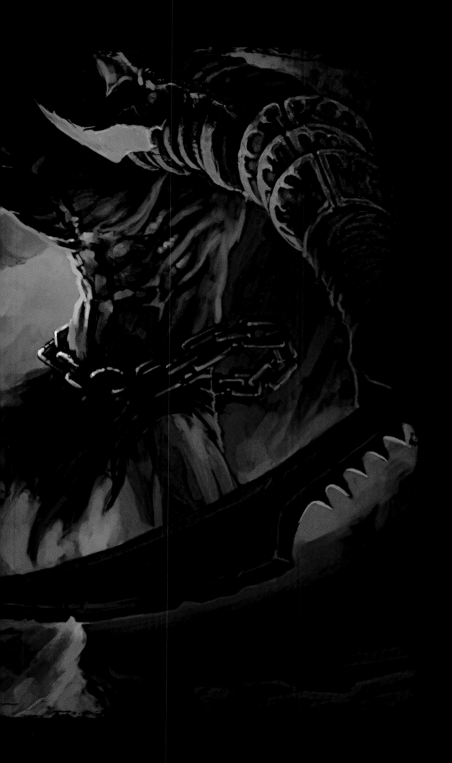

CONTENTS

BROM

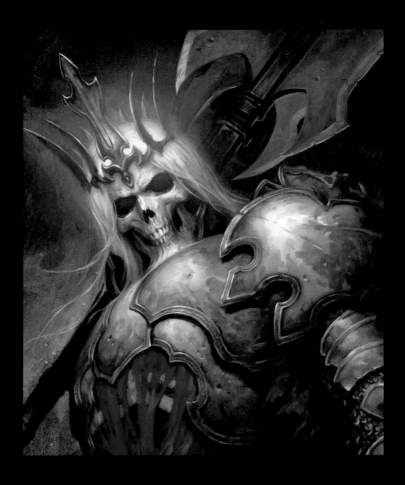

In 1994, I acquired my first home PC and was trying to figure out why I'd just laid down four g's for what seemed to be little more than an overhyped word processor. I'd heard you were supposed to be able to play games on the damn thing, so off I went in search of some high-tech entertainment. My quest proved fruitful, and I returned home with an armload of floppy disks crammed with all manner of game demos. The names of those games and companies are long forgotten with one exception: *Warcraft: Orcs & Humans* by Blizzard Entertainment.

All painting ceased in my studio as I flew through the demo and then the full version. Over the next several years I lost untold weeks of productivity to *Warcraft II*, then to Diablo, then to StarCraft. I was hooked; I couldn't get enough. If the Blizzard logo was on the case, I knew I was guaranteed a groundbreaking game experience. When *Diablo II* was released, there came a point at which I had to ask my wife to hide the disc from me as that cursed game was causing me to fall behind on my deadlines. As far as I was concerned, Blizzard wasn't just producing exciting and innovative games—they were setting a whole new bar for entire game genres.

None of this is news, we are all aware of the magic created by the folks at Blizzard; what some of us might not be aware of is the culture behind these amazing games, the ingredients that produce the mojo.

Here's what I think makes Blizzard games so imaginative: prima
company with a creative-driven culture. The voices that crafted the ga
same ones steering the company today. Blizzard is not a culture of "
right." This can at times be challenging for the rest of us as we anxio
n the end it's this drive for perfection that continues to separate t
mitators out there.

Vision is another key ingredient. Blizzard has made a point of c
working to ensure the unique look of each world, avoiding the
aesthetic, and instead striving to give each brand its own distinct a
established early on at Blizzard by such industry legends as Chris Me
Bill Petras, and Nick Carpenter, and they are carried on by the insp
Lichtner, Justin Thavirat, Chris Robinson, Glenn Rane, Wei Wang, a
and designers.

Since first being contacted by Blizzard in the late '90s to paint th
fortunate to have worked with most of these talents and to have cre
worlds. Painting can at times be a lonely, solitary business, but my
always been collaborative. They understand the craft, they're artis
the end, it's this spirit of teamwork and collaboration that makes
enjoyable experience.

On the occasions that I've visited the Blizzard fortress (which, b
located within a secret enclave upon the Hellfire Peninsula), I alw
the cavernous halls and catacombs, of peering into the pits and c
skulls and Wacom tablets, the battle-axes and Manga statuary, is ar
wall, covering every desk, and piled upon every chair are paintings,
scribbles by the very top talents in the industry.

I always walk away from these visits inspired, my creative mana re
as there is such energy, such vision, such passion in the work. So I a
of this work collected here, out from the drawers and hard drives, ou
within these pages for us all to admire.

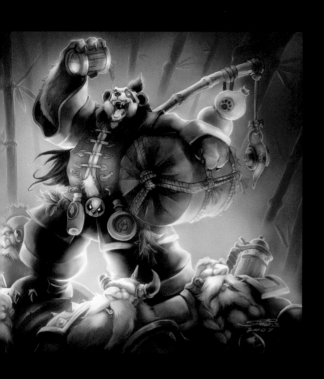

zzard Entertainment, all I ever drew were barbarians wielding bro-
ribly drawn women from monsters. I still can't draw girls to save my
watching artists at Blizzard, I'd say I've expanded my arsenal some
mimicked the lines, trying to capture what the artists at Blizzard do
d pixel. These people have influenced and inspired me as much, i
tasy and science-fiction painters of past and present times.

How did you learn how to draw?" If I wanted to give the full answer, I
w to do lighting and shade by emulating the style of Roman Kenney
l the art of armor crafting and costuming from Chris Metzen (page
say that I learned to paint environments by studying the mastery of
tras (page 86). Bill also showed me how to use Photoshop. Over the
e of the massive paintings of Wei Wang (page 106) and the power-
created by Glenn Rane (page 83). There are so many examples of
me that it is impossible to sum them up.

d's artwork, and it is an honor to be a part of the art team. We
g, and creating new races, characters, and worlds. No paper is left
is safe. And the steady stream of new blood (n00b blood) that we
stuff gets better every year. I don't know if this is true, but it seems
ur art team is or was the best artist at their high school or college.

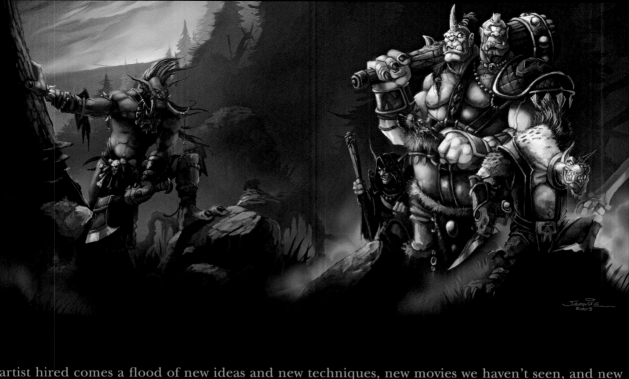

artist hired comes a flood of new ideas and new techniques, new movies we haven't seen, and new music we've never heard. These new ideas and influences inspire our pencils and pixels to wilder and grander creations. Our established traditions, values, and philosophies harness this energy and hammer it into a solid form. Ah, the old meets with the new—the Circle of Art, my friends. It does indeed move us all.

Throughout the pages of this book you will see a lot of incredible art. You will also see some that is not so incredible. But those images may be the most important ones for you to see because they are what started this whole crazy thing. The path to artistic inspiration was laid with pencil, paper, and a whole lot of passion. Many artists cringe at seeing their old works, but not me. It's like looking at old pictures of our babies. I see how tiny and young Thrall looked when he was newly born into the world, all bald with no shoulder pads, just a scrawny green kid. And little Sarah Kerrigan with the crusty dreads and ripped purple-and-green spandex outfits. Big Red (Diablo n00b) didn't start out so hot either, with all his weird muscle configurations and gigantic horns sticking out at every angle. But as kids will do, they eventually grew out of the awkward stage and developed. They matured into the heroes and villains we all love today. Thrall, Sarah, and the D-man aren't just drawings anymore, and they are more than just our babies or our artwork—they have become the faces of Blizzard Entertainment.

And they have become part of your lives as well. You've lived in their worlds. You might have missed work or missed anniversaries because of them. It all worked out, though, for you also helped them save Azeroth and conquer the Koprulu sector. You've even battled them in the fiery pits of the Burning Hells time and time and time again (for those SoJs, baby). We don't get upset or take sides, Alliance or Horde; High Heavens or Burning Hells; terran, protoss, or zerg. We love all of our kids, and I'd like to thank you for loving them right along with us. You make our jobs possible. If it wasn't for the passion you've shown to our games and our artwork, everyone at Blizz would be working some other job. But because of you, we have all gathered here, together, united under the banner of the Black and the Blue that is Blizzard Entertainment, and we will keep drawing and keep making the best games around as long as you guys keep loving them and playing.

WORLD of WarCraft®

Since its humble beginnings with 1994's *Warcraft: Orcs and Humans*, the Warcraft franchise has developed into one of the most visually distinct fantasy settings ever created. Warcraft's colorful, hyper-realized setting has always been punctuated with mighty warriors and grizzly monsters—all armed with oversized weapons and ornate super-stylized costumes and armor sets.

Visual bombast has always been core to the look of Warcraft. The series' developers wanted to create a setting that was bigger than life but that still retained an immediate visual accessibility for its broad gaming audience. For a world defined so heavily by its exotic races and cultures, Blizzard's art team always took great pains to balance detailed world-building, dramatic storytelling, and their own distinct visual authenticity.

Balancing dozens of distinct races and culture kits over the course of World of Warcraft's development was no easy task. Warcraft's races needed to create an immediately striking impression and communicate the various themes and values unique to each, but they also had to balance against each other as well. The races that comprised both the Alliance and Horde were chosen to exemplify certain facets of each faction (the strong race, the subtle race, the savage race, etc.). Analogous to developing a comic book super-team, the races that defined the Alliance and Horde needed to mesh as a distinctive whole—and show players how different the factions were from one another.

While many of Warcraft's races have left a lasting impression, the world itself spoke loudest to its player base. From the outset, Blizzard's artists pushed themselves to define an unforgettable worldscape filled with bright, rich colors and detailed, transporting environments. In many ways, the zones and vistas of World of Warcraft serve as the setting's most critical visual components. No matter what race or faction players might choose, it's the world they're ultimately immersed in and the authenticity of its craftsmanship that complete the grand illusion.

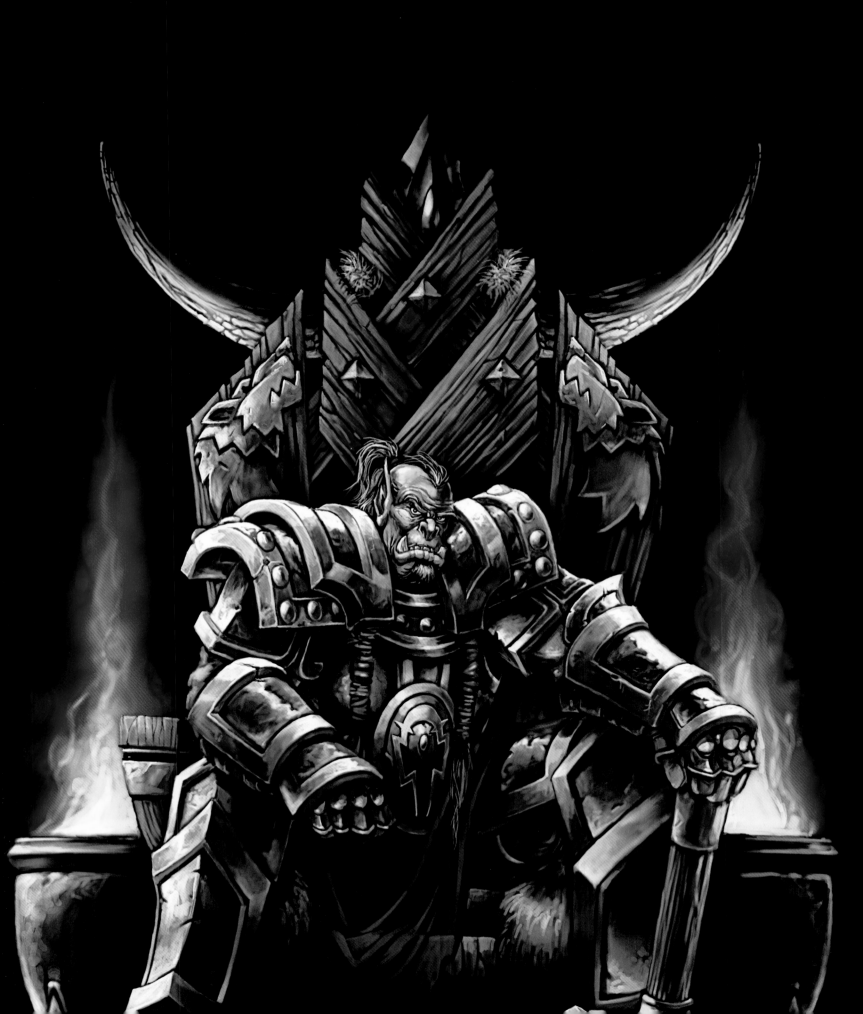

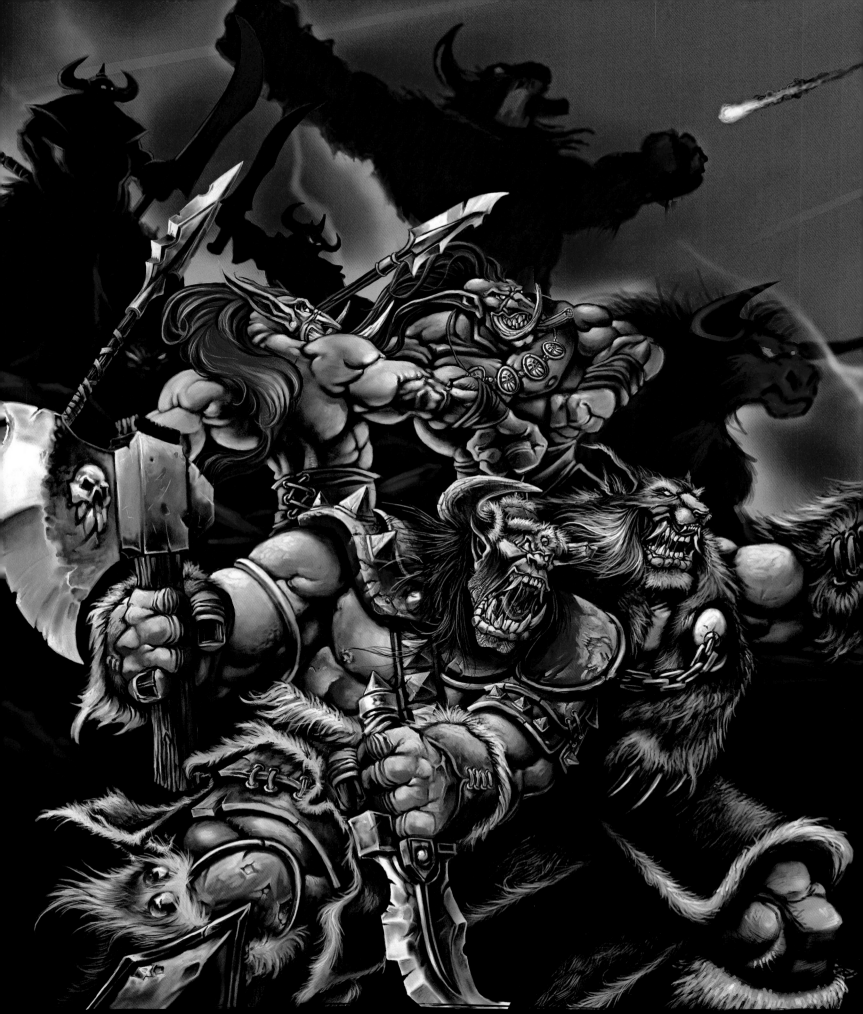

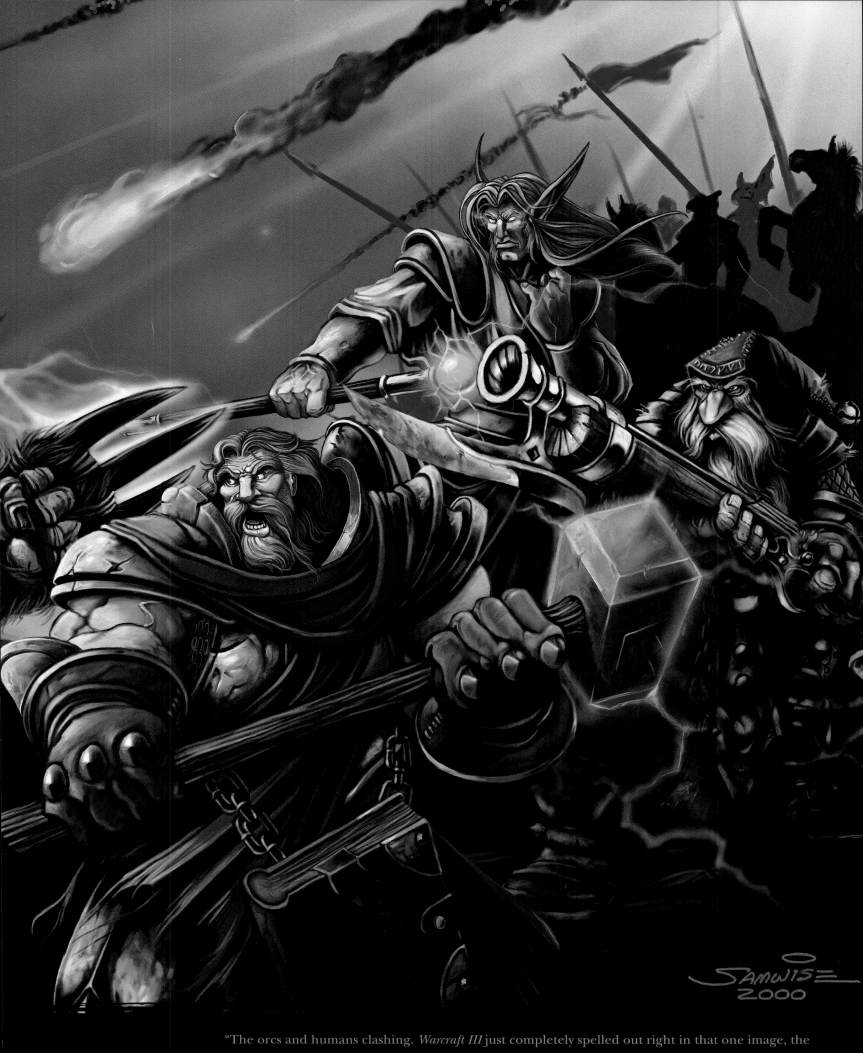

"The orcs and humans clashing. *Warcraft III* just completely spelled out right in that one image, the Burning Legion falling from the sky. Sam would bury himself in his office and then come out with these images and they were so iconic, just completely represented where we were going with these games. In a lot of ways it helped everybody know exactly what this game was gonna be."

—Nick Carpenter

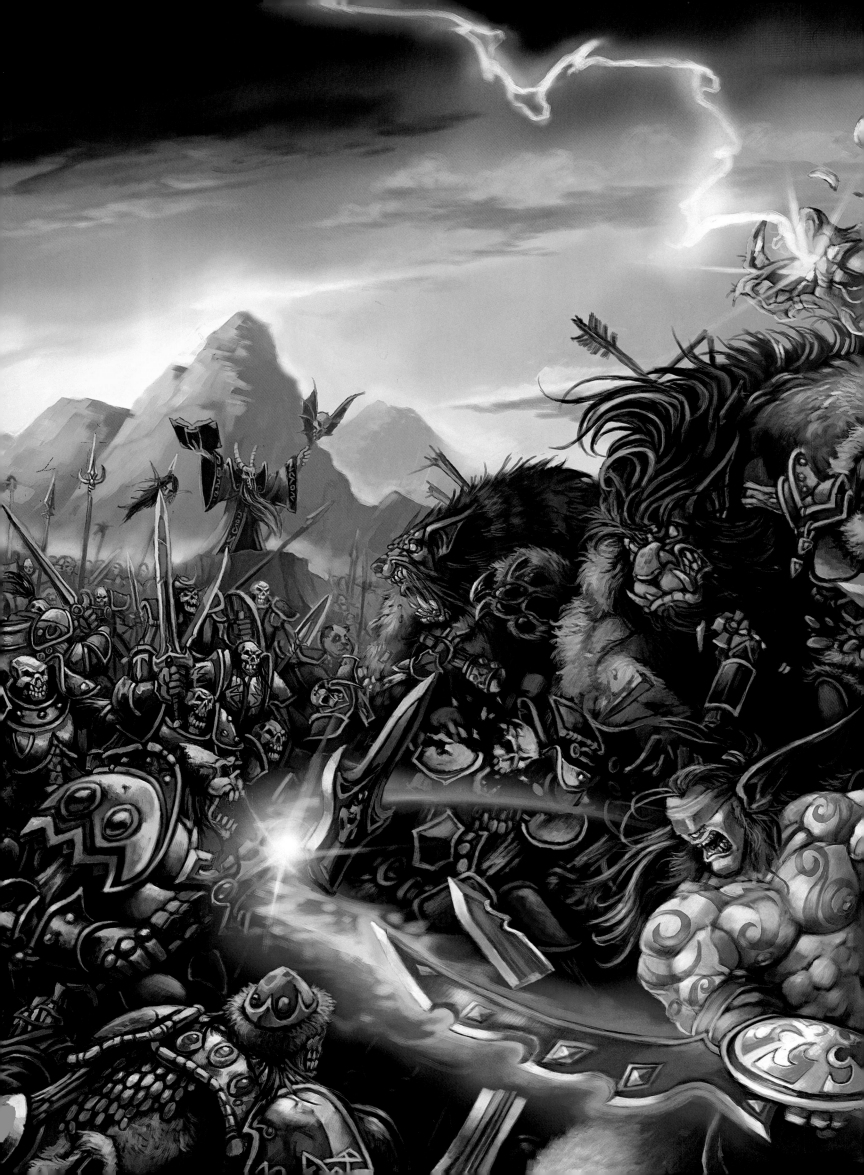

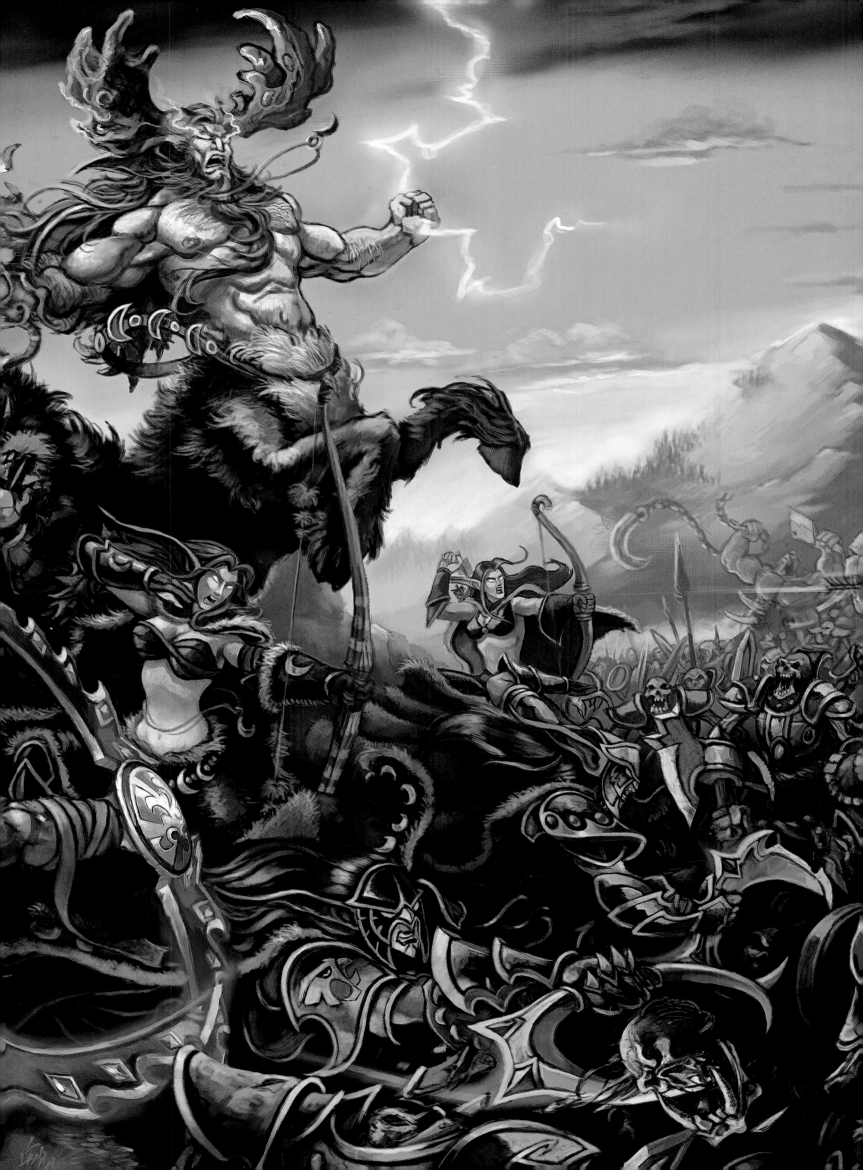

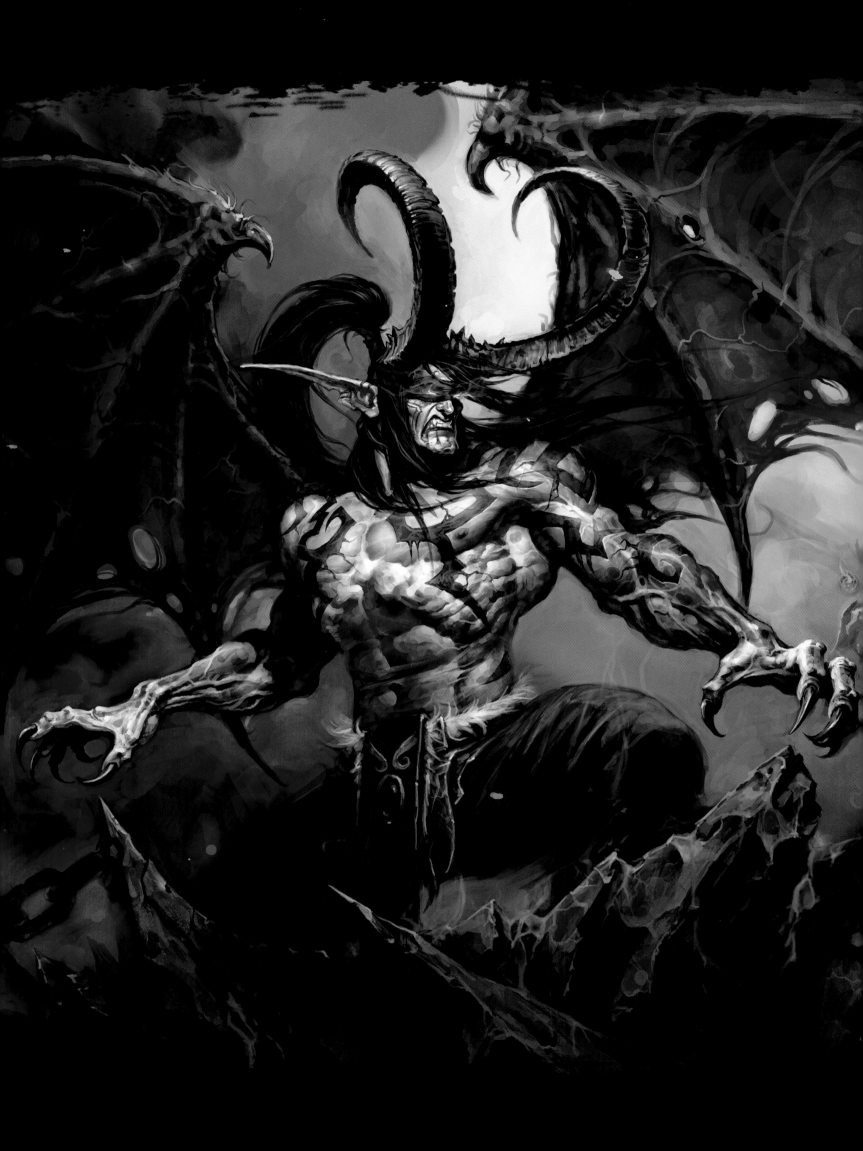

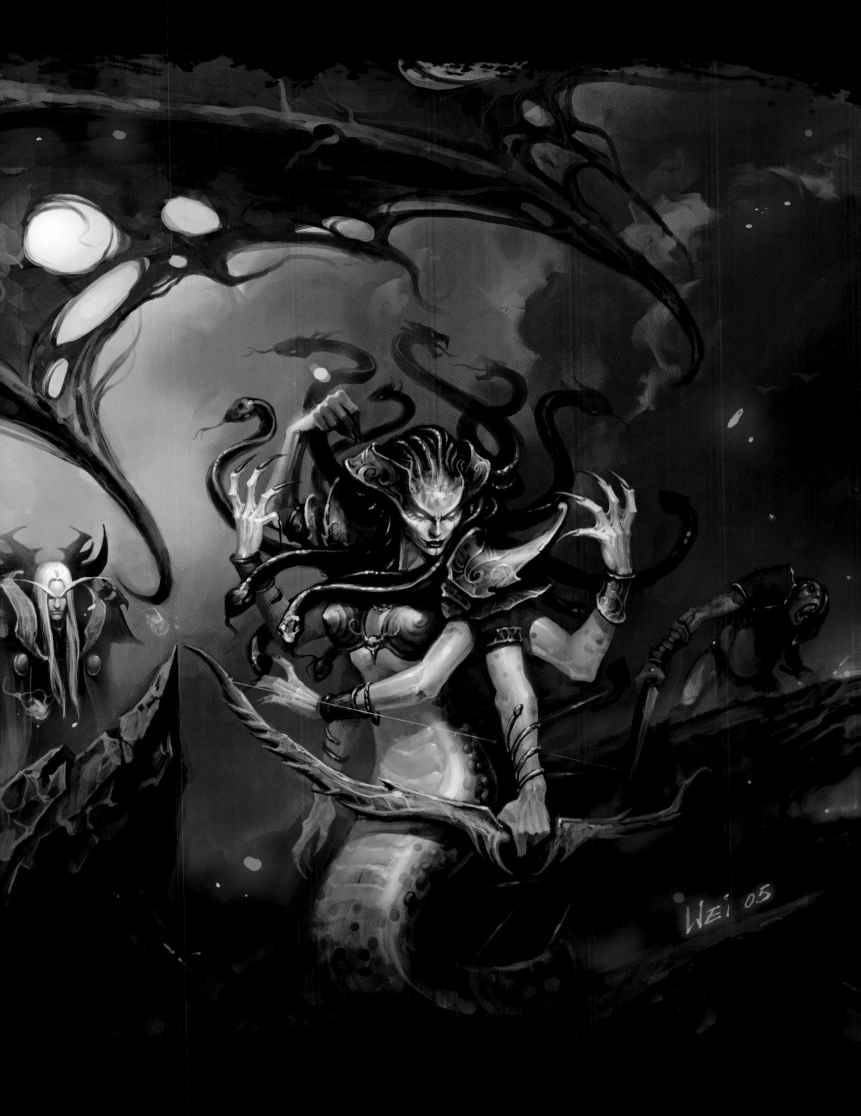

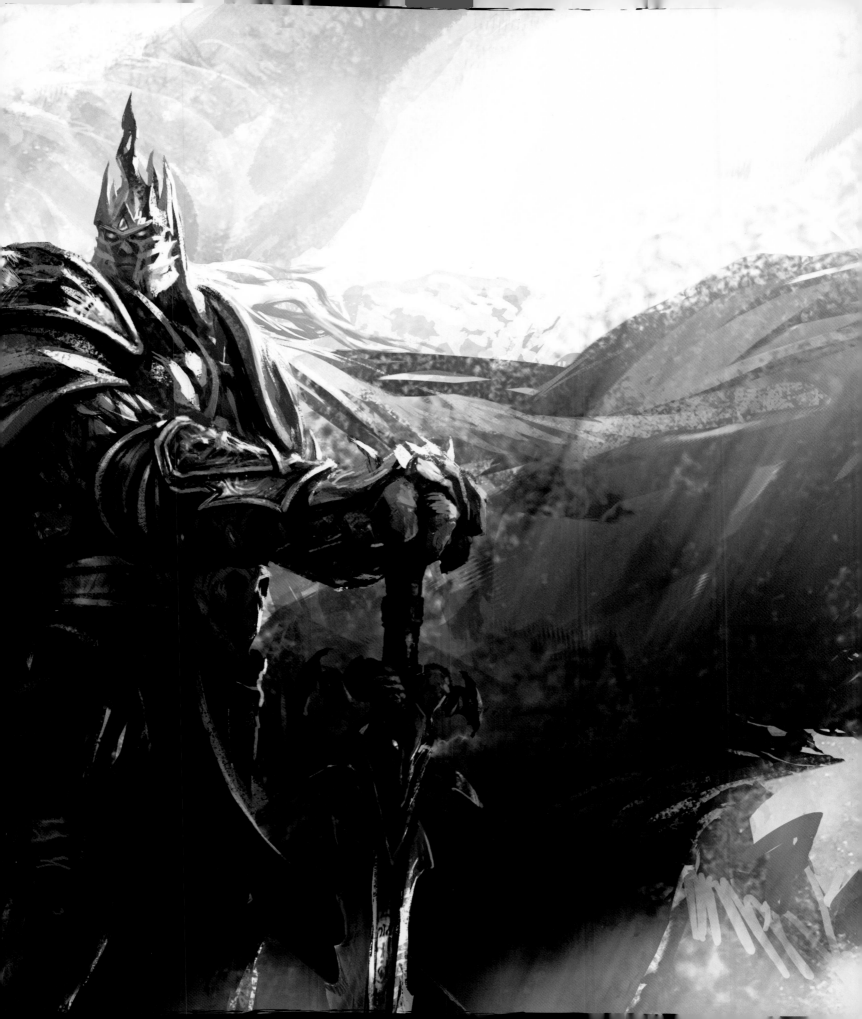

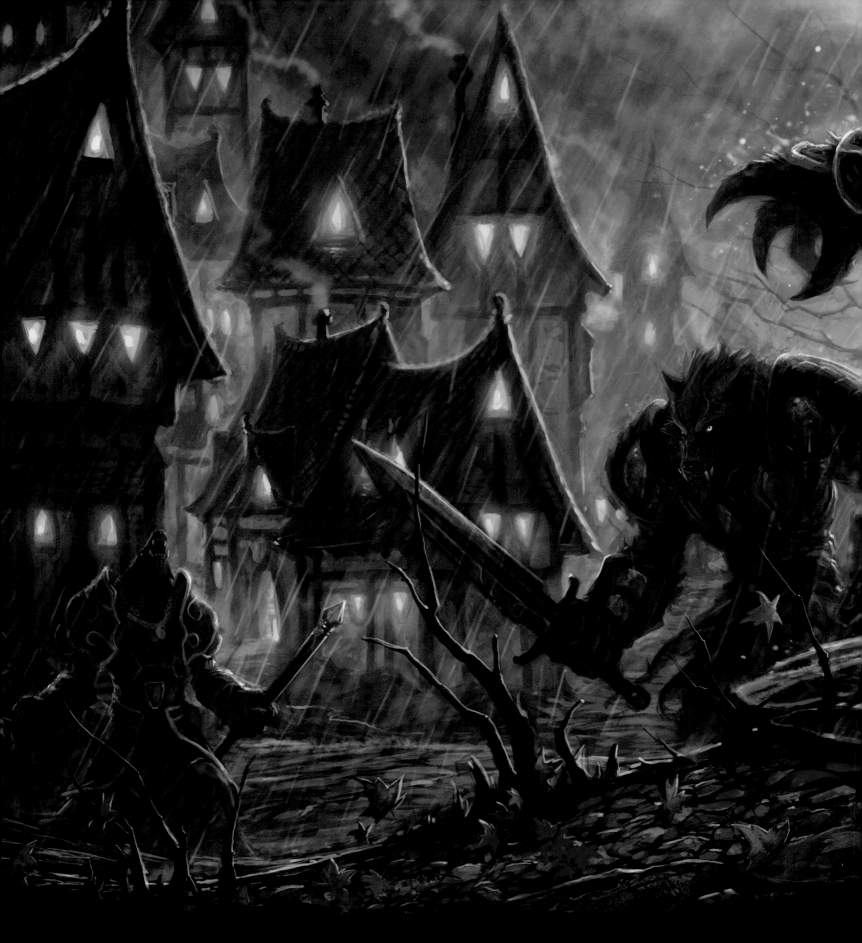

"We get to a point when all of our separate art teams are finished working on a racial kit. When the characters are built and animated, the buildings are textured and placed in the environment, and the props are propping. And then we hand it off to our illustrators to put together a piece like this. When this one came together it was really the first time that the worgen race felt fully fleshed out."

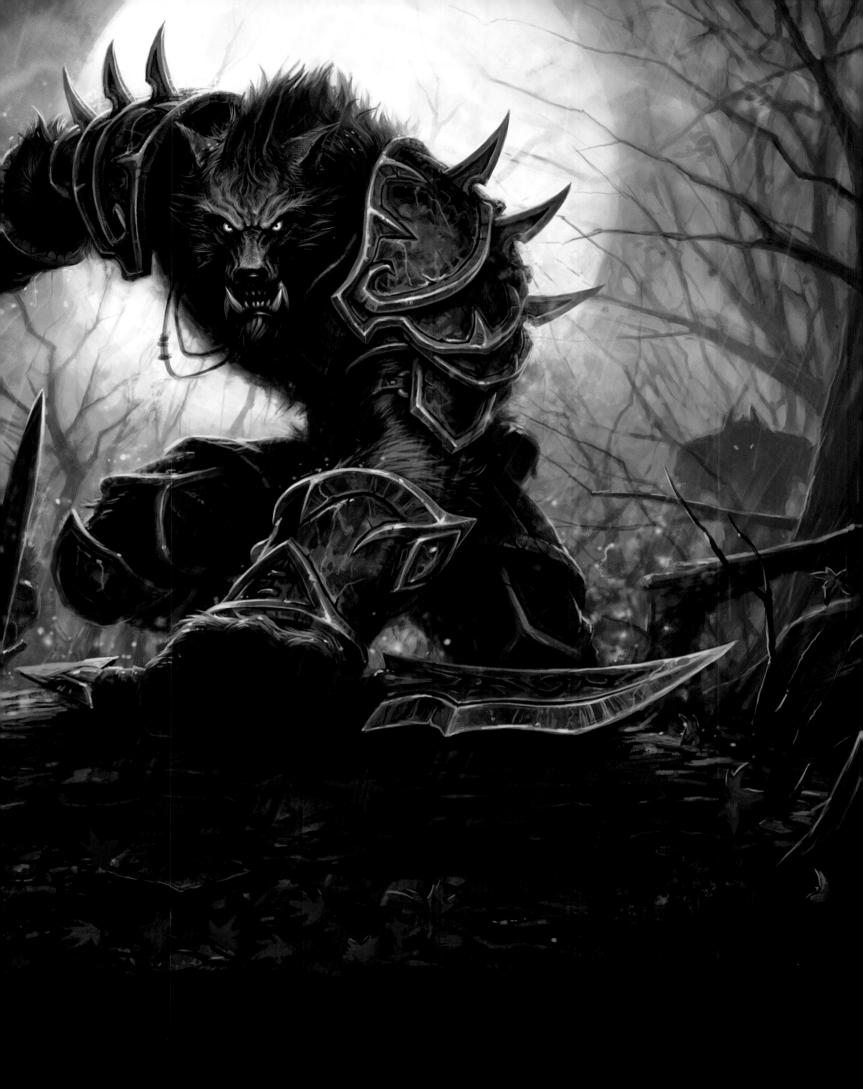

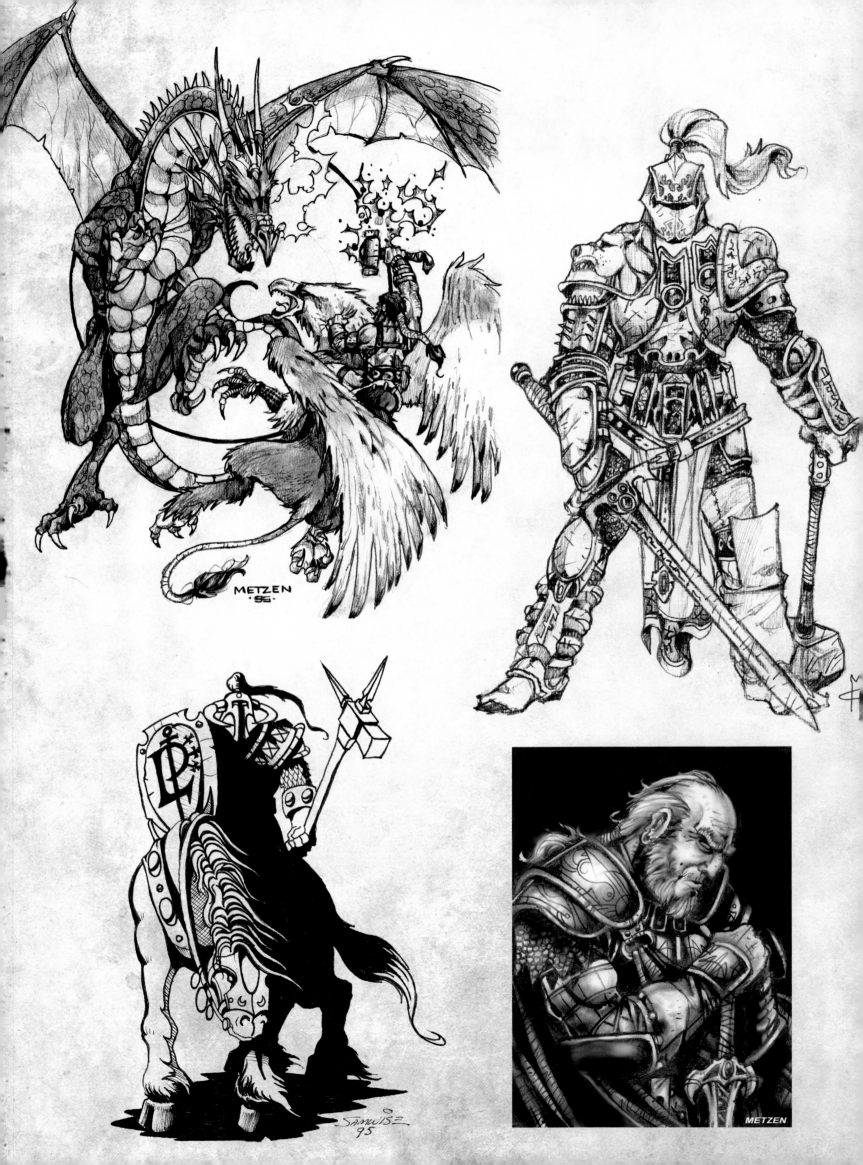

METZEN
'95'

SAMWISE
95

METZEN

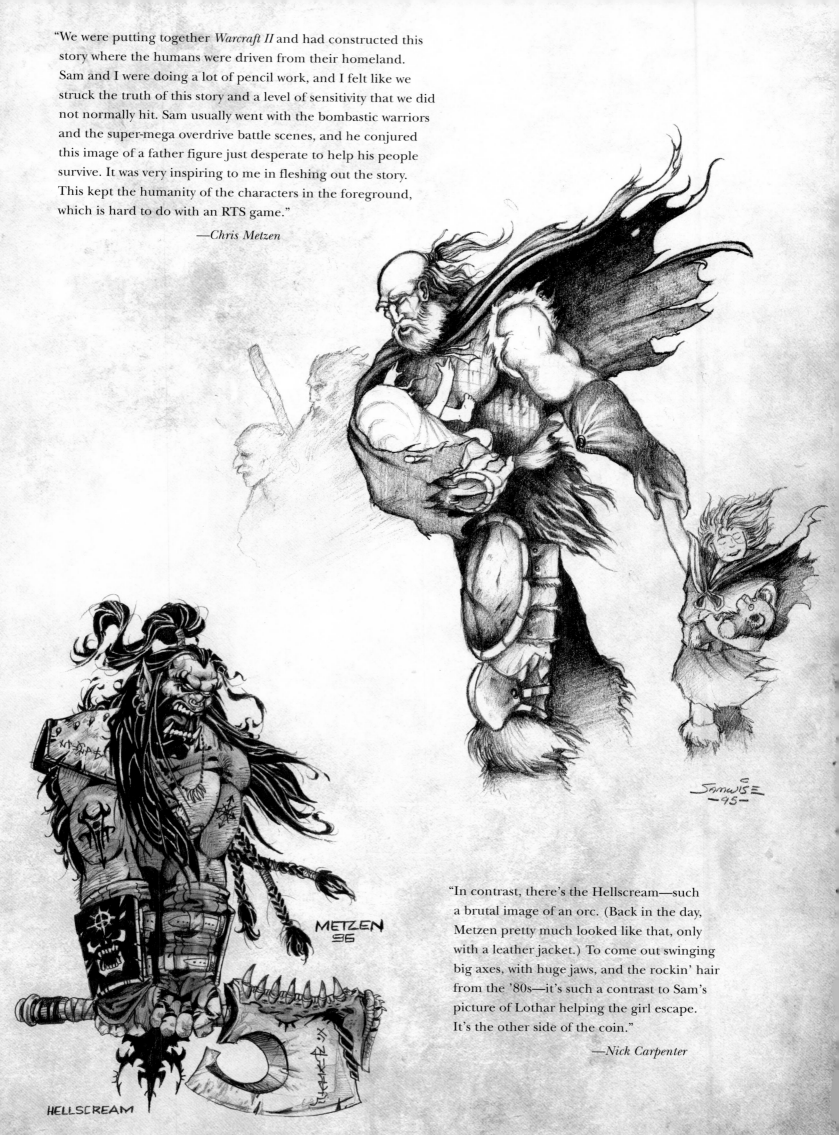

"We were putting together *Warcraft II* and had constructed this story where the humans were driven from their homeland. Sam and I were doing a lot of pencil work, and I felt like we struck the truth of this story and a level of sensitivity that we did not normally hit. Sam usually went with the bombastic warriors and the super-mega overdrive battle scenes, and he conjured this image of a father figure just desperate to help his people survive. It was very inspiring to me in fleshing out the story. This kept the humanity of the characters in the foreground, which is hard to do with an RTS game."

—*Chris Metzen*

"In contrast, there's the Hellscream—such a brutal image of an orc. (Back in the day, Metzen pretty much looked like that, only with a leather jacket.) To come out swinging big axes, with huge jaws, and the rockin' hair from the '80s—it's such a contrast to Sam's picture of Lothar helping the girl escape. It's the other side of the coin."

—*Nick Carpenter*

HELLSCREAM

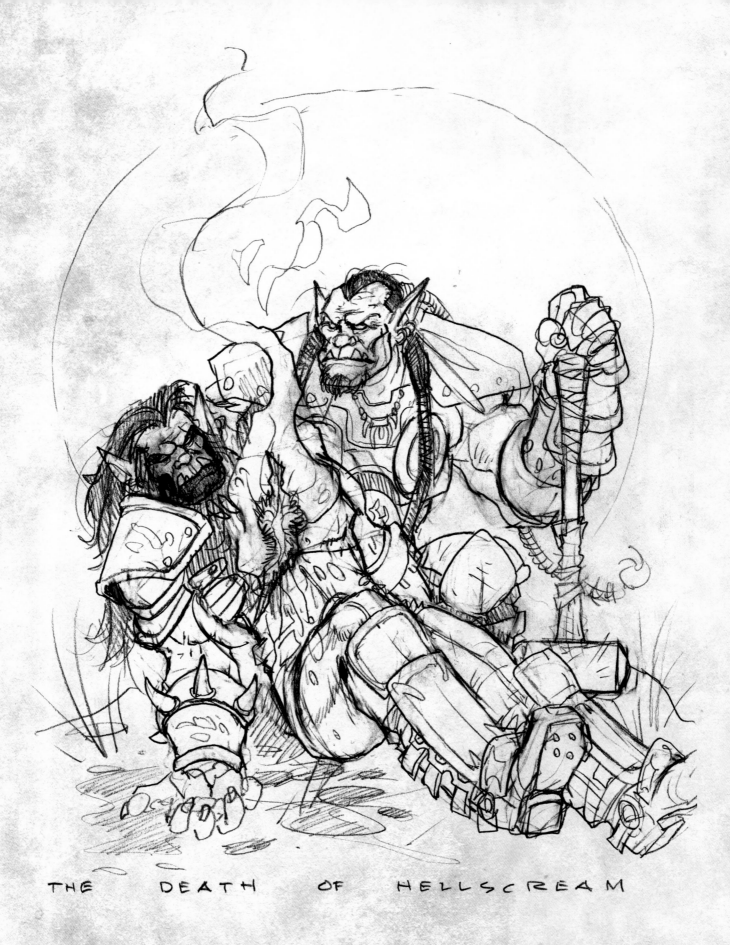

THE DEATH OF HELLSCREAM

"In trying to portray the orcs more as noble creatures with feelings, we came up with these two characters that would go through an experience where one of them would die. With this image, I remember it crystallizing for me who these guys were and thinking, 'Wow. Who's Thrall going to be after this?' It was an inside look at how we can be telling stories just through art without words."

—*Nick Carpenter*

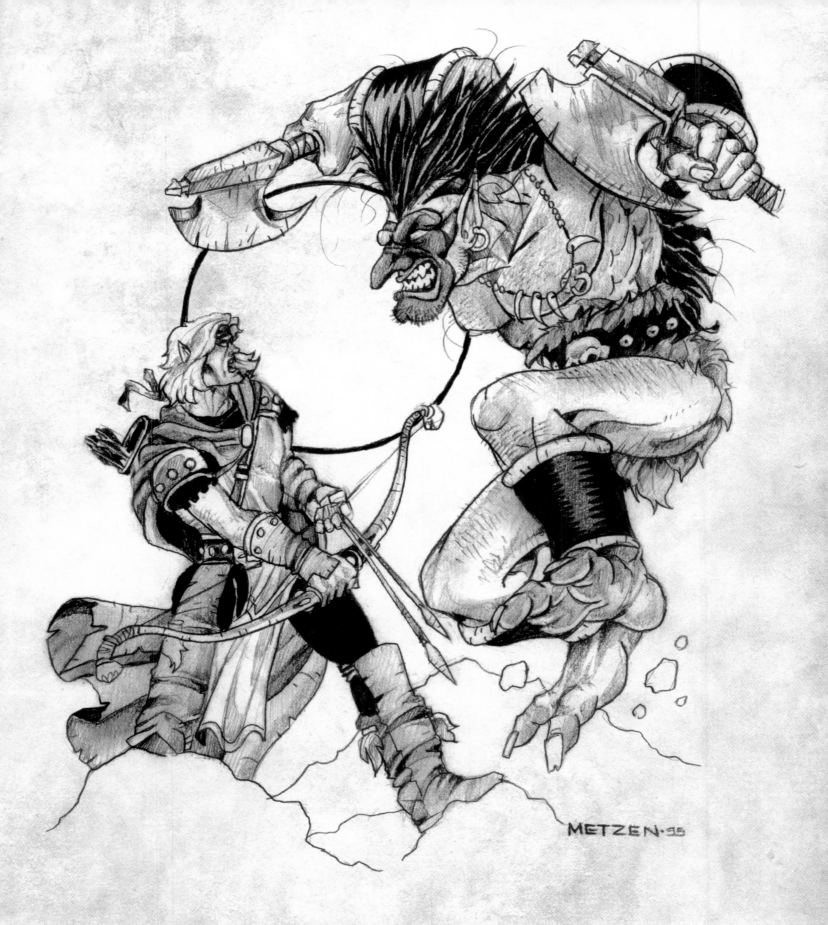

"We were just getting into developing *Warcraft II,* and these new races were being included in the Alliance and the Horde. Some of the first we had jammed were the ranged attackers. As you develop video games, you start with the functional mode first and then kit a character around the function. Elven archers, à la rangers, felt perfect, but it might have been Sam's hook in using trolls to be the ranged attackers on the Horde side—that just seemed like an immediate natural enmity. I remember doing this and just having a lot of fun. But it also serves to show that we still can't figure out how many frickin' toes trolls have."

—*Chris Metzen*

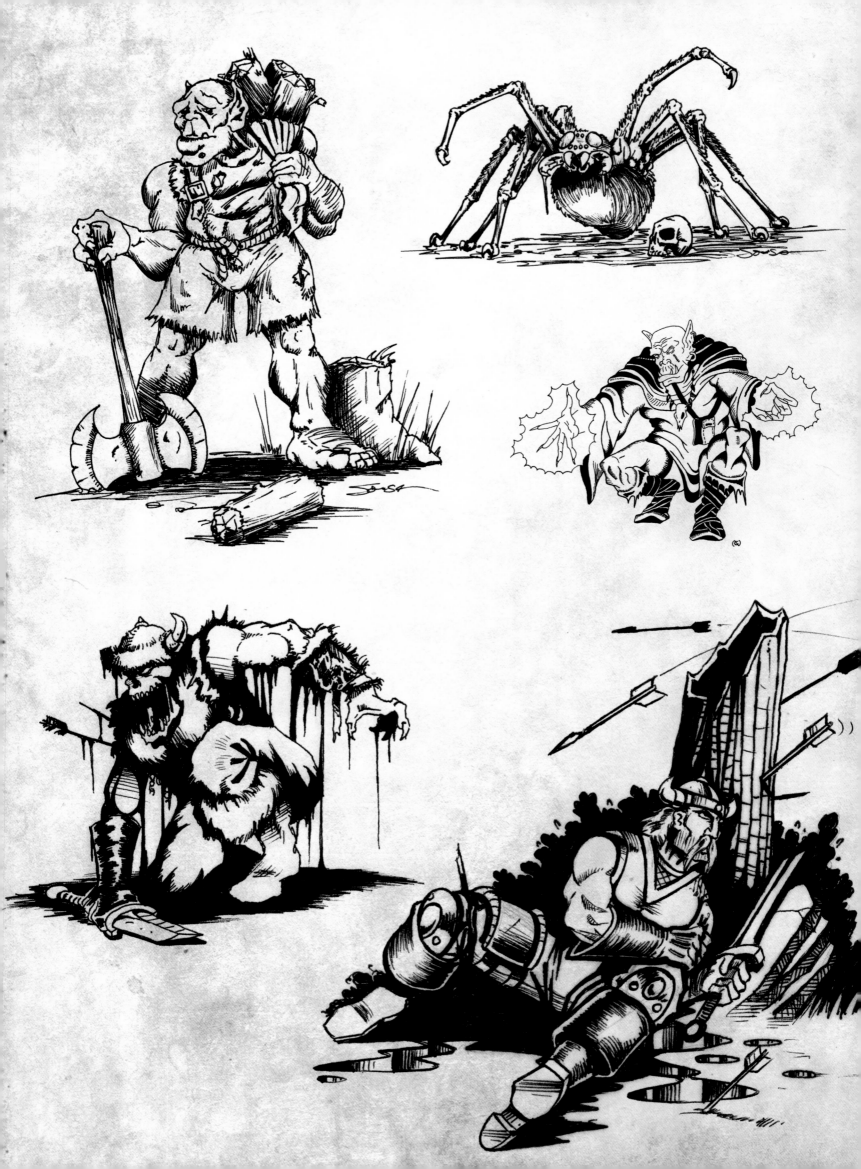

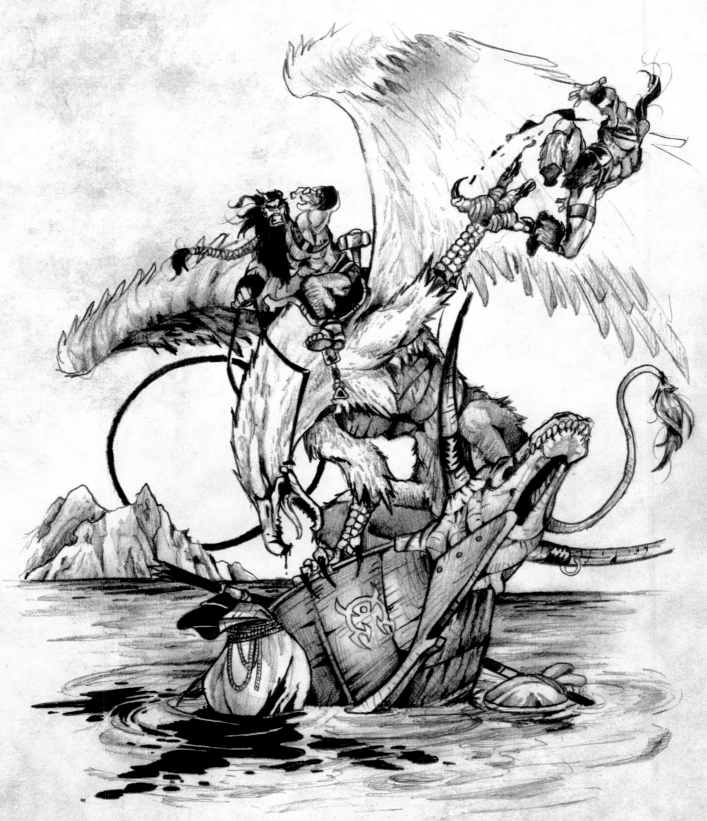

"The play dynamic of resourcing and getting gold, getting oil, getting whatever to fuel your fleets was such a big part of *Warcraft II*. It's funny looking at it now. It's not like anyone asked for that drawing . . . it's just what was going on back in the day."
—*Chris Metzen*

"You look at that and because it's a black-and-white image—is that blood or oil floating in the water? And the best thing about this image is in the upper right-hand corner, that orc getting *tossed*."
—*Samwise Didier*

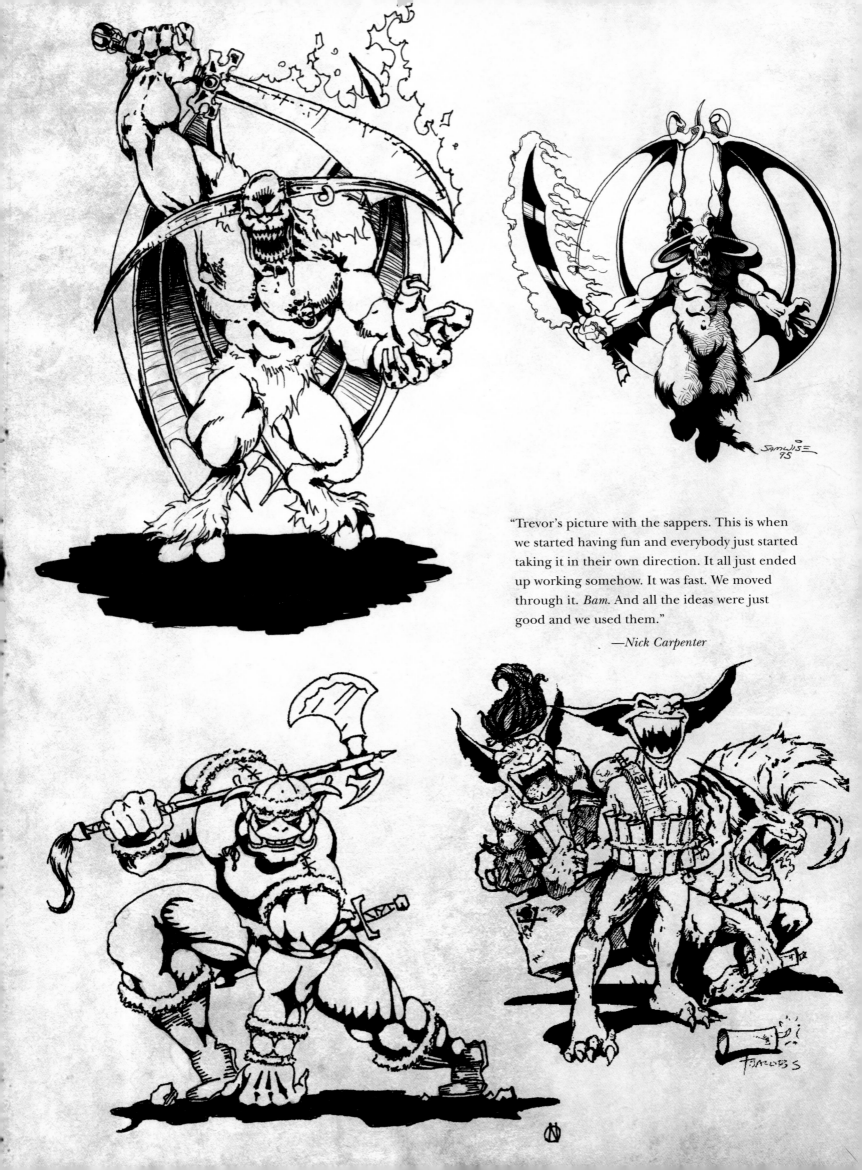

"Trevor's picture with the sappers. This is when we started having fun and everybody just started taking it in their own direction. It all just ended up working somehow. It was fast. We moved through it. *Bam.* And all the ideas were just good and we used them."

—*Nick Carpenter*

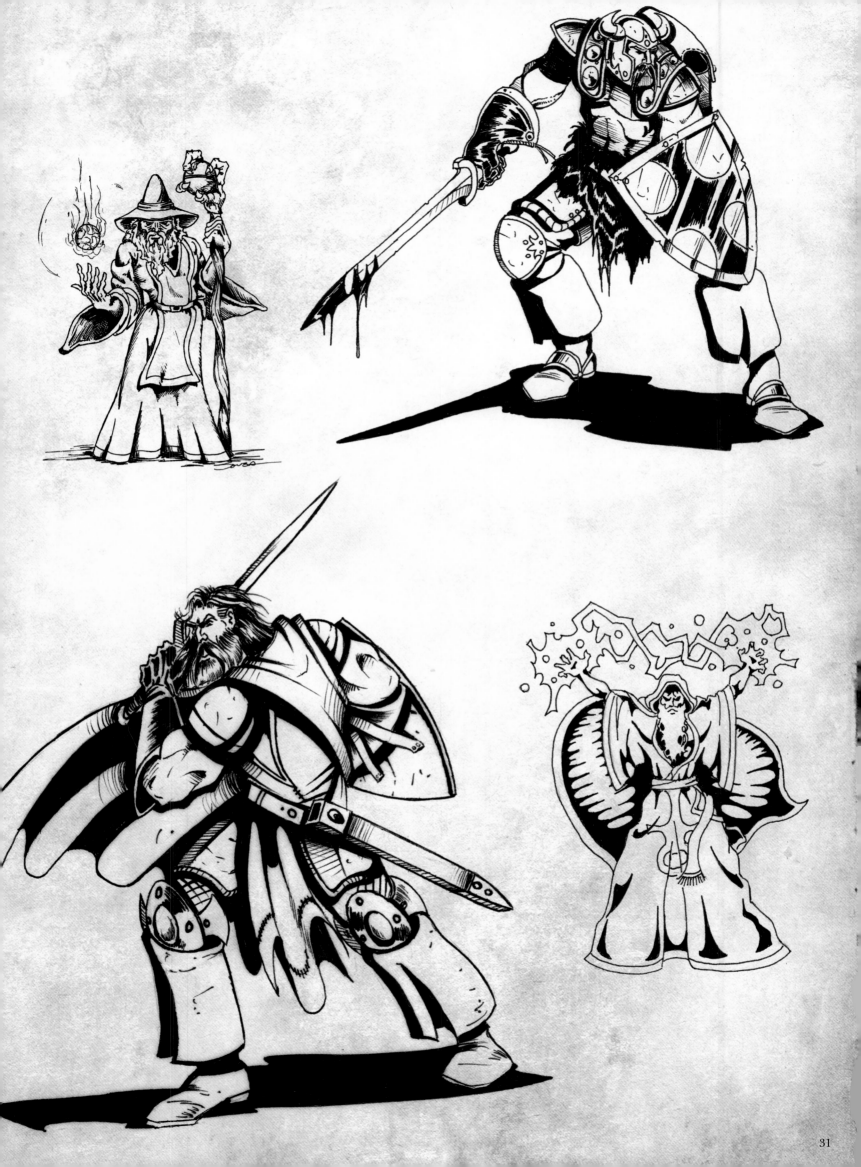

"I always loved that first tauren image. Sammy just really defining
their bulk and their ferocity. It was a definitive image."

—*Chris Metzen*

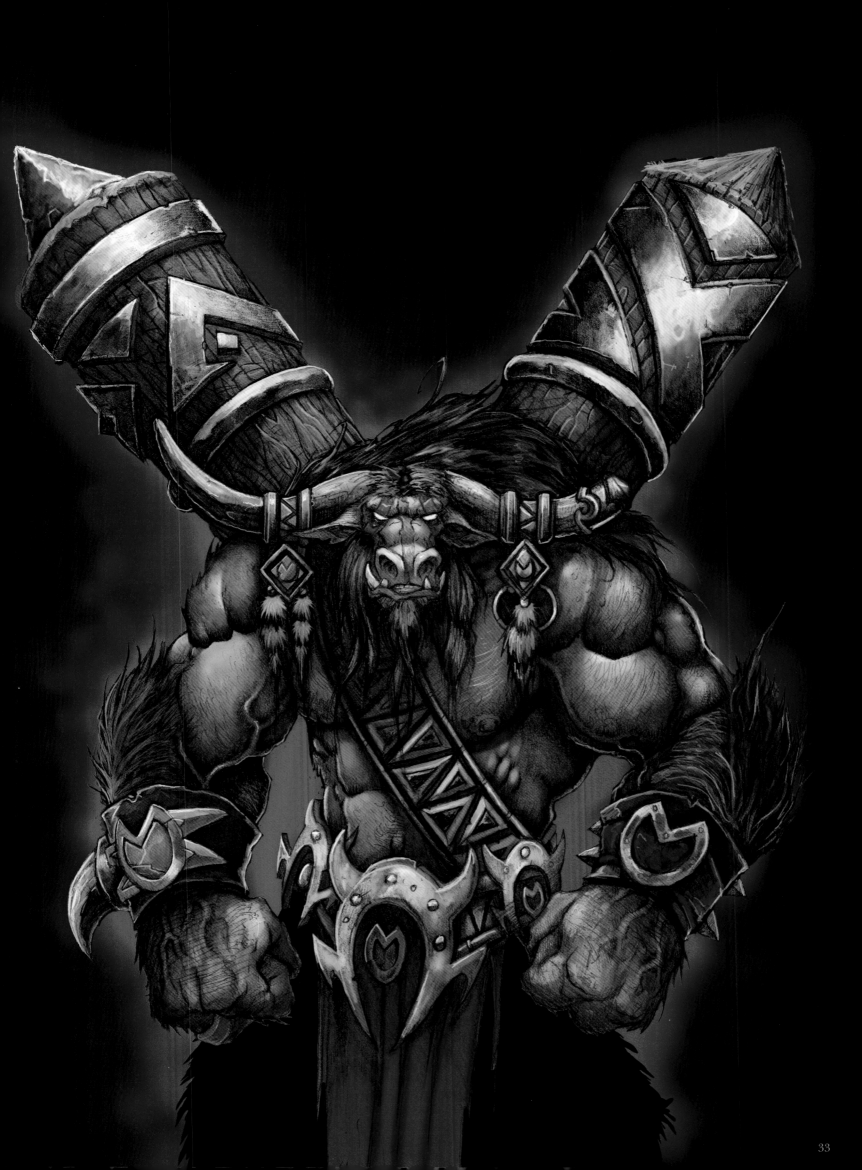

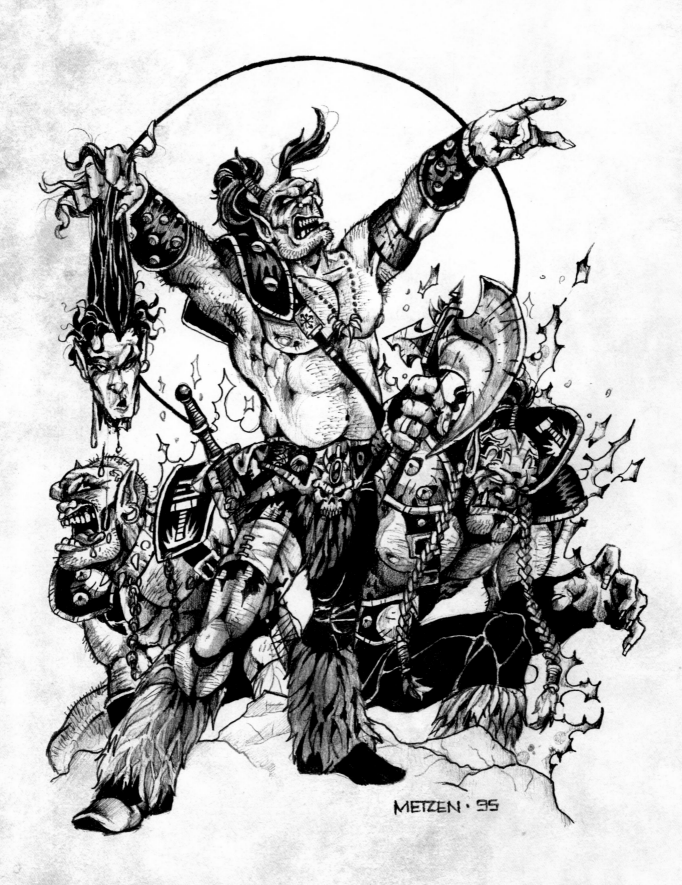

"The circle motif was just a way of tying them together. It didn't really mean anything. It wasn't a sun or a moon. In a lot of old-school Norman Rockwell from the *Saturday Evening Post*, he would just bind it with some kind of shape. It just drew your eye in and anchored the image. I made this from a bowl or coffee cup or something on my desk, and I just busted that out and traced it."

—*Chris Metzen*

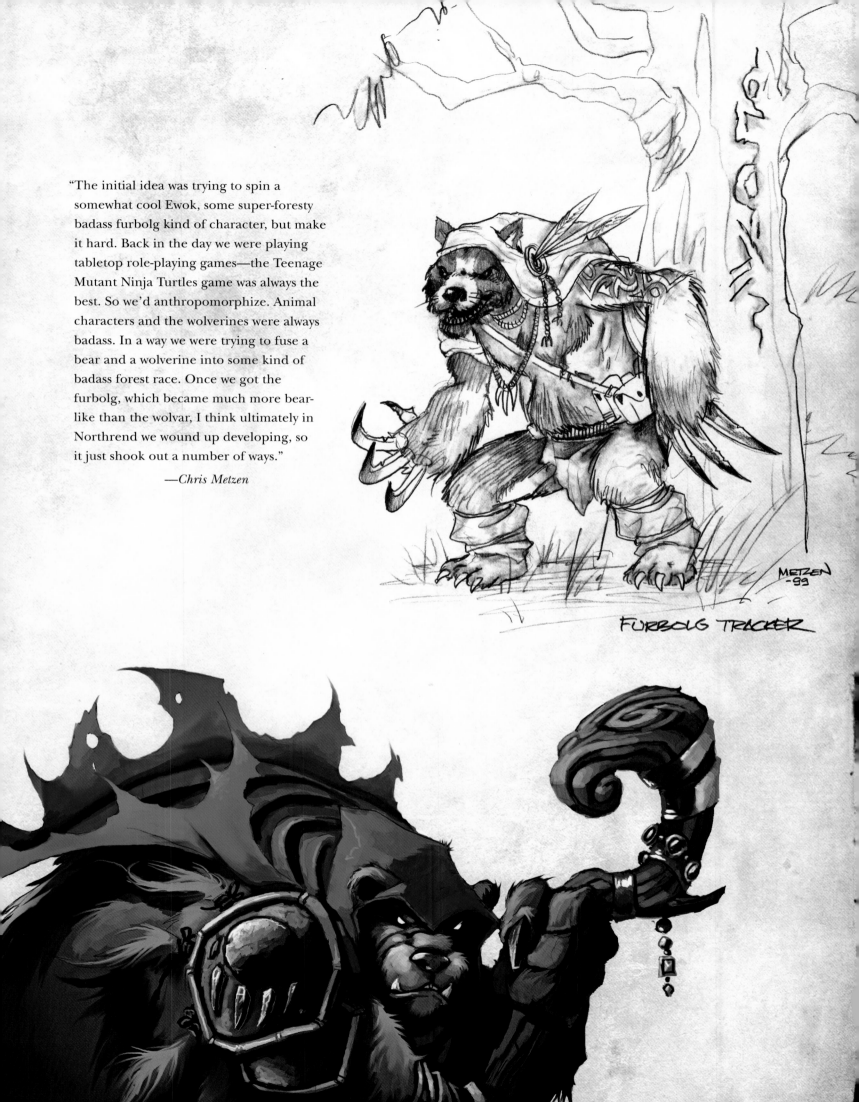

"The initial idea was trying to spin a somewhat cool Ewok, some super-foresty badass furbolg kind of character, but make it hard. Back in the day we were playing tabletop role-playing games—the Teenage Mutant Ninja Turtles game was always the best. So we'd anthropomorphize. Animal characters and the wolverines were always badass. In a way we were trying to fuse a bear and a wolverine into some kind of badass forest race. Once we got the furbolg, which became much more bear-like than the wolvar, I think ultimately in Northrend we wound up developing, so it just shook out a number of ways."

—Chris Metzen

FURBOLG TRACKER

35

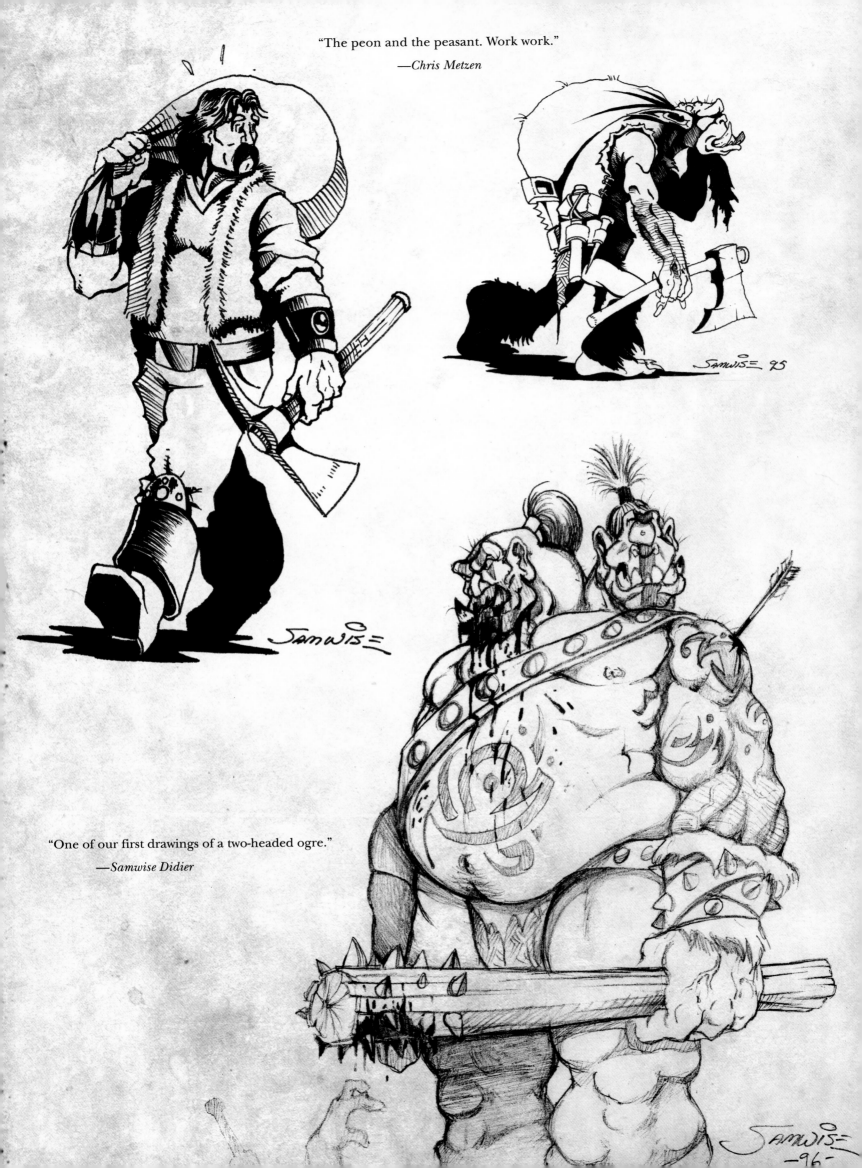

"The peon and the peasant. Work work."
—Chris Metzen

"One of our first drawings of a two-headed ogre."
—Samwise Didier

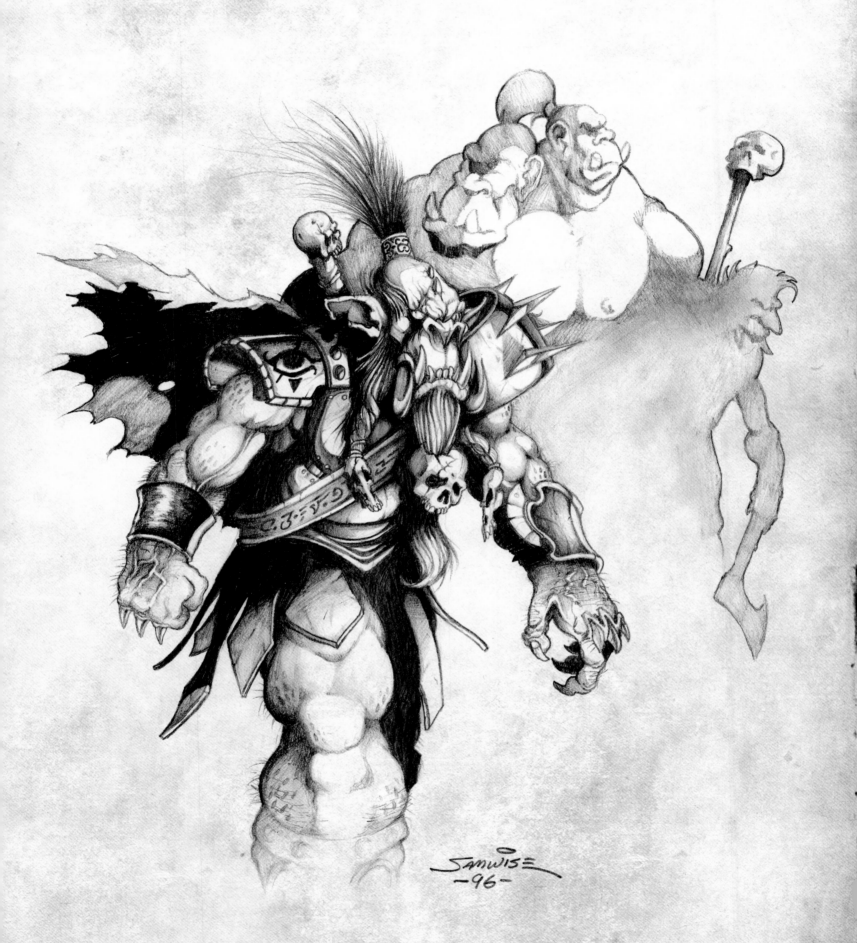

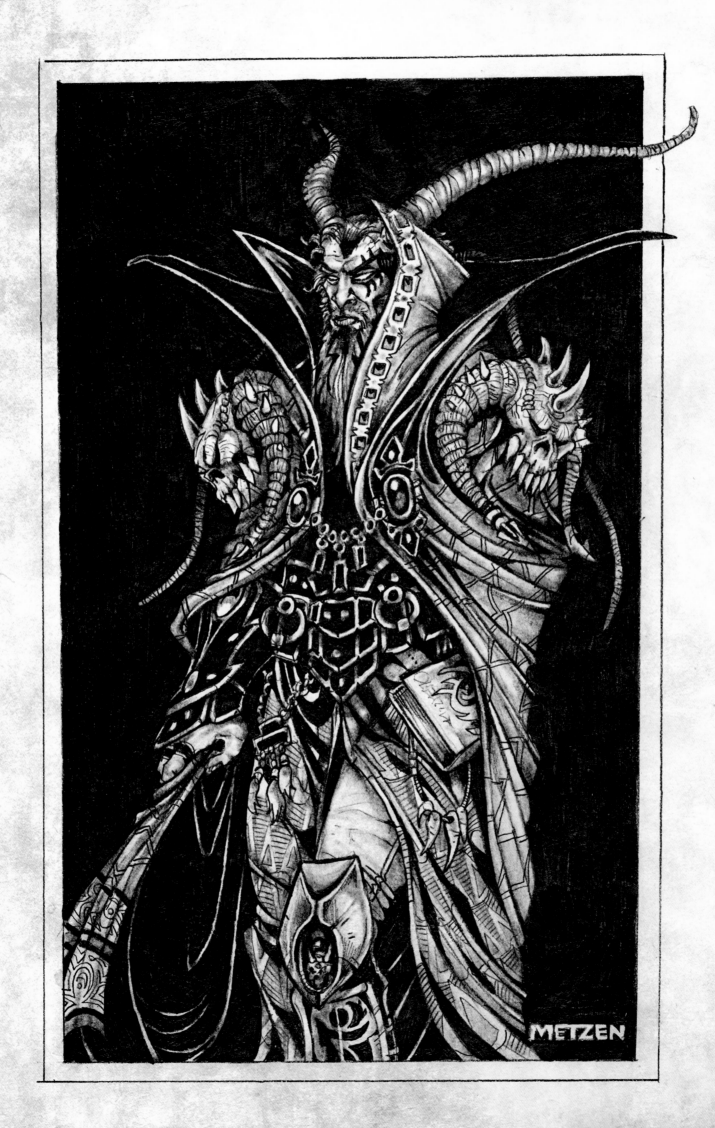

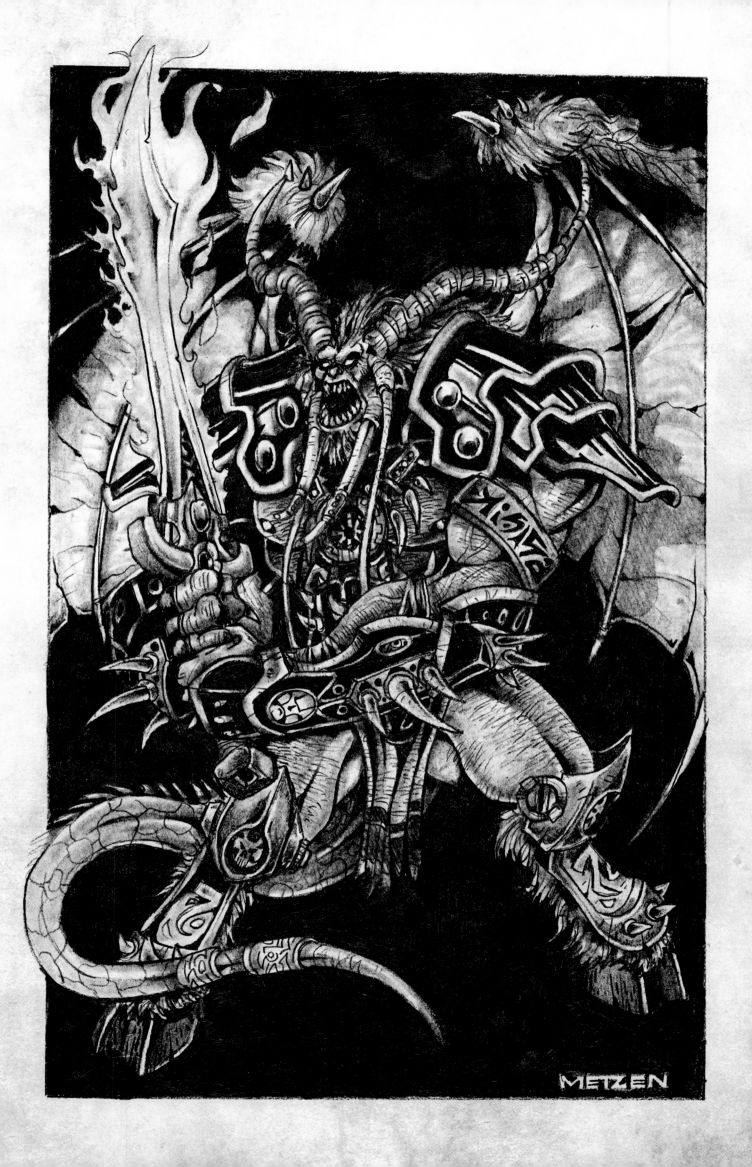

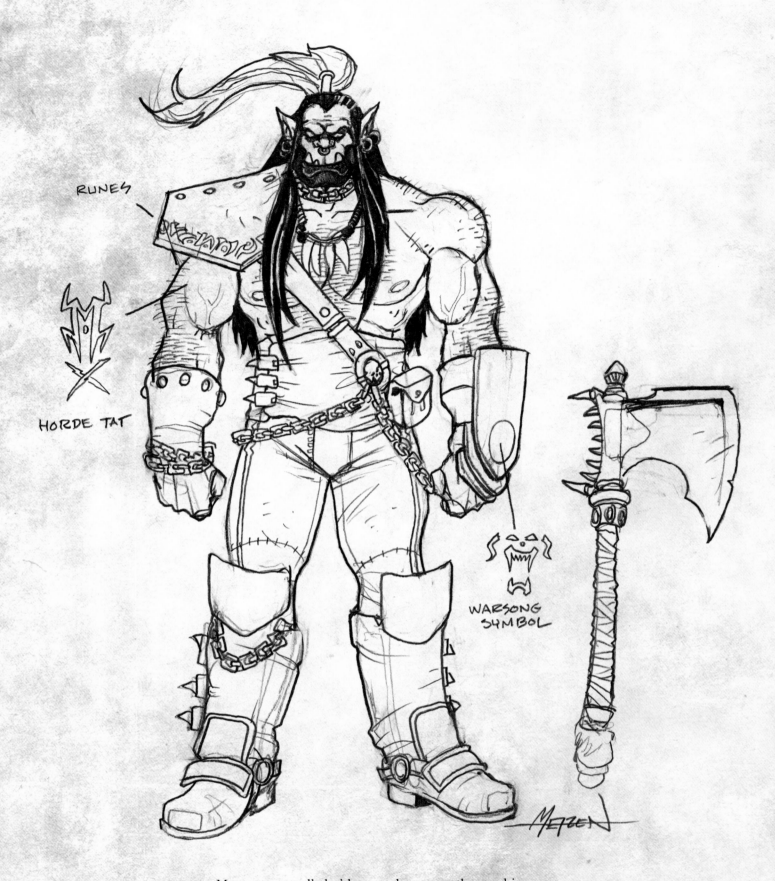

RUNES

HORDE TAT

WARSONG SYMBOL

NICK: Metzen, normally he'd never draw an orthographic.

SAMWISE: Not a lot of black on that image.

NICK: But we were changing the way we were doing things. We were
 gonna have to interpret these drawings. So, I'm over there going,
 "Can you just draw them flat so I can see what the hell he looks like?"

CHRIS M.: "What the hell is his costume?"

NICK: Yeah. "Is that blood on his chin or . . . ?"

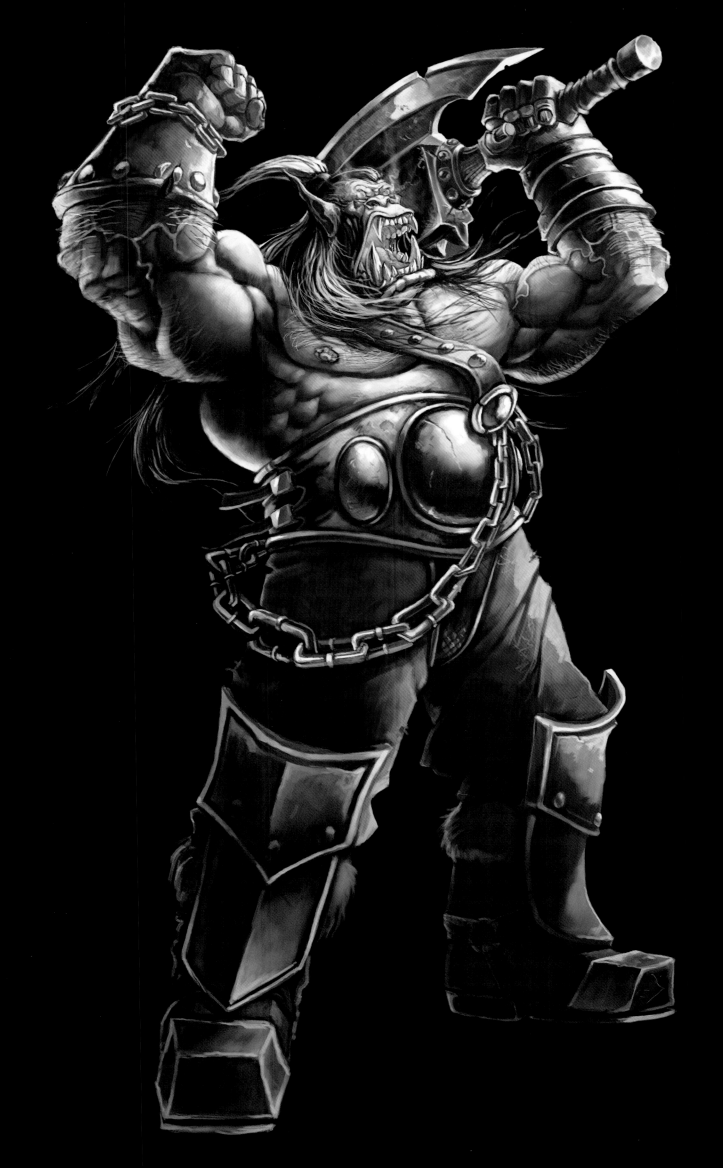

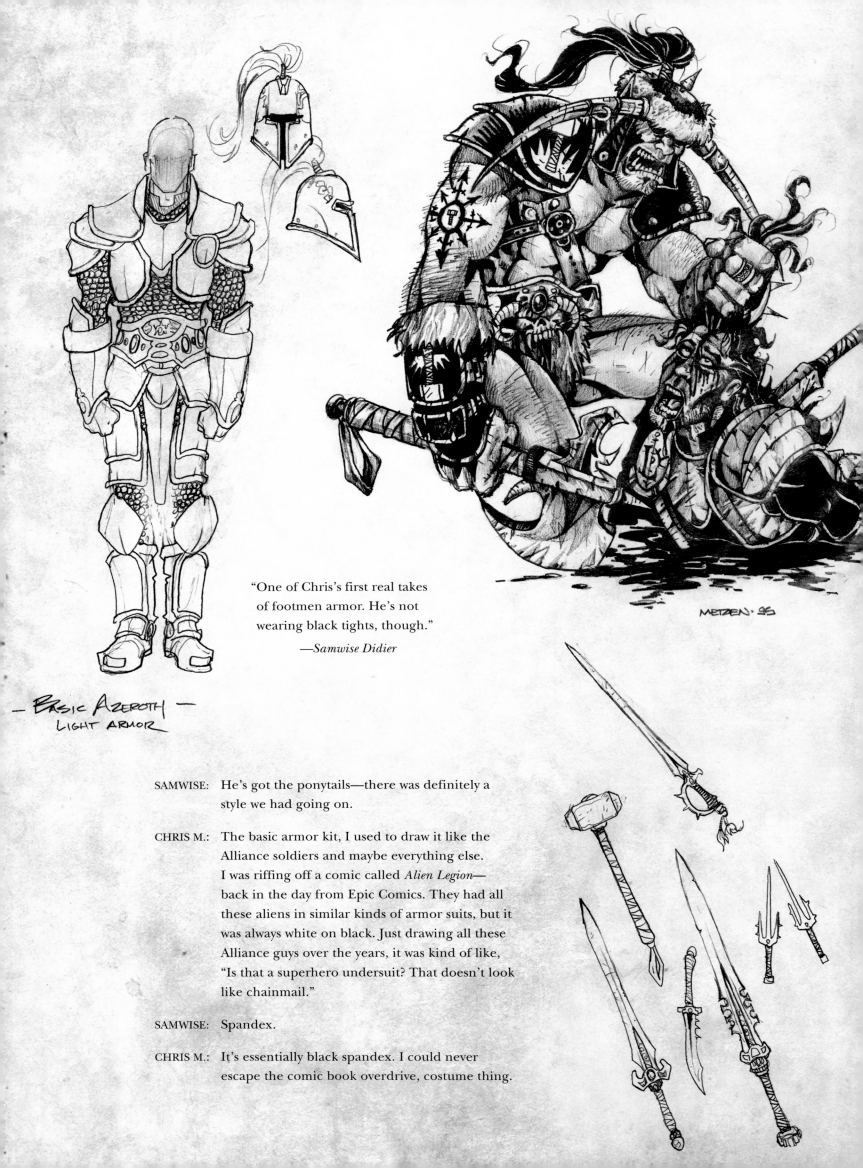

"One of Chris's first real takes of footmen armor. He's not wearing black tights, though."
—*Samwise Didier*

— BASIC AZEROTH —
LIGHT ARMOR

METZEN · 95

SAMWISE: He's got the ponytails—there was definitely a style we had going on.

CHRIS M.: The basic armor kit, I used to draw it like the Alliance soldiers and maybe everything else. I was riffing off a comic called *Alien Legion*— back in the day from Epic Comics. They had all these aliens in similar kinds of armor suits, but it was always white on black. Just drawing all these Alliance guys over the years, it was kind of like, "Is that a superhero undersuit? That doesn't look like chainmail."

SAMWISE: Spandex.

CHRIS M.: It's essentially black spandex. I could never escape the comic book overdrive, costume thing.

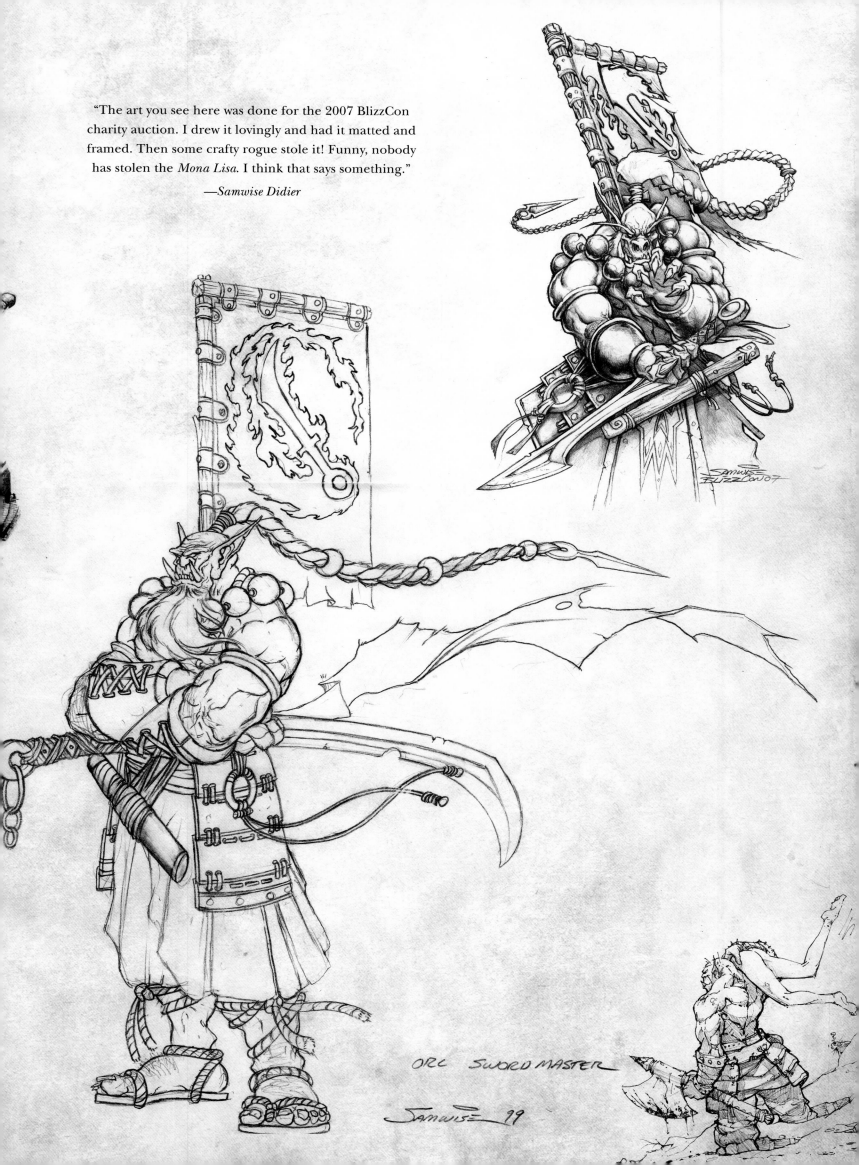

"The art you see here was done for the 2007 BlizzCon charity auction. I drew it lovingly and had it matted and framed. Then some crafty rogue stole it! Funny, nobody has stolen the *Mona Lisa*. I think that says something."

—*Samwise Didier*

ORC SWORD MASTER

Samwise 99

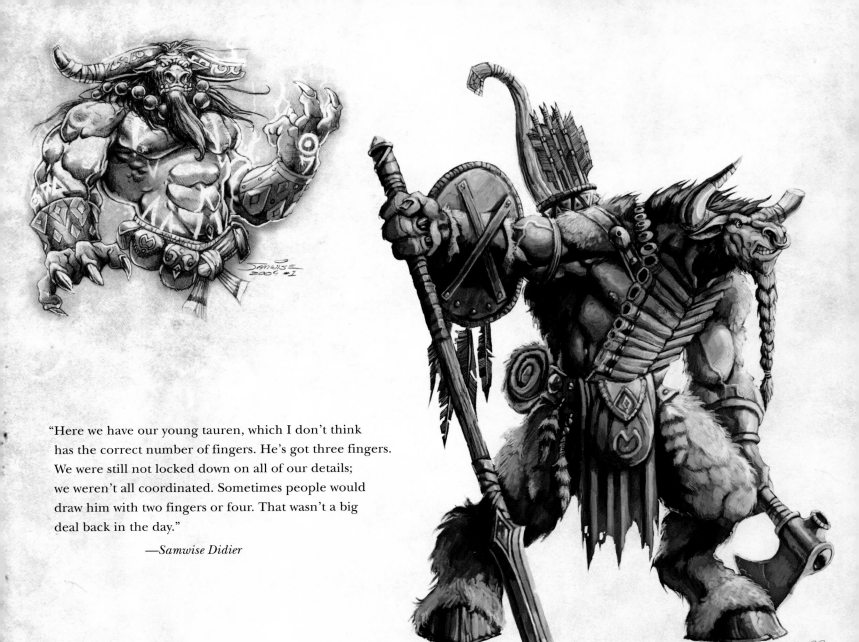

"Here we have our young tauren, which I don't think has the correct number of fingers. He's got three fingers. We were still not locked down on all of our details; we weren't all coordinated. Sometimes people would draw him with two fingers or four. That wasn't a big deal back in the day."

—*Samwise Didier*

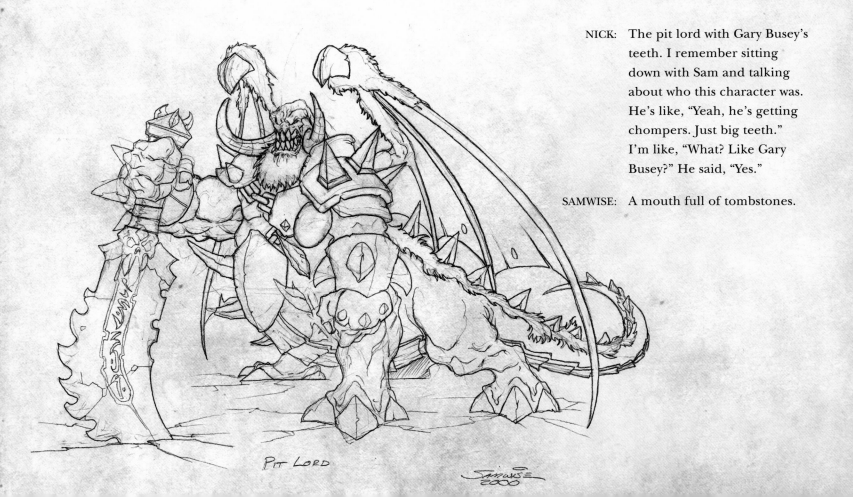

PIT LORD

NICK: The pit lord with Gary Busey's teeth. I remember sitting down with Sam and talking about who this character was. He's like, "Yeah, he's getting chompers. Just big teeth." I'm like, "What? Like Gary Busey?" He said, "Yes."

SAMWISE: A mouth full of tombstones.

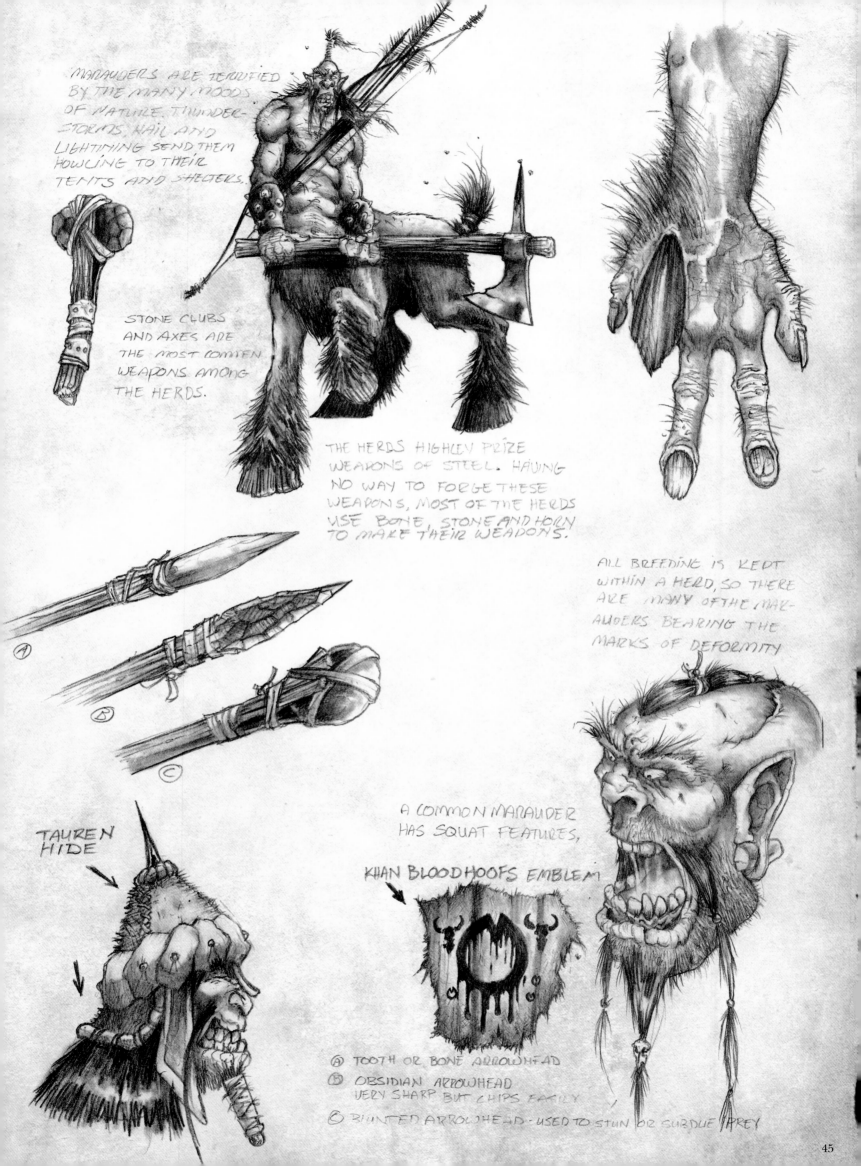

MARAUDERS ARE TERRIFIED BY THE MANY MOODS OF NATURE. THUNDER-STORMS, HAIL AND LIGHTNING SEND THEM HOWLING TO THEIR TENTS AND SHELTERS.

STONE CLUBS AND AXES ARE THE MOST COMMON WEAPONS AMONG THE HERDS.

THE HERDS HIGHLY PRIZE WEAPONS OF STEEL. HAVING NO WAY TO FORGE THESE WEAPONS, MOST OF THE HERDS USE BONE, STONE AND HORN TO MAKE THEIR WEAPONS.

Ⓐ

Ⓑ

Ⓒ

ALL BREEDING IS KEPT WITHIN A HERD, SO THERE ARE MANY OF THE MAR-AUDERS BEARING THE MARKS OF DEFORMITY

TAUREN HIDE

A COMMON MARAUDER HAS SQUAT FEATURES.

KHAN BLOODHOOFS EMBLEM

Ⓐ TOOTH OR BONE ARROWHEAD

Ⓑ OBSIDIAN ARROWHEAD VERY SHARP BUT CHIPS EASILY

Ⓒ BLUNTED ARROWHEAD - USED TO STUN OR SUBDUE PREY

45

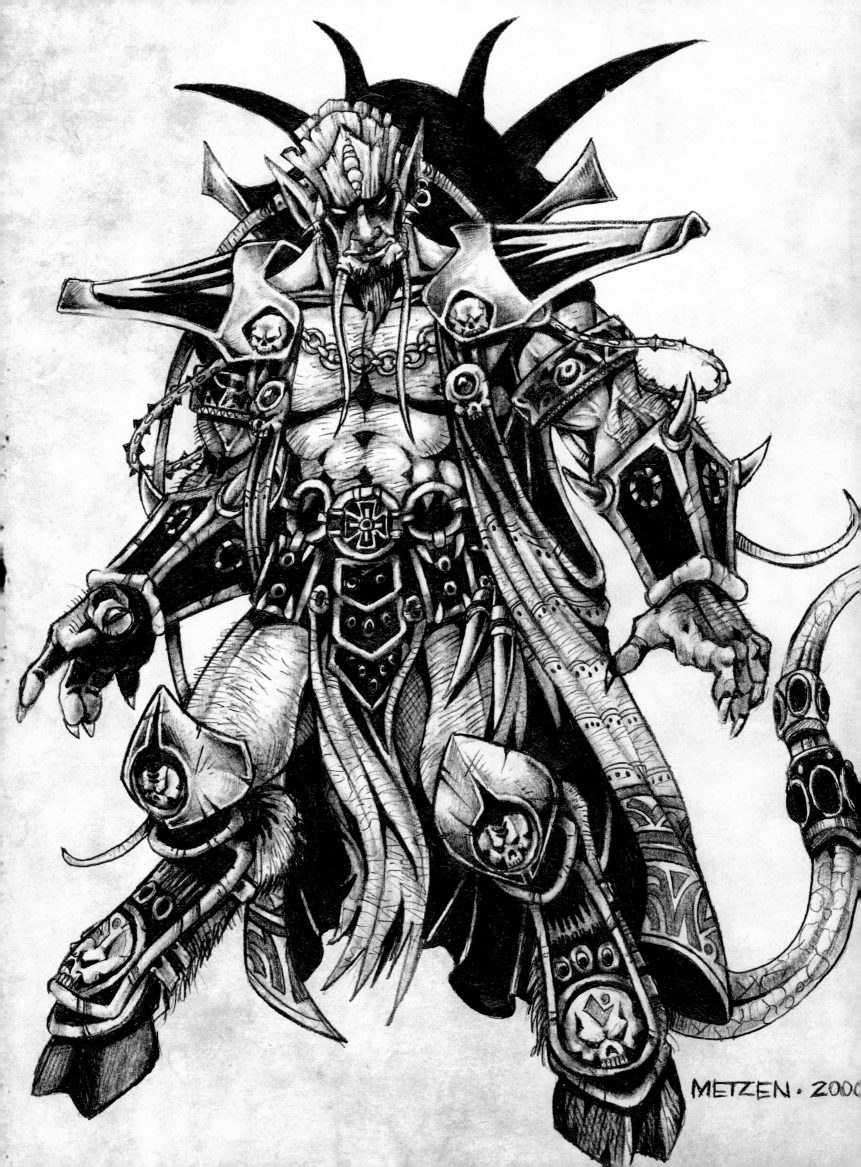

METZEN · 200

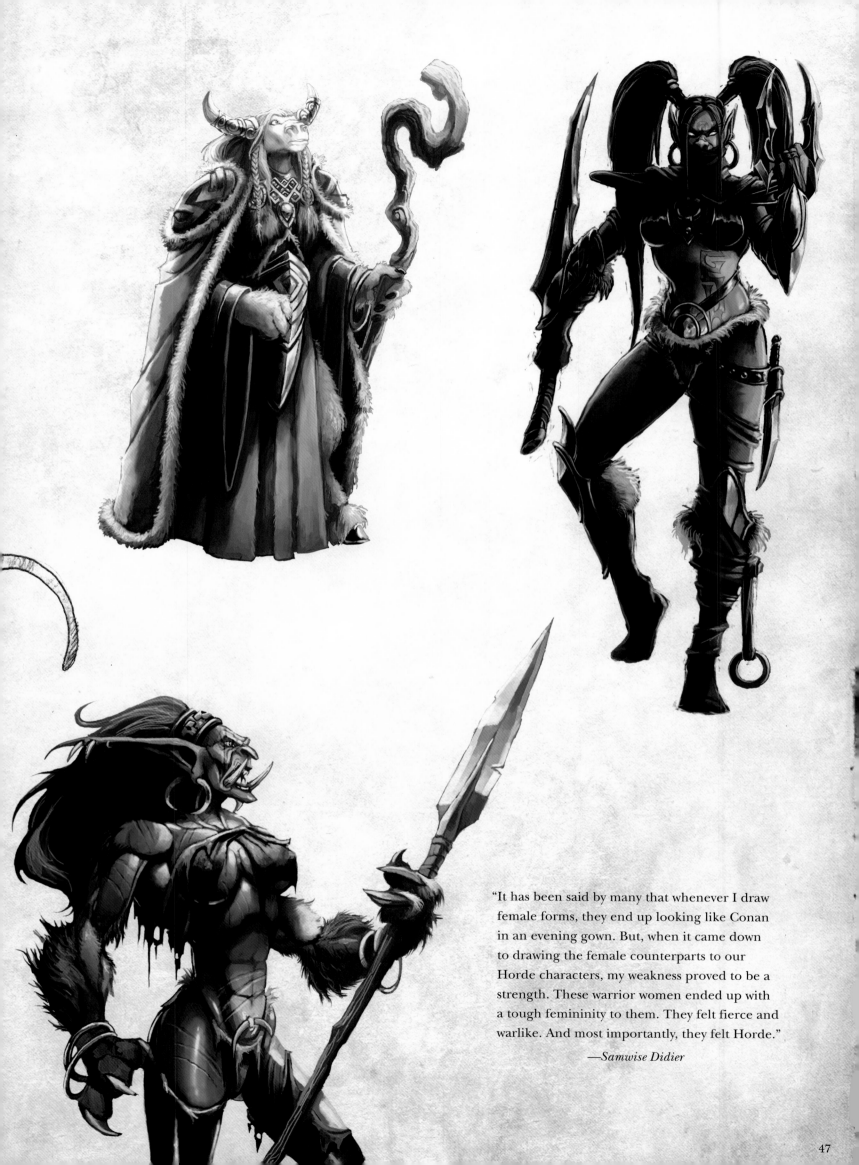

"It has been said by many that whenever I draw female forms, they end up looking like Conan in an evening gown. But, when it came down to drawing the female counterparts to our Horde characters, my weakness proved to be a strength. These warrior women ended up with a tough femininity to them. They felt fierce and warlike. And most importantly, they felt Horde."

—Samwise Didier

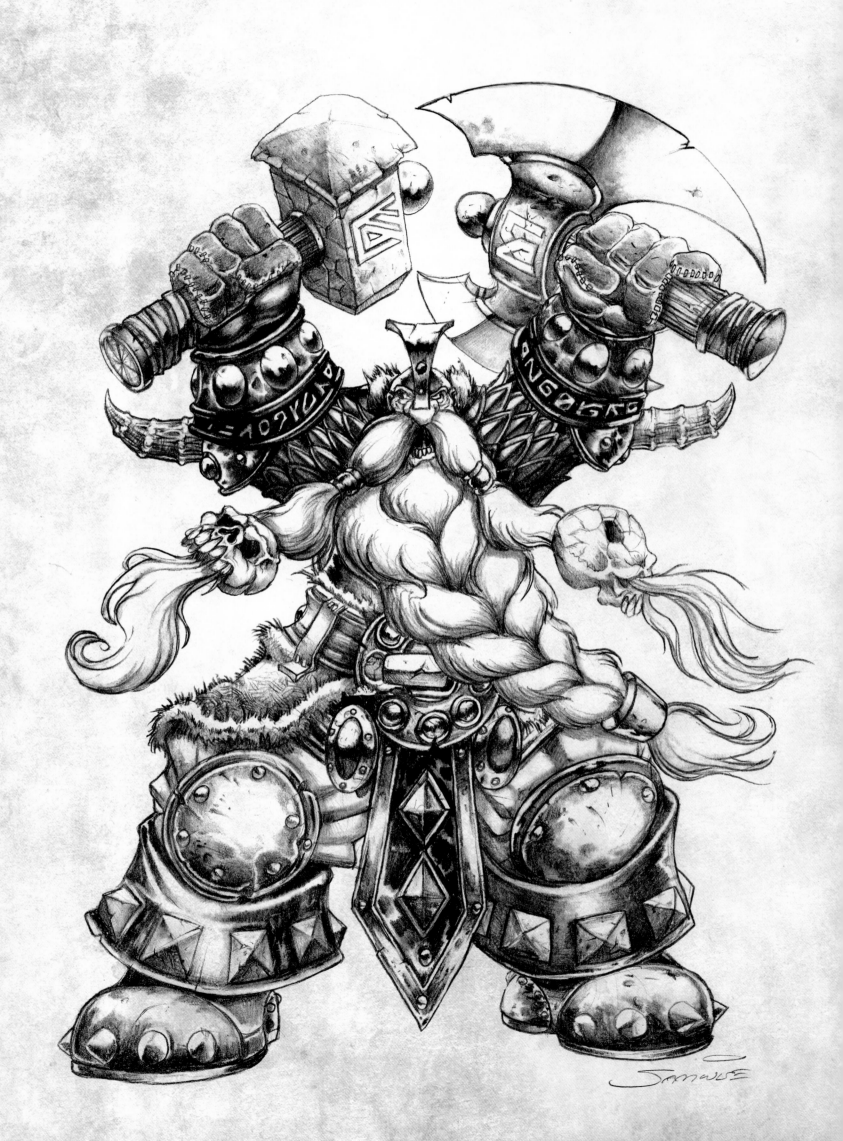

THE GNOLLS.

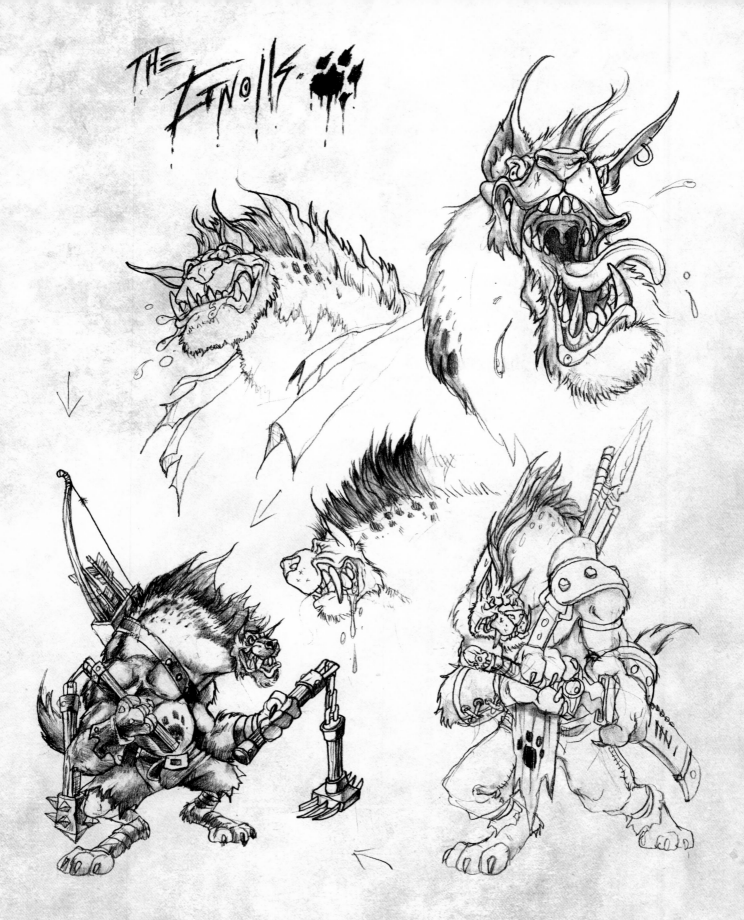

"These were the first drawings for the gnolls, the first concepts done for *Warcraft III*, for some of the critters in the background. So they rolled into WoW."

—*Samwise Didier*

"I always loved the kind of raised back hackles. The hyena look was definitely a very cool spin for gnolls. You know, we hadn't quite seen it before, and it added to that quasi-cartoon, quasi-savage WoW thing."

—*Chris Metzen*

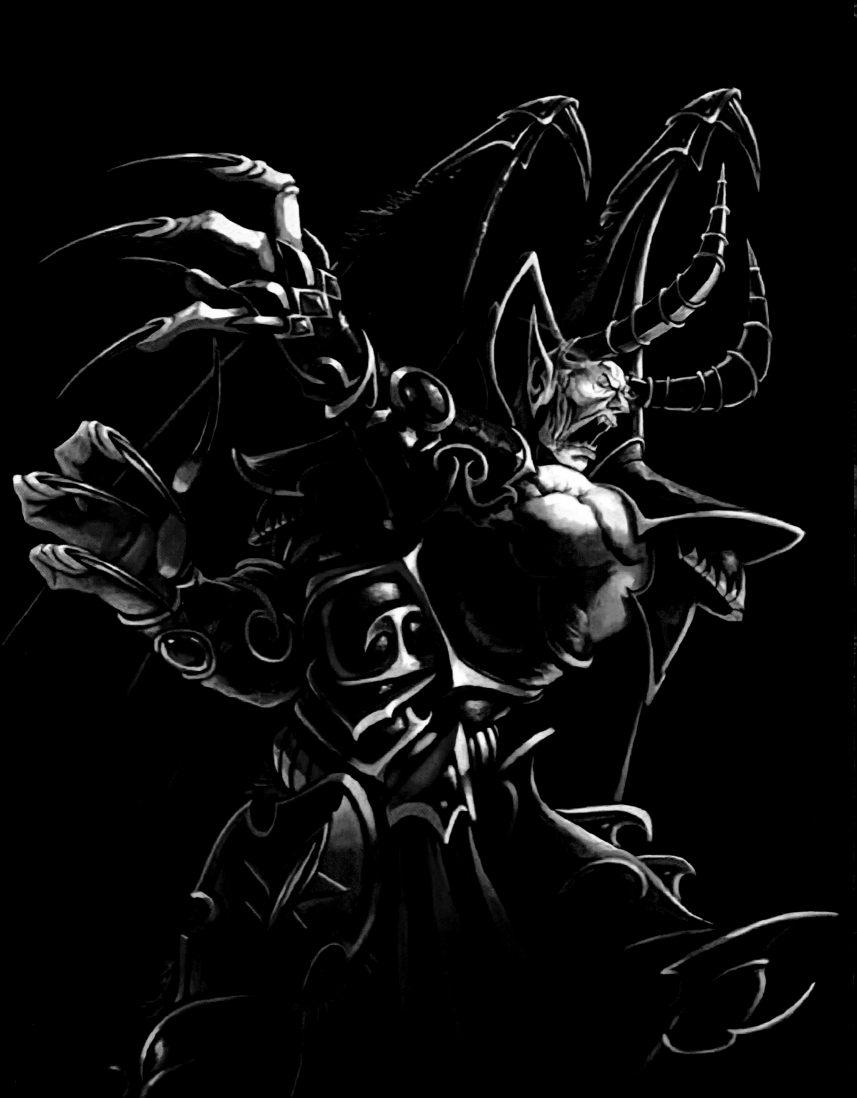

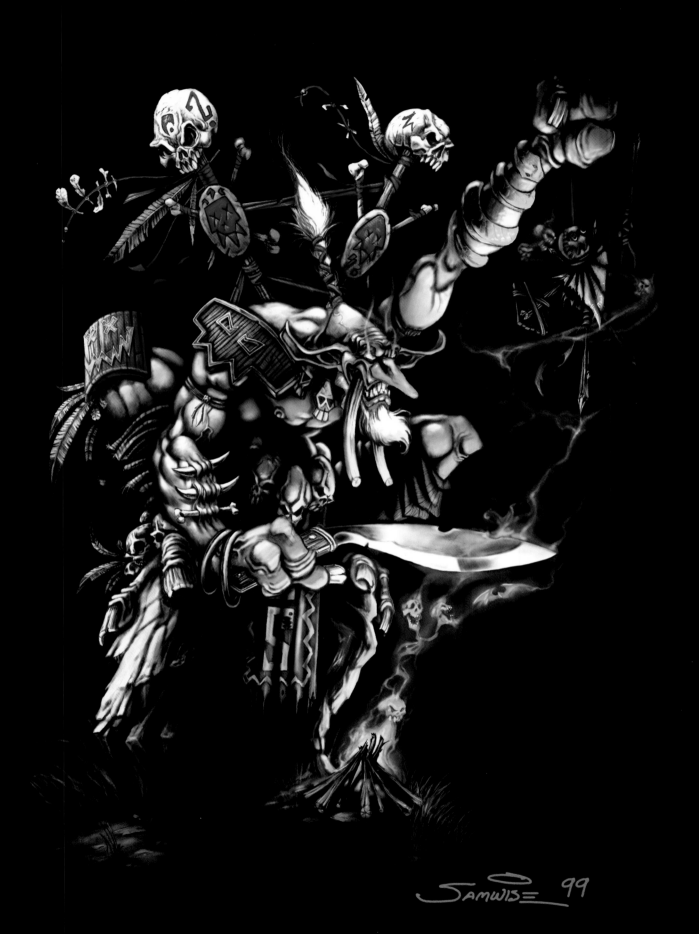

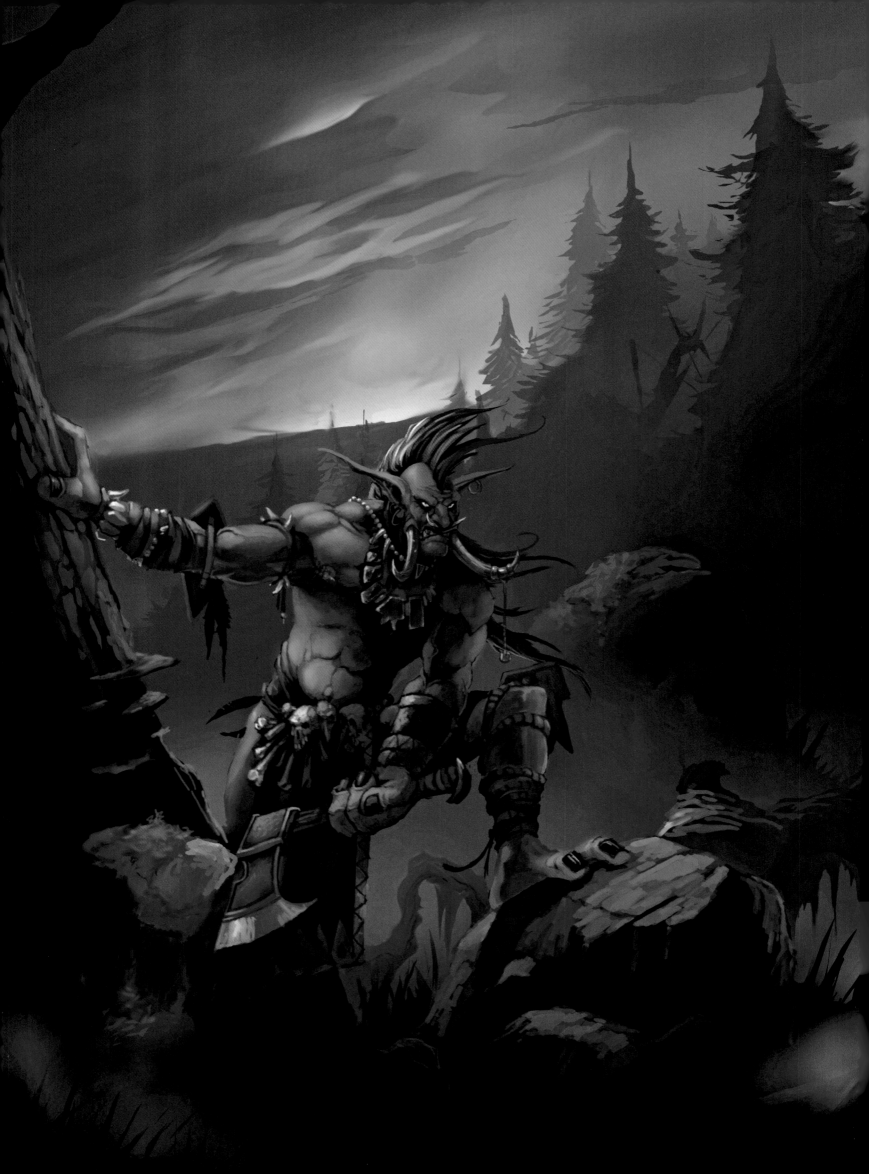

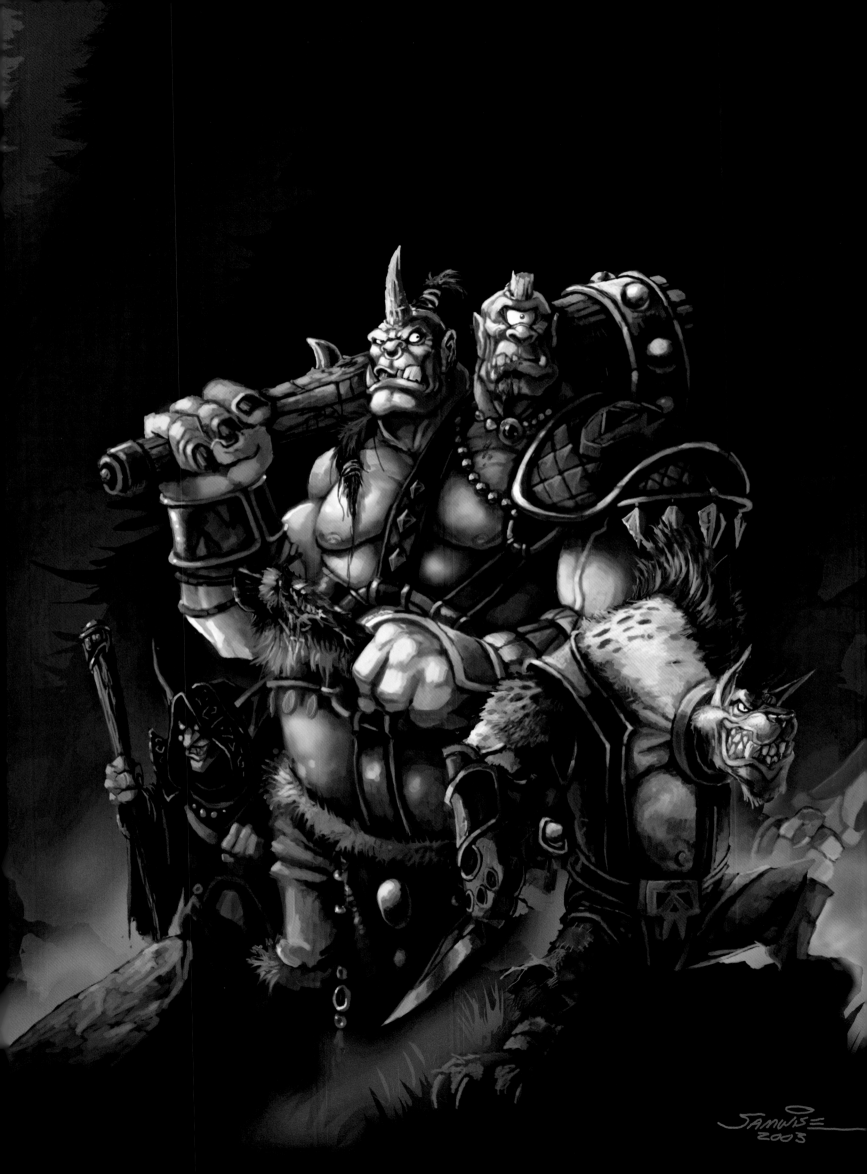

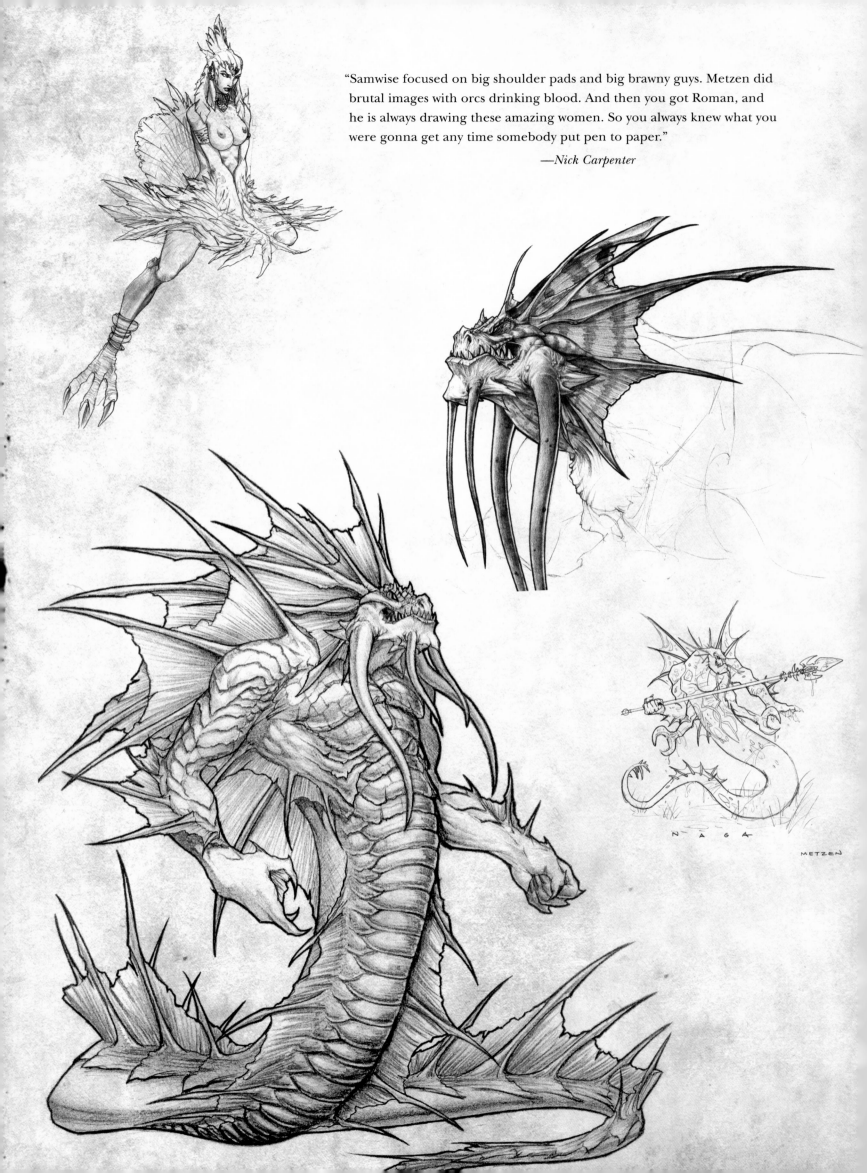

"Samwise focused on big shoulder pads and big brawny guys. Metzen did brutal images with orcs drinking blood. And then you got Roman, and he is always drawing these amazing women. So you always knew what you were gonna get any time somebody put pen to paper."

—*Nick Carpenter*

NAGA

METZEN

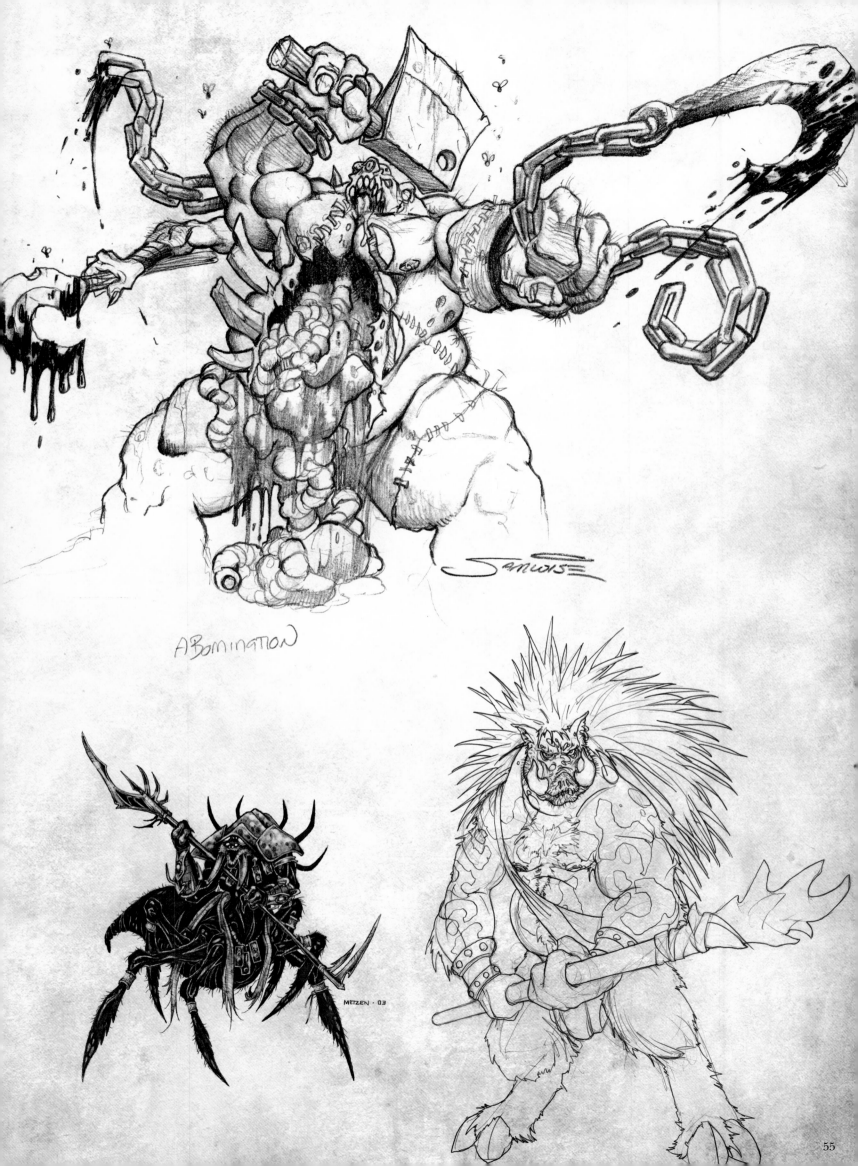

ABomination

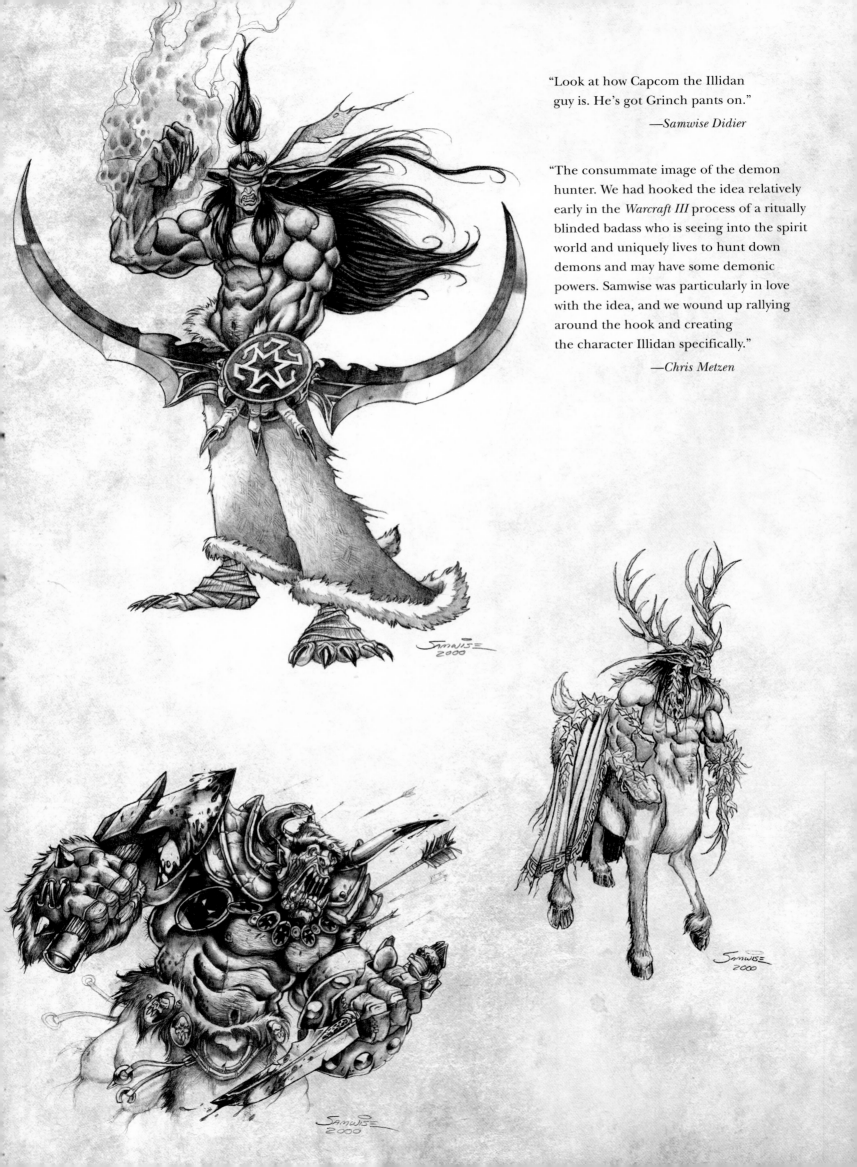

"Look at how Capcom the Illidan guy is. He's got Grinch pants on."

—*Samwise Didier*

"The consummate image of the demon hunter. We had hooked the idea relatively early in the *Warcraft III* process of a ritually blinded badass who is seeing into the spirit world and uniquely lives to hunt down demons and may have some demonic powers. Samwise was particularly in love with the idea, and we wound up rallying around the hook and creating the character Illidan specifically."

—*Chris Metzen*

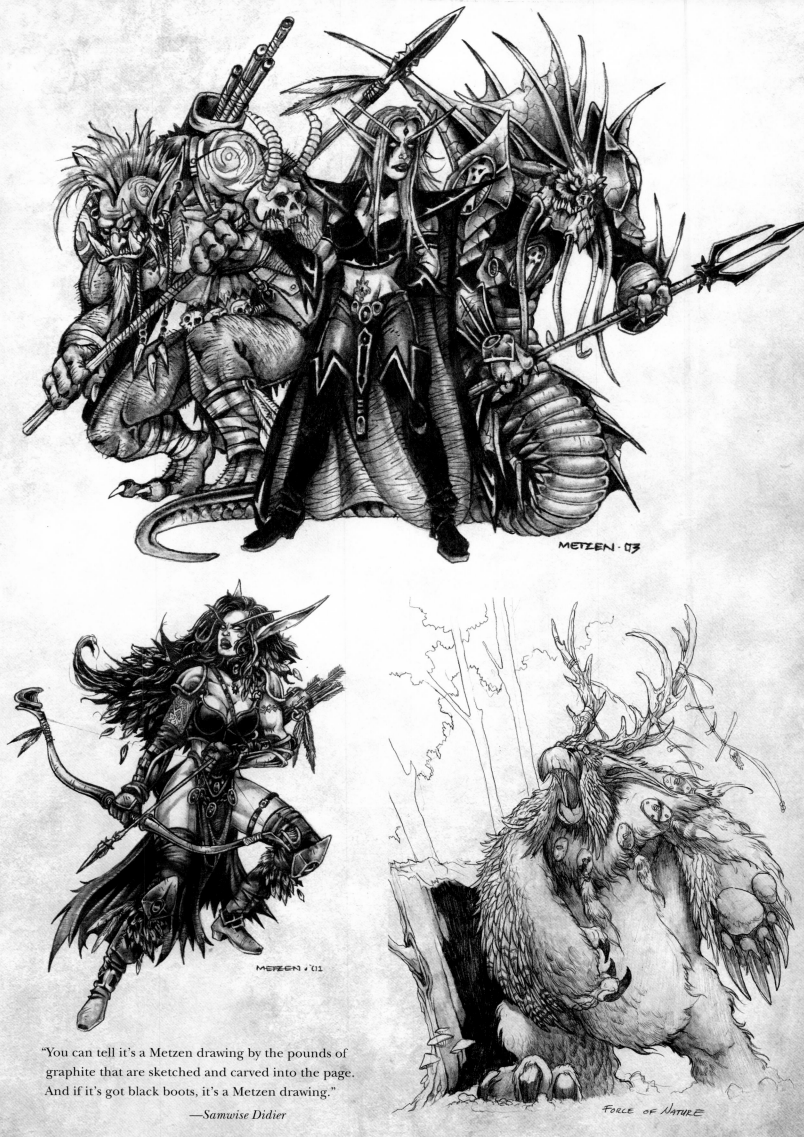

"You can tell it's a Metzen drawing by the pounds of graphite that are sketched and carved into the page. And if it's got black boots, it's a Metzen drawing."

—Samwise Didier

METZEN · 03

METZEN · 01

FORCE OF NATURE

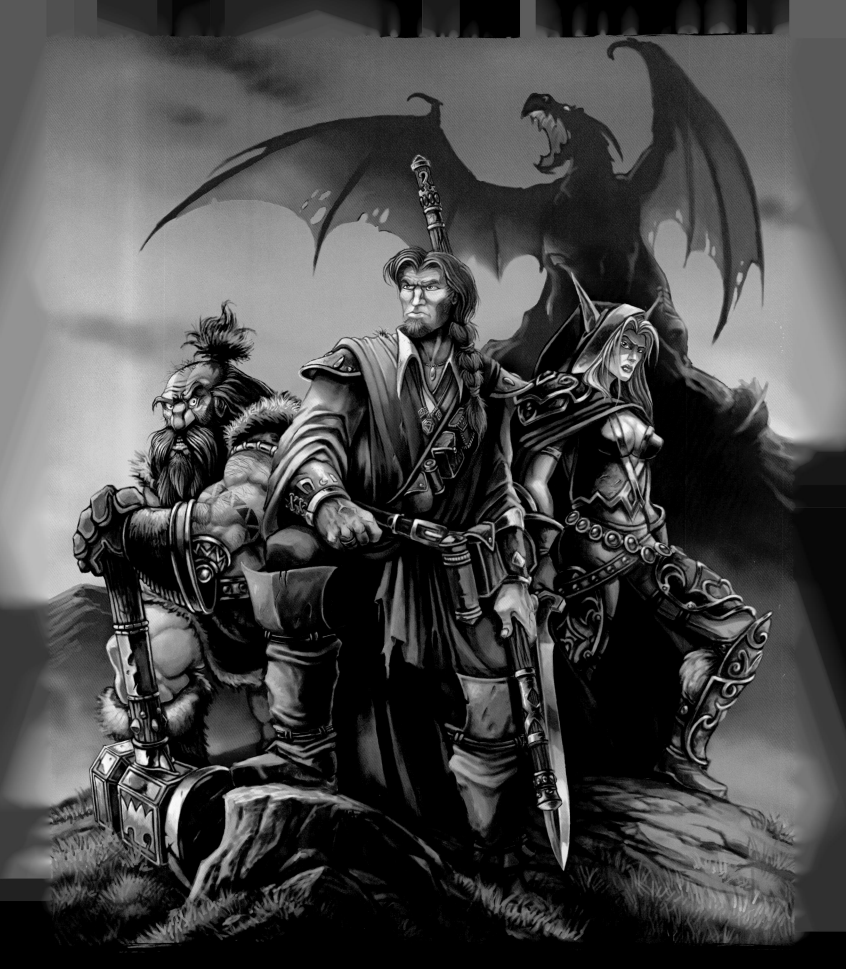

"This is the cover for the first book we ever put out. Finally getting to see a look of adventurers in Warcraft. It wasn't a story necessarily about the armies that we had built the franchise around. It was just a couple people hanging out, a dwarf, an elf, a human. This was one of those seminal images where you just start going, 'Huh.' Where you can see that it's a world made up of individuals that come from very exotic and different places. Like her leather armor versus his tattered wizard robes. And I always particularly loved the silhouetted vision of Deathwing—this is one of the most effective dragon images we ever did, and it's an eighth of the level of detail that we usually chase. But it always struck me harder."

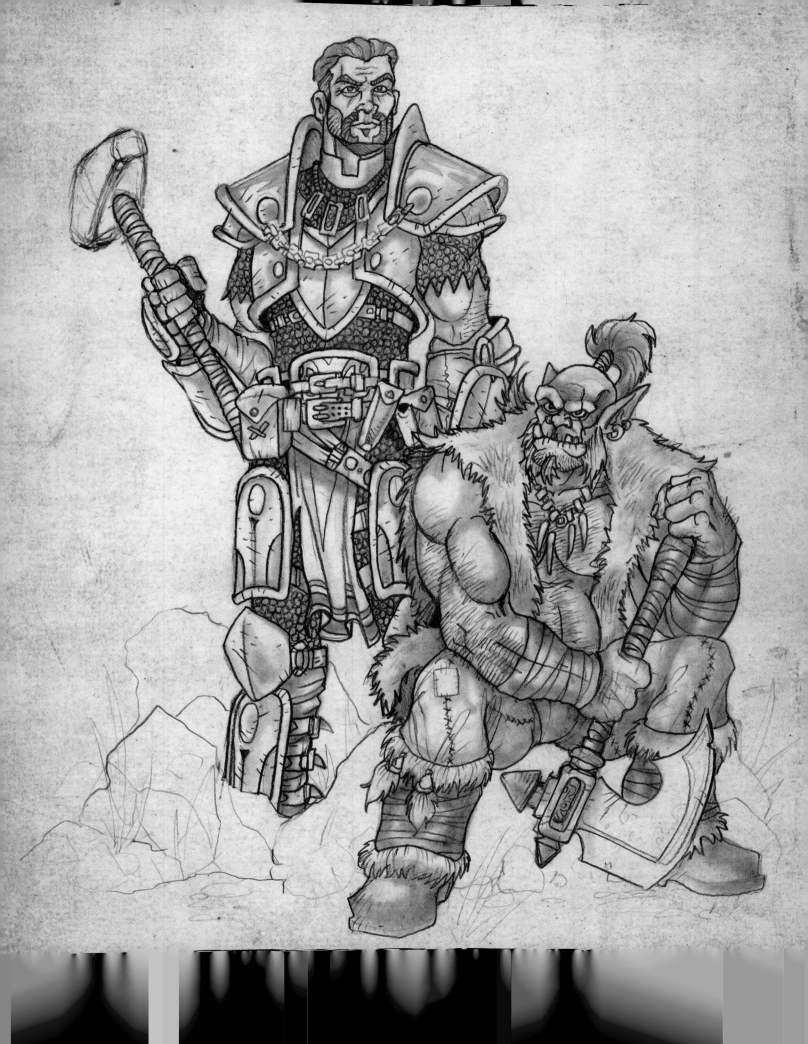

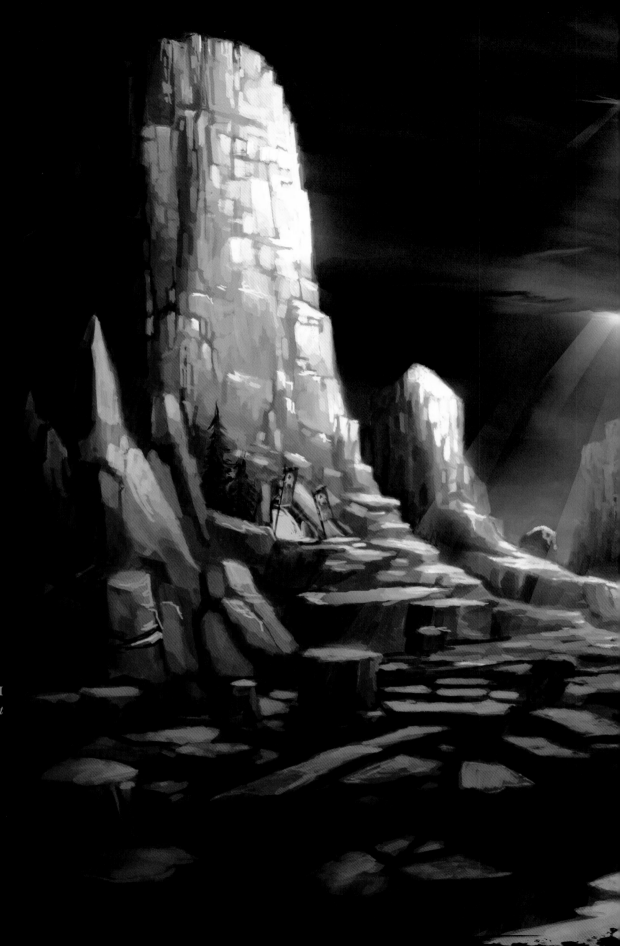

This is one of the favorite pieces I
have ever done. It is called *Duel at
Thunder Ridge* and deals with my
two favorite races, dwarves and
orcs, and my two favorite heroes
from *Warcraft III*, the mountain
king and the blademaster. Gone
are the armies and other military
trappings. It is just about two
warriors battling to see who will
reign supreme. The dwarf drew
first blood but the orc chopped
the dwarf's hammer in half!"
 —*Samwise Didier*

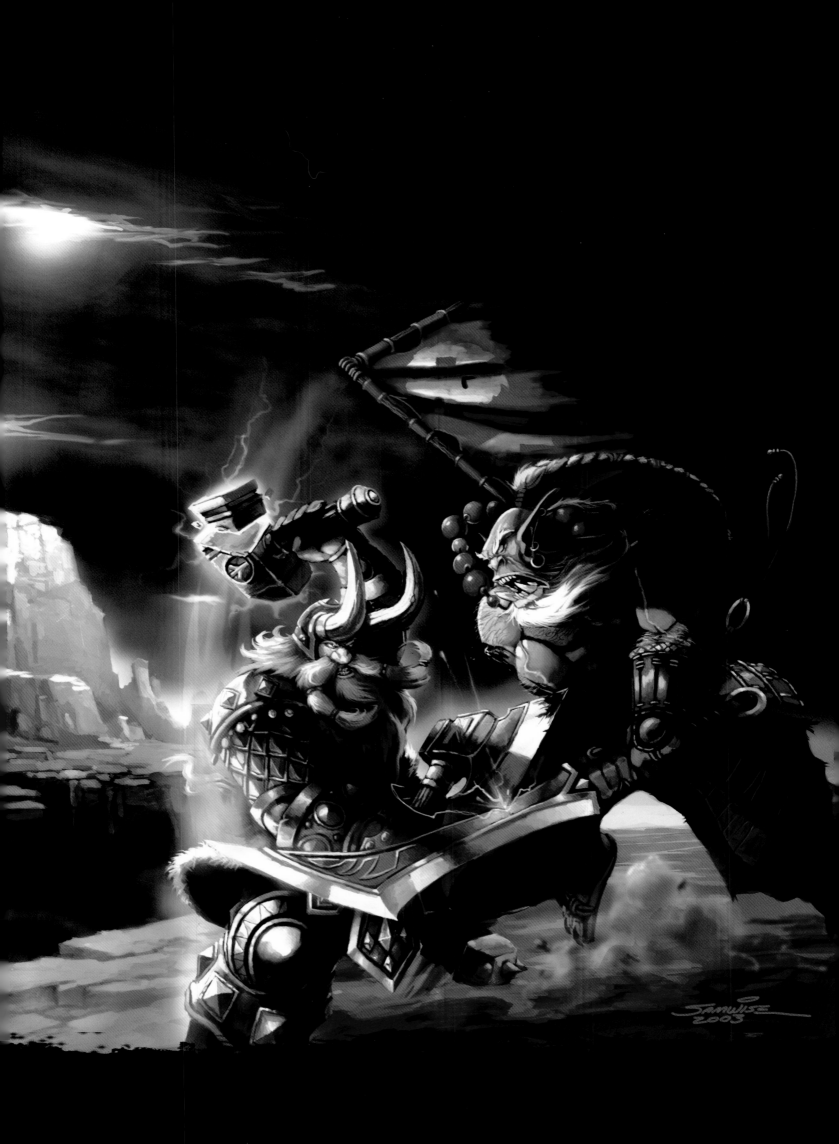

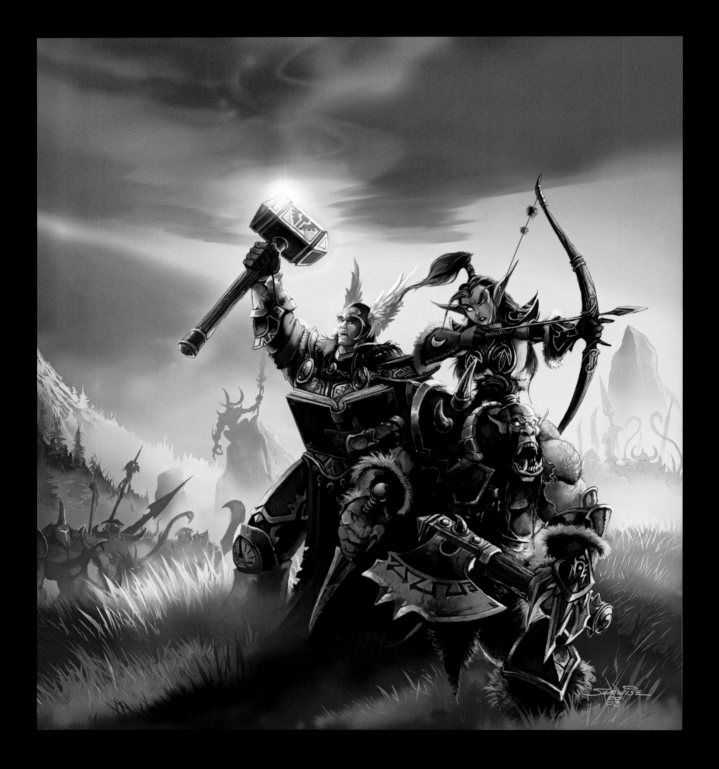

"This was the cover of the first RPG book we put out. It was right at the time we had shipped *Warcraft III*, so the Burning Legion, which features there in the background of the image, was the common franchise villain. The idea of an orc and a night elf and a human at an adventure party—like, 'Wow. Let's cross faction lines.' The night elves we had created up until then were ten thousand years old, and this girl looks like she's just starting her adventure. The mix of that chemistry and the colors—it was a fascinating image of Warcraft for me, and I just fell straight into it. It just opened up the world in a way that I had not looked at before."

—*Chris Metzen*

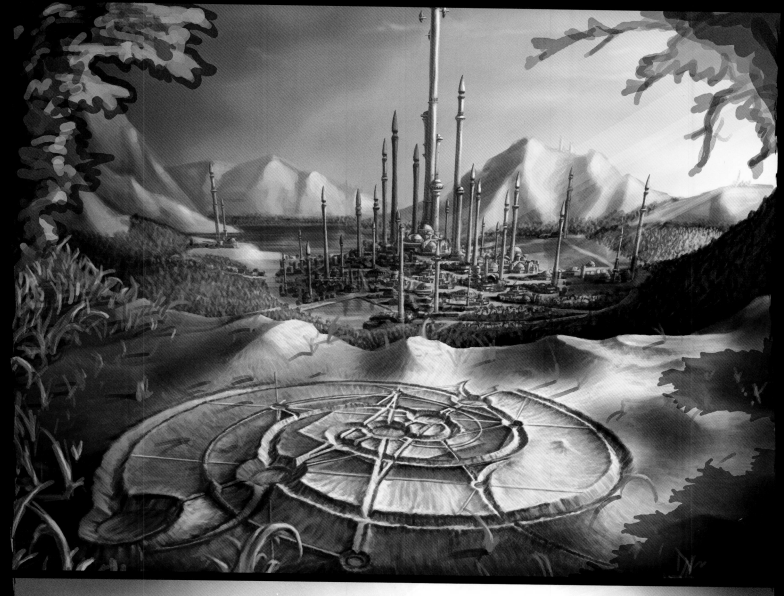

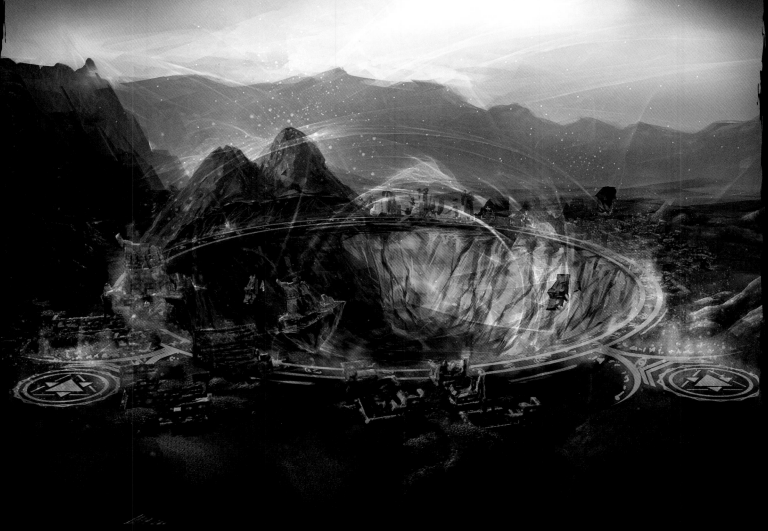

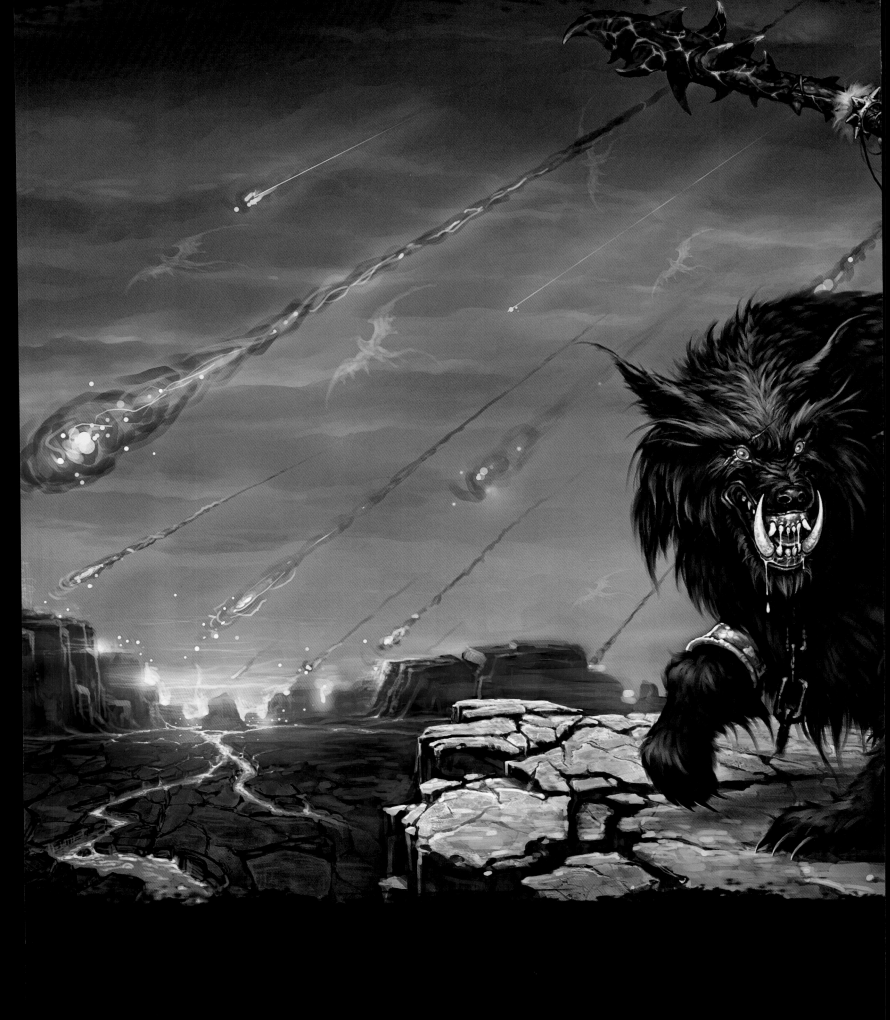

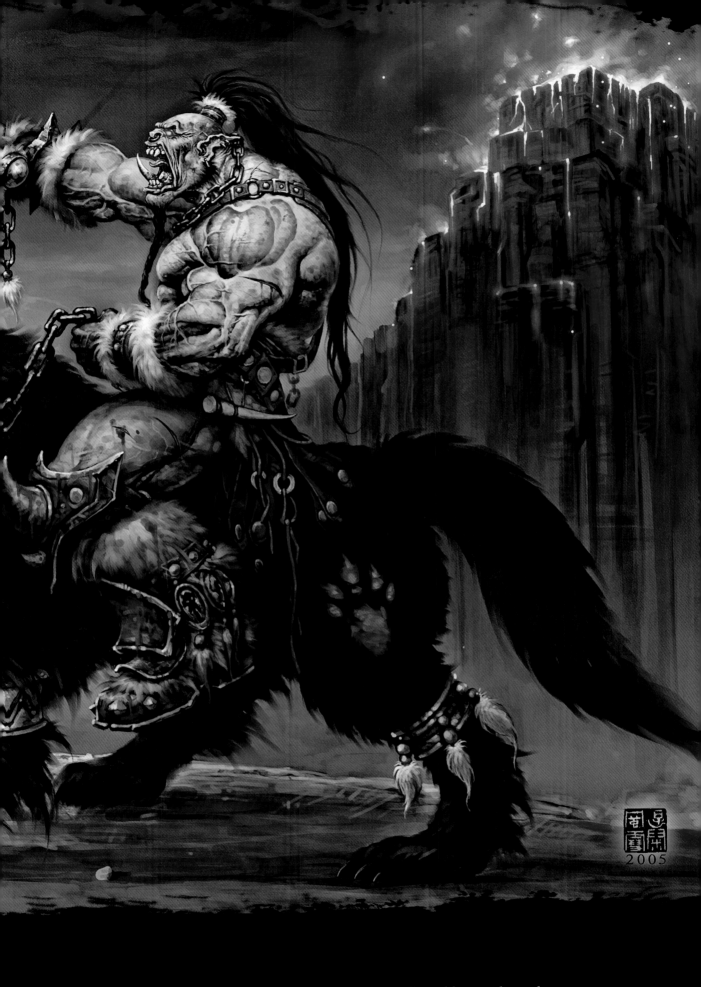

SAMWISE: This is Wei's fan art. Ever since then, Blizzard has not been the same.

CHRIS M.: Wei had sent it to Mike Morhaime and Mike went, 'Wow. This is amazing.' Based on tha
find this kid, so we contacted Wei. I think he was working with the Chinese office at the
we got his portfolio, and it was just mind-blowing. We offered him a chance to paint for
worked out of the Chinese office for a couple years. And he just got better, and better, a

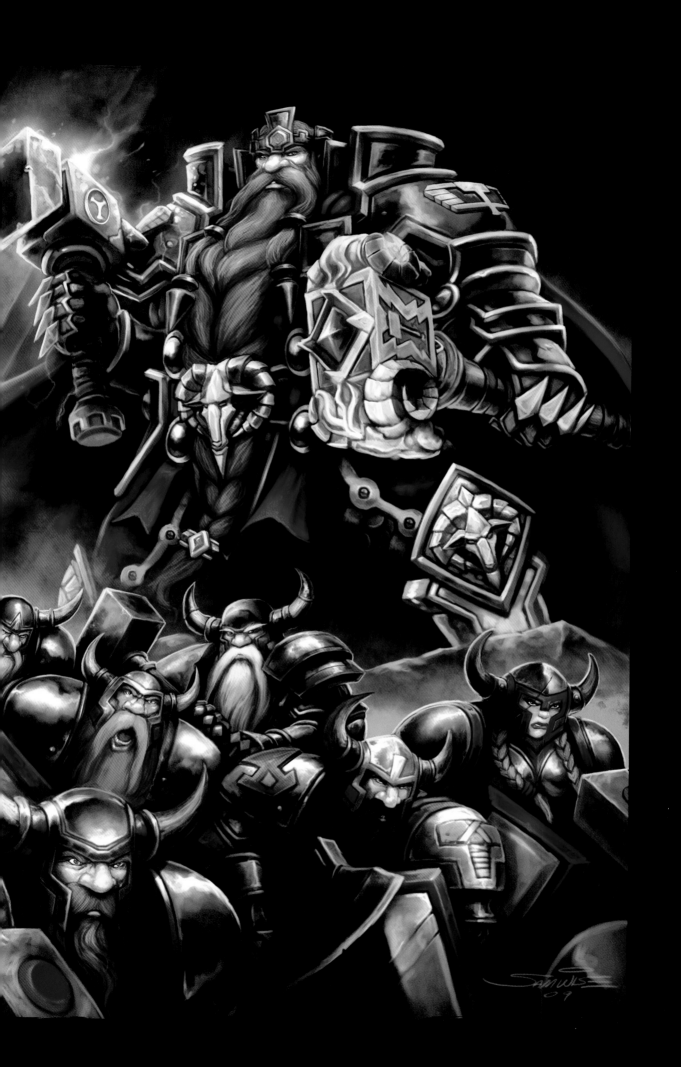

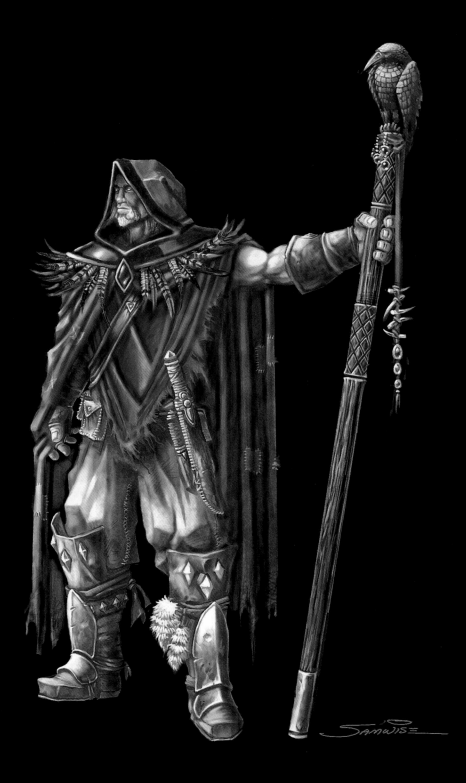

"Once again, you see all the same trademarks, right? The bold colors, the motor-
cycle boots, right? The Metzen gruff chin, right? It's all in there. At this point we're
archetype. But this image, I think it was when the guys were just starting to dig out
some of the *Warcraft III* storyline, and we knew he was gonna be a pivotal character
in that space. And, you know, we knew he was gonna be a large character. And so
Sam busted this out and we ended up building him in 3D."

—*Nick Carpenter*

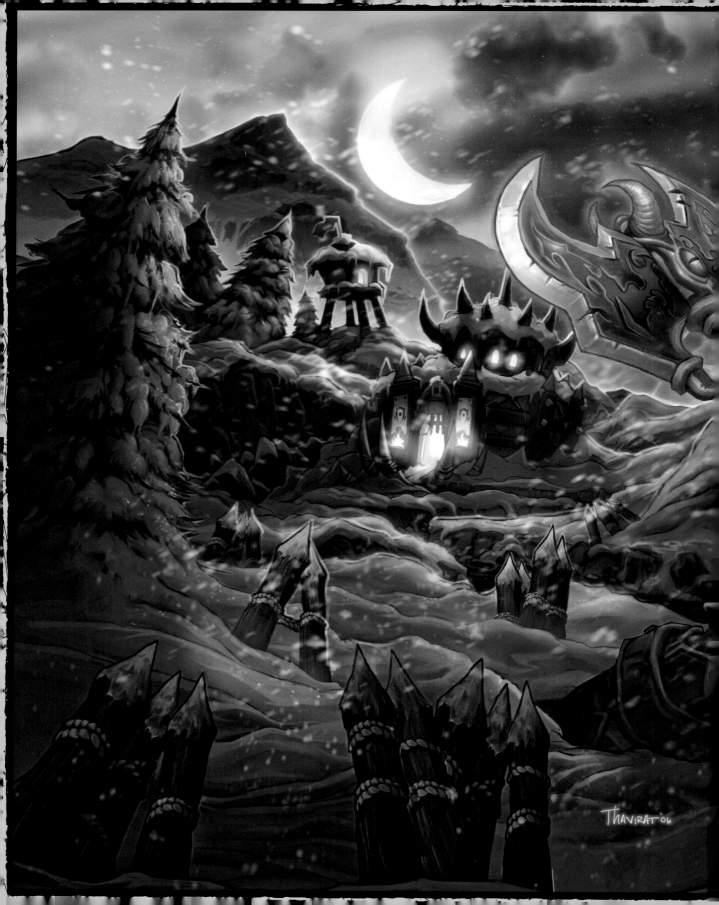

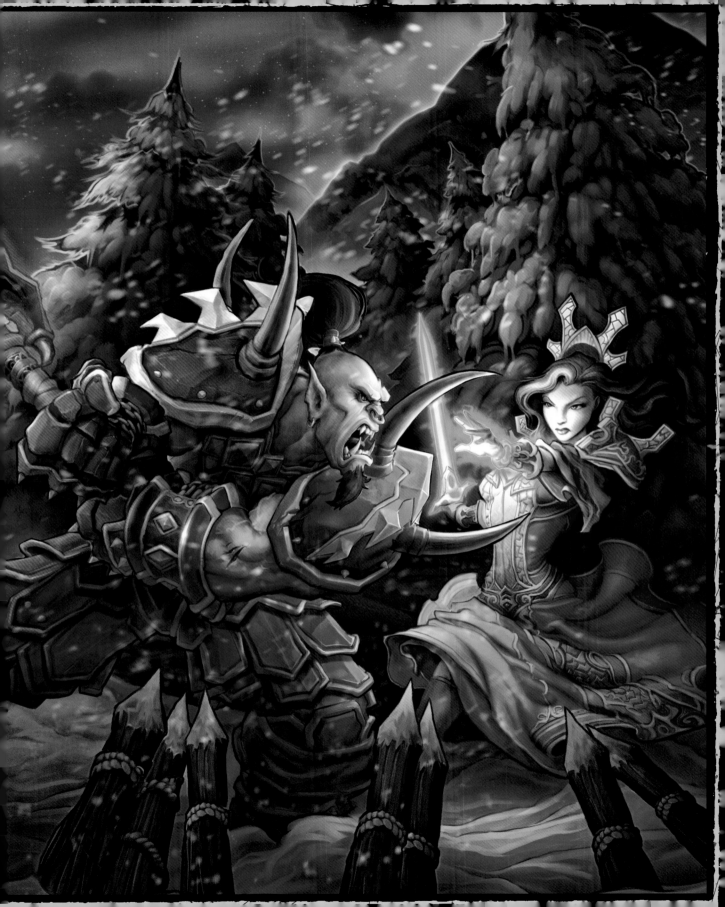

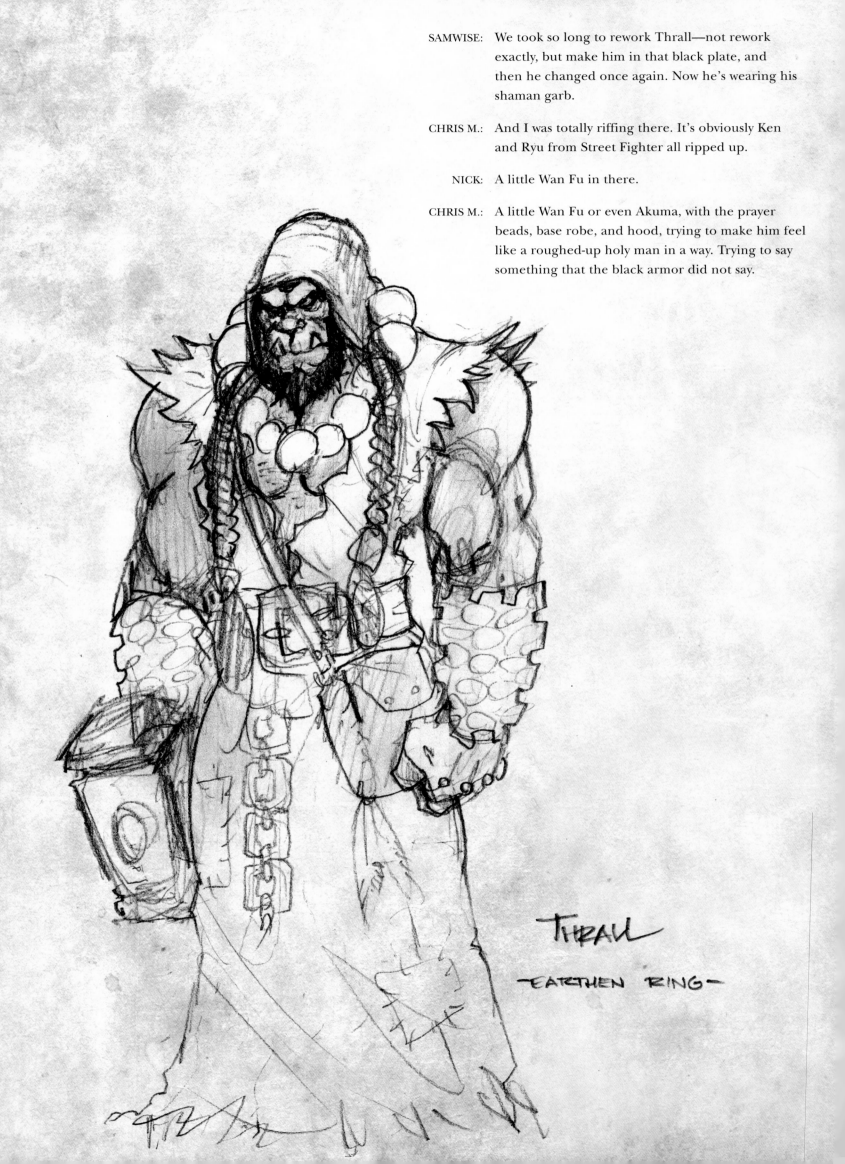

SAMWISE: We took so long to rework Thrall—not rework exactly, but make him in that black plate, and then he changed once again. Now he's wearing his shaman garb.

CHRIS M.: And I was totally riffing there. It's obviously Ken and Ryu from Street Fighter all ripped up.

NICK: A little Wan Fu in there.

CHRIS M.: A little Wan Fu or even Akuma, with the prayer beads, base robe, and hood, trying to make him feel like a roughed-up holy man in a way. Trying to say something that the black armor did not say.

THRALL

—EARTHEN RING—

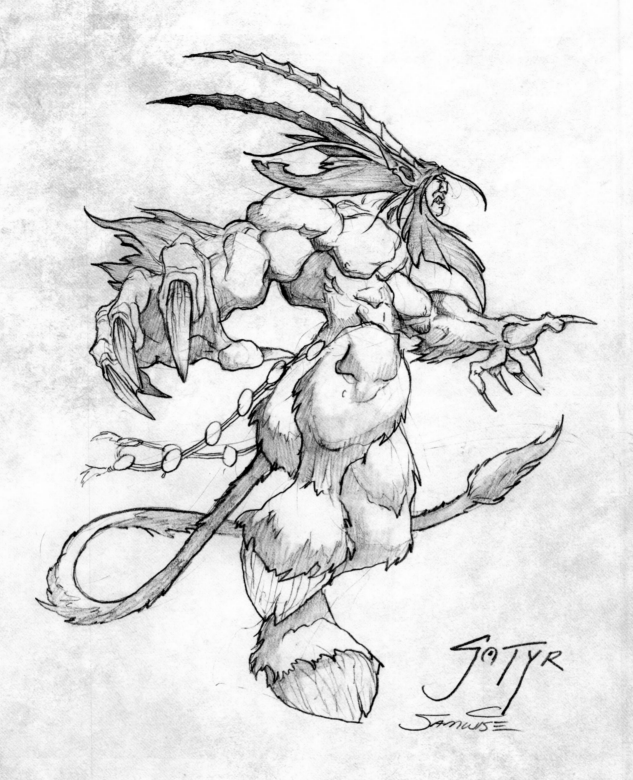

SATYR

Samwise

"This satyr picture really just said everything. It was part of conceptualizing *Warcraft III*.
We'd sit for inordinate amounts of time and try and think about the opportunity to
expand the world since *Warcraft II* and really develop other races and cultures we
wanted to use—archetypal races and cultures we found growing up playing all these
fantasy games that we had devoured as kids. But how do we make them relevant to this
emergent world that we're building? And so making the satyrs a corrupted version of
the night elves, that was really cool, with the big long ears. Certain components of the
night elf body. It warped demonically. Like the cloven hoofs, but it's just a perfect
fusion, you know. And it fit perfectly into the kit that we were building at the time."

—*Chris Metzen*

"Normally satyrs are little puffy forest guys with pan flutes,
and we just made him a demonic goatman."

—*Samwise Didier*

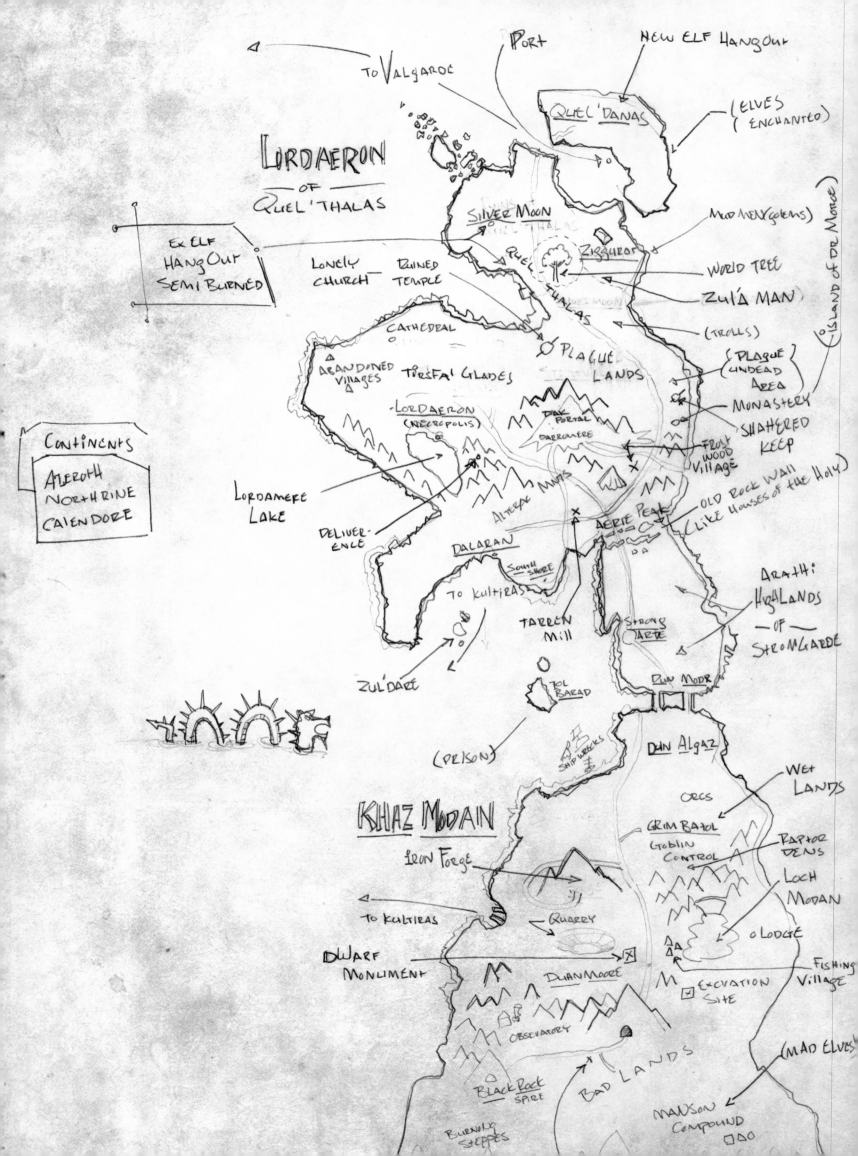

TO VALGARDE

PORT

NEW ELF HANGOUT

QUEL'DANAS

(ELVES (ENCHANTED))

LORDAERON
— OF —
QUEL'THALAS

SILVER MOON
QUEL'THALAS

MUD MEN (GOLEMS)

WORLD TREE

ZIGGURAT

ZUL'A MAN

(TROLLS)

ISLAND OF DR MONCE

EX ELF HANGOUT SEMI BURNED

LONELY CHURCH

RUINED TEMPLE

CATHEDRAL

PLAGUE LANDS

(PLAGUE (UNDEAD AREA))

MONASTERY

SHATTERED KEEP

ABANDONED VILLAGES

TIRISFAL GLADES

LORDAERON (NECROPOLIS)

DAK PORTAL

DARROWMERE

FROST WOOD VILLAGE

Continents
Azeroth
Northrine
Calendore

LORDAMERE LAKE

DELIVER- ENLE

ALTERAC MNTS

AERIE PEAK

OLD ROCK WALL (LIKE HOUSES OF THE HOLY)

DALARAN

SOUTH SHORE

TO KULTIRAS

TARREN MILL

STRONG GARDE

ARATHI HIGHLANDS — OF — STROMGARDE

ZUL'DARE

TOL BARAD

DUN MODR

(PRISON)

SHIP WRECKS

DUN ALGAZ

WET LANDS

ORCS

GRIM BATOL

GOBLIN CONTROL

RAPTOR DENS

KHAZ MODAIN

IRON FORGE

LOCH MODAN

TO KULTIRAS

QUARRY

o LODGE

DWARF MONUMENT

DUANMOORE

EXCAVATION SITE

FISHING VILLAGE

OBSERVATORY

(MAD ELVES)

BLACK ROCK SPIRE

BURNING STEPPES

BAD LANDS

MANSON COMPOUND

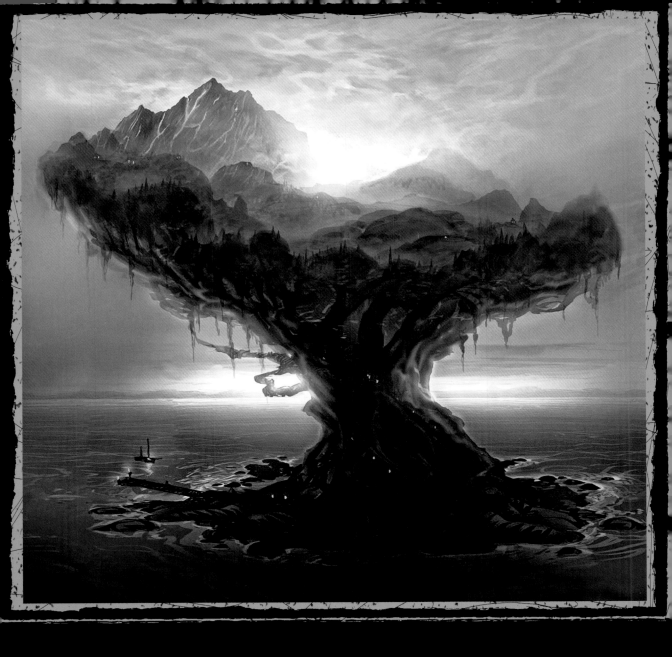

"The painting of Teldrassil, the night elves' starting zone. In the game we
didn't really get the visual impression that it was a tree quite as much as this
whole zone with mountains and forests that all lived within the bounds of
this colossal tree. This image is one of the only ones we have of Teldrassil,
and I've always loved how it really set that fantasy in your mind."

"I always loved the Roman and Petras gryphon rider picture—one of the iconic early WoW images. It tied in the strategy game and familiar unit type, but really set it in the world; it made the world feel very big."
—Chris Metzen

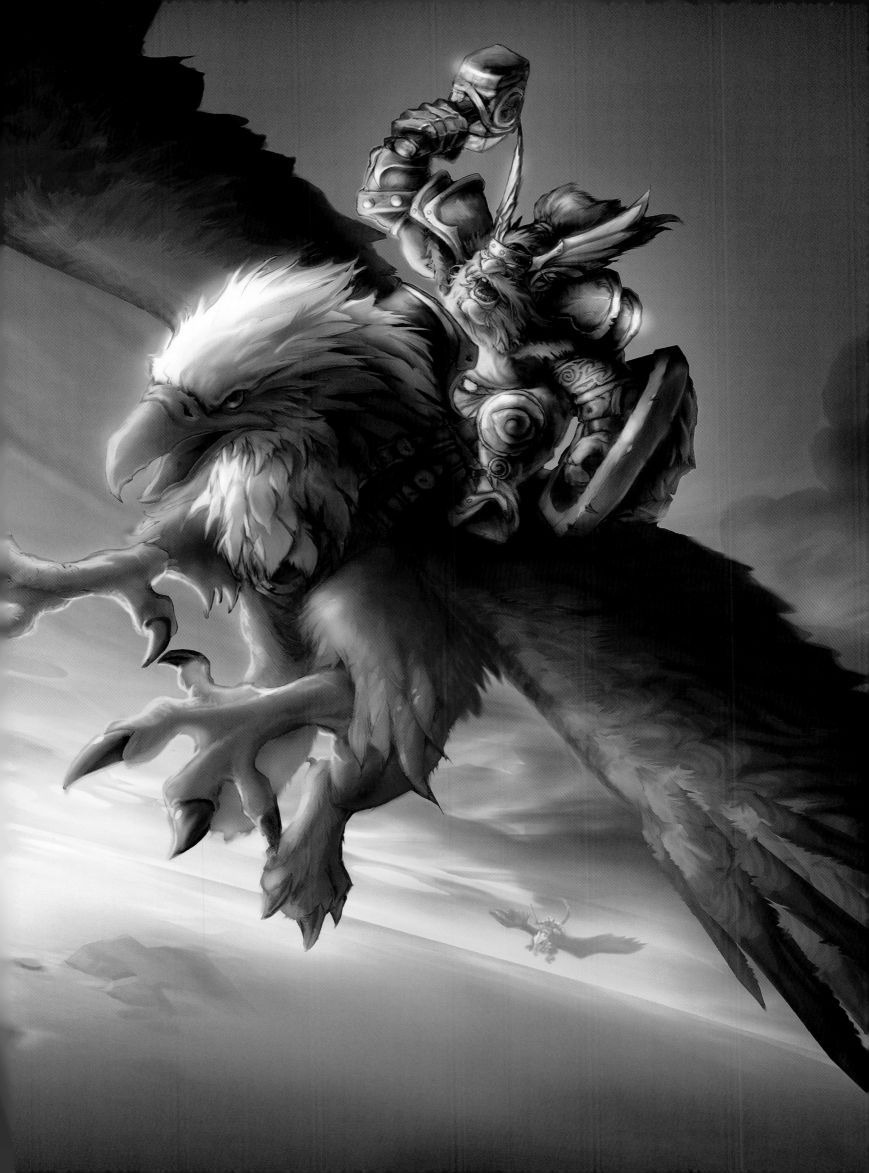

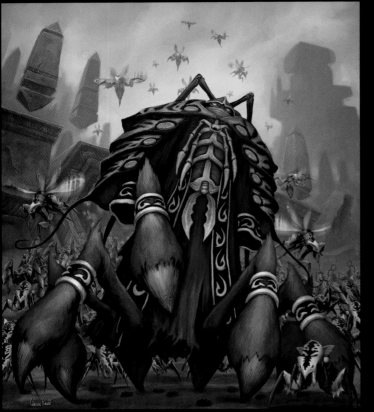

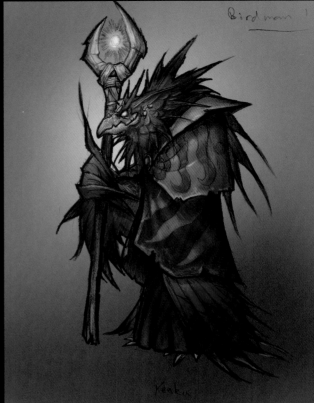

Birdman!

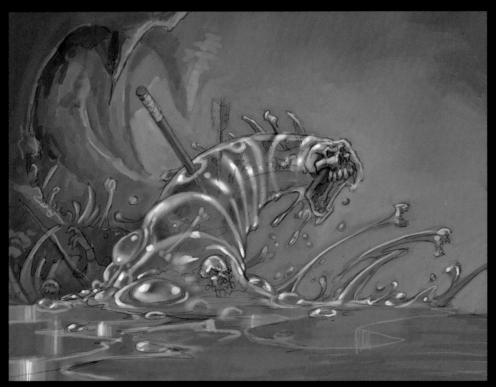

CHRIS M.: The designers were on the slime beast in the game and were like, "I don't know how that would ever be cool. It's just the stupidest idea." So of course Sammy runs off and comes back with a comp and was like, "What if we just filled it with weapons and it's got this crazy skull," and somehow it absolutely worked. So once again, you have the impossible visual problem to solve and Sammy runs off and—

NICK: —solves it.

SAMWISE: Add skulls and weapons, it's good.

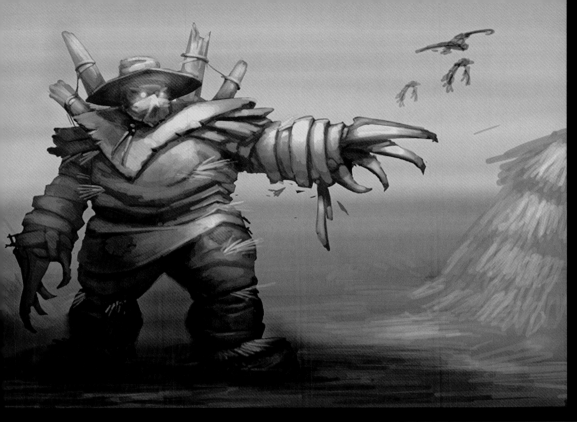

"This is a concept Thav did for Westfall. We were doing this big kind of Halloween farming zone—How do you make that scary? I'm like, 'What about scarecrows?' How do you make that cool? So Bill came up with the harvest golem, which was a big monstrosity."
—Chris Metzen

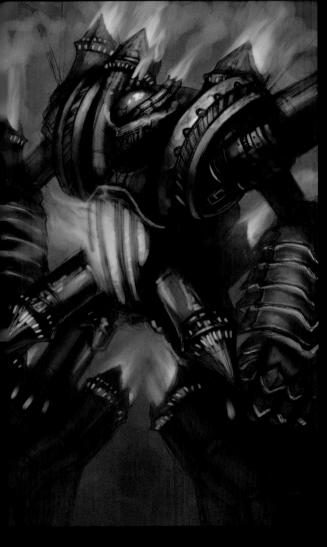

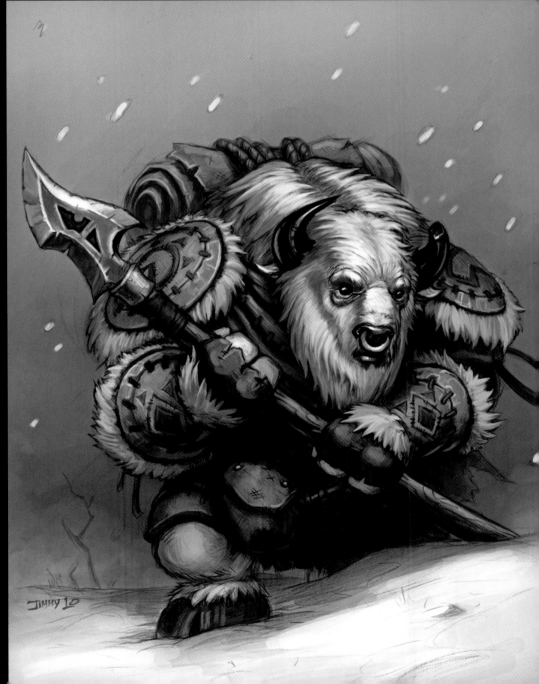

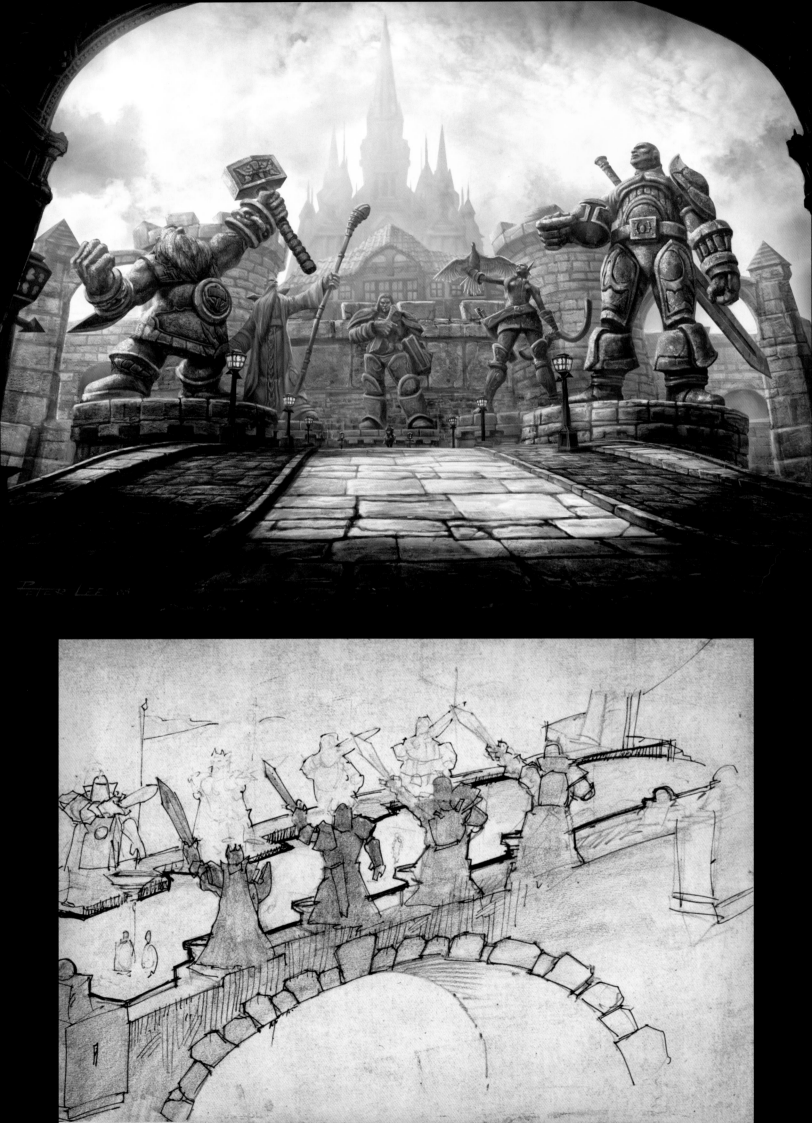

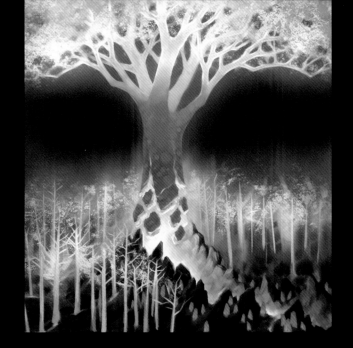

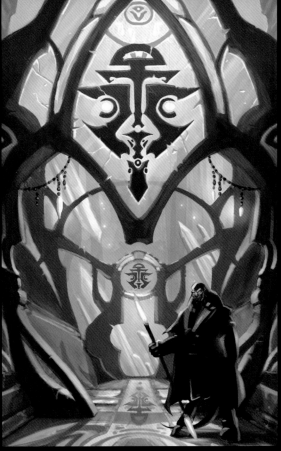

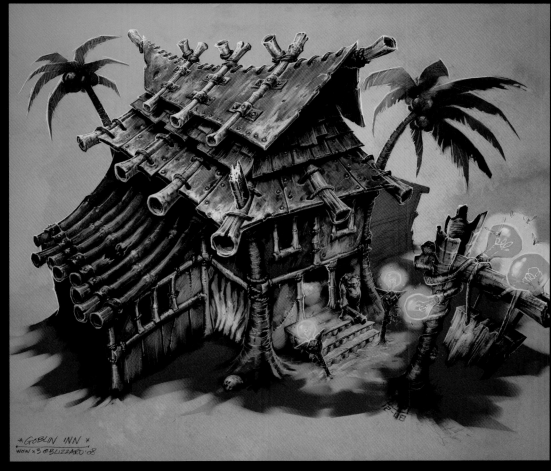

GOBLIN INN
WOW X3 ©BLIZZARD '08

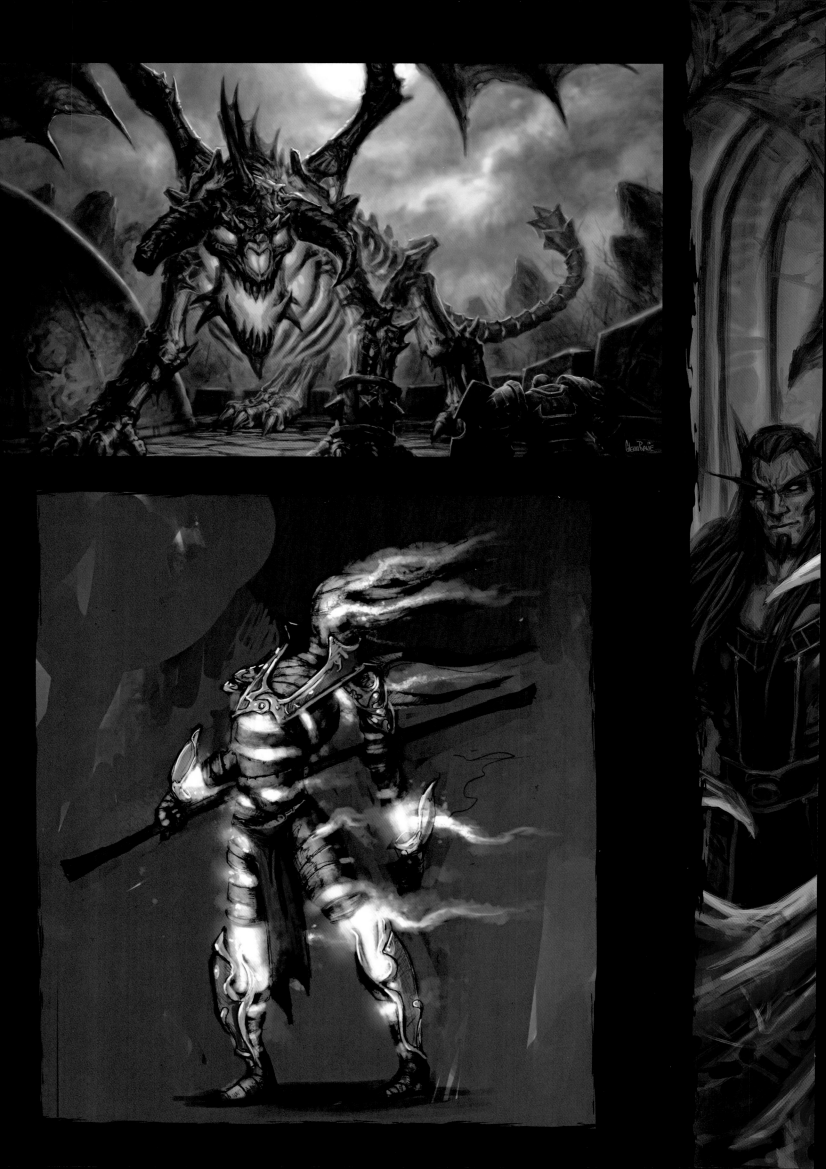

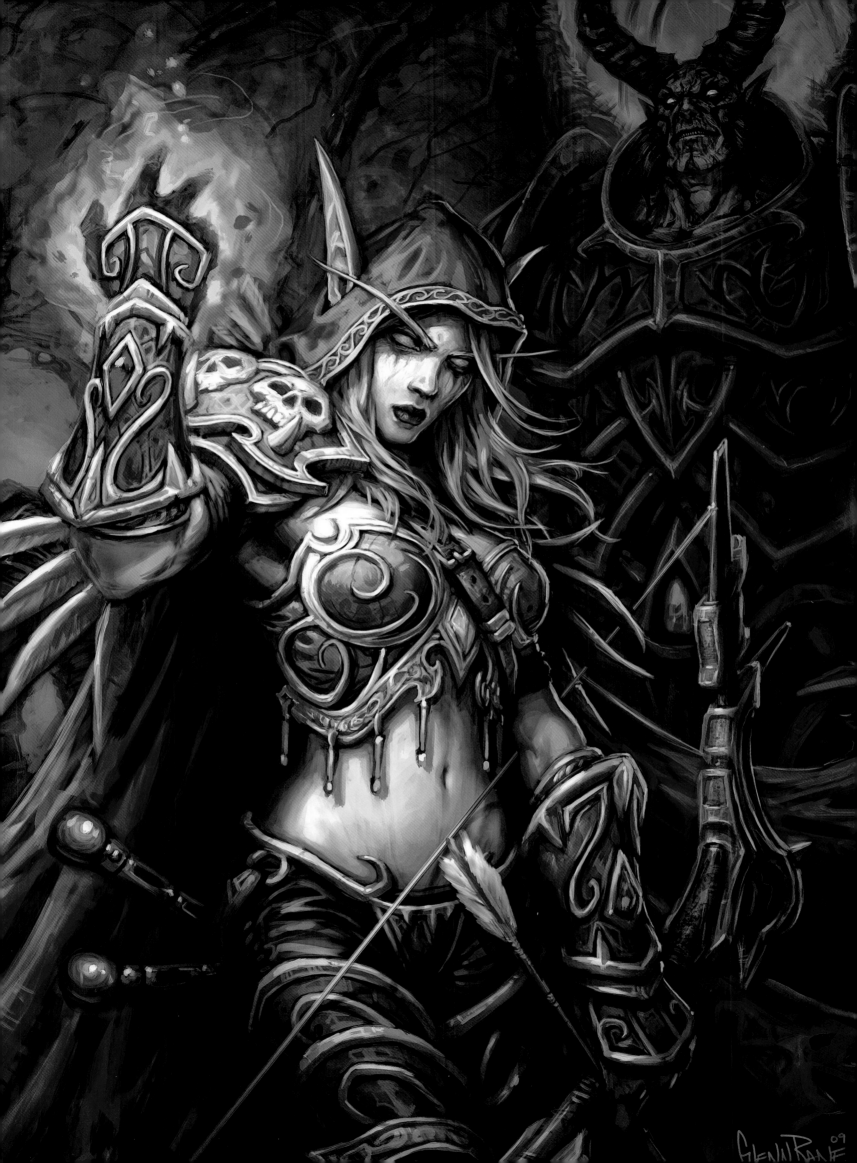

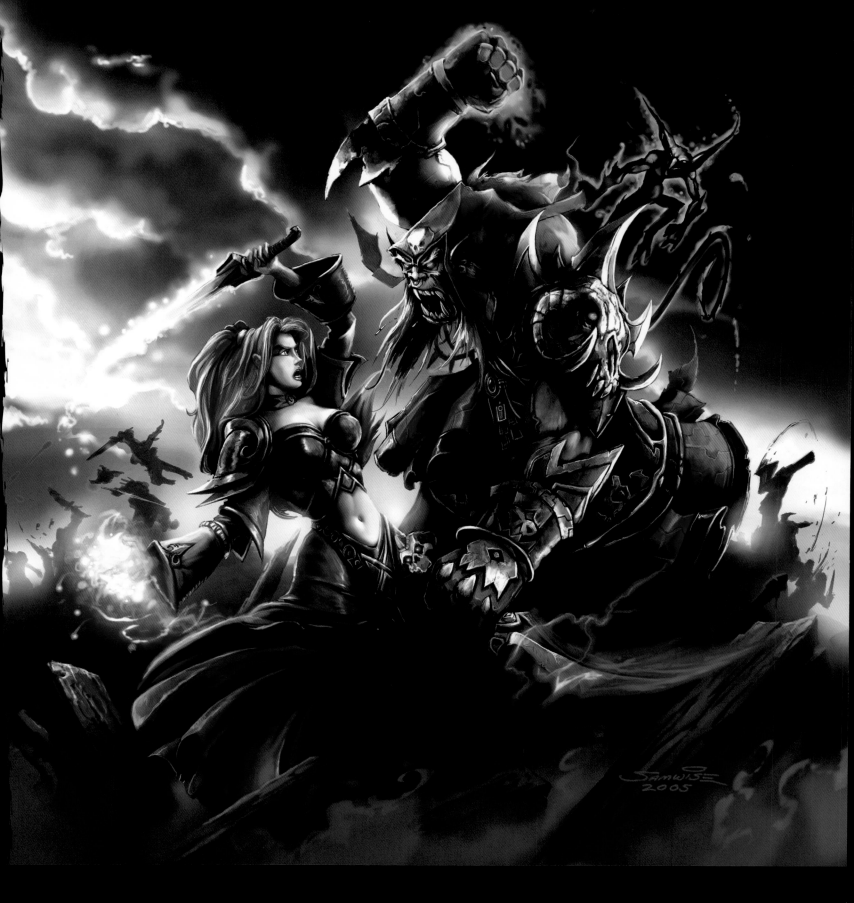

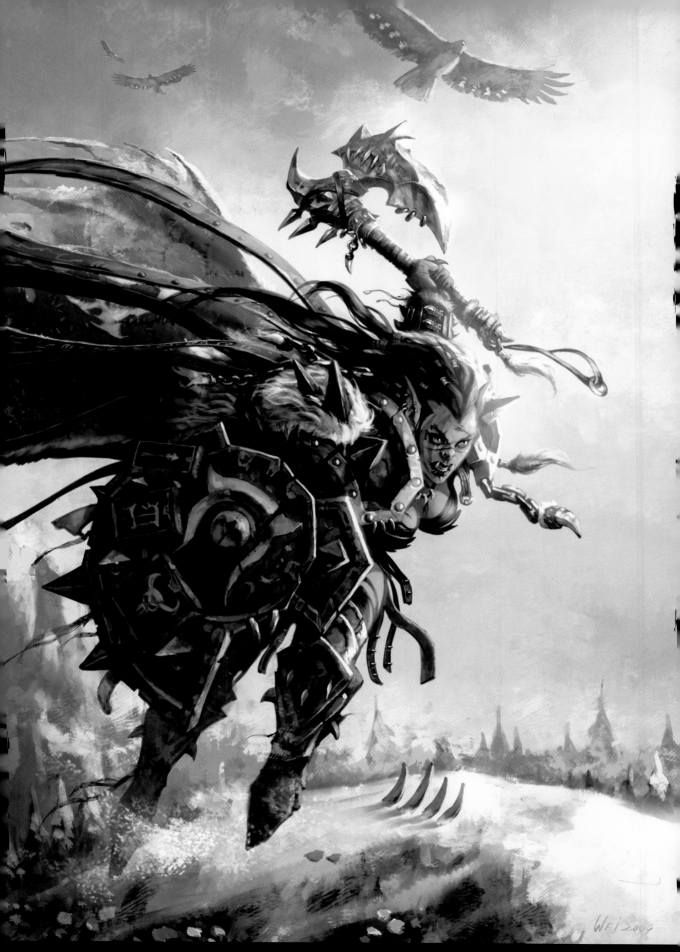

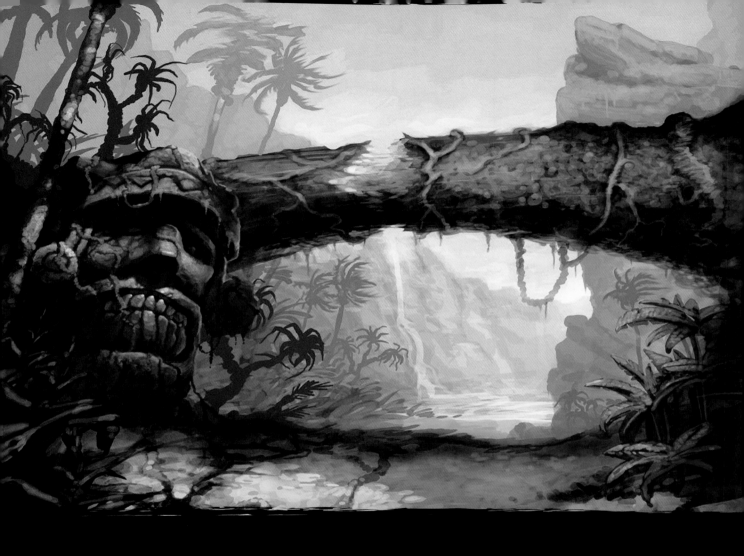

"The Stranglethorn picture is one of the ultimate images that Petras has ever done in my opinion. It totally made our game feel like a concept from a Disney movie almost. This looks like it's straight up out of some Disney adventures cartoon or ride."

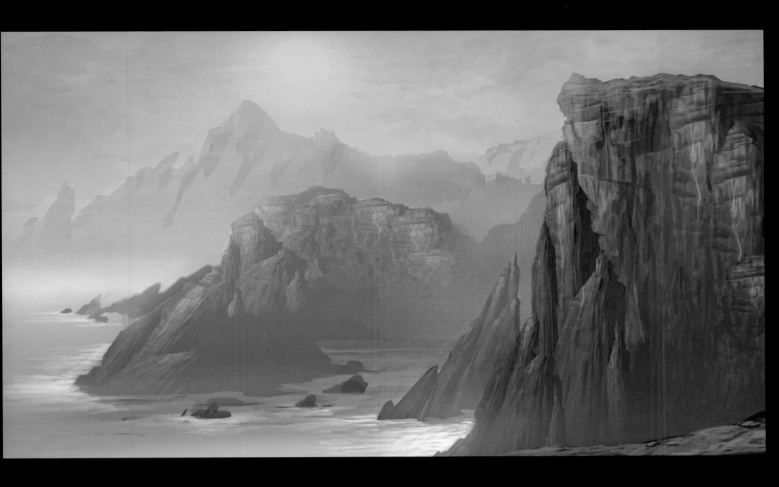

SAMWISE: This is still one of the images I remember seeing and thinking, "Hell yeah. We're gonna be unleashing this soon on the world."

NICK: Bill and I looked at painting very differently, and Bill just came with these big broad colors and warm tones. In this image the colors themselves transport you. I remember the buildup to Warcraft and those images dropping on the website as teasers, and at first I thought maybe this was StarCraft related. And it was all of it. WoW was everything.

CHRIS M.: I remember that series of images, and they began to turn a corner from looking at the Warcraft franchise, looking at the world in terms of characters and soldiers and army kits—looking at the world largely from the top down—and really being forced to look at it in terms of, "No, it's a sprawling thing out in front of you." It's mountains, it's shores, it's vast landscapes. Sam had certainly painted a number of those, but I think collectively we hadn't really made that mental turn. Every square inch of this world—

NICK: —is the character.

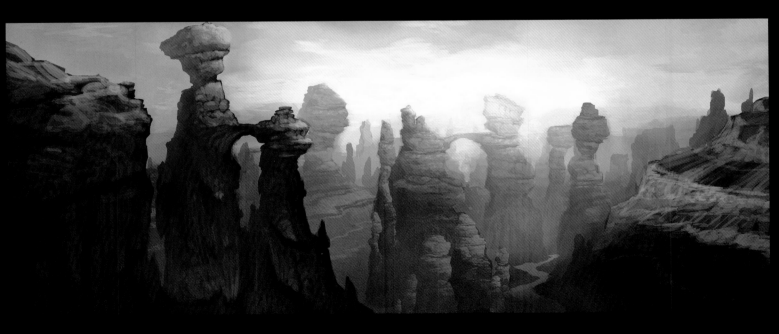

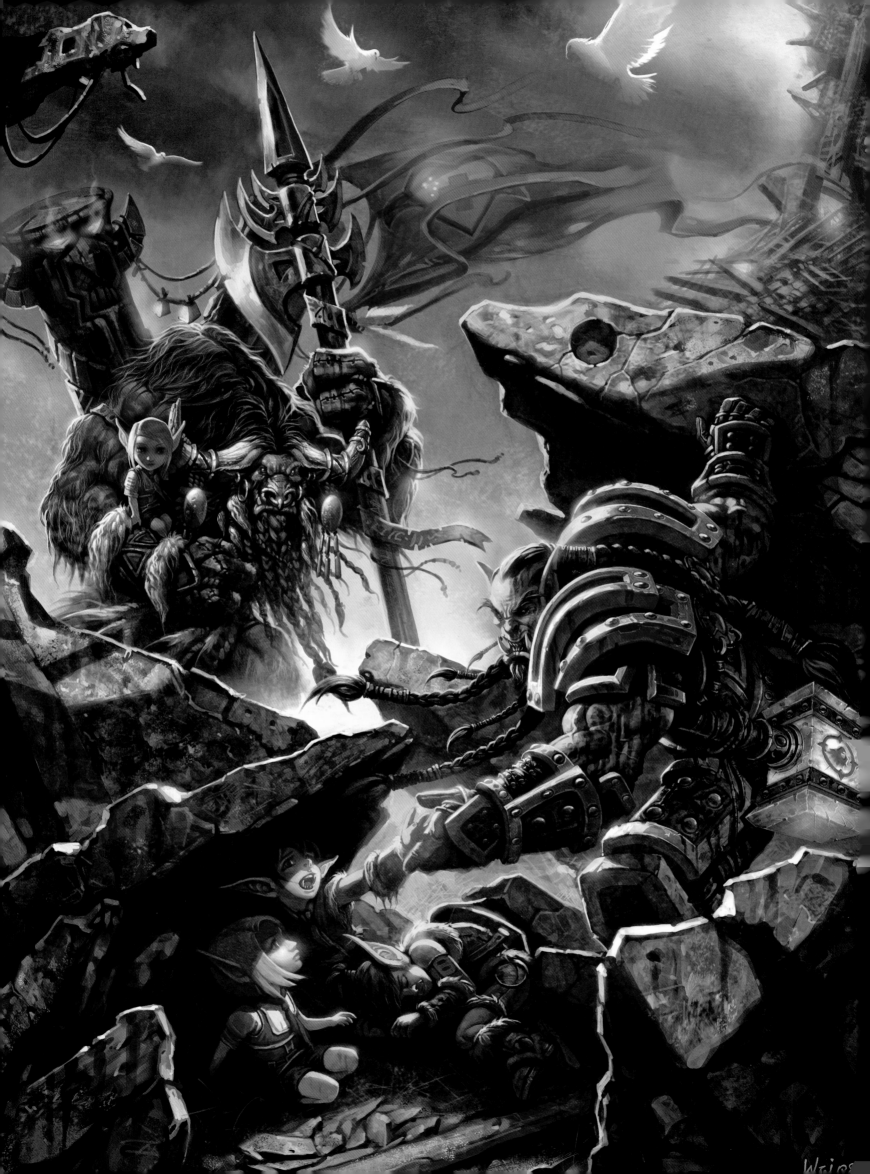

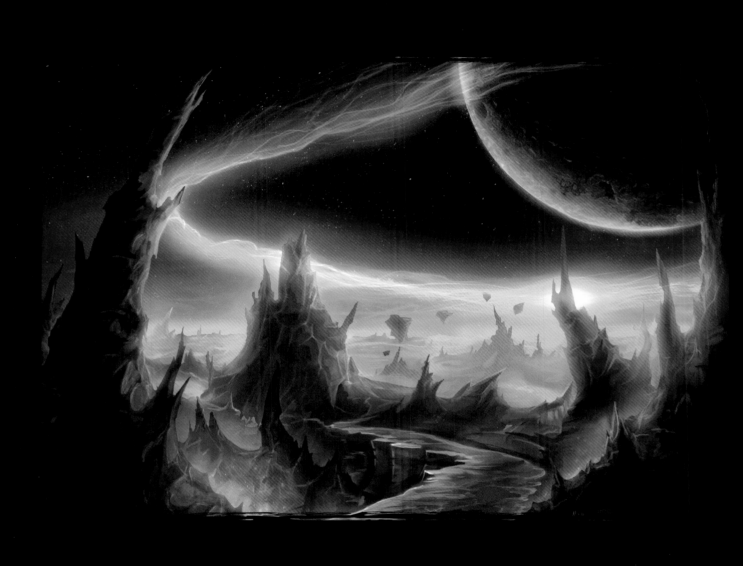

"One of the iconic images of Outland—this broken world
with its savage landscape. It was a pretty big departure from
the classic fantasy we had been chasing."
—*Chris Metzen*

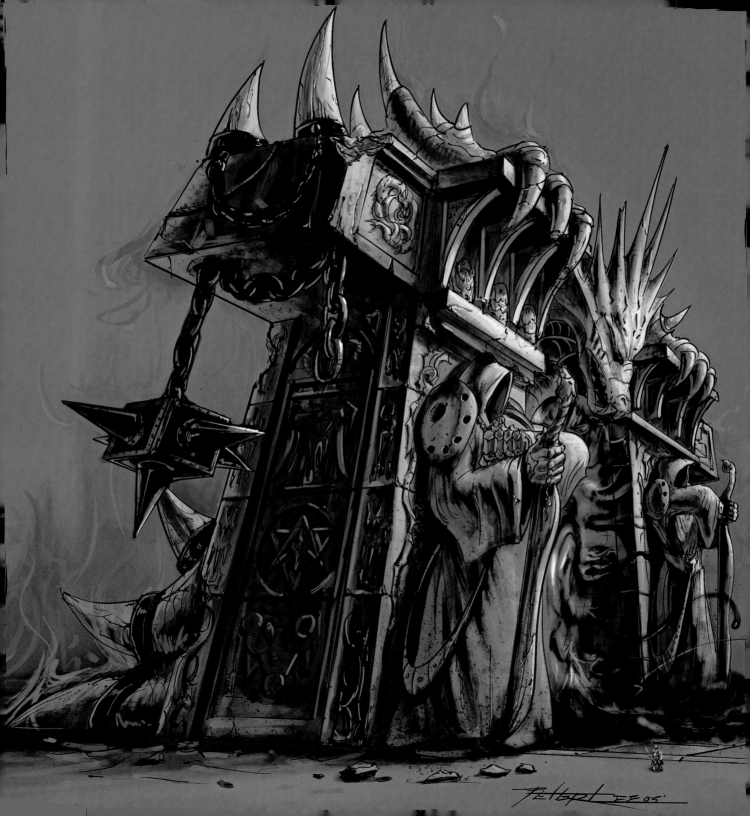

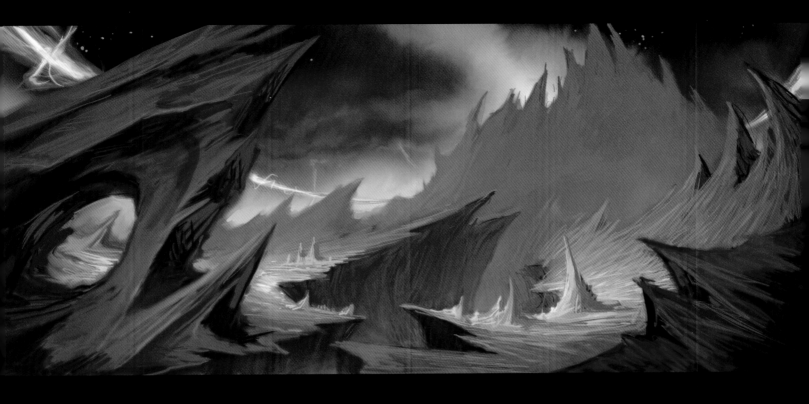

"Outland always reminded me of our version of a Rodney Matthews or a Dean brothers kind of world. Planets with broken, floating things and cool nebulas."
—*Samwise Didier*

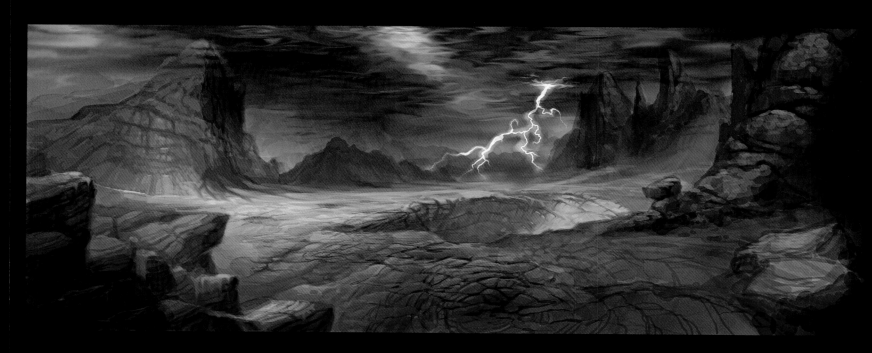

"Blasted Lands. This is another one of the
classic WoW images, in my top ten."

—*Samwise Didier*

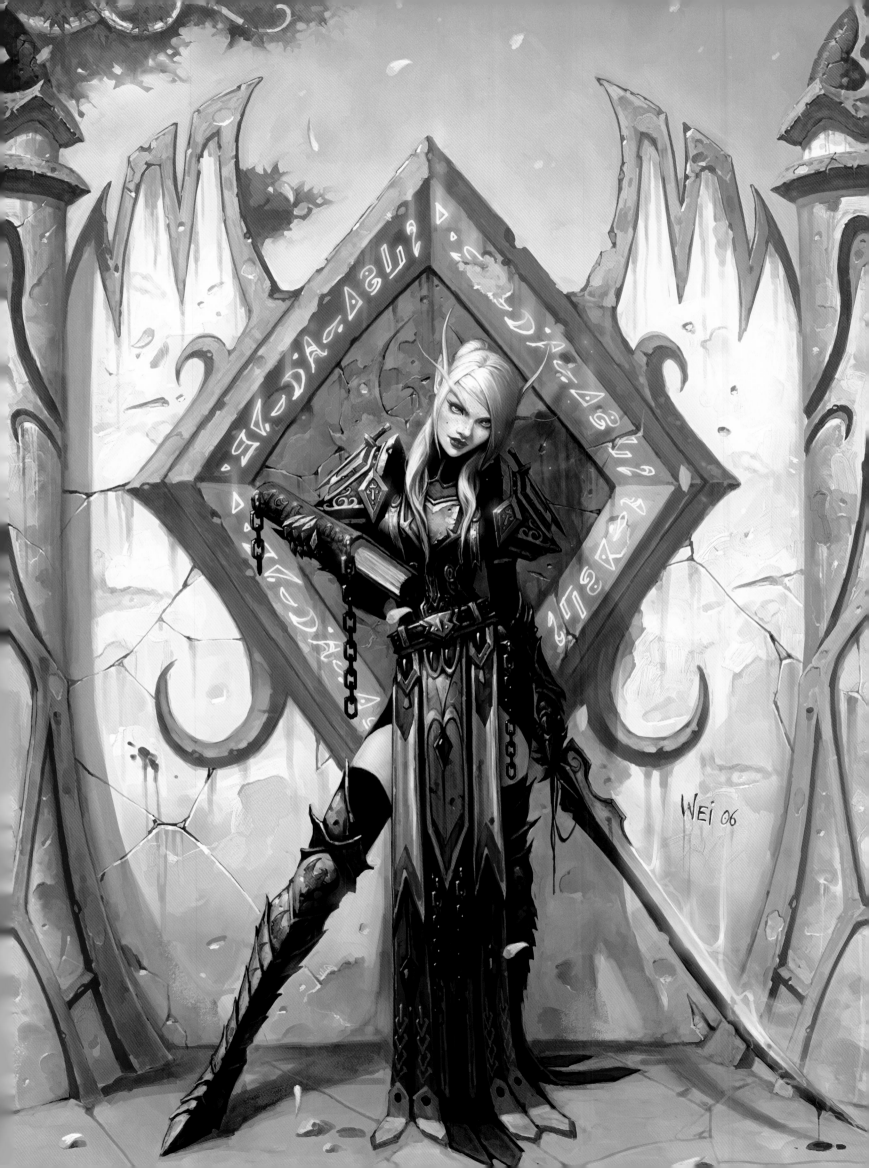

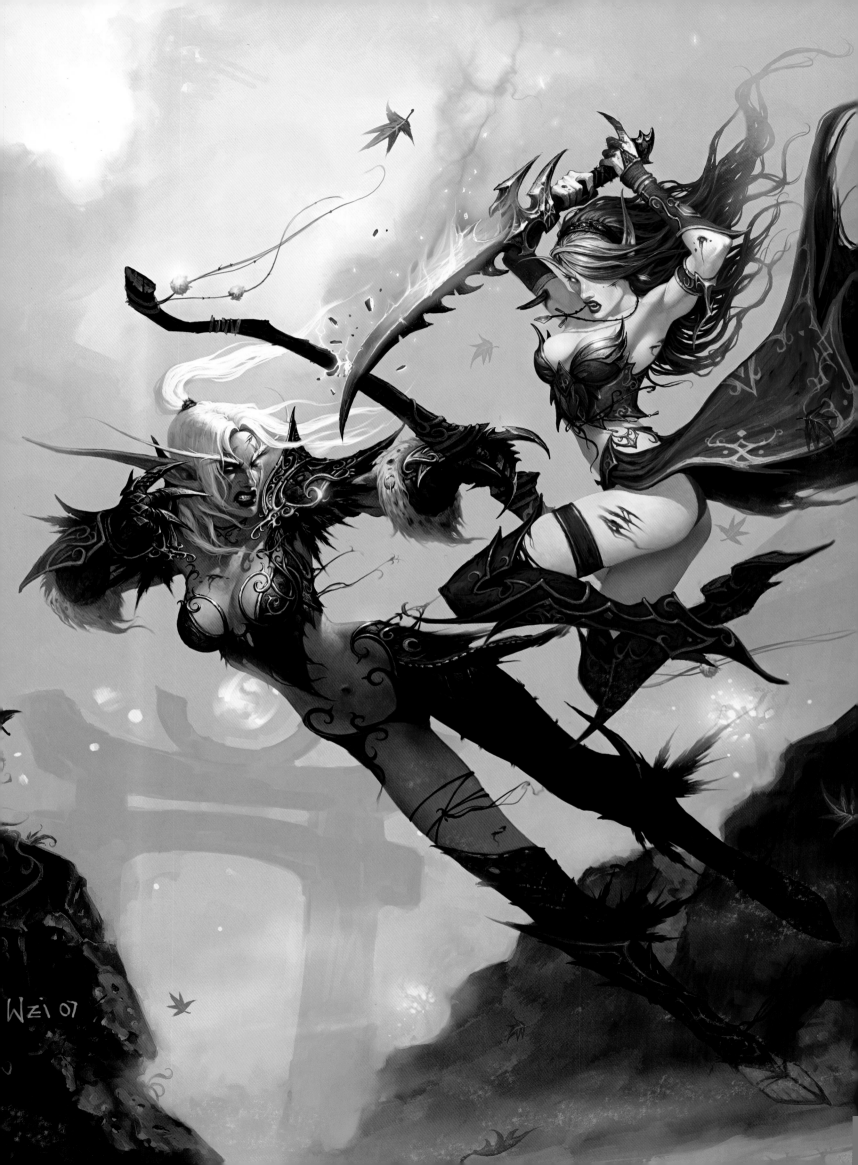

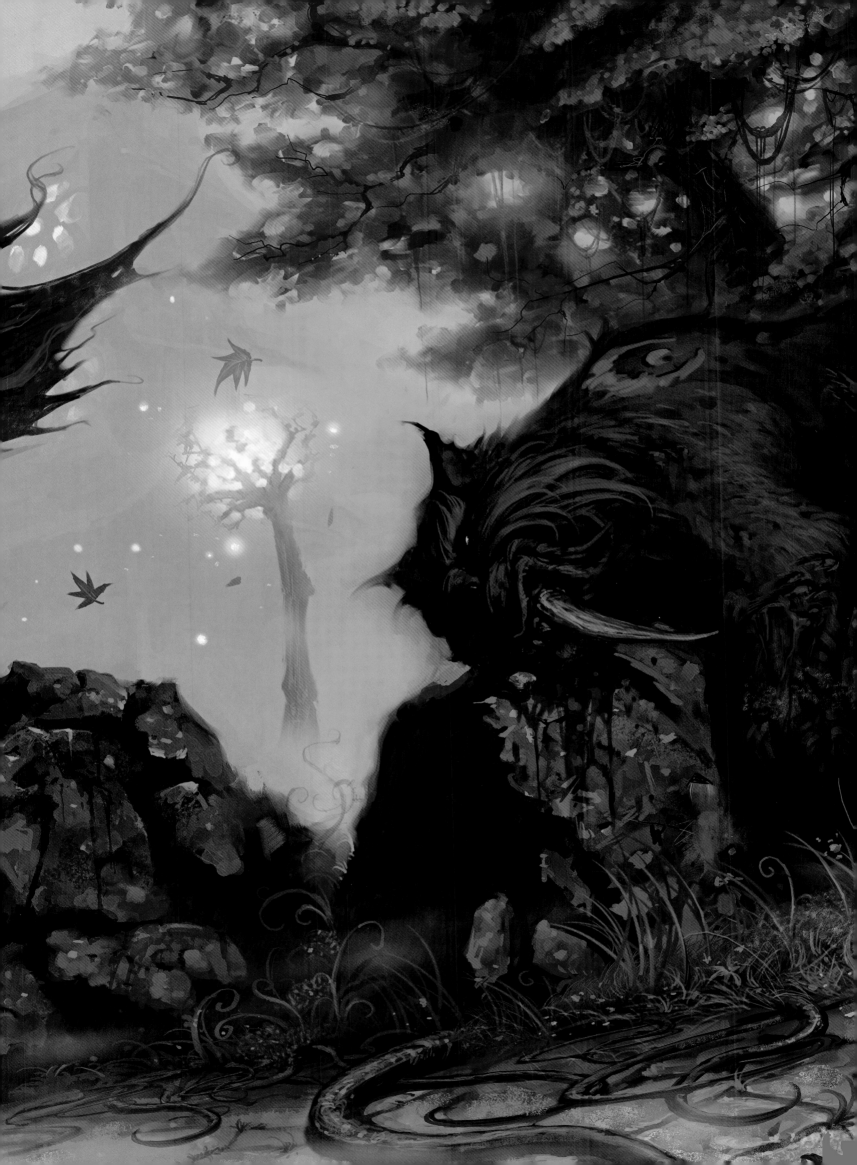

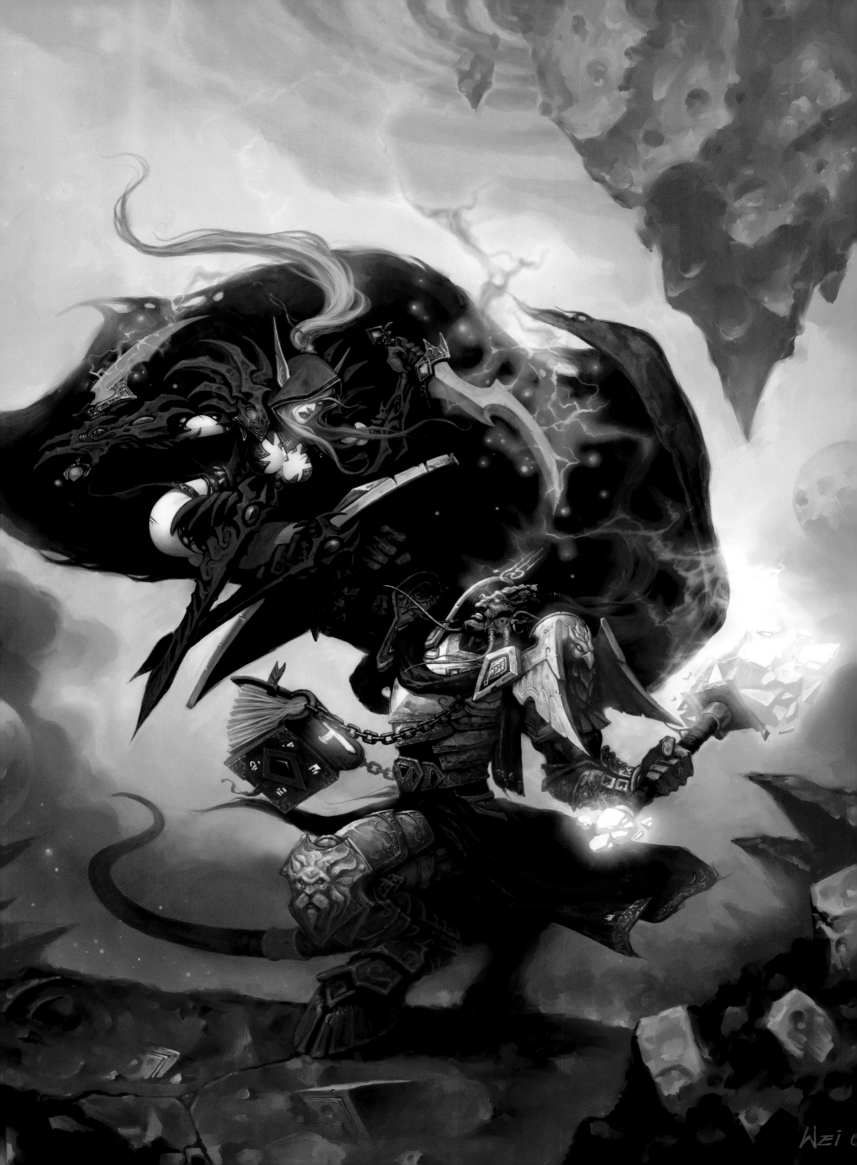

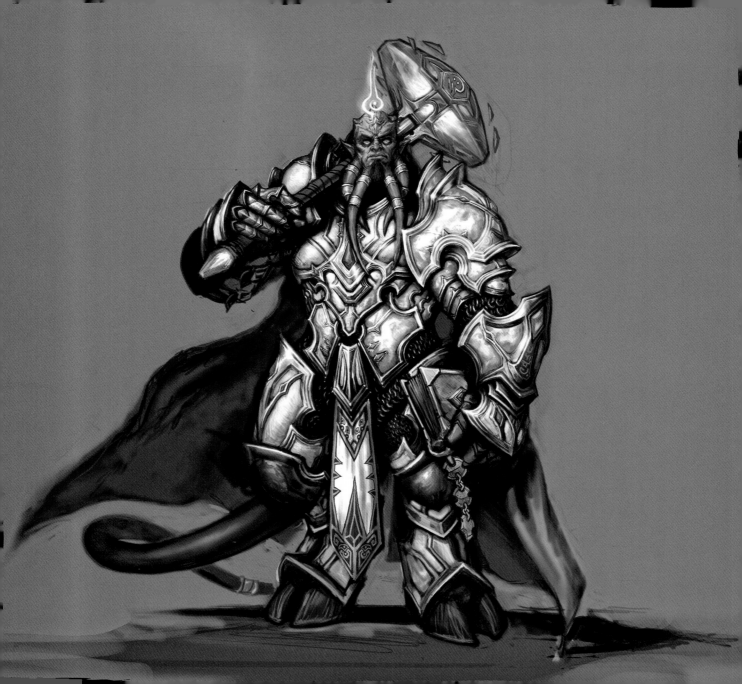

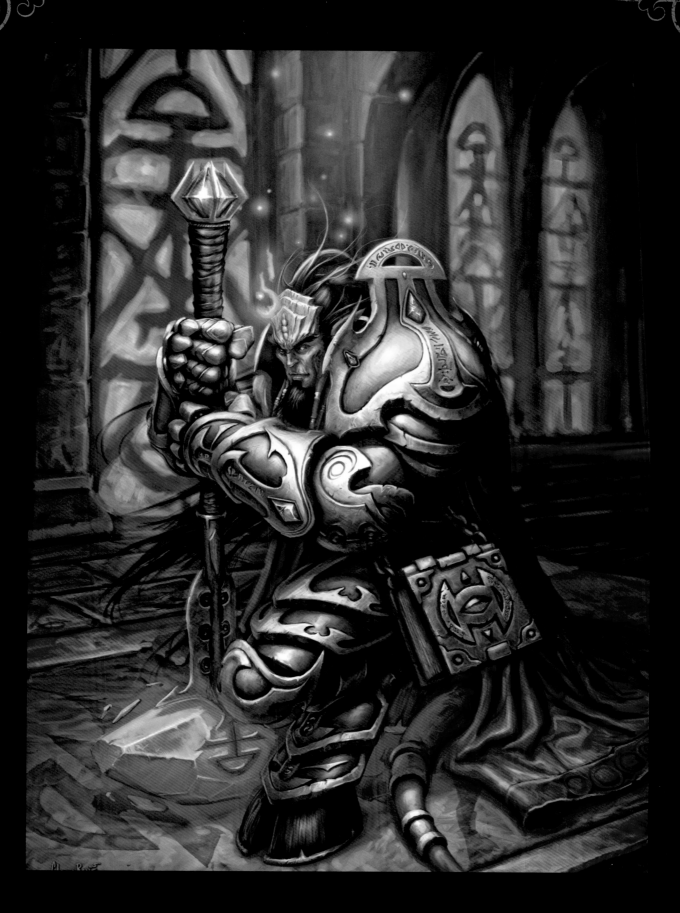

"The one Glenn did of the draenei kneeling down is still
one of the ultimate draenei paladin images for me."

—*Samwise Didier*

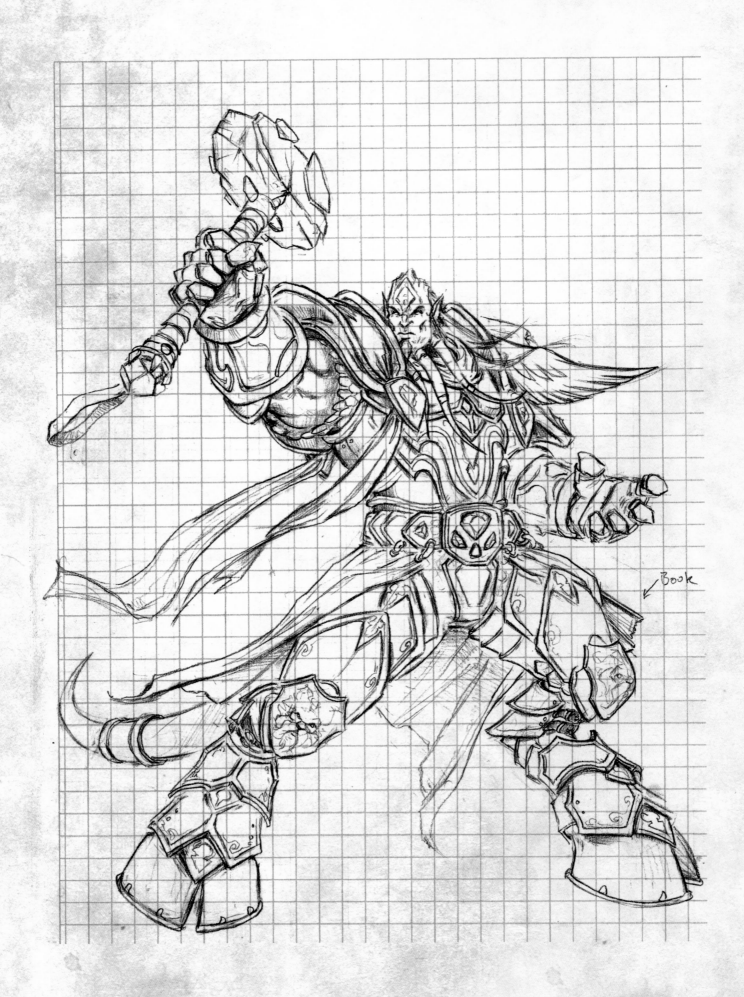

Book

"That's art right there. Pencil drawing on blue-lined paper. Probably a homework assignment on the back—that's the kind of stuff we look for when we're hiring people."

—*Samwise Didier*

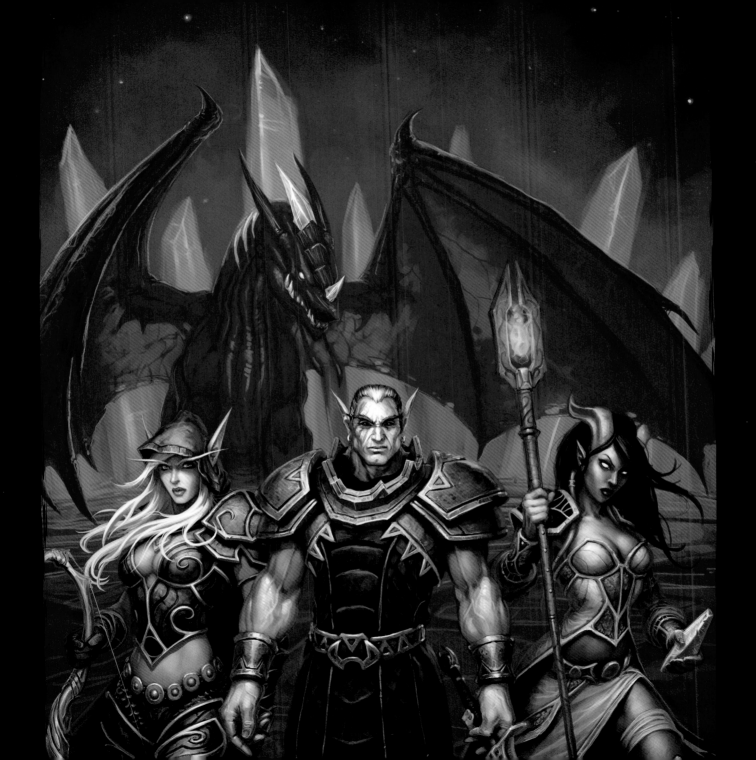

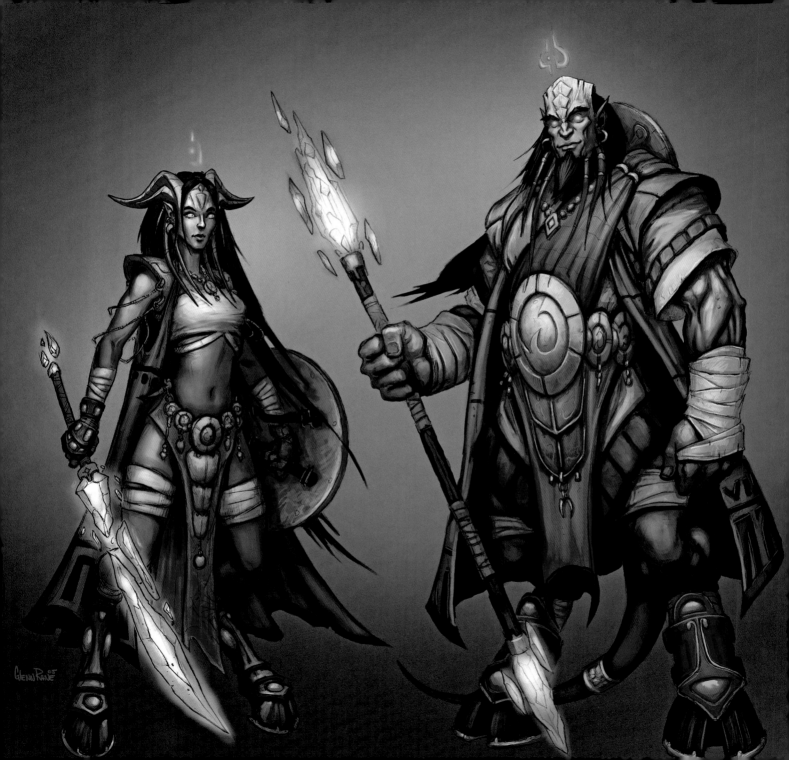

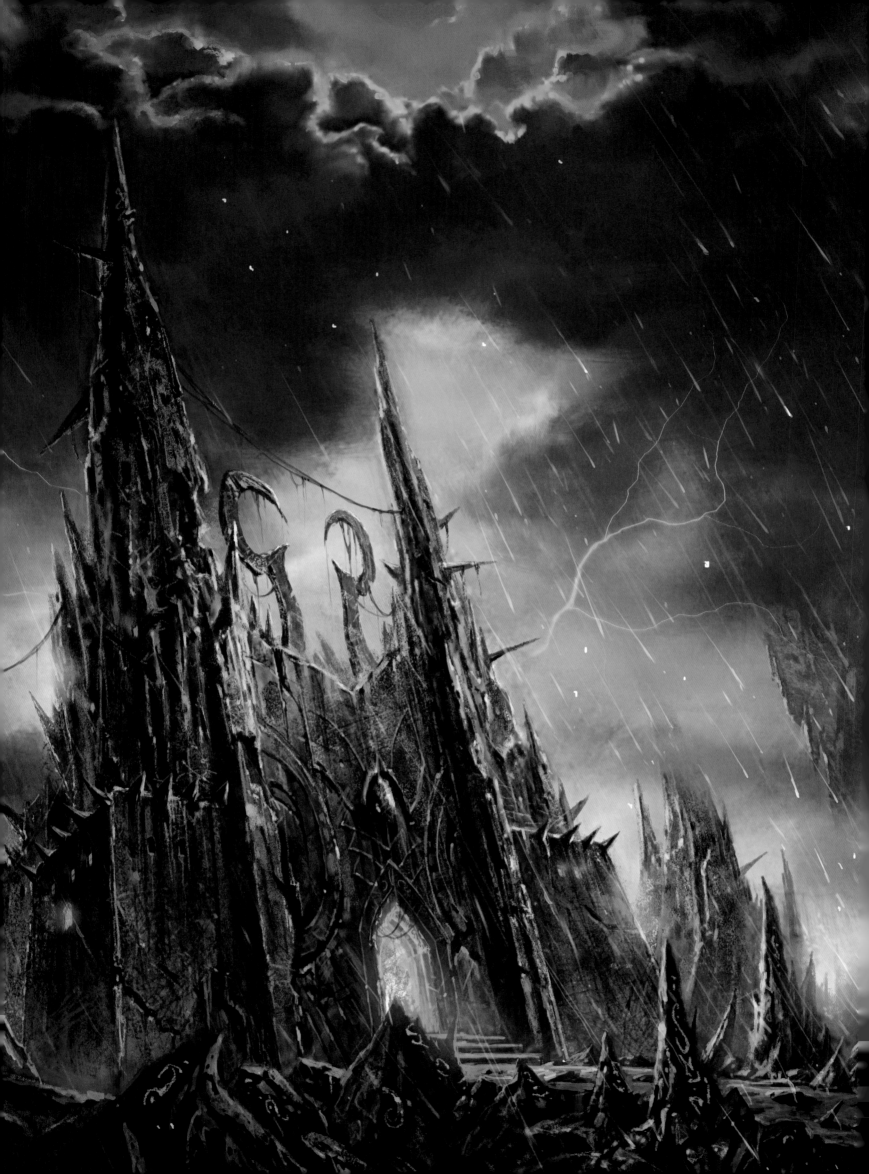

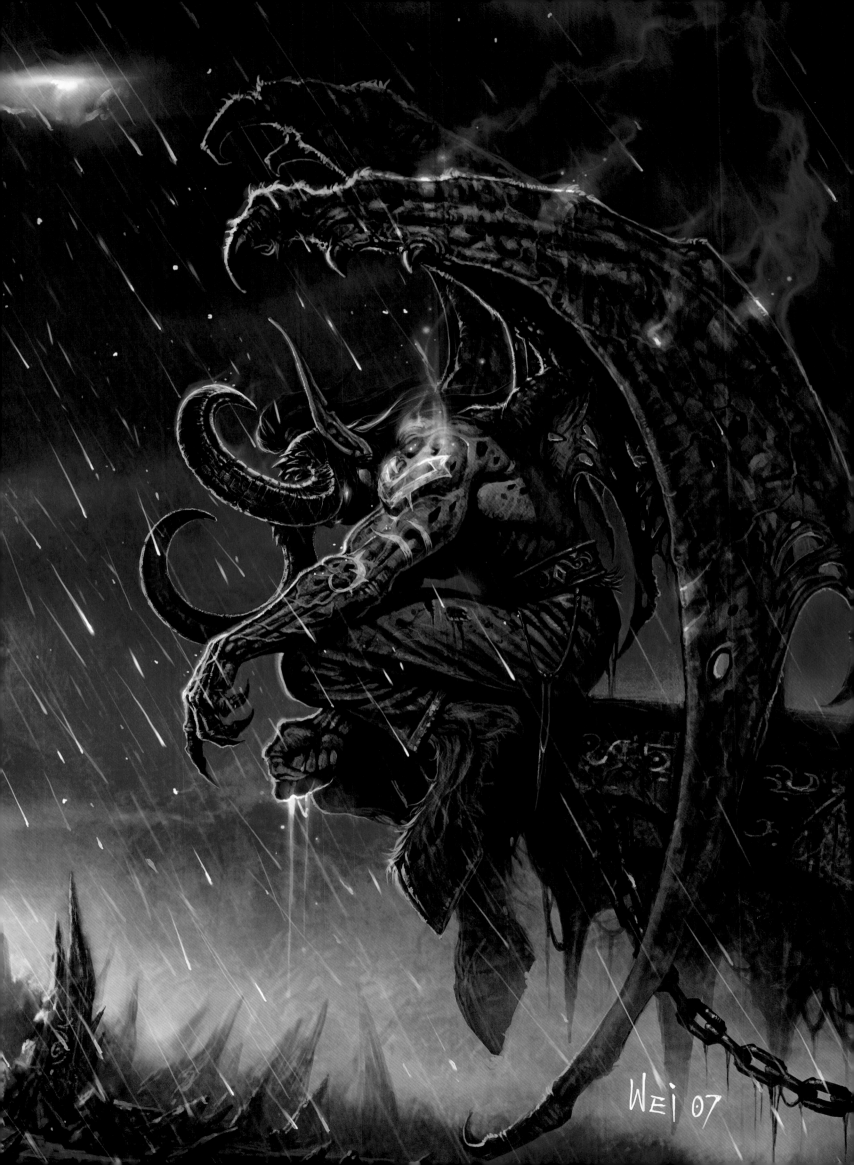

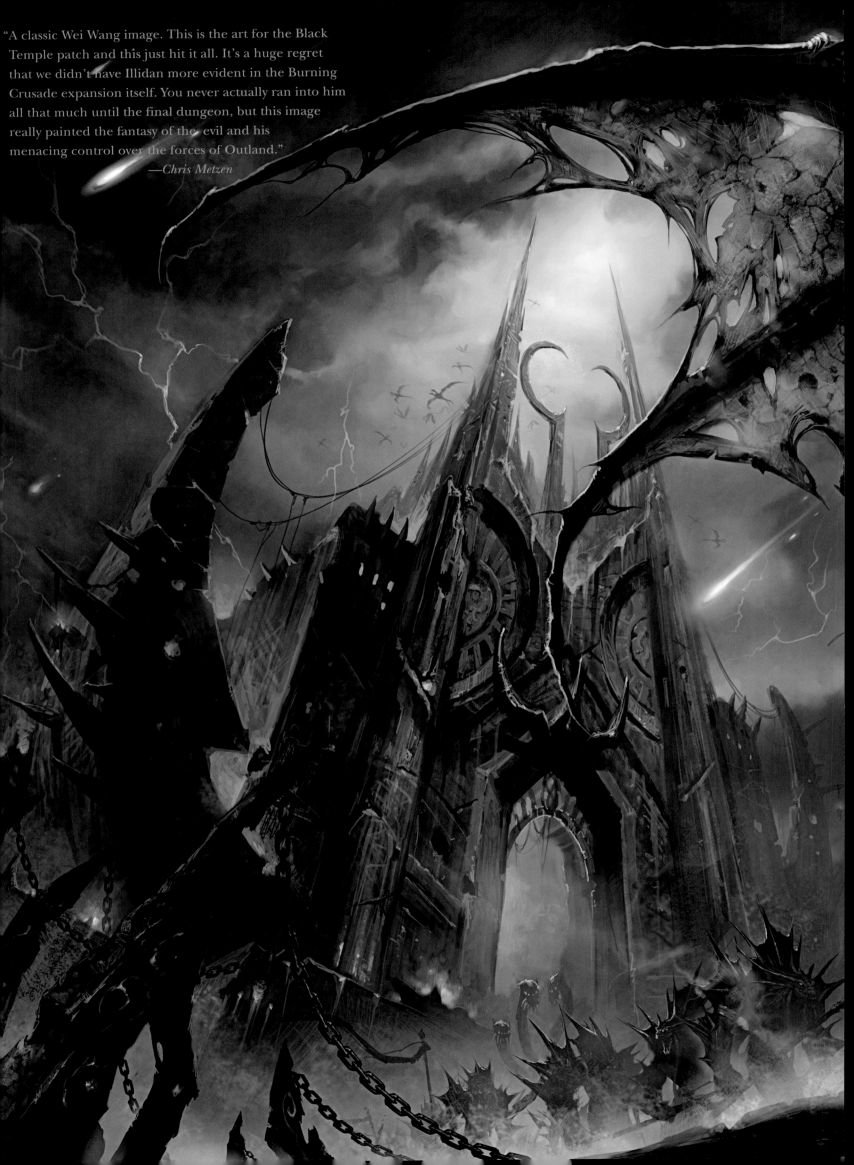

"A classic Wei Wang image. This is the art for the Black Temple patch and this just hit it all. It's a huge regret that we didn't have Illidan more evident in the Burning Crusade expansion itself. You never actually ran into him all that much until the final dungeon, but this image really painted the fantasy of the evil and his menacing control over the forces of Outland."
—Chris Metzen

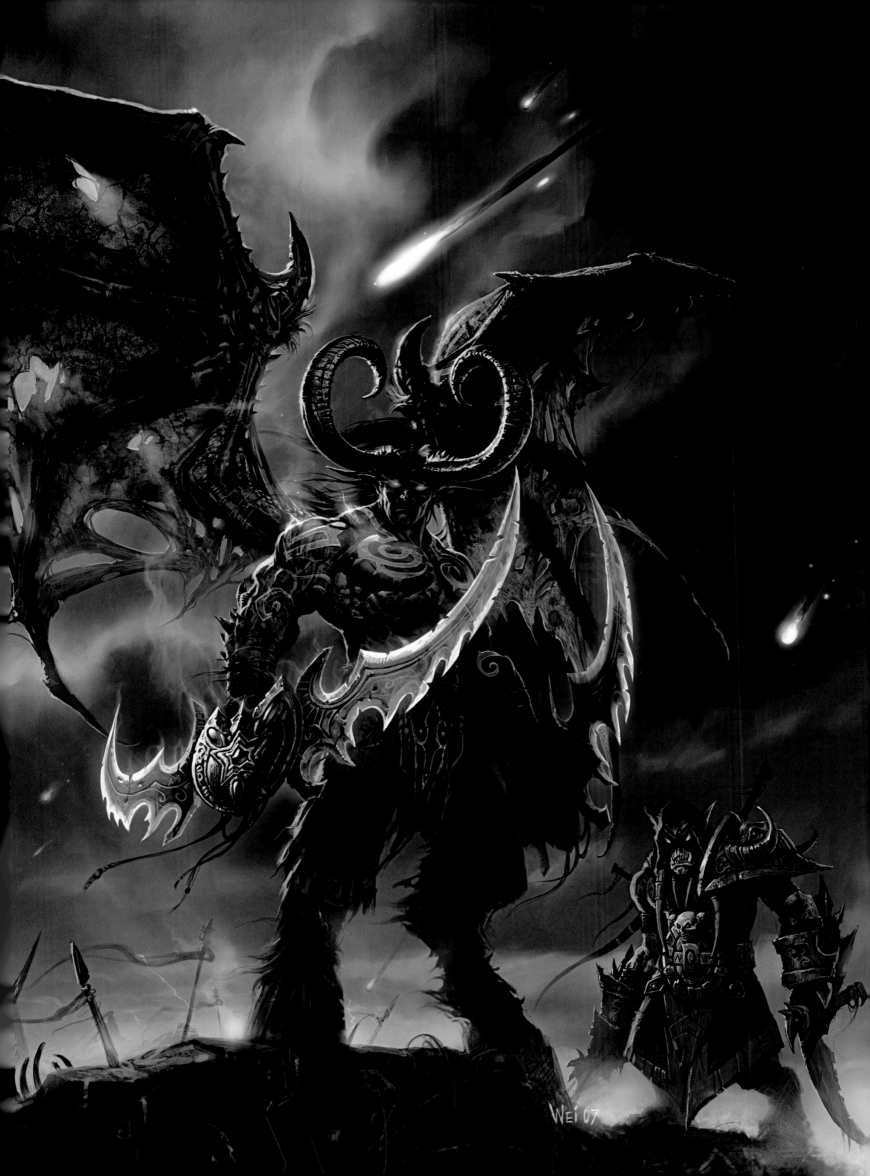

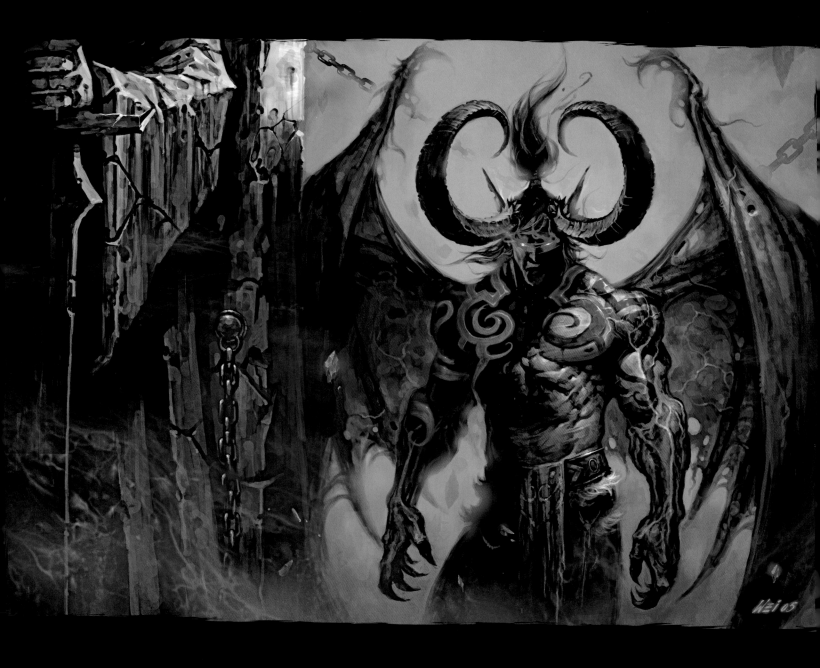

CHRIS M.: Wei's first Illidan image.

SAMWISE: That's more purple than Prince.

NICK: I thought it was cool that it was showing the shadow side of him versus the lit side.

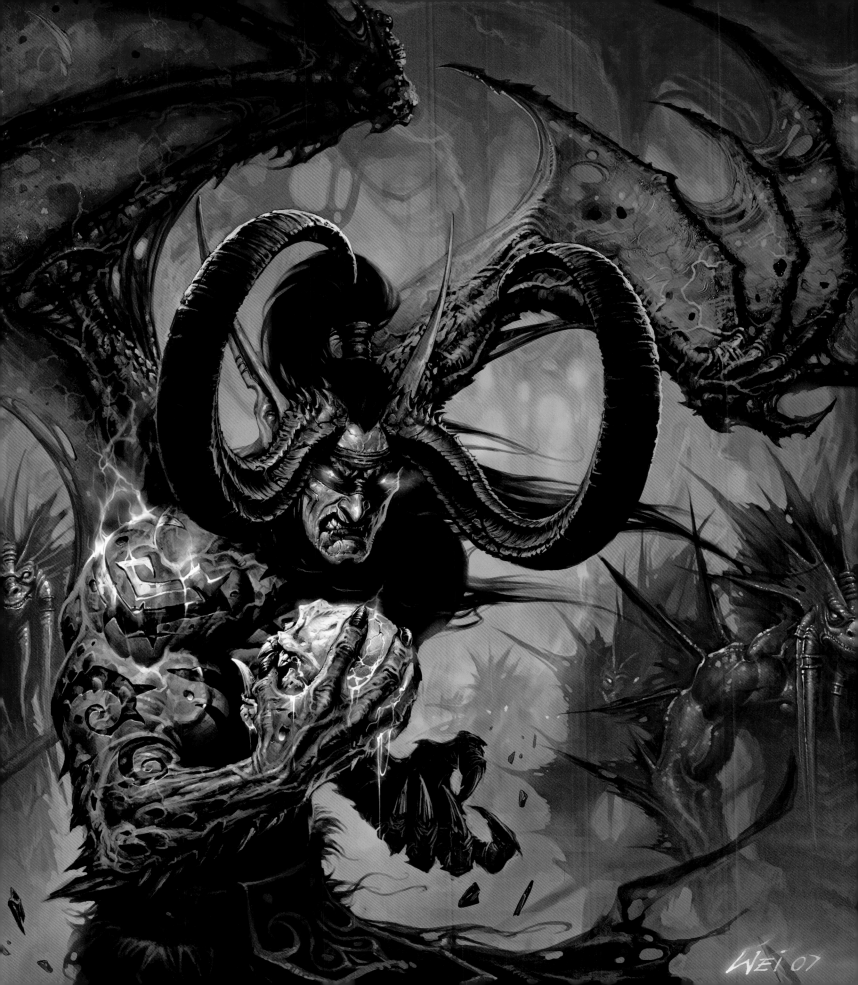

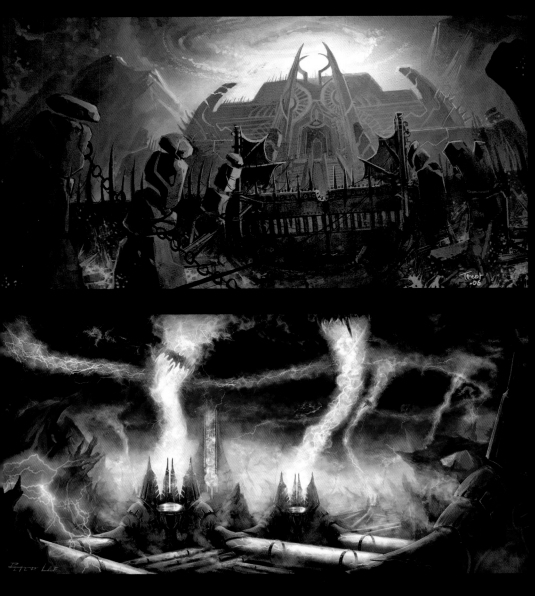

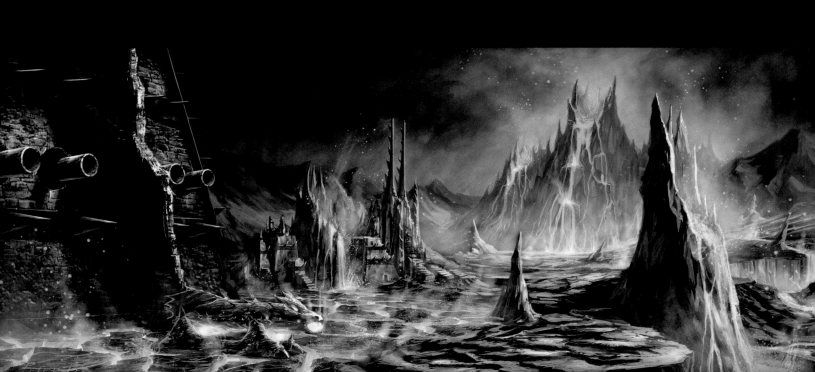

CHRIS M.: Peter Lee, Shadow Moon Valley. I remember when these images were coming in, he was just killing it. Identifying the broad color values—How do you do a volcanic zone without the color red? And he just absolutely hit it.

SAMWISE: All of our demonic energies from the demons were green fire, so it was only appropriate. That's awesome.

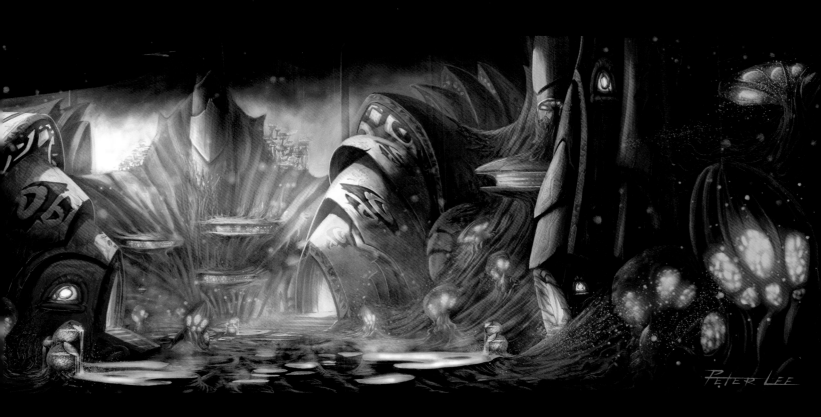

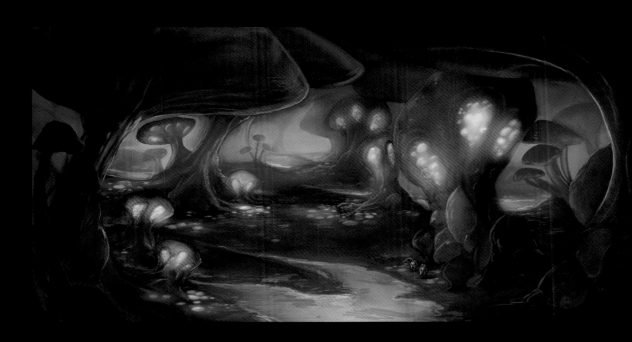

SAMWISE: I feel like the whole environmental kit for Zangarmarsh was just ridiculous with all the neon light and phosphorescent creatures. Long before *Avatar*, our zone was really happening with this insane ecology lit with this phosphorescent color.

NICK: Cameron played WoW, he admits it.

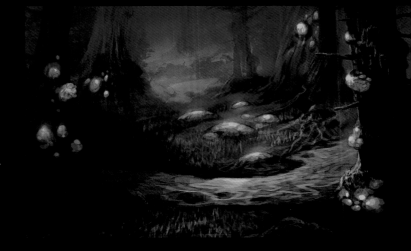

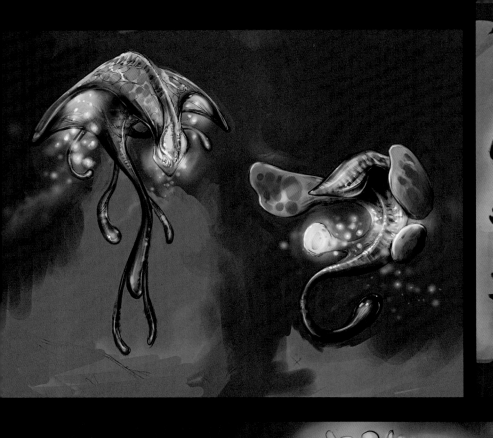
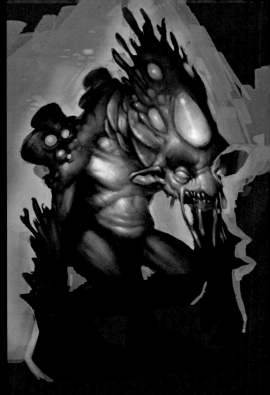
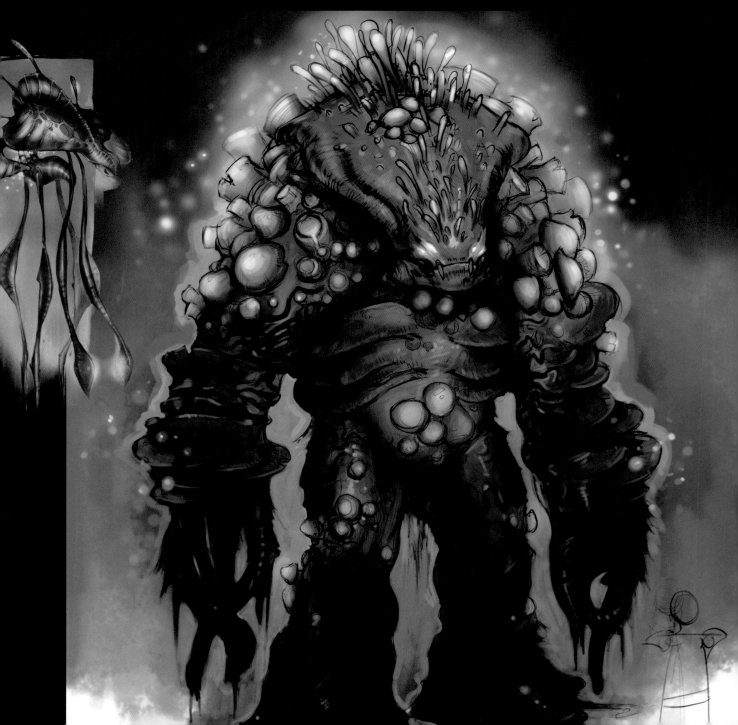

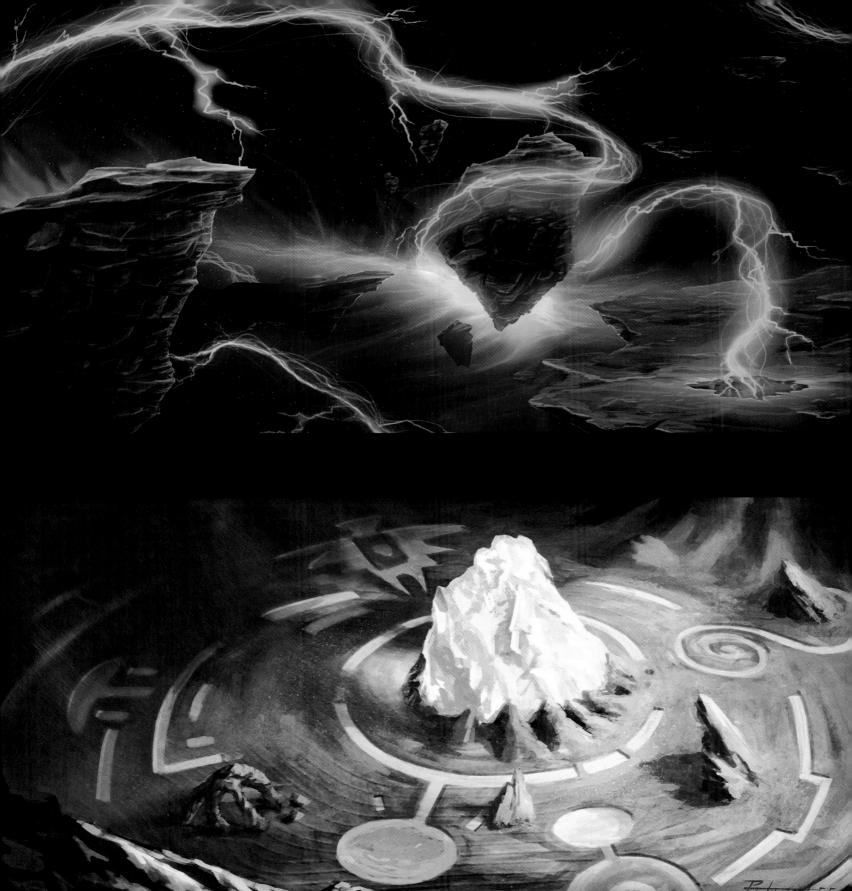

"Another Peter Lee of Nagrand, an area called Oshu'gun. Trying to do this weird crop circles idea that was, you know, these kind of tracks of ground that were cut out, these crystals growing out. It was just a really funky zone, and I think Pete really found a visual balance that just put it over the top and gave it a really strong character."

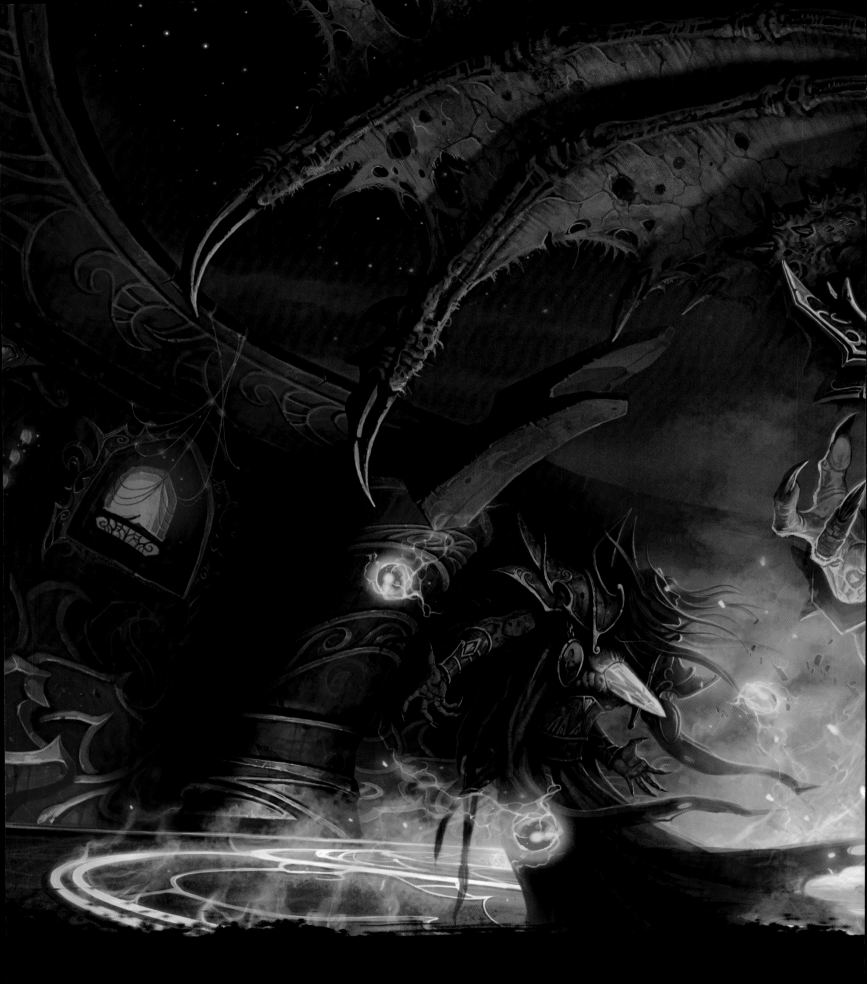

CHRIS M.: This is Wei's art for the Sunwell Patch. It shows the demon Kil'jaeden rising up out of the Sunwell and a very corrupted Prince Kael'thas summoning him. This was one of the first great demon images we had, and we had plenty of cool paintings of demons—mostly of Illidan—but this showed the scale of Kil'jaeden and the scale of the threat that waited beyond the universe to devour mankind.

SAMWISE: All in a big fiery toilet. Flush him and he's done.

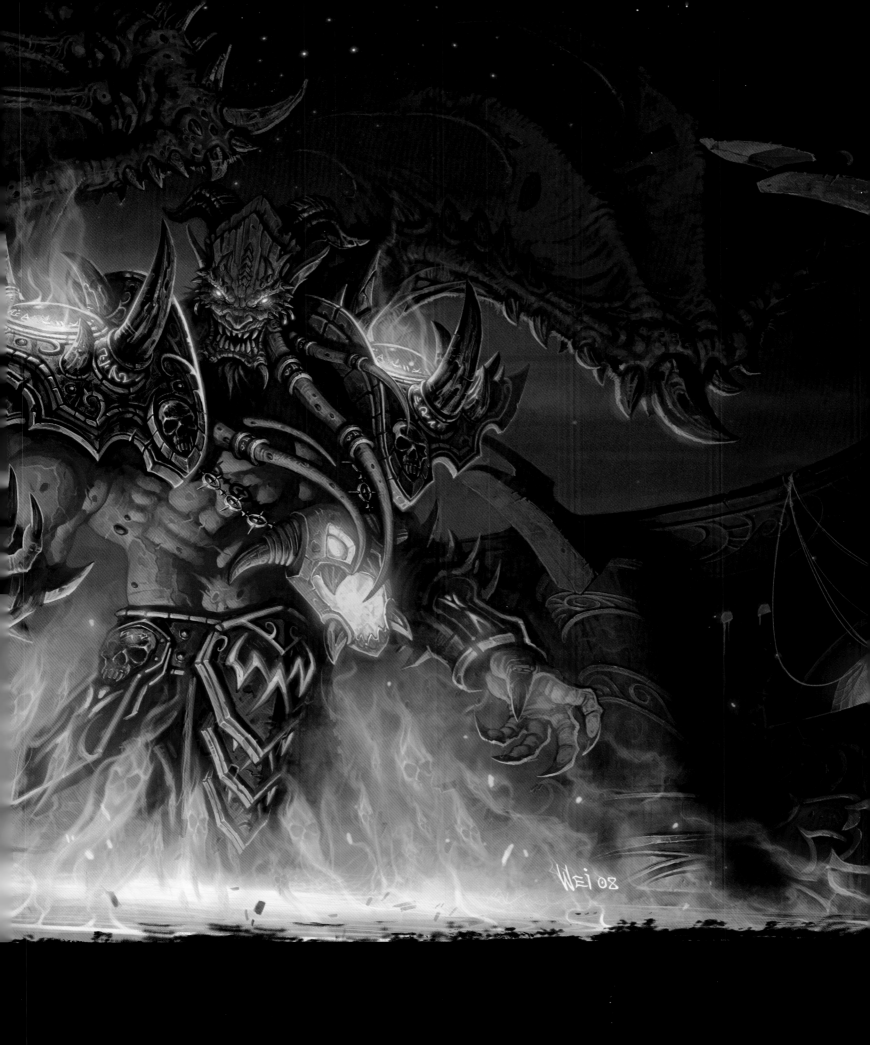

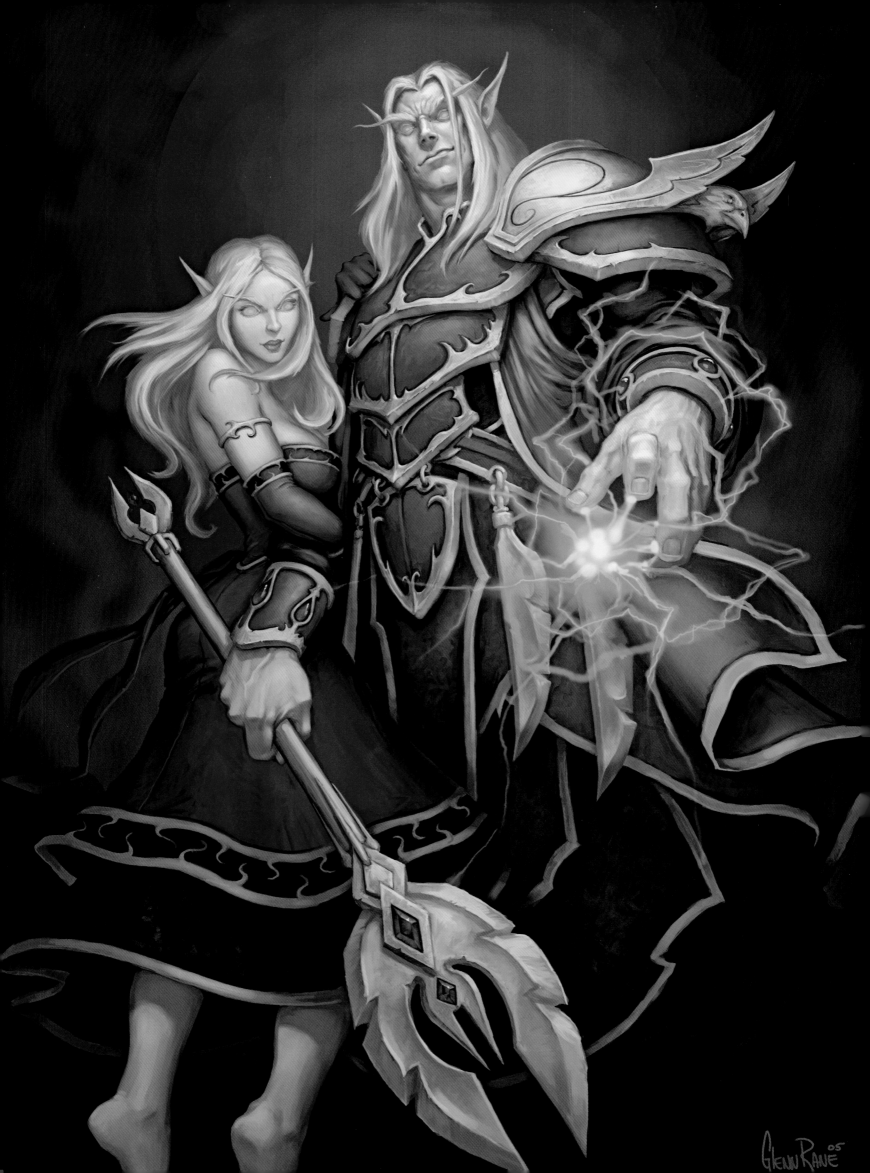

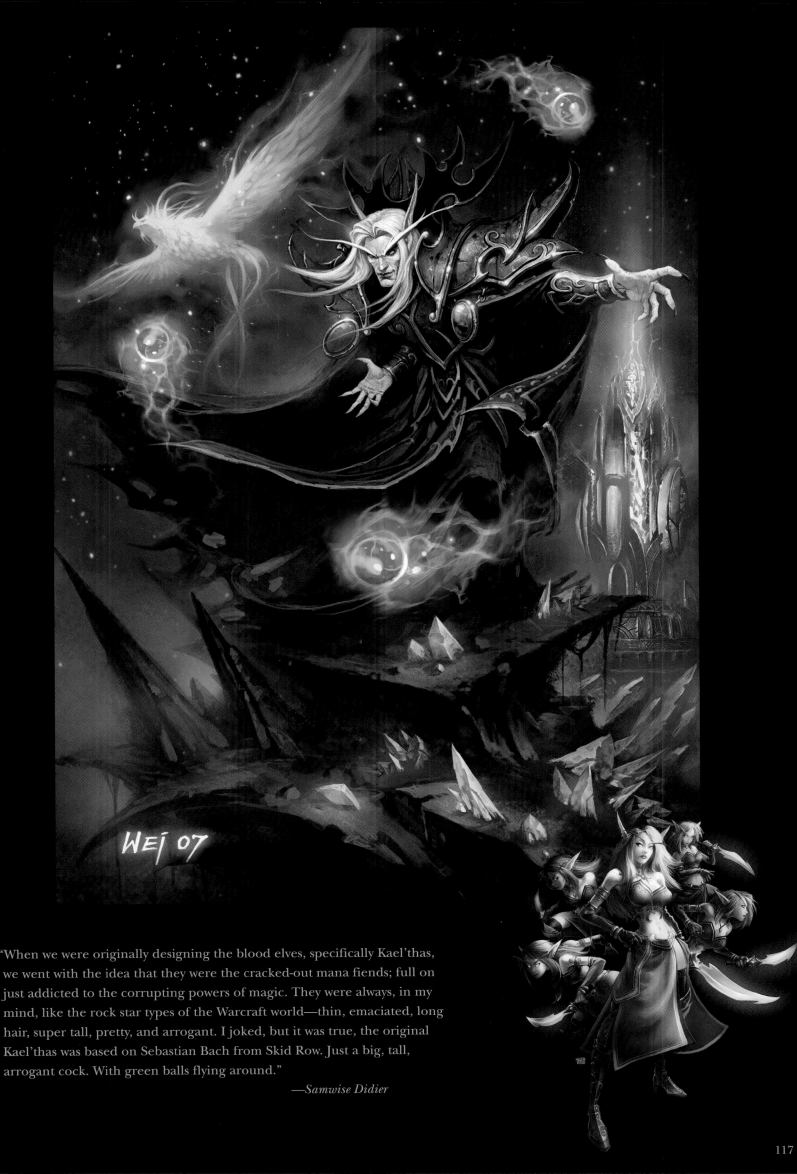

"When we were originally designing the blood elves, specifically Kael'thas, we went with the idea that they were the cracked-out mana fiends; full on just addicted to the corrupting powers of magic. They were always, in my mind, like the rock star types of the Warcraft world—thin, emaciated, long hair, super tall, pretty, and arrogant. I joked, but it was true, the original Kael'thas was based on Sebastian Bach from Skid Row. Just a big, tall, arrogant cock. With green balls flying around."

—*Samwise Didier*

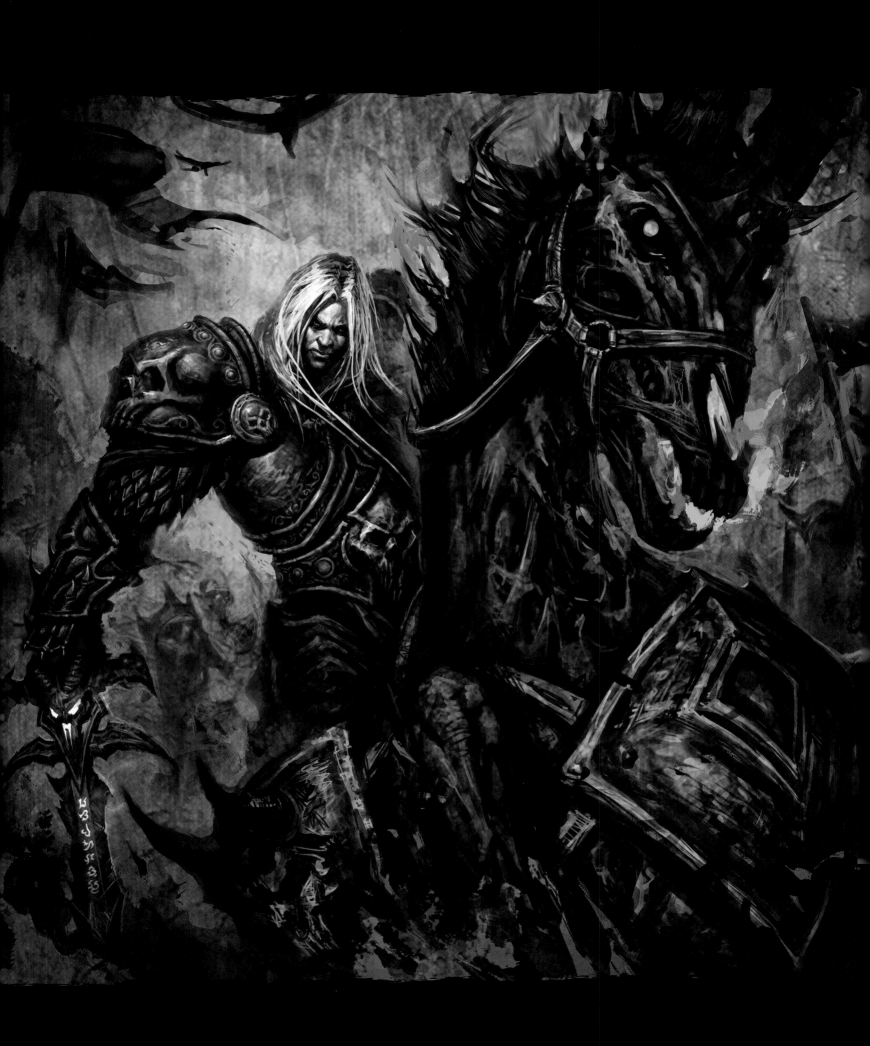

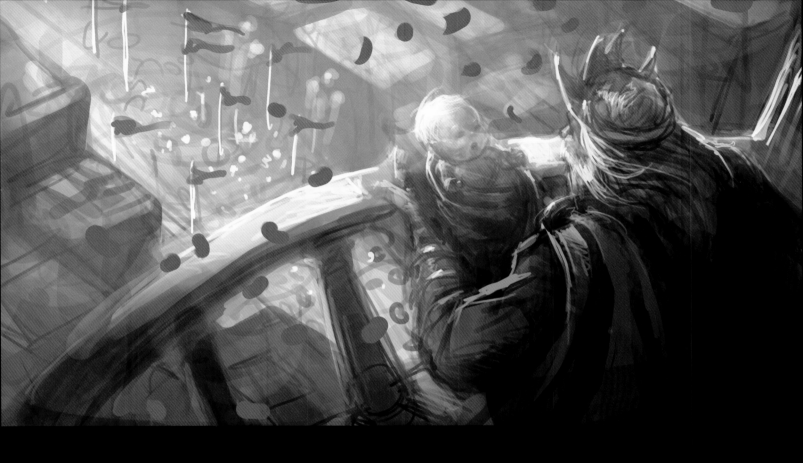

"The king with the baby Arthas. This wasn't done for anything and it's a rough image, but it shows
that we all start off nice and young and innocent—and then we turn into Lich Kings."

—*Samwise Didier*

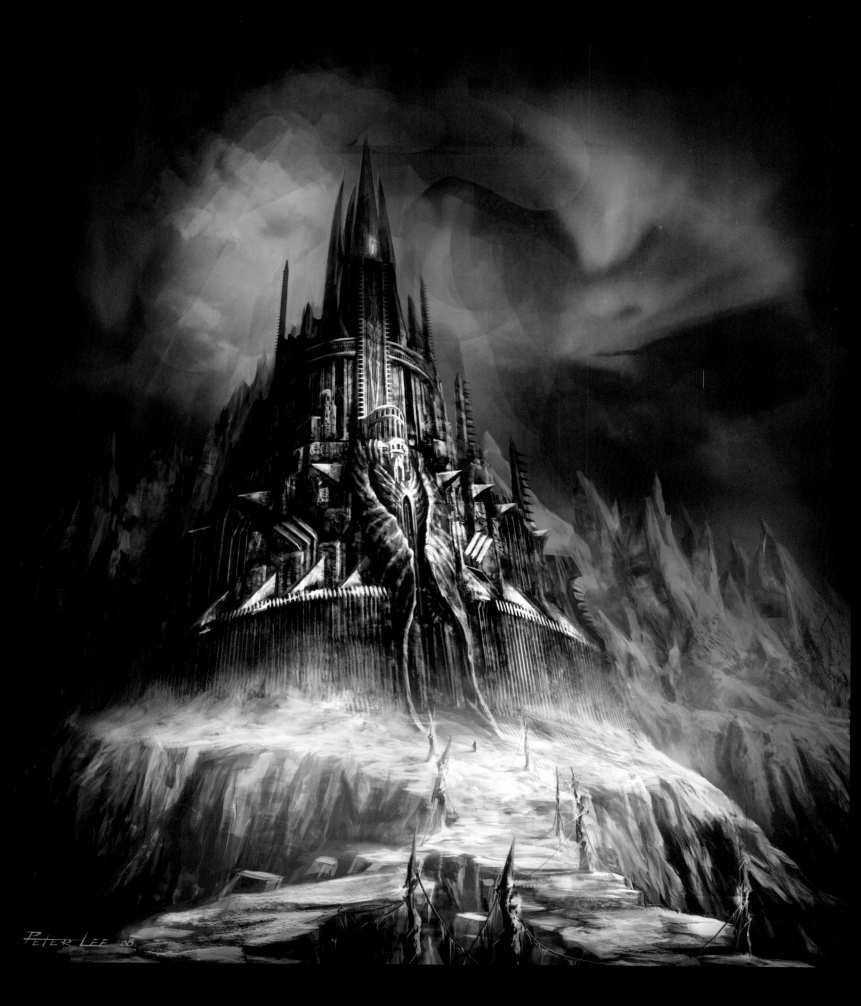

"One of the first paintings of Icecrown Citadel, which is another major site of import for the world—to see the power of the Lich King. This is his realm and all the power of Northrend emanates from here."

—*Chris Metzen*

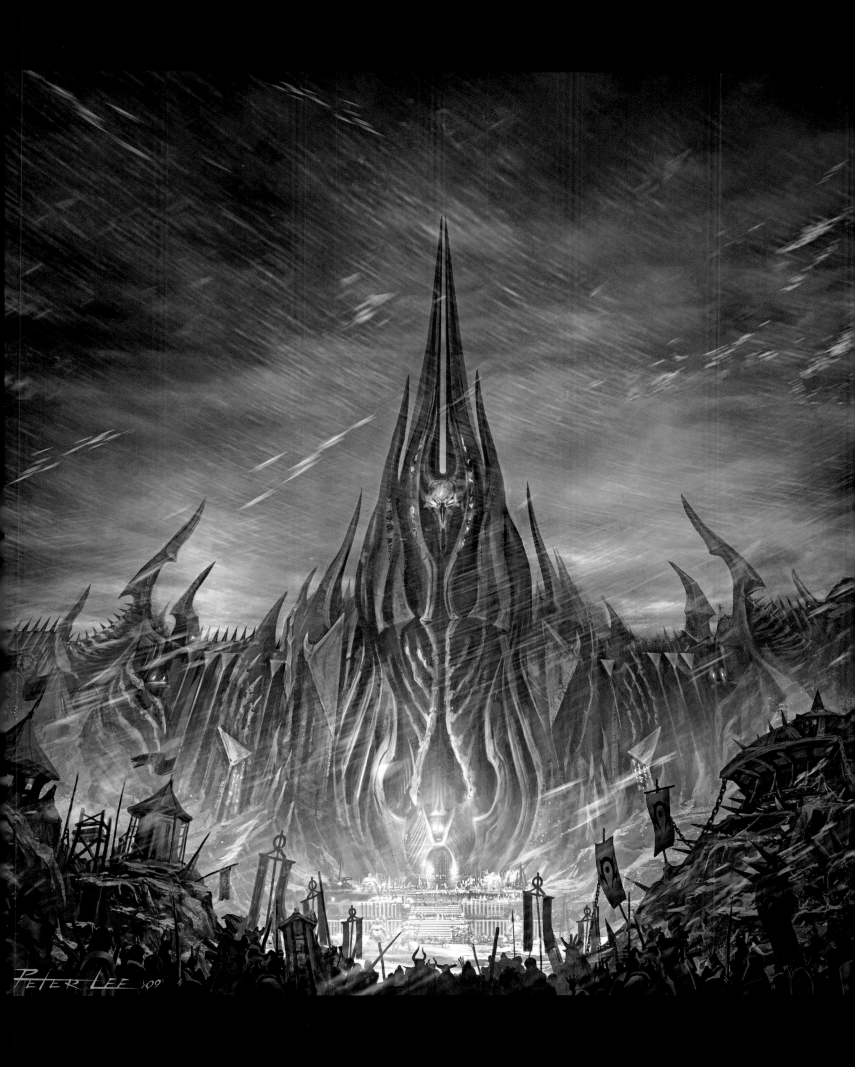

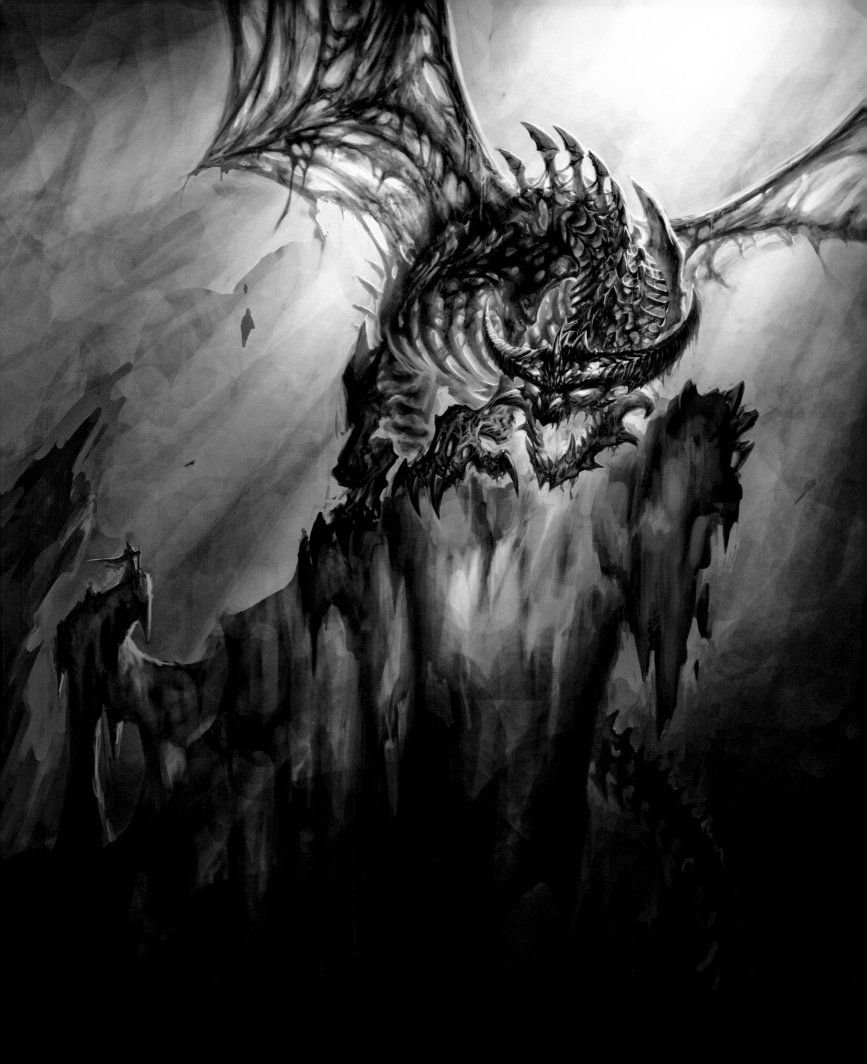

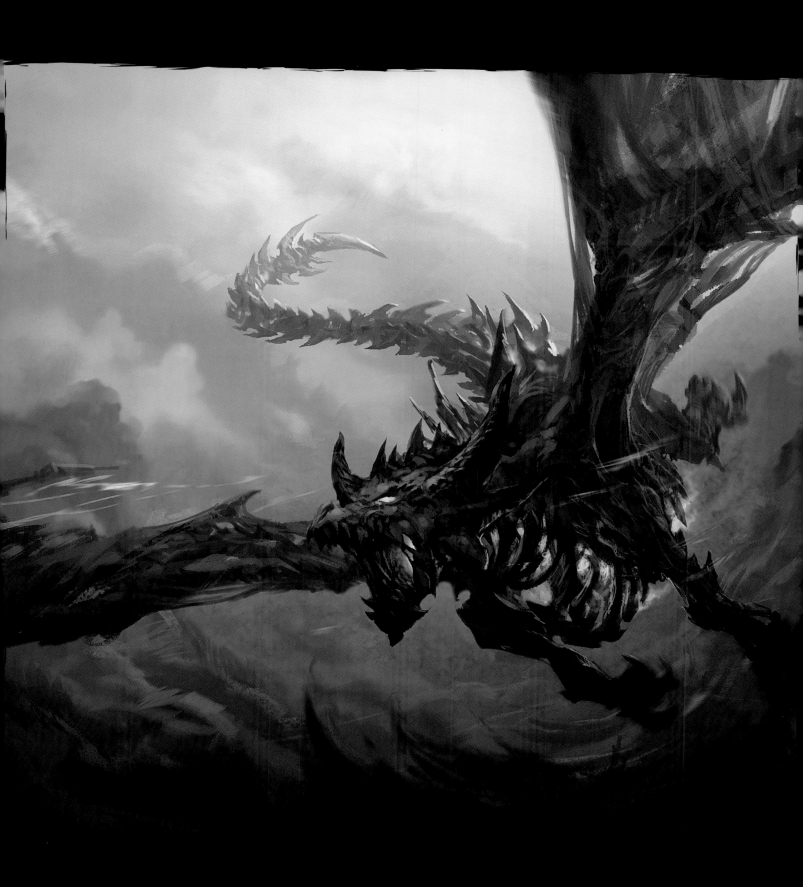

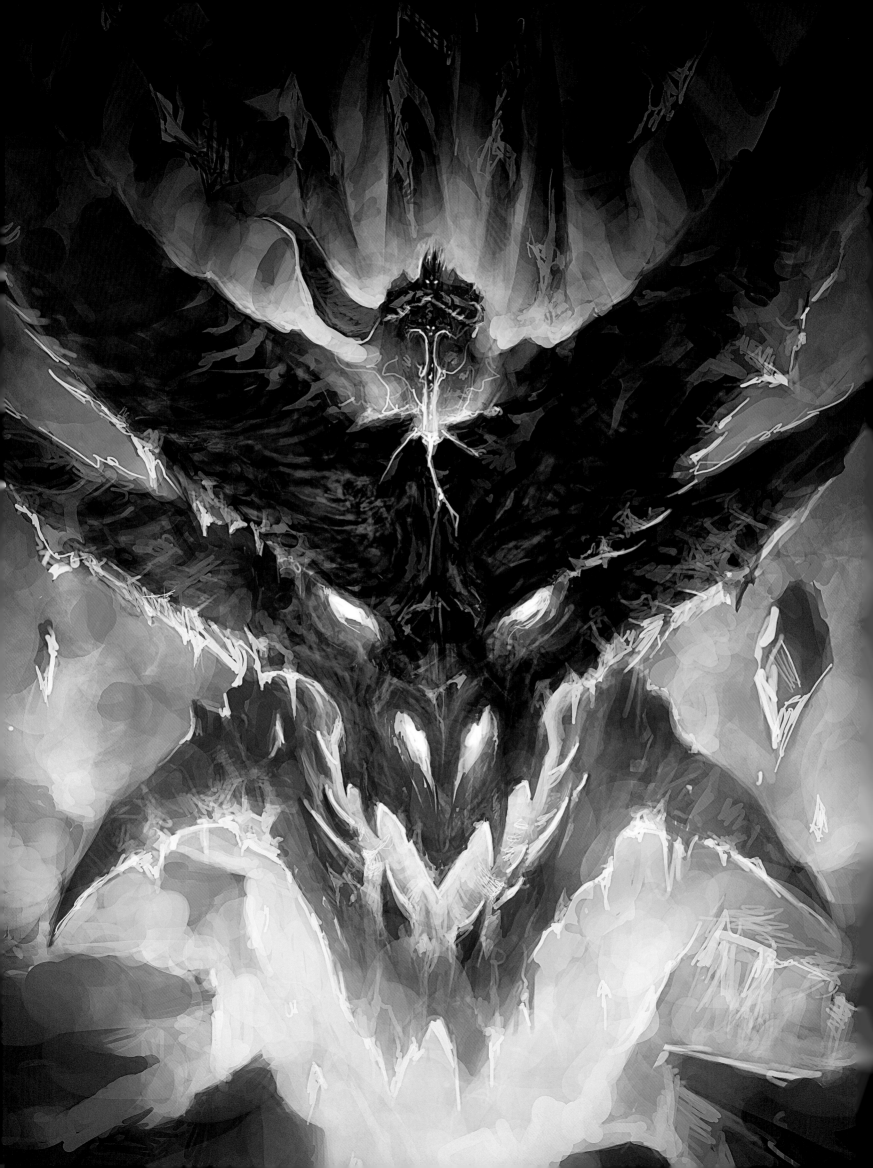

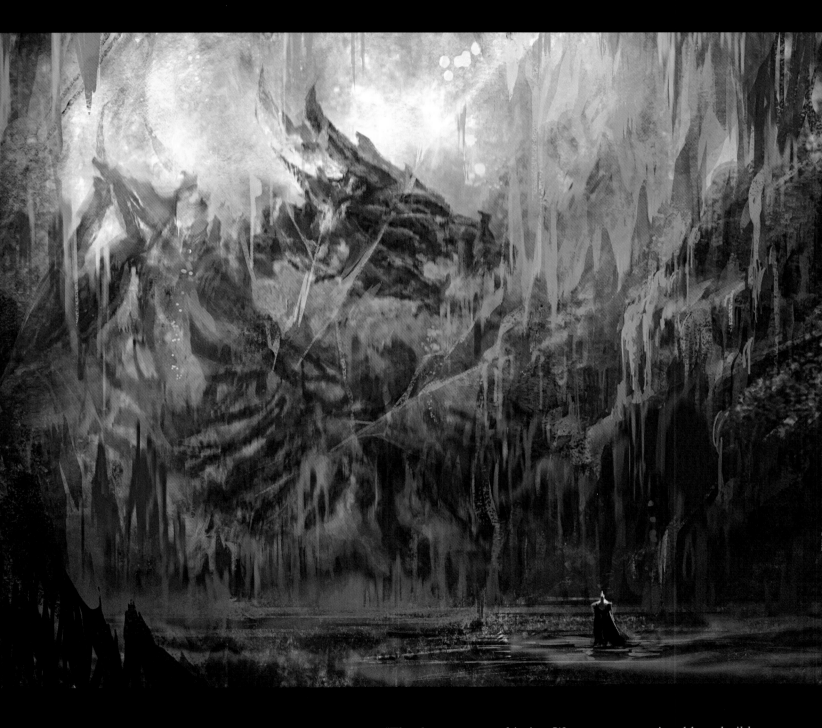

There is nothing like a big giant frickin' face, dude."
—*Samwise Didier*

"The dragon trapped in ice. We were never quite able to build a
space like that in the game, but it was a really inspirational image."
—*Chris Metzen*

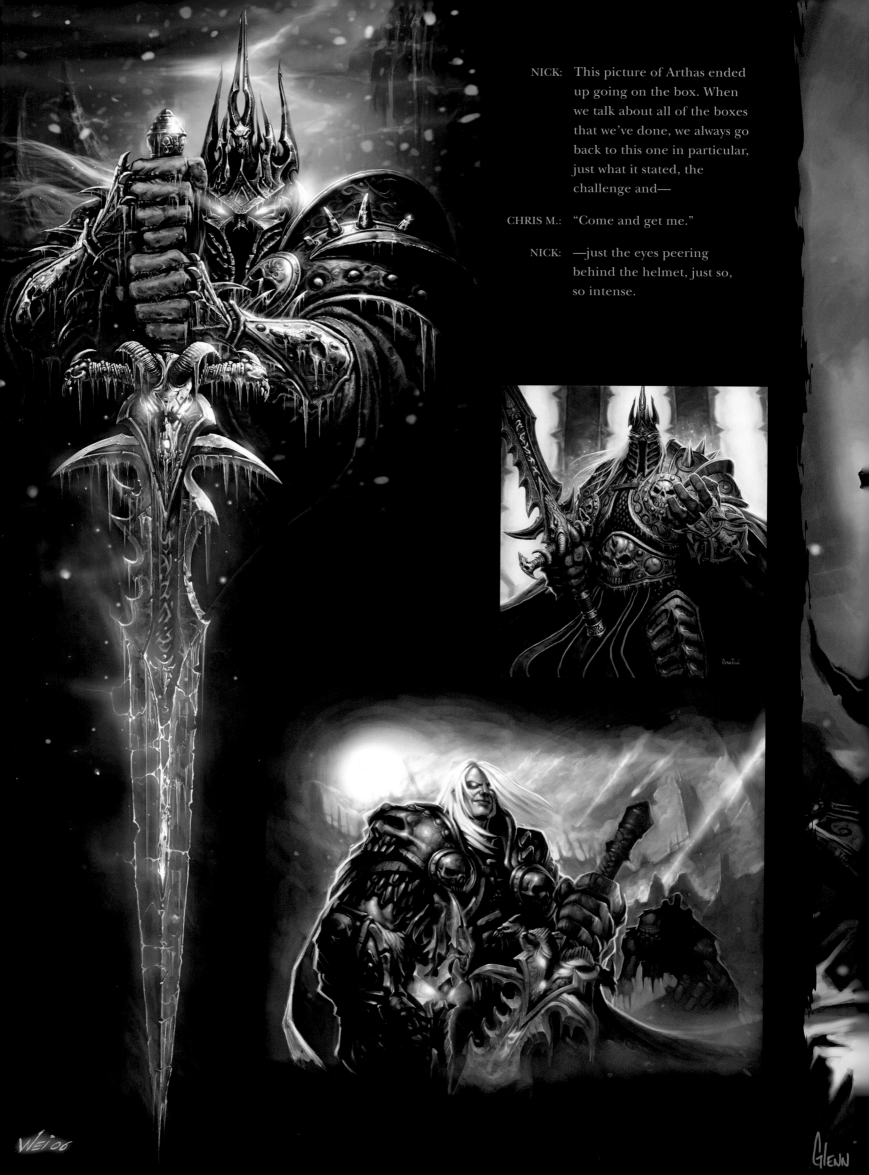

NICK: This picture of Arthas ended up going on the box. When we talk about all of the boxes that we've done, we always go back to this one in particular, just what it stated, the challenge and—

CHRIS M.: "Come and get me."

NICK: —just the eyes peering behind the helmet, just so, so intense.

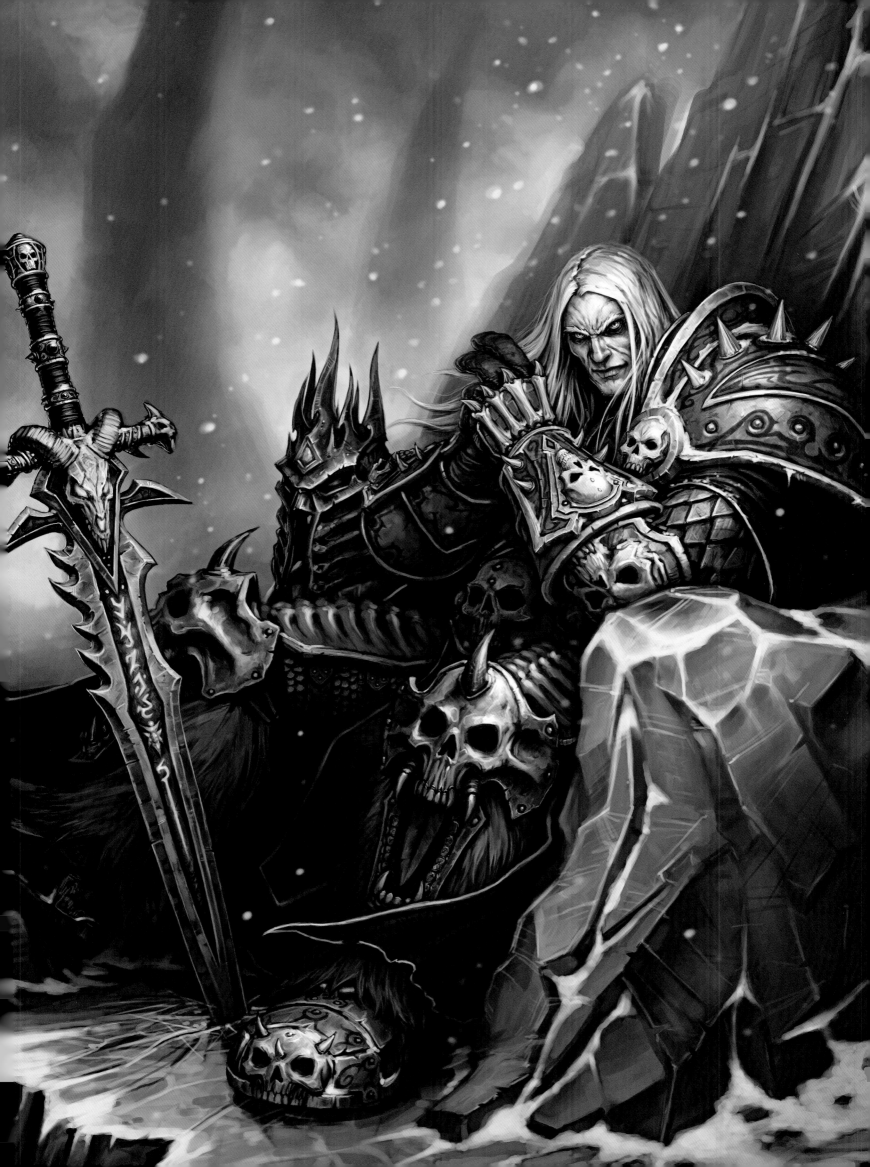

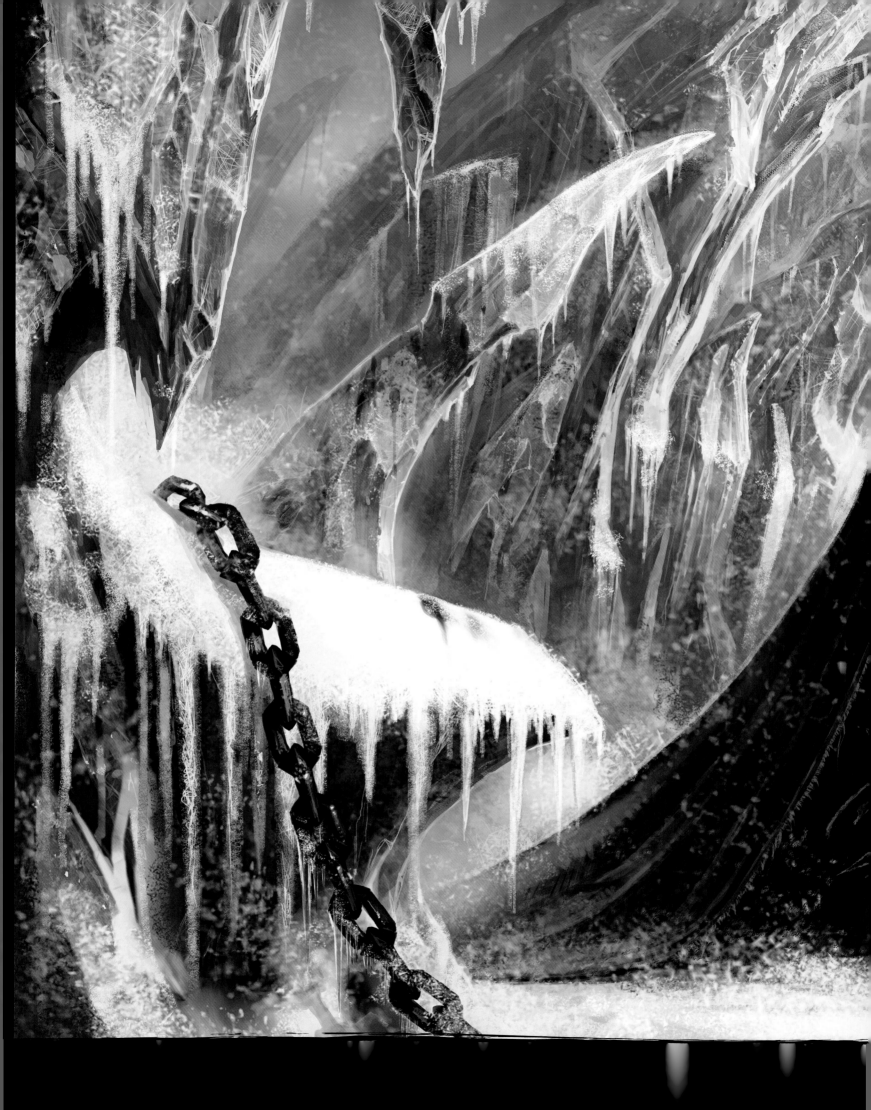

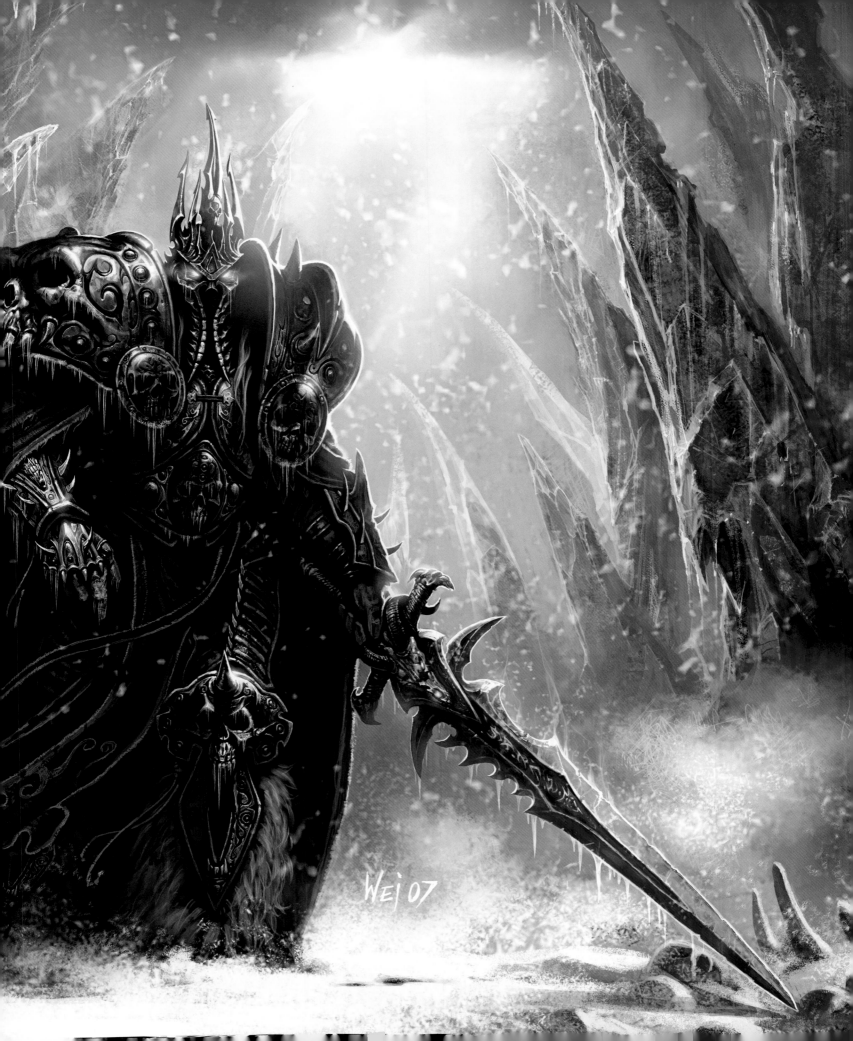

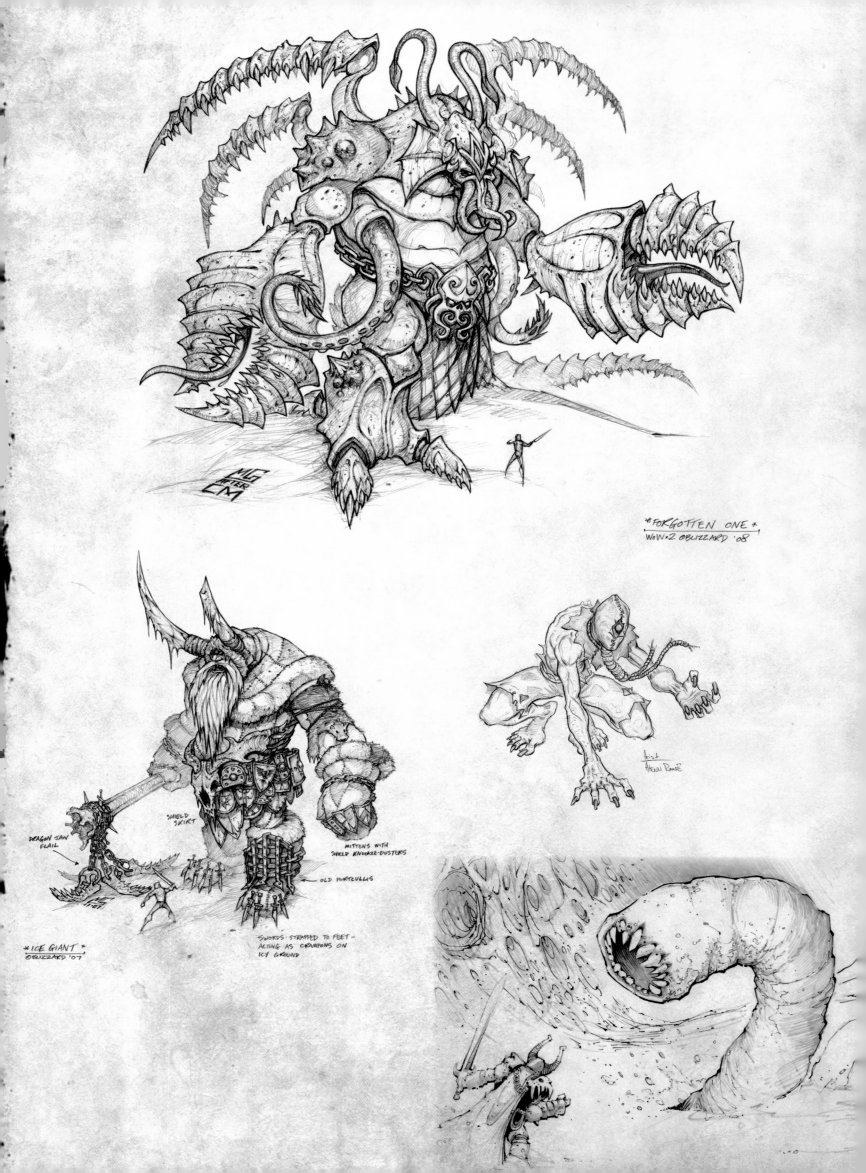

* FORGOTTEN ONE *
WoW×2 ©BLIZZARD '08

SHIELD
SKIRT

DRAGON JAW
FLAIL

MITTENS WITH
SHIELD KNUCKLE-DUSTERS

OLD PORTCULLIS

* ICE GIANT *
©BLIZZARD '07

SWORDS STRAPPED TO FEET
ACTING AS CRAMPONS ON
ICY GROUND

Artist
ALENN RAME

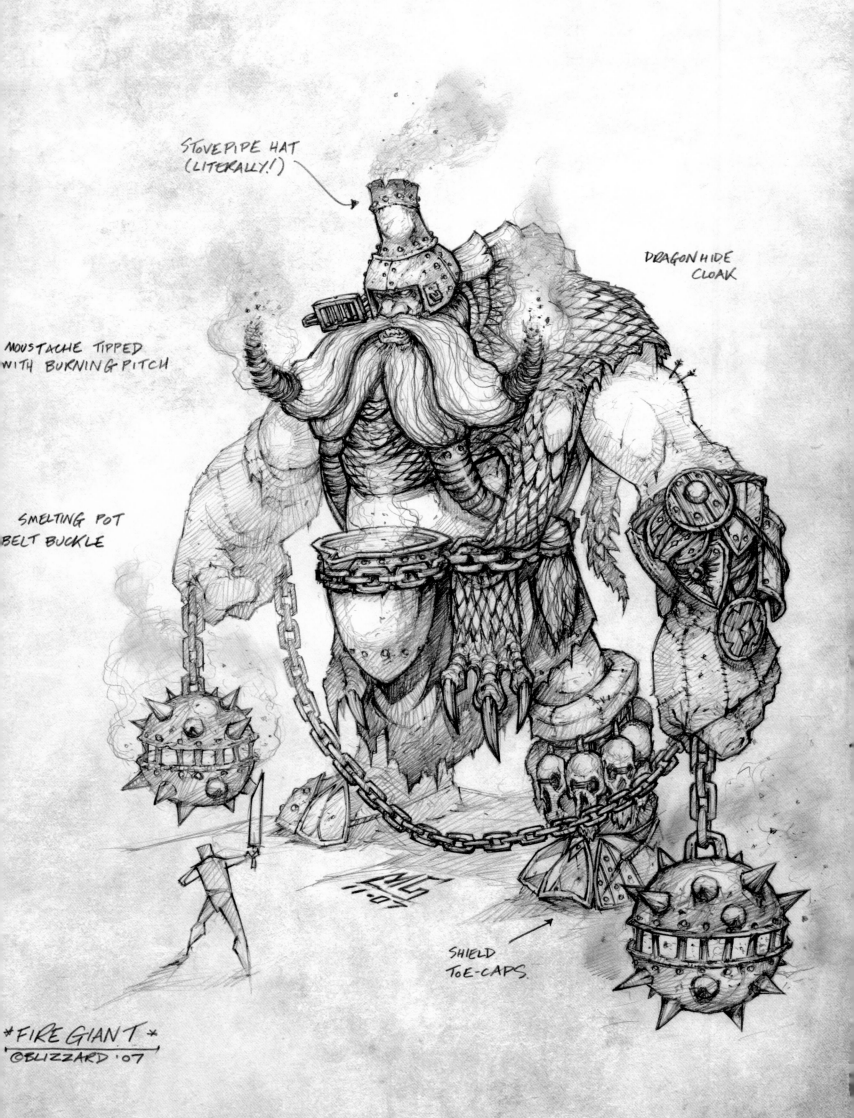

STOVEPIPE HAT
(LITERALLY!)

DRAGON HIDE
CLOAK

MOUSTACHE TIPPED
WITH BURNING PITCH

SMELTING POT
BELT BUCKLE

SHIELD
TOE-CAPS.

FIRE GIANT
©BLIZZARD '07

131

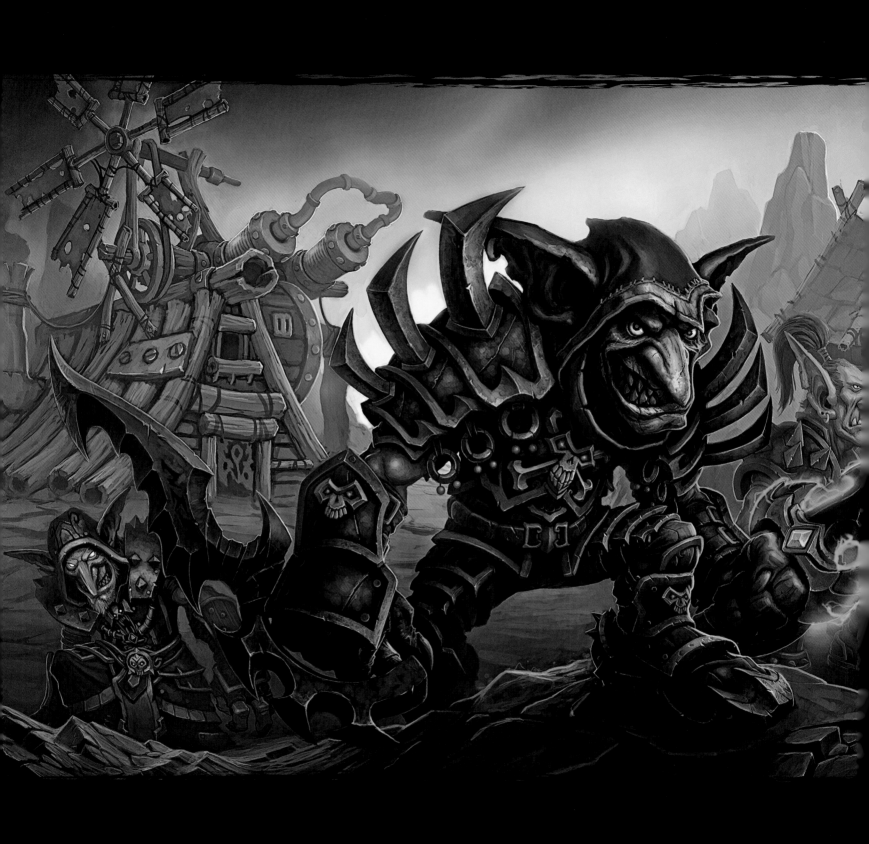

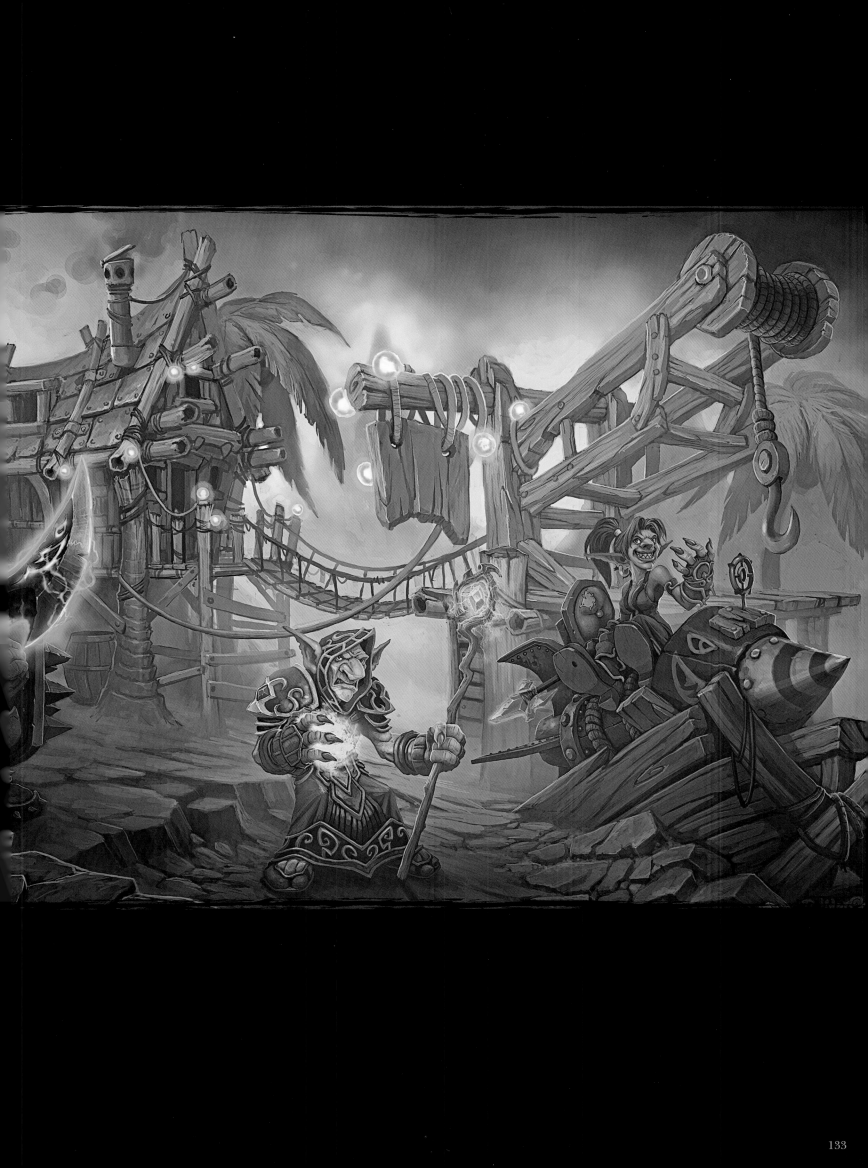

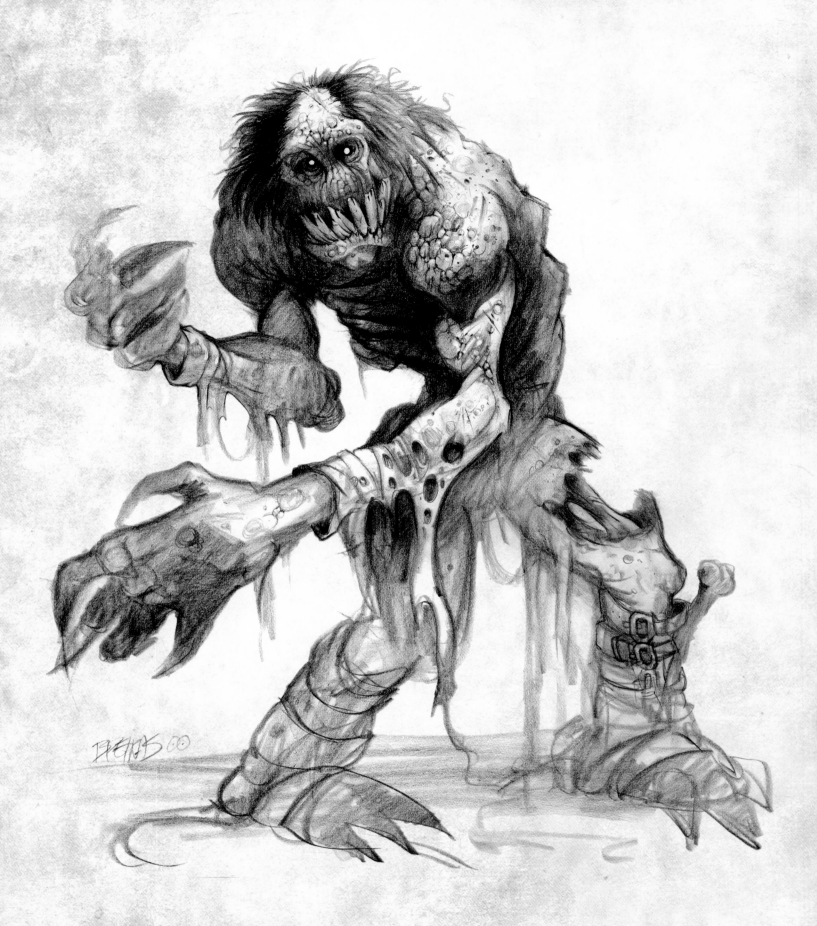

NICK: The ghoul was such an awesome picture for me. I think that was Petras.

CHRIS M.: Yeah, it was early on in WoW.

SAMWISE: Well, we hadn't had the ghouls yet for *Warcraft III*. When we saw this
image, we changed our face to look like that, because that was the one
done for WoW. So we made our ghouls look like WoW.

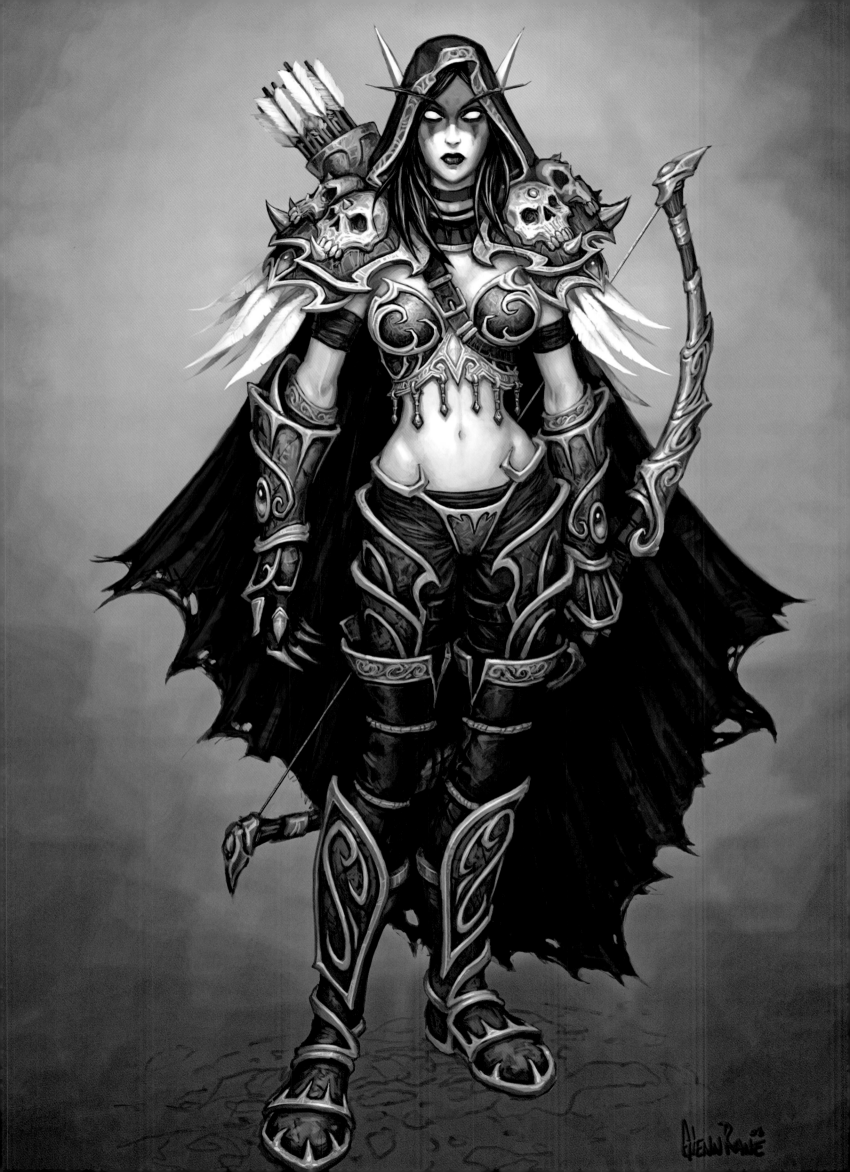

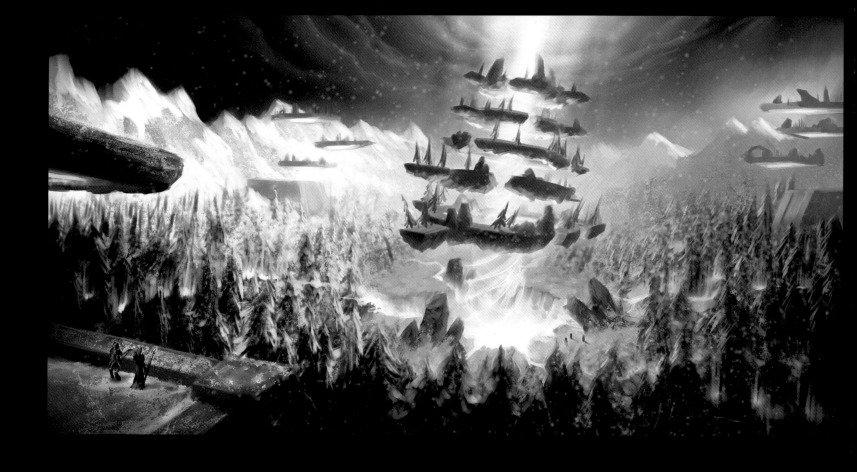

"Nexus and Coldarra—it was just the right mix of rooted, but
high concept. These concentric rings of land that had been
lifted by magic. It's just really transporting for me."
—*Chris Metzen*

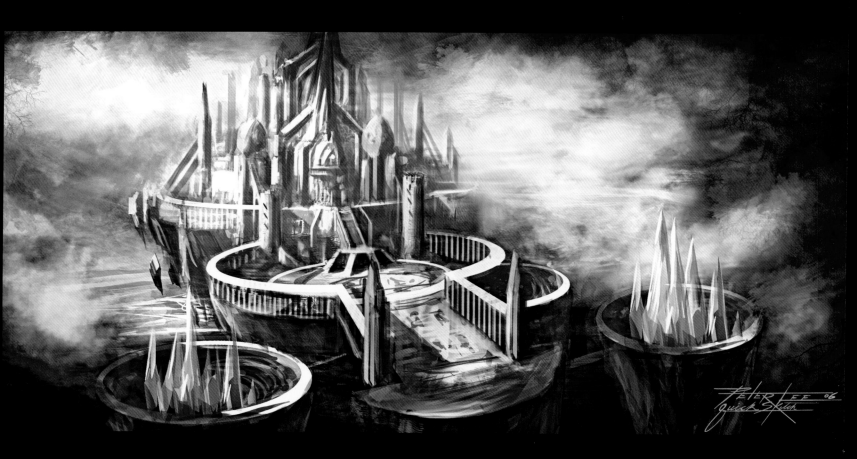

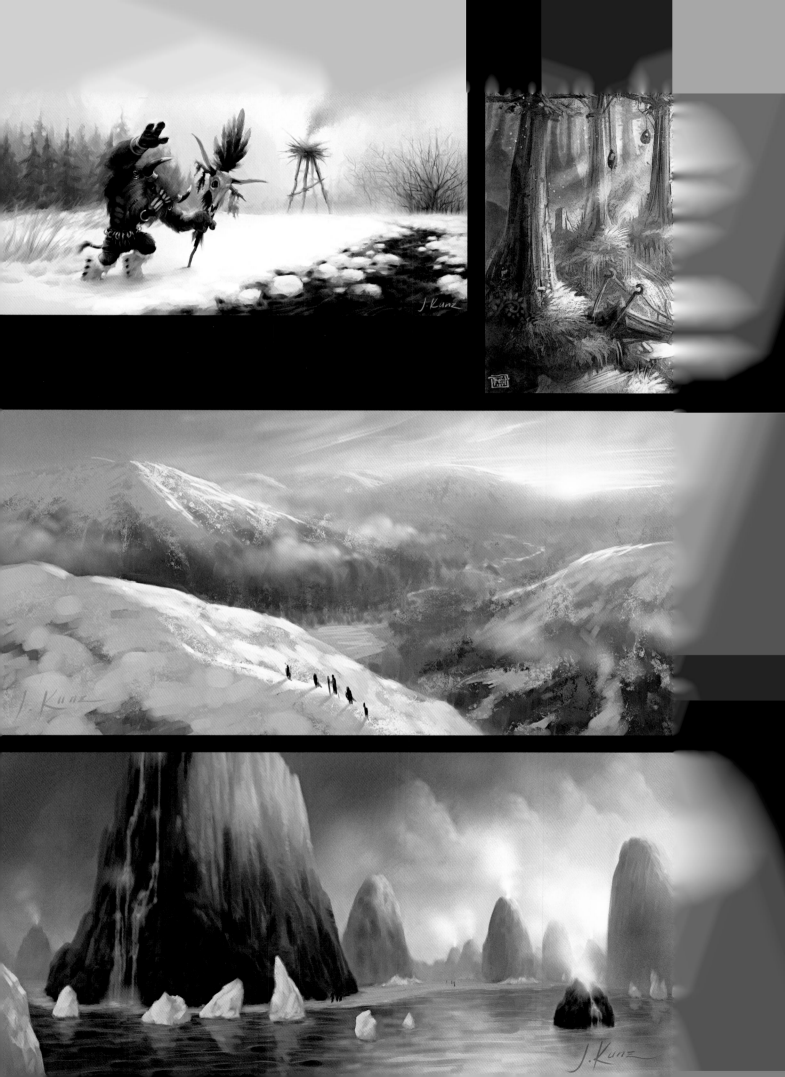

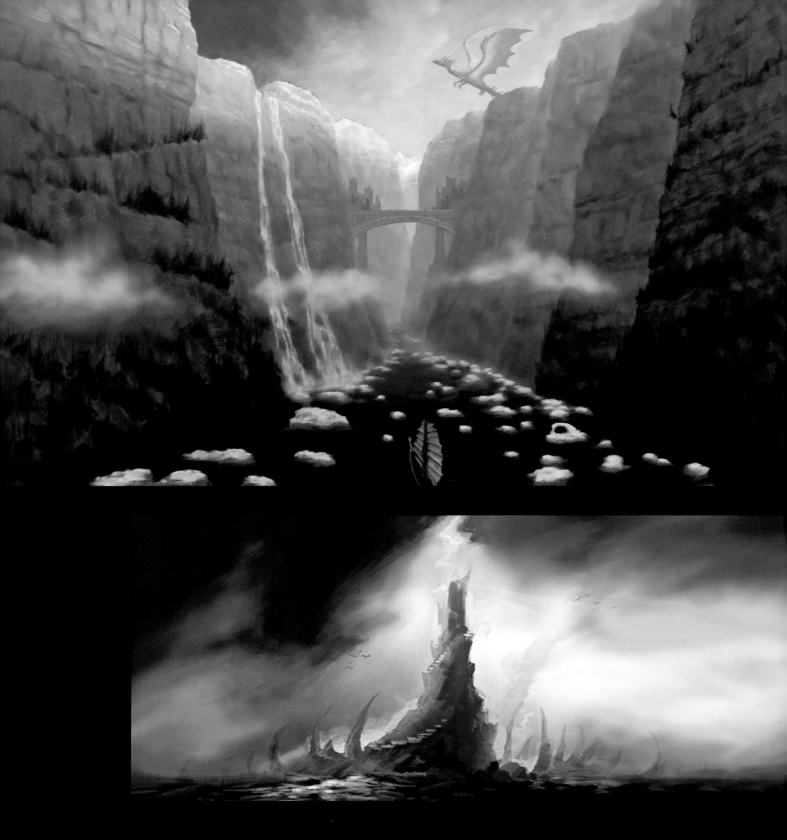

NICK: Sam's frozen throne image.

SAMWISE: I think that's the only background I've ever done.

NICK: Well, it was pivotal also.

CHRIS M.: It got it done. We wound up building Icecrown Citadel around that spire of stone, even evidenced in the game all these years later, you pretty much fight Arthas on that piece of rock, even though it's exposed through the top of the castle.

SAMWISE: Hear that aspiring artists: Draw it first and it usually sticks.

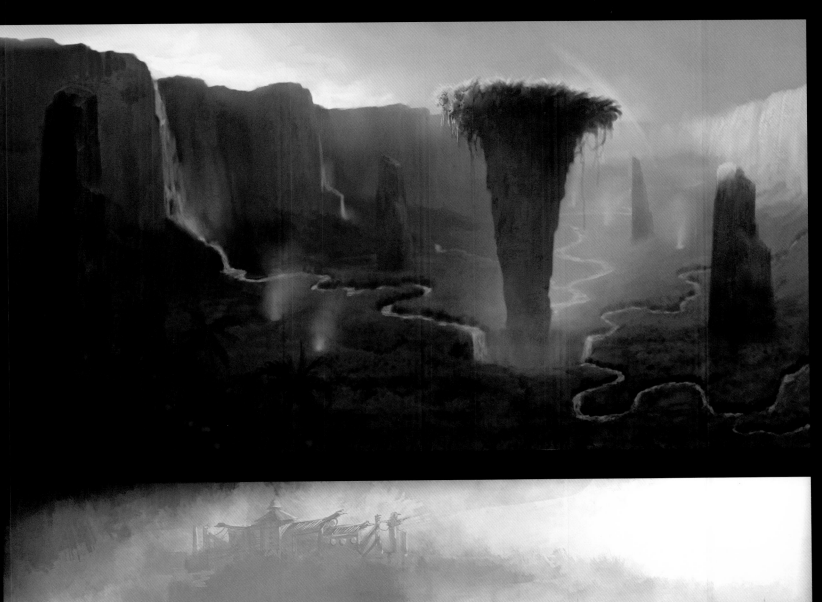

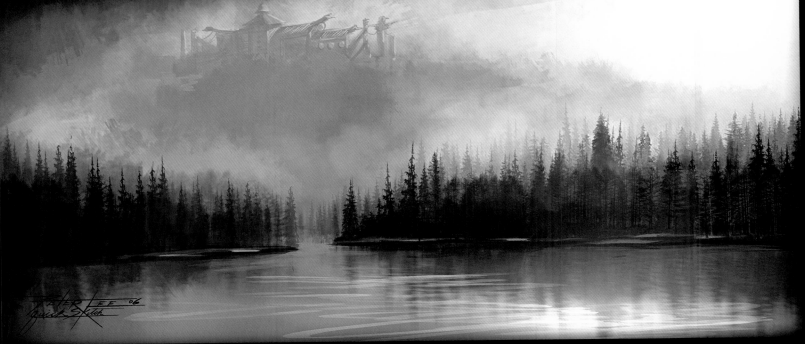

"In Howling Fjord, it's an area called Skorn and it's one of the vrykul villages. This village was painted before we actually had all that dialed in, but it was so impactful, it wound up working its way into the game. I loved the vibe of Northrend that it gave—the mist rising above the tree lines. It was very anchoring after the highfalutin concepts of Outland, for the guys to be conceptualizing areas that could plausibly exist within terrestrial Azeroth."

—Chris Metzen

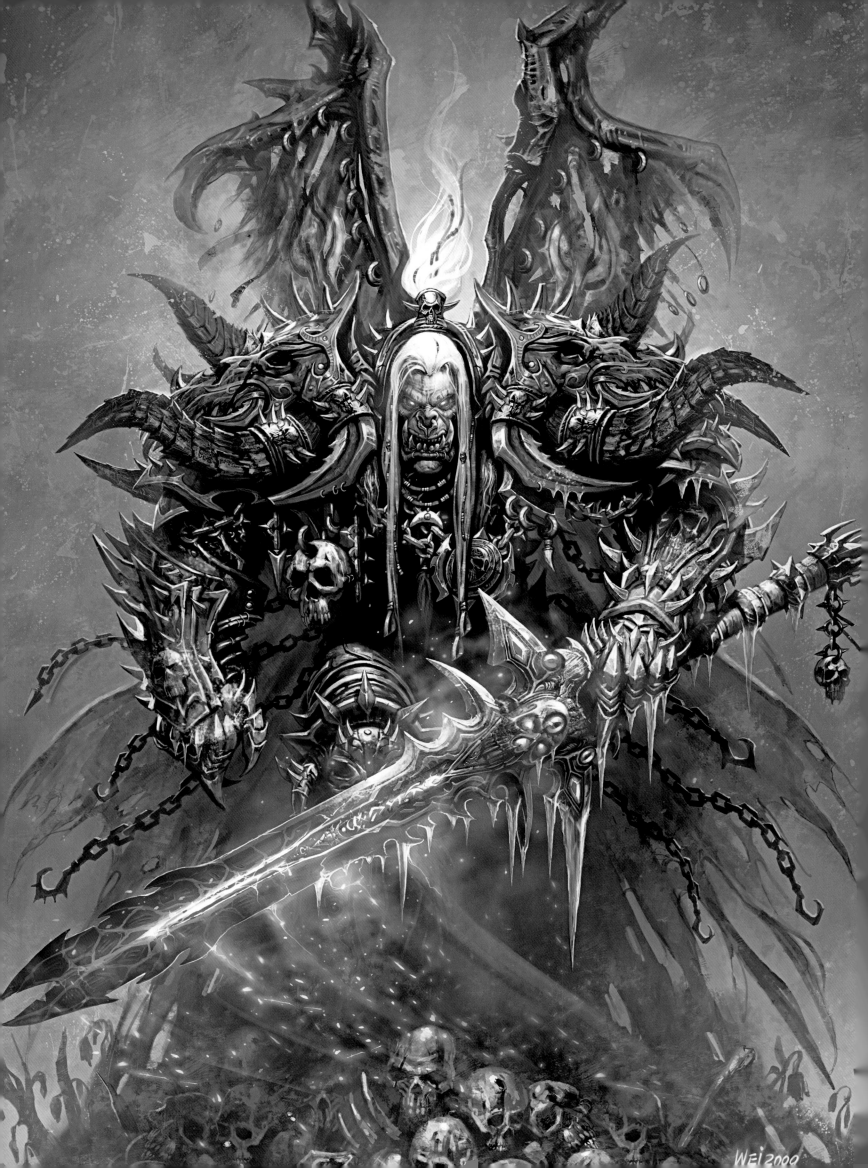

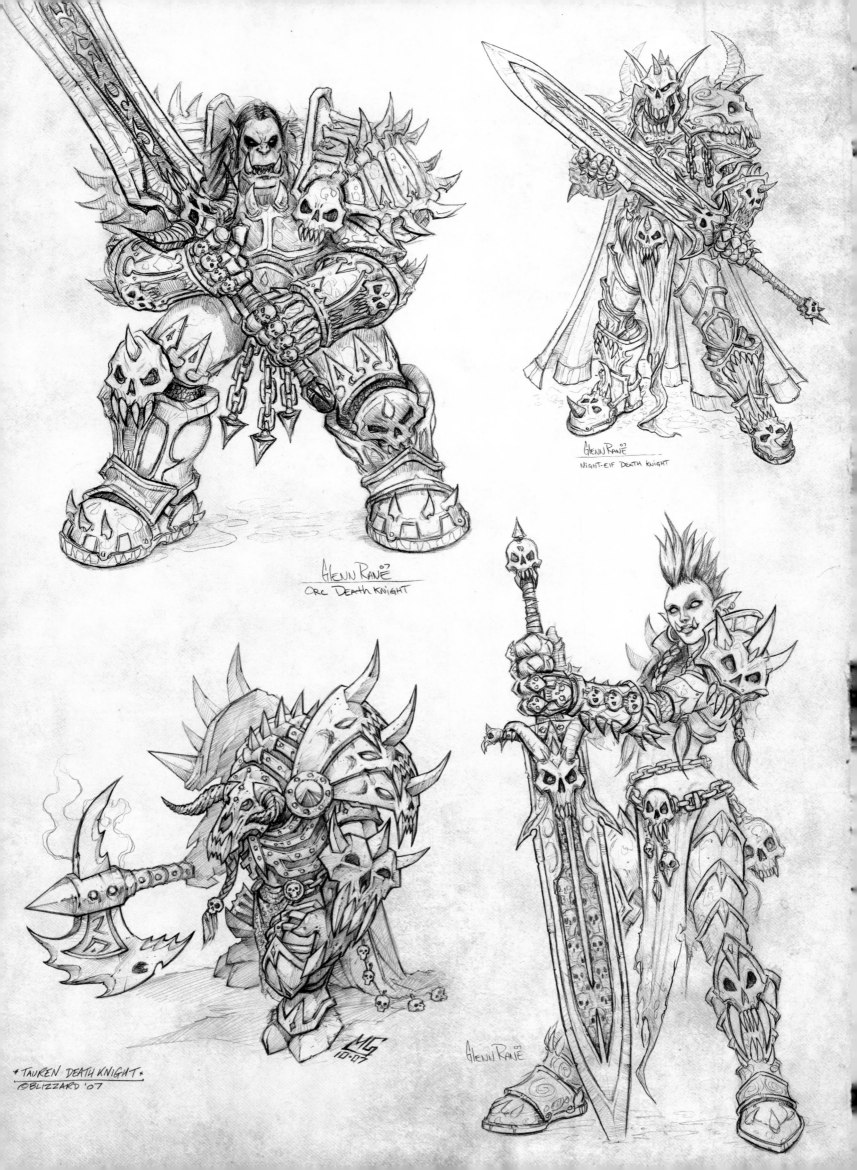

Glenn Rané '07
Orc Death Knight

Glenn Rané '07
Night-Elf Death Knight

Glenn Rané '07

Tauren Death Knight
©Blizzard '07

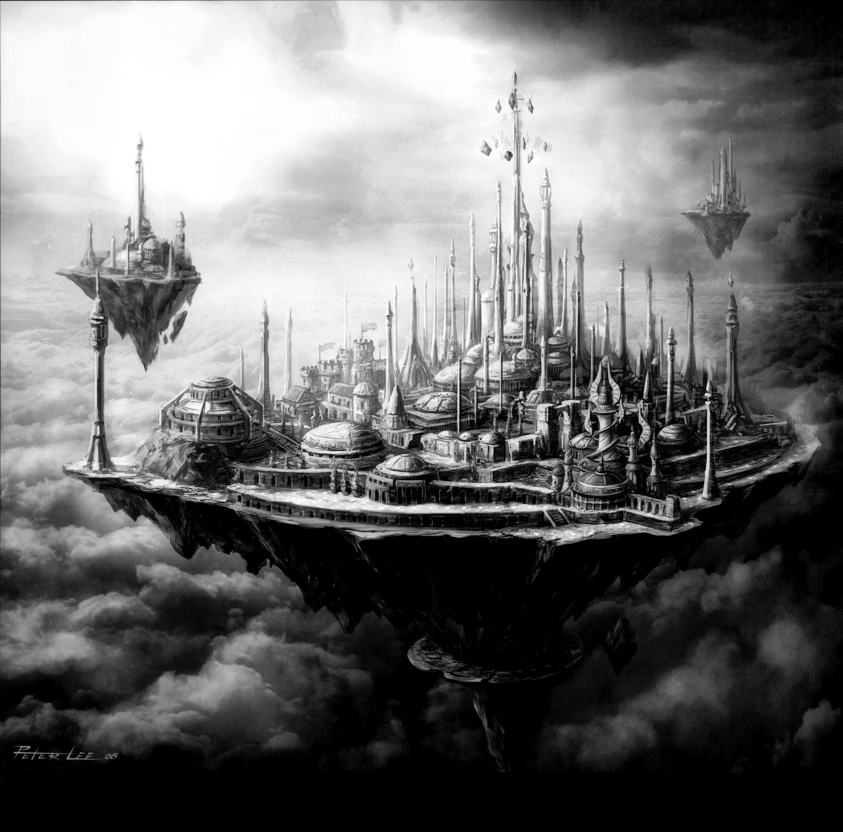

"Dalaran is this city of wizards that they had lifted out of the ground and kind of teleported into the skies above Northrend, and this image was one of the first to really establish that look."

—*Chris Metzen*

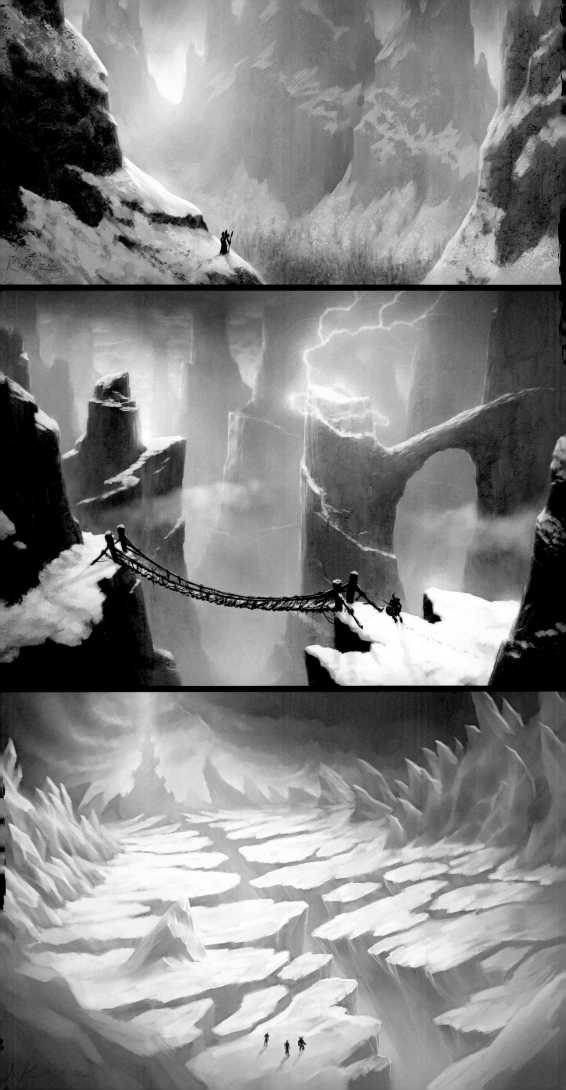

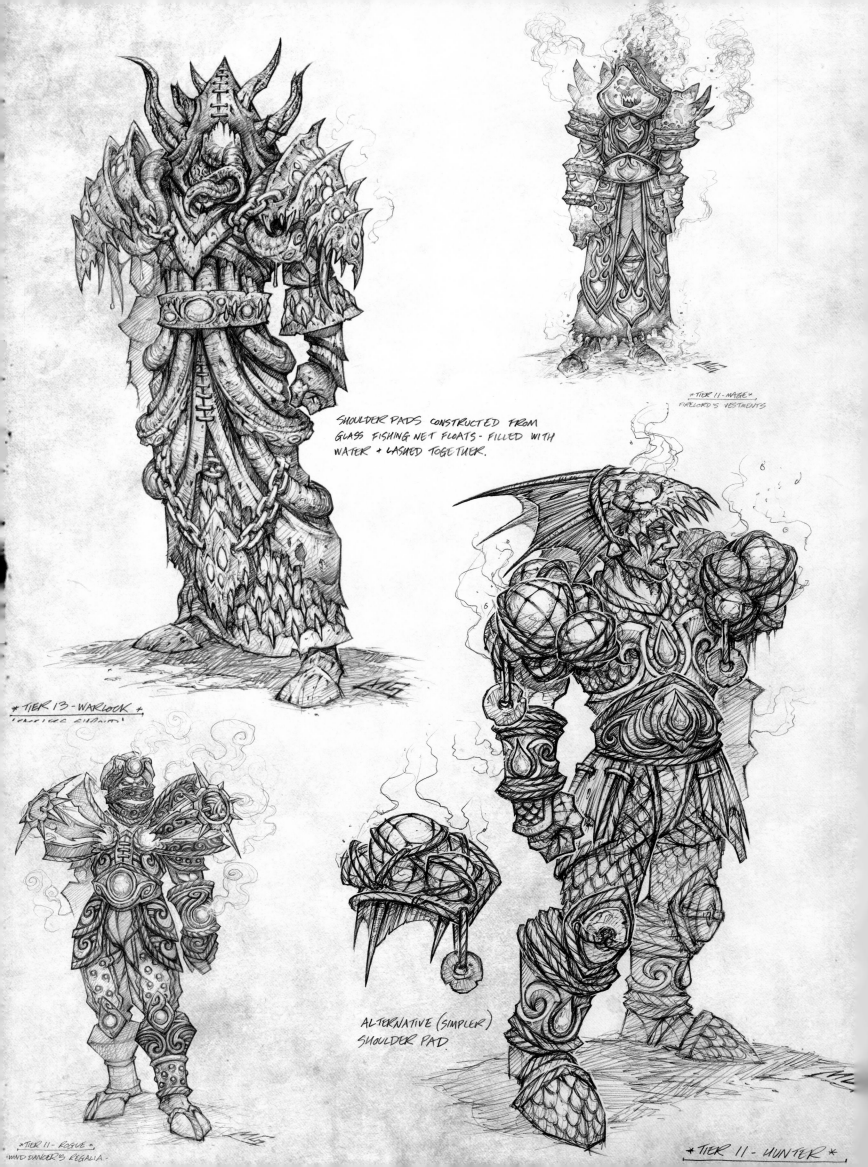

SHOULDER PADS CONSTRUCTED FROM
GLASS FISHING NET FLOATS - FILLED WITH
WATER + LASHED TOGETHER.

* TIER 11 - MAGE *
FIRELORD'S VESTMENTS

* TIER 13 - WARLOCK *

ALTERNATIVE (SIMPLER)
SHOULDER PAD

* TIER 11 - ROGUE *
WIND DANCER'S REGALIA

* TIER 11 - HUNTER *

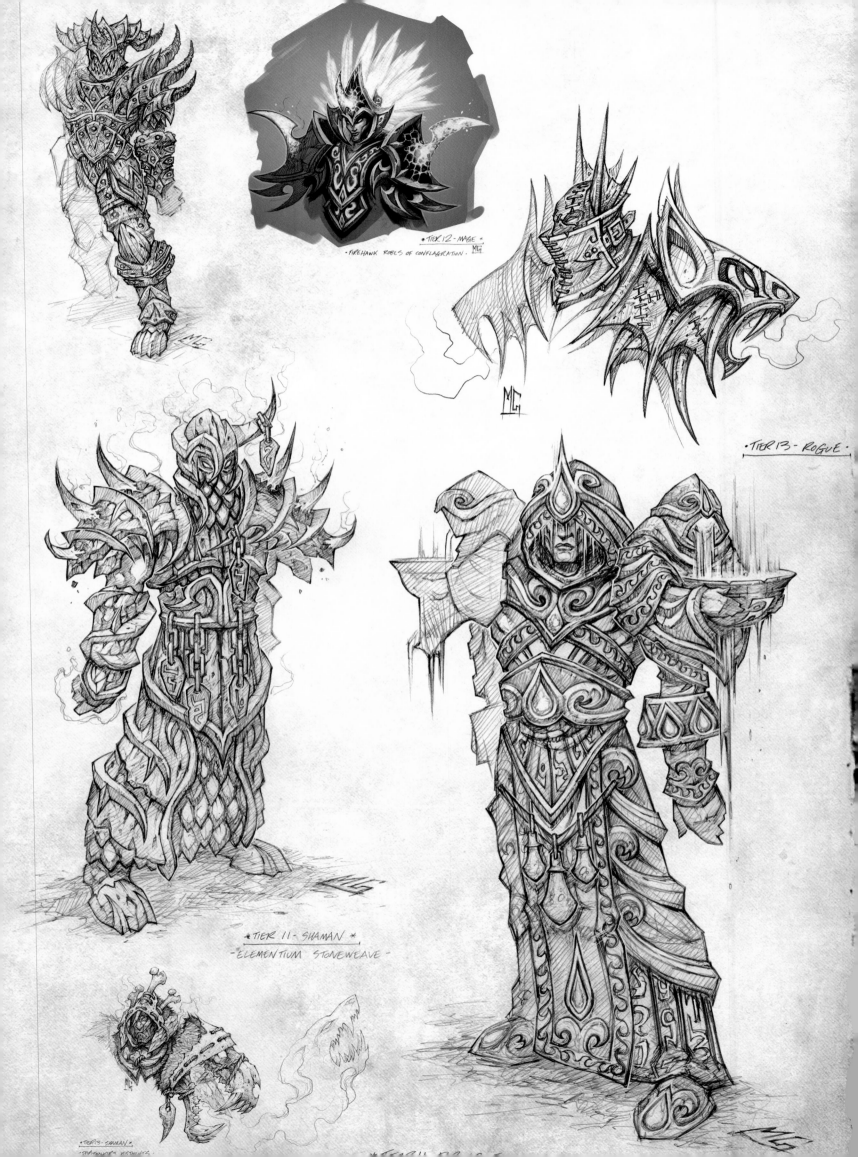

· TIER 12 - MAGE ·

· FIREHAWK ROBES OF CONFLAGRATION · MG

· TIER 13 - ROGUE ·

* TIER 11 - SHAMAN *

- ELEMENTIUM STONEWEAVE -

· TIER 13 - SHAMAN ·

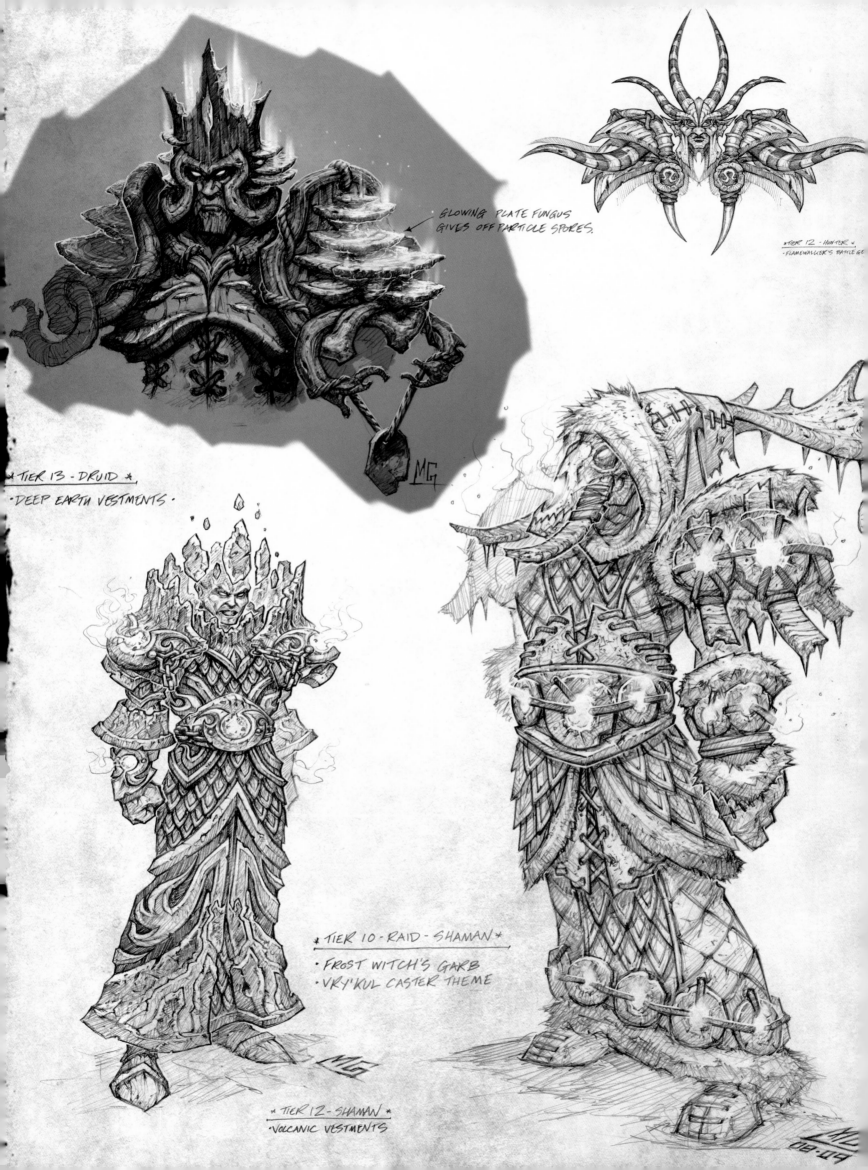

GLOWING PLATE FUNGUS
GIVES OFF PARTICLE SPORES.

* TIER 12 - HUNTER *
· FLAMEWALKER'S BATTLE GE

* TIER 13 - DRUID *
· DEEP EARTH VESTMENTS ·

* TIER 10 - RAID - SHAMAN *
· FROST WITCH'S GARB
· VRY'KUL CASTER THEME

* TIER 12 - SHAMAN *
· VOLCANIC VESTMENTS

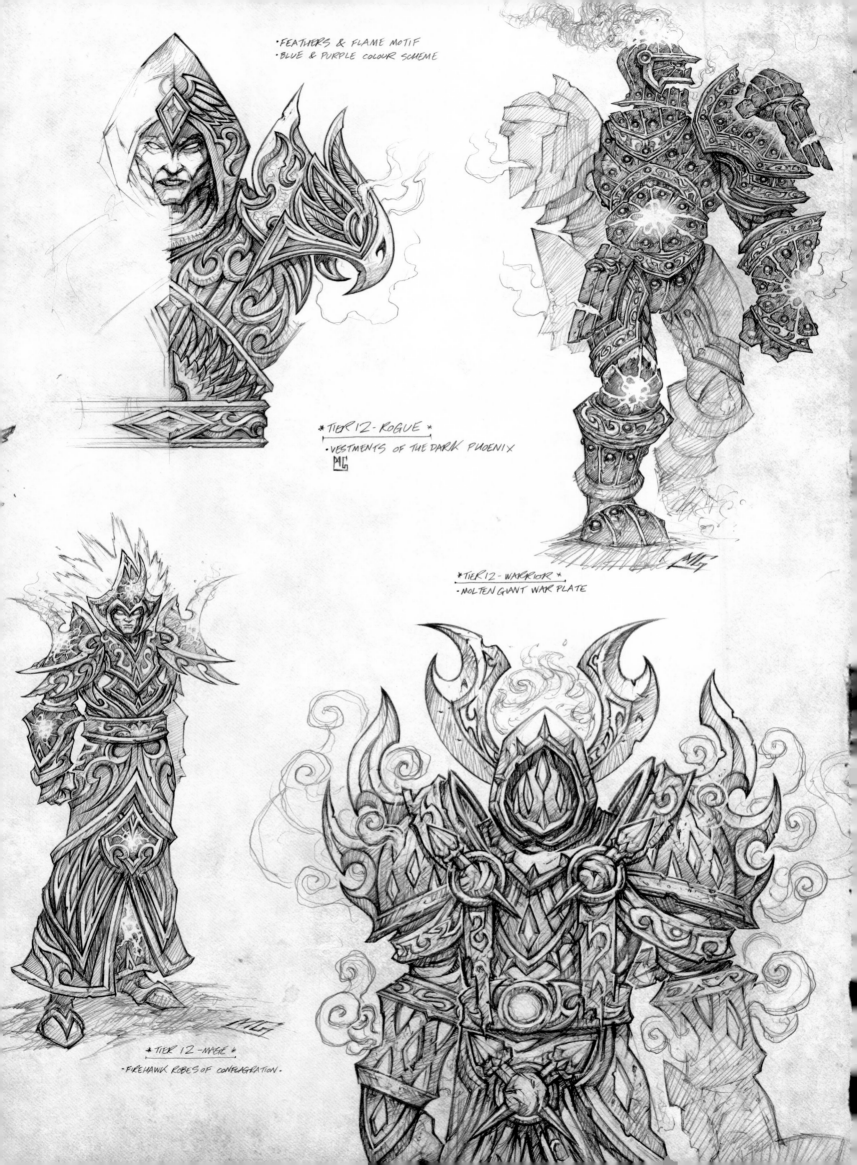

• FEATHERS & FLAME MOTIF
• BLUE & PURPLE COLOUR SCHEME

* TIER 12 - ROGUE *
• VESTMENTS OF THE DARK PHOENIX

* TIER 12 - WARRIOR *
• MOLTEN GIANT WAR PLATE

* TIER 12 - MAGE *
• FIREHAWK ROBES OF CONFLAGRATION

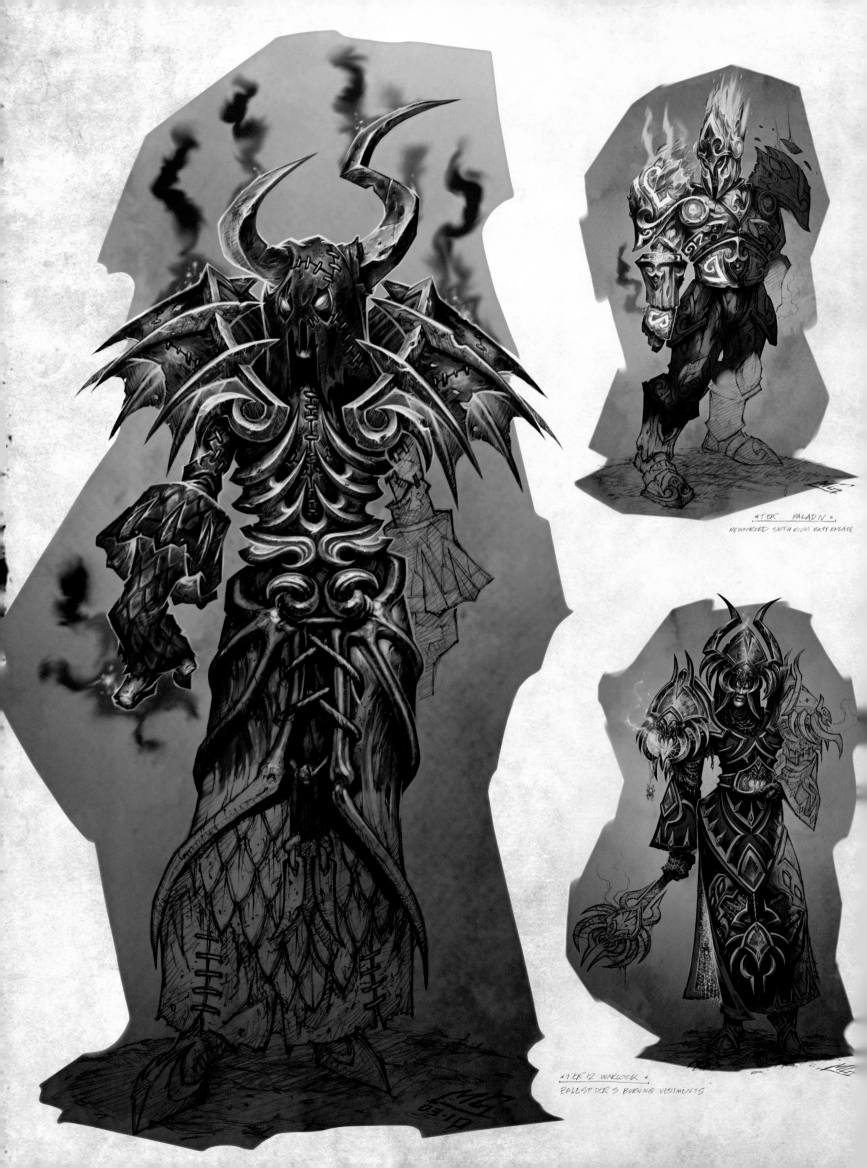

* TIER PALADIN *
REINFORCED SAPPHIRIUM BATTLEPLATE

* TIER 12 WARLOCK *
BALESPIDER'S BURNING VESTMENTS

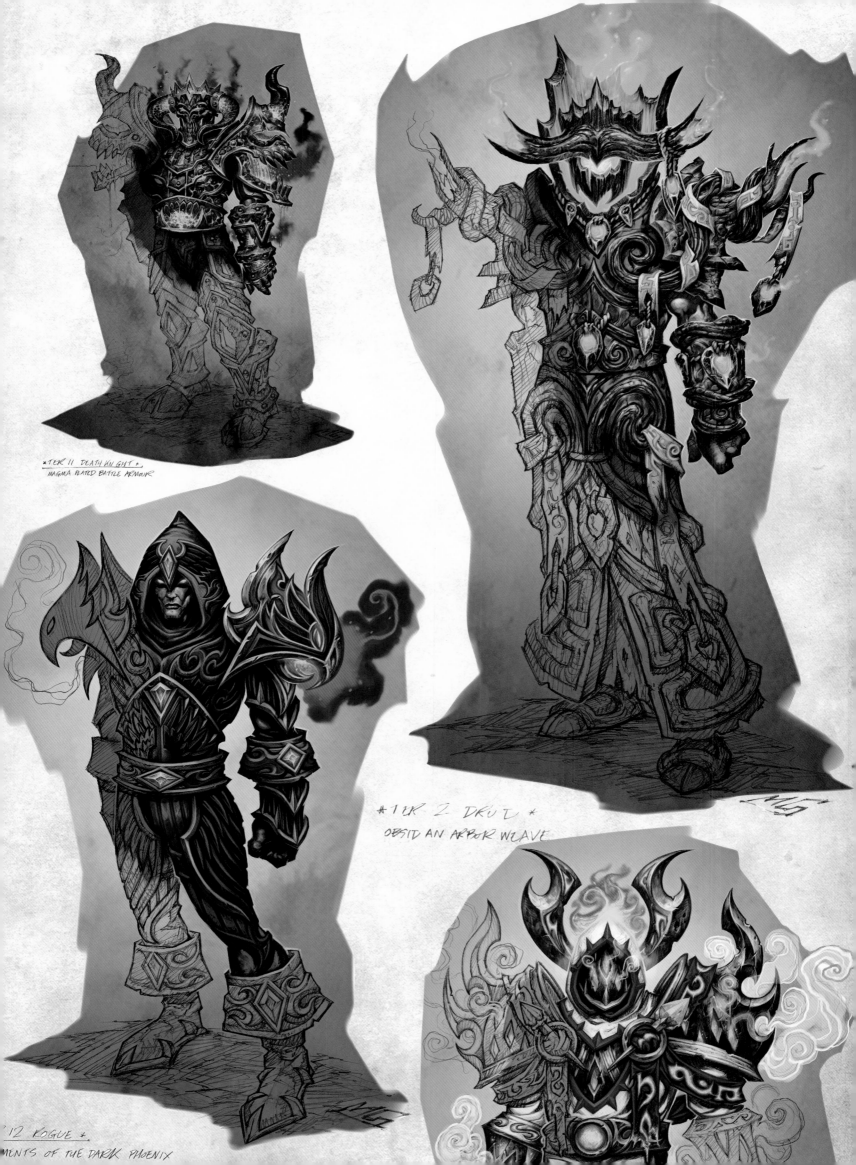

* TIER II DEATH KNIGHT *
MAGMA PLATED BATTLE ARMOUR

* TIER 2 DRUID *
OBSIDIAN ARBOR WEAVE

'12 ROGUE *
MOUNTS OF THE DARK PHOENIX

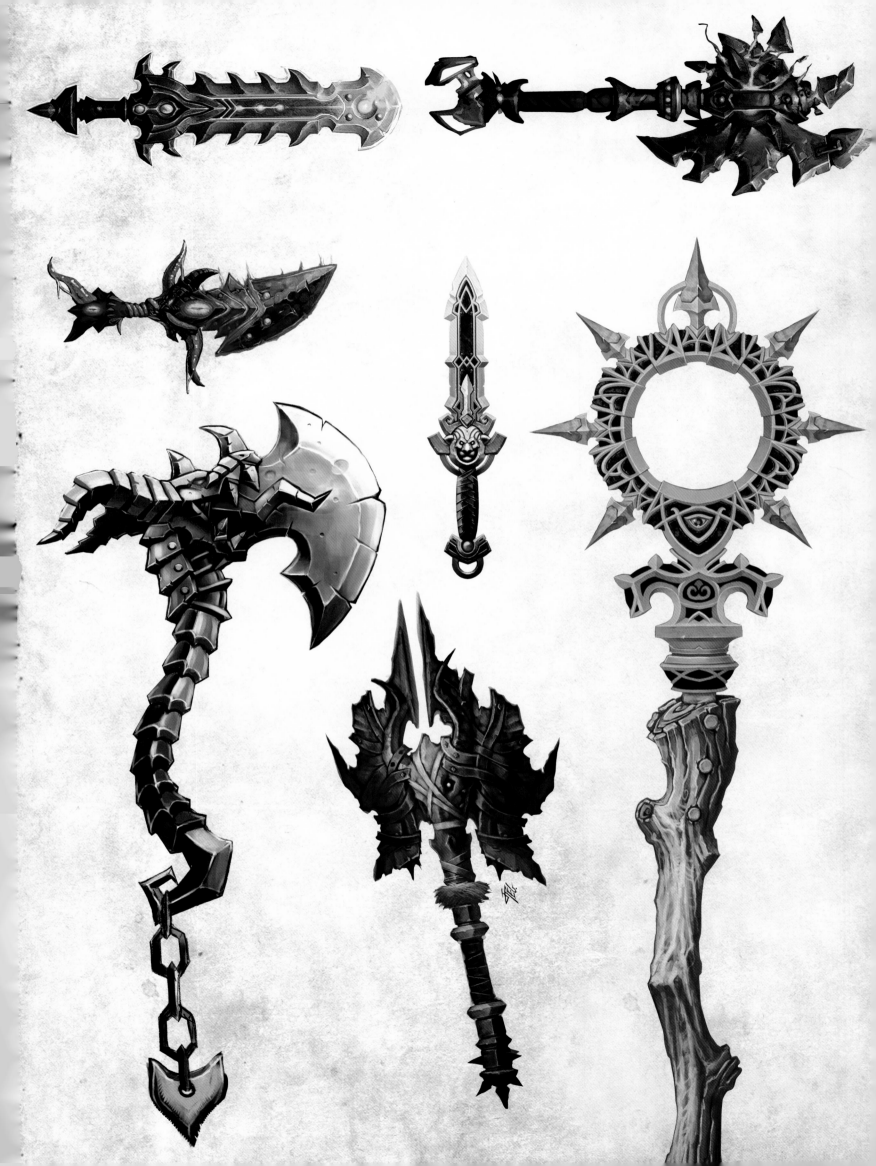

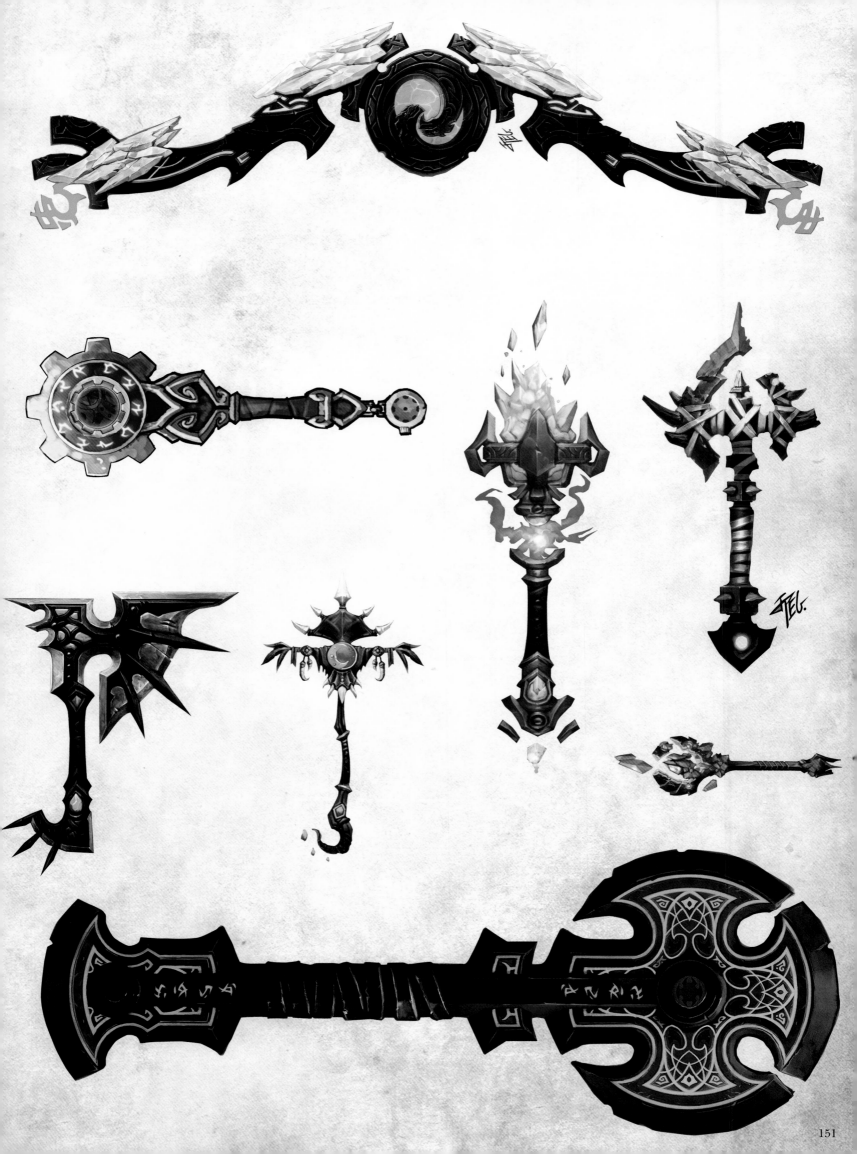

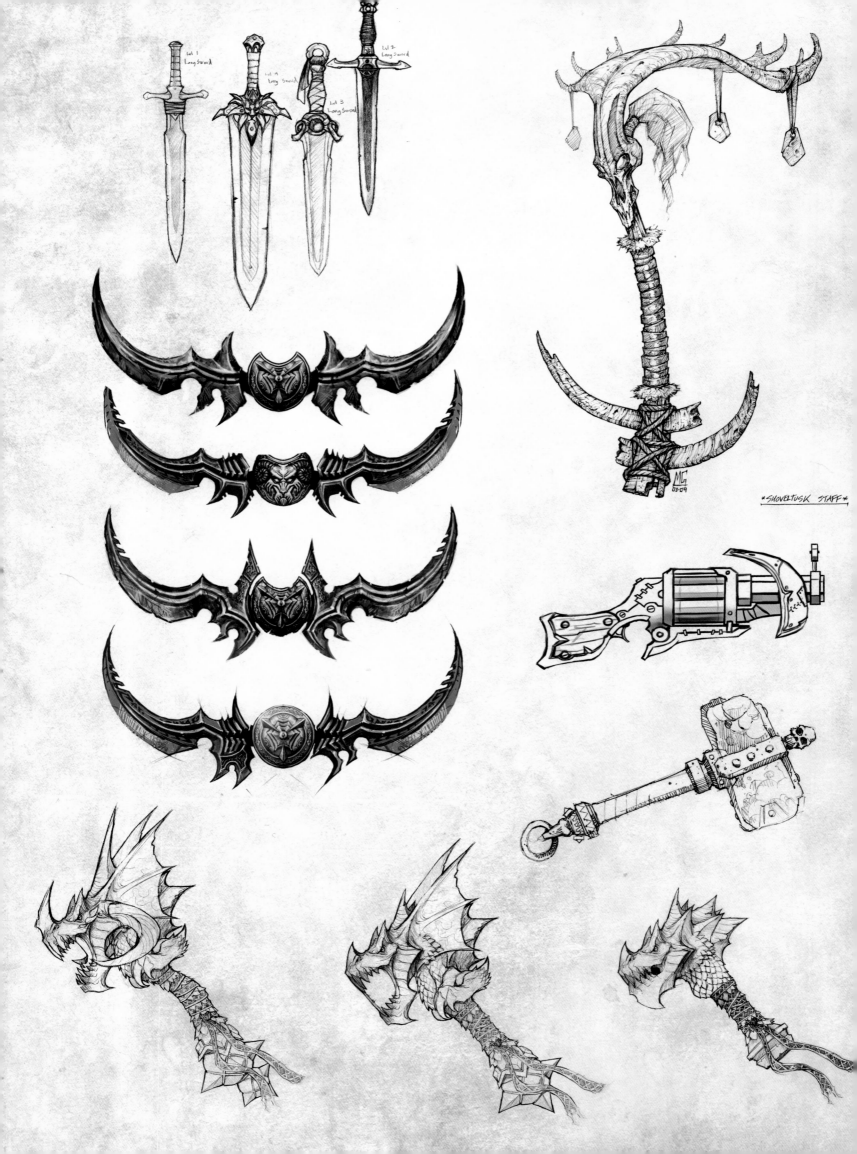

SHOVELTUSK STAFF

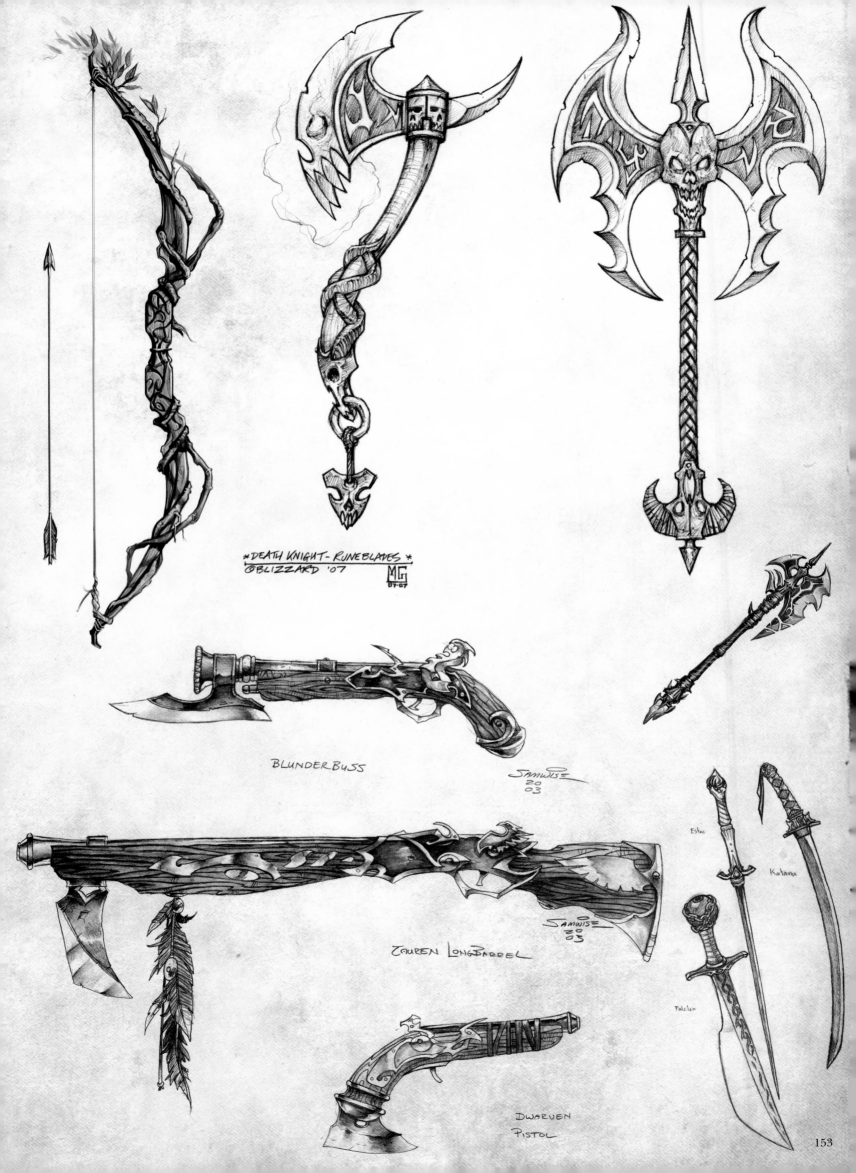

DEATH KNIGHT - RUNEBLADES
©BLIZZARD '07

BLUNDERBUSS

TAUREN LONGBARREL

DWARVEN
PISTOL

Estoc

Katana

Falcion

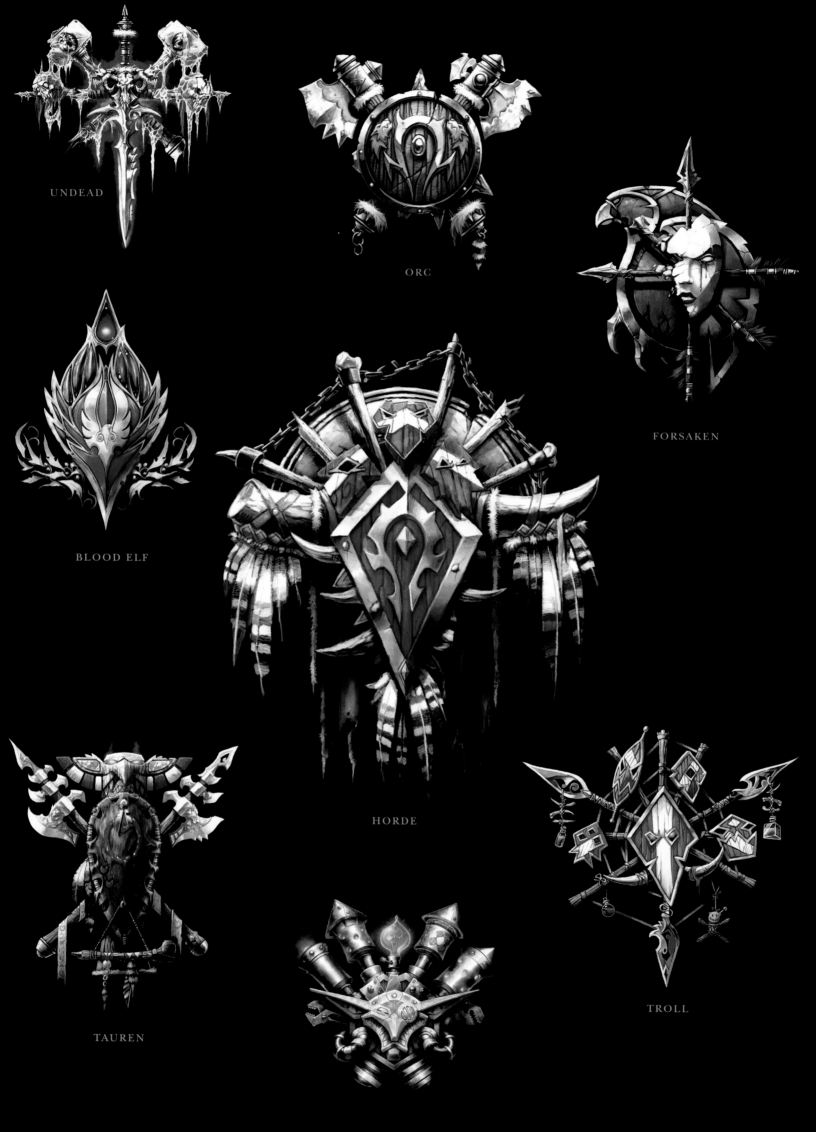

UNDEAD

ORC

FORSAKEN

BLOOD ELF

HORDE

TAUREN

TROLL

GOBLIN

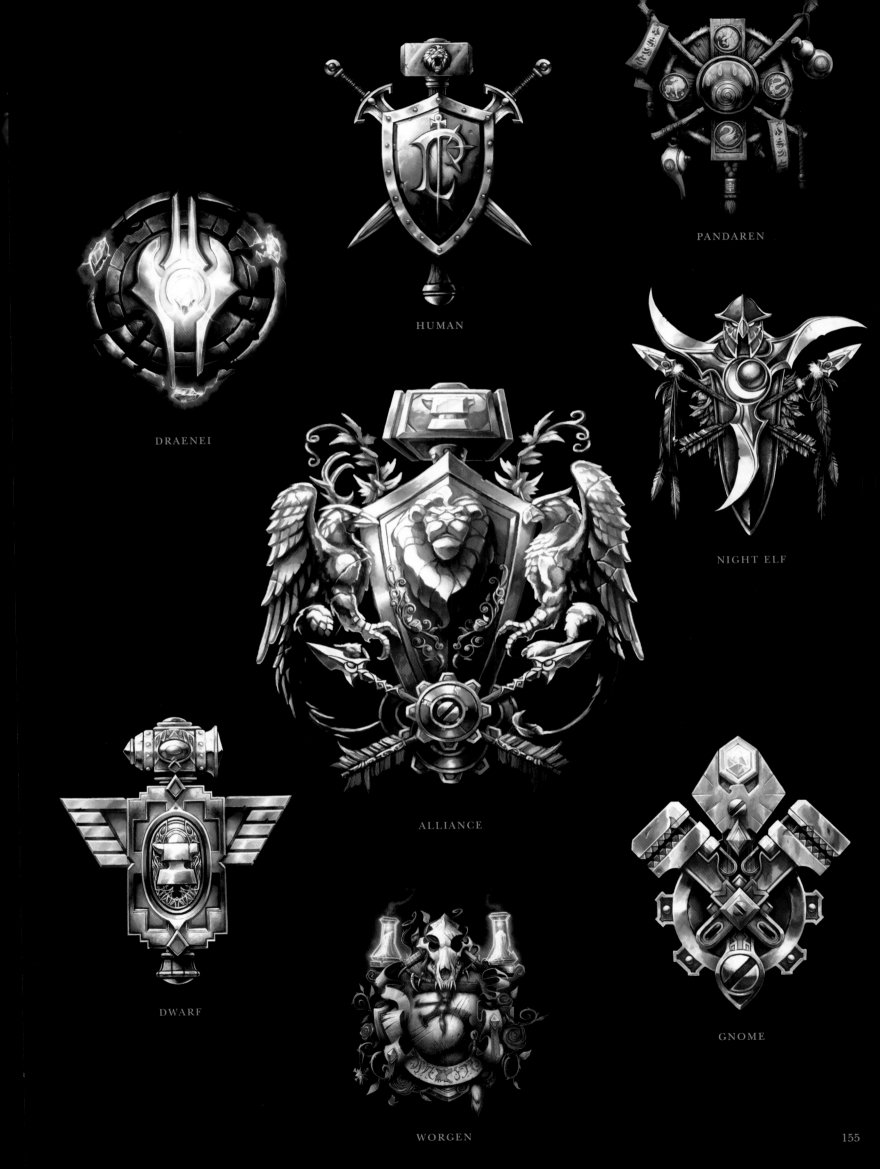

DRAENEI

HUMAN

PANDAREN

NIGHT ELF

ALLIANCE

DWARF

WORGEN

GNOME

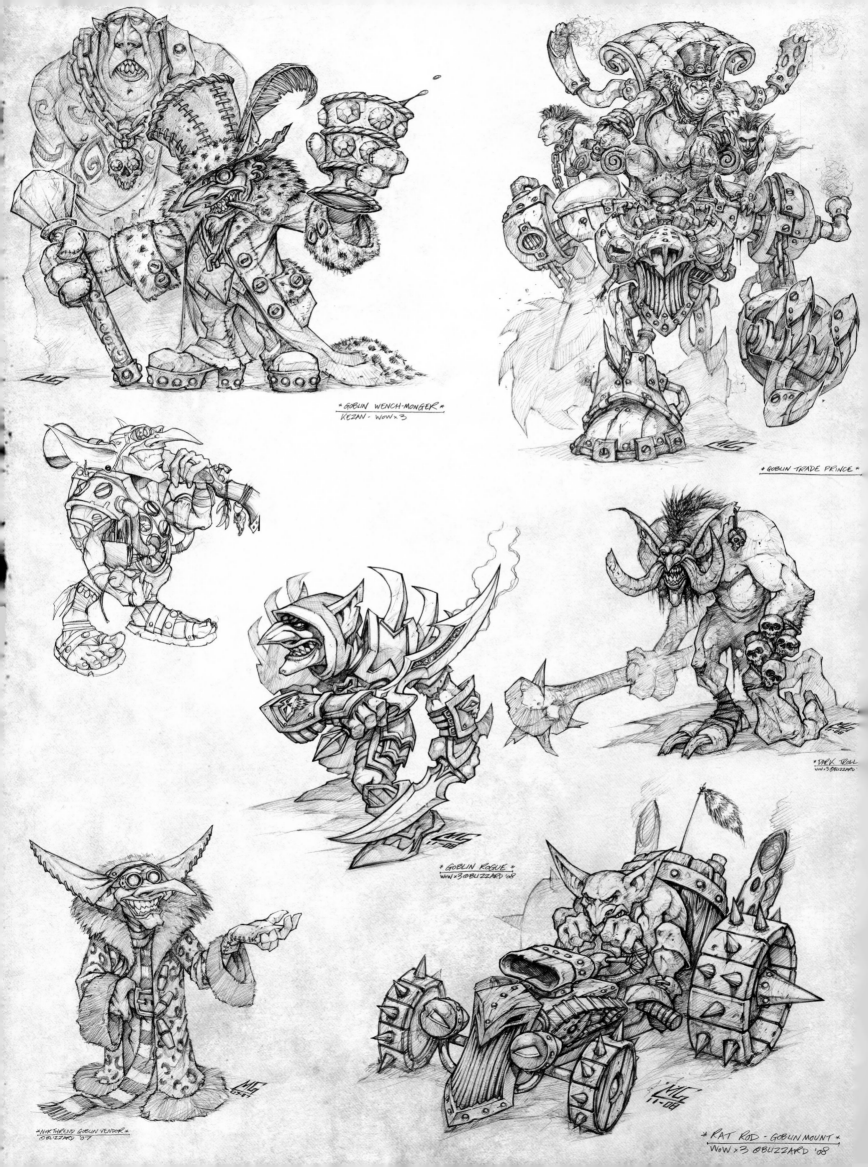

* GOBLIN WENCH-MONGER *
KEZAN · WoW×3

* GOBLIN TRADE PRINCE *

* DARK TROLL *
WoW×3 ©BLIZZARD

* GOBLIN ROGUE *
WoW×3 ©BLIZZARD '08

NORTHREND GOBLIN VENDOR
©BLIZZARD '07

* RAT ROD · GOBLIN MOUNT *
WoW×3 ©BLIZZARD '08

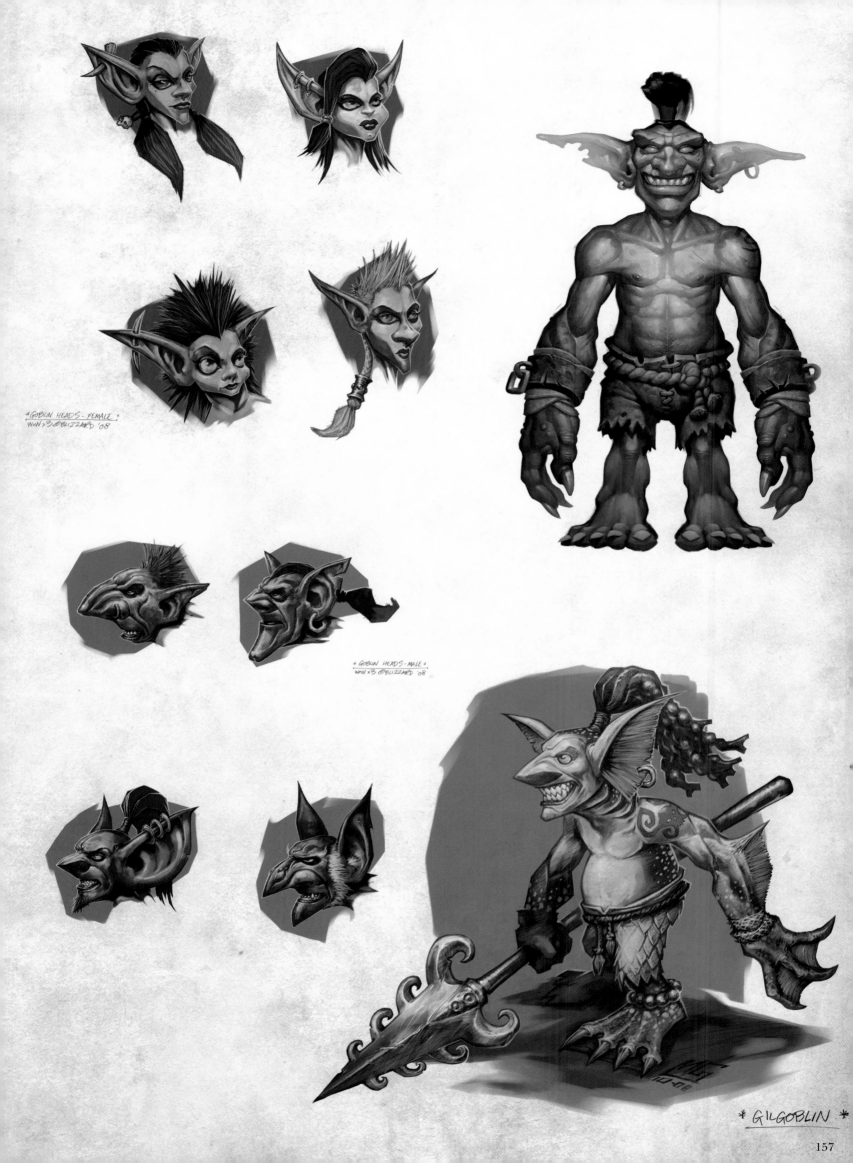

* GOBLIN HEADS - FEMALE *
WoW x3 @BLIZZARD '08

* GOBLIN HEADS - MALE *
WoW x3 @BLIZZARD '08

* GILGOBLIN *

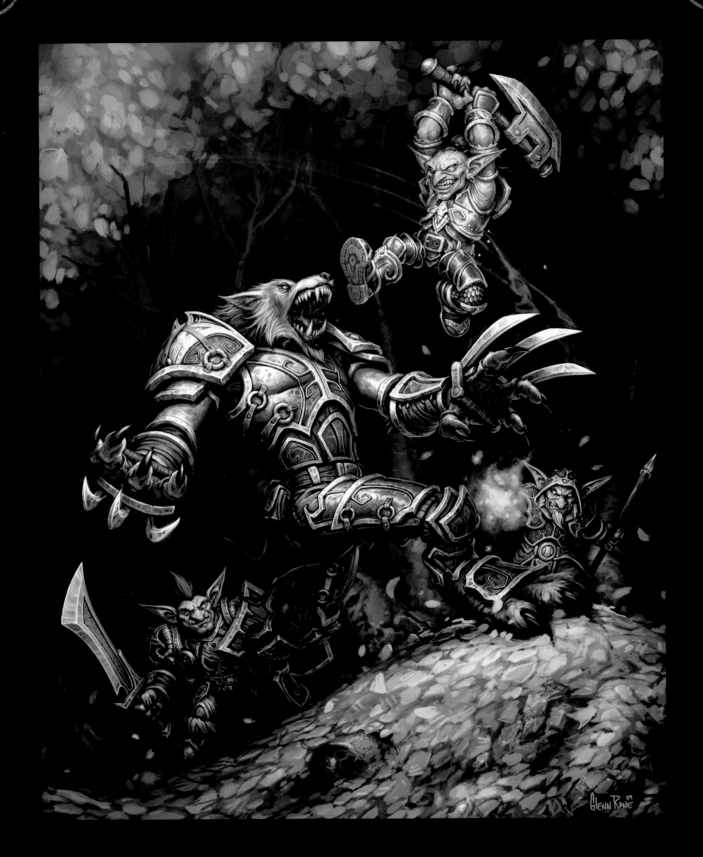

"An image Glenn did of one worgen versus three goblins. It's not necessarily
their quintessential image, but it's kind of cool showing the little group
of goblins working together against the one big worgen. It reminds me of
looking at an old Larry Elmore painting or something from the old D&D
books. This could be the cover of a *Dragon* magazine."

—Samwise Didier

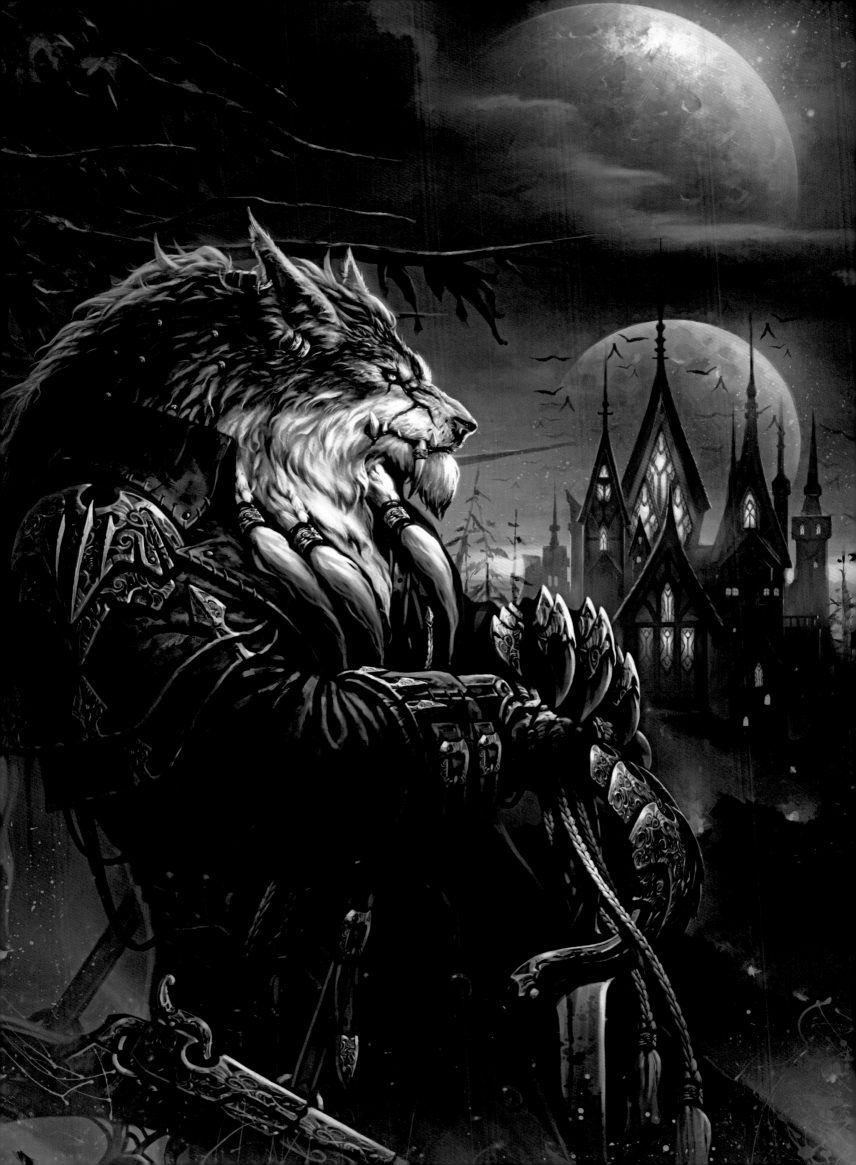

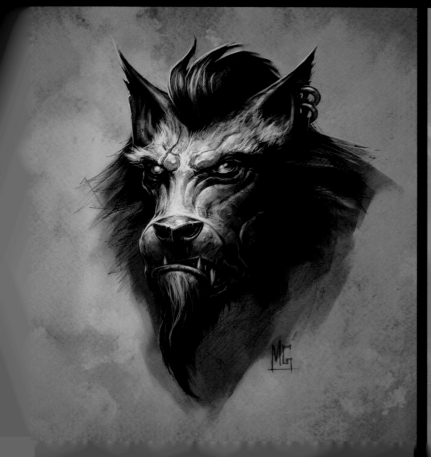
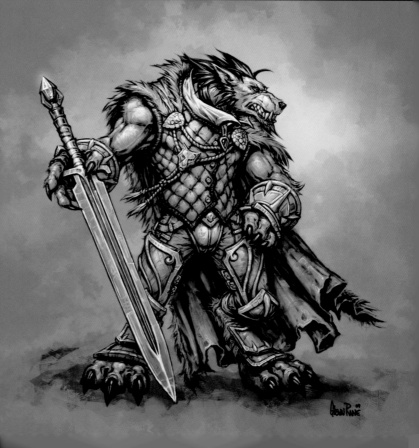

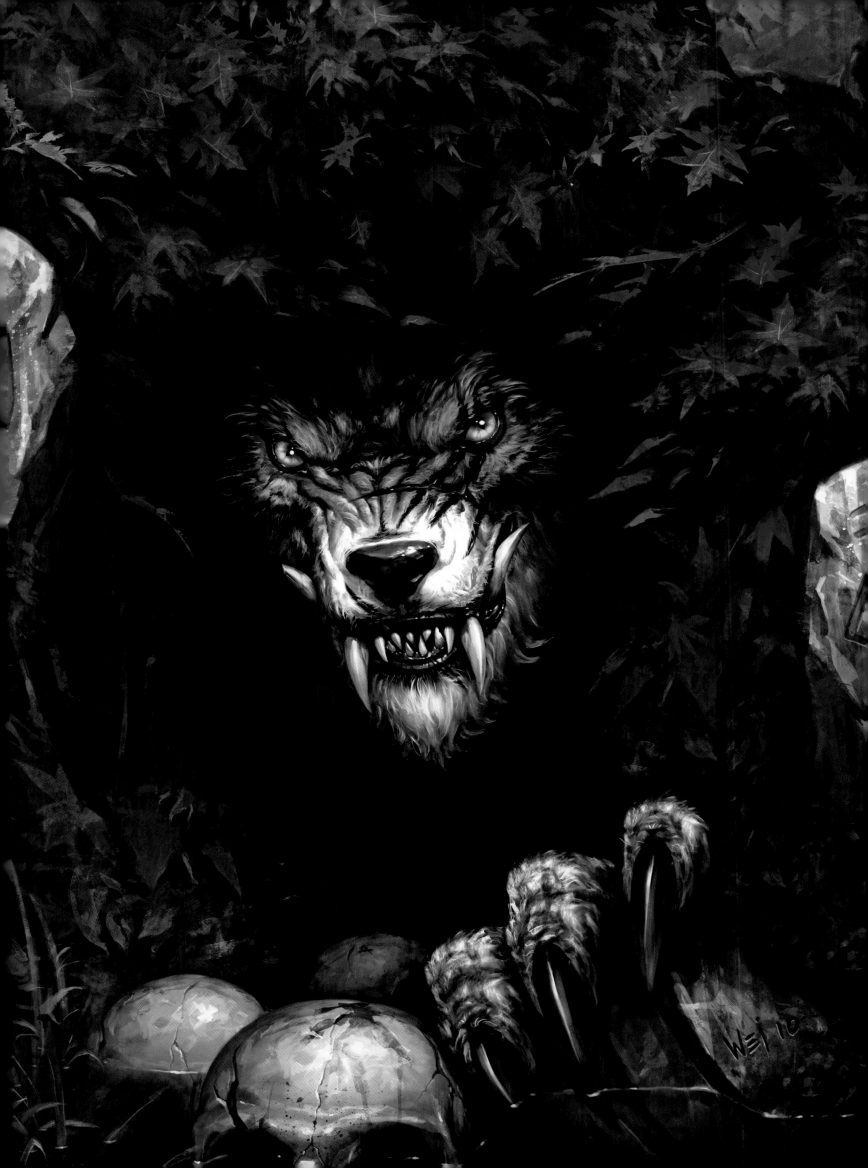

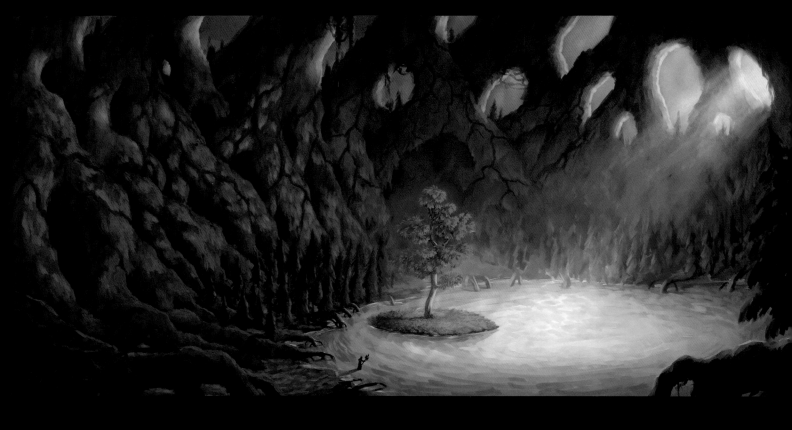

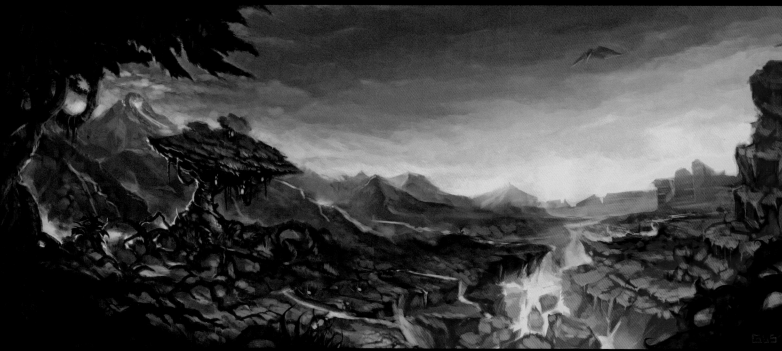

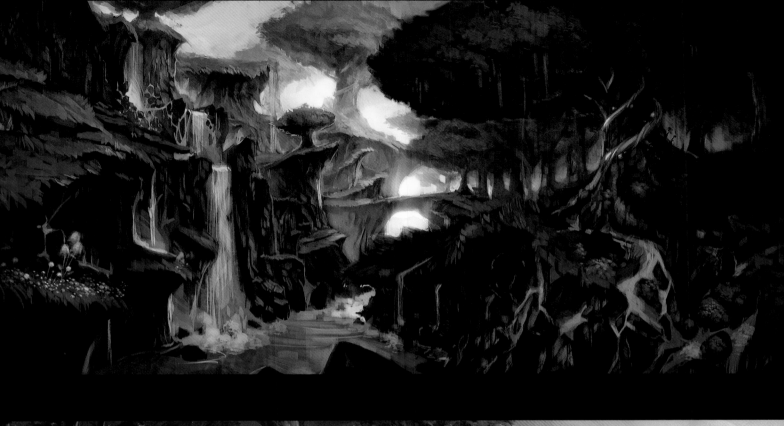
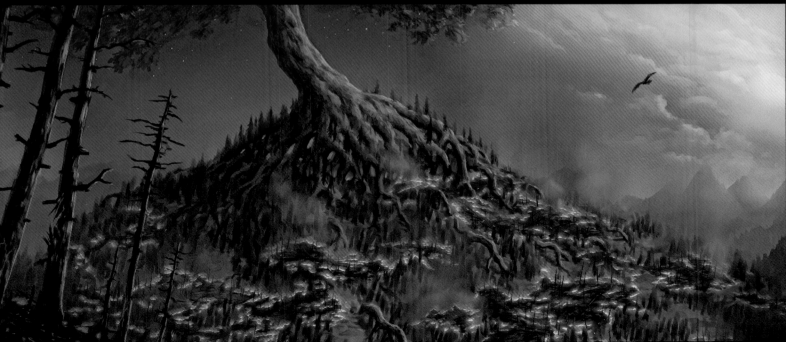

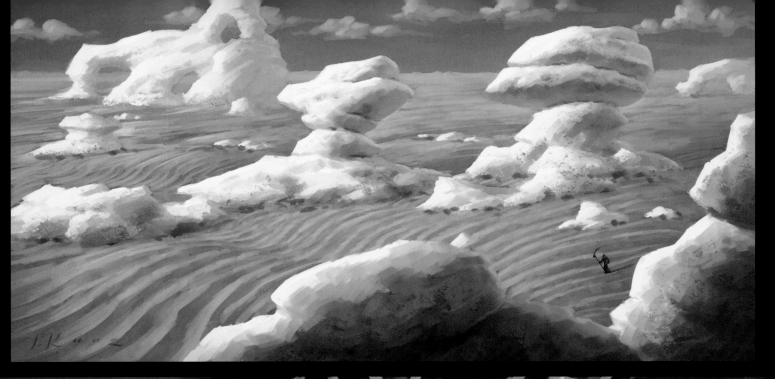

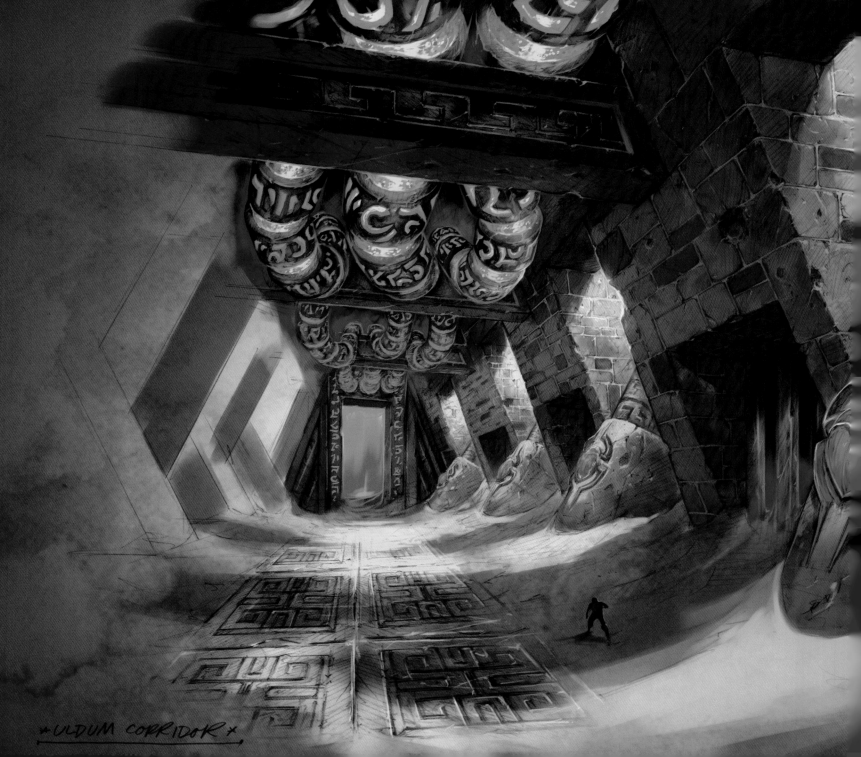

ULDUM CORRIDOR

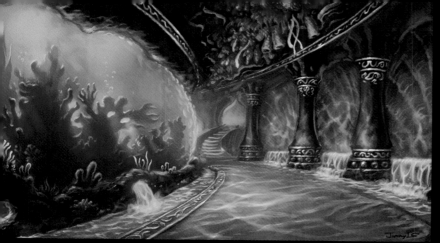
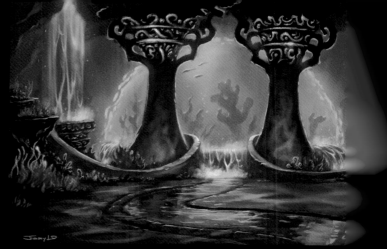

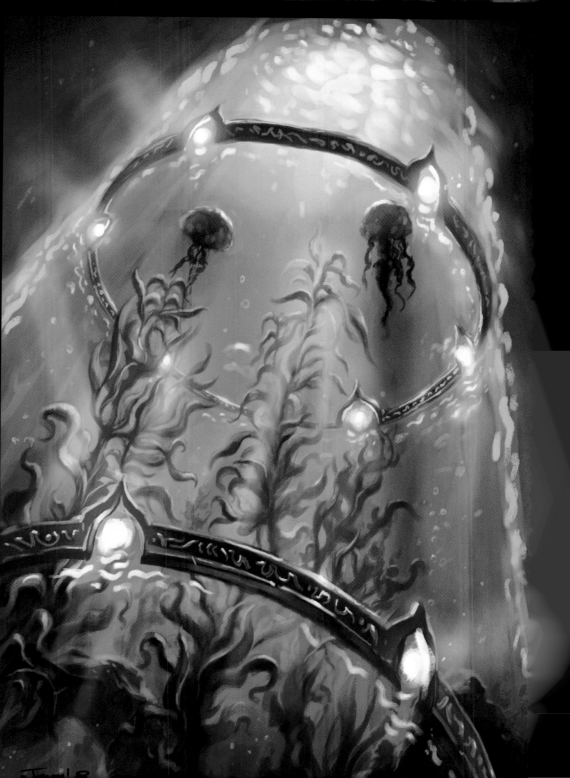

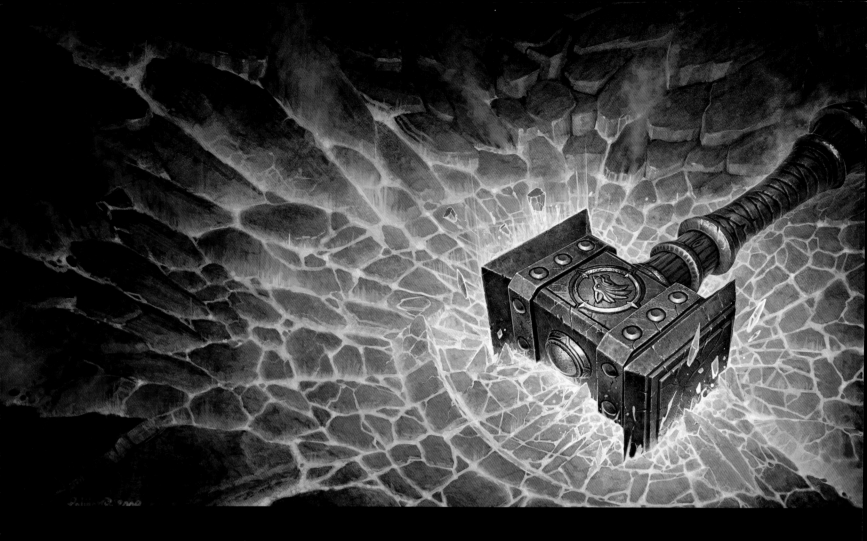

"The image was the cover for a book we had done called *The Shattering*.
I think it's one of the most iconic images we've ever done for Warcraft—
the hammer being the symbol of the Horde, thus discarded."

—*Chris Metzen*

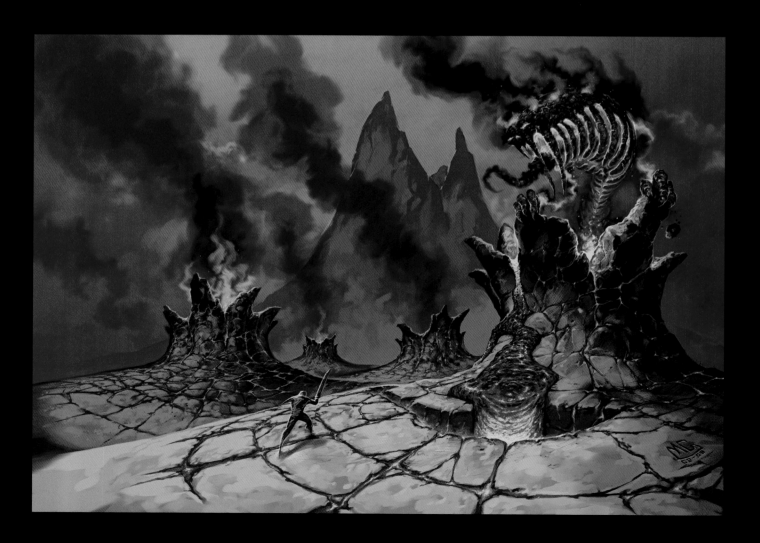

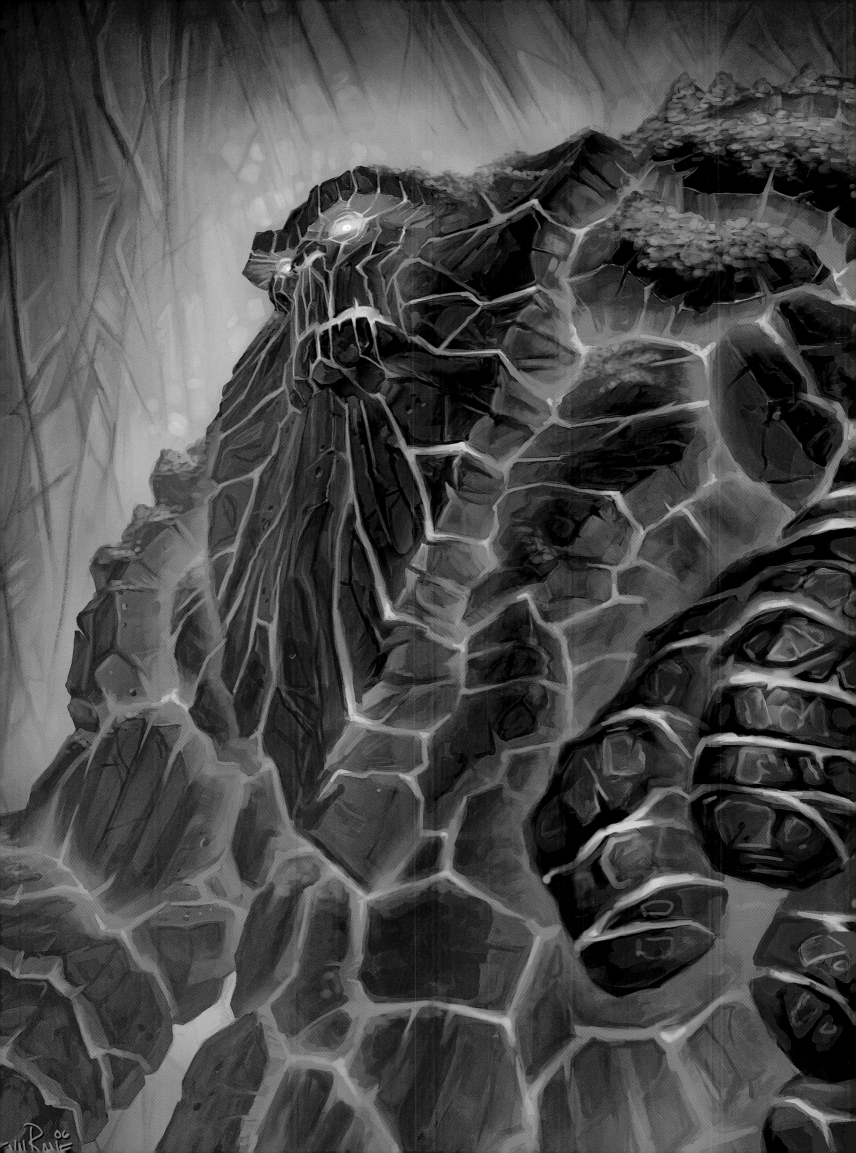

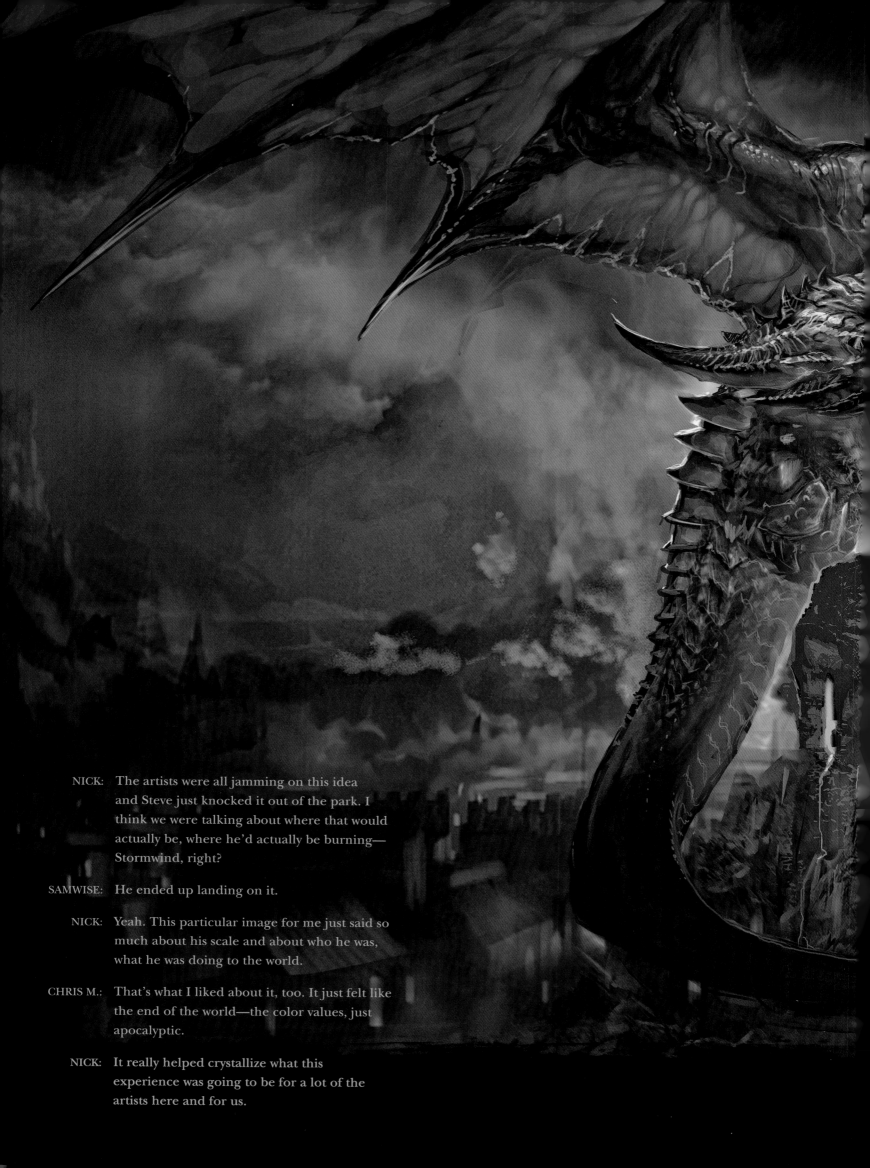

NICK: The artists were all jamming on this idea
and Steve just knocked it out of the park. I
think we were talking about where that would
actually be, where he'd actually be burning—
Stormwind, right?

SAMWISE: He ended up landing on it.

NICK: Yeah. This particular image for me just said so
much about his scale and about who he was,
what he was doing to the world.

CHRIS M.: That's what I liked about it, too. It just felt like
the end of the world—the color values, just
apocalyptic.

NICK: It really helped crystallize what this
experience was going to be for a lot of the
artists here and for us.

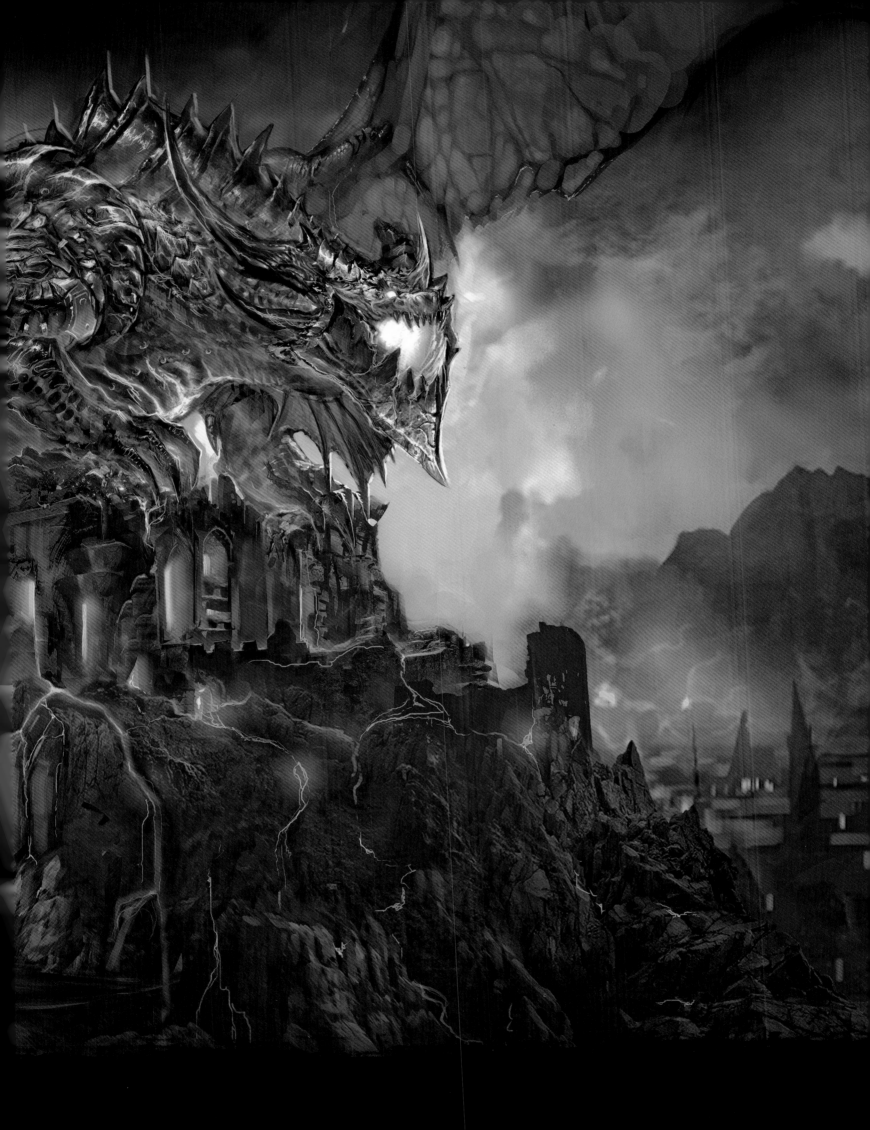

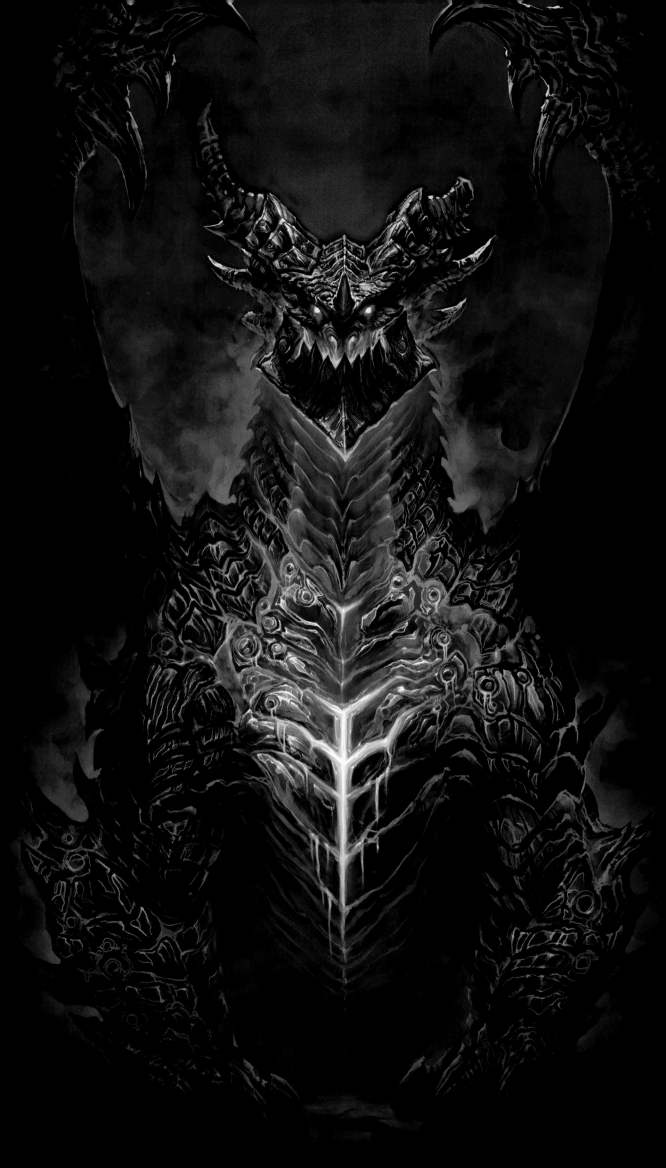

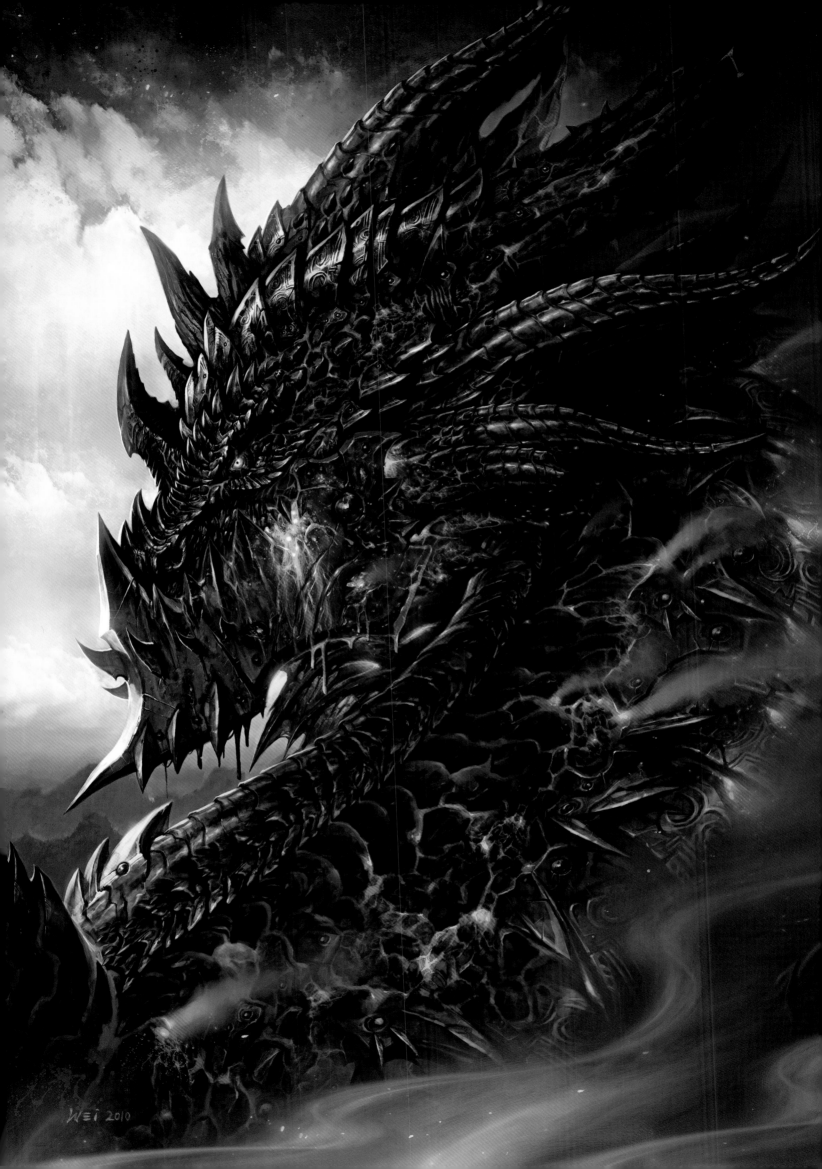

WEI 2010

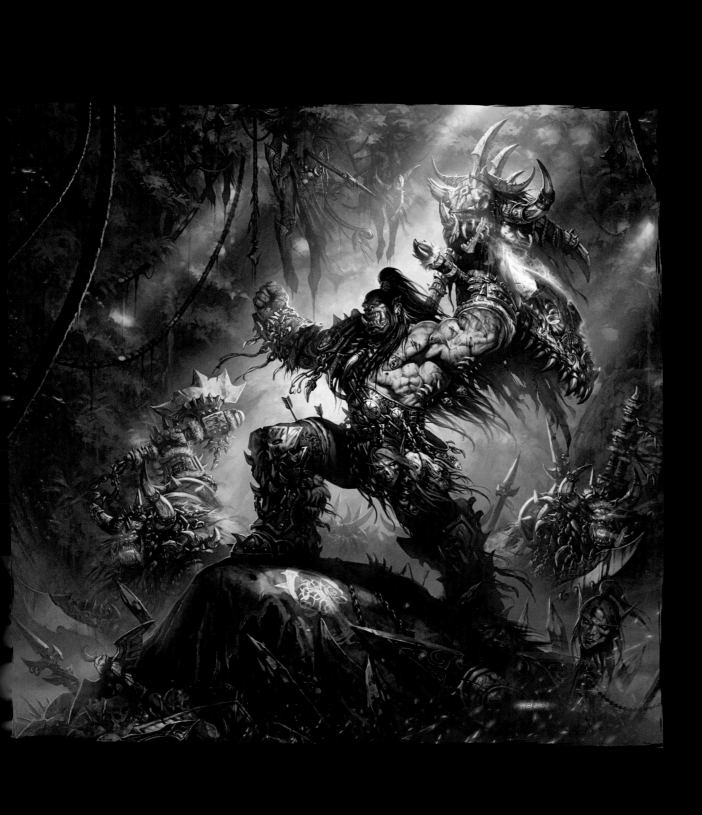

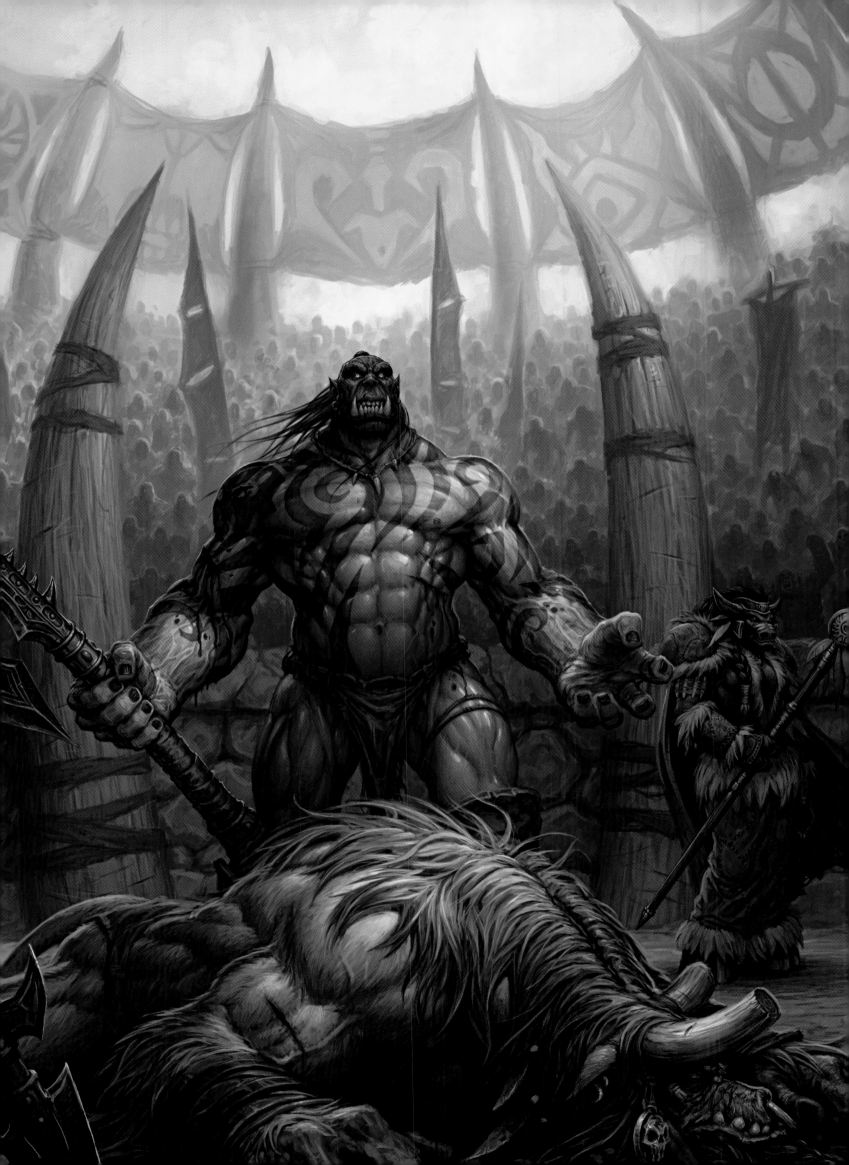

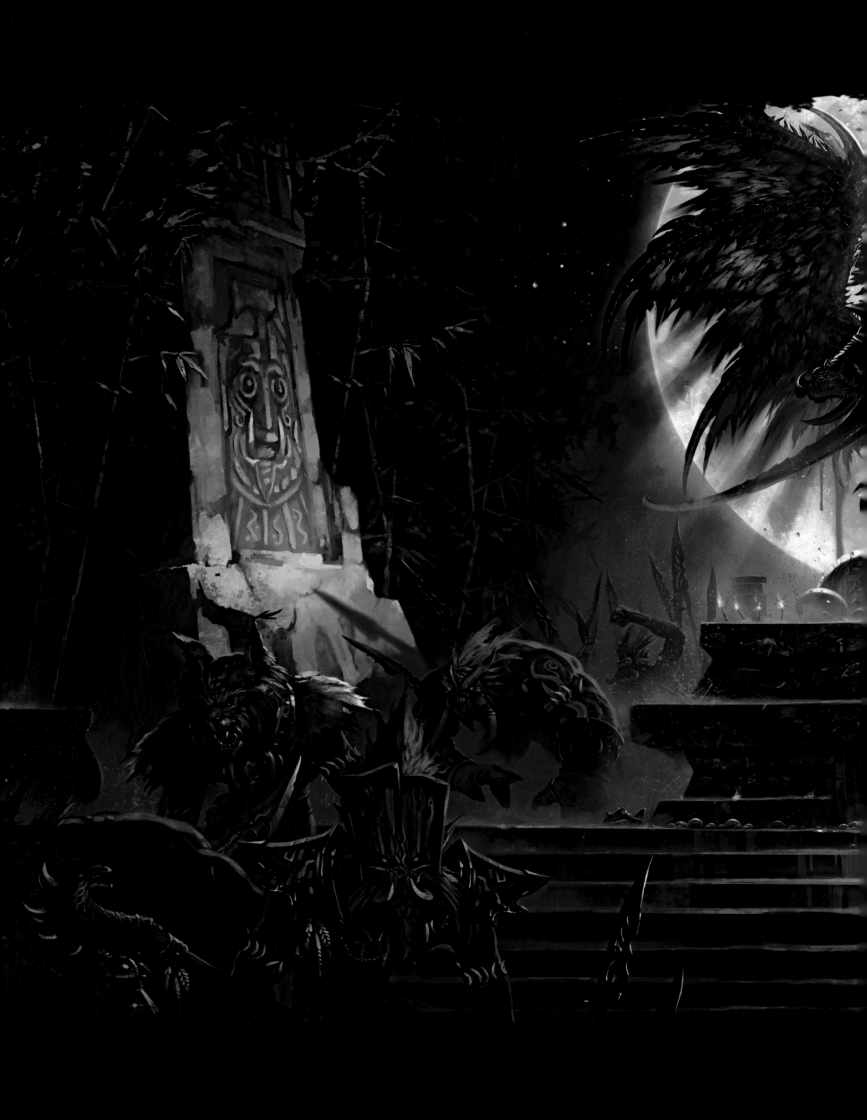

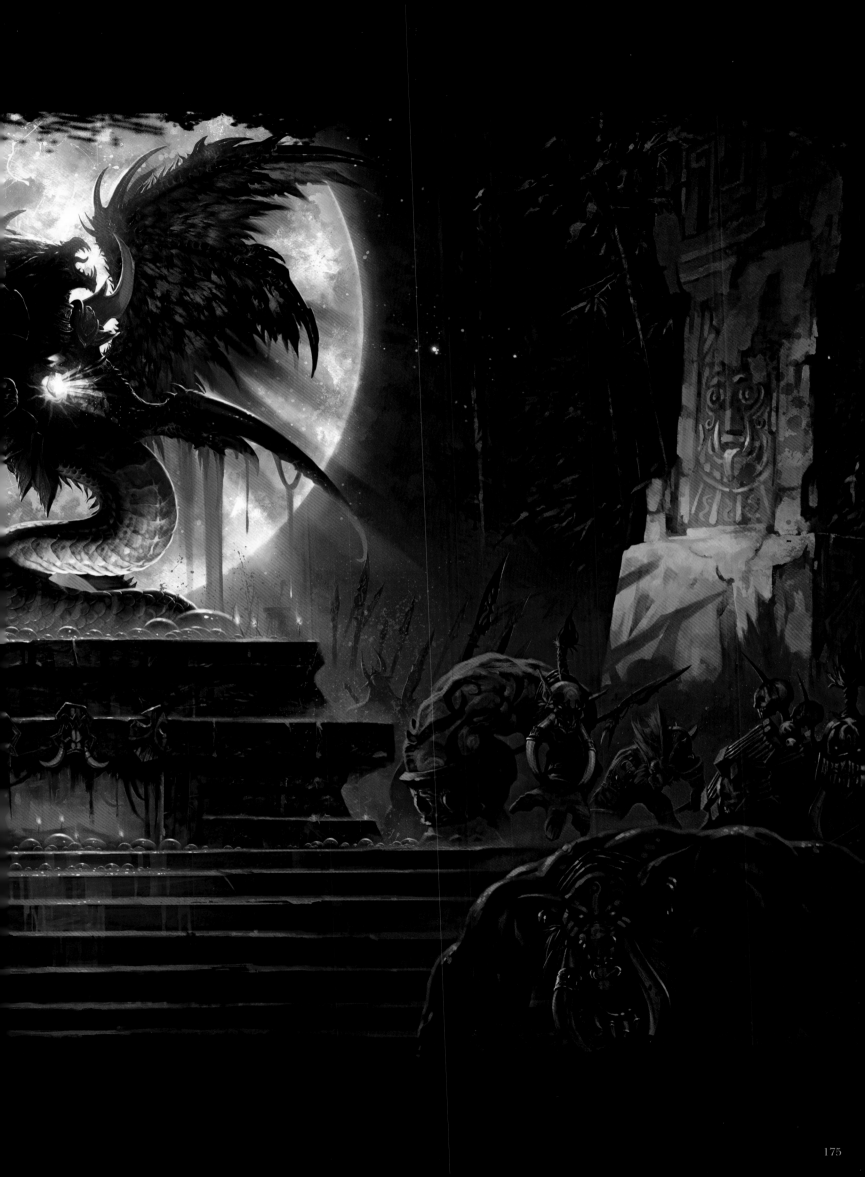

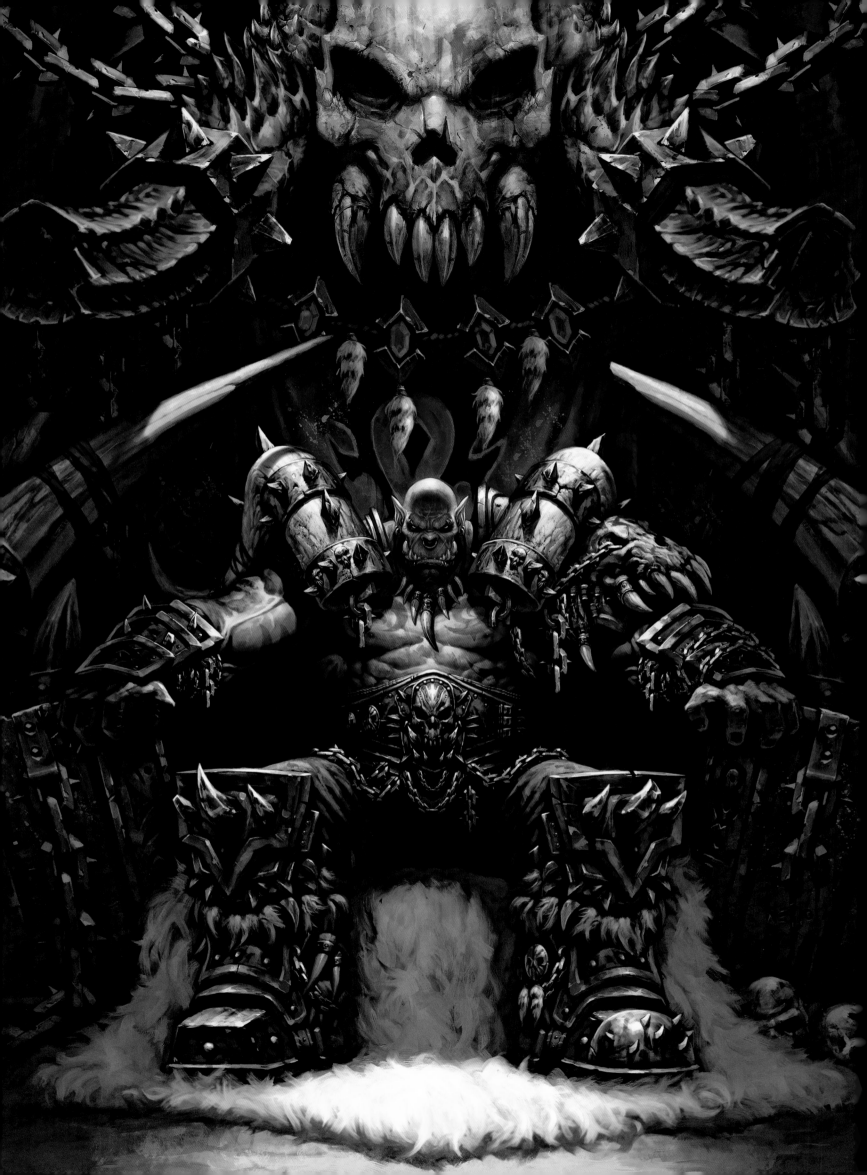

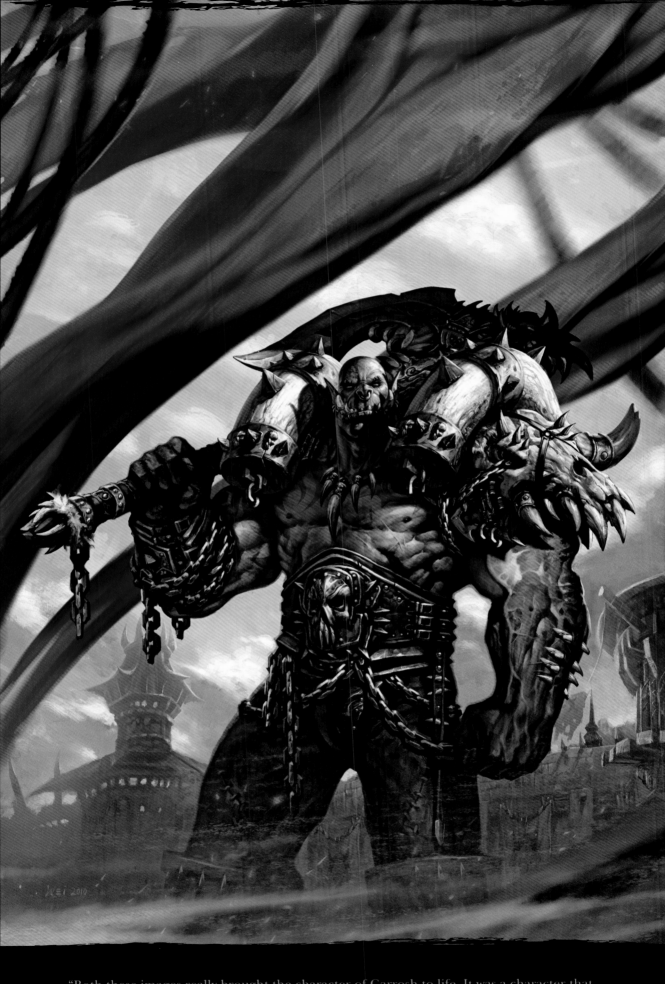

"Both these images really brought the character of Garrosh to life. It was a character that was greatly maligned in the storyline, and people were really pissed at where we were taking him because he was replacing a very beloved character as leader of the Horde. These images really started to pull out his character and help the fan base understand him a little bit, understand how powerful he was, and some of the details of his costume kit."

—*Chris Metzen*

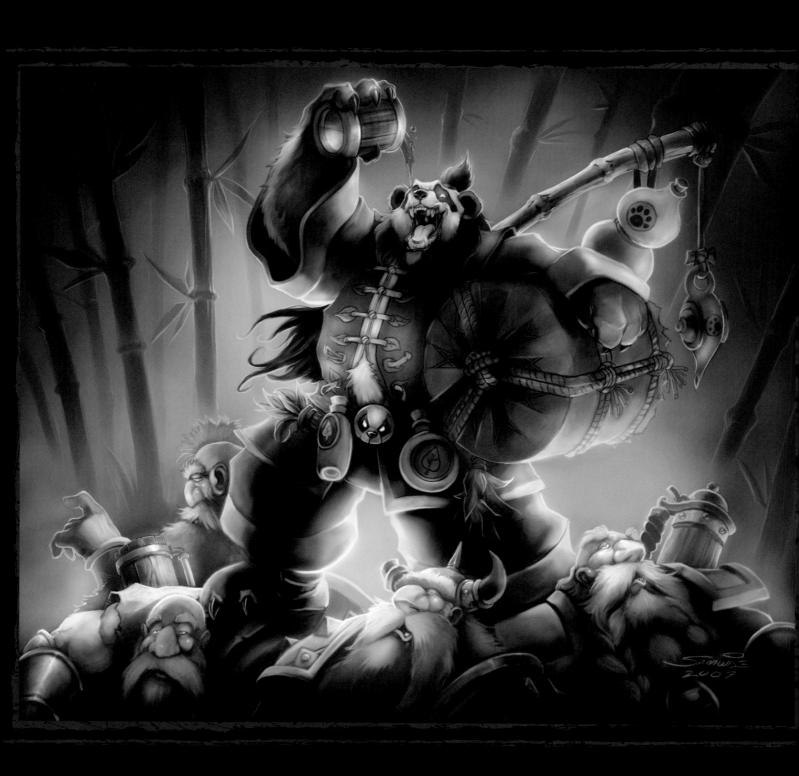

"It might be difficult to tell from this painting, but drinking plays an important role in pandaren culture. I'm sure at some point someone asked Sammy who would win in a drinking contest between a panda and a dwarf . . . and I'm guessing that this image was his answer."

—*Chris Robinson*

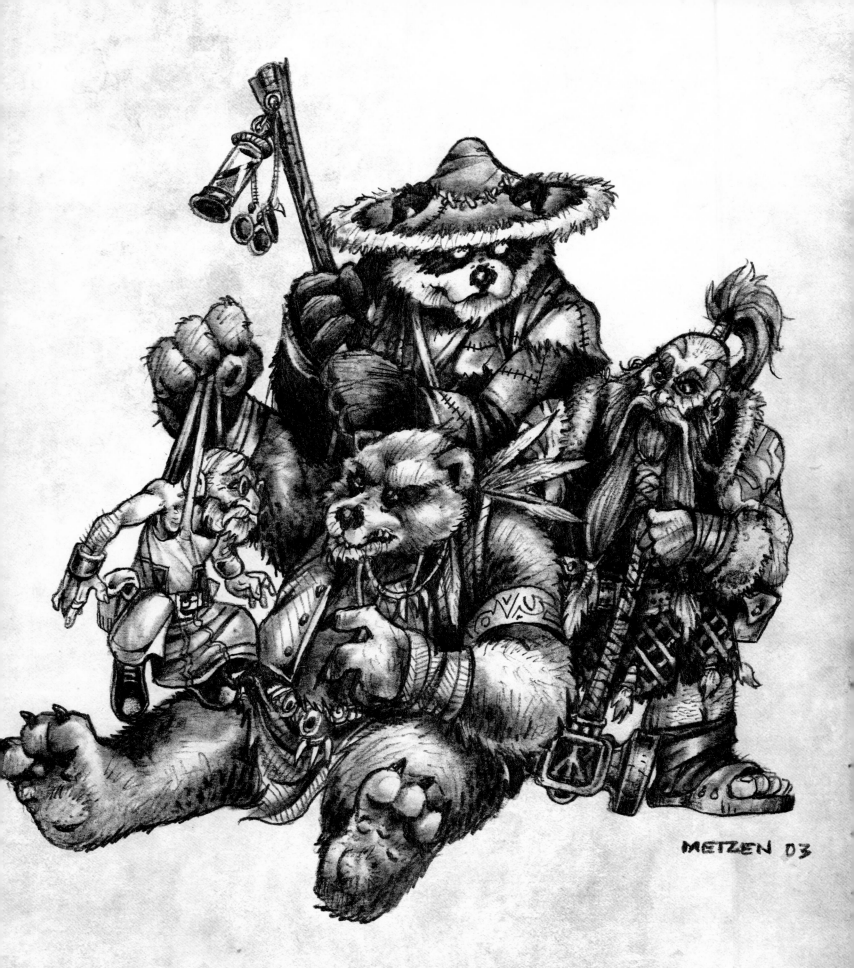

"This is Metzen exploring how the pandaren would interact with our existing races. He's always done this great impression of what a panda would say when confronted on the battlefield by another race. It sounds like a mix of Jeff Spicoli and Mister Miyagi. Regardless of alignment, it's good to see that the pandaren support gnome harassment."

—*Chris Robinson*

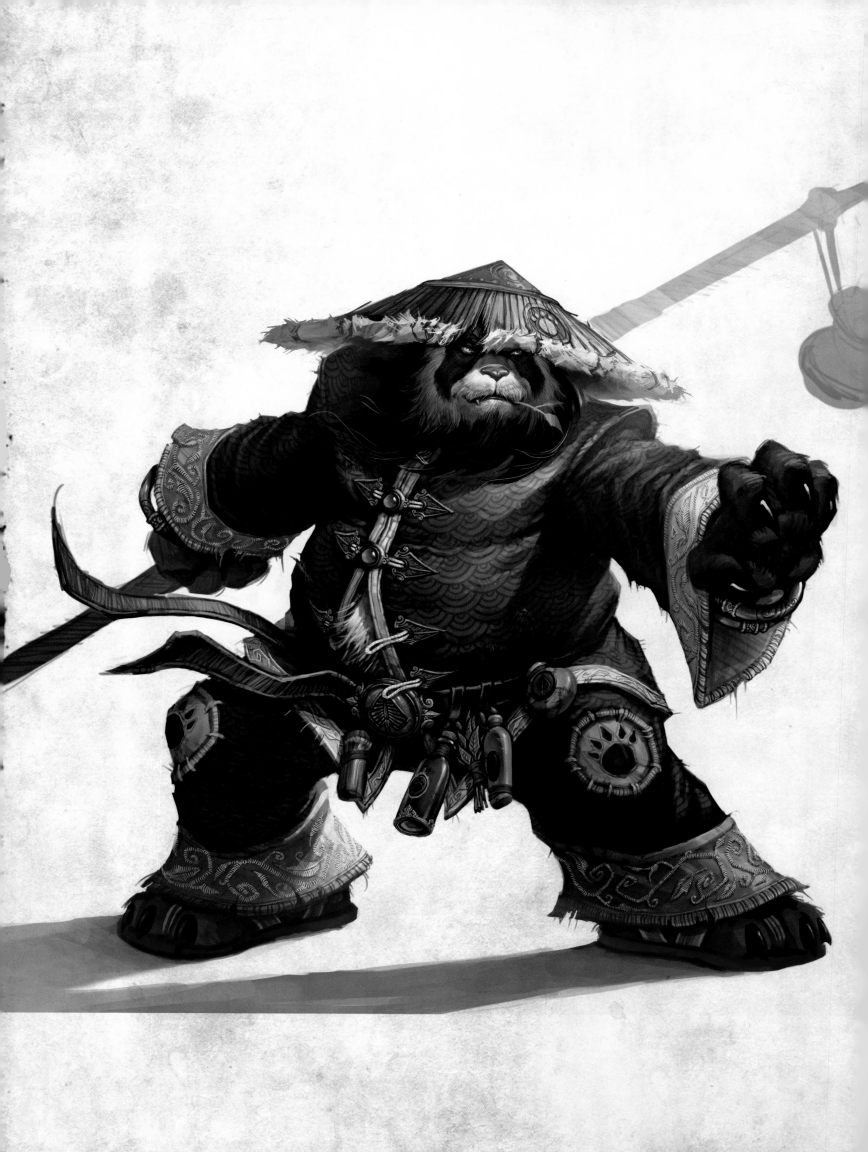

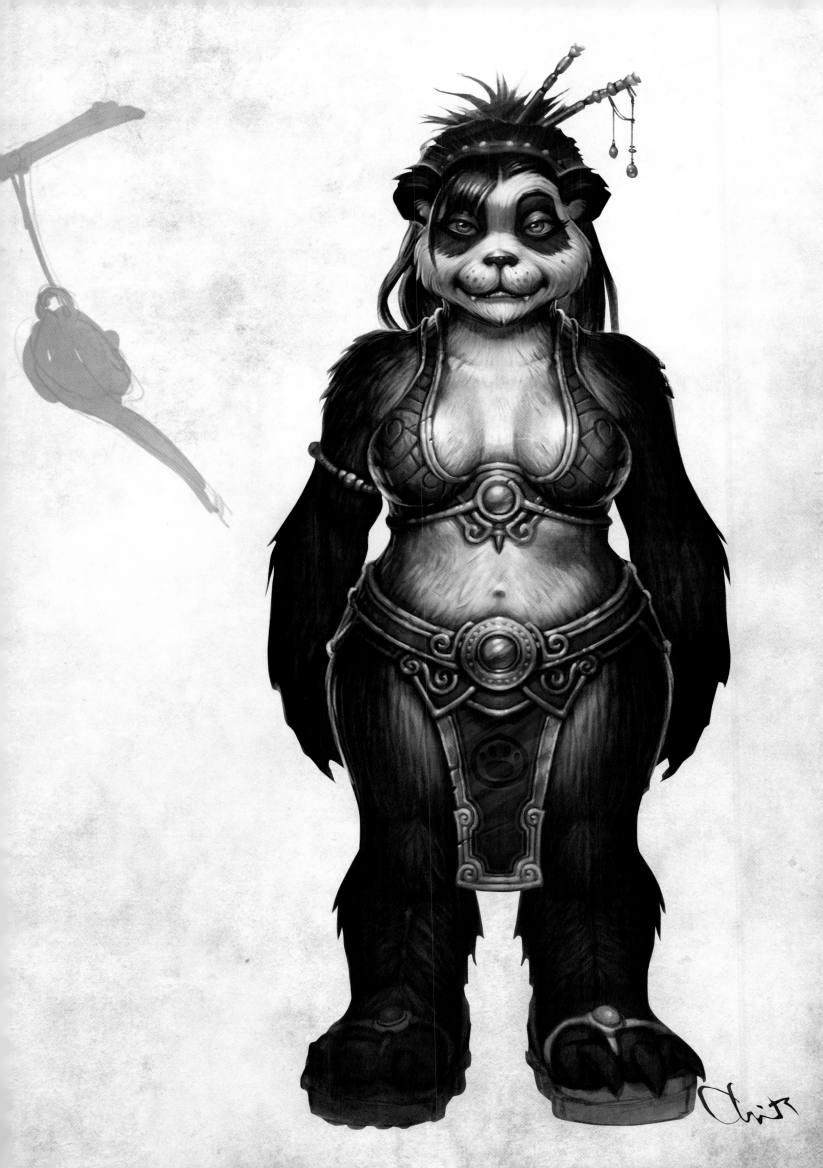

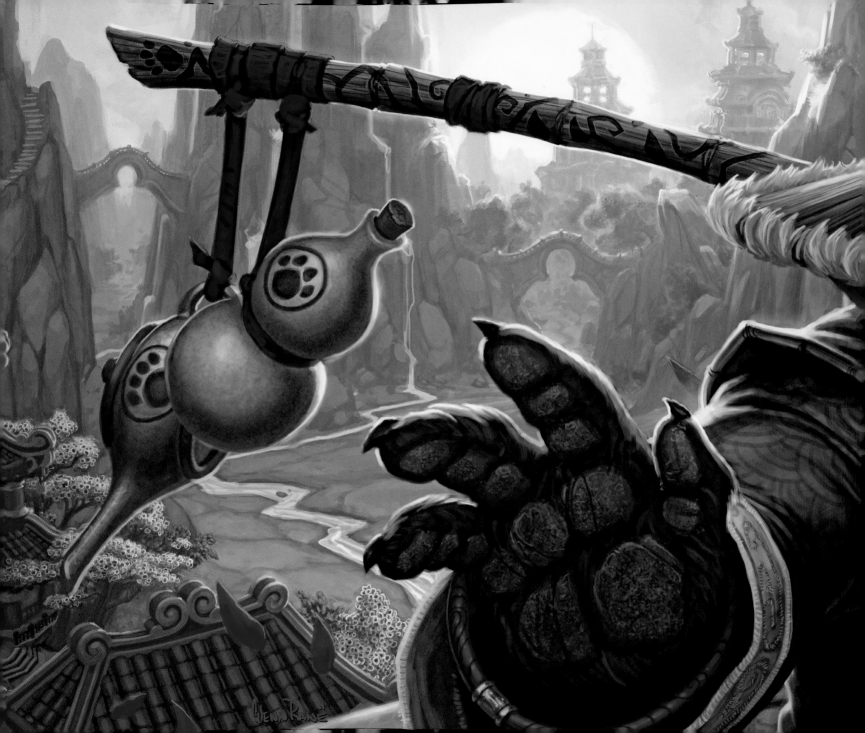

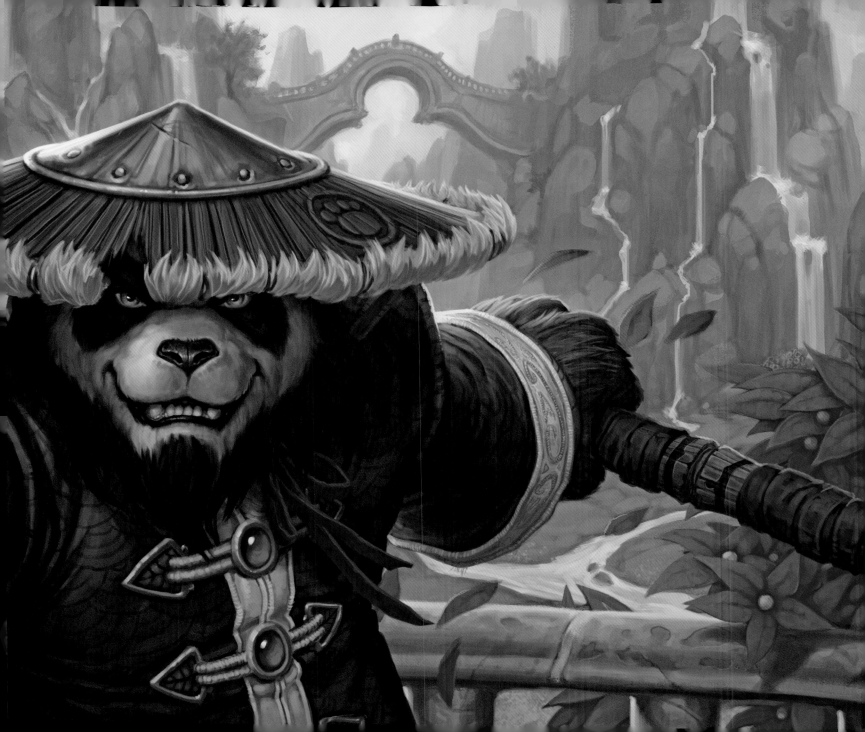

DIABLO

In the mid 1990s, Blizzard helped usher in a new era of hack-and-slash action RPGs with its landmark release of *Diablo*. Since its inception, Diablo has conjured images of nightmarish landscapes rife with malefic and dangerous denizens. Set in the fires of the Burning Hells, and ultimately transcending to the High Heavens, Diablo allowed players to become heroes in the eternal conflict between good and evil. It was this backdrop that rallied the artists at Blizzard to develop a visually distinct and truly memorable world.

Sanctuary served as a significant opportunity for Blizzard to explore the grittier side of design and color, allowing for a fresh artistic style to emerge in the fantasy/horror genre. Focusing on the gothic undertones and the unsettling nature of this world while staying true to the company's long-established artistic values was an extremely tall order. The developers had to dig deep into the subconscious and their surroundings to create images that would be relatable and at the same time terrifying.

Ultimately, the creative team at Blizzard pushed the dark boundaries to create a frightening game world—but the weapons and armor were what became iconic for the point-and-click action thriller. Bold silhouettes served as a visual cue of your progress and a distinctive weapon aesthetic was critical in the conceptual phase of this game. Whether it was skull-laden shoulder pads or bombastic two-handed blades of death, the art had to inspire you to keep kicking ass, to feel that much more powerful than you did before. There were many dramatic design decisions like this along the way, shaping a game that would stand the test of time and forging a franchise that has been engaging players for over fifteen years. Hopefully, it will continue to do so for decades to come.

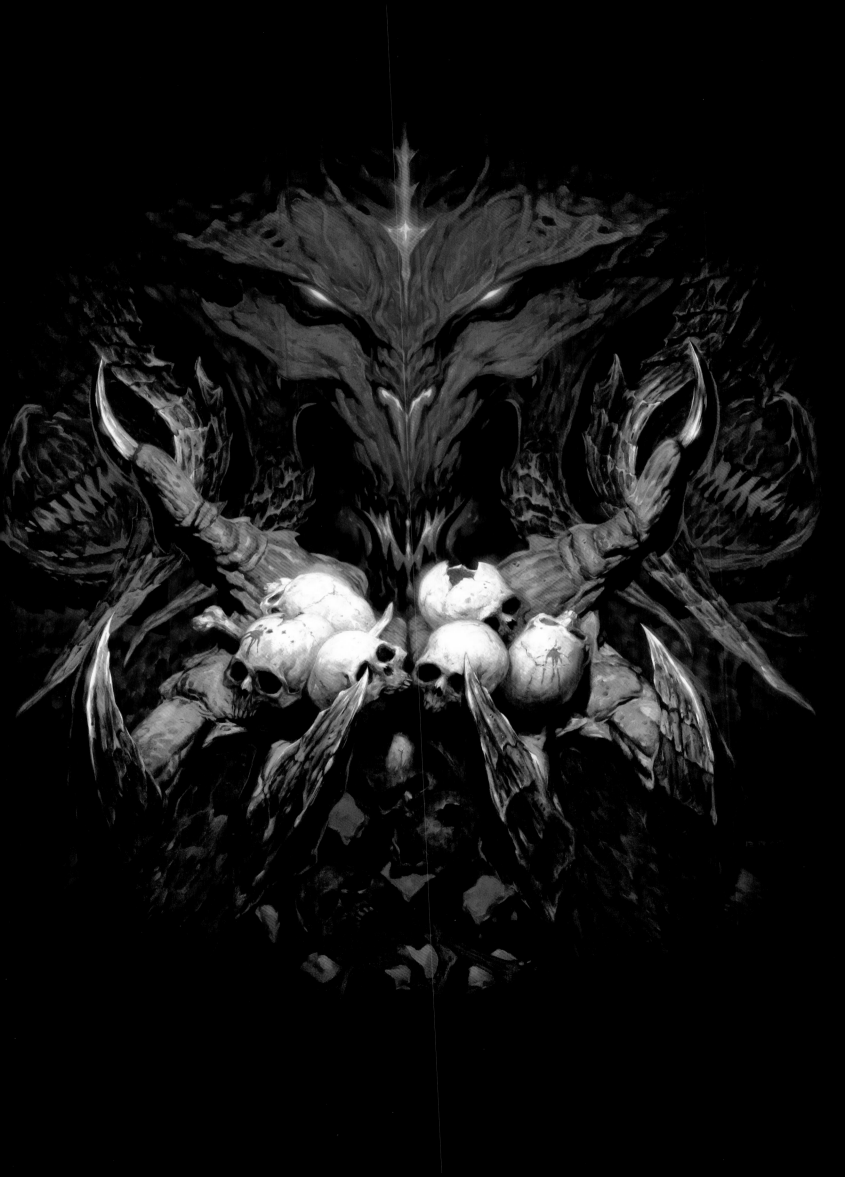

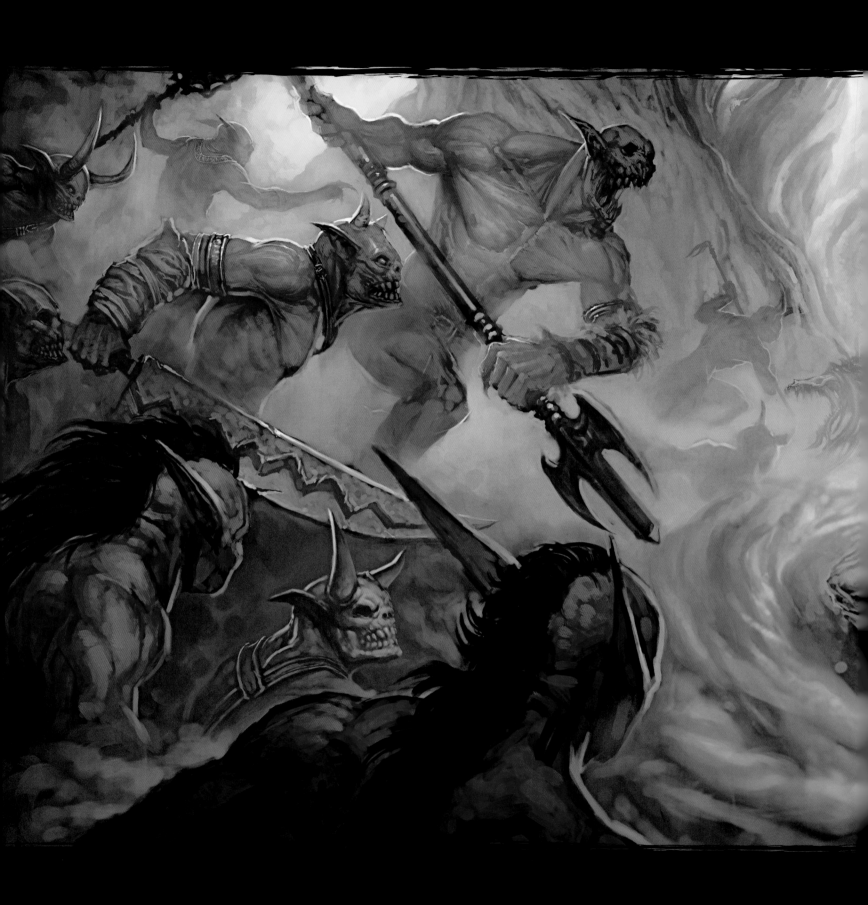

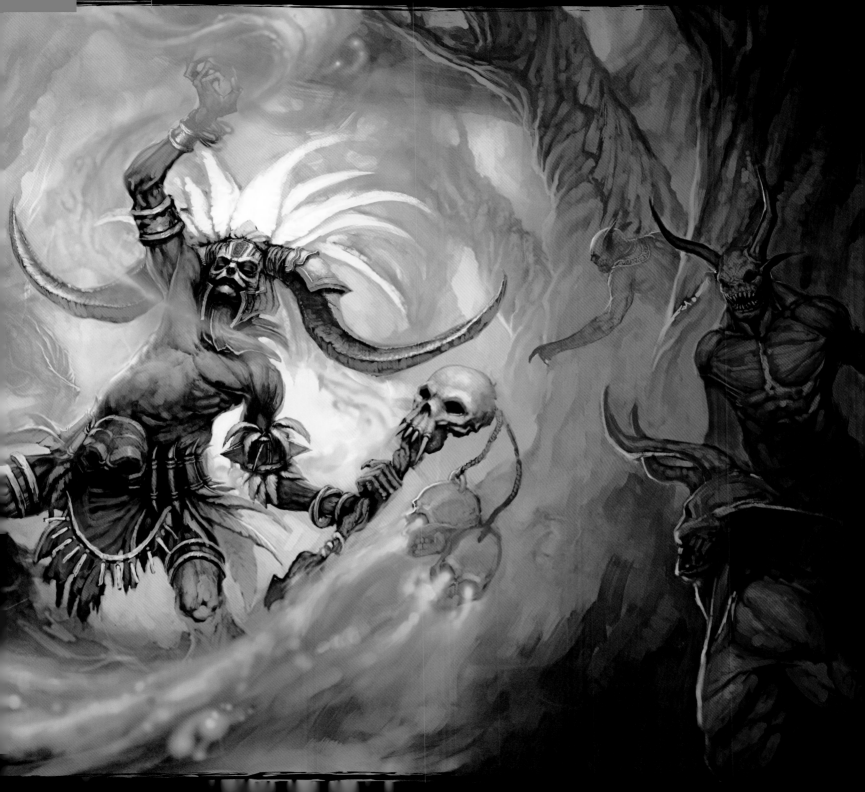

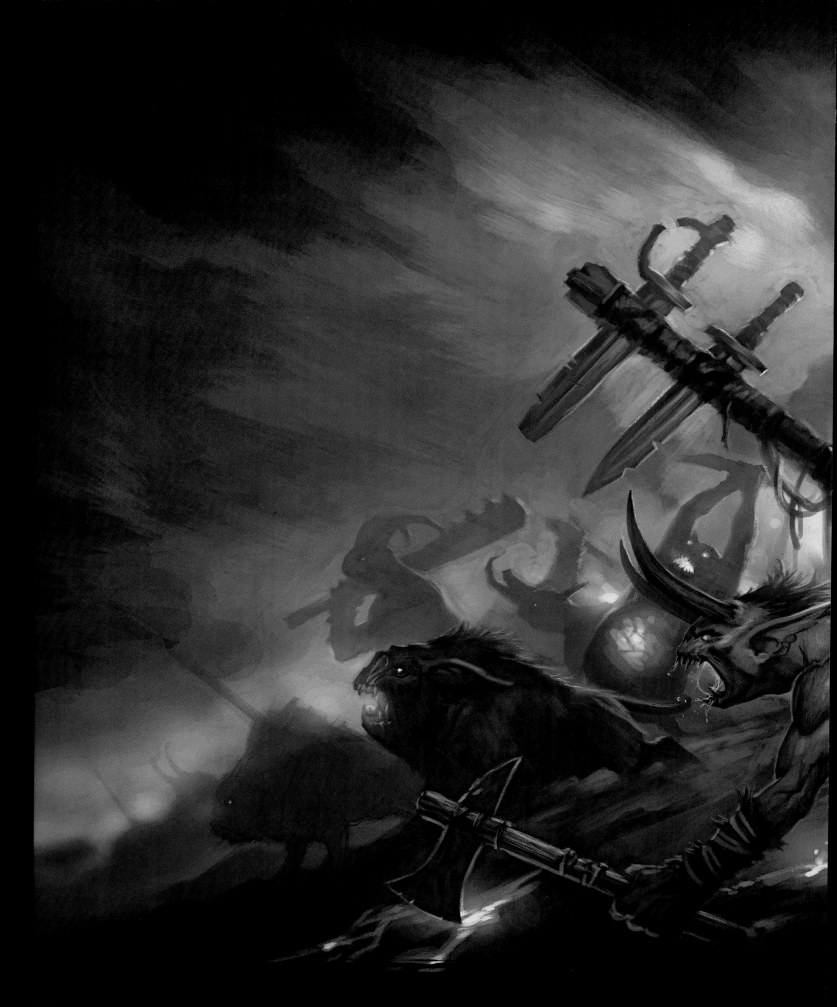

"Phroi just conjured a core concept of *Diablo III*—Hell's invasion of the world after all these years. Phroilan just killed it with this. It gives you that sense of savagery and of the raw elemental evil coming up to destroy civilization. It's a very powerful image that really helped people rally around the concept."
—*Chris Metzen*

"The fallen look so insignificant normally when you see one or two of them. You charge them and then you see there are actually ten . . . then thirty. They are like the murlocs of Sanctuary. This looks like a photo taken seconds before my barbarian died."
—*Samwise Didier*

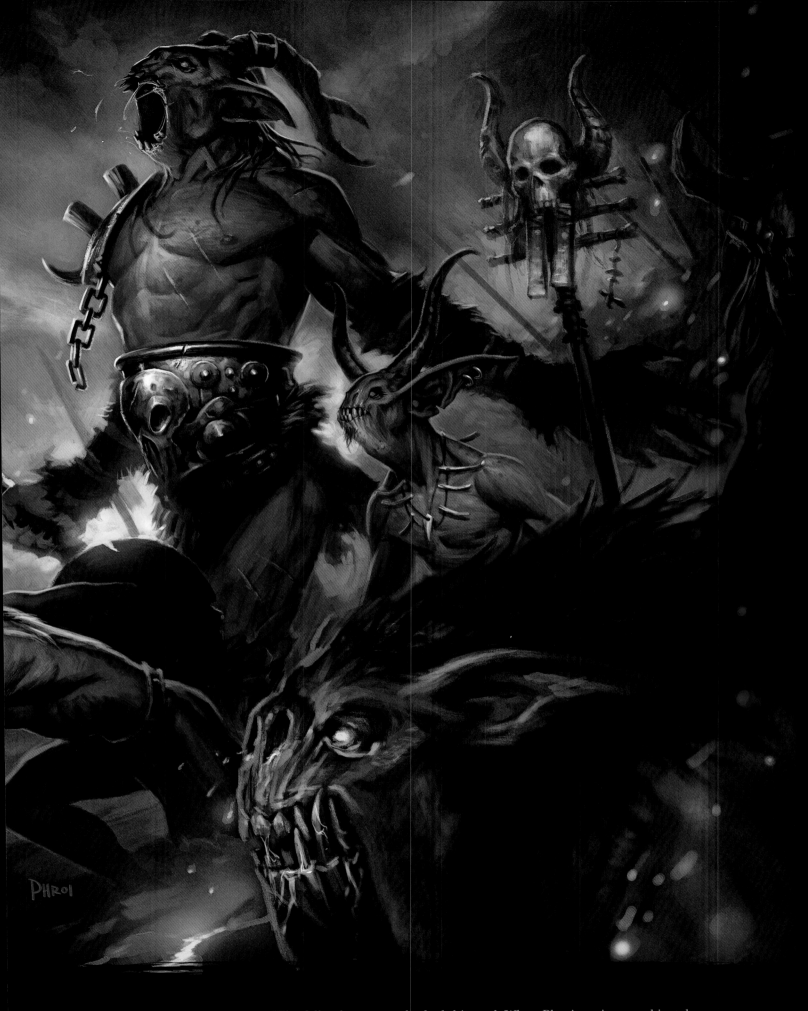

"The fallen have never looked this cool. When Phroi was into a subject, he just wouldn't stop until it was awesome. The fallen, which are somewhat comical, are shown with the power and darkness that you only rarely see in the game. Phroilan never told anyone he was working on this, and then one day he dropped it on our laps and we were all blown away."
—*Christian Lichtner*

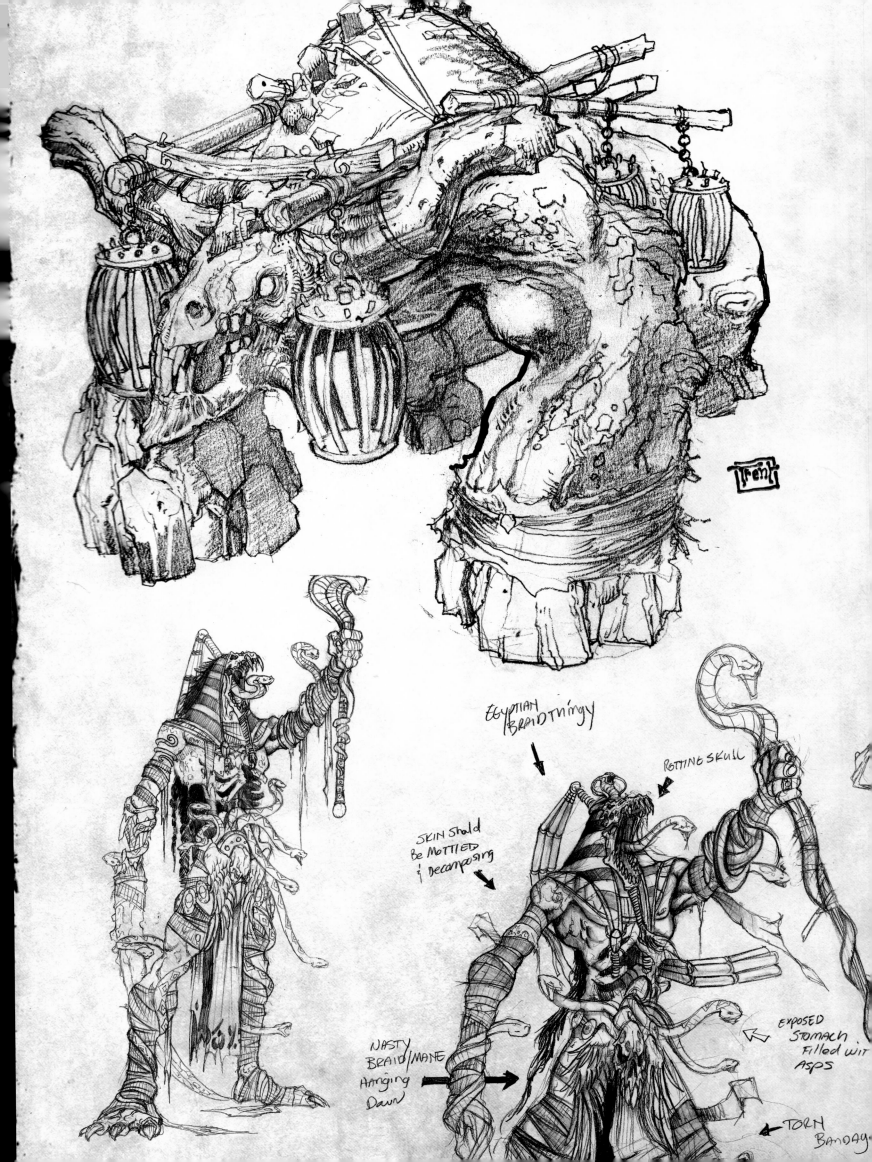

EGYPTIAN
BRAID THINGY

ROTTING SKULL

SKIN should
be MOTTLED
& Decomposing

NASTY
BRAID/MANE
Hanging
Down

EXPOSED
STOMACH
Filled wit
ASPS

TORN
BANDAG

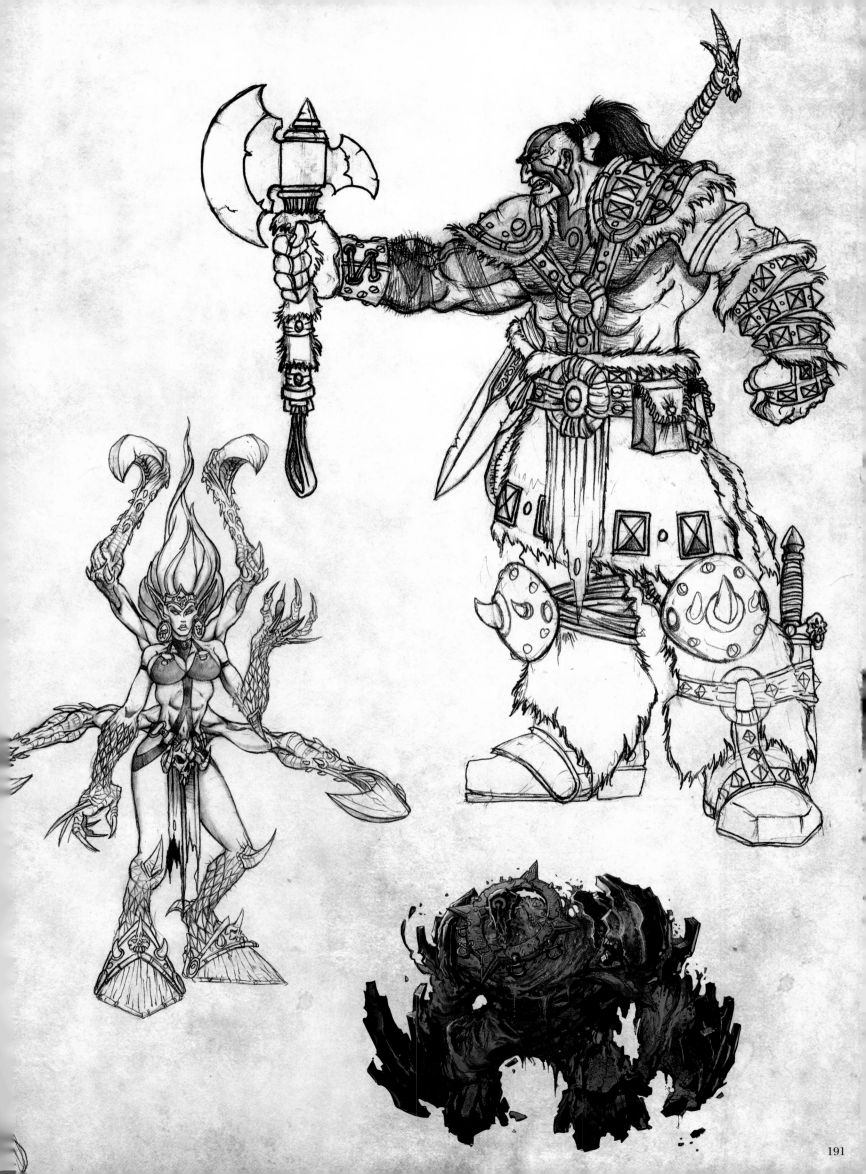

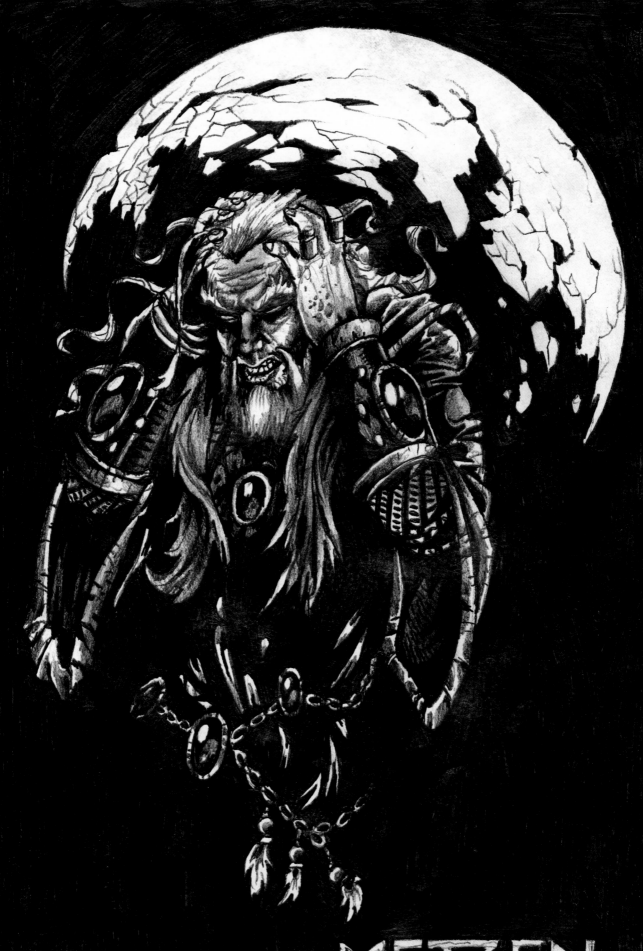

METZEN

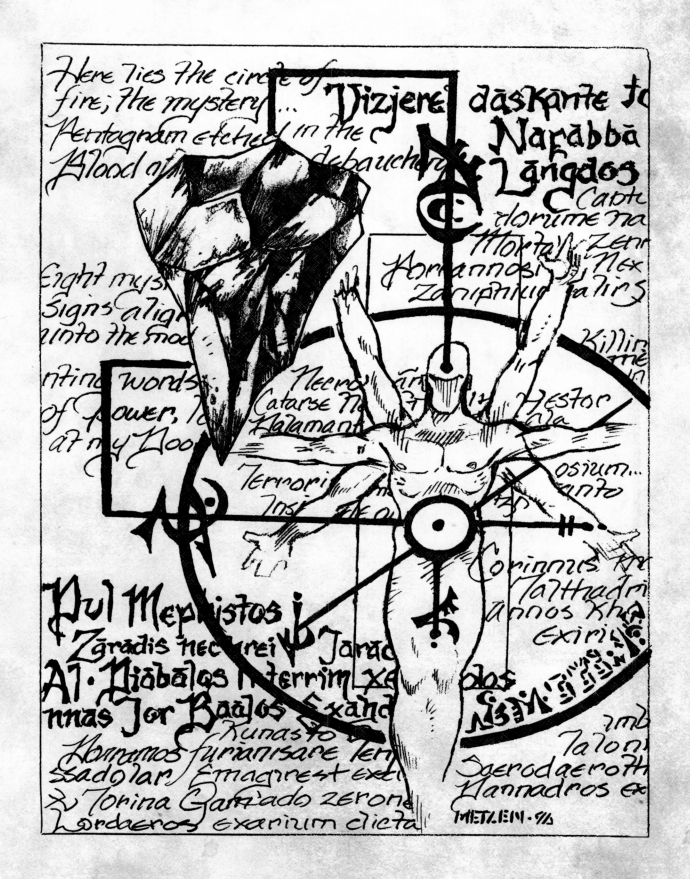

193

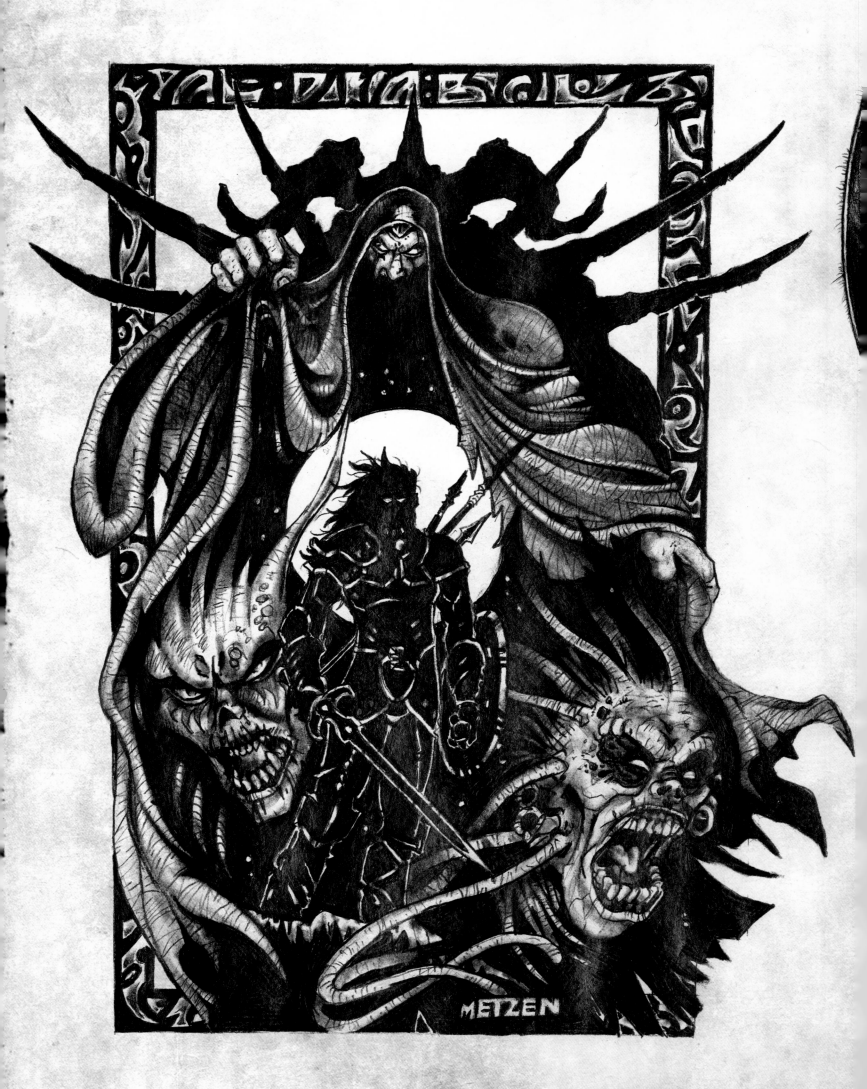

METZEN

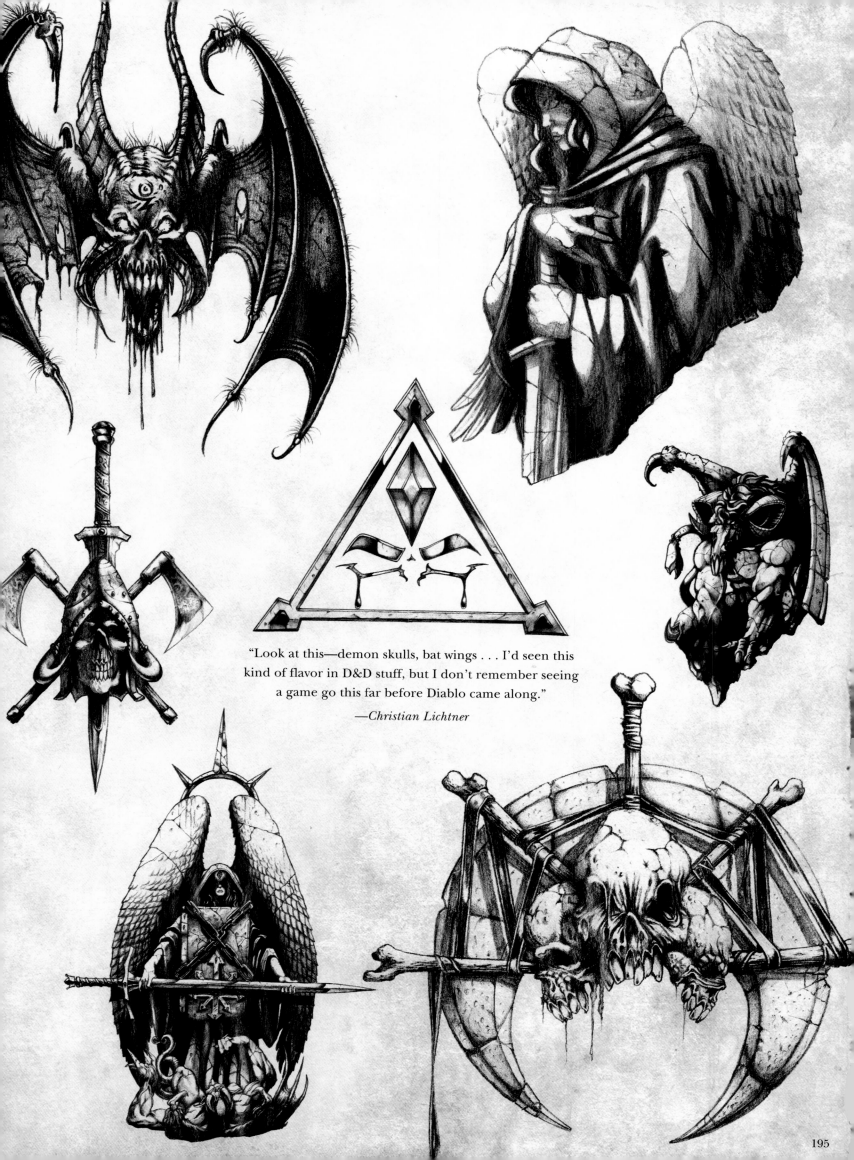

"Look at this—demon skulls, bat wings . . . I'd seen this kind of flavor in D&D stuff, but I don't remember seeing a game go this far before Diablo came along."

—*Christian Lichtner*

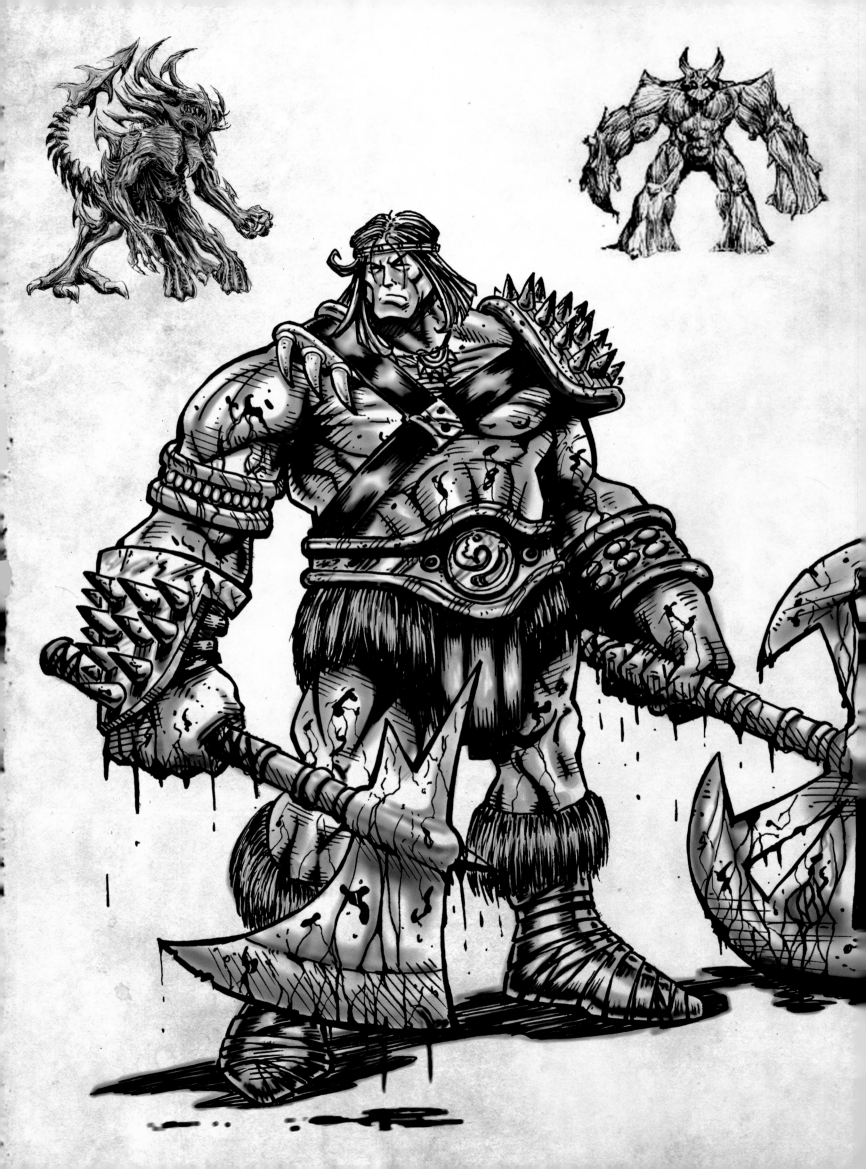

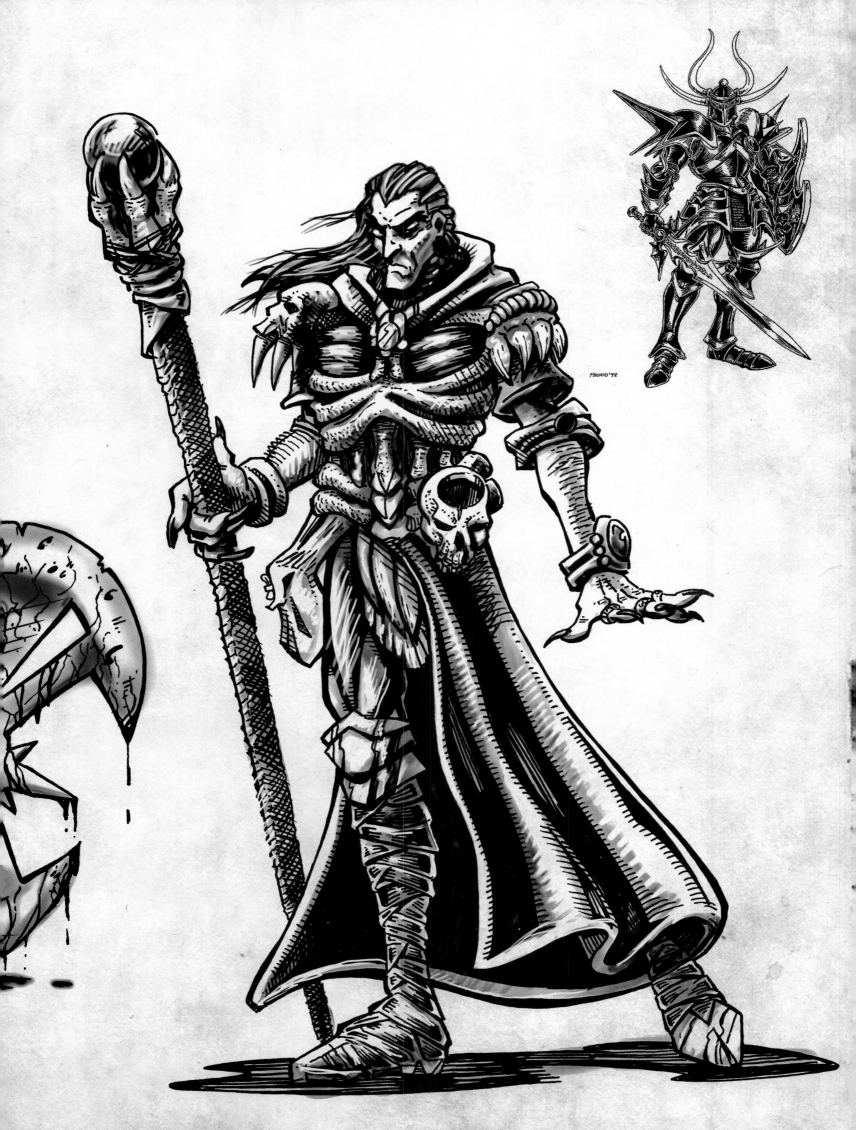

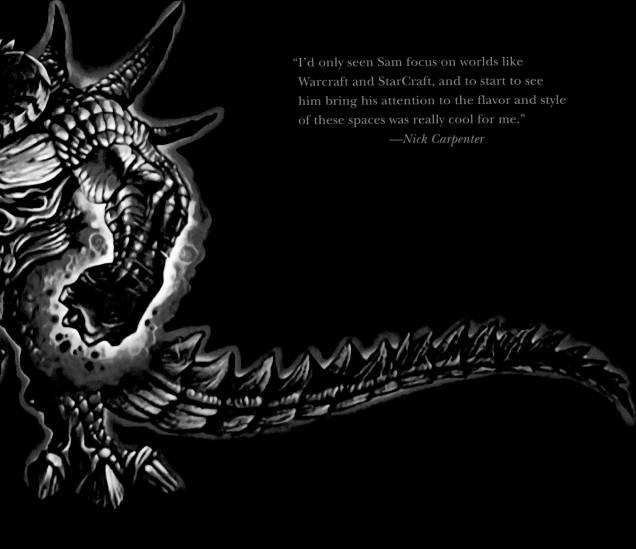

"I'd only seen Sam focus on worlds like
Warcraft and StarCraft, and to start to see
him bring his attention to the flavor and style
of these spaces was really cool for me."
—*Nick Carpenter*

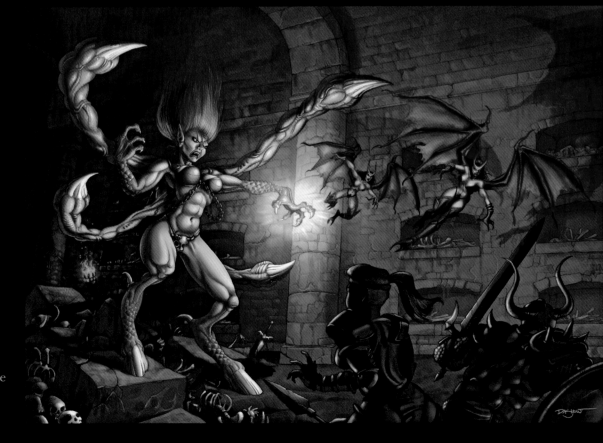

se
ally
ell in
irst
cool
to have
back."
ner

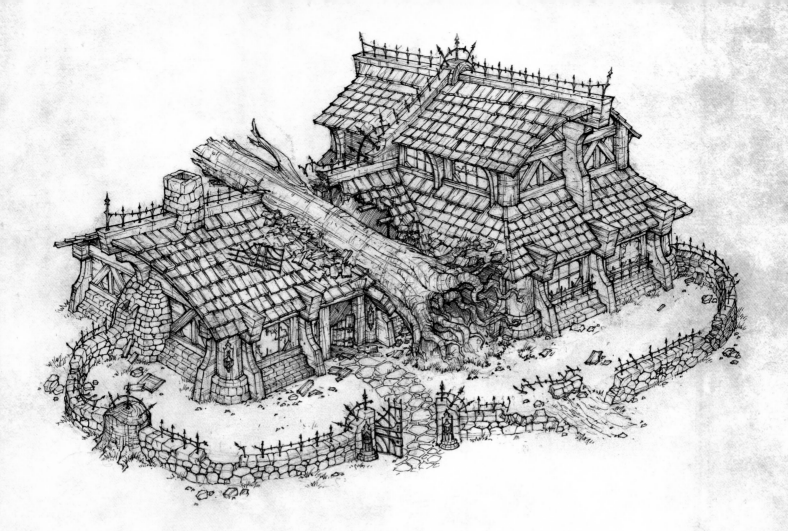

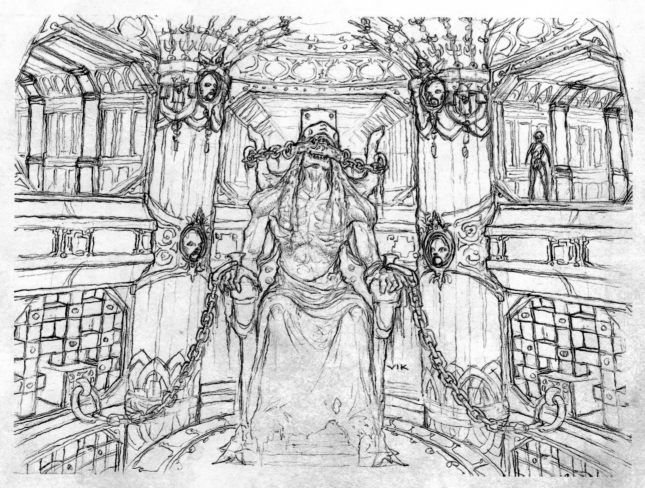

"I feel like any time you look at Vic's work, there is some element of pain . . .
Look at this piece and then look at some of his other stuff. It's disturbing,
and it always gives his work a unique hook."

—Christian Lichtner

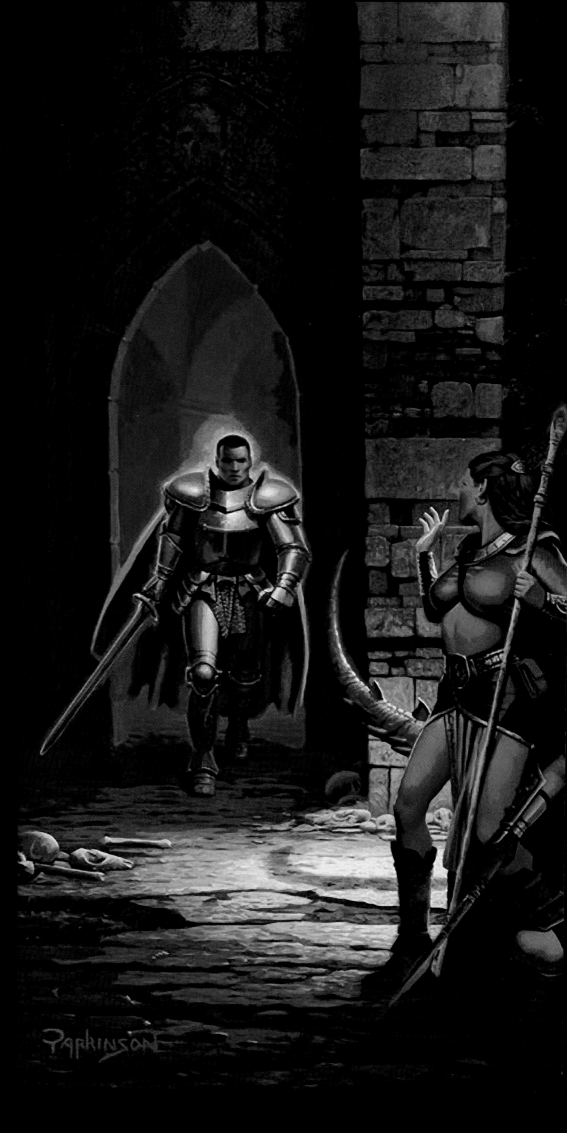

"I'm in awe of this thing. He's one of those few guys in the world of fantasy that everyone knows. I have a print of this piece at home, and now I go to work and there's the original painting hanging in the office thirty feet from my desk. It's surreal."

—*Christian Lichtner*

CHRIS M.: This is a picture we commissioned from Keith Parkinson, an artist whom many of us grew up loving back in the old TSR days. It was a great privilege to be able to work with Keith before he passed. It always felt like he had taken this image of the *Diablo II* Adventure Team fighting Diablo and brought us into that space in a way we hadn't seen before—each class either getting rocked or otherwise.

NICK: Telling its own little story.

CHRIS M.: I love the paladin coming in to save the day, not knowing whether he will get his ass beat or not.

NICK: I remember when you told me we were working with Keith. I was like, "Who are we and how fortunate are we to have these guys touching our content?" It was very surreal. I remember thinking, "Boy . . ."

CHRIS M.: ". . . have we made it?"

NICK: Yeah. This image really helped crystallize that moment.

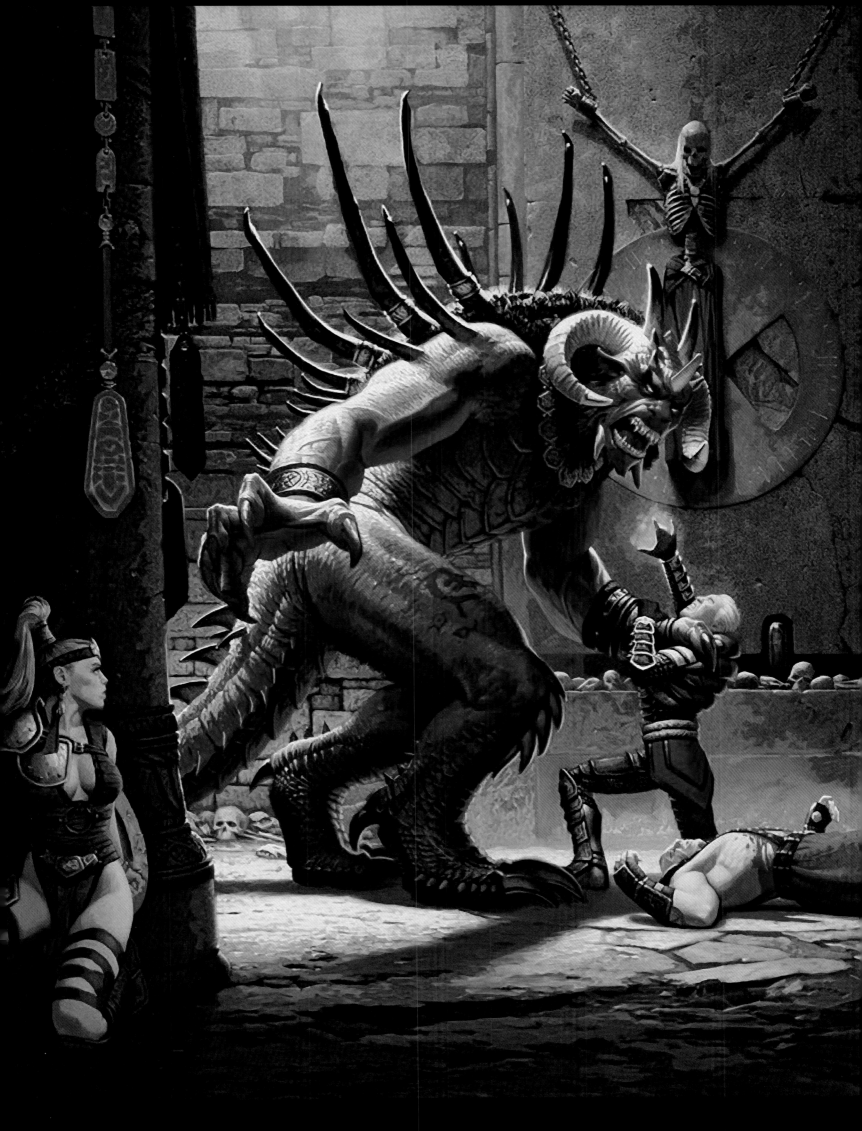

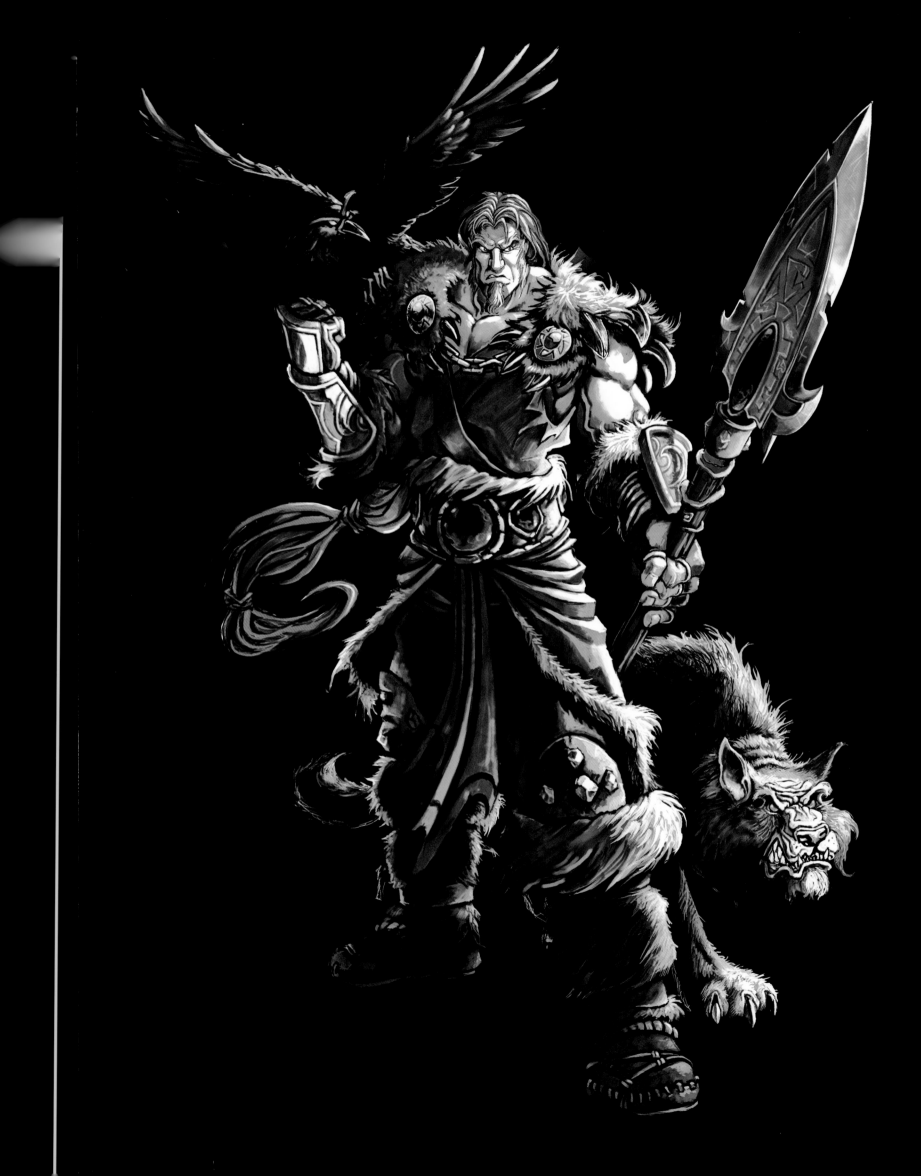

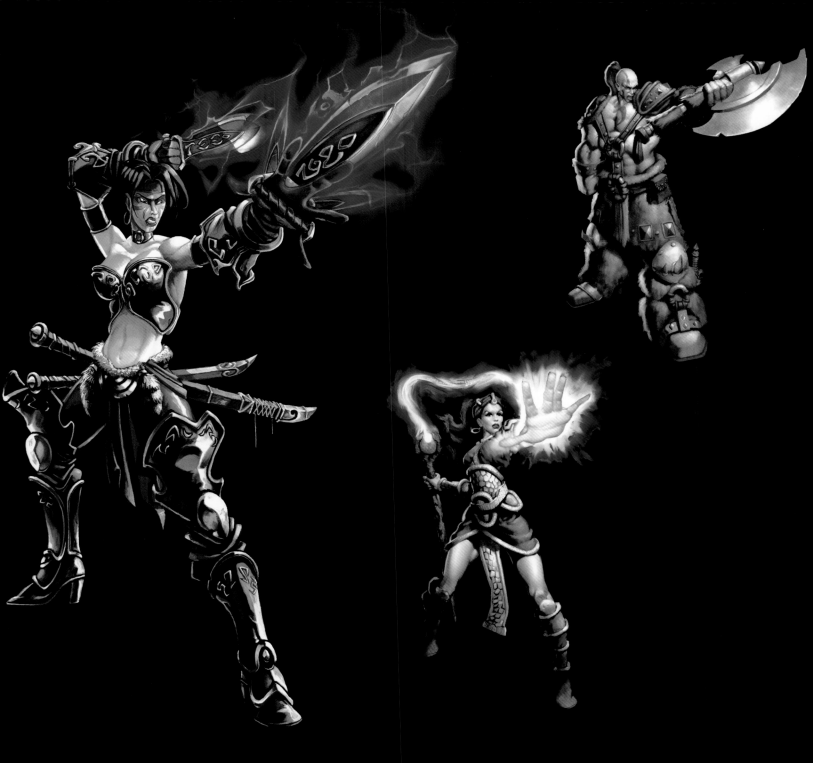

"As much as Vic is a visionary with character and costume design, his environments are totally unique, too. Just from an art standpoint—his lighting, his line work is absolutely transporting. Like his character designs, his environments and his architecture sets are totally uninformed by things that you might readily recall. He hits things that are so immediately alien but familiar."

—*Chris Metzen*

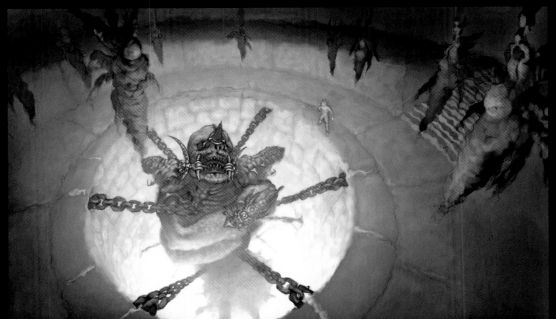

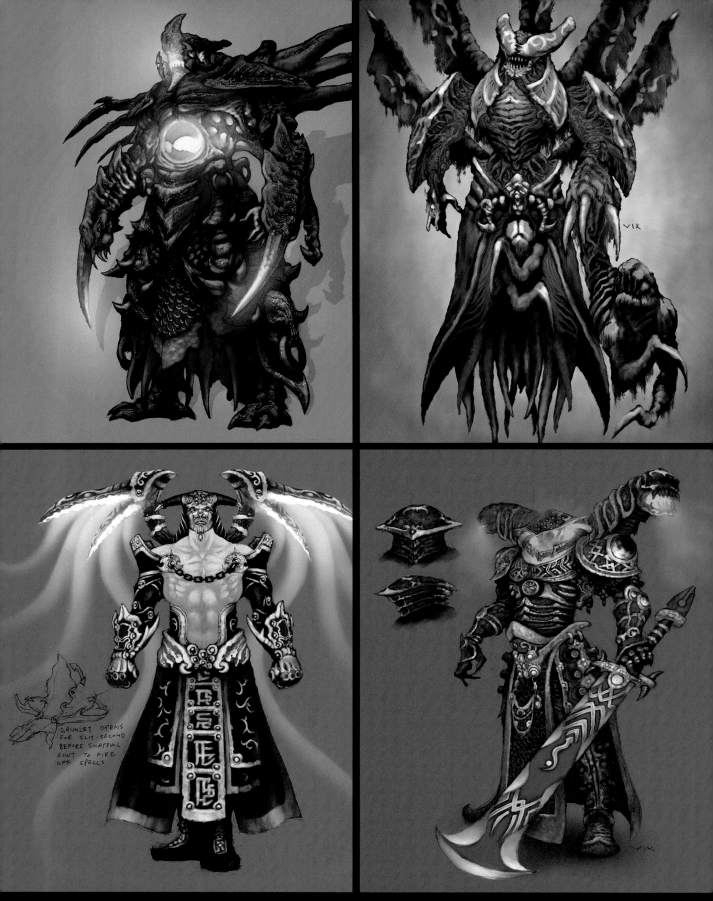

GAUNTLET OPENS
FOR SLIT-SECOND
BEFORE SNAPPING
SHUT TO FIRE
OFF SPELLS

"One of the things about these images is that they are all beautiful on their own,
but they all exist to serve the creation of a game. We can't make art for art's sake—
we design things to become assets in a 3D game. It's harder, but it's more rewarding."

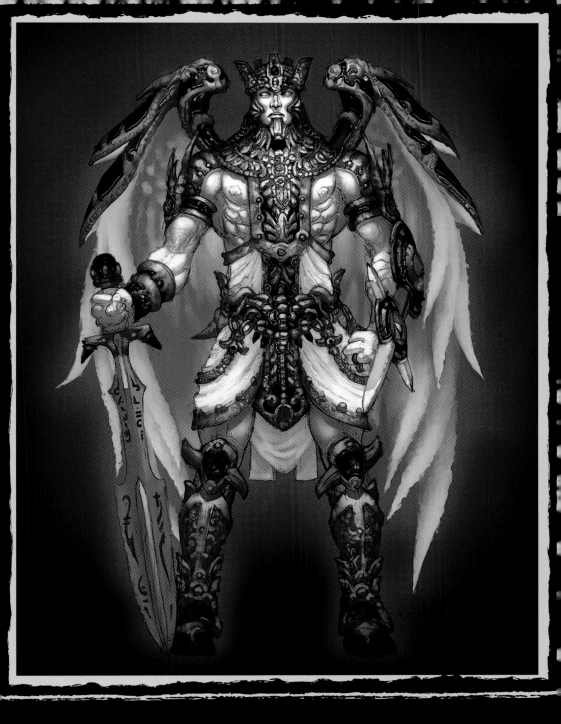

"Victor Lee has been the smart bomb of the *Diablo III* visual design team. Vic just has a singular vision for costume design, character design, environmental design. One of the most distinct voices working today, as far as I'm concerned. And his sensibility has shaped the tone and specificity of the Diablo universe—it just doesn't look like anything else out there in terms of the armor design and gilding."

—*Chris Metzen*

"Vic kept Diablo Diablo. A lot of us have the sensibility of making it bigger and brighter, you know, big shoulder pads and stuff. Vic would throw these bold concepts out and still be true to our values—but they'd be twisted with different faces and different imagery, and he really just kept the macabre in Diablo. When they saw him producing this artwork, a lot of the team just could not wait to dig into building some of this stuff."

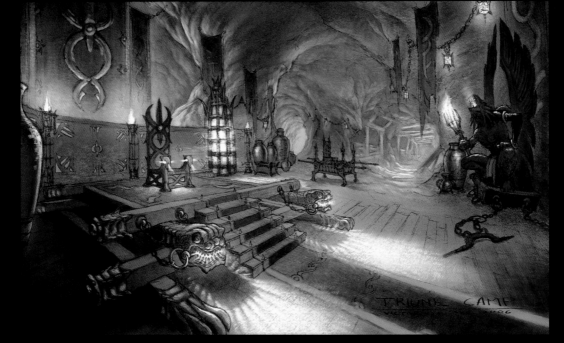

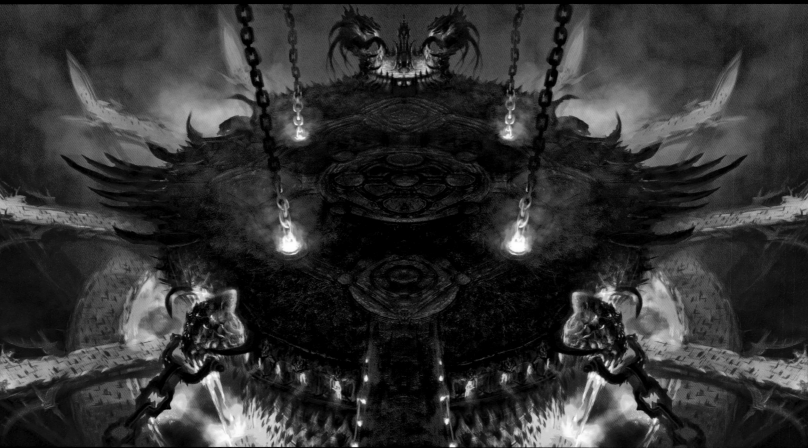

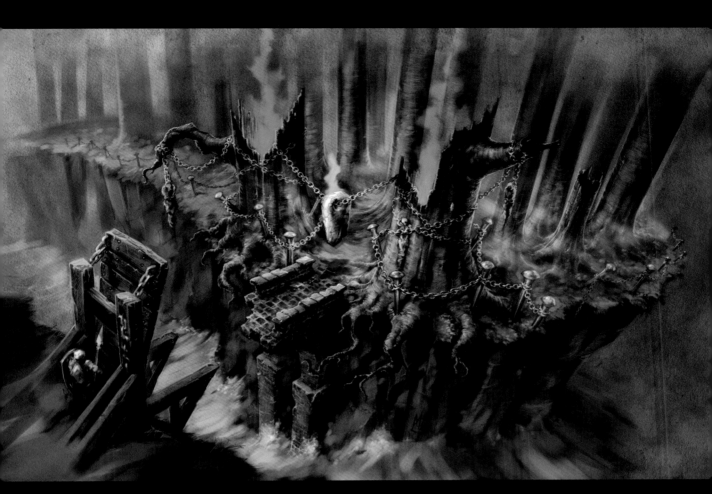

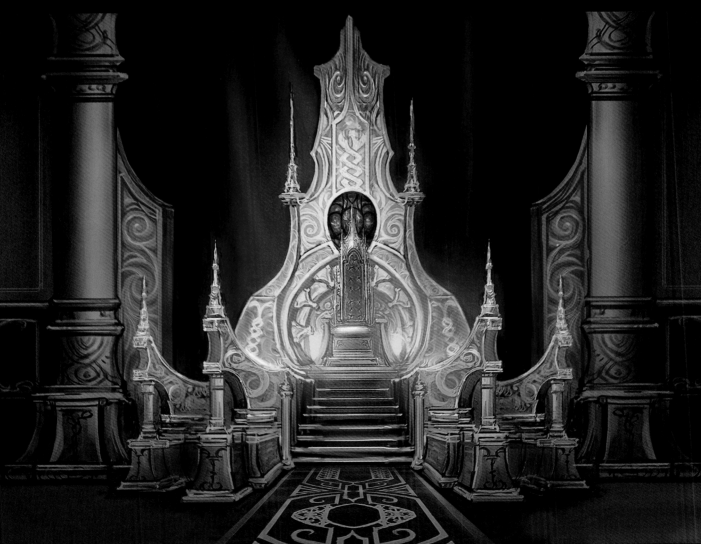

"We went through several iterations coming up with a final look for environments of Diablo. This throne room epitomizes the ostentatious nature of Caldeum—rich fabrics, fine metals, this city being the Jewel of the East."

—*Christian Lichtner*

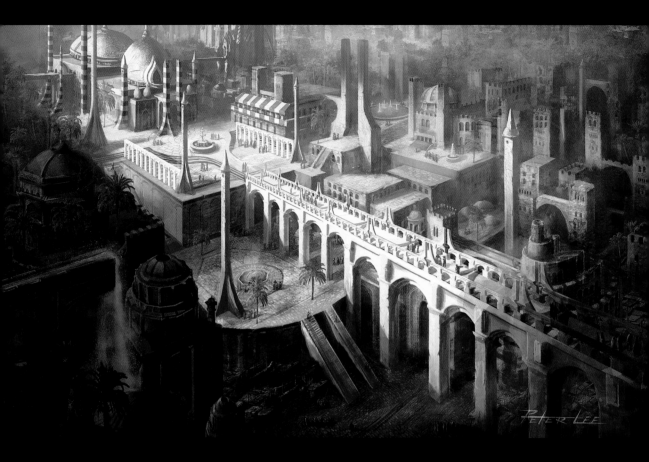

"This is a Peter Lee image of Caldeum, the Shining Jewel of the East. For my money, Peter Lee's one of the most transporting environmental artists working today. He takes pictures of the invisible. He sees things in his head that do not exist, and you are utterly convinced, looking at his art, of the reality of these places. Here, it's the sense of the commerce and the culture of Caldeum."

—*Chris Metzen*

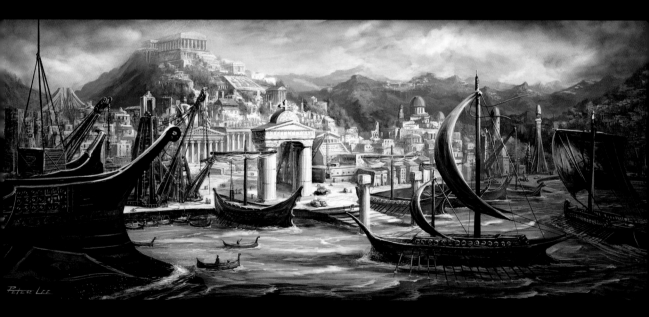

"We had conceptualized a tileset of locations in the world, the Skovos Isles, which were very Hellenistic and Greek in their feel. But at the time *God of War* was rocking out, and a lot of the developers felt they had really put their mark on ancient Greece, and maybe *300* had also come out. So we pulled away from using it as a core title set, but I still hold out hope that one day we'll come to Skovos Isles, 'cause the storyline just absolutely kicks ass. Peter Lee just hit the whole concept with this image."

—*Chris Metzen*

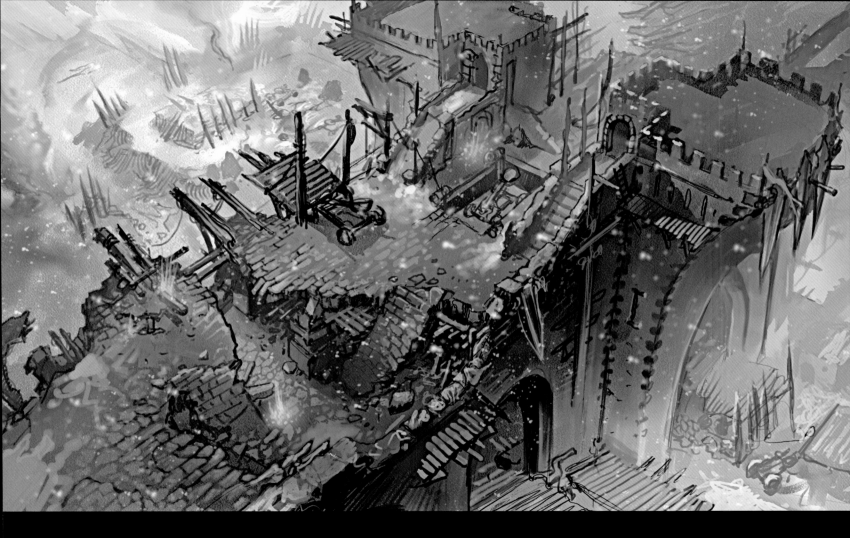

"Some of Trent's early exploration for Battlefields. The Battlefields ended

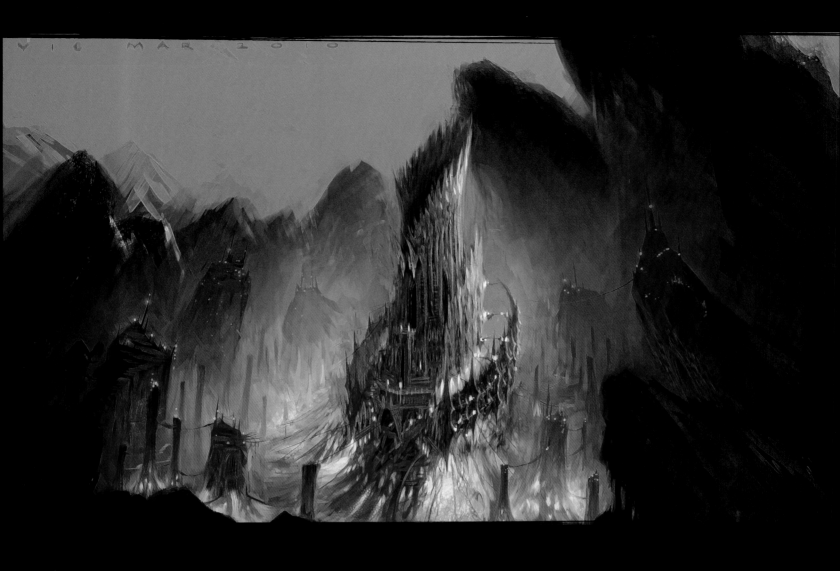

"We knew *Act III* would be in this shattered mountain, this hellish volcanic
environment, and then we had this crazy idea of putting towers rising out
of the middle of that crater. We went to Vic to define what an organically
evolving Hell tower would be, and he gave us this piece."

—*Christian Lichtner*

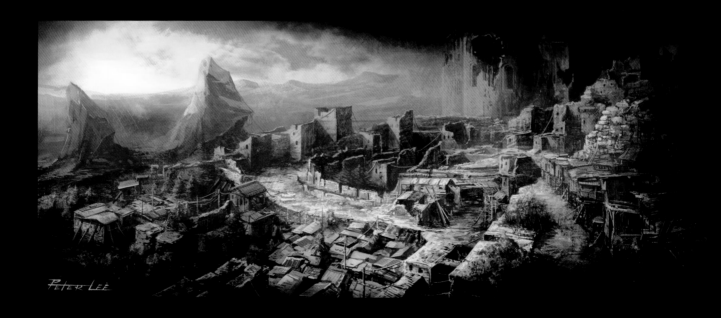

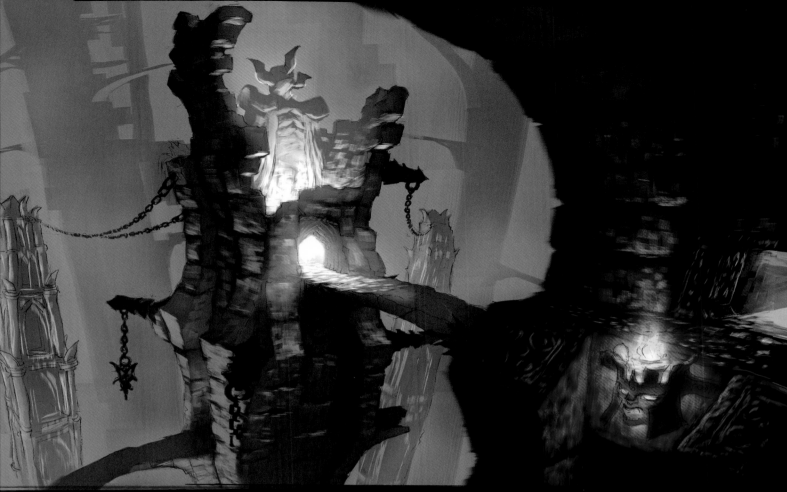

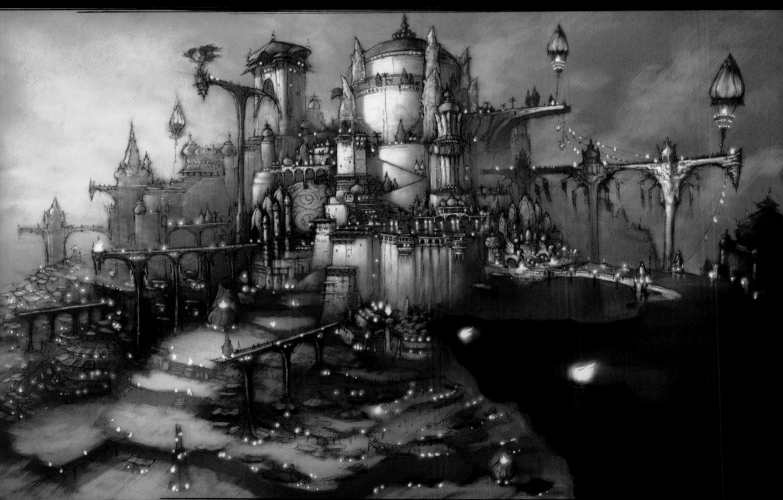

"This shot of Caldeum was one of the quintessential establishing
shots that defined the rich culture of the region."

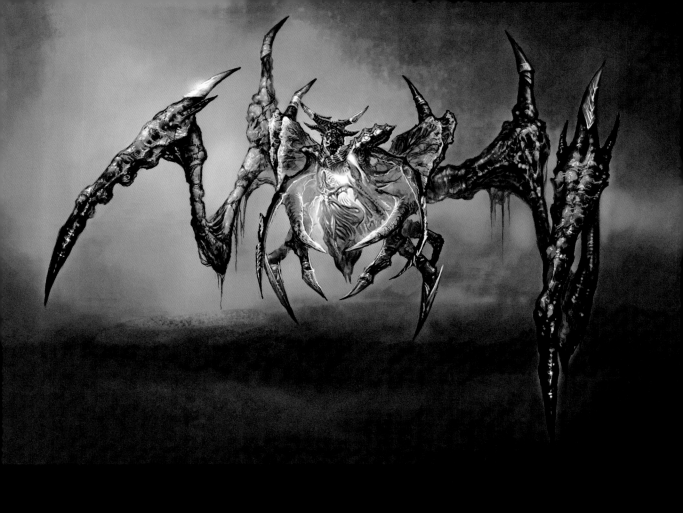

"Yup. Vic and demons are a match made in heaven."
—*Nick Carpenter*

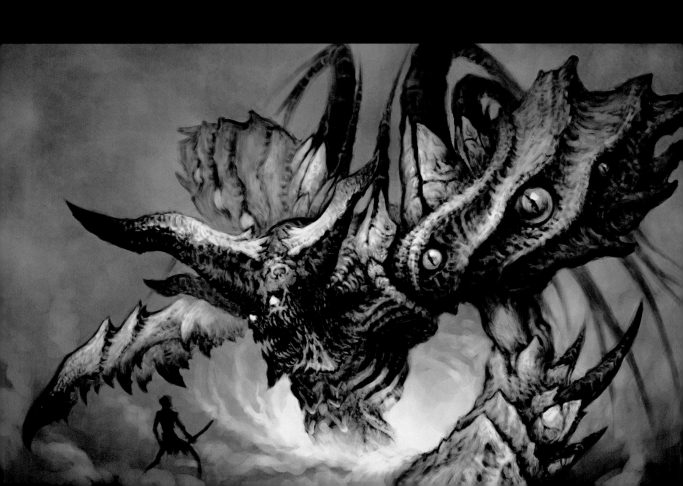

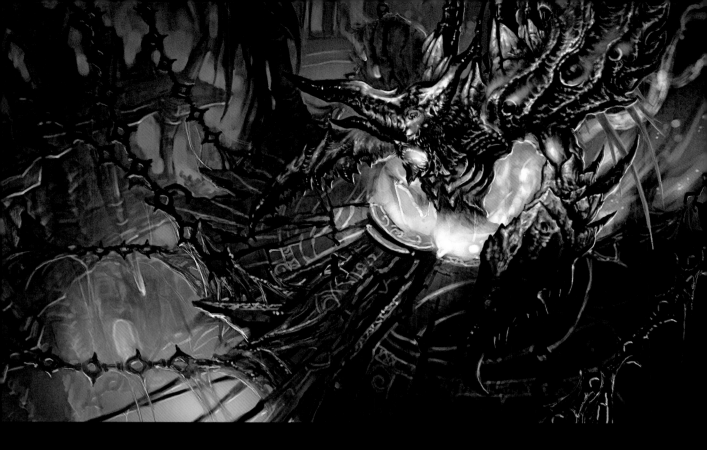

"Belial went through a redesign phase, and when Vic dropped these images, it was such a unique and fresh look at these characters and creatures. I felt like he was drawing inspiration from the works of Yasushi Nirasawa, but he was pushing it in a way that I had never seen before. And I remember thinking to myself, 'Good Lord, if we make this game, it's certainly going to resonate.' These ideas are so twisted and so unique that you're gonna feel Vic's impression on this world for a long time."

—*Nick Carpenter*

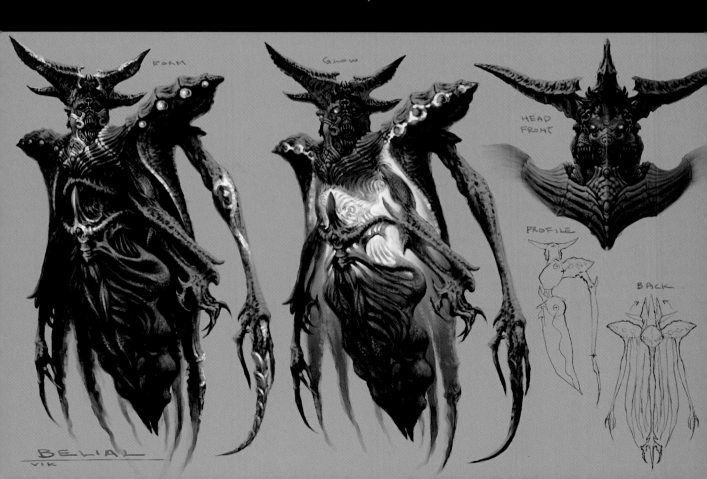

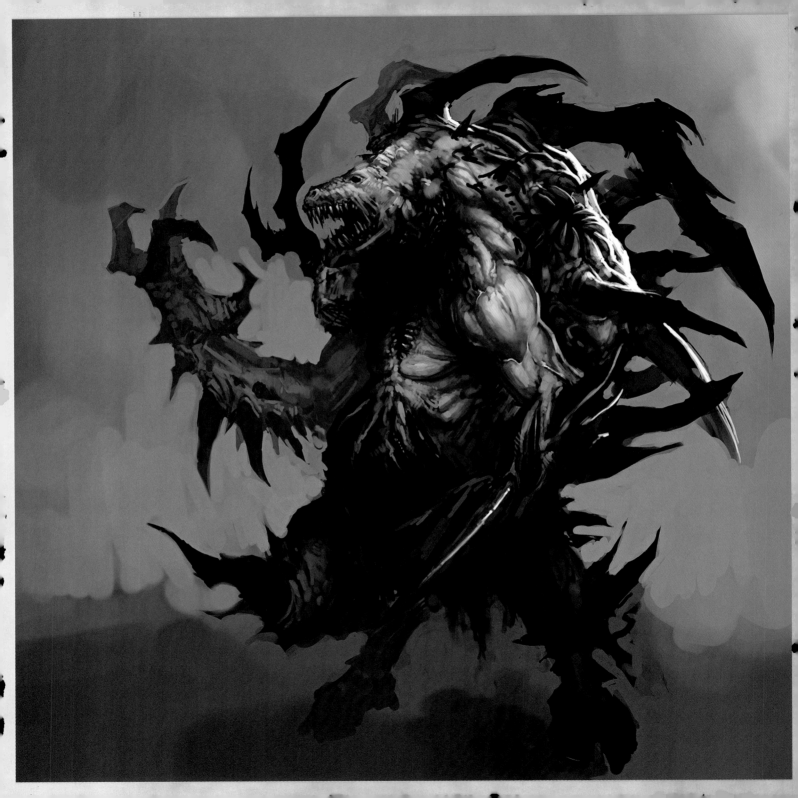

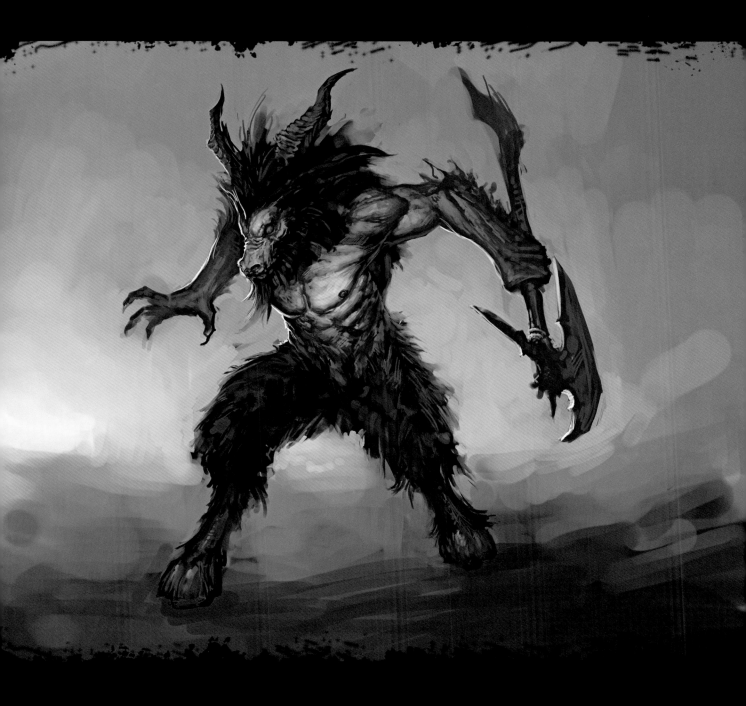

CHRISTIAN: All the goatmen Josh did turned out amazing. Goatmen are kind of essential to Diablo, and we had him making all kinds of warped, freakish versions. I love this one [above].

JOSH TALLMAN: Can I still tweak that?

CHRISTIAN: No.

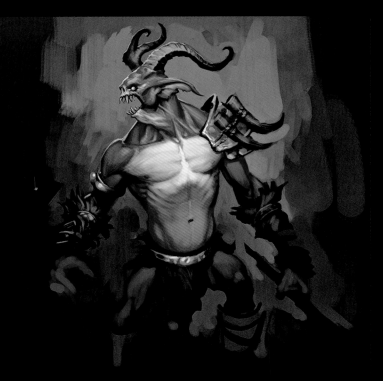

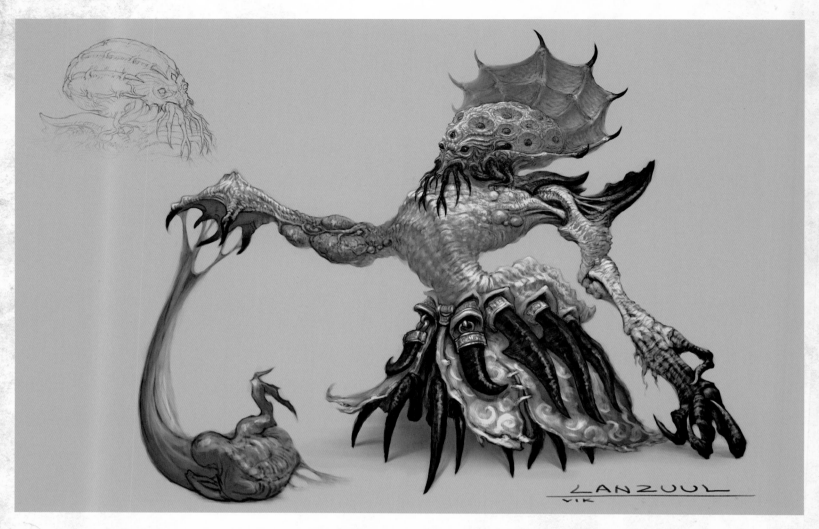

LANZUUL
VIK

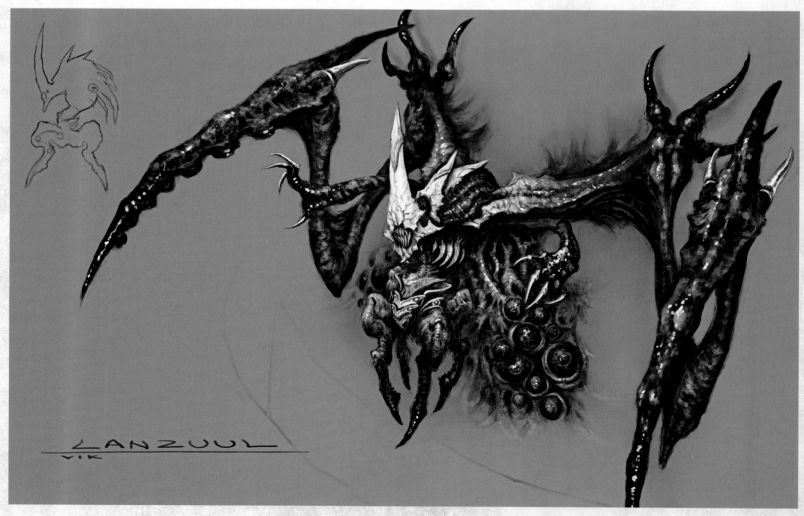

LANZUUL
VIK

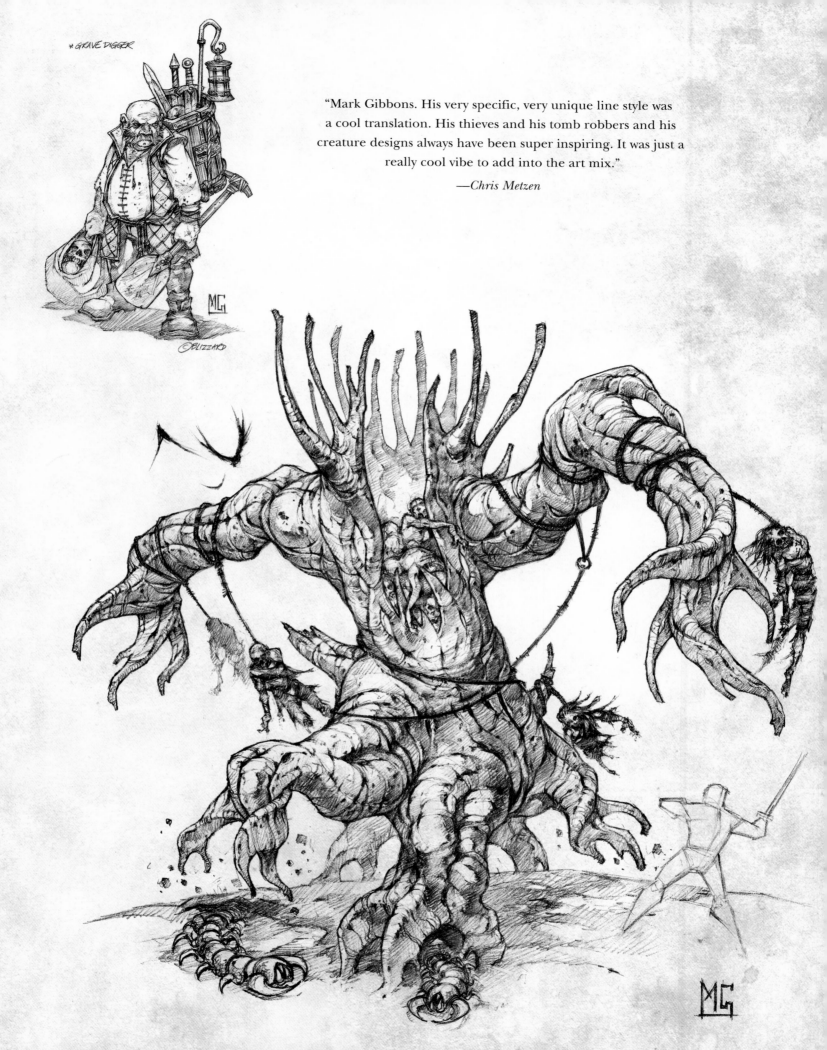

* GRAVE DIGGER

"Mark Gibbons. His very specific, very unique line style was a cool translation. His thieves and his tomb robbers and his creature designs always have been super inspiring. It was just a really cool vibe to add into the art mix."

—Chris Metzen

"The wood wraiths were really difficult to implement, and we had to change their design a number of times. Having them pop from 2.5D to 3D became a real technical challenge, but we all liked the idea of going into a forest and not knowing which of the trees were going to come to life and attack us."

—Christian Lichtner

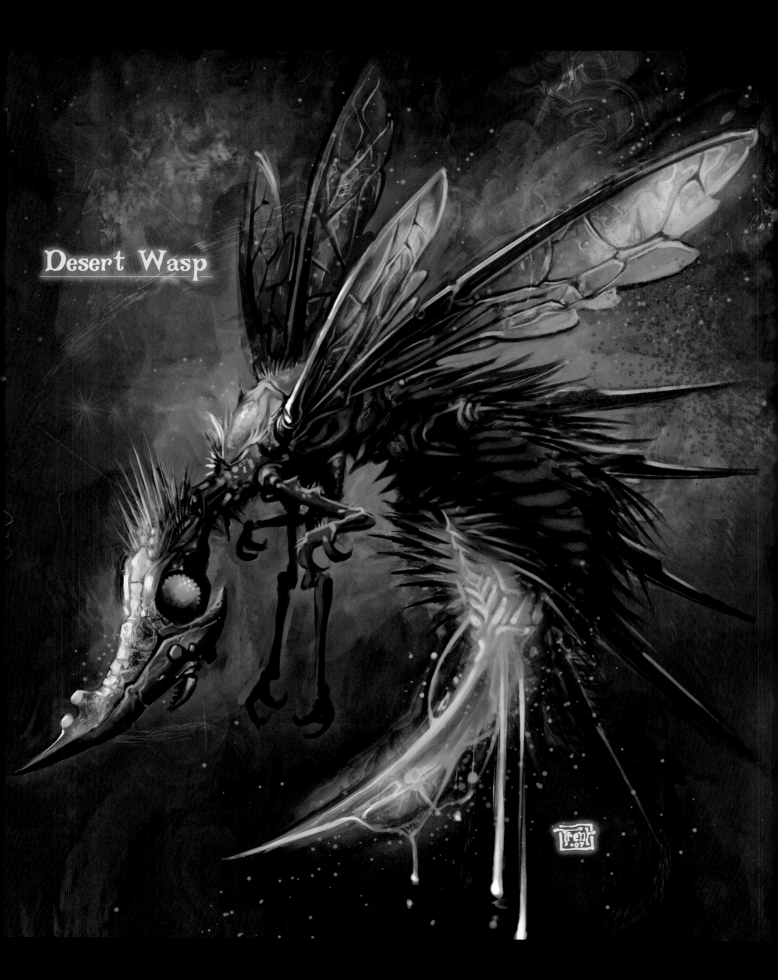

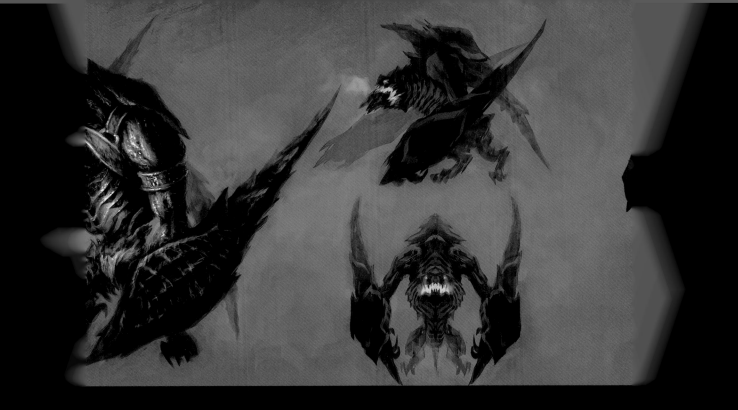

"Damn, I hate fighting sand wasps. The wasp
shoots other wasps. I mean, seriously."

—*Christian Lichtner*

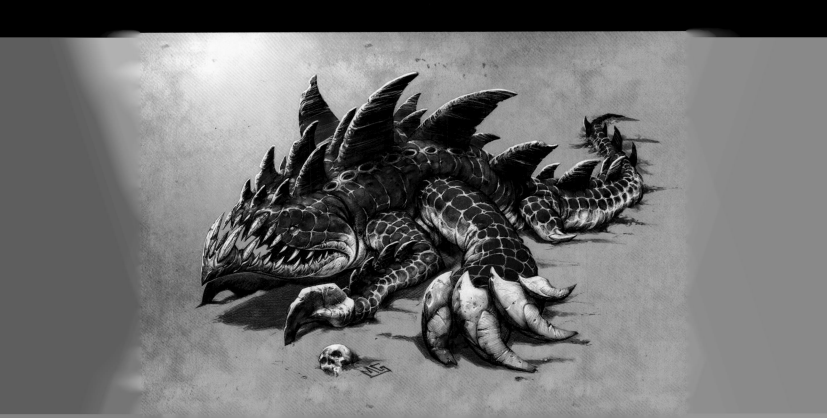

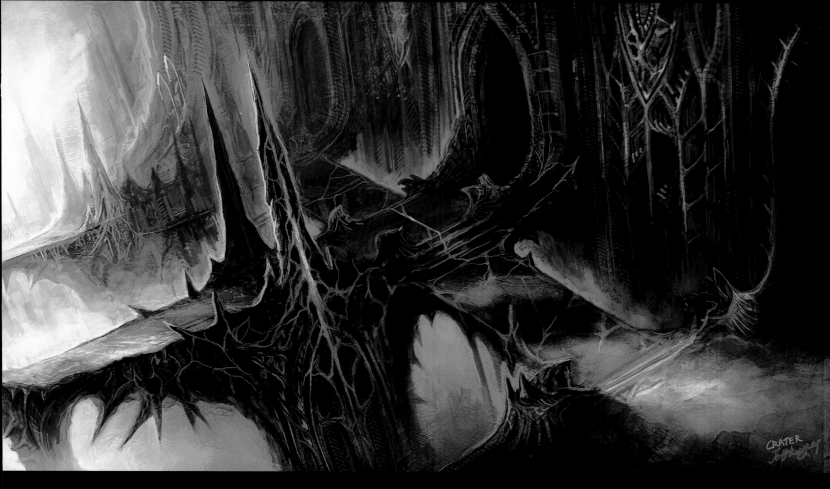

"Coming up with a look for Hell physically encroaching on Sanctuary was a huge challenge. We always had this idea that it would manifest as this warped demonic cathedral. You don't normally see cathedral shapes in natural, organic forms, and then you add giant, living hearts powering each of the towers, and you really start to throw nasty twists at the audience. It's perversion, but not to shock. We don't want weirdness or gore just to shock people—that's easy, and it tires quickly. We try to give them something unexpected, which is harder but creates a more lasting design."

—*Christian Lichtner*

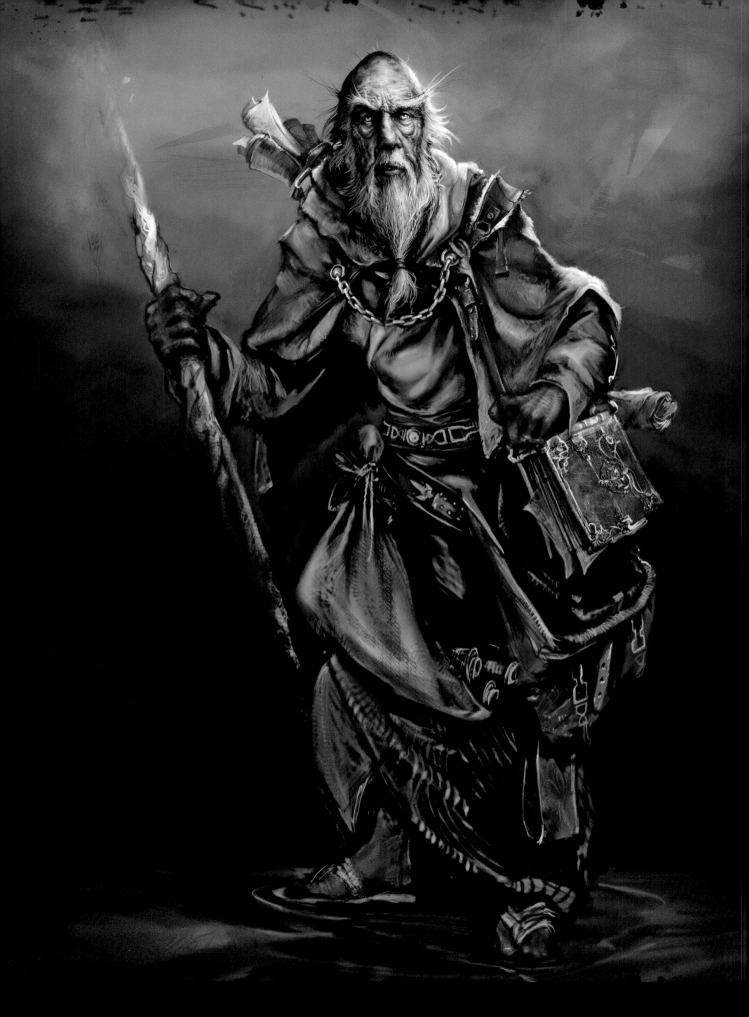

PAUL DARTECHS: Just for the record, those are some damn long eyebrows.

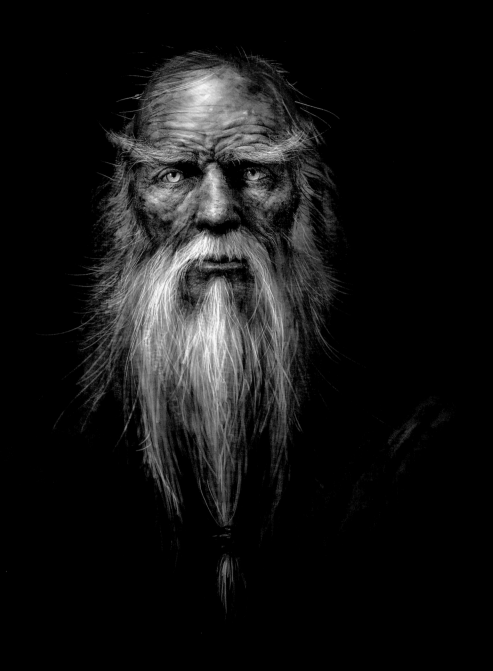

"When we knew we were going to explore a story with Deckard Cain, we had to understand what he looked like. We had rendered him out so he was only like three pixels. And we knew we were gonna have these close-up shots with him and that he was gonna act and have to show emotion, so we really had to dig down and try to figure out who he was. I remember the conversation going back and forth, 'Well, he sounds like Sean Connery and he looks Indian. But every time we drew him he looked like he was Caucasian. So we just kept making him tanner and tanner and tanner 'til eventually we found this look. In the industry at the time there was the *Lord of the Rings* movie, and we were trying to stay away from Gandalf, but still have some of those inspiring elements to him. Super important were the eyes, trying to create a sense of journey—this guy had seen a lot and we really focused on those pale eyes. When you're trying to mix the different skin color with the eyes, you get into this totally different area. When we had gotten to a point where everybody was pretty happy with the design, one of the artists came to me and said, 'Man, his face is so transporting. I want to see what he's seen.'"

—*Nick Carpenter*

"These were created for the Black Soulstone. Really they are images from Cain's book in the cinematic. We had always talked about Cain being a sort of scribe who would jot down these ideas or images that he had seen into his book. I knew that they needed to be pretty intense and horrific, but they also needed to help you understand where you were going and what he had gone through. Bernie Kang had drawn these, and I know it was pretty tedious work for him, but I really felt it came off. It was kind of my way to pay homage to the earlier Diablo games and try to bring some of that horror back into the game."

—*Nick Carpenter*

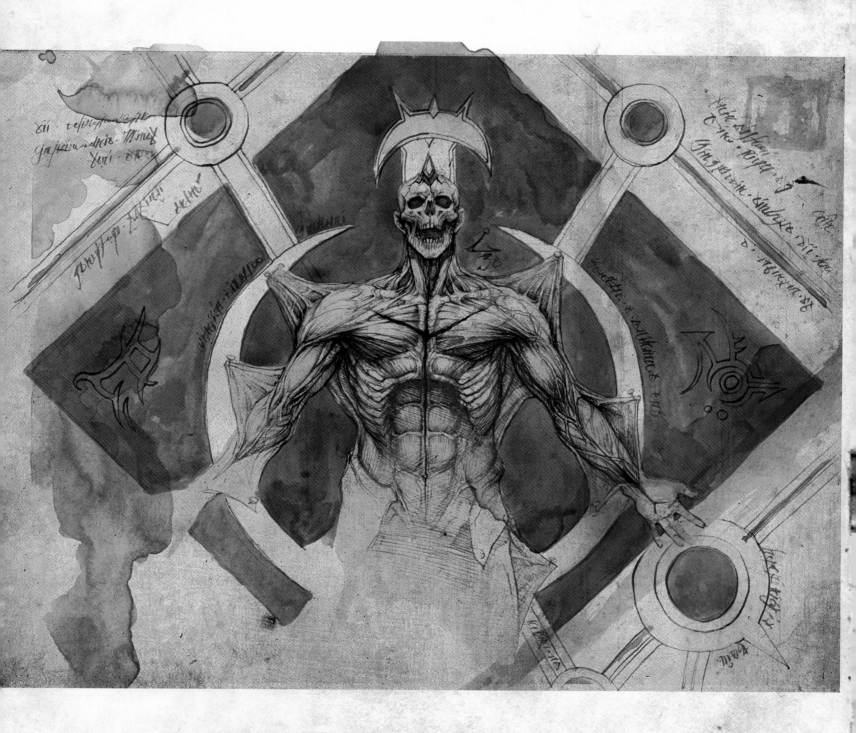

"I don't know how Bernie did these, but I wouldn't be surprised if he actually
spilled liquid on these pages. Hell, he probably used blood."

—*Christian Lichtner*

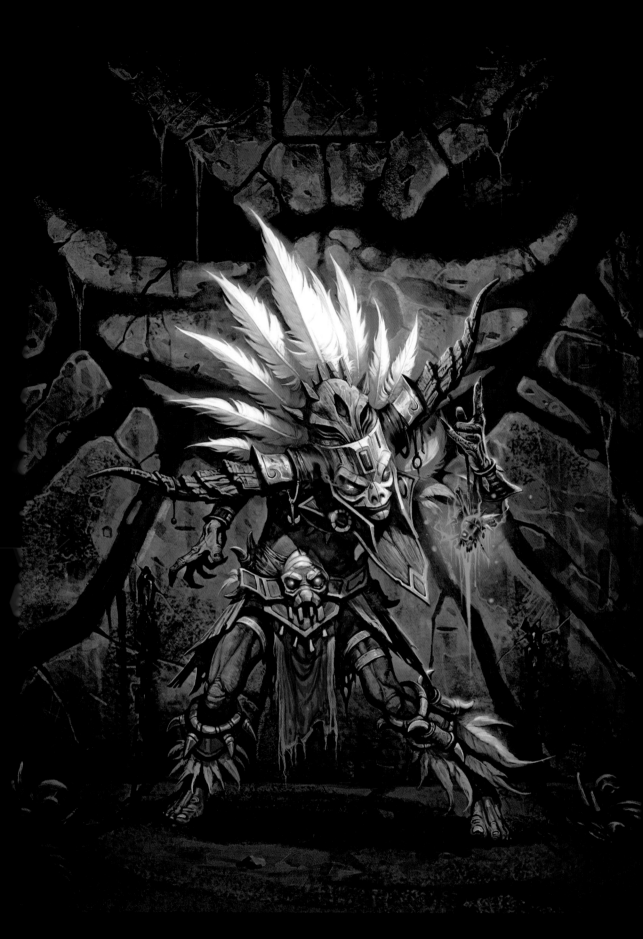

"What I've always loved about Diablo is that a lot of the classes unabashedly glom onto classic arche-types. There's no question what you're looking at. This is a witch doctor. If anyone in the world looks at that, he knows exactly what he's looking at. But the little details transport it into more of a fantasy set. How many of us have ever met a witch doctor in real life? But there's an authenticity to it because these guys dig out details and the costume kits and the tattooing and the unique weaponry. The culture behind this kit is believable and immersive. That's what I love about Diablo—while it clings to certain archetypes, it makes them uniquely authentic within the frame of its fiction."

—*Chris Metzen*

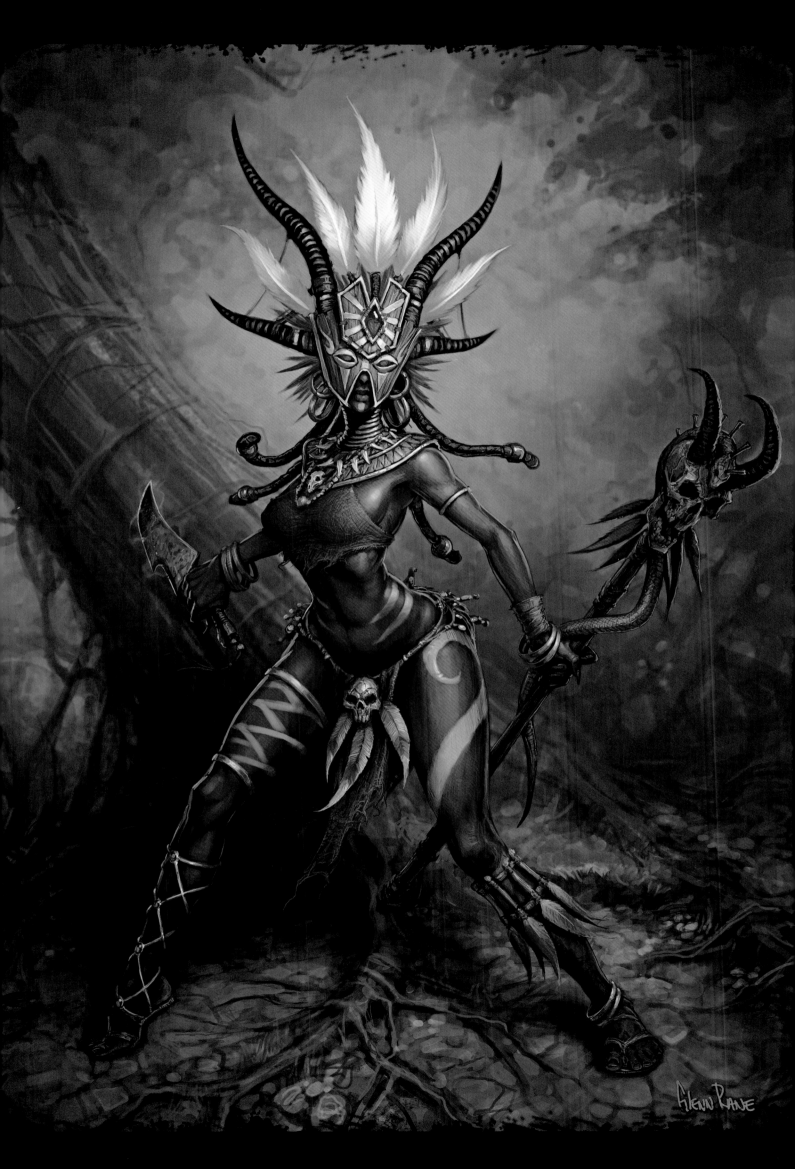

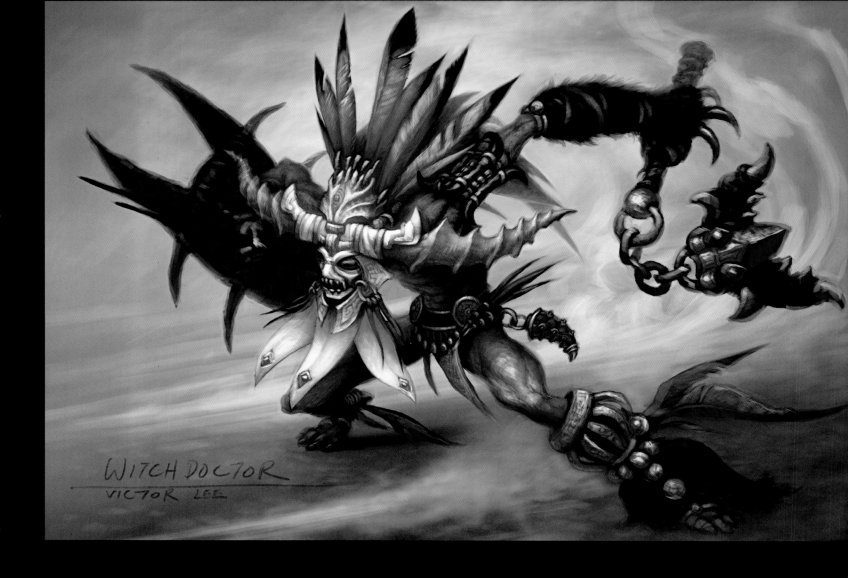

WITCH DOCTOR
VICTOR LEE

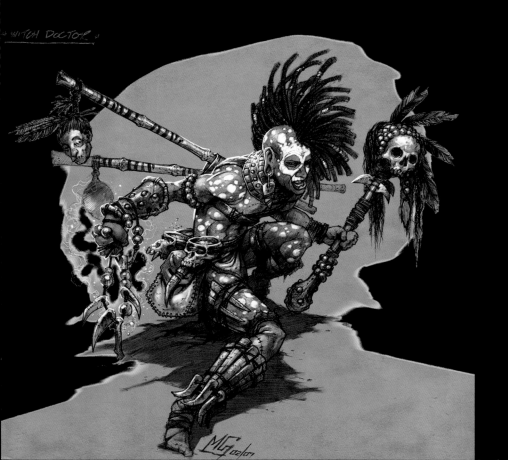

WITCH DOCTOR

"The witch doctor was a character that came about from a teamwide exploration—everyone contributed a concept, and we narrowed down from there. People were really involved in this one."

—*Christian Lichtner*

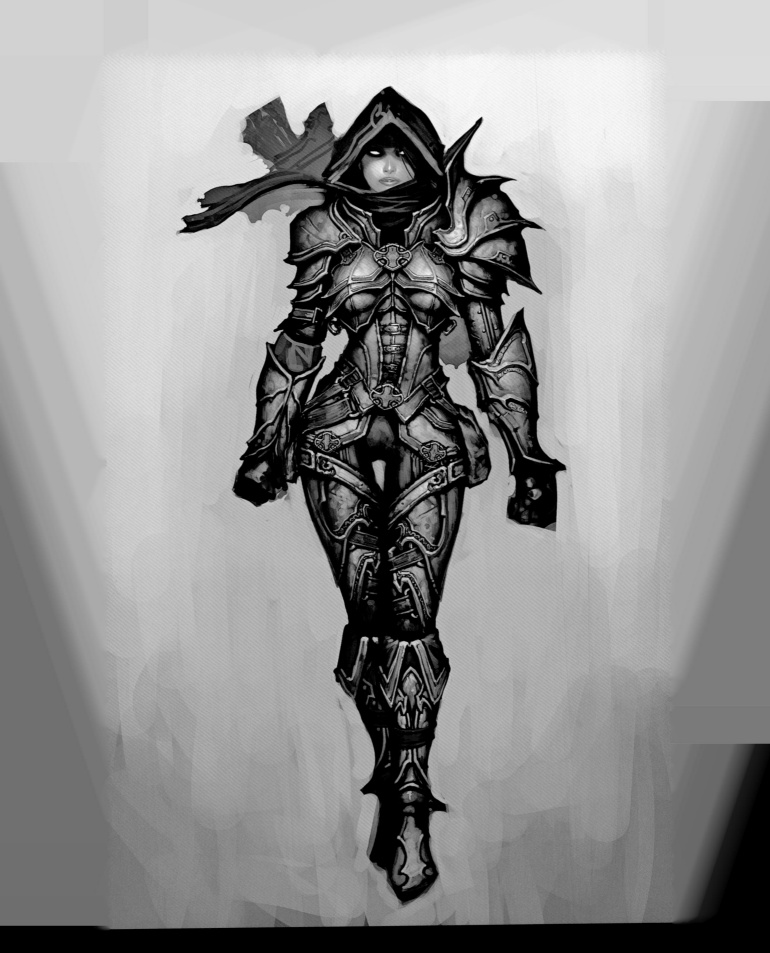

"This is the definitive. I could care less about the super-armored form. That's the demon hunter, right there. No weapon in her hand and I still get what she is."

—*Chris Metzen*

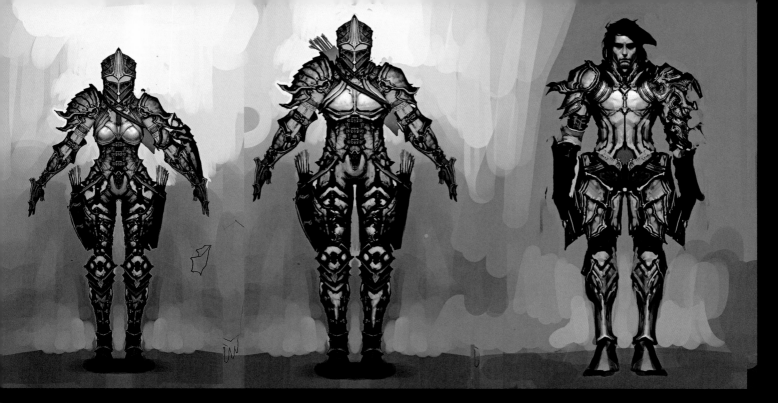

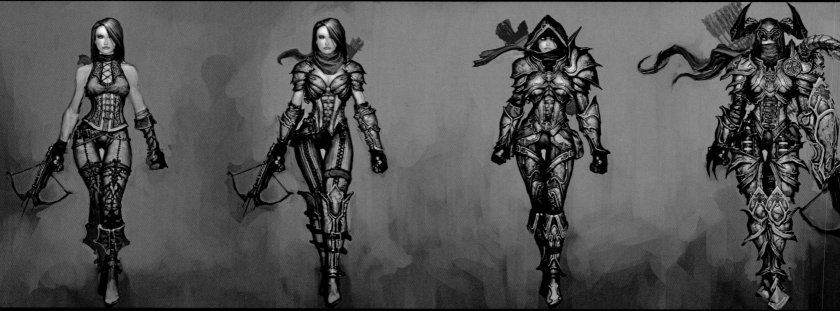

"Demon hunter? This doesn't look
like Illidan! Hehe."
—*Samwise Didier*

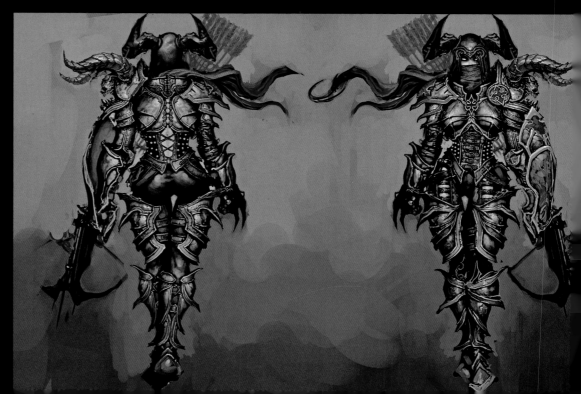

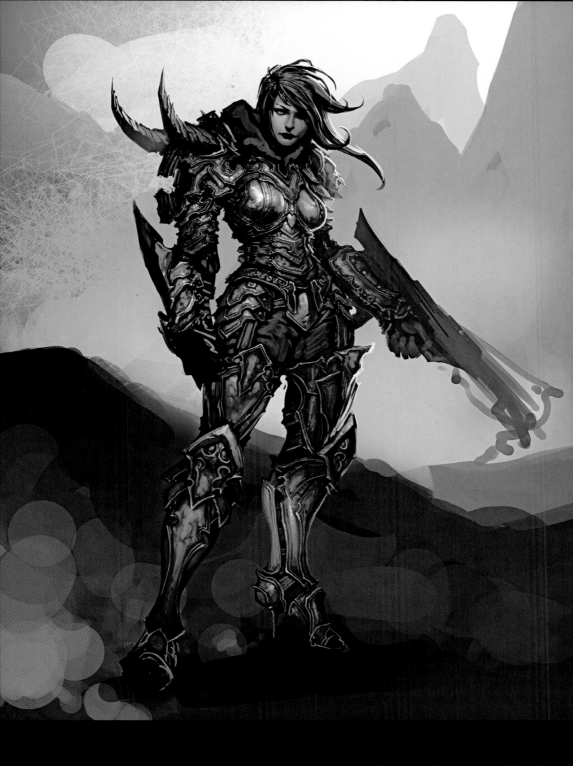

NICK: Josh Tallman's female demon hunter. This is when Josh was really spinning his epic vision of what this world needed to look like. When you're dealing with females in these spaces, it's always difficult because everybody has a different idea of what they want to see. And I think Josh was able to bring everybody's ideas and wants and needs under one roof. The level of execution and detail and understanding of this character was awesome. It was so strong it ended up making it onto our box cover.

HRIS M.: The inside sleeve of the box set. The demon hunter from what I remember was a tough nut to crack. Some of the other classes, like the witch doctor, are defined by the big masks, or the barbarians, just this hulking thing with tattoos. The demon hunter was a much subtler visual class to capture because it was really about these crossbows and what type of armor do you use—Do you go super evil? Do you go with a more crusading kind of character? It was a particularly difficult visual to finalize. When the guys finally found it, with the mix between the crossbows and the hooded look and the Van Helsing–esque scarf trailing off the back, they really found it.

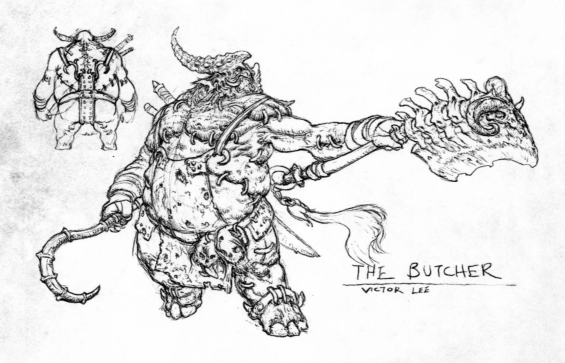

THE BUTCHER
VICTOR LEE

"To get the opportunity to work with Brom was epic. Brom had done artwork for *Diablo II* and covers for *Diablo II*. Those images were very high quality, but they weren't necessarily indicative of his style. There were so many demands on the cover, in terms of marketing and how we needed the illustration to go. When we finally got Brom into the studio, he actually sat for long stretches of time with our art staff and just started pounding out classic Brom—visions based on the Butcher, King Leoric. He had the Skeleton King, even Tyrael. He started hitting some of these very iconic Diablo characters but in his unique visual style. We were all thrilled that one of these titans we had come up venerating was playing ball on our goofy little field. It was a great honor."

—*Chris Metzen*

"I was a huge Brom fan since his old Dungeons and Dragons days. Later on he did our Diablo and WoW covers for us. Next thing I know he was here with us at Blizzard working on Diablo stuff, going to lunch with us, talking about the old TSR days. How frickin' cool is that?"

—*Samwise Didier*

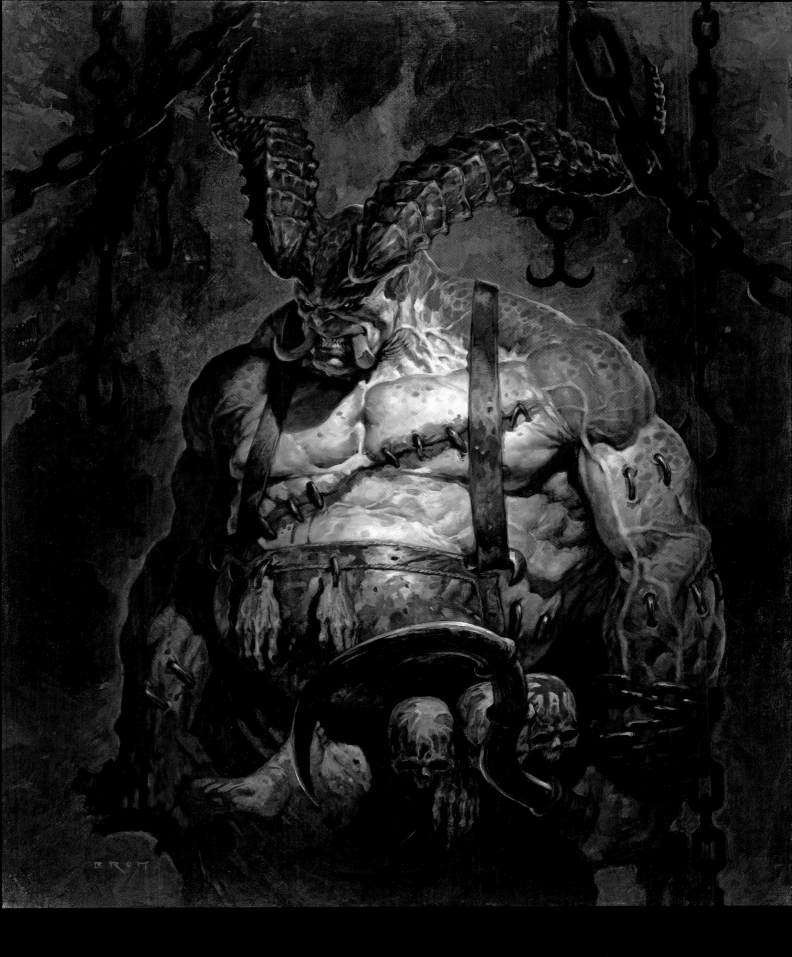

"This is my favorite Brom Diablo piece. It's hard to pick one,
but when pressed, a lot of people on the team agree."
—*Christian Lichtner*

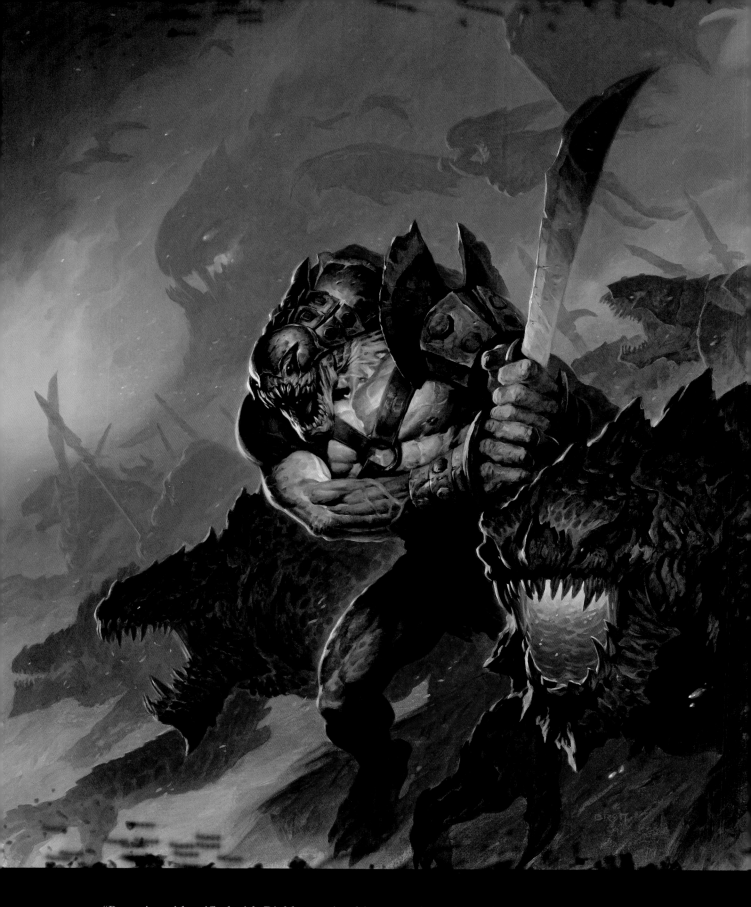

"Brom is so identified with Diablo, getting him to work on this with us was a pleasure. We all nerded out when we found out he was going to be doing his paintings, traditionally, in oil, here in the studio, and a bunch of us snuck over to bother him while he was working."

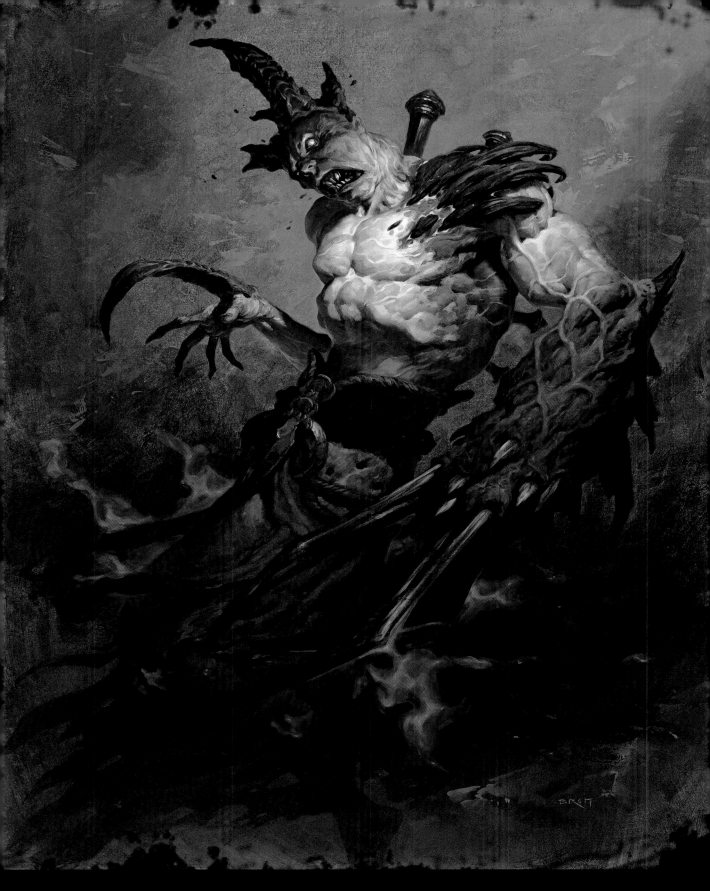

"We're traditionally a digital house and Brom uses oils. To see his type of art style being executed on our grounds was such an honor. I remember walking in, and it was this awkward moment where I wanted to pay him respect, and he wanted to pay me respect, and we kind of almost got to this space where we were bowing at each other. And all I wanted to do was just look at his work! After all the praise and compliments, I peeked around his canvas and I saw him working on this image, and I was like, 'Oh, my God, what an incredible image.' The thing that has always been amazing for me is to see how this stuff translated between

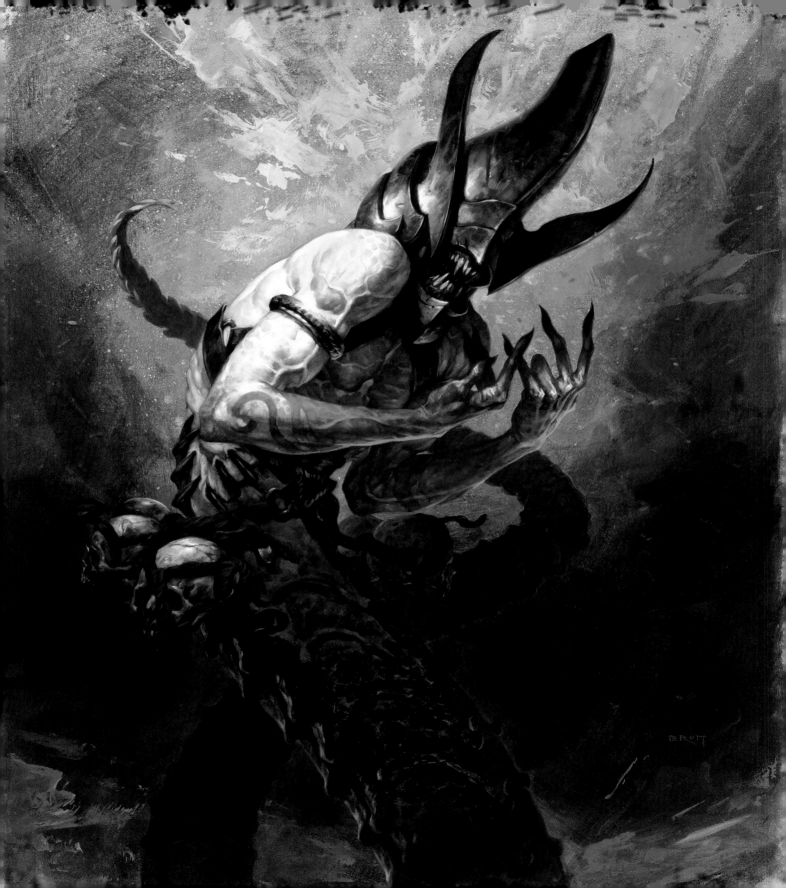

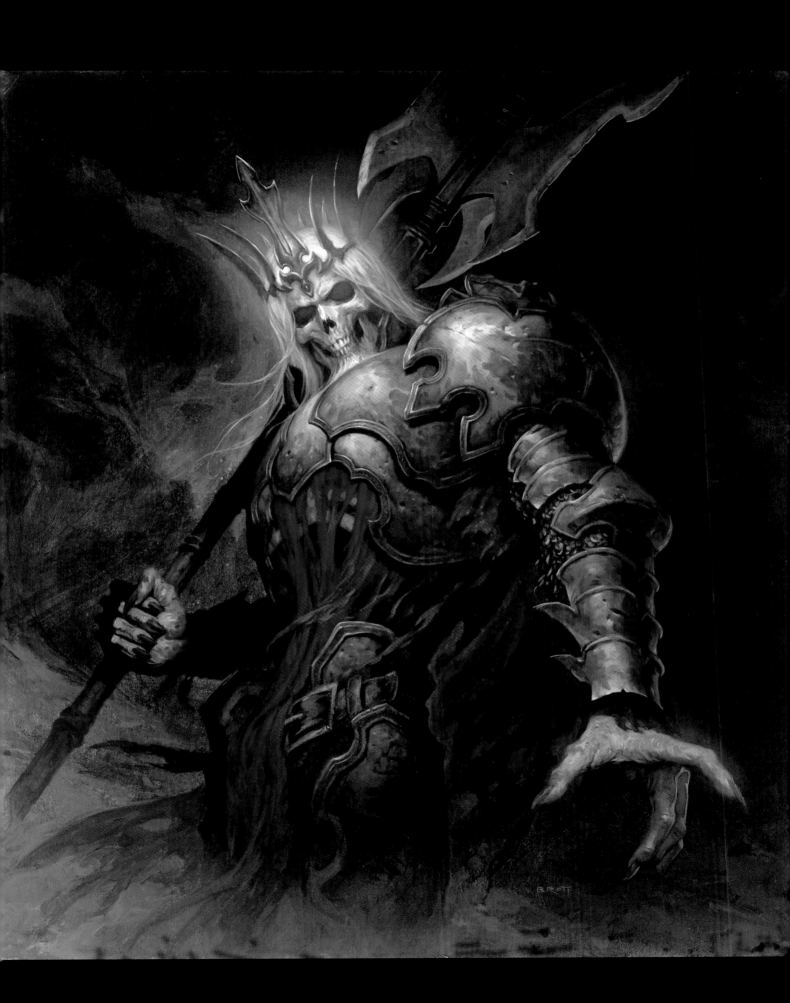

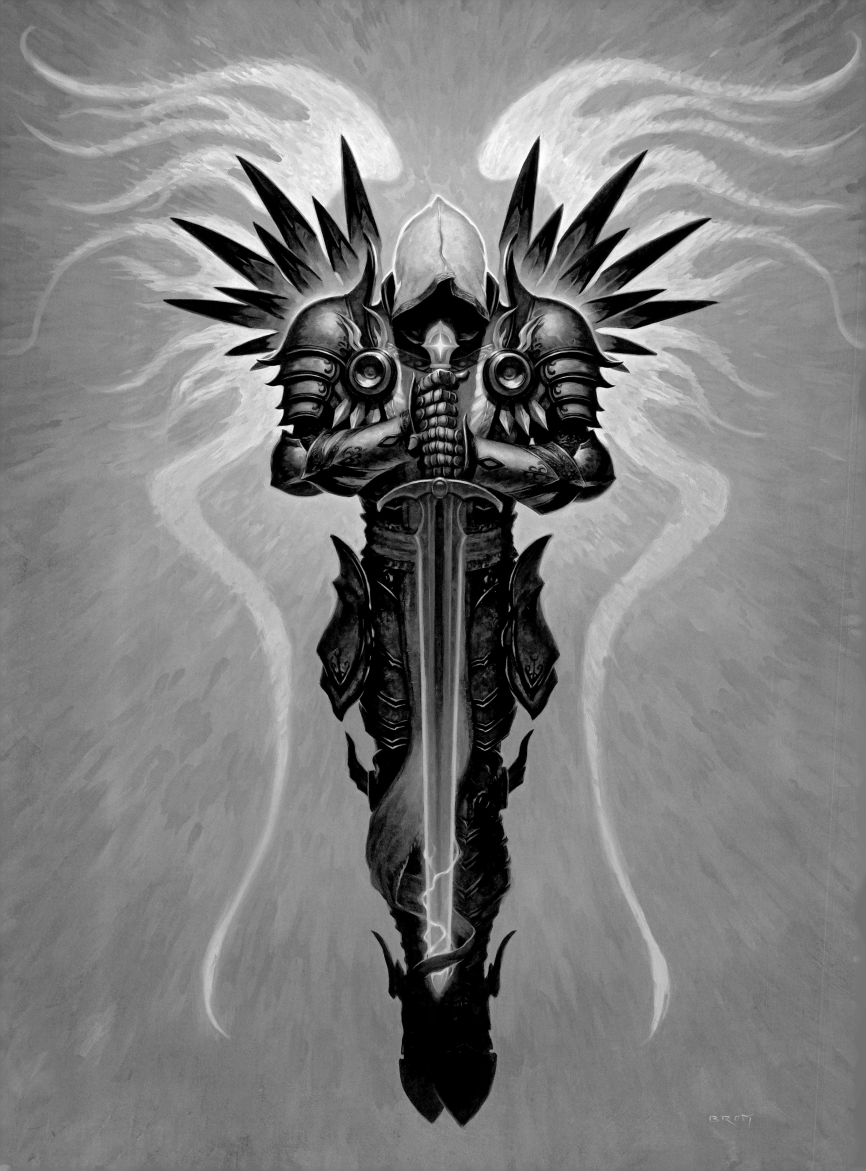

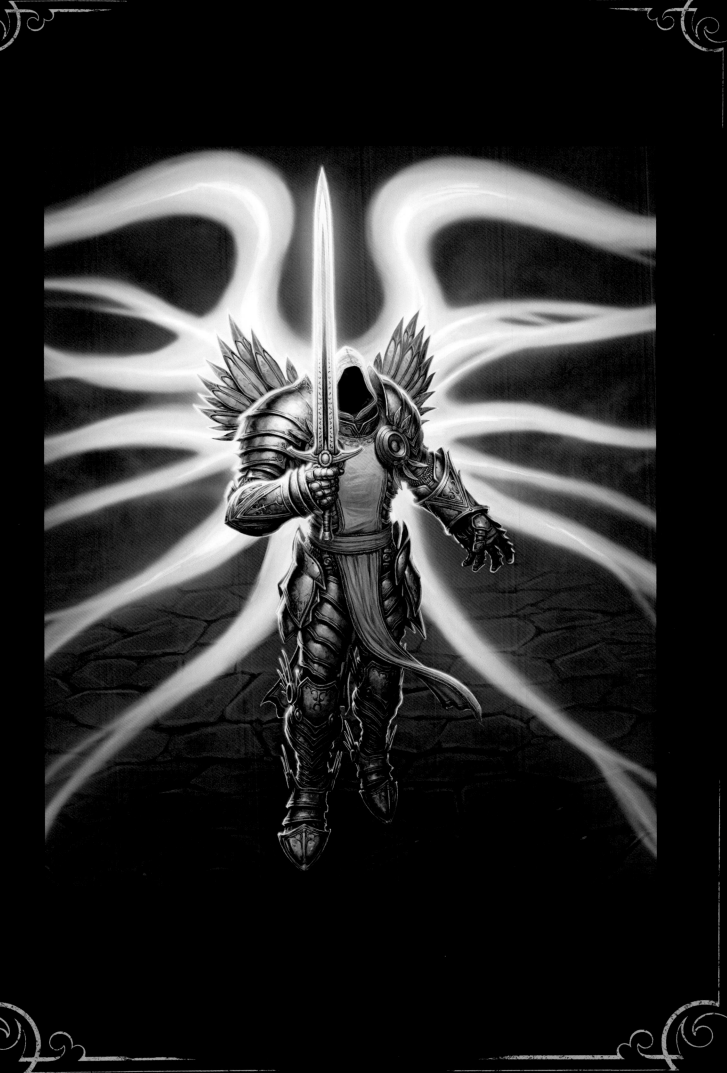

INTERIOR
SILVER SPIRE

"We knew we wanted to attack the High Heavens, and these are some of the first images that Vic started putting out. That's an old image for *Diablo III* [above]. It's one of the first environmental concepts. And to this day when you look at those tilesets in the finished game, all these years later, that image is still embedded into every stone that was laid to create the illusion of that city. It's a definitive piece of art that absolutely shaped the vision of not only this game, but the franchise."

—*Chris Metzen*

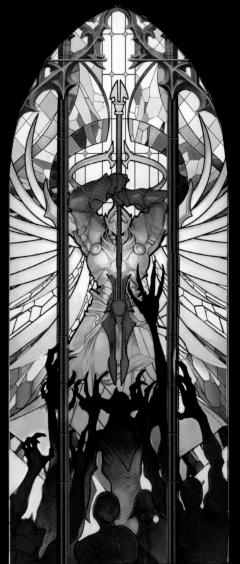

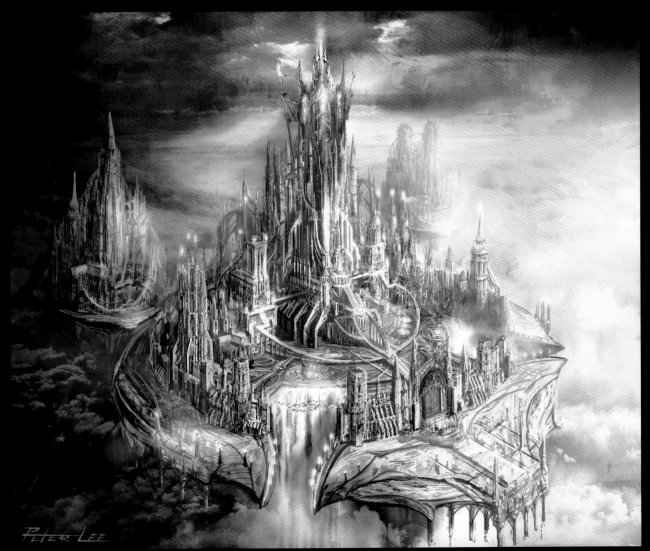

Peter Lee

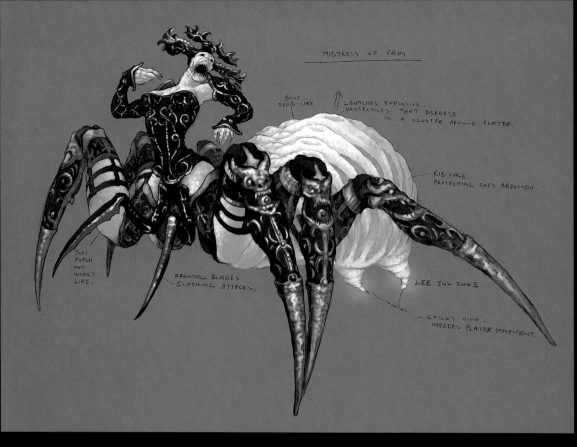

MISTRESS OF PAIN

BONE SPIKE-LIKE

LAUNCHES EXPLOSIVE PROJECTILES THAT DISPERSE IN A CLUSTER AROUND PLAYER.

RIB CAGE PROTECTING SOFT ABDOMEN.

LEE JUL 2003

SOFT FLESH NOT INSECT LIKE.

FRONTAL BLADES SLASHING ATTACKS.

STICKY SILK. IMPEDES PLAYER MOVEMENT.

"Really great design. Looking at the gilding of the design and the level of detail, it doesn't look like any culture that has ever existed on Earth. That's what I mean about Vic, he just taps into motifs and hooks that are ultimately convincing but just utterly his own."

—*Chris Metzen*

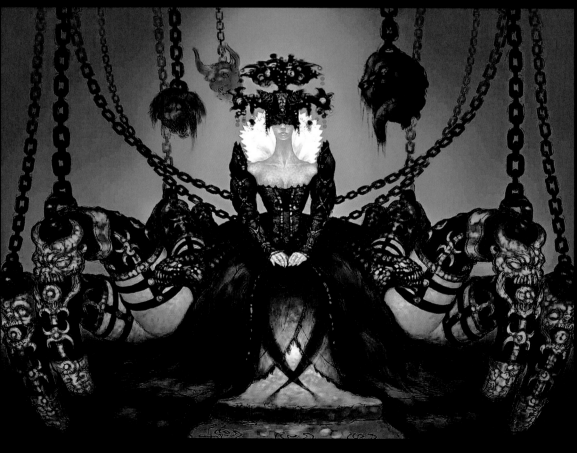

"Mistress of Pain is one of our all-time team favorite characters. We originally cut her for scheduling reasons, but the concept art was up on the website and getting a strong reaction with fans. When we went to BlizzCon, this very talented cosplayer had created an amazing costume of her, and we came back and changed the game production schedule to make sure we included her in the game."

—*Christian Lichtner*

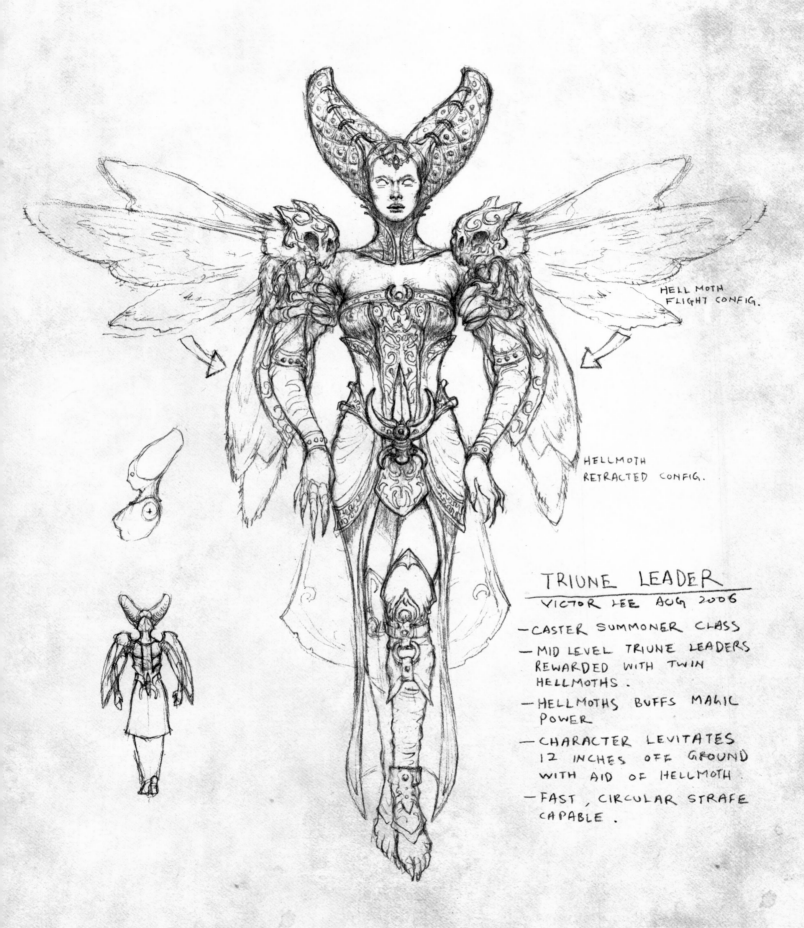

HELL MOTH
FLIGHT CONFIG.

HELLMOTH
RETRACTED CONFIG.

TRIUNE LEADER
VICTOR LEE AUG 2006

- CASTER SUMMONER CLASS
- MID LEVEL TRIUNE LEADERS REWARDED WITH TWIN HELLMOTHS.
- HELLMOTHS BUFFS MAGIC POWER
- CHARACTER LEVITATES 12 INCHES OFF GROUND WITH AID OF HELLMOTH.
- FAST, CIRCULAR STRAFE CAPABLE.

"Having moths attached to your shoulders is cool as hell. It may not be initially apparent that she is actually being suspended by these things, but she is, and it gives her this strange beauty."

—*Christian Lichtner*

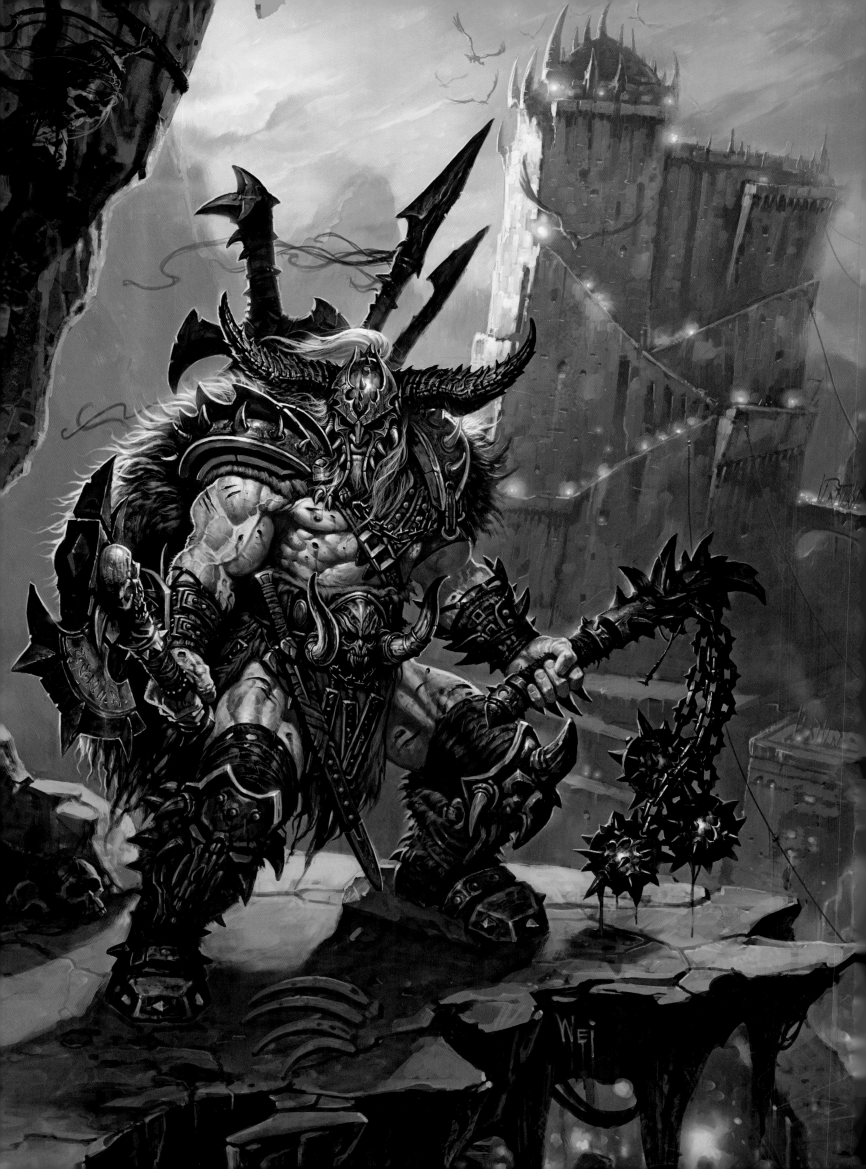

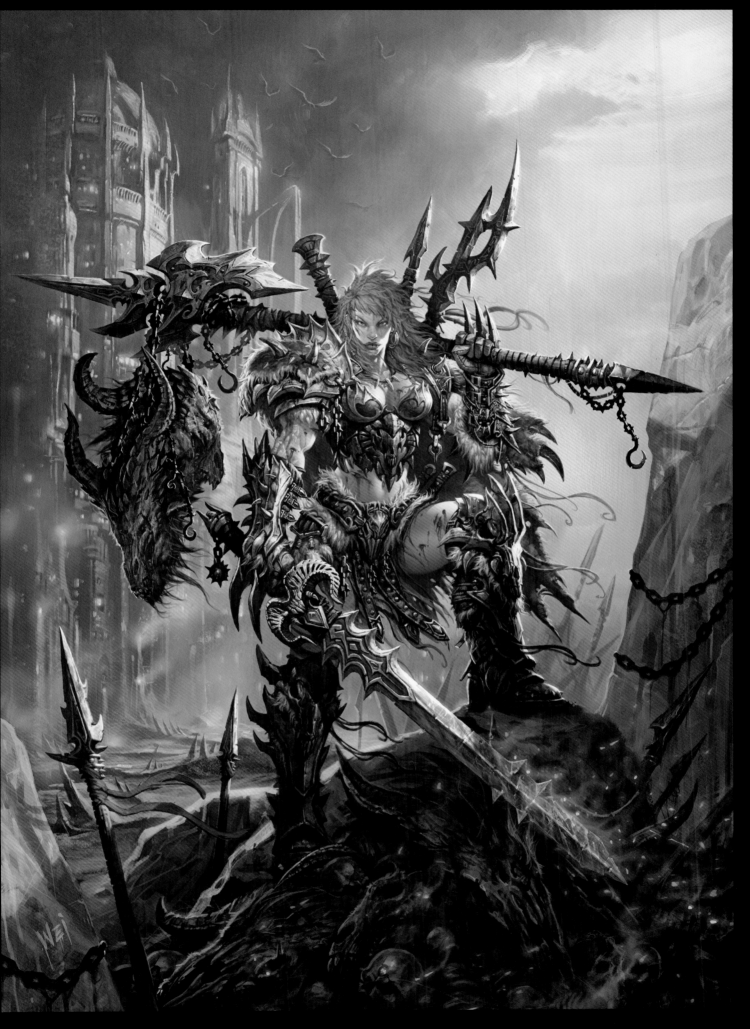

"My favorite *Diablo III* character hands down.
A Blizzard version of Red Sonja."
—*Samwise Didier*

"Oh my God." —*Nick Carpenter*

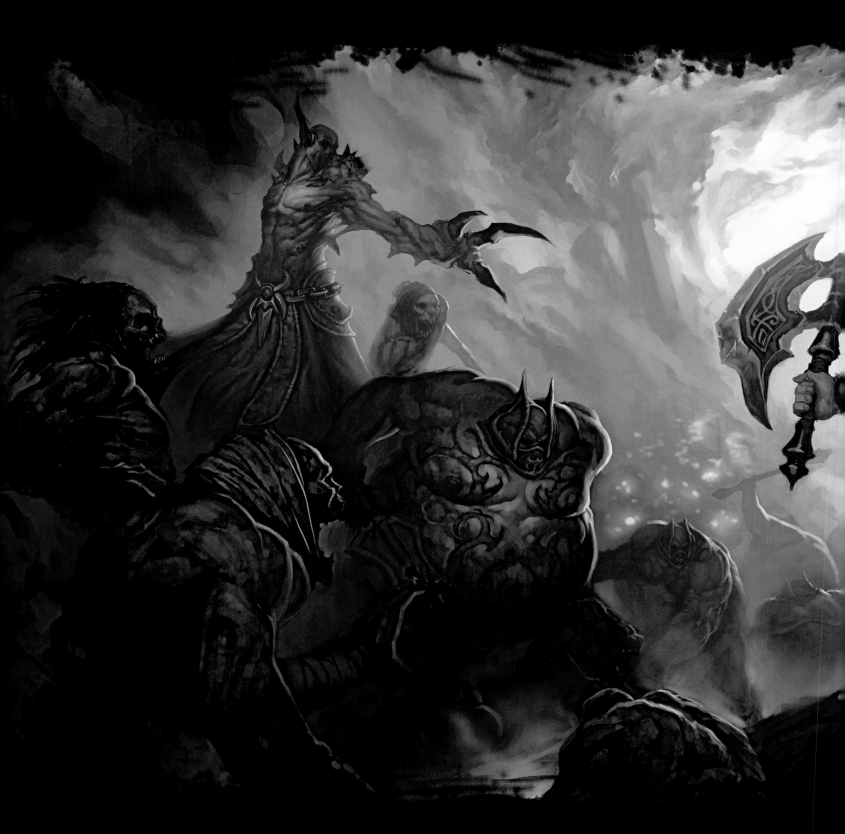

"For anyone who has played *God of War*, you'll understand that it's just hyperkinetic. Apart from the puzzles, it just feels furious and raging the entire time—moving through that game is a hyper-mega and violent process. We wanted to bring some of that sensibility into Diablo, which is ridiculous given that it's just a point-and-click inter-face. But we wanted to make each of these classes feel mighty, so that they're just ripping up the screen. This type of imagery very early on absolutely laid down the pepper and just inspired everyone. Whether you're working on the tilesets or whether you're working on class design, whether you're working on character design, you just wanted to chase down that mega-level, rage thing and make sure that everything felt like it was over the top."

—*Chris Metzen*

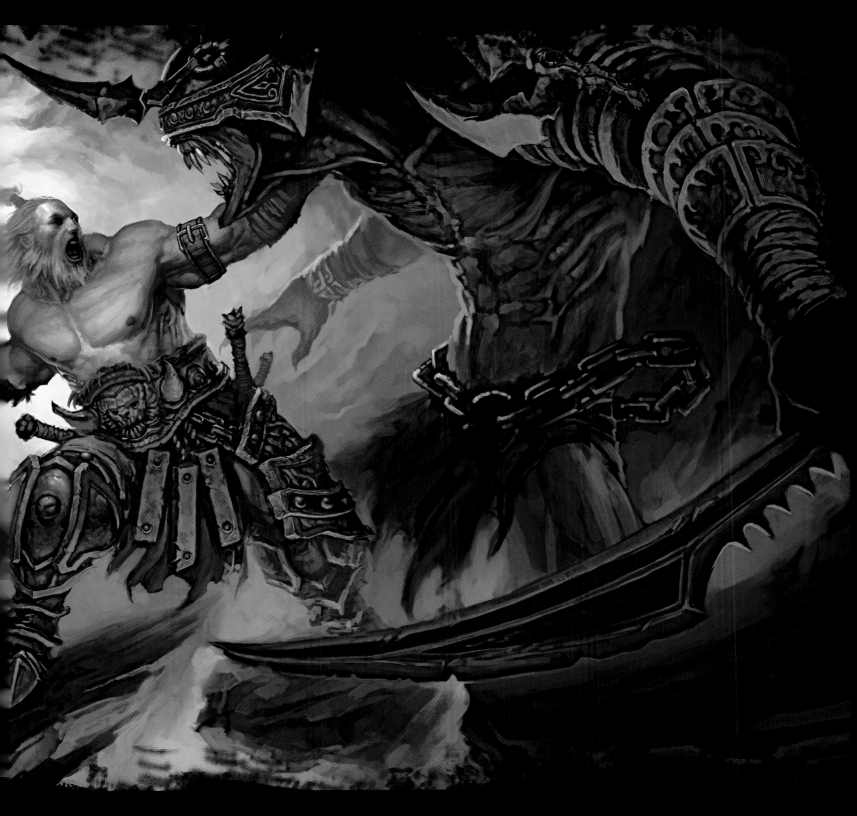

"I think the cool thing about images like this for me is that when you see them, it transports you somewhere and you cannot wait to kick ass in the game. When this dropped, I was like, 'Oh, my God, I know who I'm gonna be first!'"

—*Nick Carpenter*

"One of my favorite Josh Tallman pieces. It's epic, it's the right mix of realism and stylization, and it's got the barb-killing demons. It feels like something painted two hundred years ago. It's telling an ancient story."

—*Christian Lichtner*

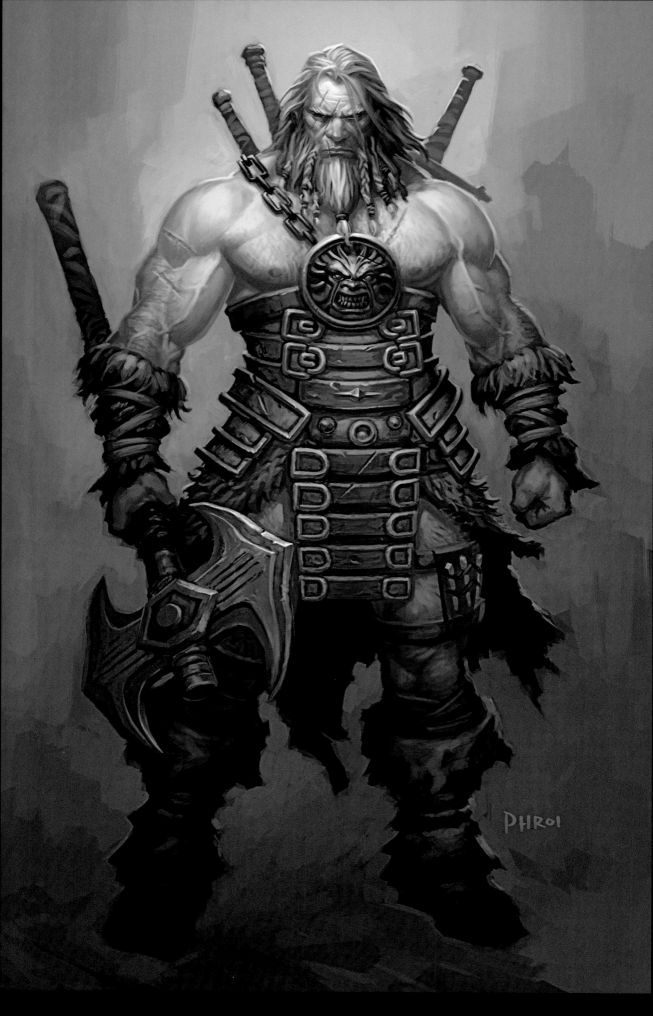

"I've come to the conclusion that Phroi must have been a barbarian in a former life. He loves
drawing these characters more than anyone I know. And he does an amazing job at it!"
—*Christian Lichtner*

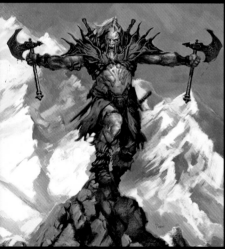

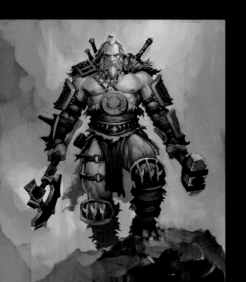

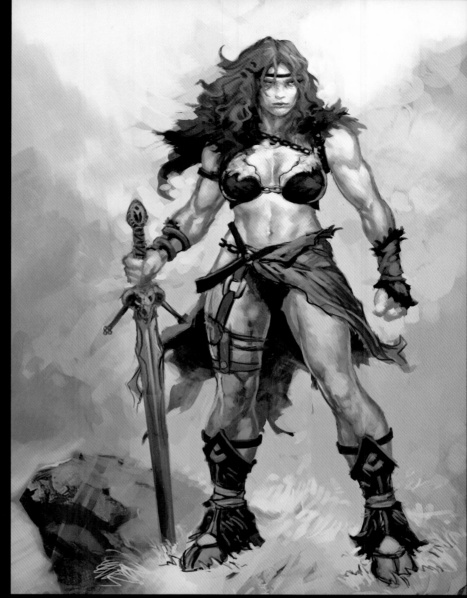

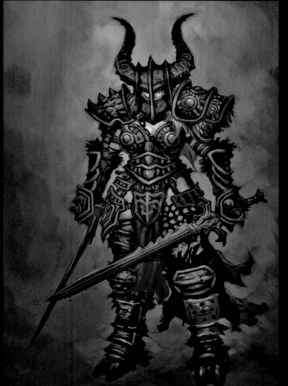

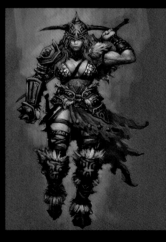

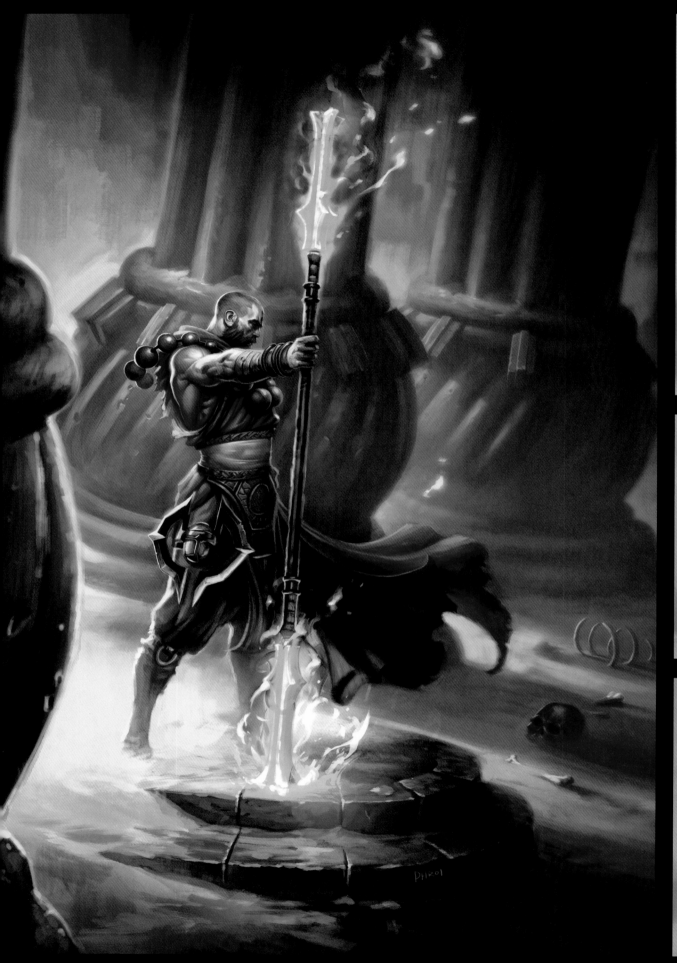
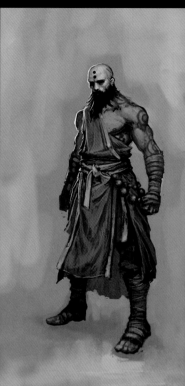
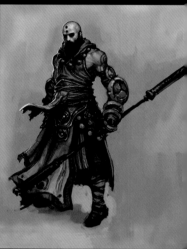
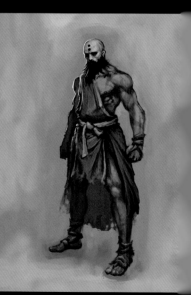

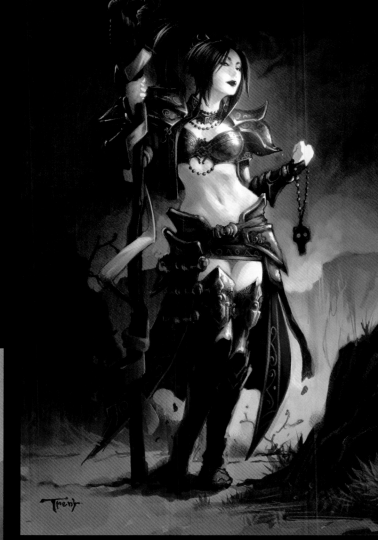

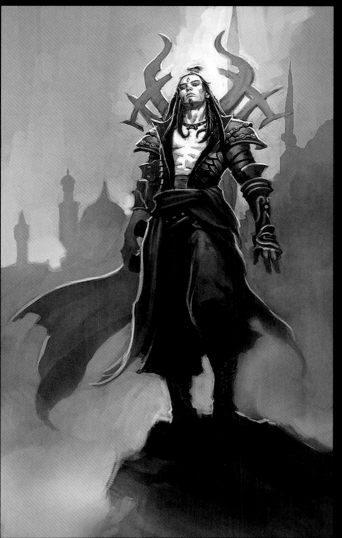

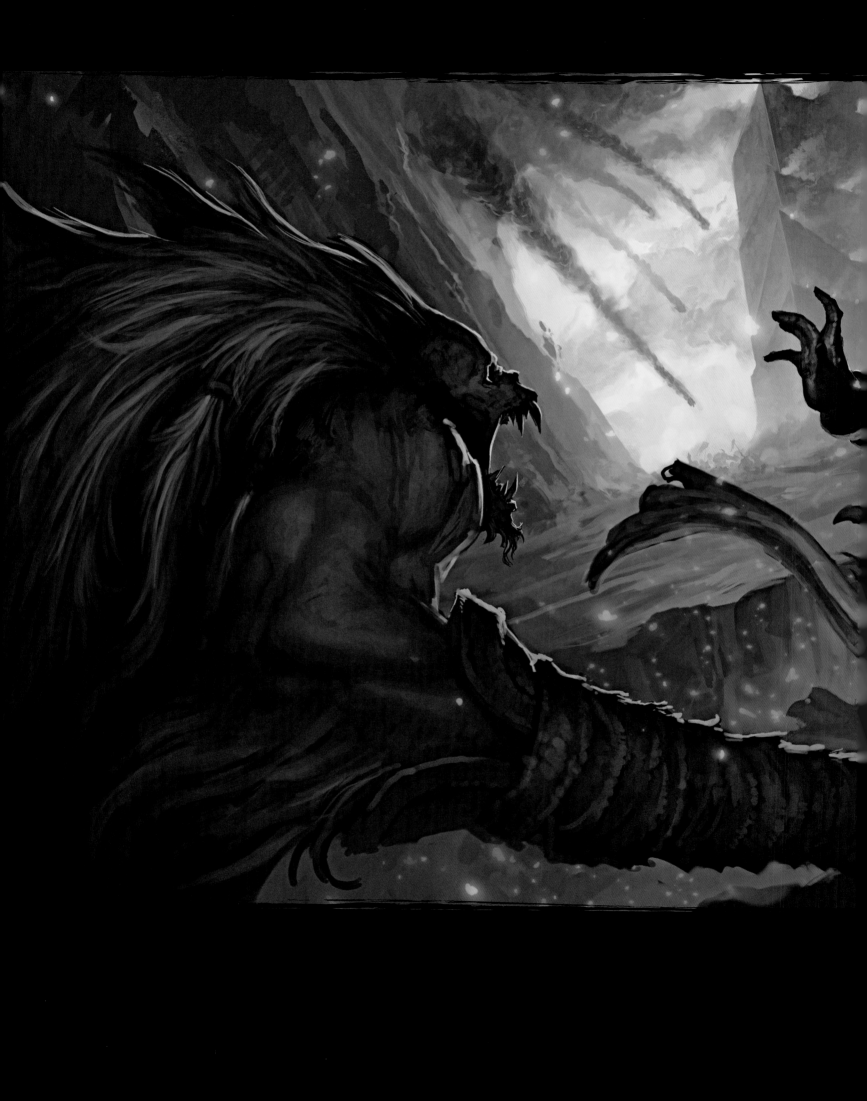

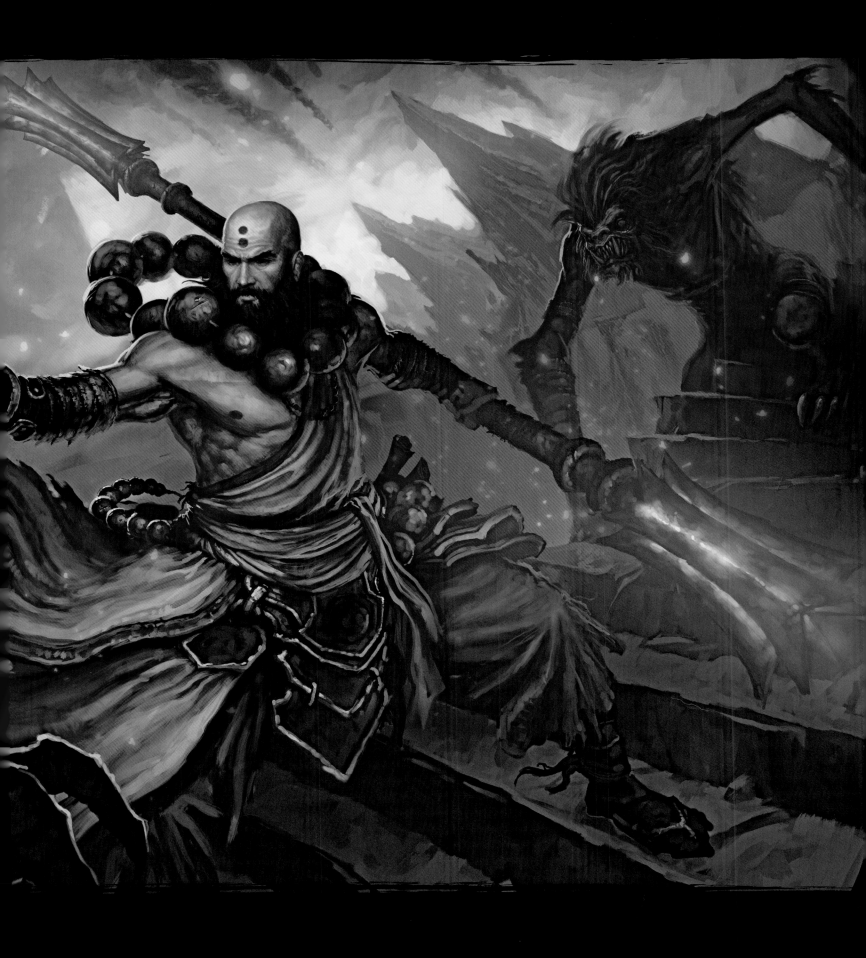

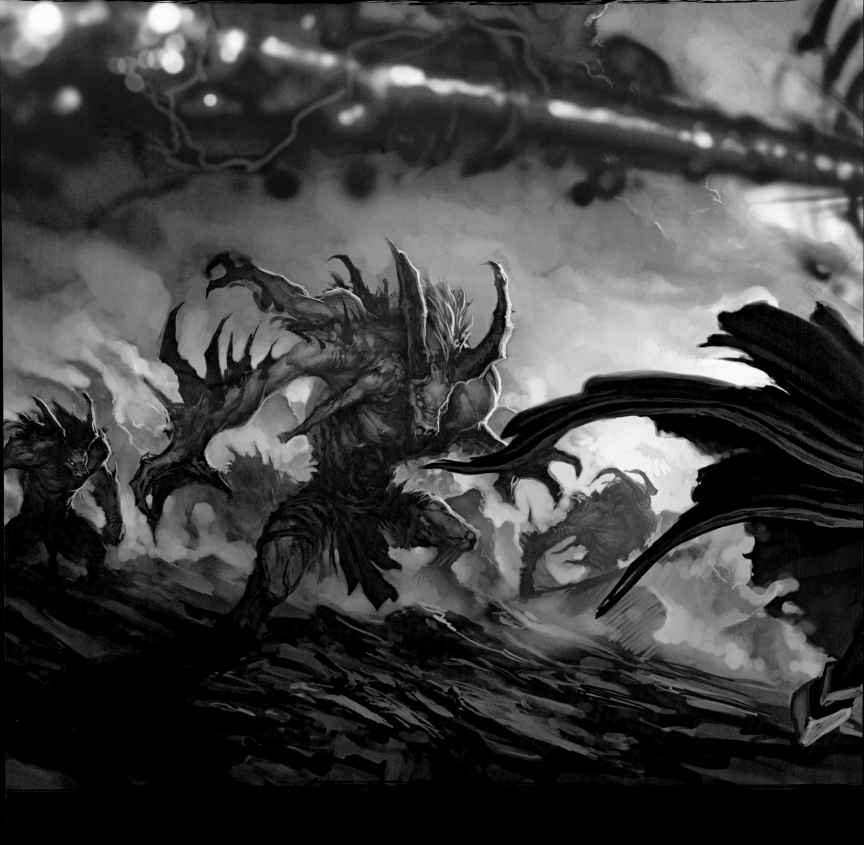

"Every time we did one of these class pieces, Josh found something that really nailed the flavor
of the class and helped the rest of the team hone in on the character of that hero."

—Christian Lichtner

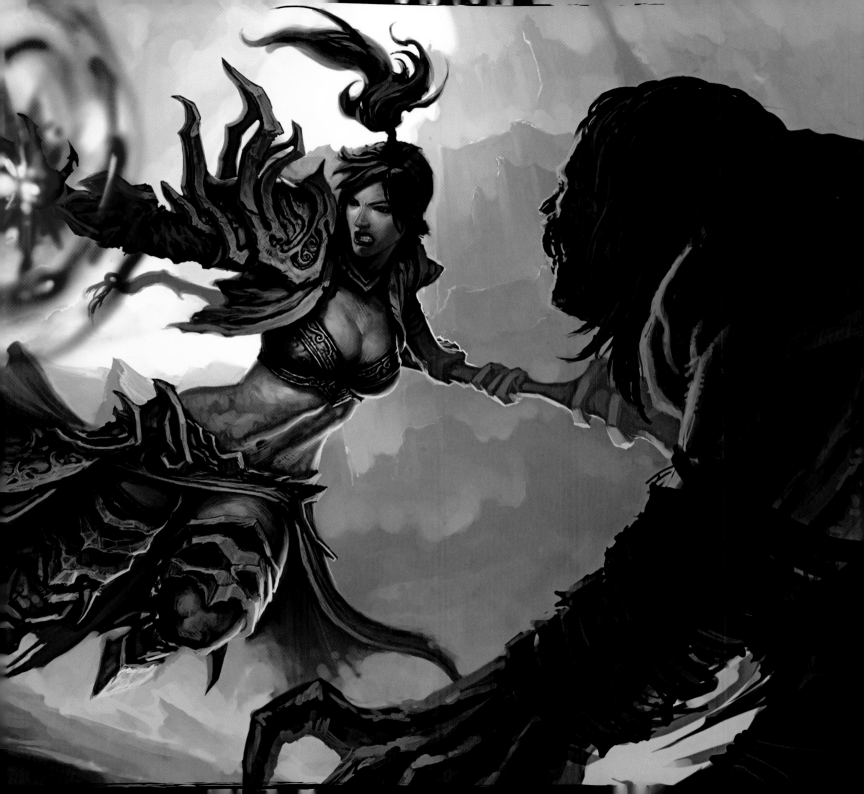

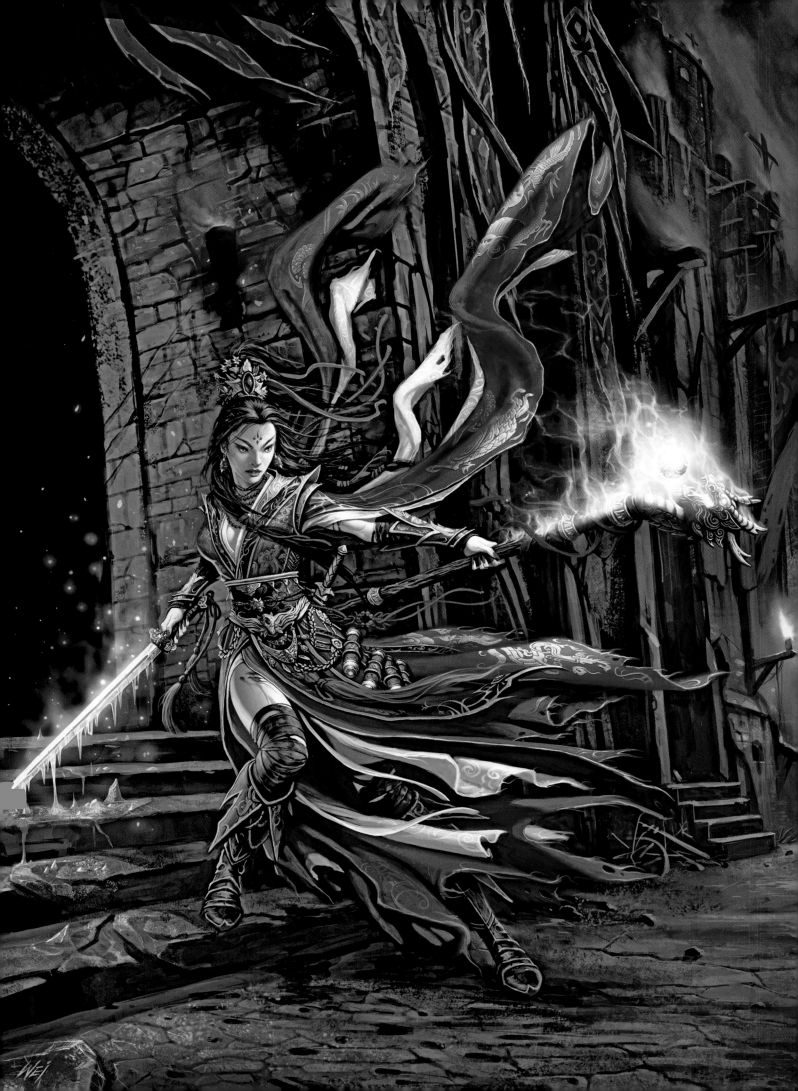

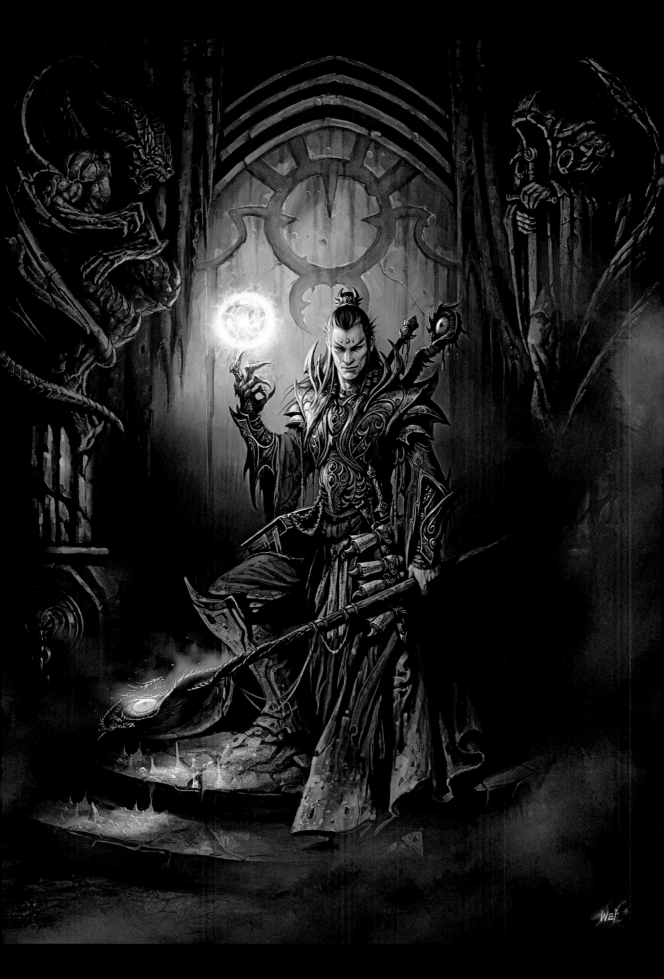

NICK: These images are just so amazing. Wei's understanding of
 movement, composition, color, and, of course, detail.

CHRIS M.: On the male version, I love the frost at his feet. Just the
 master of the elements.

NICK: The story.

CHRIS M.: Yeah, he's telling a story.

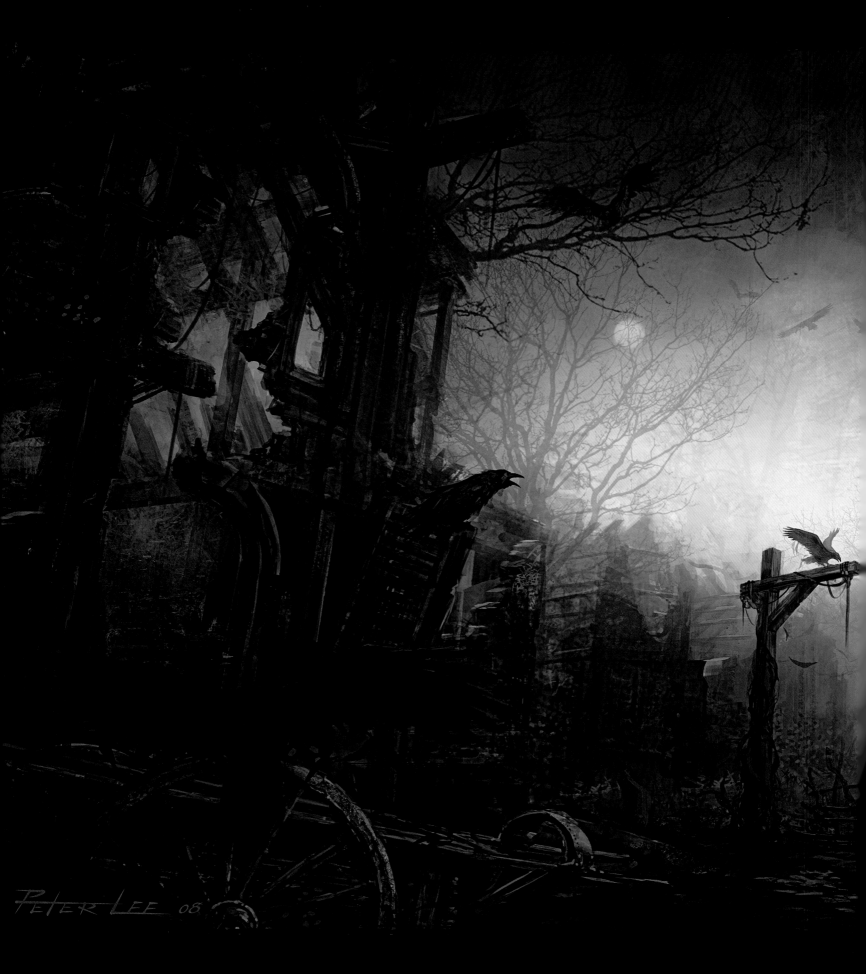

"This is one of my all-time favorite pictures of Peter Lee's. I think a lot of it is just because it holds so true to the original idea of what Diablo is. Yeah. It starts off dark and bleak, and yet the world of Diablo expands into these amazing spaces, but something about this image is just so core to the IP for me."

—*Nick Carpenter*

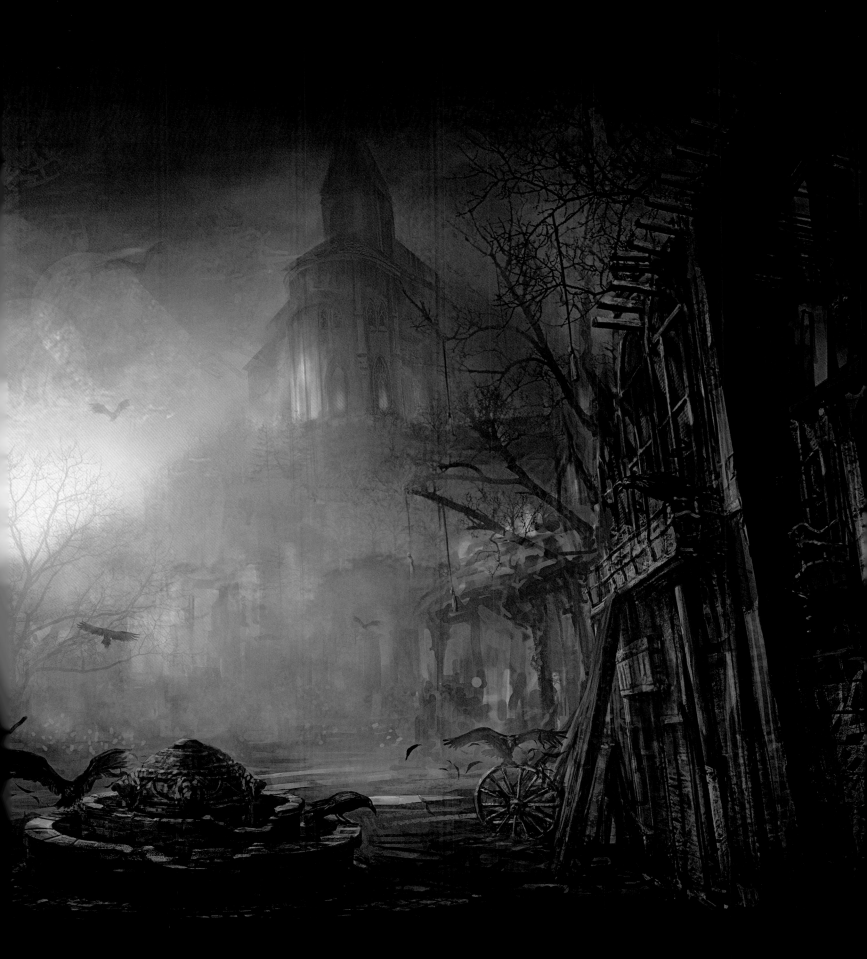

"It's a very anchoring image. I understand the loss and the heaviness and the desolation of
Tristram, with the crows on the gibbet. It puts me right into the thick of the story."

—*Chris Metzen*

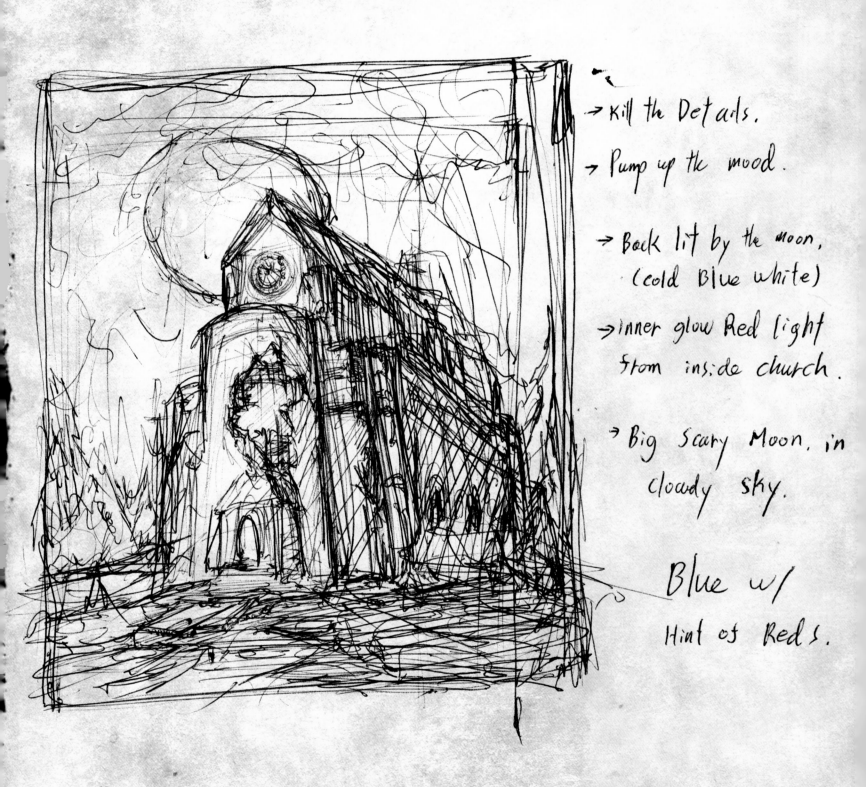

→ Kill th Details.

→ Pump up the mood.

→ Back lit by the moon, (cold Blue white)

→ inner glow Red light from inside church.

→ Big Scary Moon, in cloudy sky.

Blue w/ Hint of Reds.

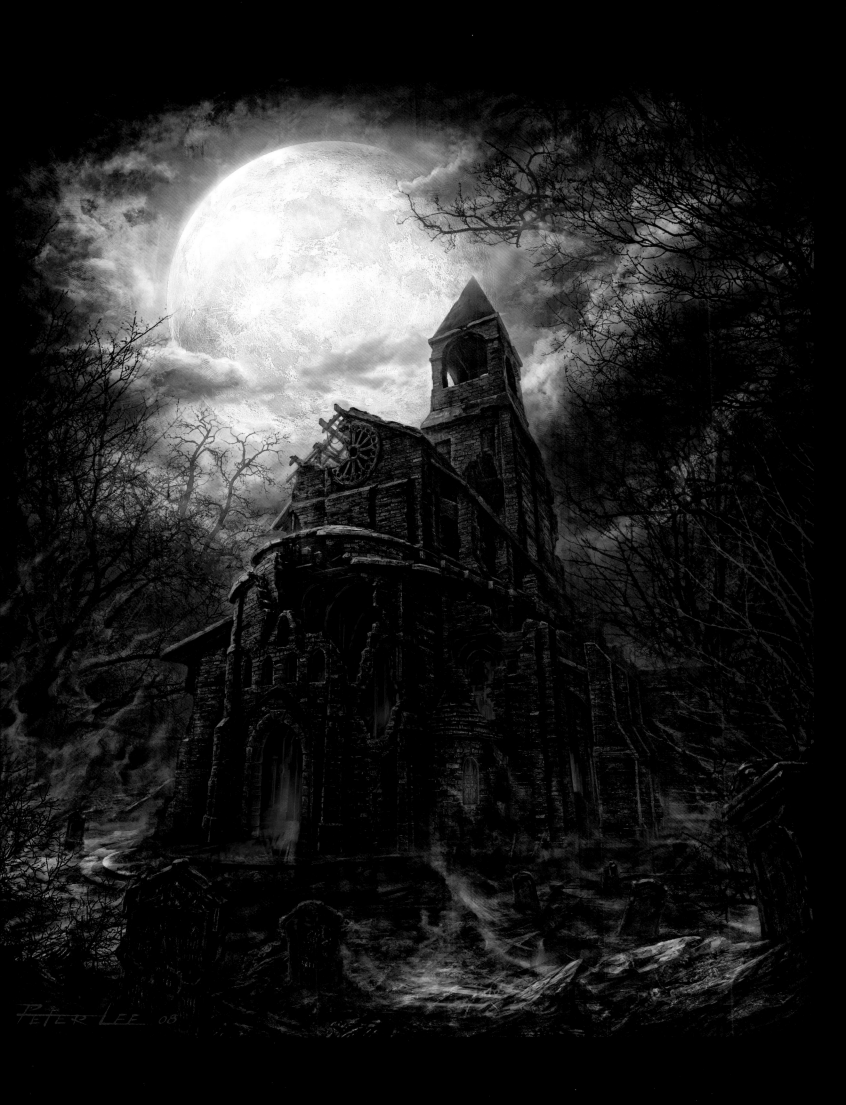

"It took a lot of iterations to get Diablo to the point where he was being properly represented. Vic invented the mouth shoulders in one of the early iterations, and the idea stayed with Diablo as he evolved, becoming one of the signature design elements of the character."

—*Christian Lichtner*

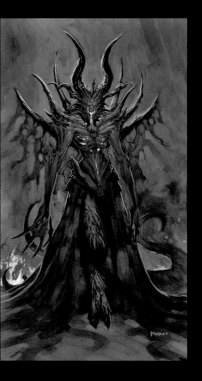

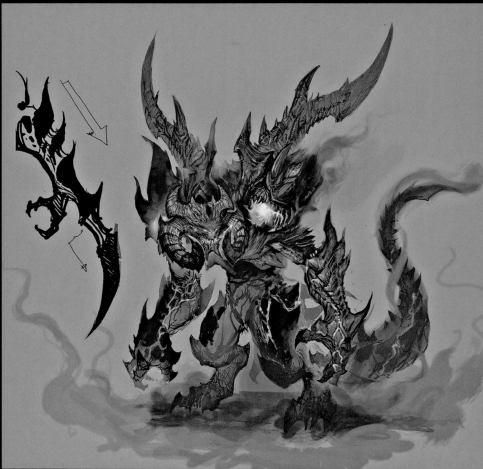

ASSAULT
BEAST-LAND

- ABLE TO STAND
 ON JUST HIND
 LEGS FOR FOUR
 ARM ATTACKS.

- DOWN ON ALL
 LIMBS FOR
 TOWING GREAT
 LOADS.

VIK JUN 2004

"The siegebreaker was one of the first character designs the *Diablo III* team did that started to put the concept into orbit. It brought hyper-proportionate creatures into the mix. It was one of the first big bosses they developed, and it really changed everybody's perspective on how mighty Diablo was shaping up to be."

—Chris Metzen

"An epic sensibility. This [above] was one of the first pieces created and it actually ended up in the game."

—Nick Carpenter

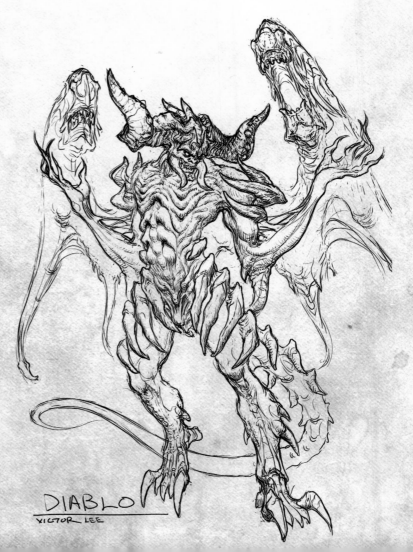

DIABLO
VICTOR LEE

263

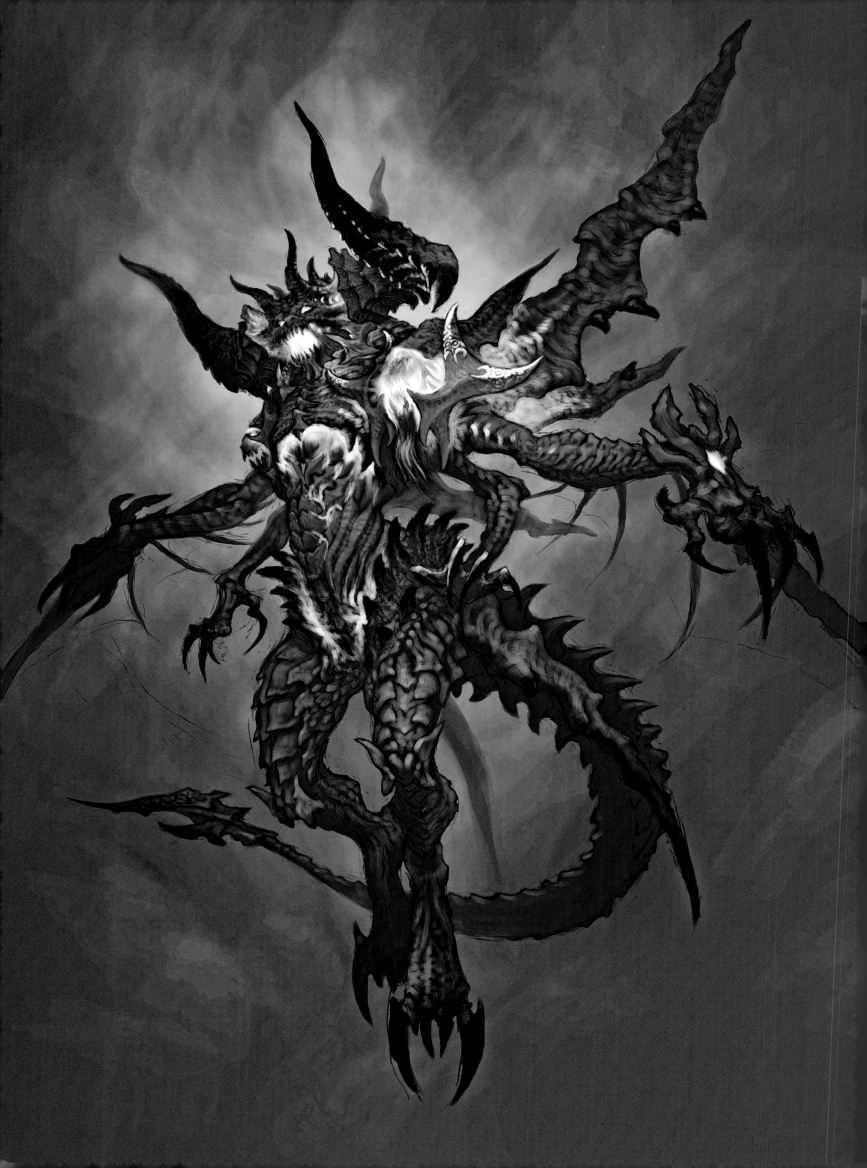

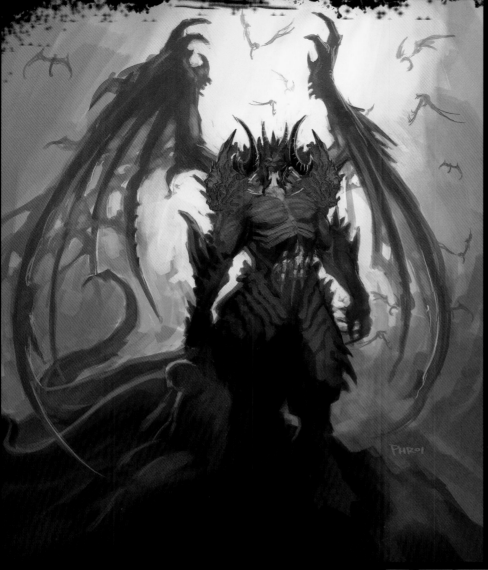

"The redesign was a big, big art process in the course
of *Diablo III*—'What will Diablo look like this time?'
So these were some of the first ones the team did.
It was a mix of Team III and Cinematics guys that
ultimately pounded out the new vision, which was
female. These were core Team III hooks."
—*Chris Metzen*

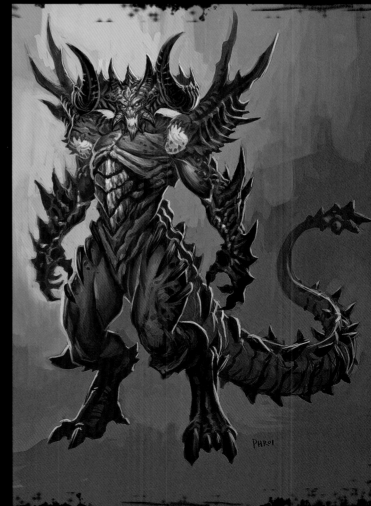

"The thing about these images is that any one of them could hold a game, right? Any one of these designs is amazing on its own terms and could be the boss."

—*Nick Carpenter*

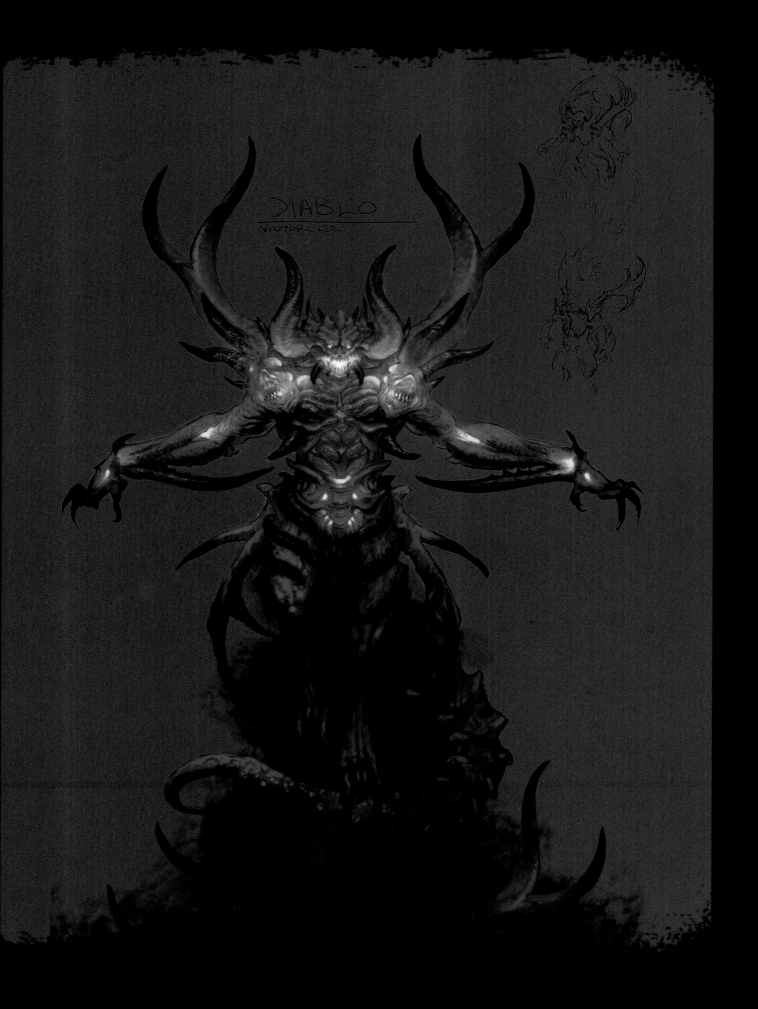

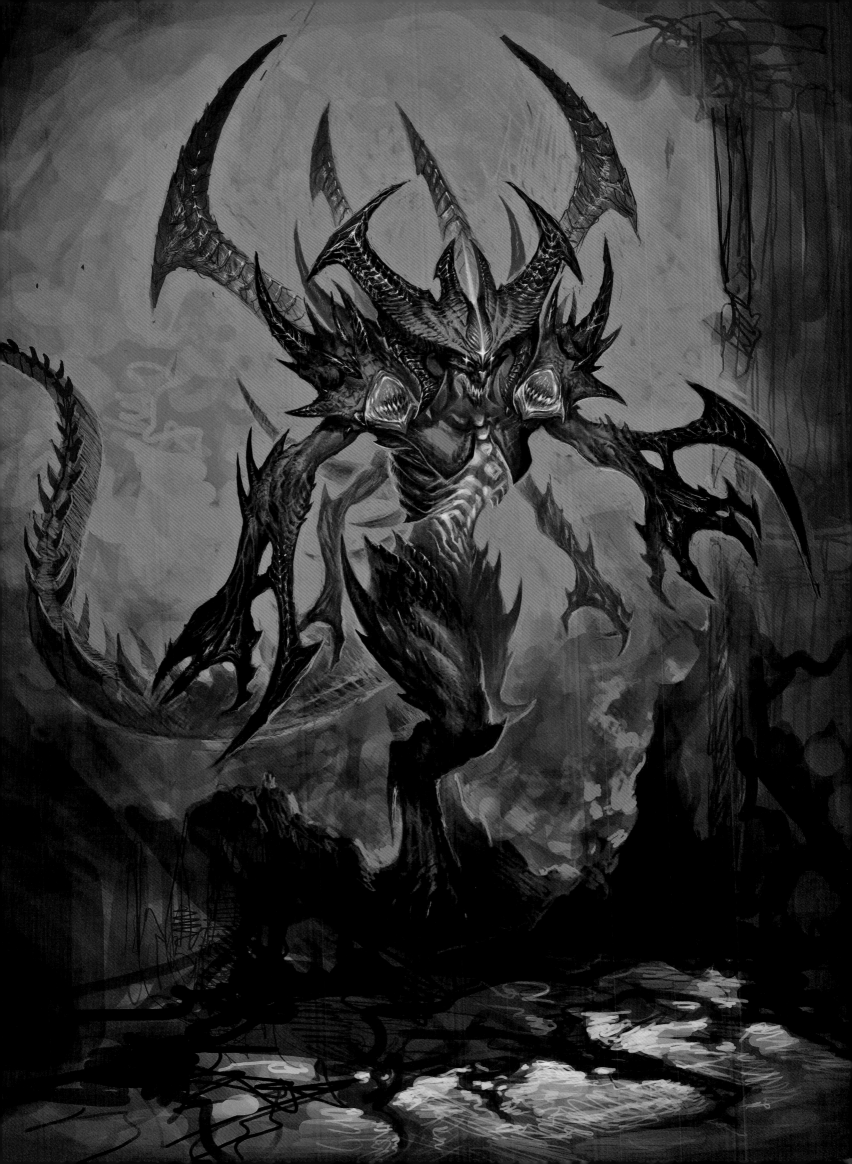

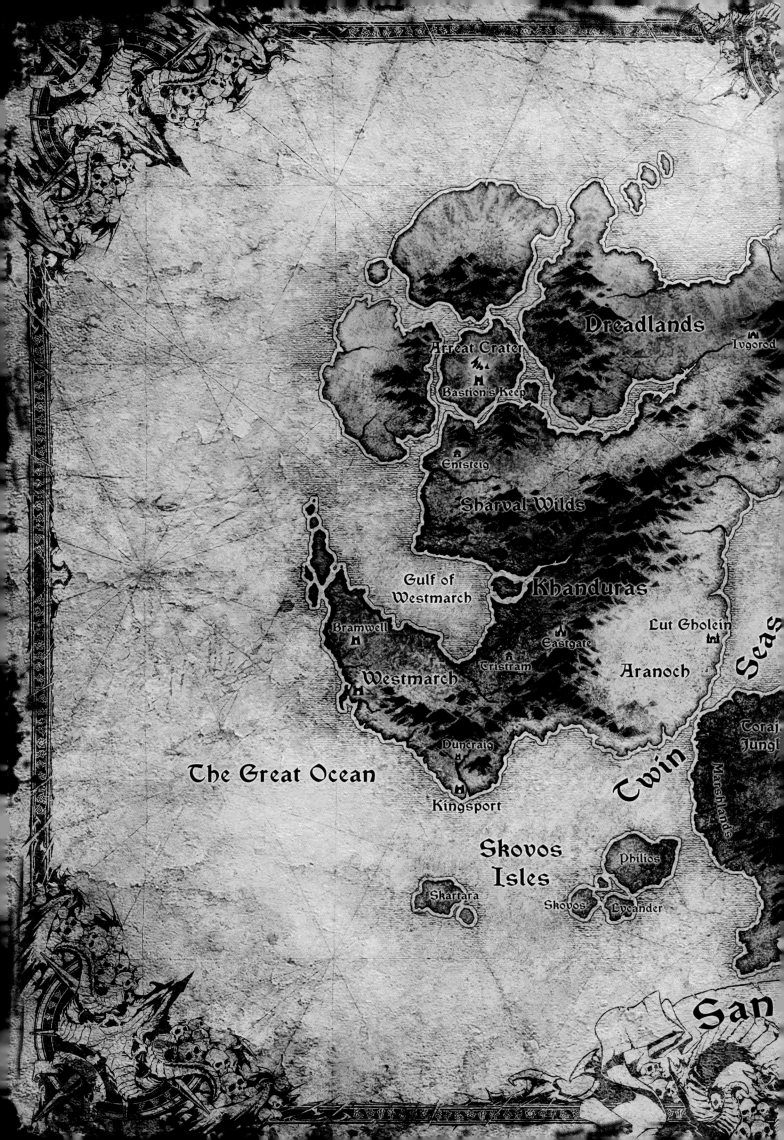

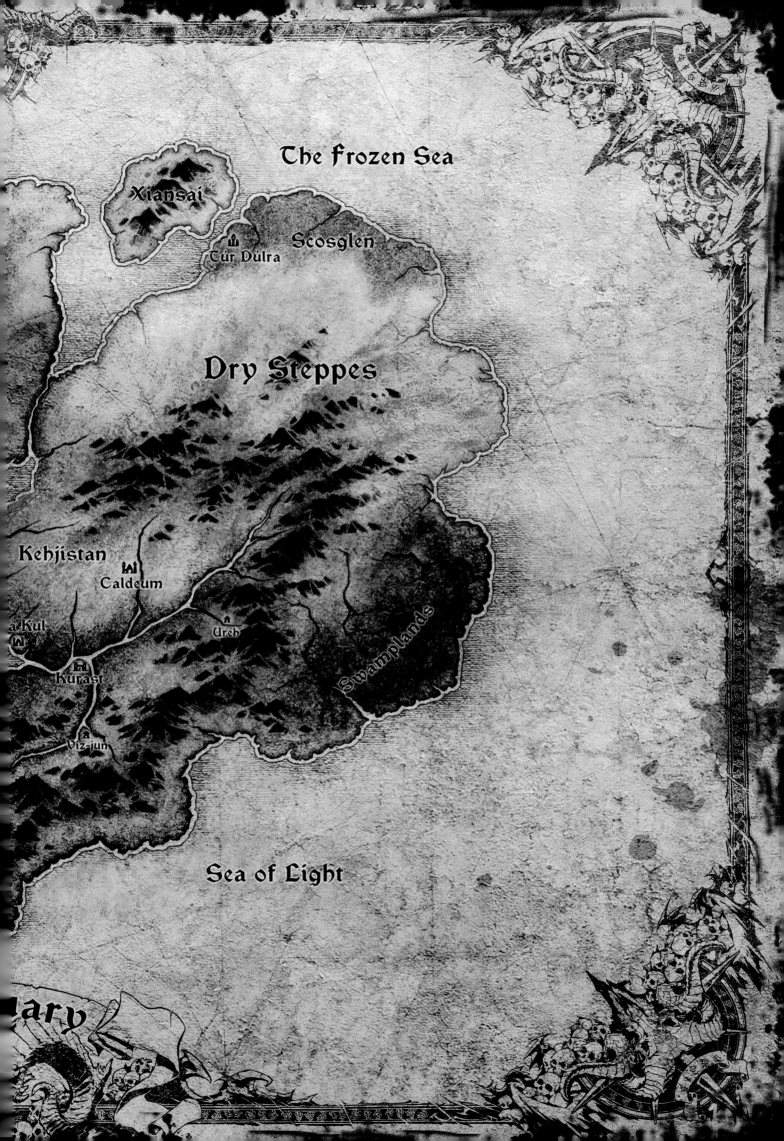

The Frozen Sea

Xiansai

Tur Dulra

Scosglen

Dry Steppes

Kehjistan

Caldeum

a Kul

Ureh

Swamplands

Kurast

Viz-jun

Sea of Light

ary

STARCRAFT®

The StarCraft universe was our take on the classic space opera, delivering a cosmic-scale story fraught with war and deception—and hell, there was even a love story somewhere amid all the carnage. Far from the realms of Warcraft and Diablo, StarCraft is Blizzard's only non-fantasy game, which gave our artists a much-needed break from the sword-and-sorcery stylings of our other worlds.

The creative process resulted in some of the most memorable heroes and creatures Blizzard has created to date: a dashing rogue of a leading man, a tragic heroine, an elusive and shadowy alien sage, and more creepy xenomorphs than you'd find in a Tatooine cantina. We took our love of science fiction and made it all our own. We did this by creating three distinct races, each with unique stories and art styles. The terrans are not the classic spacefaring boy scouts. They're more akin to the outlaws of the Old West, except in power armor and packing gauss rifles. For the protoss, we took the typical "intelligent gray-skinned extraterrestrials" that have dominated science-fiction movies and suited them up in gleaming plate mail and psionic war blades. When the protoss come to your planet, they're not bringing messages of intergalactic peace—they smash your planet into intergalactic pieces! The last race in our trinity is the zerg. These nasty critters are a roiling miasma of teeth, claws, spines, and tendrils; they sweep across the universe infesting everything that crosses their path.

To give StarCraft a distinctive look we purposefully went a little less cartoony, a little less stylized than Warcraft, yet not as realistic in scale as in Diablo. StarCraft falls smack in the middle of our other games as far as style, delivering a blend of heroic proportions somewhat grounded in reality. Well, if your reality consists of space cowboys, swarming monsters, and eight-foot-tall golden-armored aliens.

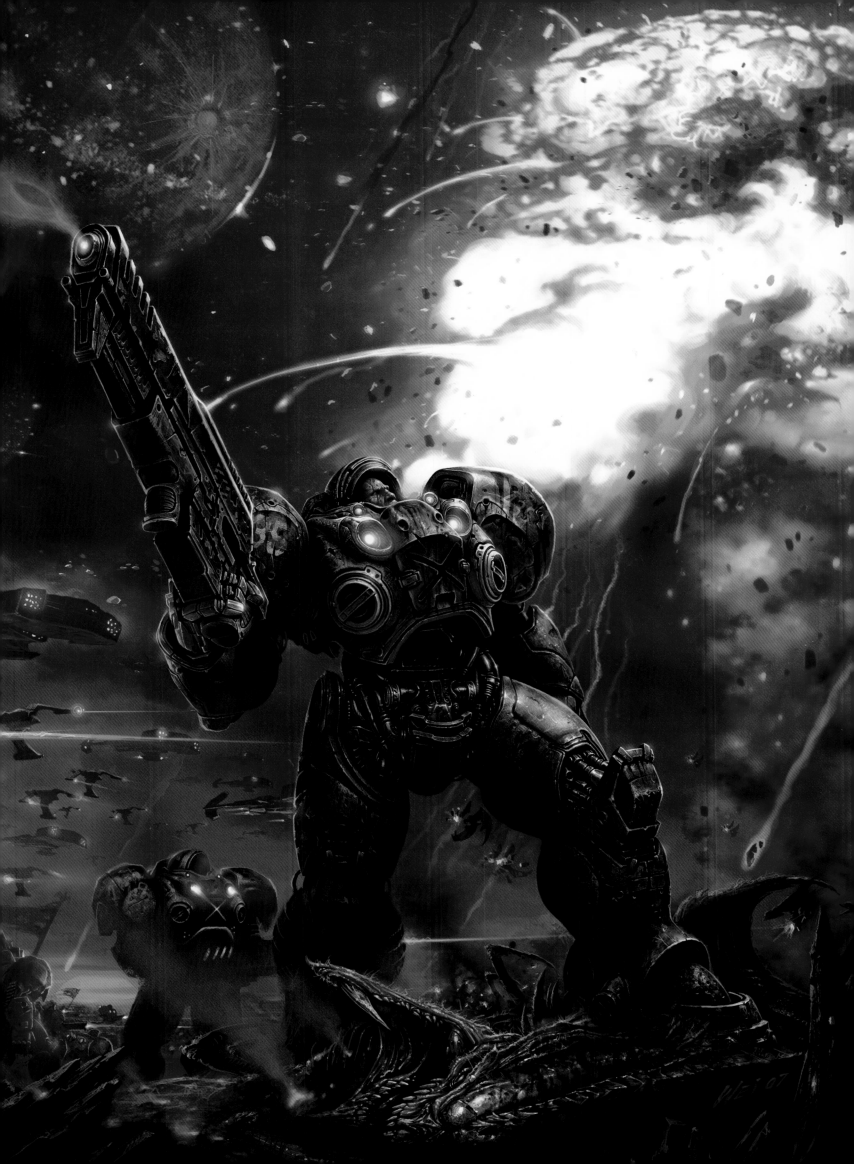

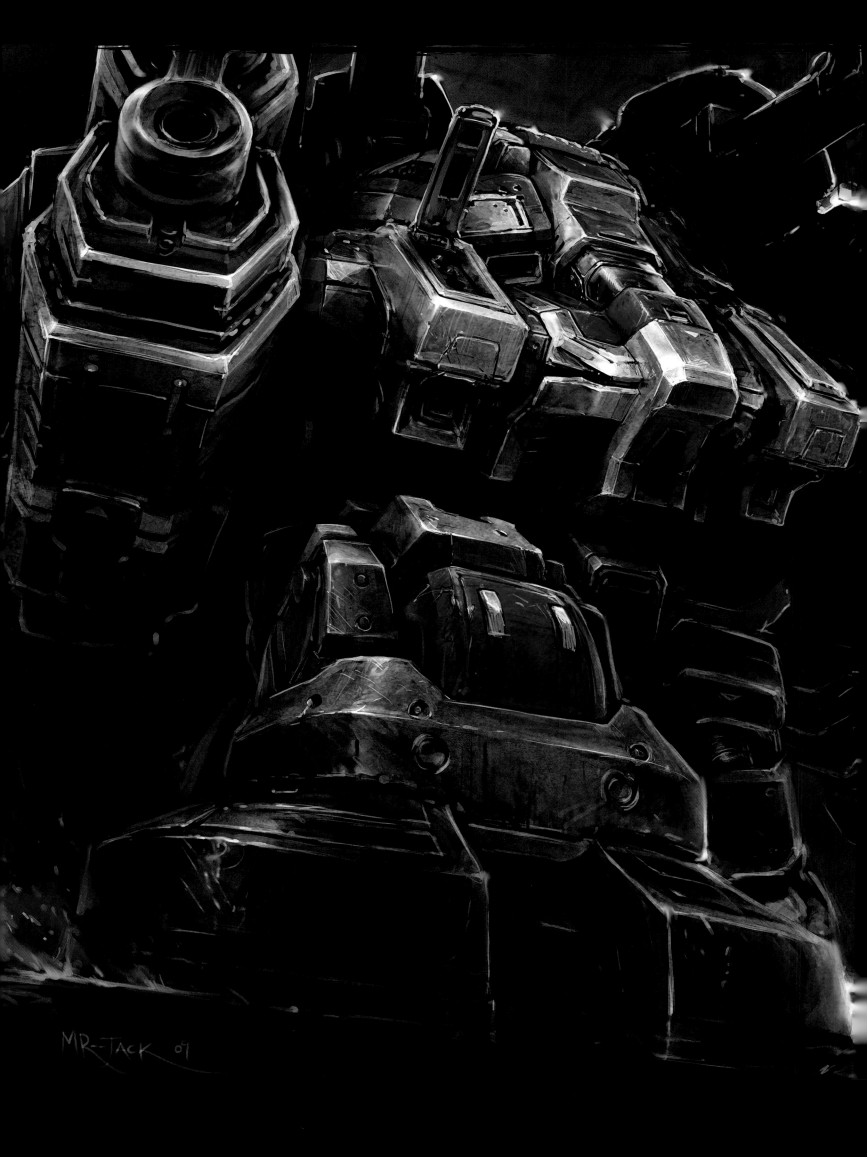

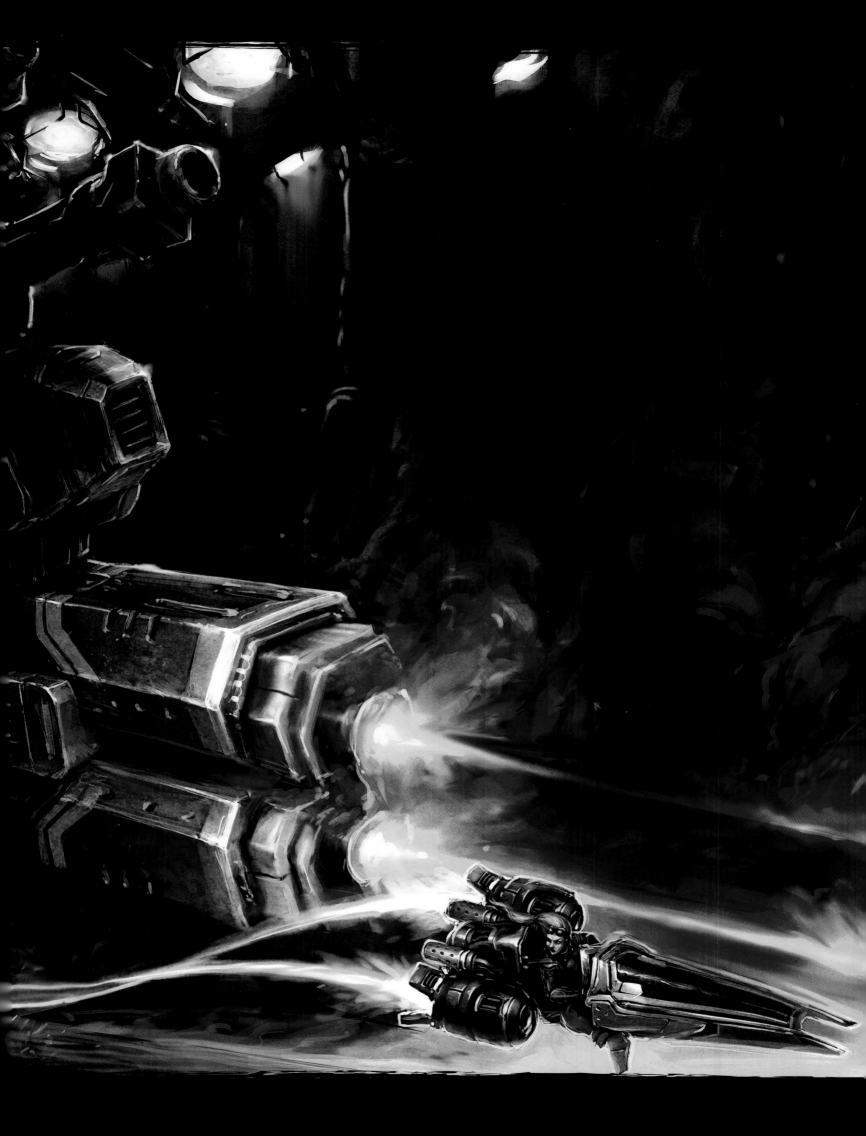

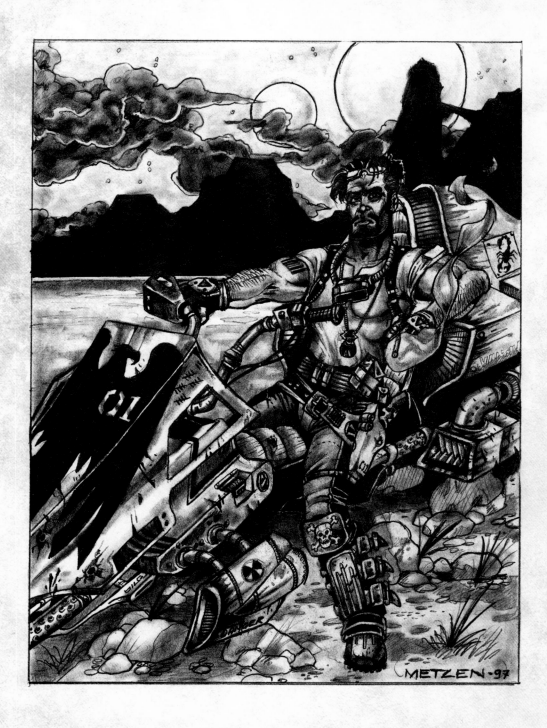

"The space cowboy. I really wanted to convey a gritty, hard-ass hero. Many, many years later, Wei Wang stepped up and, unbeknownst to me, re-created the image with his unique style. And while it's very humbling to look at these images side by side, Wei just captured everything I'd ever hoped at a level that is staggering to me. His painting rendering of Raynor and the grit and the level of detail and just the bearing of Raynor himself. We know so much more about Raynor now; when I drew the original, we didn't know all that much about him. He didn't have all the history that he has today embedded in *StarCraft II*. It was really more of an impression I was trying to create as we developed the game. So often in our early games, we did pictures and illustrations even before we had the story put together because we were just trying to communicate to our buddies down the hall traits or impressions or feelings. Maybe if they saw these images, it might rattle something in them as they're building a level; as they're building another unit; as they're designing a component of the game play. So often our art was just meant to inspire and try and get hooks out there in the world that we might activate over the course of the game's development. So after all these years of story and development and world design and level design, that painting Wei did is really a bookend for StarCraft. And etched on Raynor's face there, under Wei's calm brush, you see all the years and all the stories and everything that was created."

—*Chris Metzen*

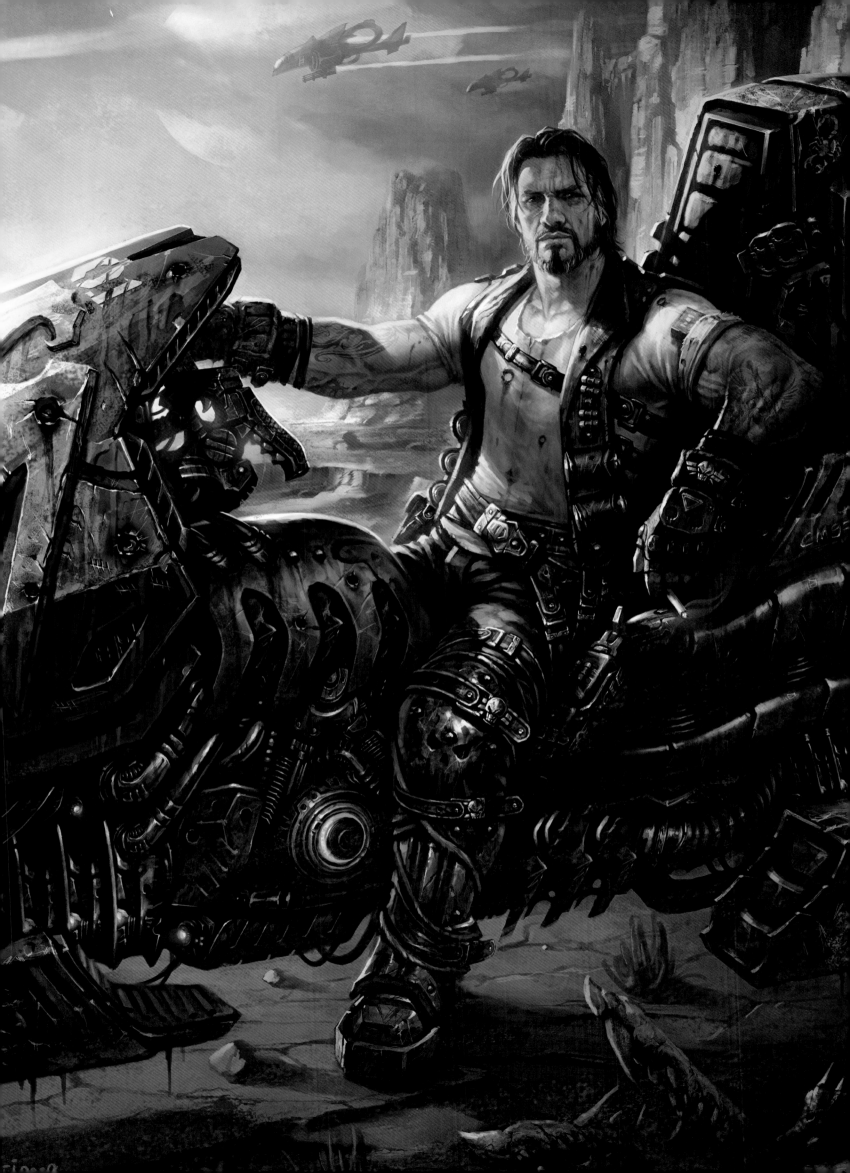

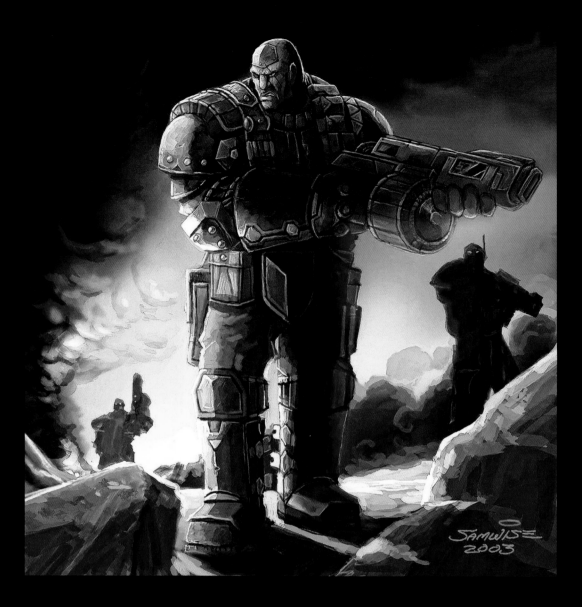

"These are some early iterations we tried, changing up the way our space marines looked. For *StarCraft II*, we were thinking of trying some new looks for some of our basic protoss, zerg, and terran units. So we had toyed with the idea of making the prison infantry guards—AKA the PIGs—be your basic line of troops. And basically these guys were just convicts that had been re-socialized and geared up in the cheapest armor and thrown out to the frontline. Why waste marines when you have prisoners?"

—*Samwise Didier*

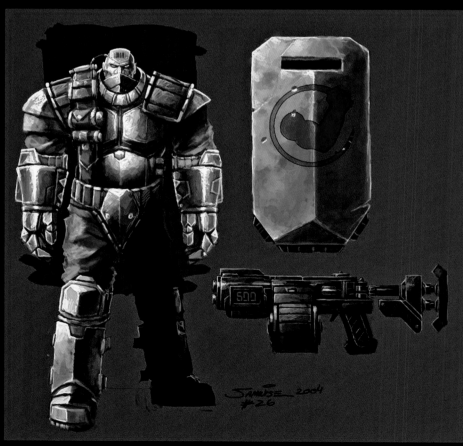

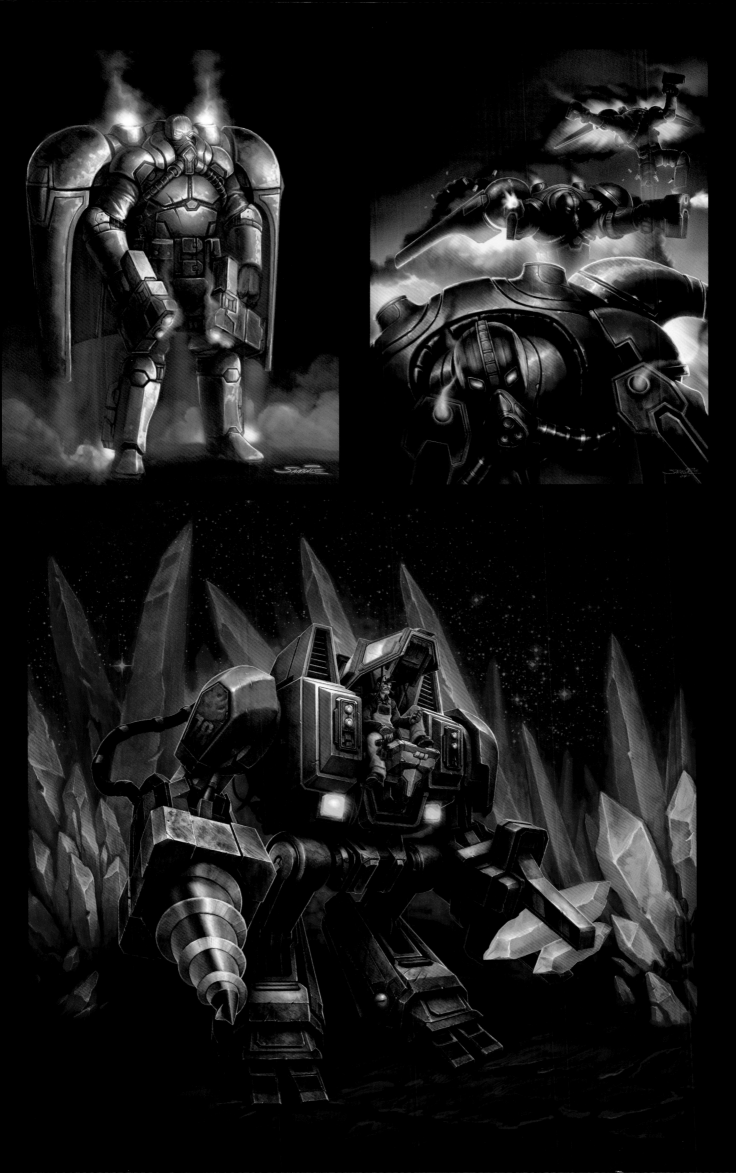

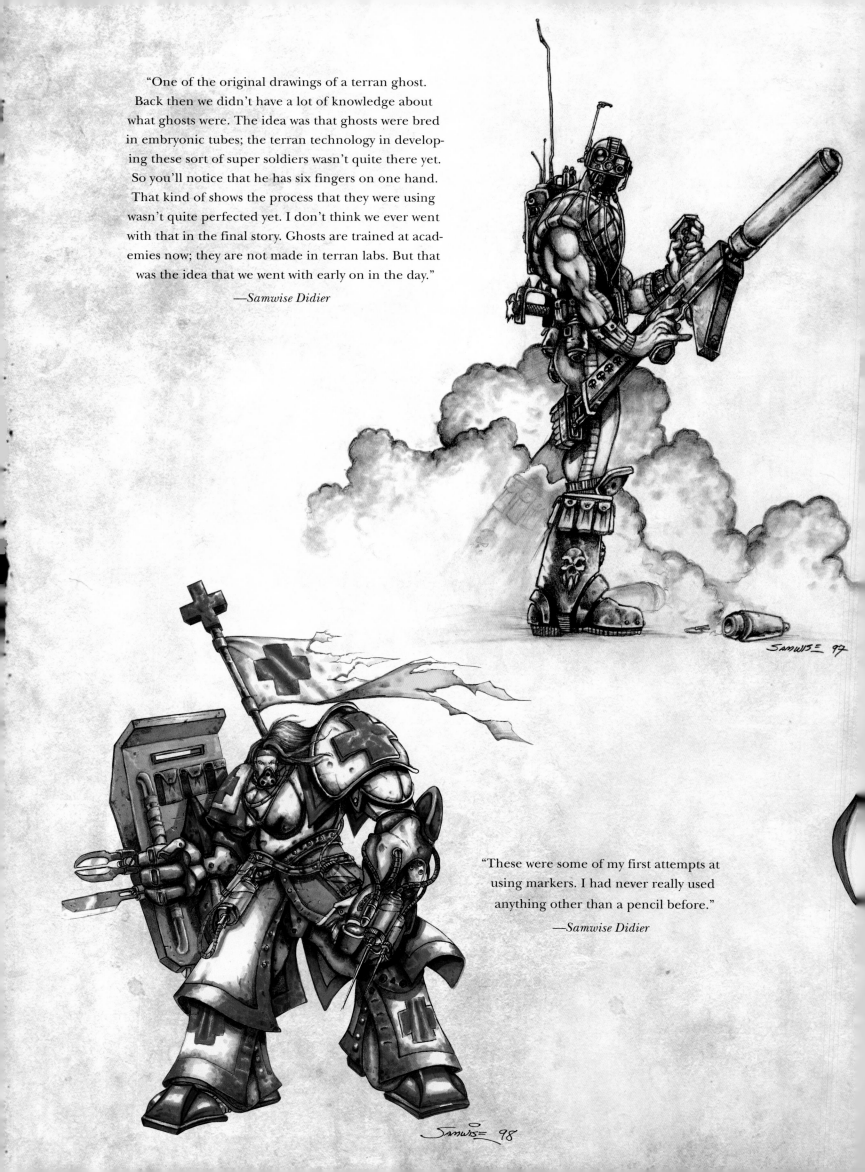

"One of the original drawings of a terran ghost. Back then we didn't have a lot of knowledge about what ghosts were. The idea was that ghosts were bred in embryonic tubes; the terran technology in developing these sort of super soldiers wasn't quite there yet. So you'll notice that he has six fingers on one hand. That kind of shows the process that they were using wasn't quite perfected yet. I don't think we ever went with that in the final story. Ghosts are trained at academies now; they are not made in terran labs. But that was the idea that we went with early on in the day."

—*Samwise Didier*

"These were some of my first attempts at using markers. I had never really used anything other than a pencil before."

—*Samwise Didier*

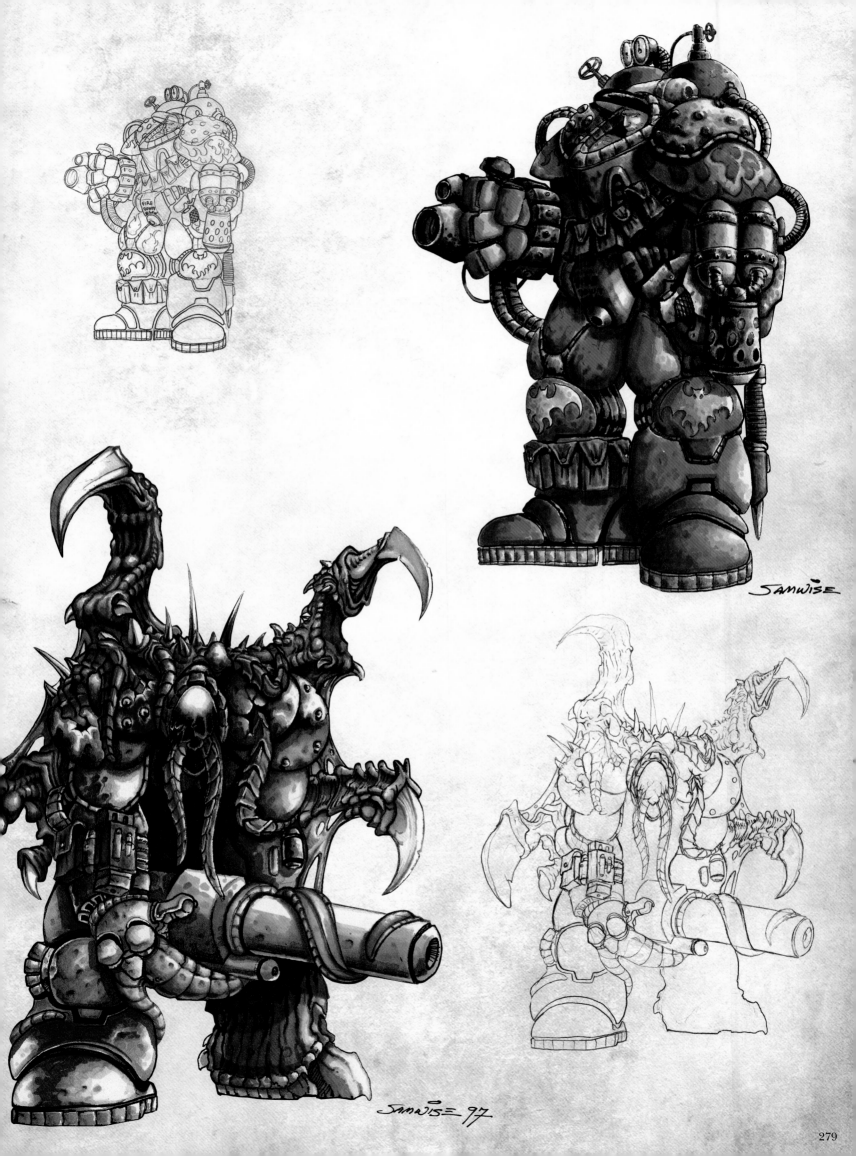

Samwise

Samwise 97

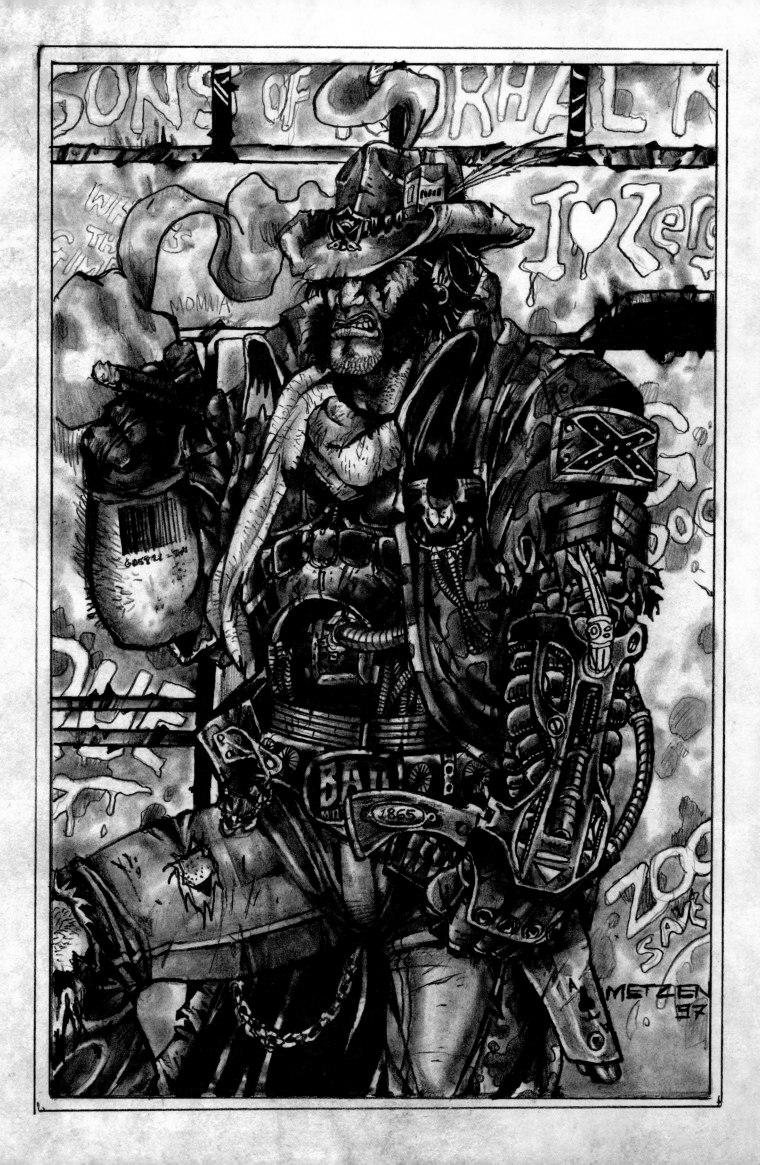

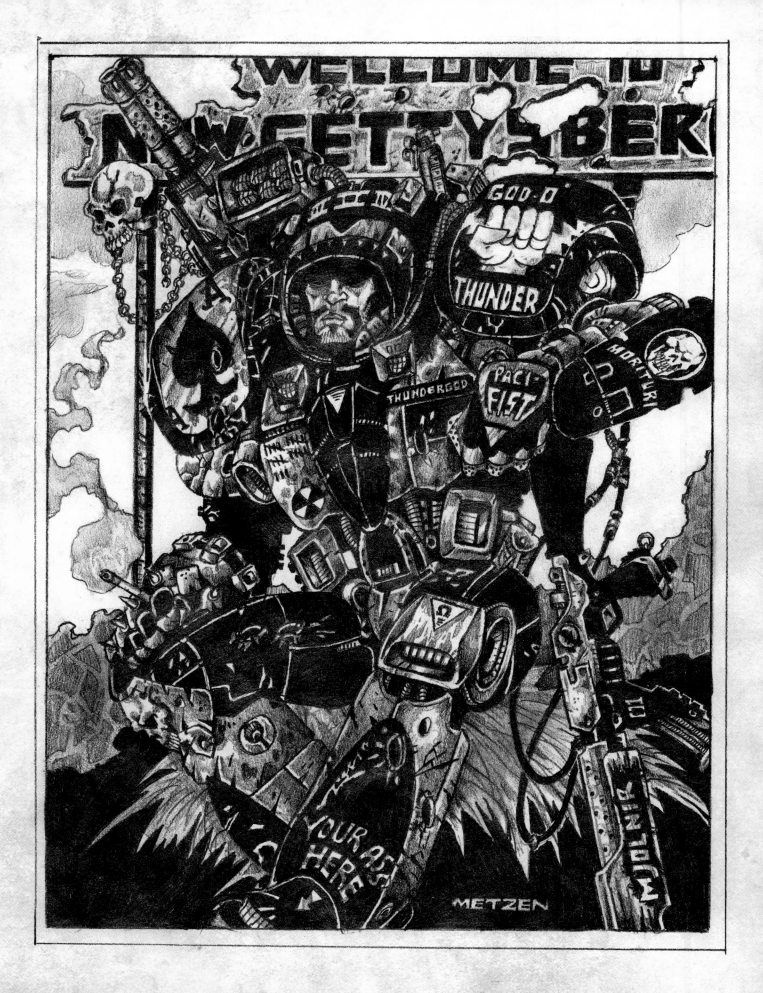

"This is a great example of some of Metzen's style in artwork. There's a lot of pencil on the page and lots of little quotes written all over the guy's armor. 'God-O Thunder' on the shoulder pad, 'Your Ass Here' pointing to the guy's foot—that's just classic Metzen and also very classic StarCraft. We did not want our space marines to be boy scouts of the universe. They were dirty, scummy prisoners shot off into space. Space cowboys, baby."

—Samwise Didier

"These old StarCraft manual pictures that Metzen did really helped define the universe for people, because when you're playing the game, a zealot, a marine, they're about eight to ten pixels. You can't really see what they are. These images help put something in your brain."

—*Samwise Didier*

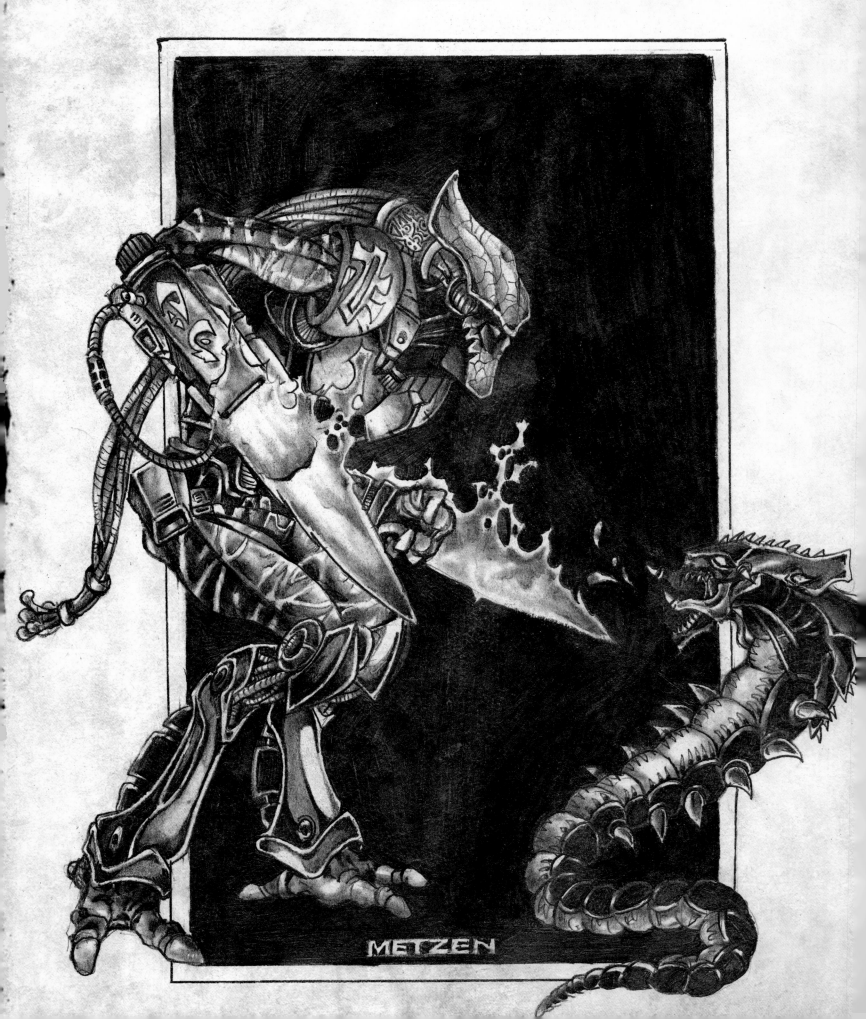

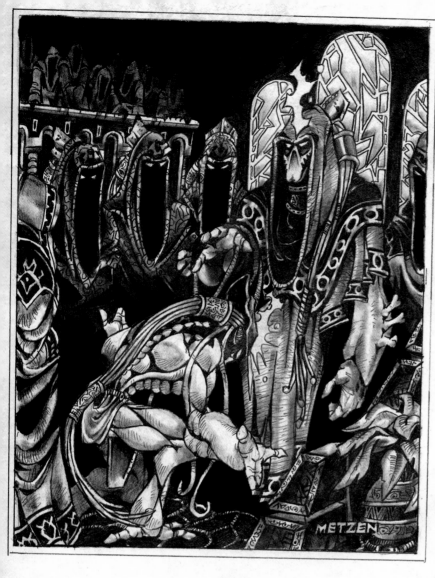

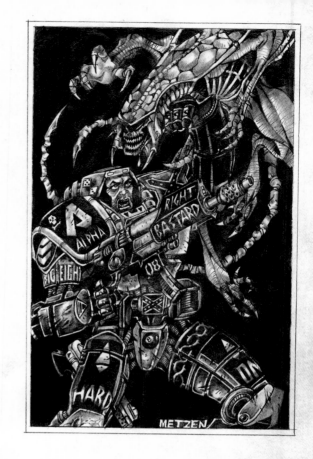

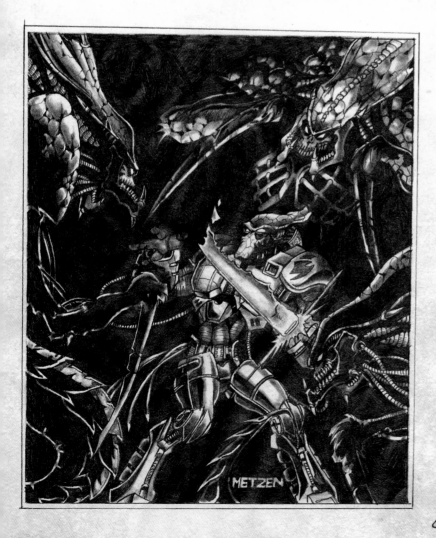

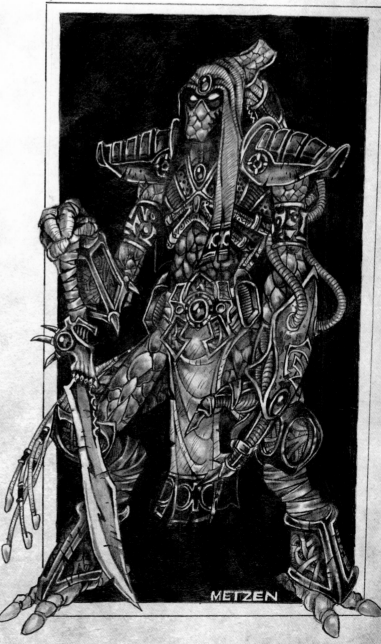

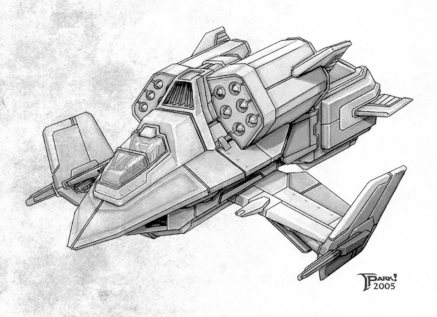
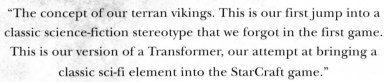
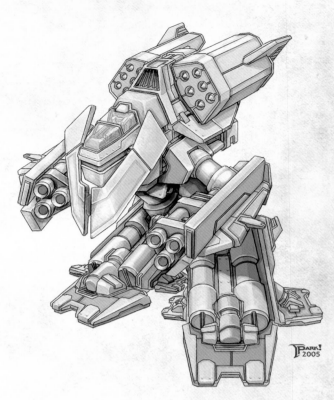

"The concept of our terran vikings. This is our first jump into a classic science-fiction stereotype that we forgot in the first game. This is our version of a Transformer, our attempt at bringing a classic sci-fi element into the StarCraft game."

—*Samwise Didier*

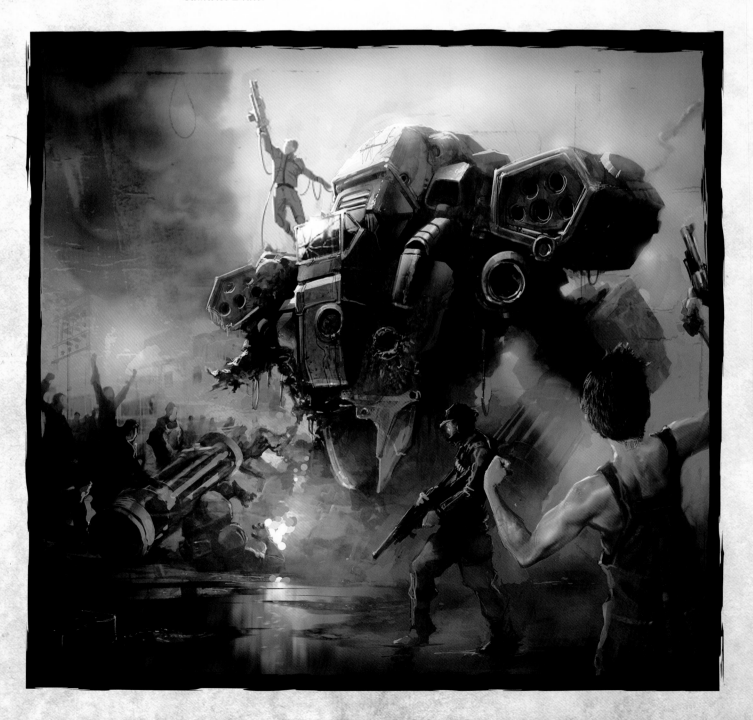

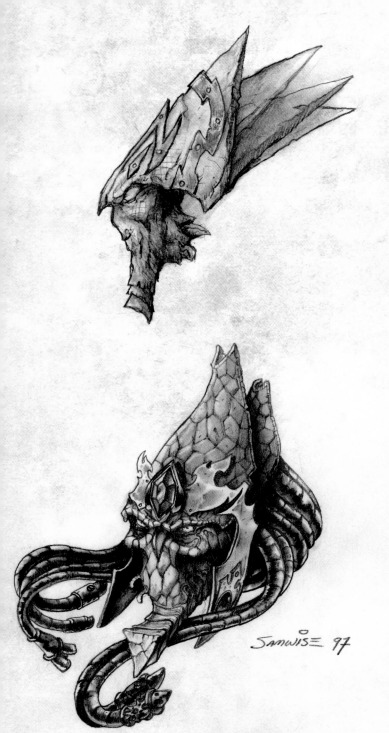

Samwise 97

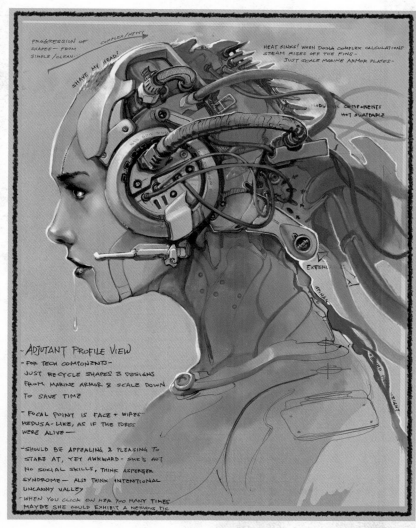

PROGRESSION OF
SHAPES — FROM
SIMPLE /CLEAN —
SHAVE MY HEAD!

COMPLEX /HEAVY

HEAT SINKS! WHEN DOING COMPLEX CALCULATIONS
STEAM RISES OFF THE FINS —
— JUST SCALE MARINE ARMOR PLATES —

MODULAR COMPONENTS
HOT SWAPPABLE

EXTEND

SPINAL

GROUND THE SPINE

-ADJUTANT PROFILE VIEW
-FOR TECH COMPONENTS-
JUST RECYCLE SHAPES & DESIGNS
FROM MARINE ARMOR & SCALE DOWN
TO SAVE TIME

- FOCAL POINT IS FACE + WIRES
MEDUSA-LIKE, AS IF THE TUBES
WERE ALIVE —

-SHOULD BE APPEALING & PLEASING TO
STARE AT, YET AWKWARD - SHE'S GOT
NO SOCIAL SKILLS, THINK ASPERGER
SYNDROME — ALSO THINK INTENTIONAL
UNCANNY VALLEY
-WHEN YOU CLICK ON HER TOO MANY TIMES
MAYBE SHE COULD EXHIBIT A NERVOUS TIC

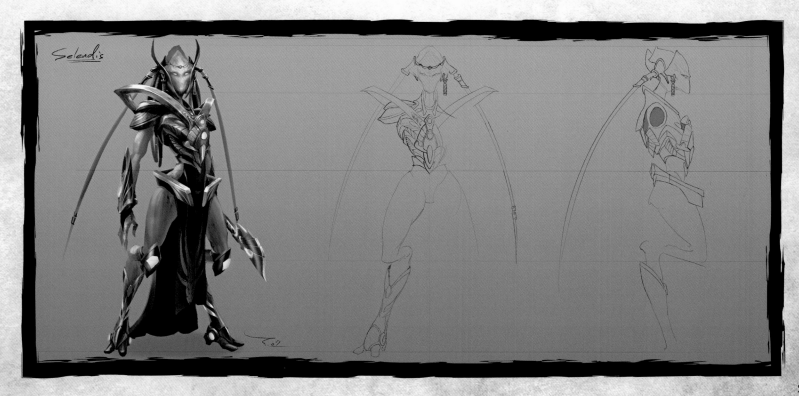

Selendis

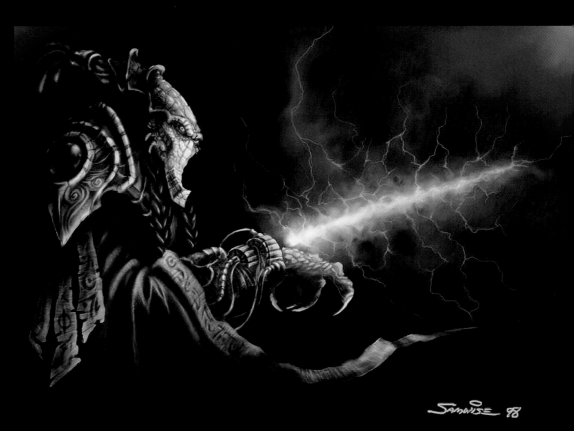

"The dark templar. The modern Zeratul has a lot of the same things—the green blade, the sort of shoulder pad with the little scrolls hanging off of it. We wanted to make him look like our space Gandalf, the old and the wise."

—*Samwise Didier*

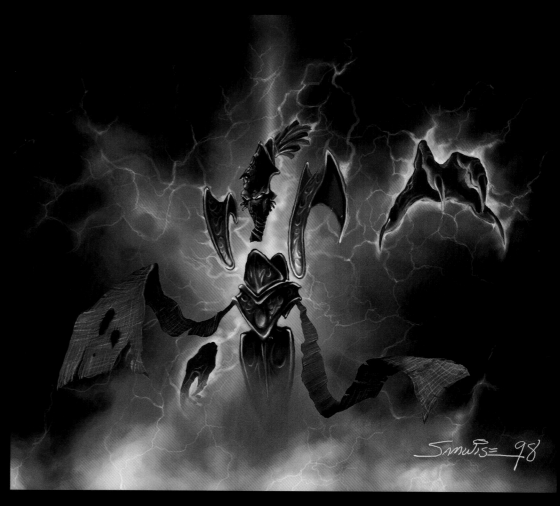

"One of our marquee images of StarCraft and one of the first ones that we did that was digital. I believe this was the third Photoshop picture that I ever did. And with a mouse."

—*Samwise Didier*

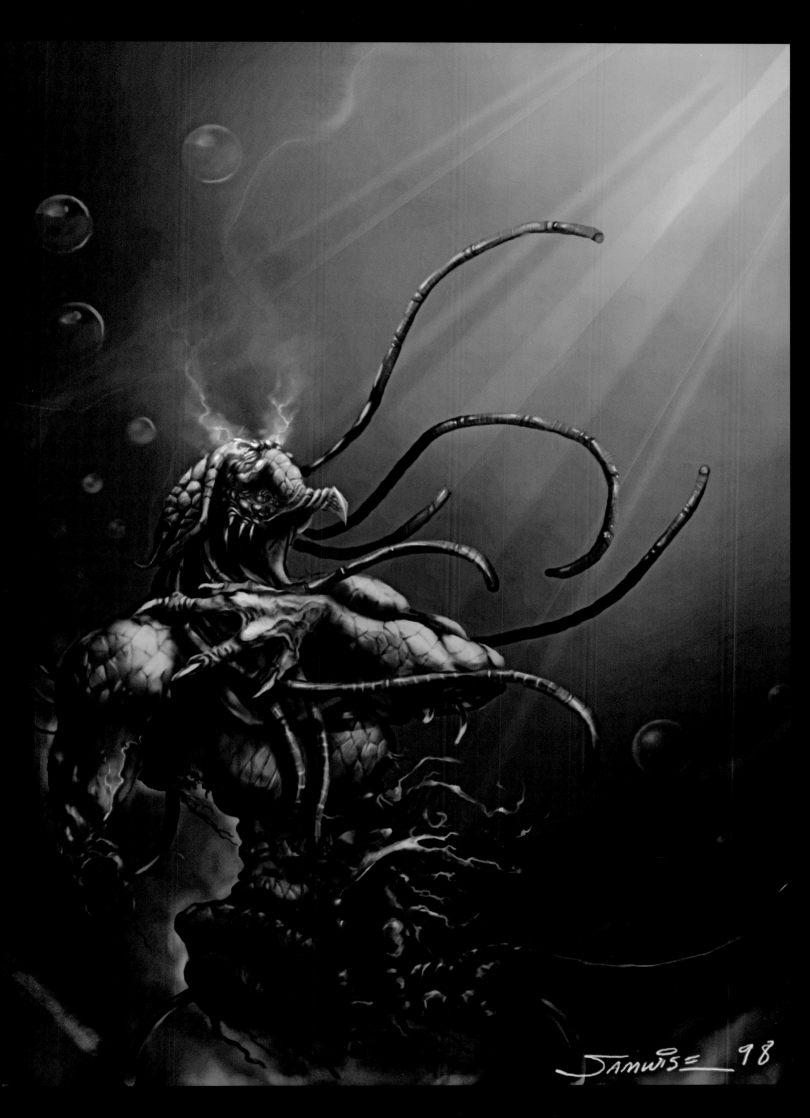

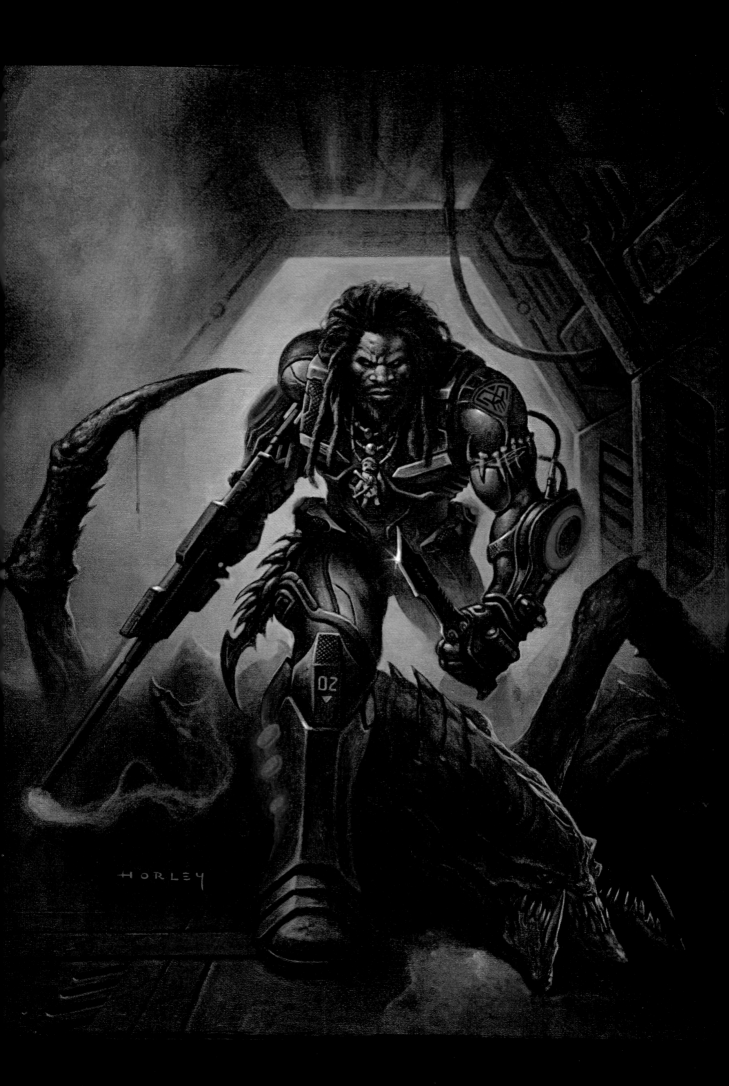

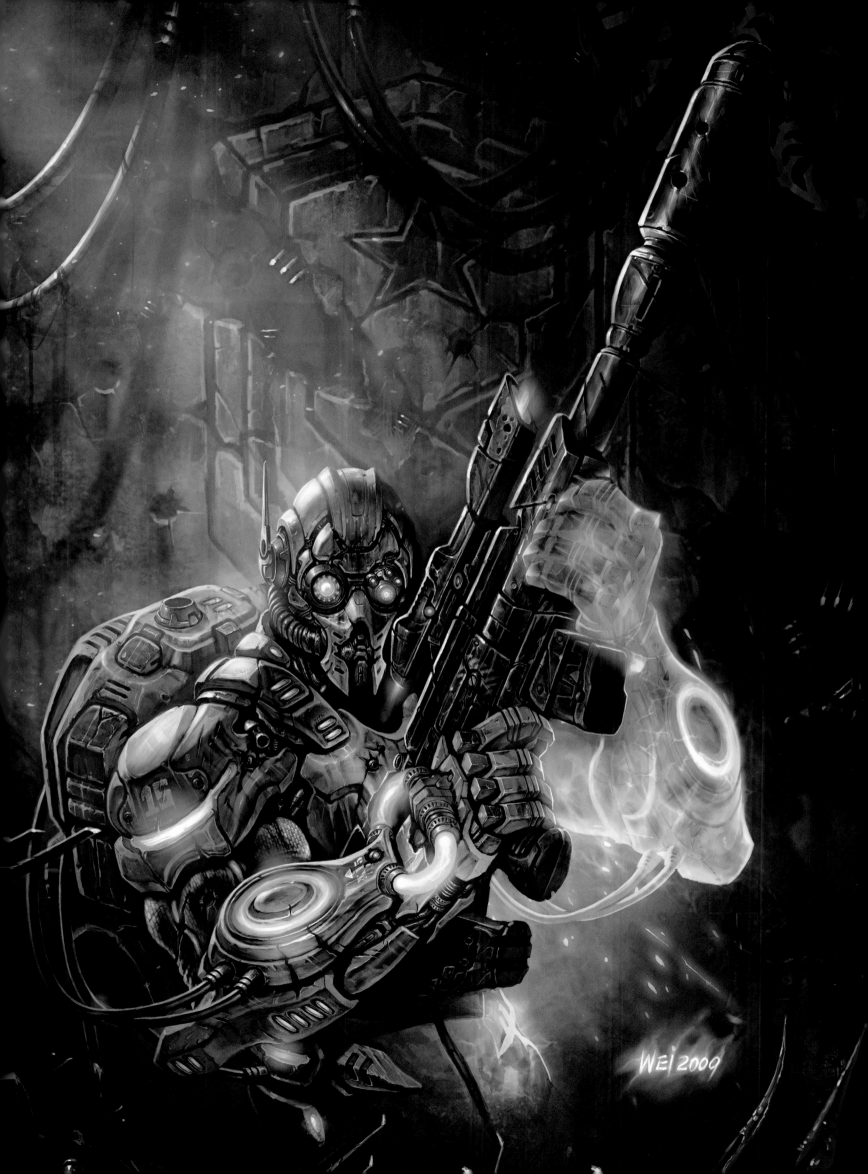

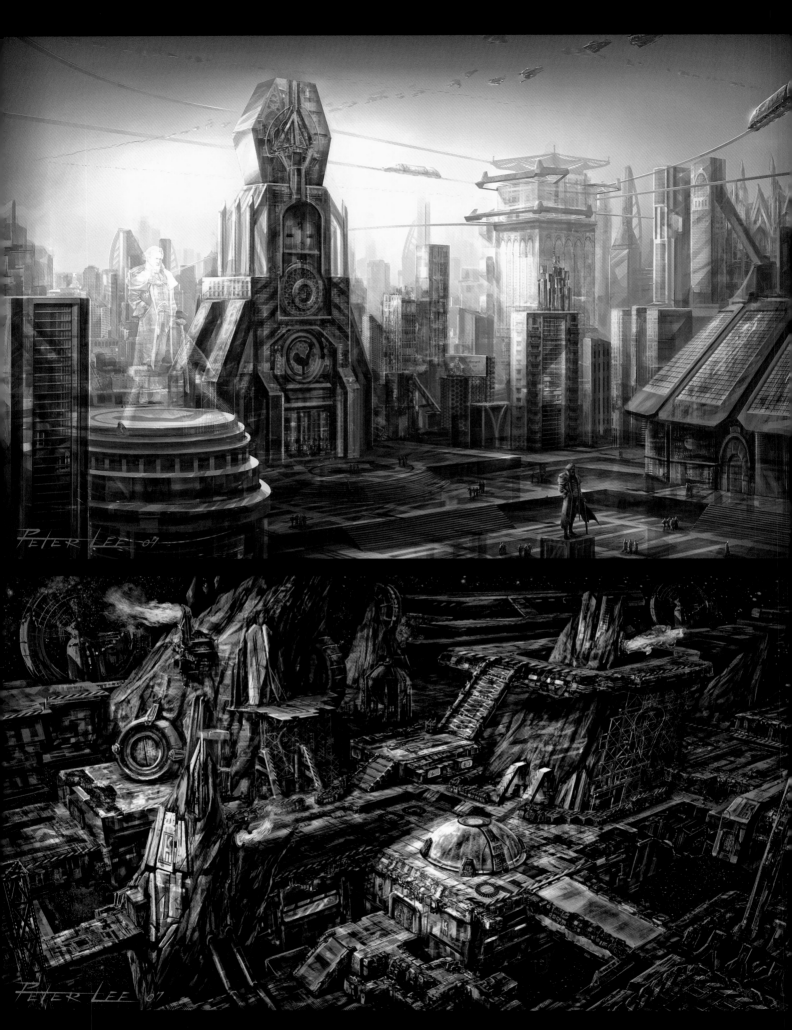

"These were some of the first images that we had Peter Lee come up with for visualizing what our *StarCraft II* world would look like. This is the first time that we began concept art years before the official game developments was even started."

—*Samwise Didier*

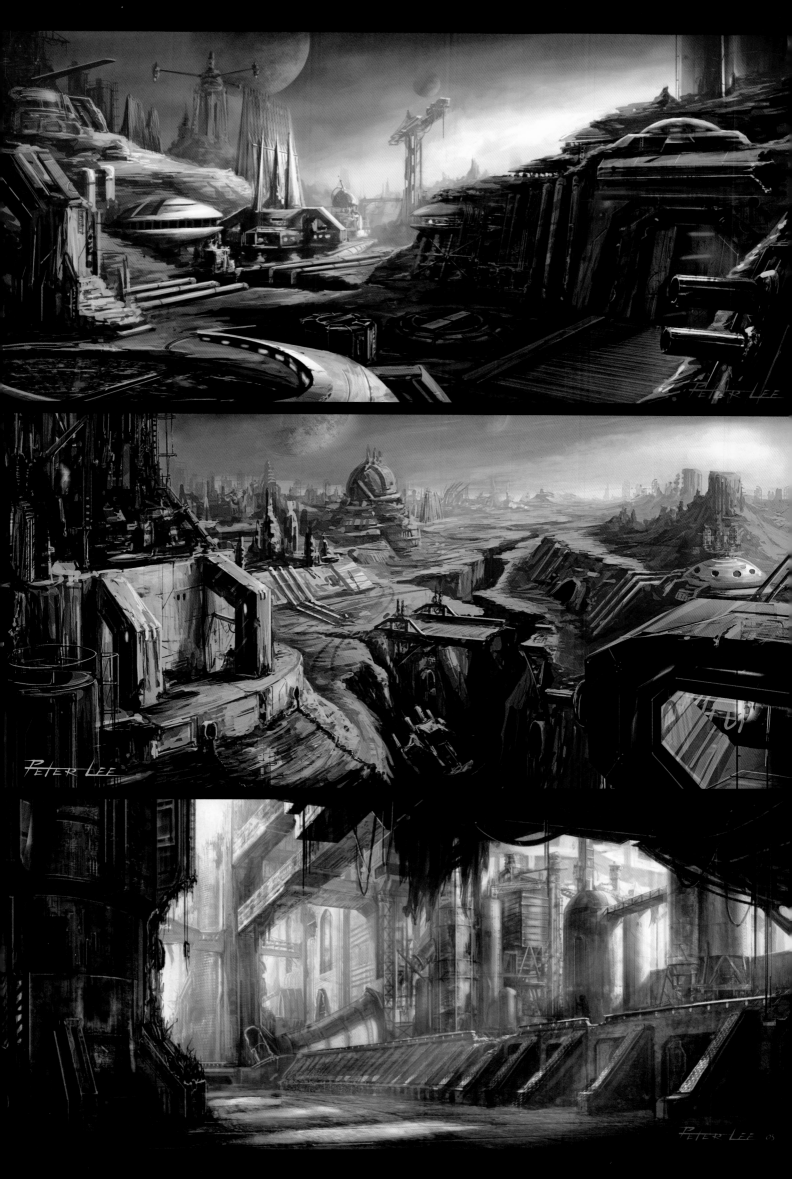

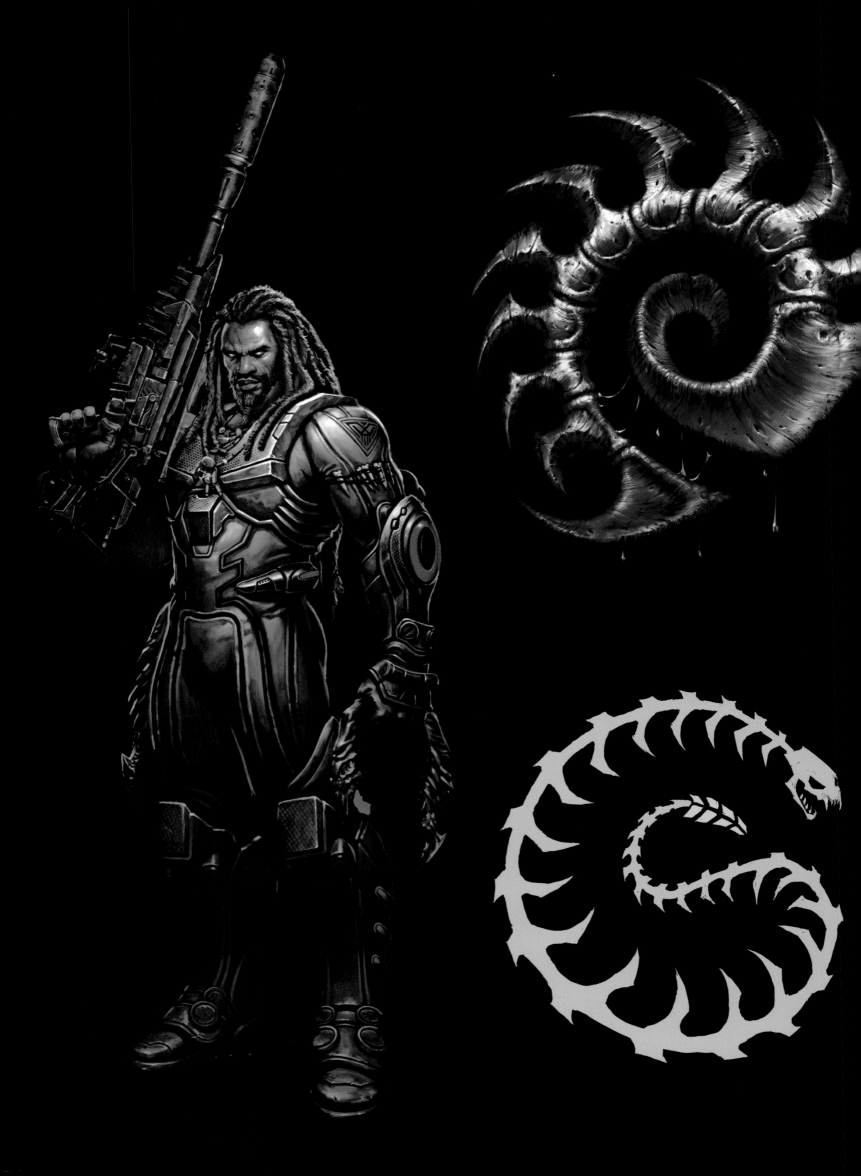

"These are our racial crests for *StarCraft*. We felt this terran one [above] was strong enough and didn't need to be redesigned like the others. It stayed through from the original *StarCraft* until now."

—*Samwise Didier*

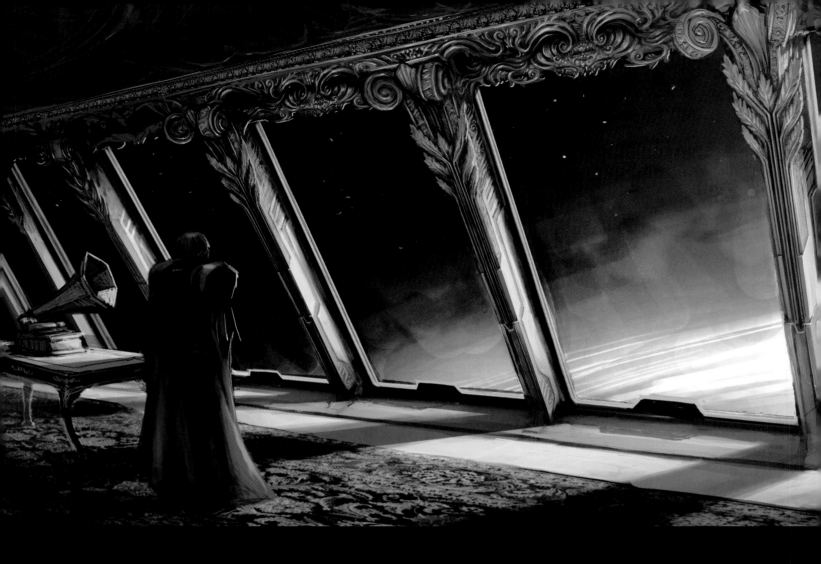

'While not an integral piece to the StarCraft lore, this image really shows the richness and the glory of the terran army. Normally we're used to seeing gritty marines and dirty, beat-up siege tanks and macs. This shows Prince Valerian overlooking a planet. Who knows if it's one he conquered or one that he wants to conquer? It's just a great piece all on its own."

—Samwise Didier

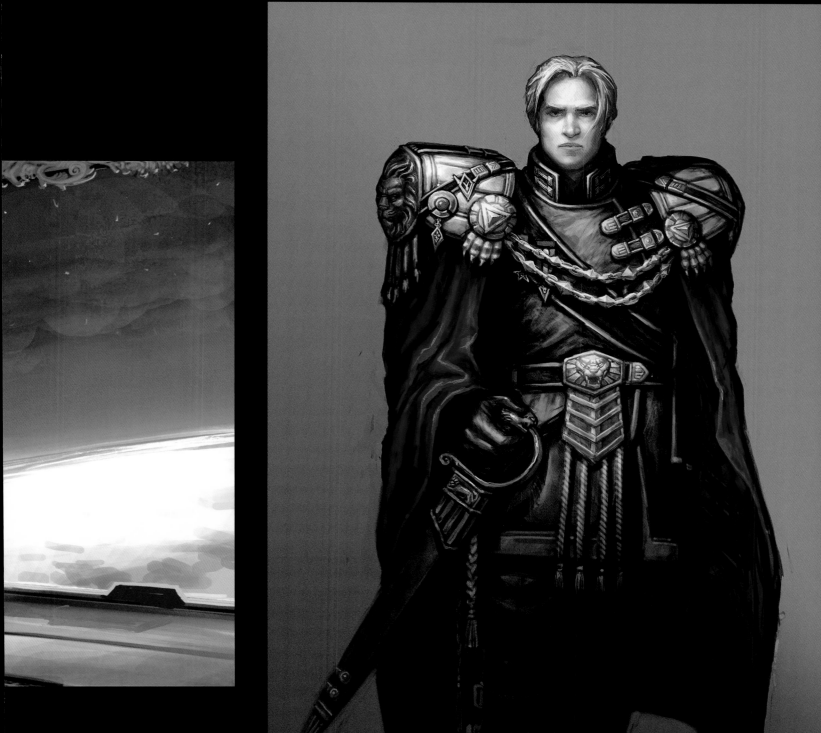

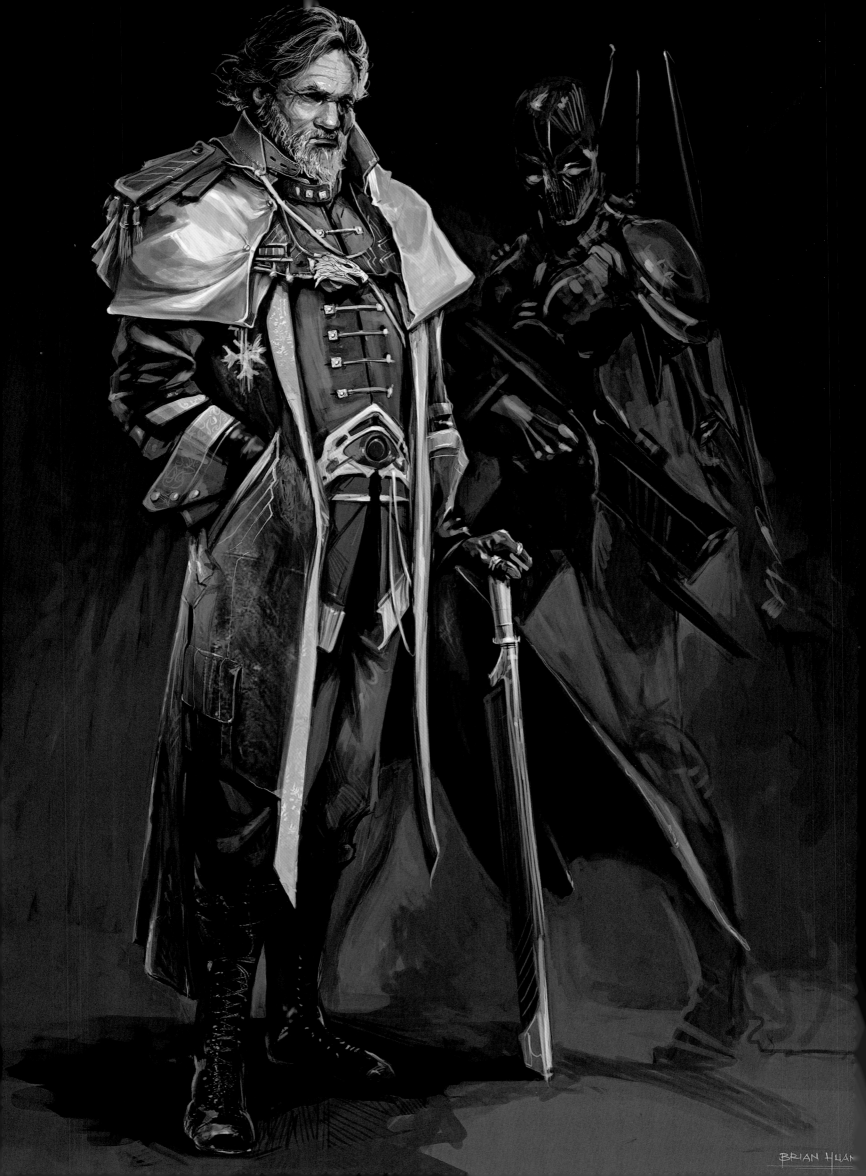

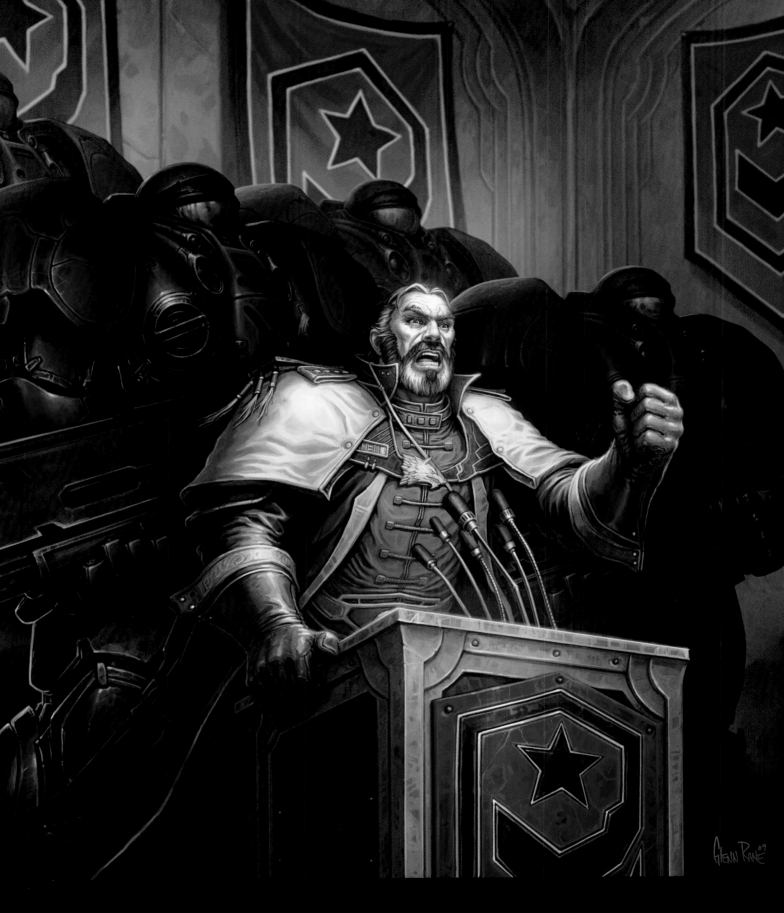

"Arcturus Mengsk, the spin doctor right here. Basically, our version of the most evil dictator who has ever lived on this world. It looks like he's preaching to the masses here about how bad Jim Raynor is. We know the truth."

Samwise Didier

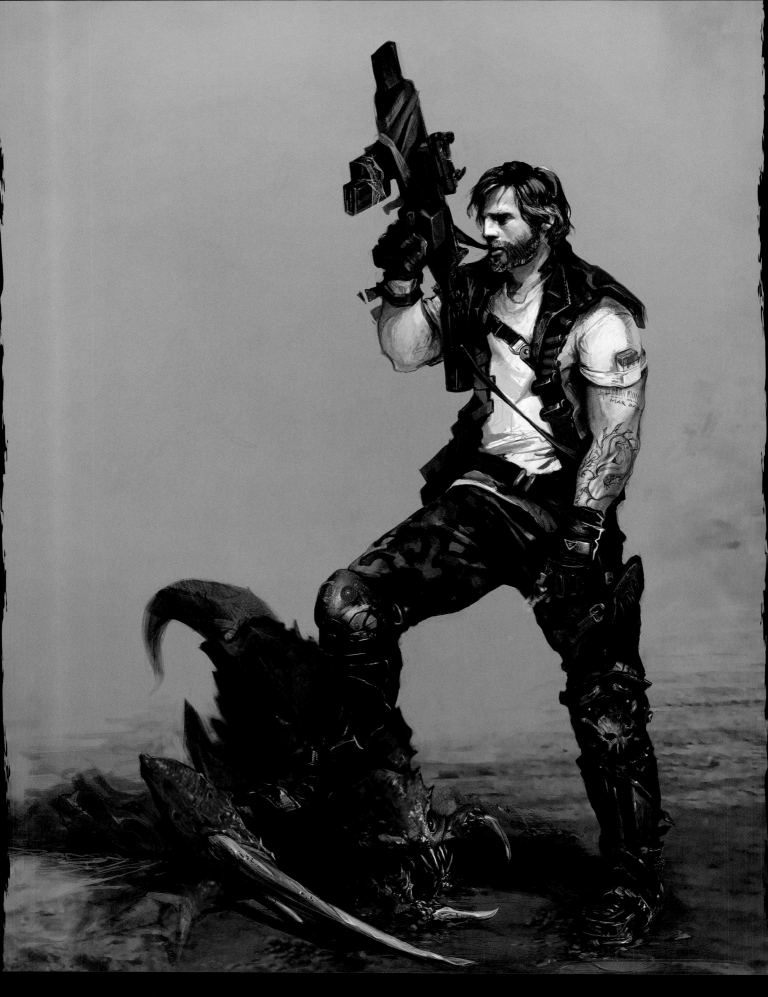

"This is our first real concept with the new Jim Raynor. Longer hair. He's no longer bald. Standing on the head of some sort of zergling or something. He's basically our Han Solo for StarCraft. He's even got the little black vest."

—*Samwise Didier*

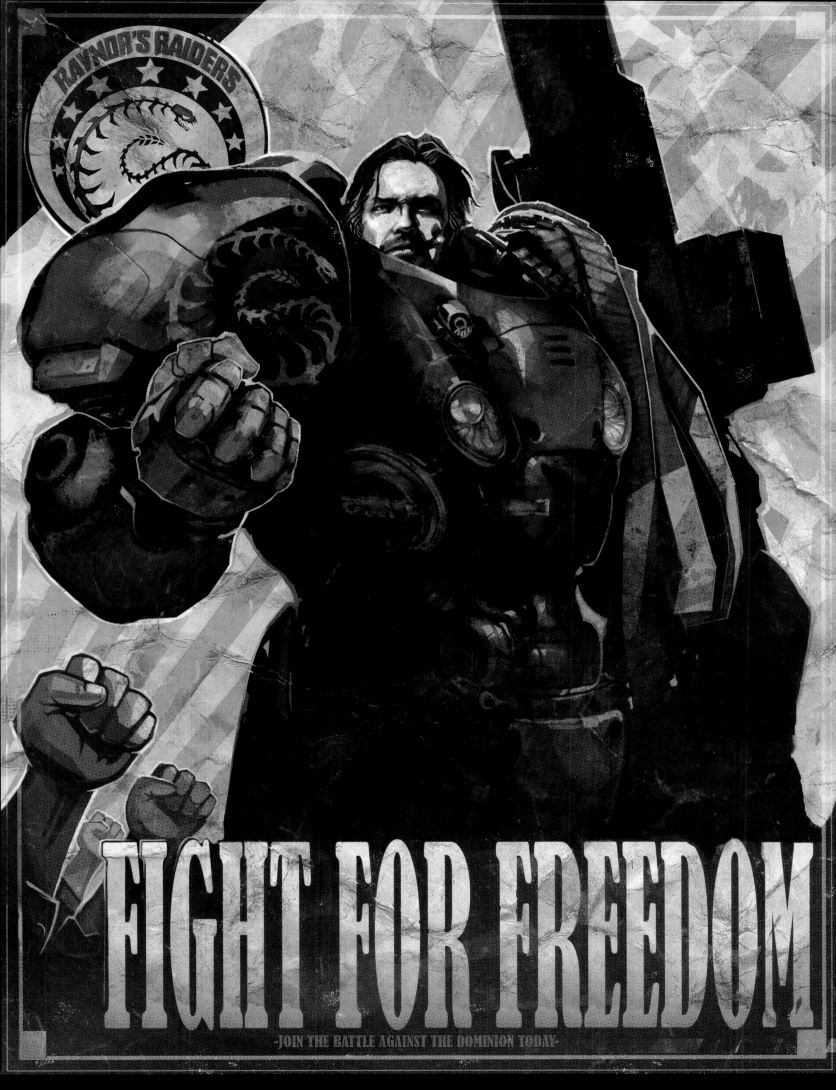

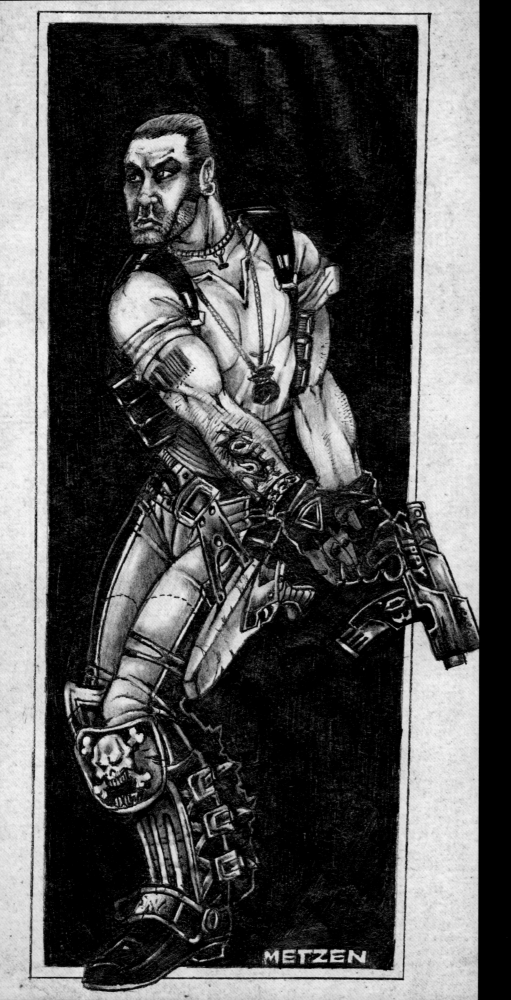

"This was the original version of Jim Raynor, which also looks like Chris Metzen. He's got the nice shiny boots and slick-back hair that Metzen had at the time. We all draw ourselves in our images. That's a sweet little pose he has there, too."
—*Samwise Didier*

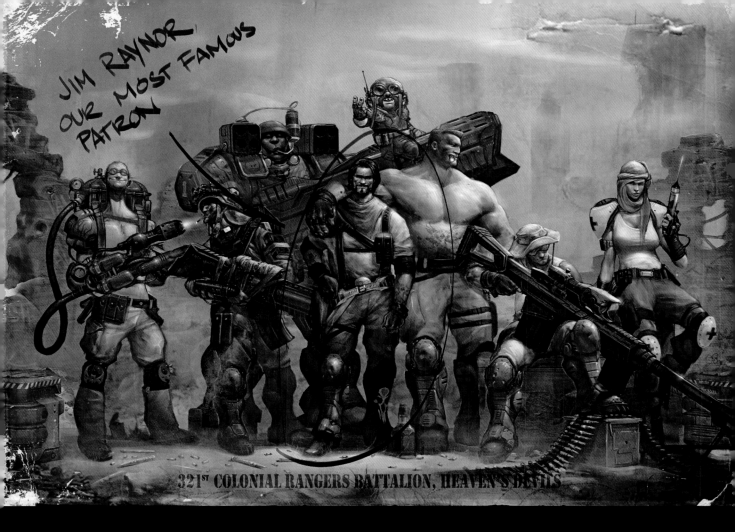

JIM RAYNOR, OUR MOST FAMOUS PATRON

321st COLONIAL RANGERS BATTALION, HEAVEN'S DEVILS

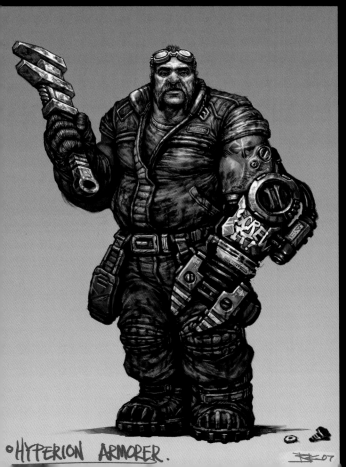

HYPERION ARMORER.

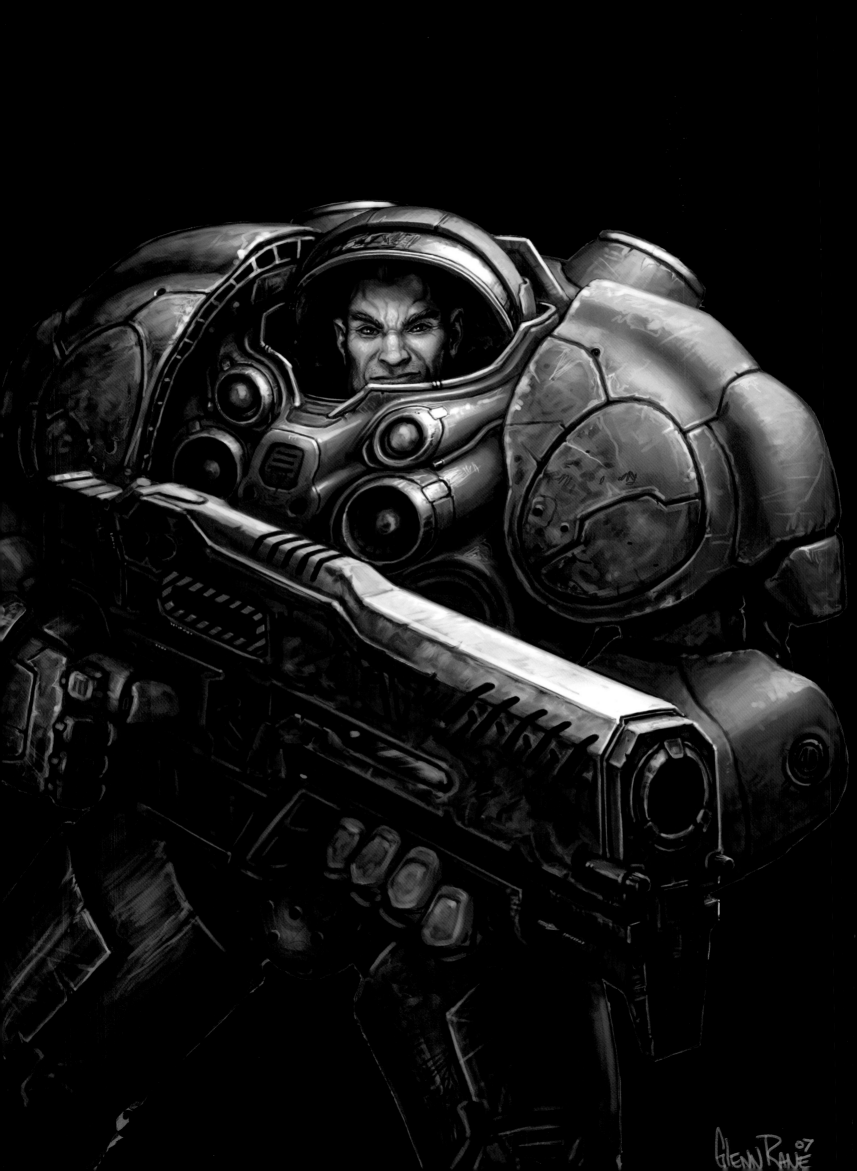

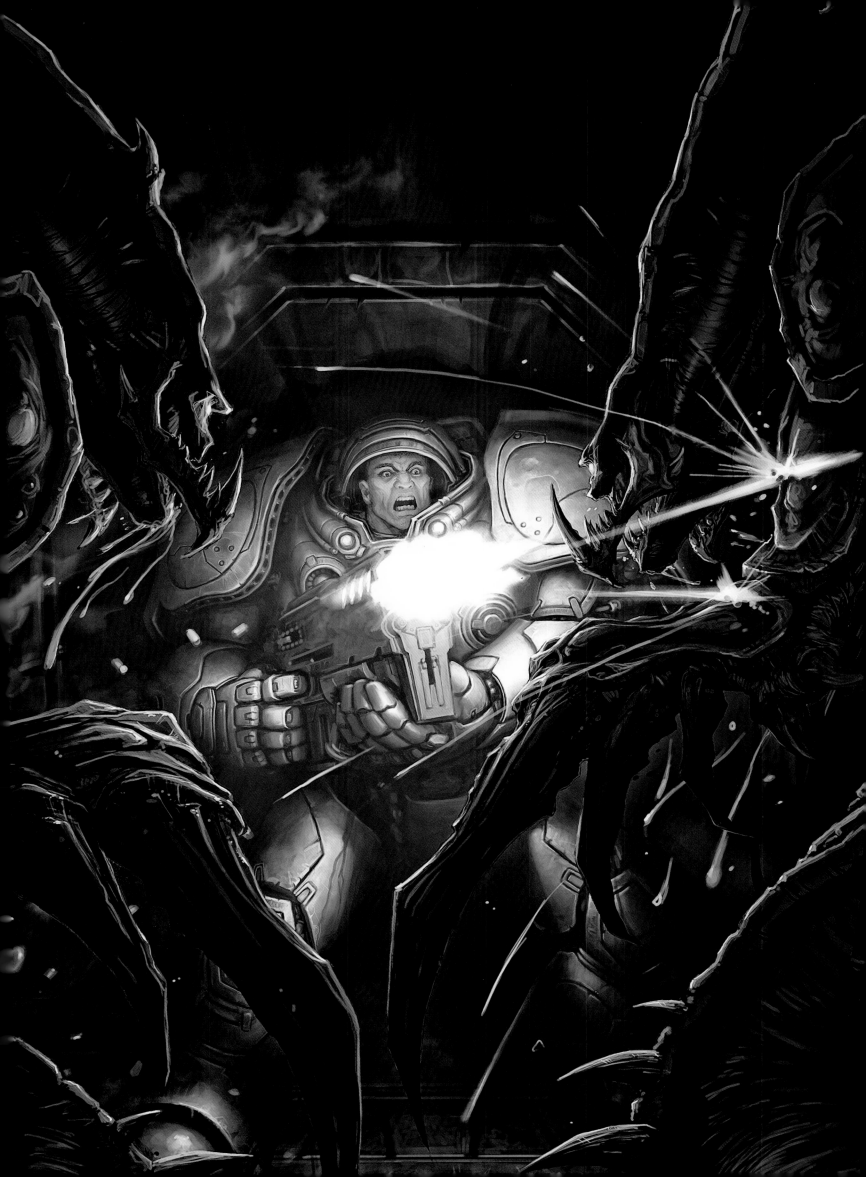

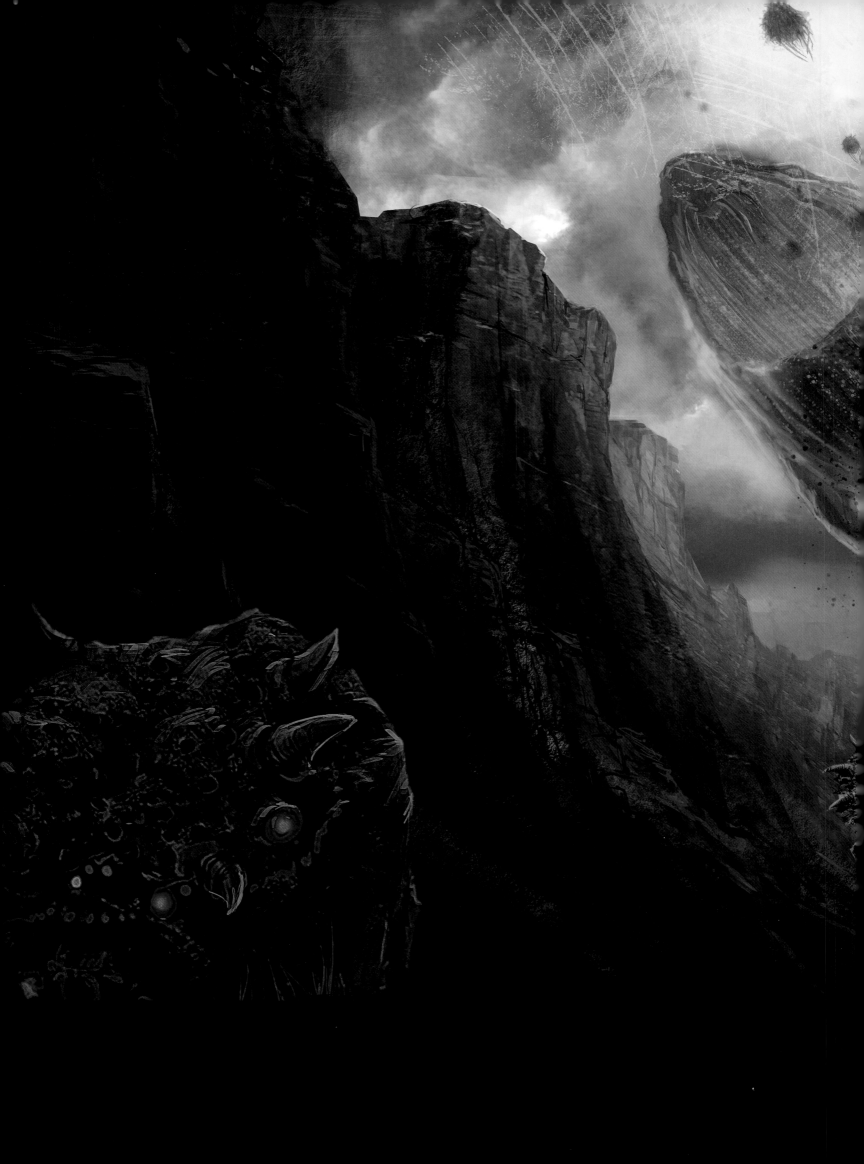

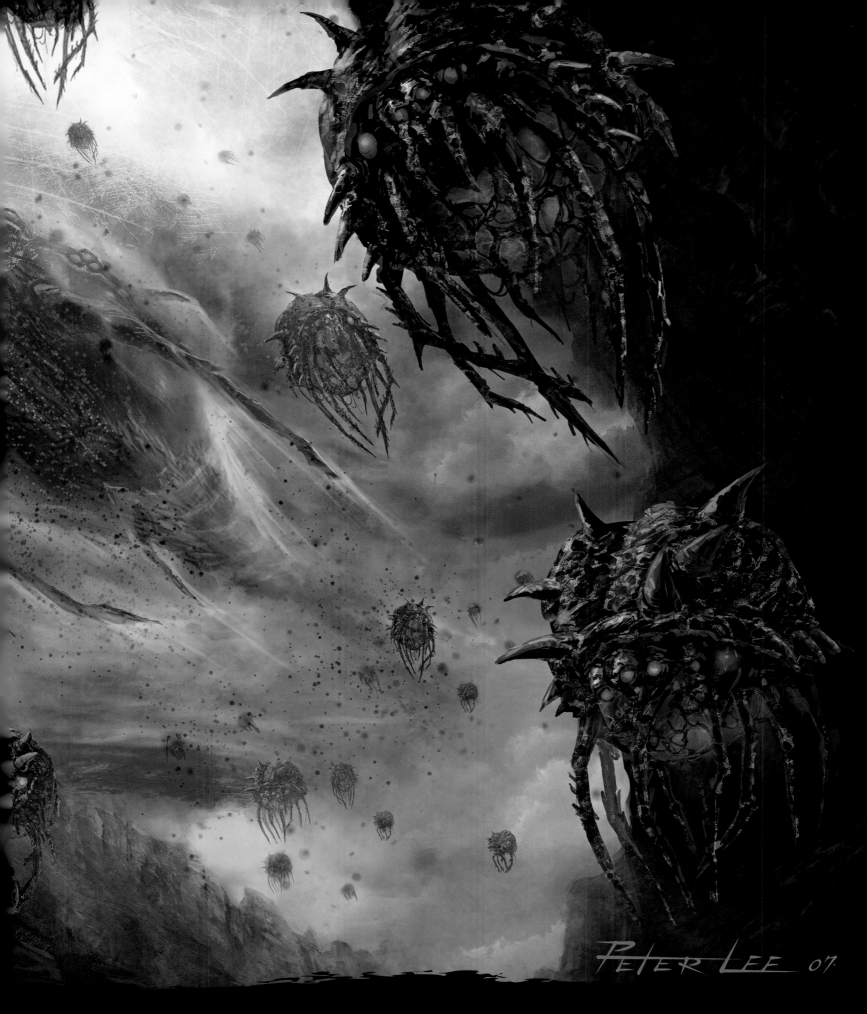

Peter Lee 07.

"One of the concepts for zerg leviathans. These giant organic ships flew around the universe carrying the zerg armies. We have a version of it now in *Heart of the Swarm* that is radically different than this, but this was a pretty inspiring image. It showed something that was just completely what you've never seen before on the zerg. The little things coming out of it are overlords. Those are what control your army. And this thing, if you look at the side, it's just dotted with them. It's pretty big."
—*Samwise Didier*

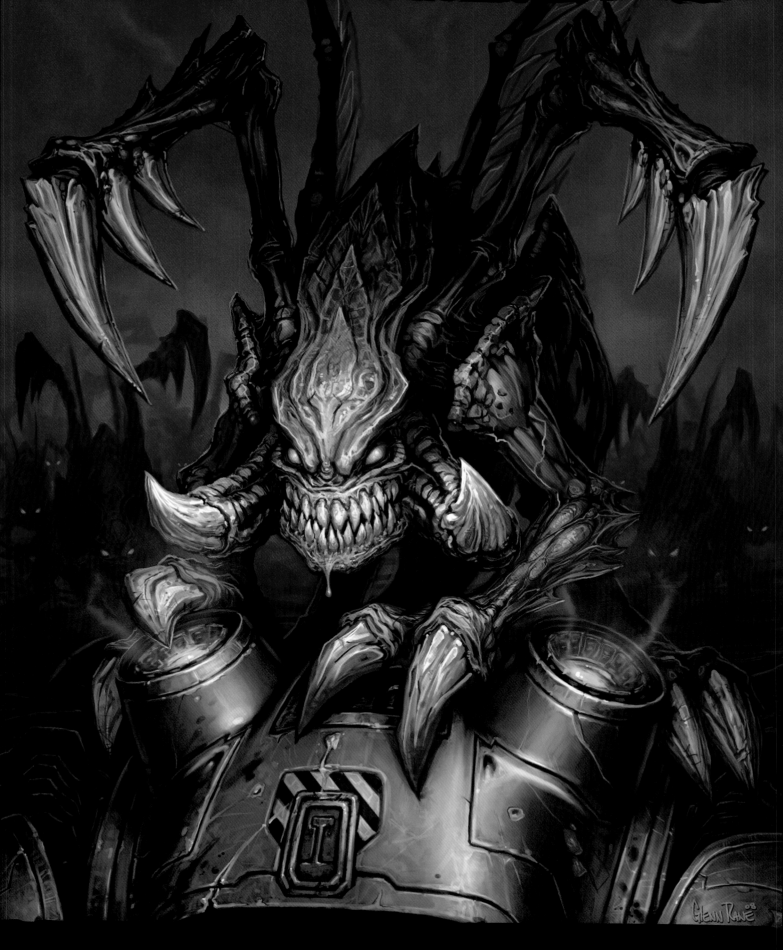

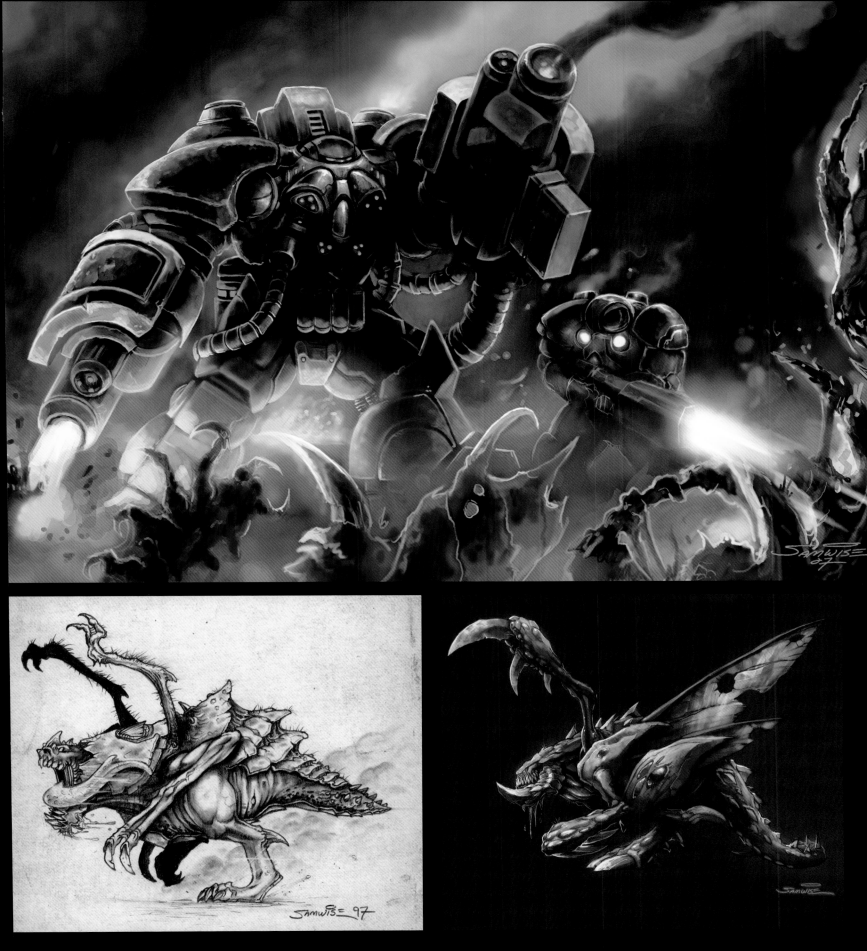

"This [above left] is the original drawing of a zergling we did for StarCraft. When we were revisualizing our basic unit, we wanted to bring a little bit more to the zergling and so I added wings. There was a complete uproar and riot in the community—'You can't have zerglings have wings!' Everybody was freaking out saying how we were ruining StarCraft. So I said, 'Okay, fine. The basic zergling doesn't have wings, but if you want to upgrade it to have better attack speed, that has the wings.'"

—*Samwise Didier*

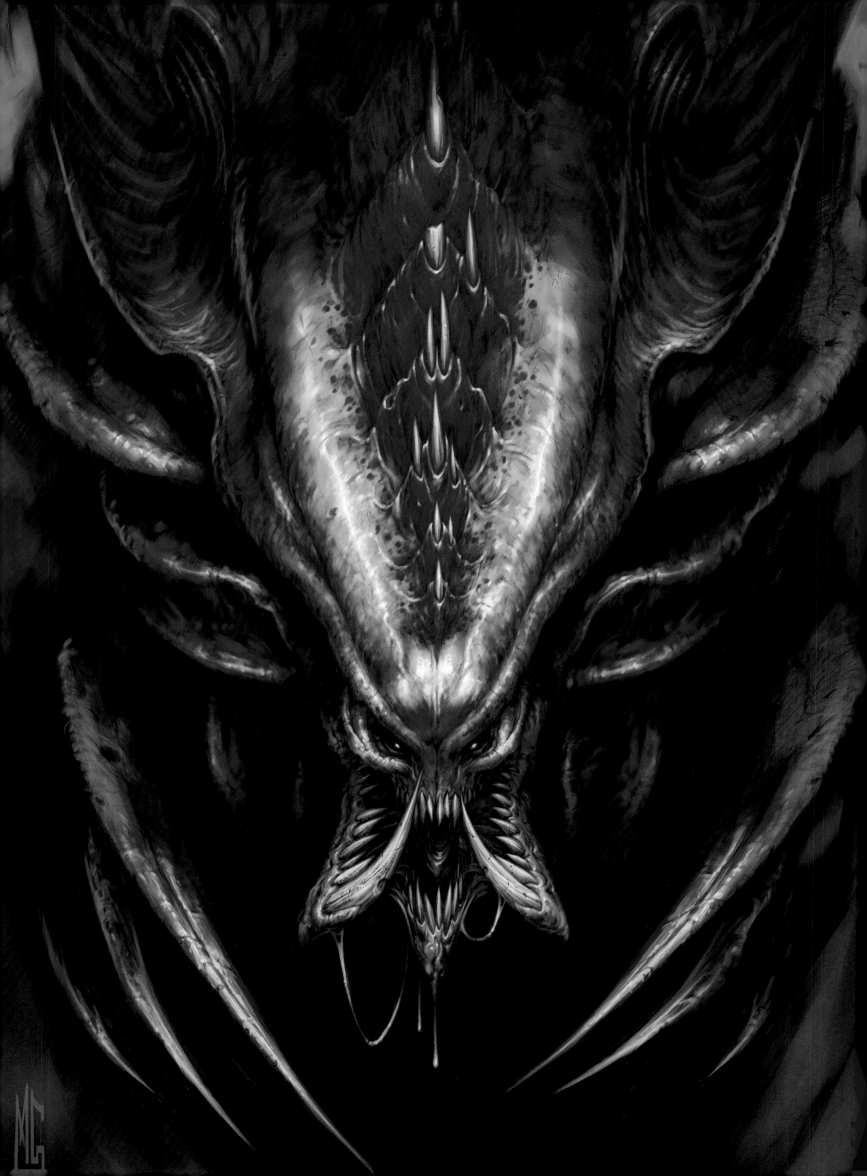

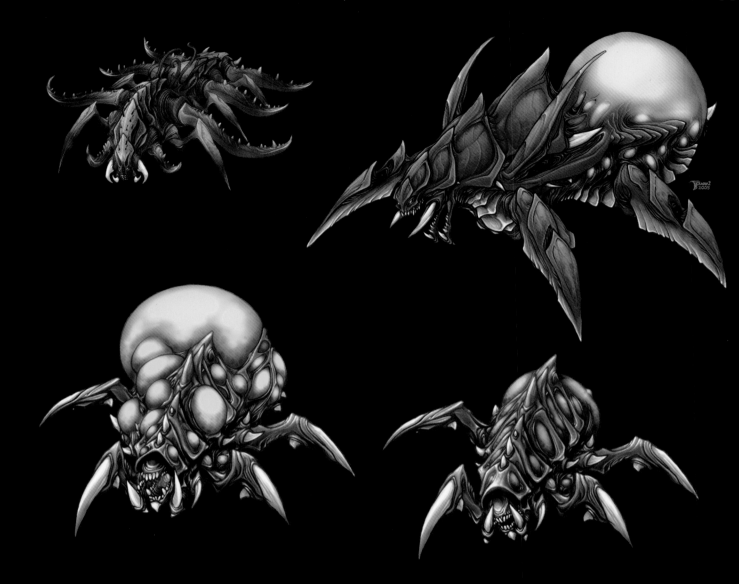

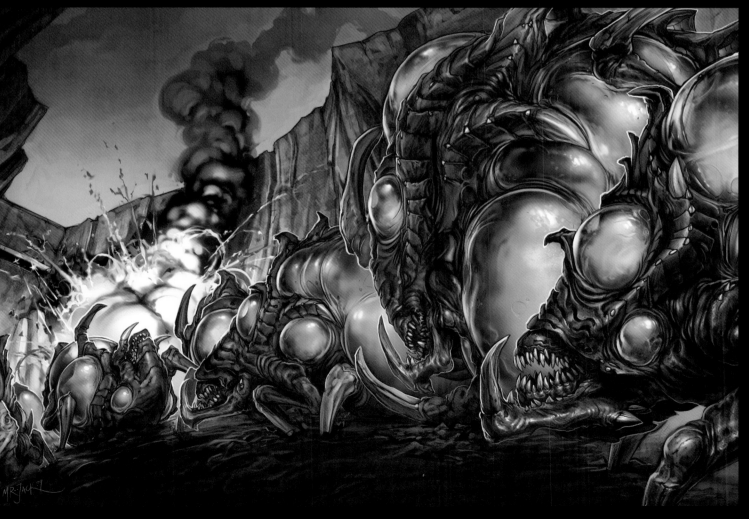

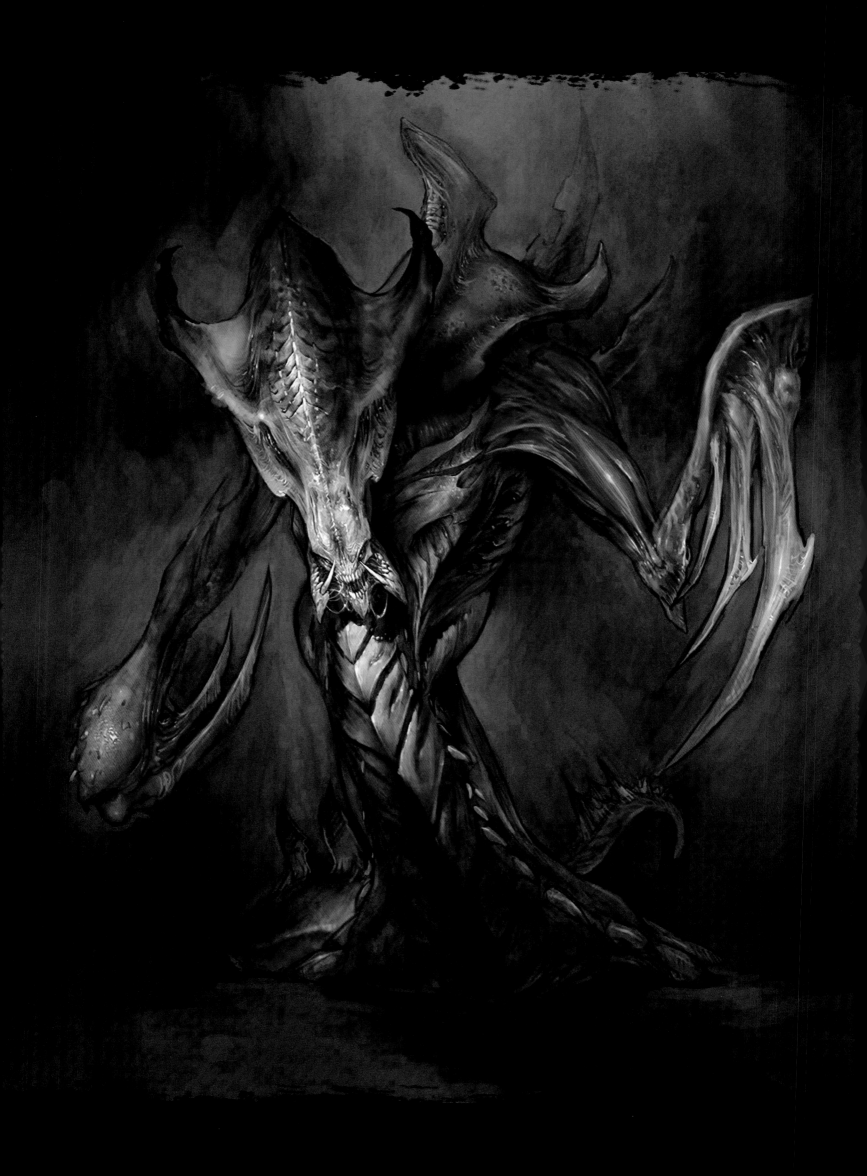

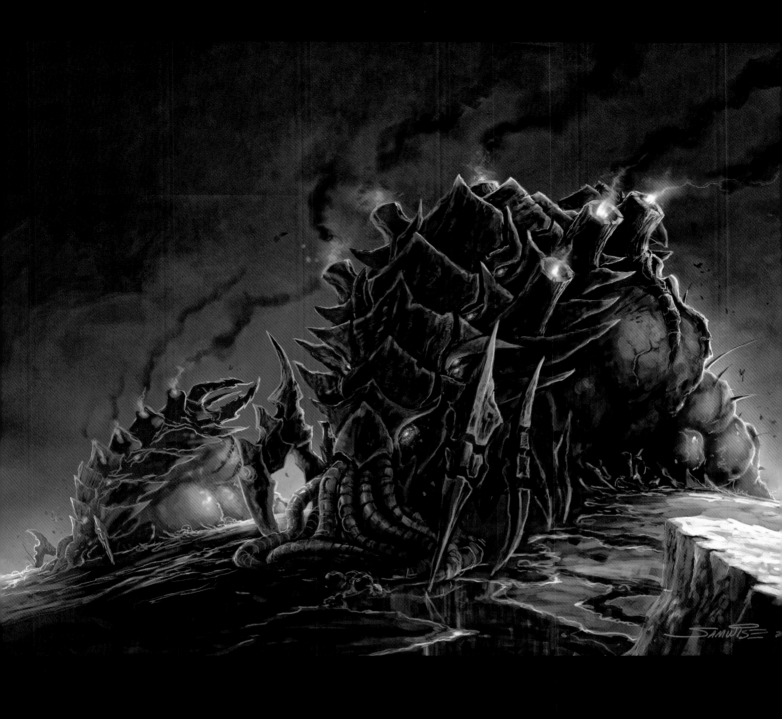

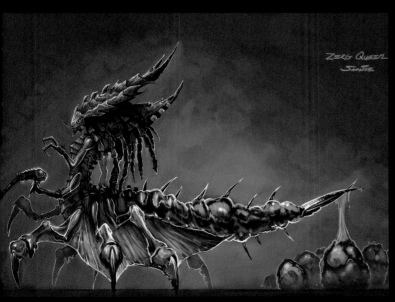

ZERG QUEEN
SAMWISE

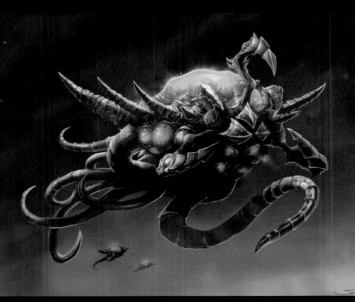

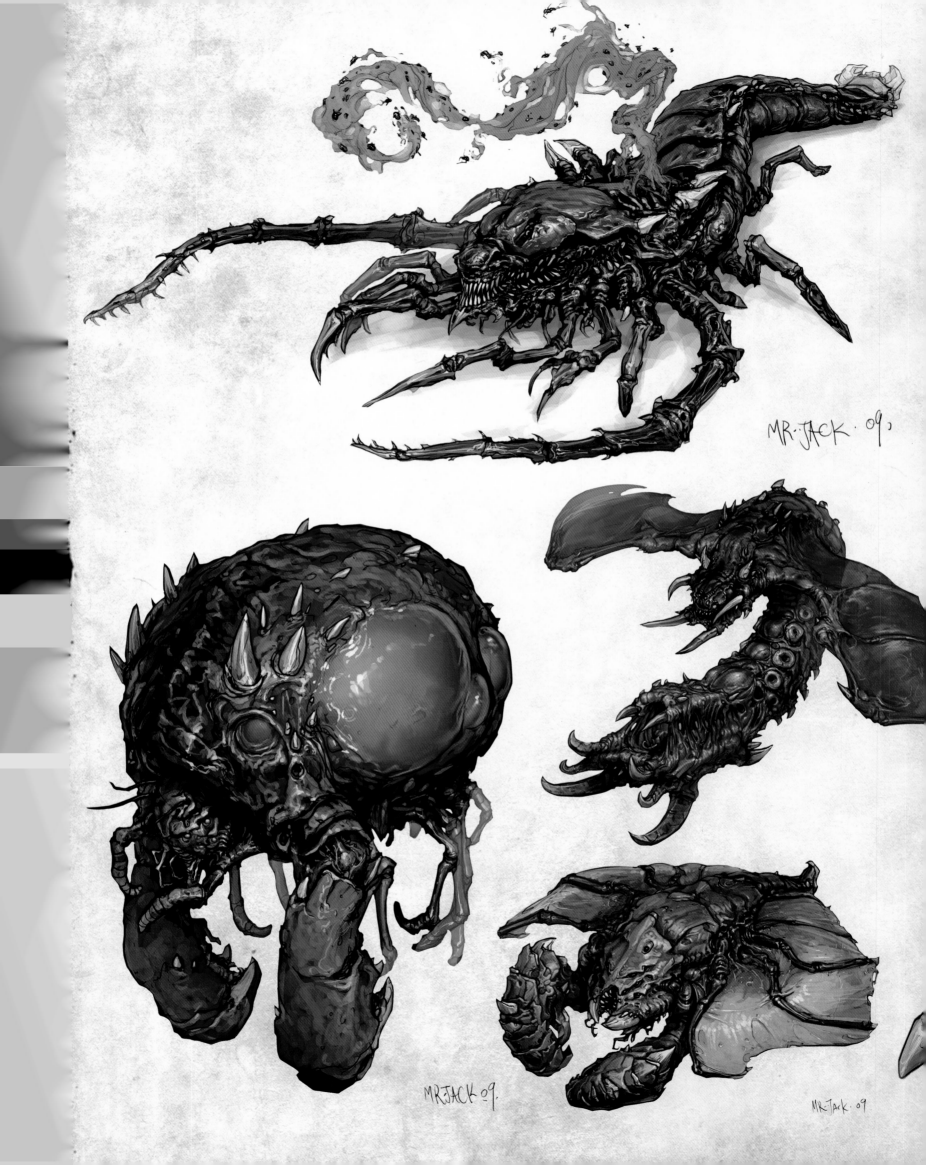

MR·JACK·09.

MR·JACK·09.

MR·JACK·09

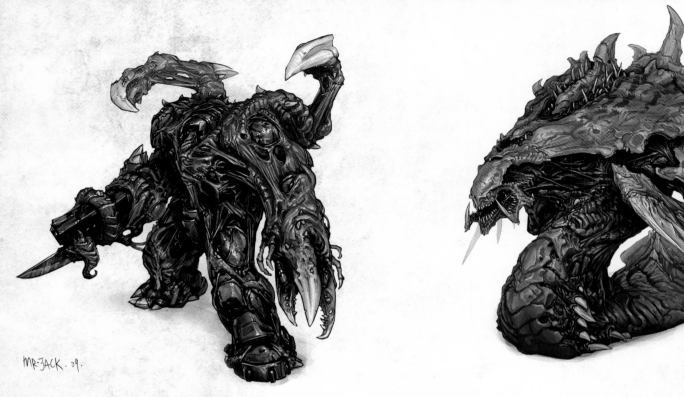

MR. JACK. 09.

"These were all done as fan art by a guy named Luke Mancini, who goes by the name Mr. Jack. He was just a fan of StarCraft, and every time we would come out with a concept for something, he would release fan art of it that just blew ours out of the water. We saw the passion that he had for StarCraft and we said, 'We need to get this guy on our team.' Now he's working on the team and it's a perfect fit. You have a guy who's a fan of our artwork, and he draws like nobody else. It's a Cinderella story."

—Samwise Didier

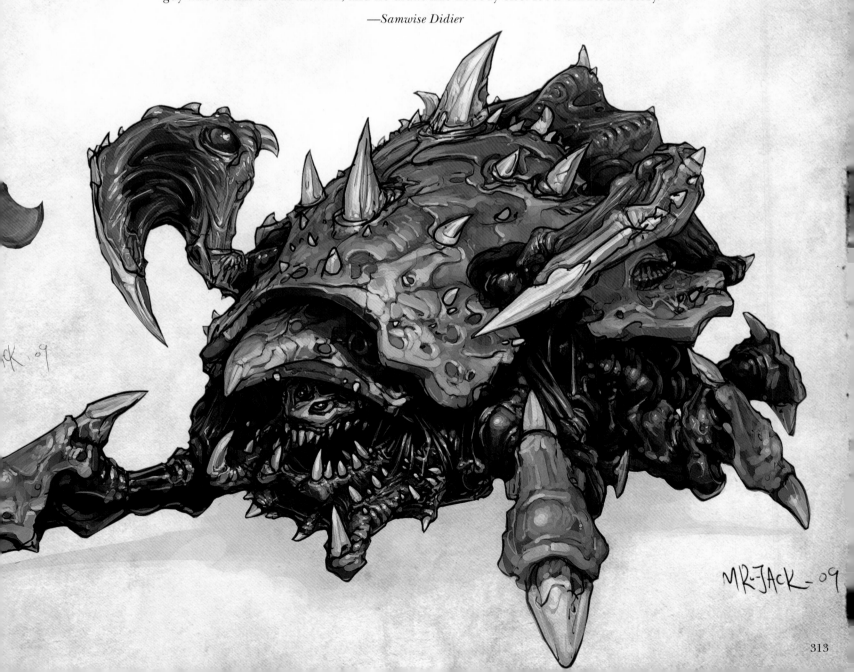

MR. JACK. 09

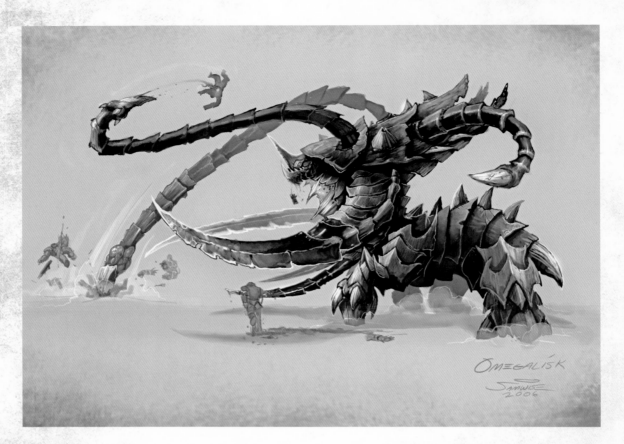

"A concept of an omegalisk, which was basically an ultralisk that had tentacles that flew out and impaled things. We had that playable in the game for a lot of our early development, and it was ruled that it was just too powerful and random. It diluted the dynamic of the zerg army to have an ultralisk that also had a ranged attack, so we cut that from the game."

—*Samwise Didier*

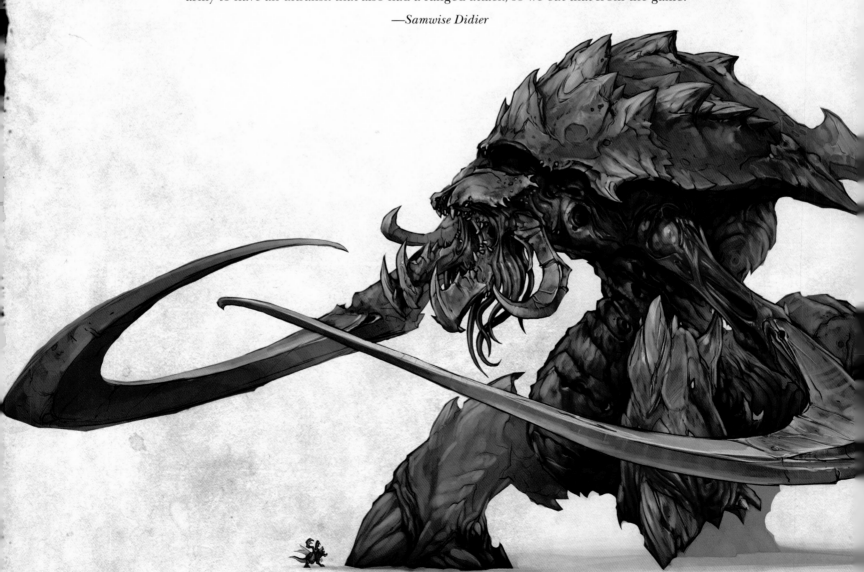

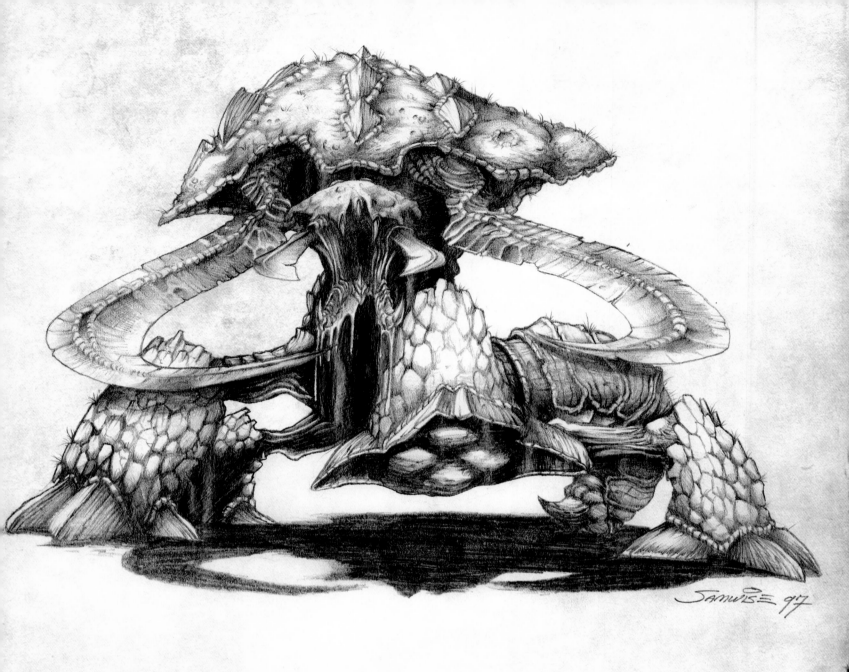

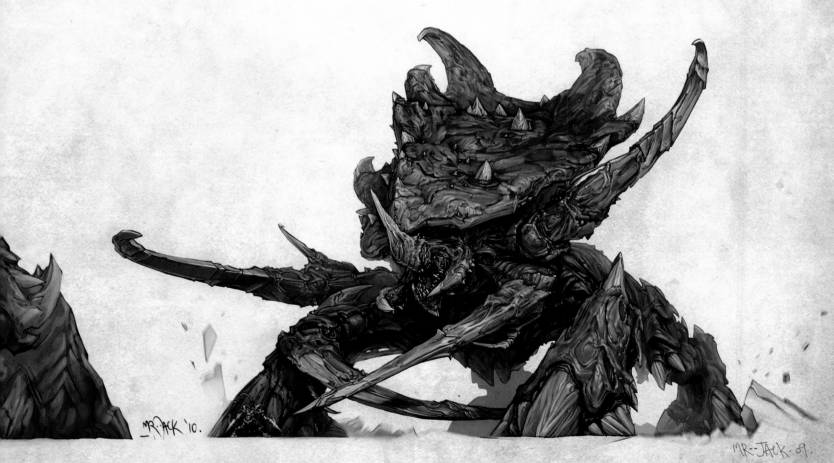

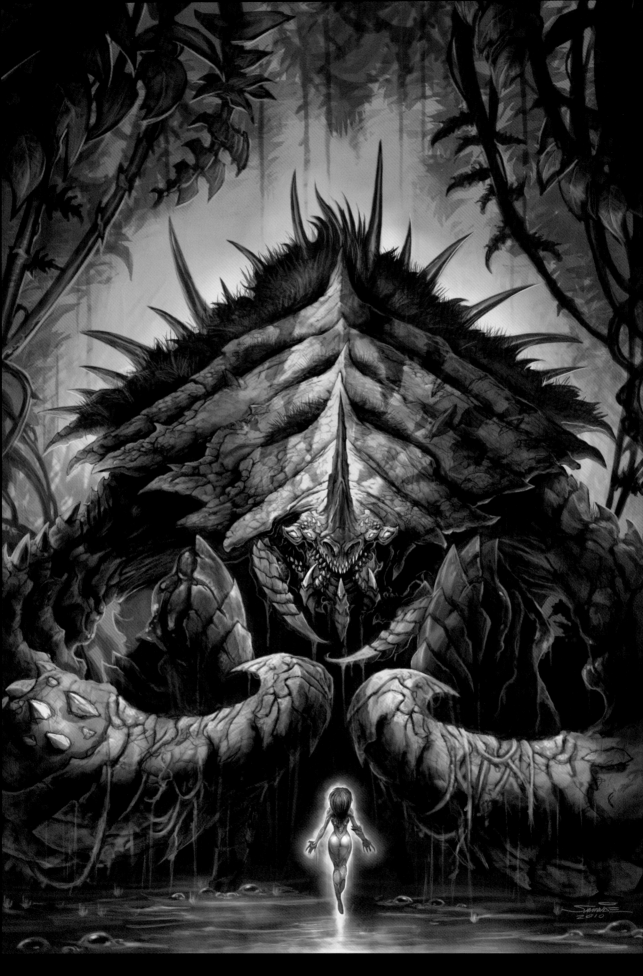

"This was the first image done to pitch the idea of Kerrigan returning to the zerg homeworld of Zerus. She's in her ghost outfit, and she's in front of Zurvan, the most ancient being on Zerus. It shows her standing in front of him, staring him down, and him looking down at her going, 'Who the hell is this little girl?' And her looking back going, 'I'm the Queen of Blades, damn it. Bow down.'"

—*Samwise Didier*

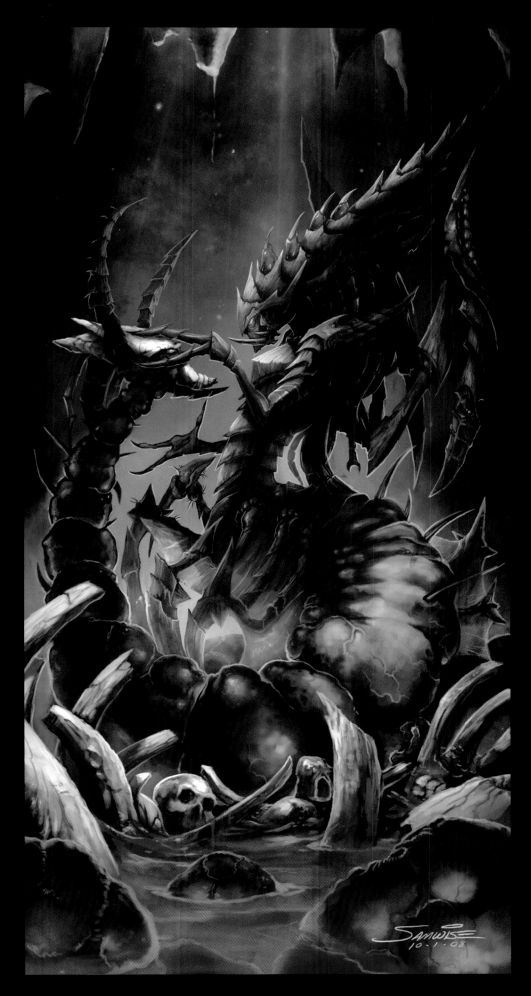

"One of the first real interpretations we had of a new zerg unit called The Queen. We had a queen in *StarCraft I*, but these new ones are totally different: They heal your buildings and units. They help production for your zerg eggs. They spread creep. So these things became integral to your zerg army, and one of the cool things about them is they are the protectors of your base. Whenever terrans come in, you know that you always have queens there to help defend."

—*Samwise Didier*

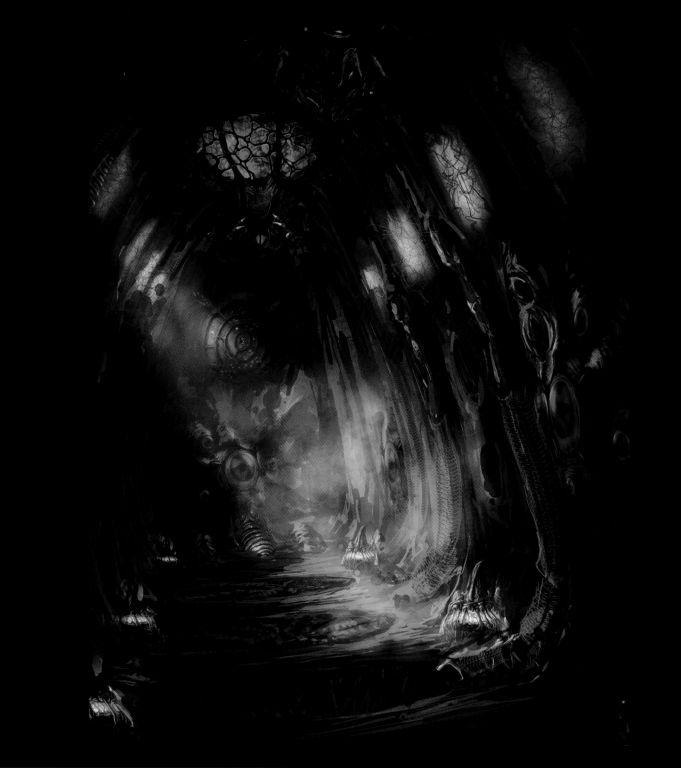
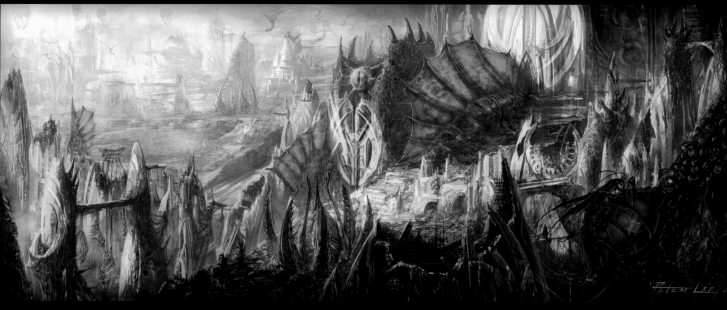

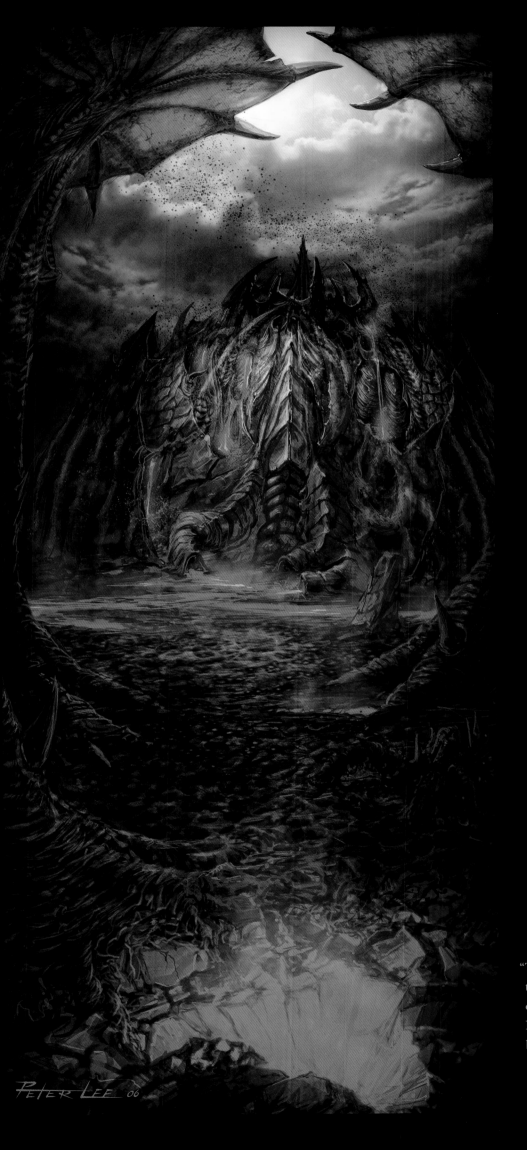

"The architecture in
the zerg homeworld
of Char by Peter Lee.
Not your typical zerg
buildings."

—Samwise Didier

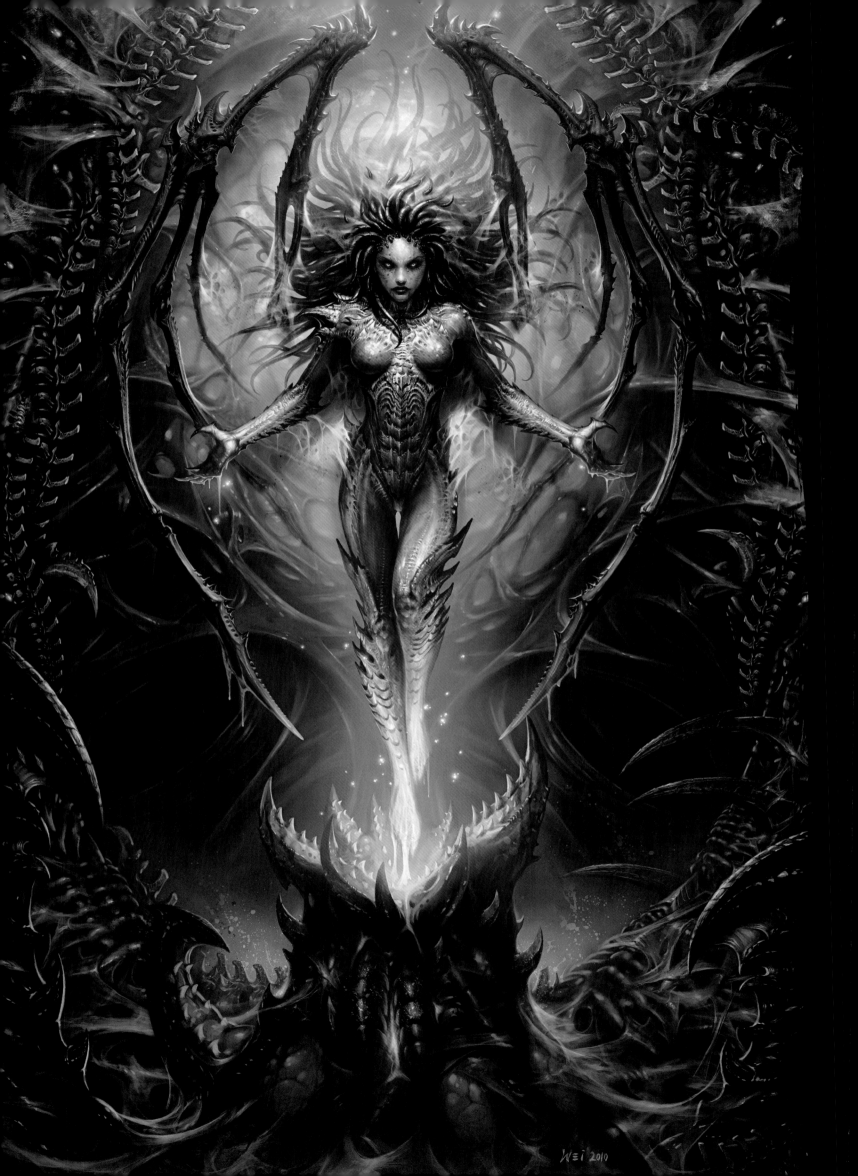

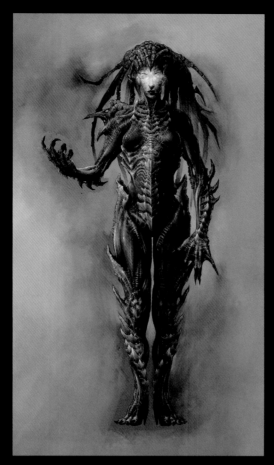
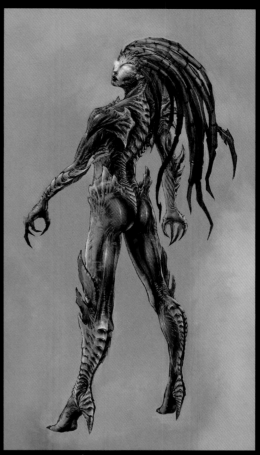

"One of our first concepts for what Kerrigan would look like for *Wings of Liberty*. We hadn't really drawn a full official Kerriga and since she was gonna be one of our main bad guys in *Wings of Liberty*, we needed to come up with what she looked like. Th was done by Joe Peterson. Everyone always gives us hell because she's a zerg queen and she's got zerg high heels on. Again, that was one of the things where we were like, 'Screw that. We want zergling with wings. We want Kerrigan in high heels.'"

—*Samwise Didier*

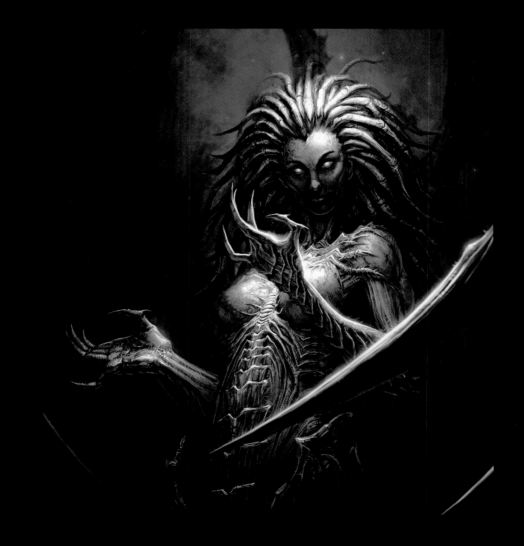

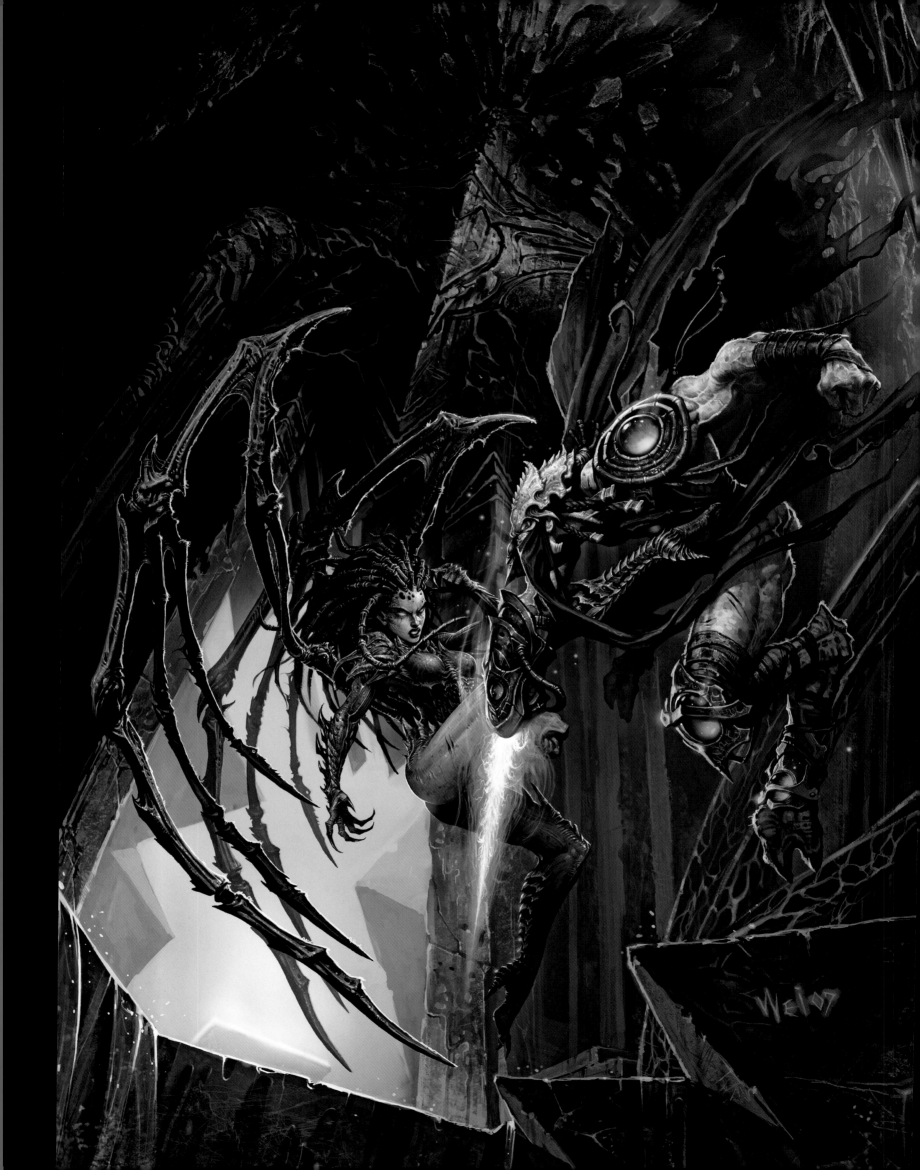

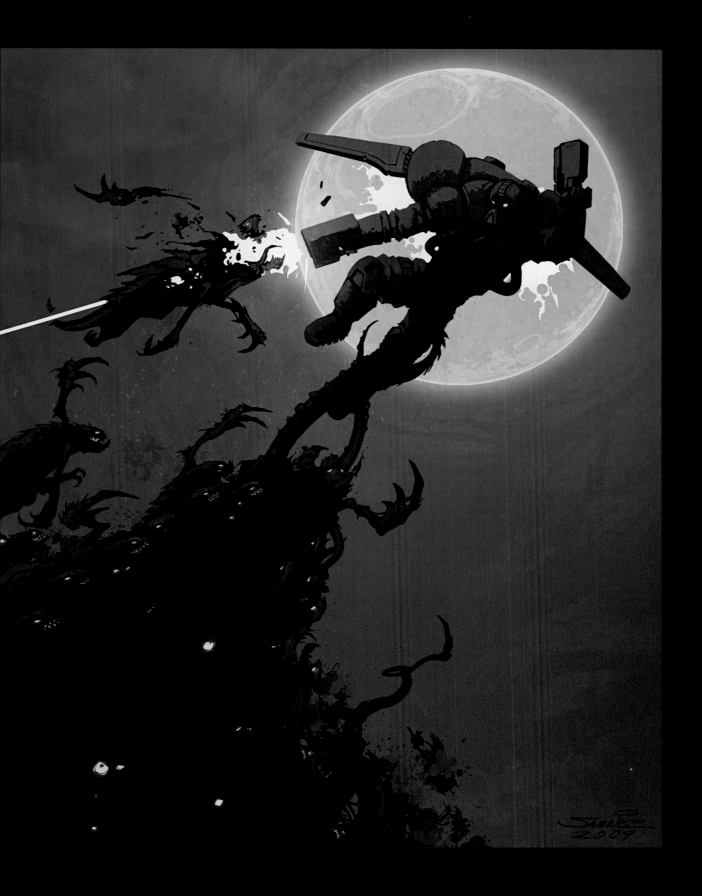

"A concept that was done for Blizzard's silent auction at BlizzCon. It shows
the swarm of zerglings running up and taking out a terran reaper, which is
one of our new units in *StarCraft II*. The title of the picture is *Gotcha!*"
—*Samwise Didier*

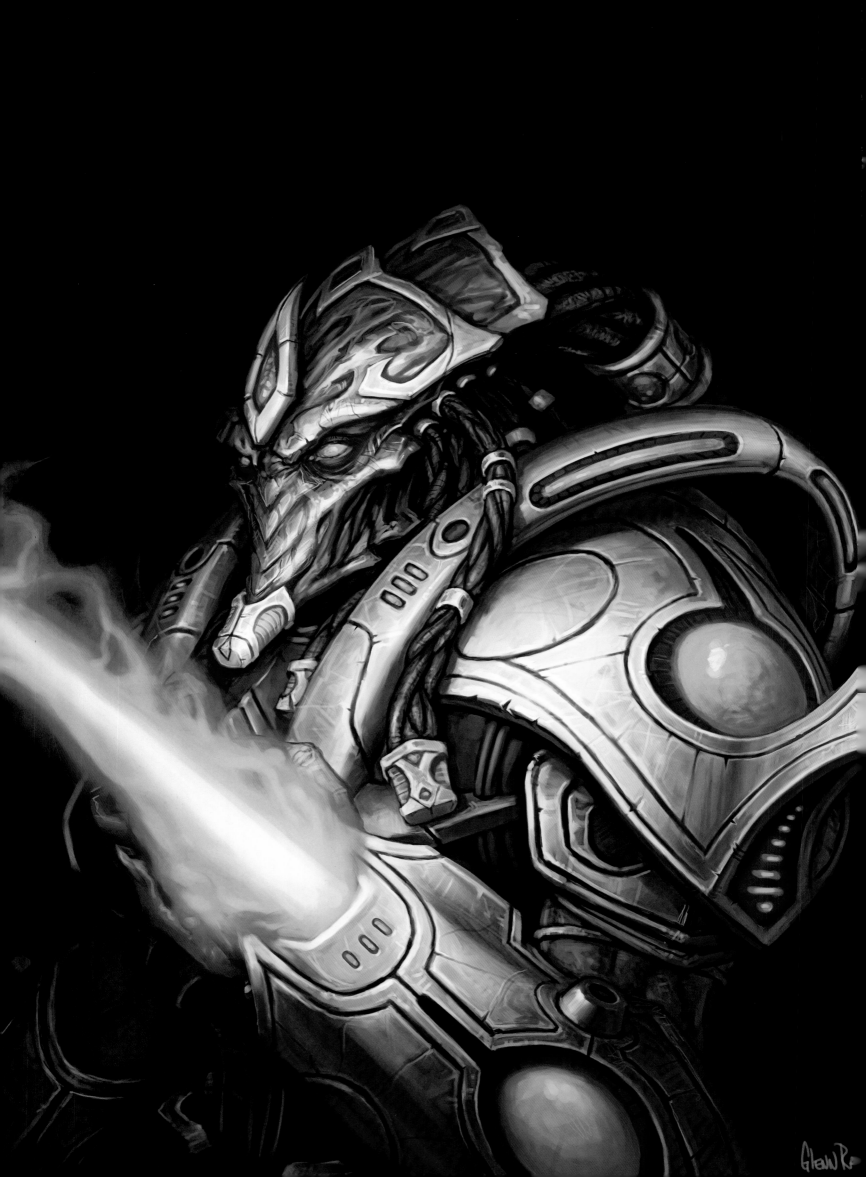

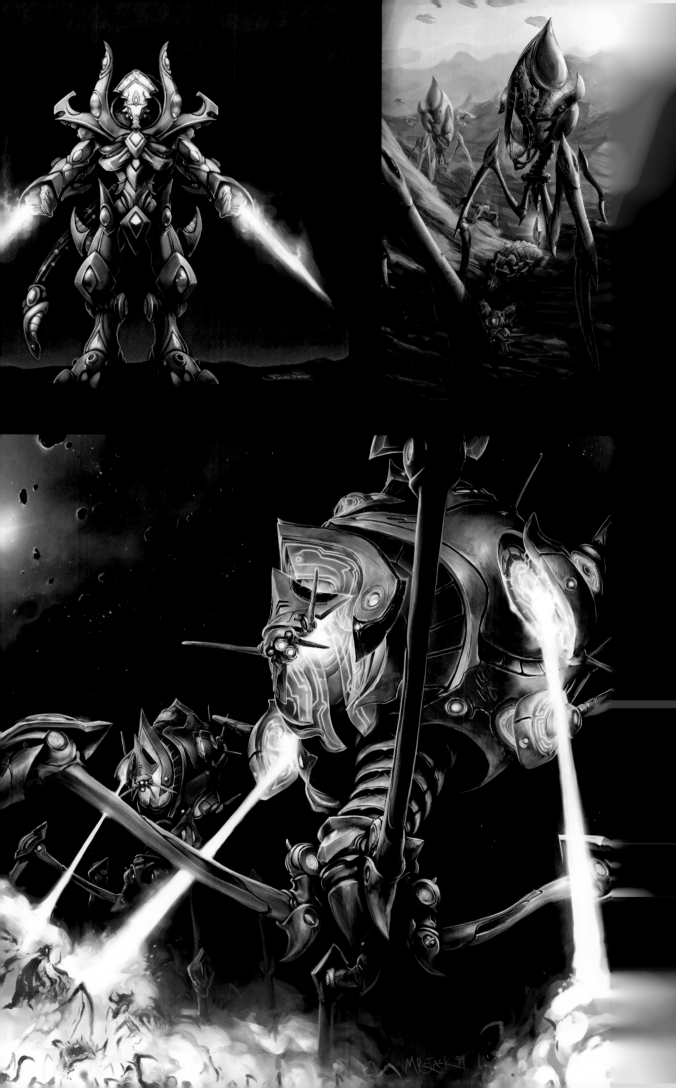

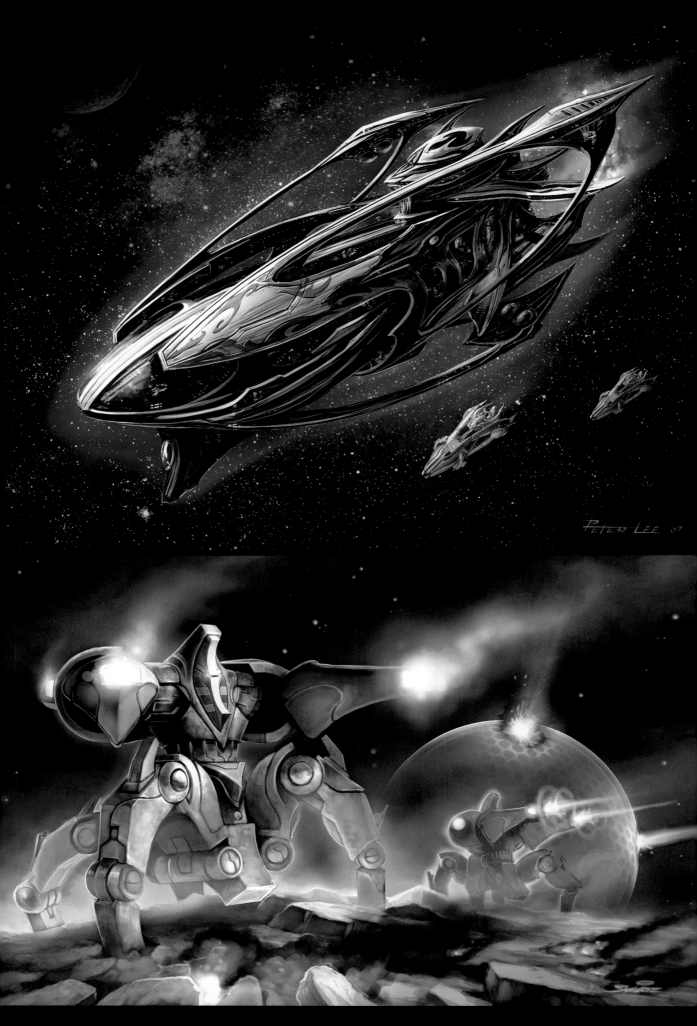

"The protoss immortal. This was a new unit. Everybody really loved the design of the protoss dragoon, and we removed it from the game in *StarCraft II*, but I wanted to carry some of that giant golden walker into the protoss army. It was a simple enough task of just adding a torso to it. The dragoon before was like a mechanical spider; this guy is like a mechanical centaur and he is just a ball whomper."

—*Samwise Didier*

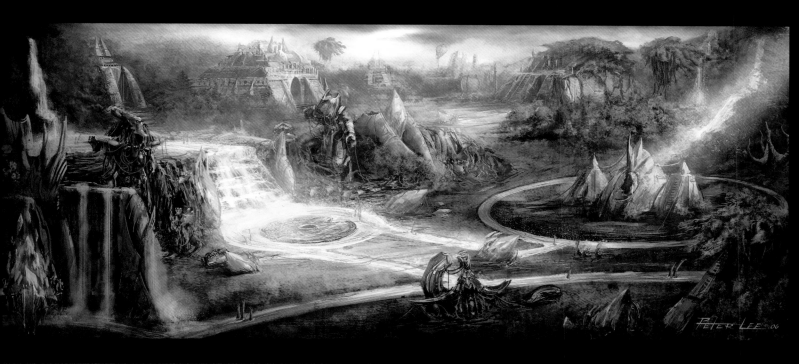

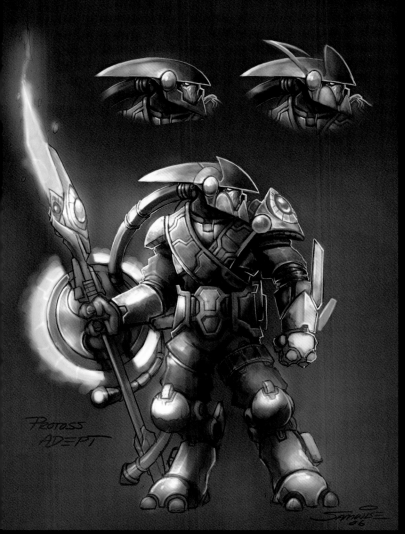

PROTOSS ADEPT

"A dead unit. This one was called the adept, and it was one of our interpretations of what a basic protoss unit could look like for *StarCraft II*. We never used this design. Instead, we went back to all of our original designs because there was really no need to change it. You want to keep some of the basic units the same so people can remember what they loved. I use the saying, 'You don't want to change Darth Vader.'"
— *Samwise Didier*

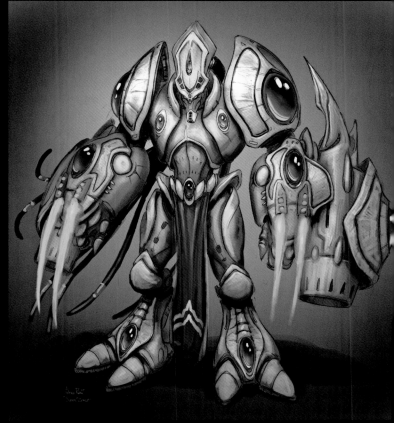

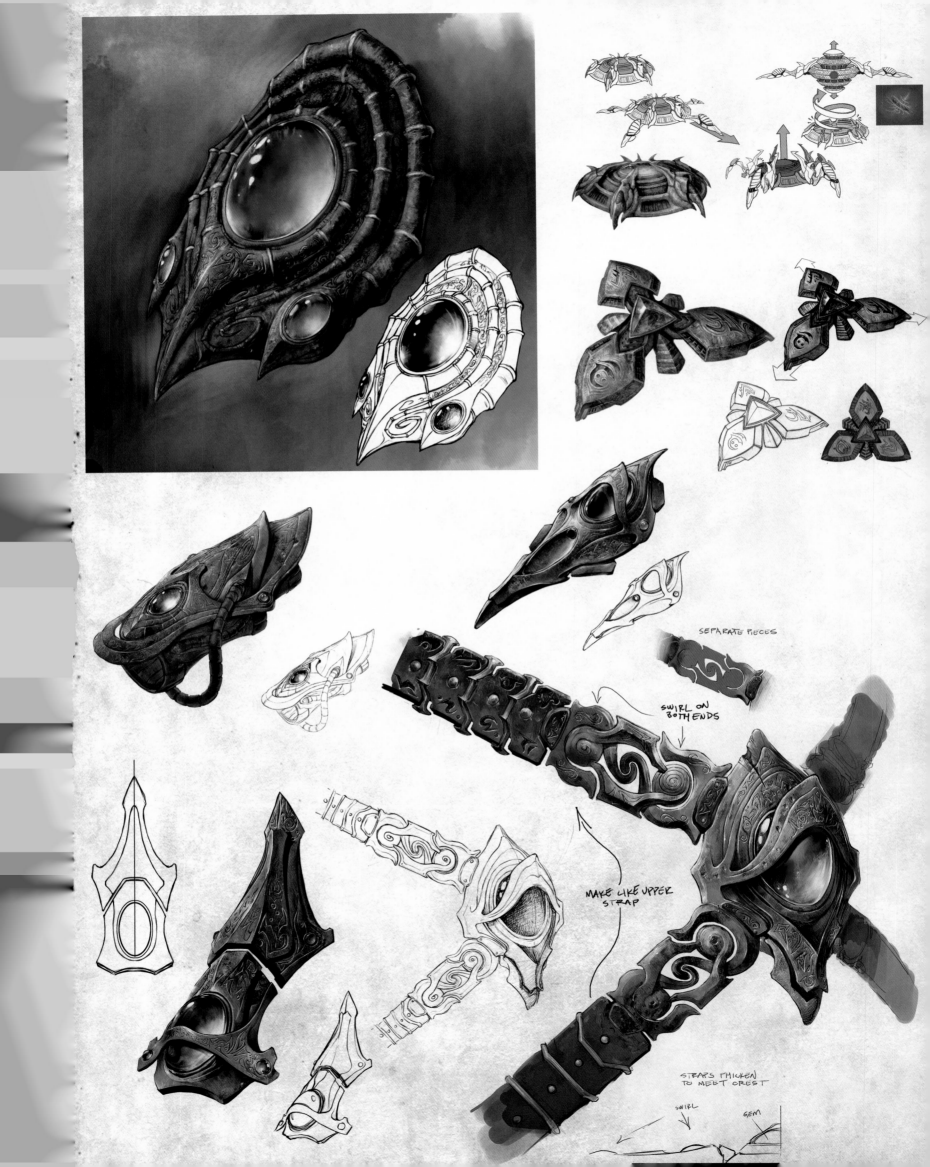

SEPARATE PIECES

SWIRL ON
BOTH ENDS

MAKE LIKE UPPER
STRAP

STRAPS THICKEN
TO MEET CREST

SWIRL GEM

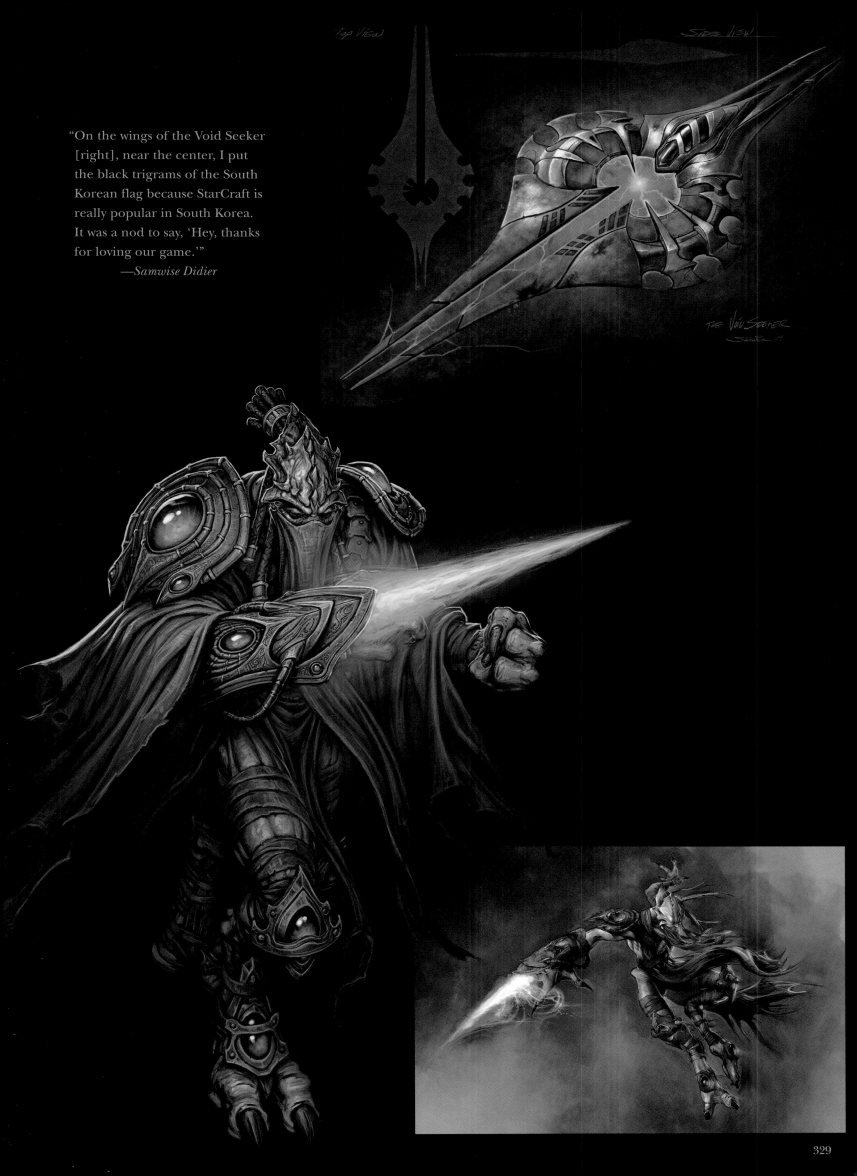

"On the wings of the Void Seeker [right], near the center, I put the black trigrams of the South Korean flag because StarCraft is really popular in South Korea. It was a nod to say, 'Hey, thanks for loving our game.'"
—*Samwise Didier*

The Void Seeker

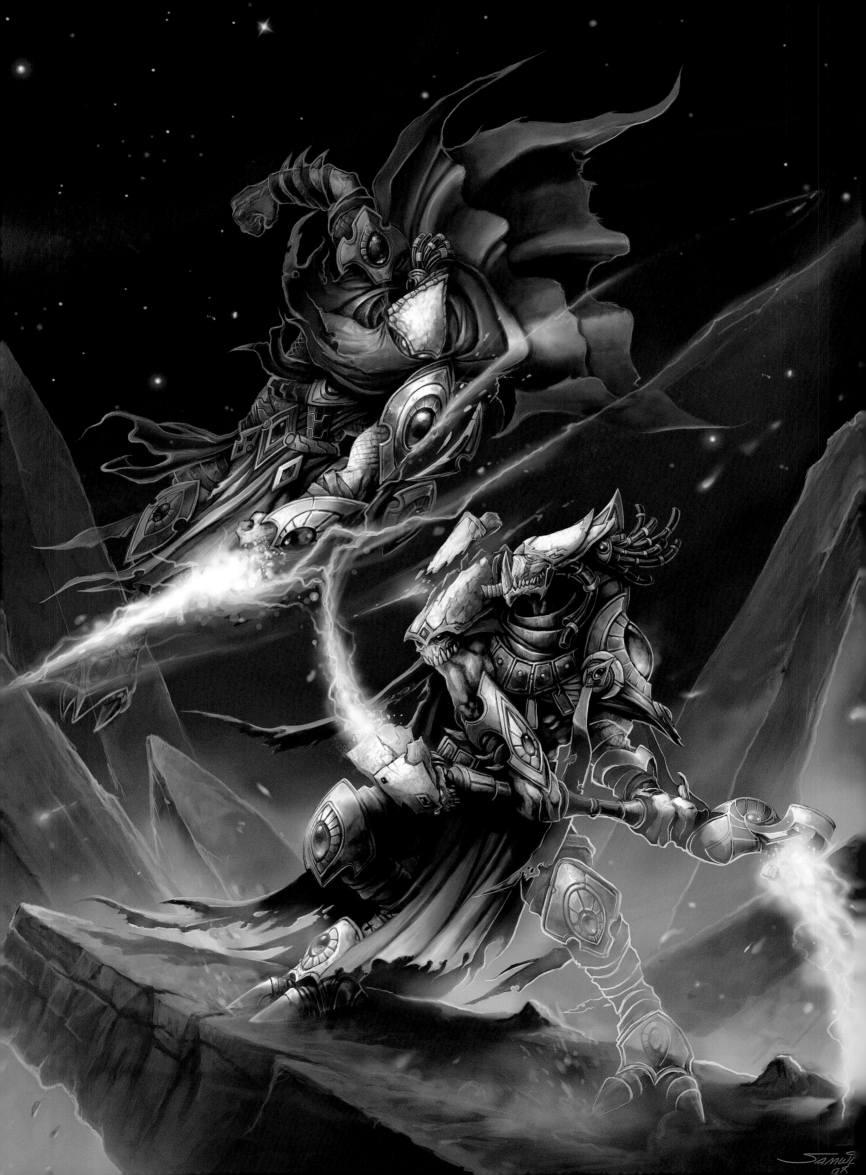

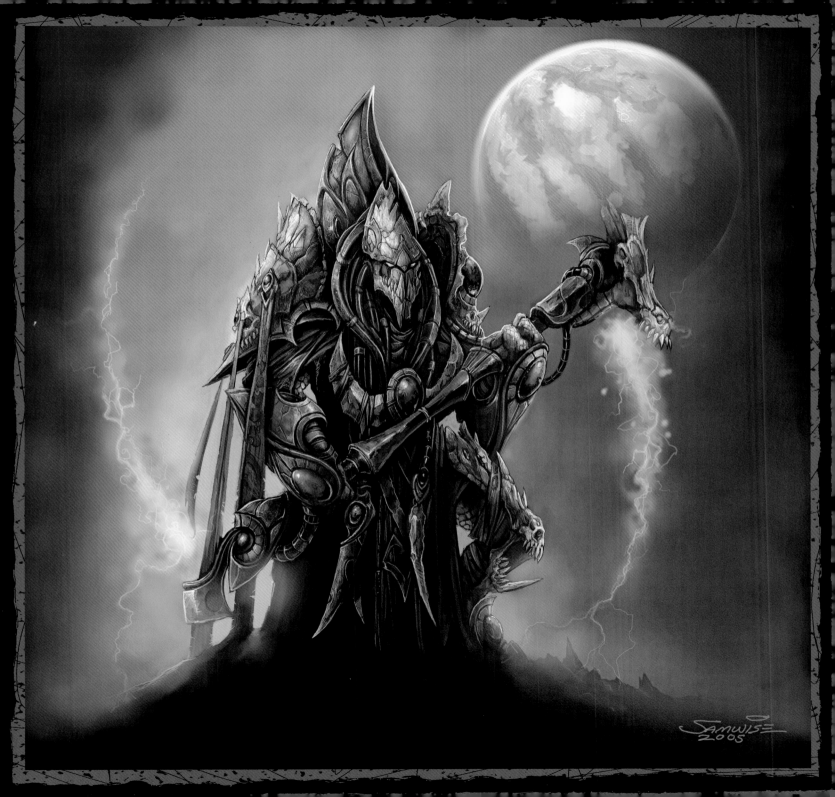

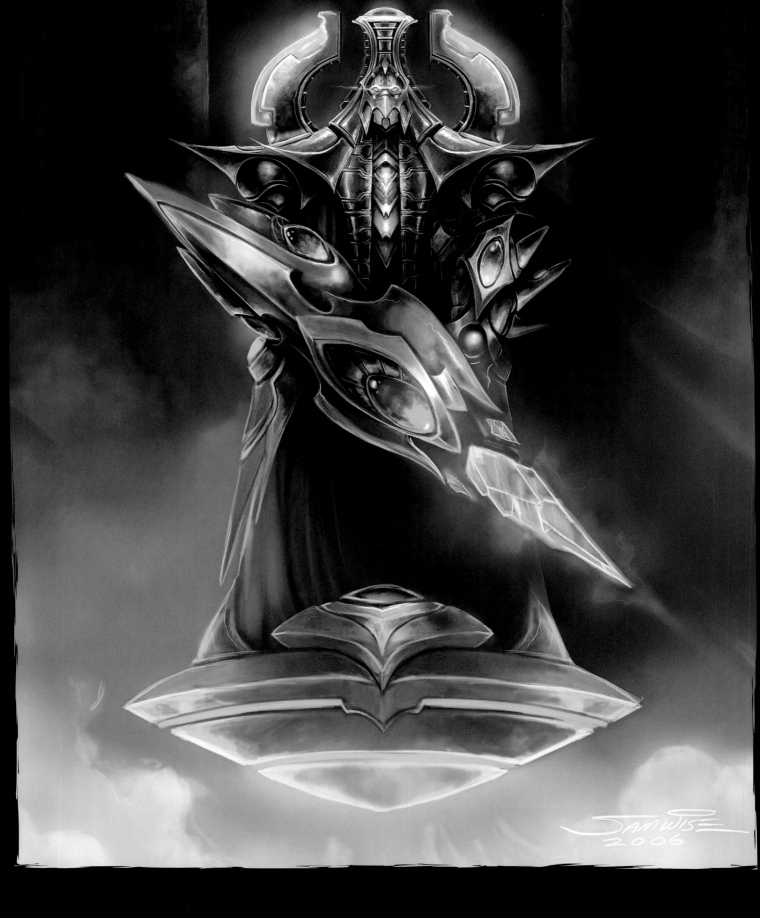

"An image of a unit called the purifier, which never went up. He got replaced by the immortal. But it's a favorite of some of the people here at Blizzard because we have the artwork on some of our walls. We actually lifted its name and that's what we call our mothership now."

—*Samwise Didier*

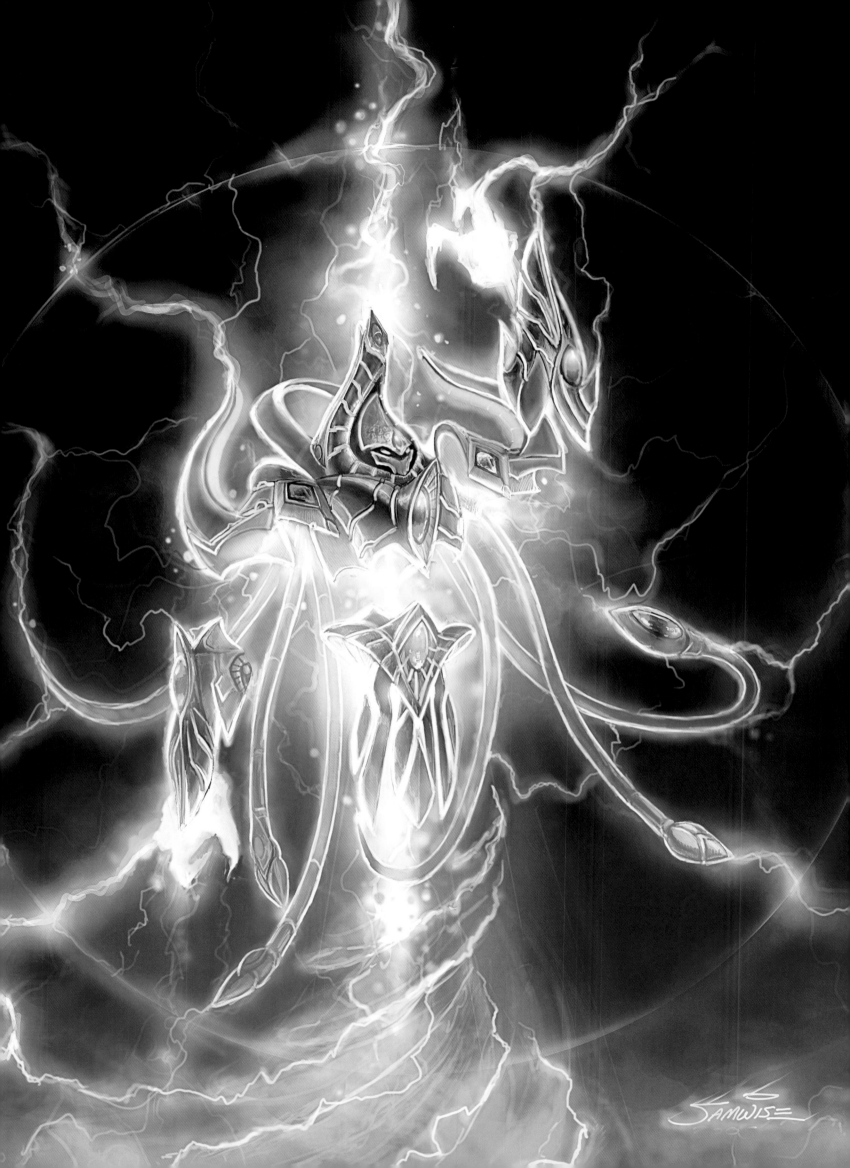

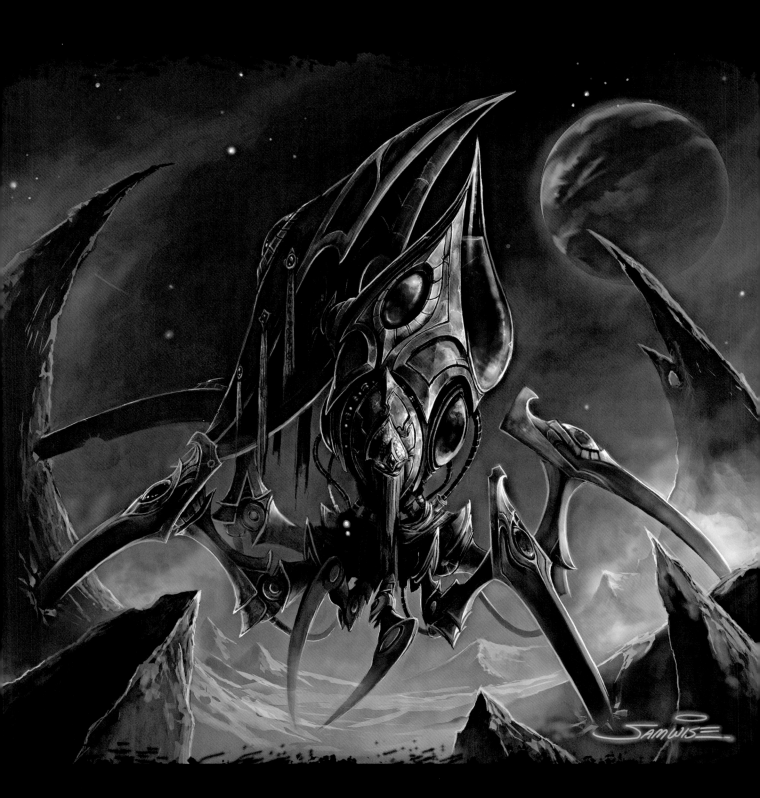

"When we were talking about changing up and making *StarCraft II* a little bit different than the original one, we removed the dragoon and replaced it with a dark templar version of it. What you see here is the stalker, and the stalker is everything the dragoon was not. The stalker is light and agile whereas the dragoon was powerful and sturdy and could march into battle. These stalkers blink around the battlefield, and you really have to be quick to catch these guys. It still looks like some sort of a spider, but this one is more of a black widow and a little bit more lethal-looking than the dragoon, which was more stocky and thick."

—*Samwise Didier*

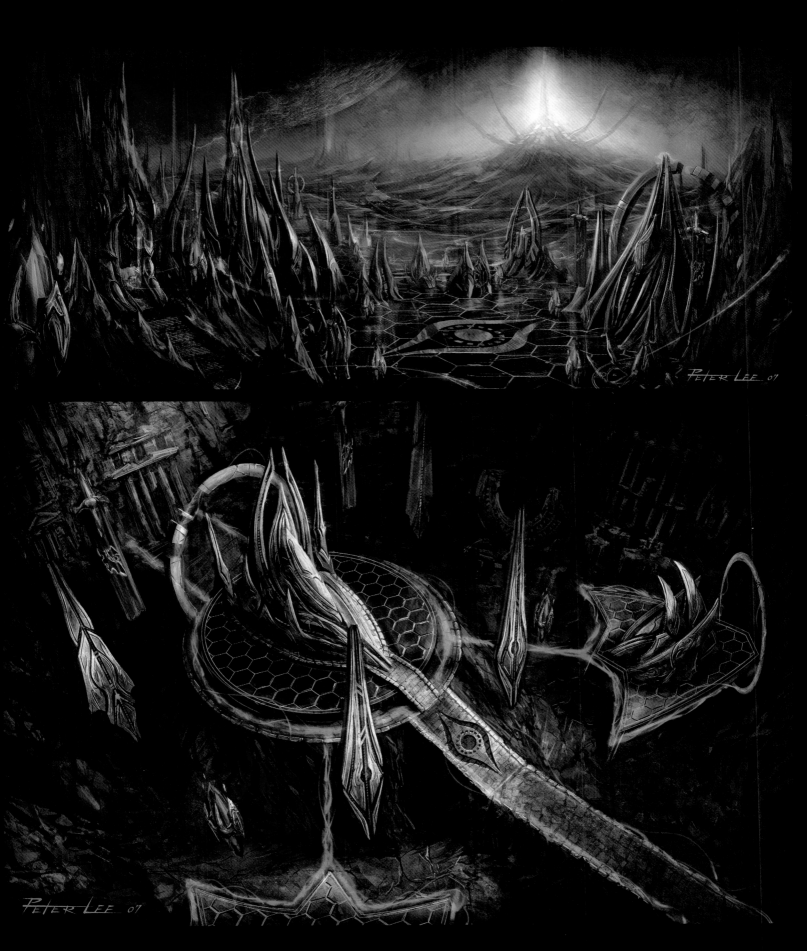

"Our first real concepts of Shakuras, the dark templar homeworld. We'd never really had a chance to draw that before, and going back to *StarCraft II* allowed us to flesh out some of these ideas. It looks very protoss, but they have a lot of purple and brass colors, where the protoss have blue and gold. It shows the symmetry between the two, but also their differences."

—*Samwise Didier*

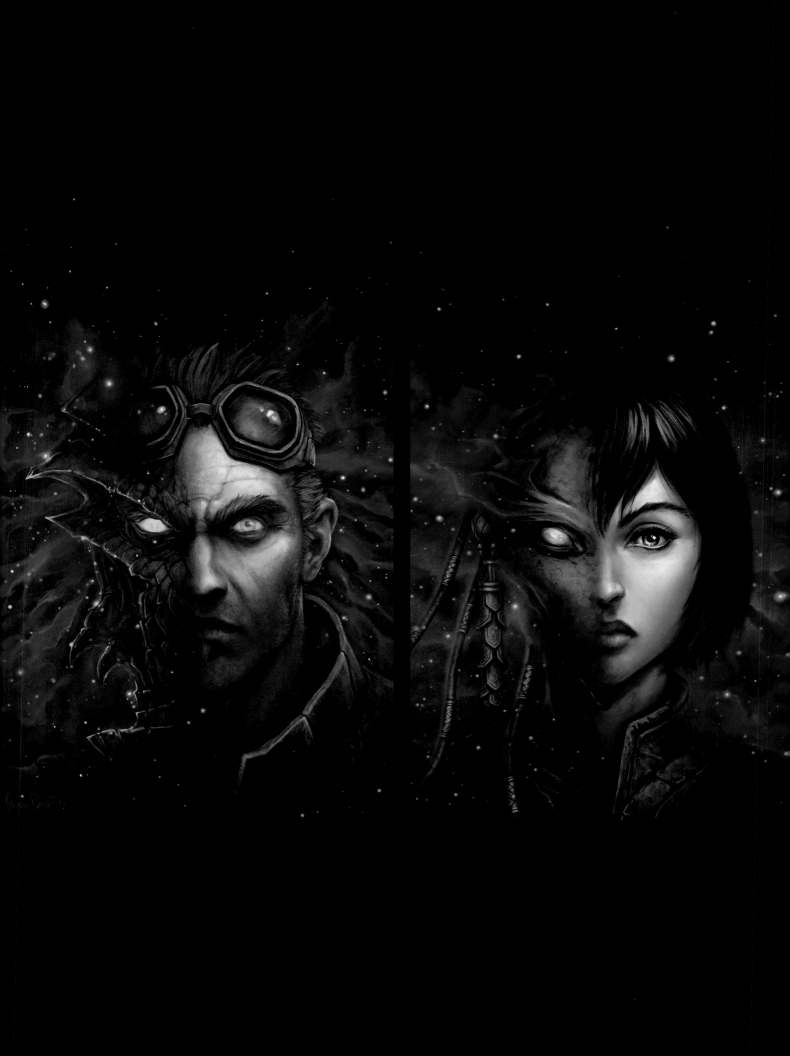

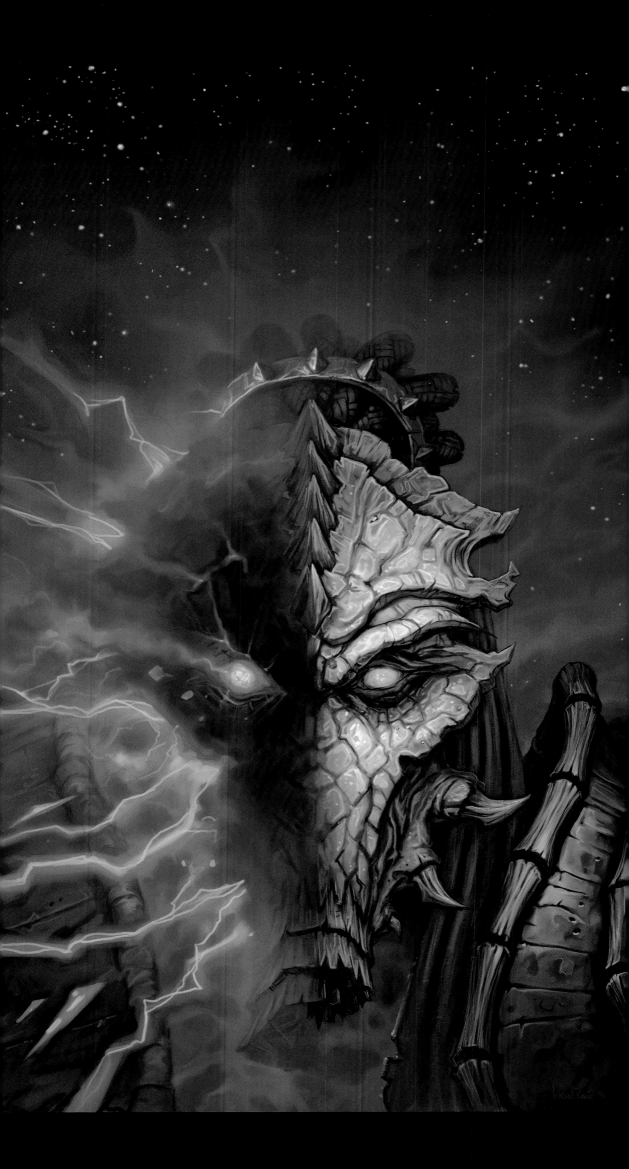

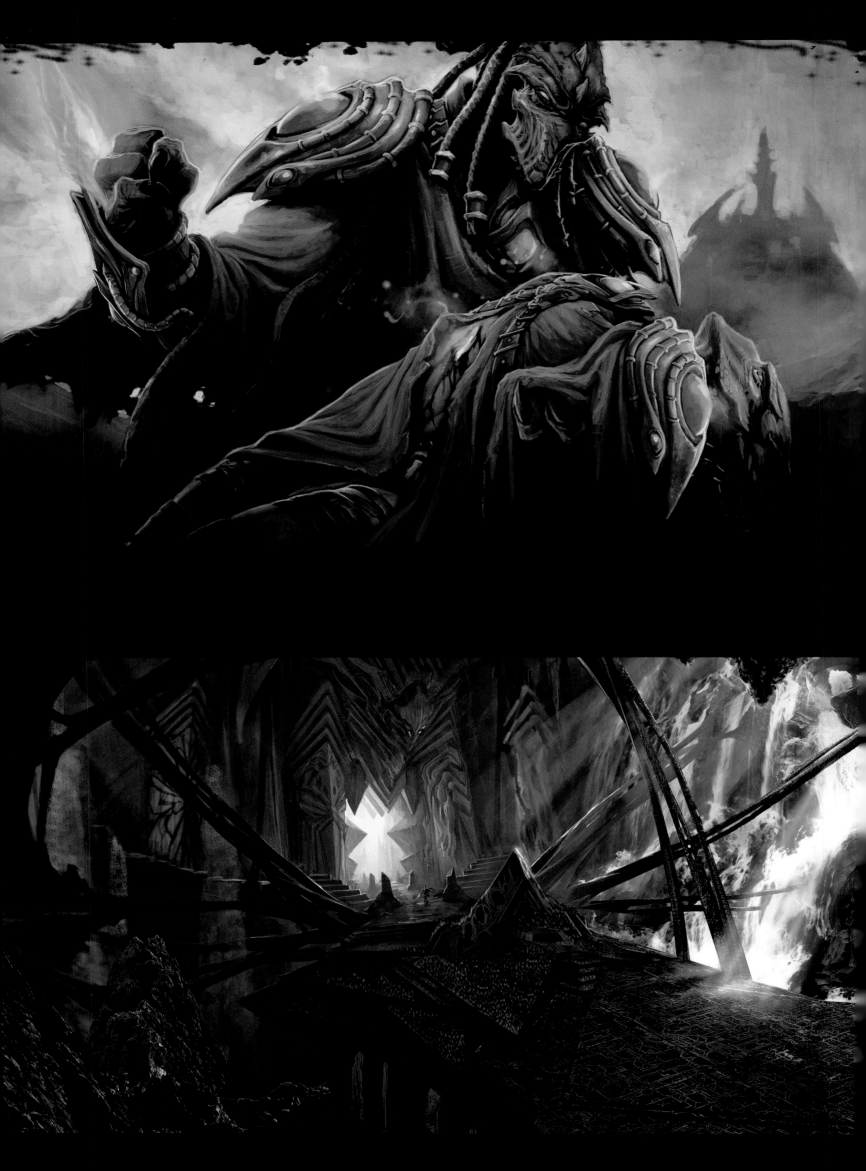

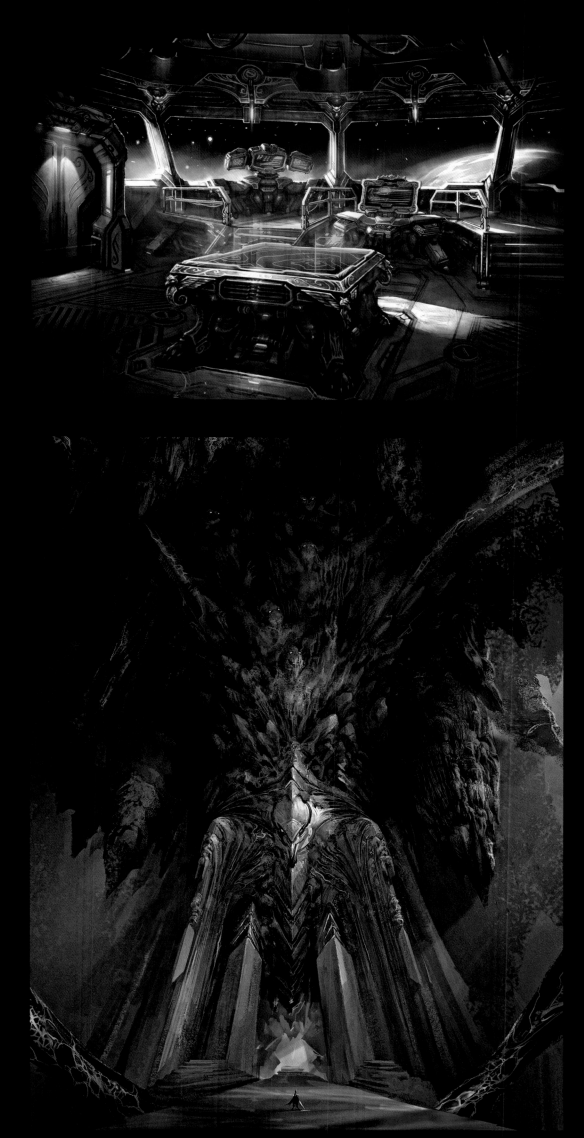

FALLEN GAMES

For years, gamers from around the world have explored the rich fantasy and science-fiction settings of Blizzard's Warcraft, Diablo, and StarCraft franchises. Ever eager for more, they have also often speculated about Blizzard's unreleased games. Blizzard spent the '90s creating brave new worlds and dreaming of other possibilities, including a number of novel game ideas and fictional settings. The company's artists and designers explored those ideas by venturing beyond the conceptual boundaries of its more established franchises. While, for various reasons, those game concepts never came to fruition, the concept art that defined them remains a lasting testament to Blizzard's formative vision. This collection, drawn from Blizzard's most secure, booby-trapped vaults, presents select pieces of concept art from the company's "games that never were."

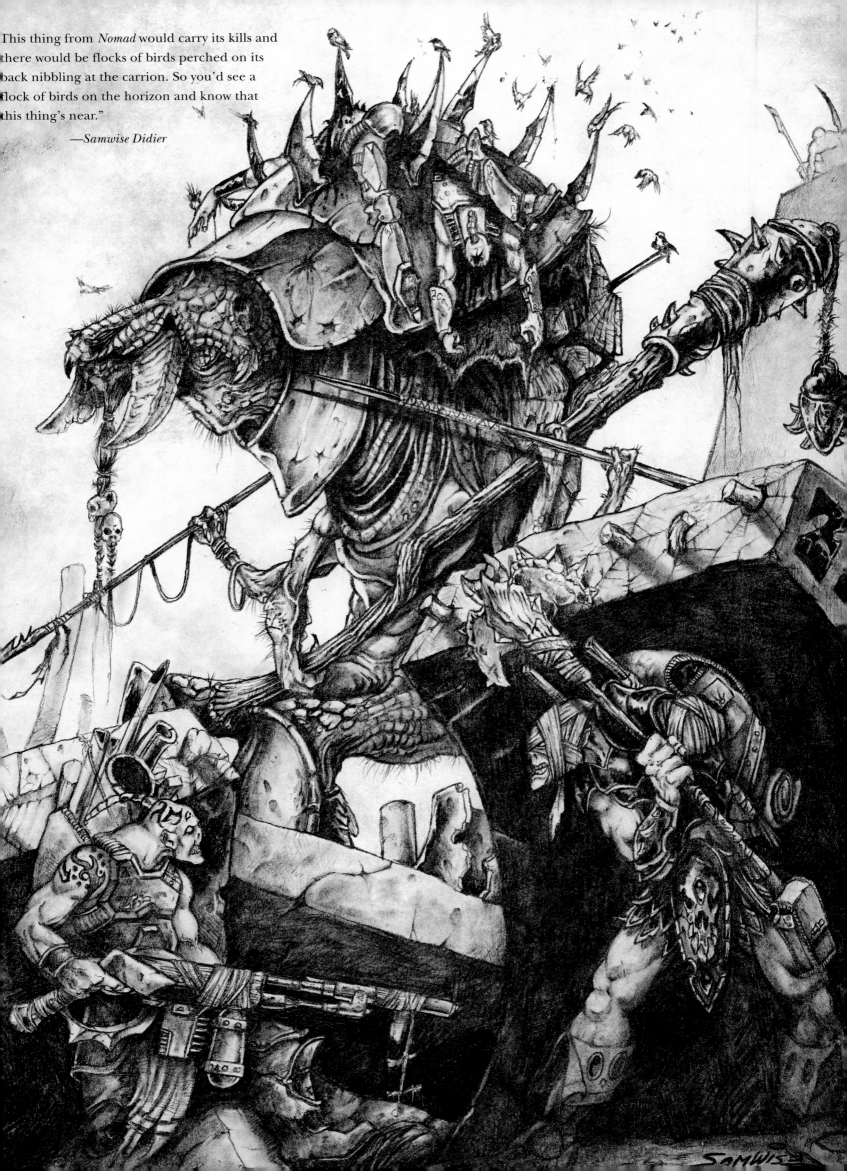

This thing from *Nomad* would carry its kills and there would be flocks of birds perched on its back nibbling at the carrion. So you'd see a flock of birds on the horizon and know that this thing's near."

—*Samwise Didier*

NOMAD

Nomad was a very ambitious action-RPG concept that was developed during the late '90s. It was set in a dying postapocalyptic world filled with diseased mutants, sand-blasted cyborgs, and malevolent arcana. The setting revolved around an eternal war between powerful overlords who fought to enslave the world's dwindling cultures and precious resources. While the game's core system design never quite coalesced, Blizzard was left with some cool world-hooks and distinctive character designs. *Nomad* was probably one of the darkest settings Blizzard conceptualized over the years, but many of its world concepts wound up bleeding into the less-traveled corners of Azeroth . . .

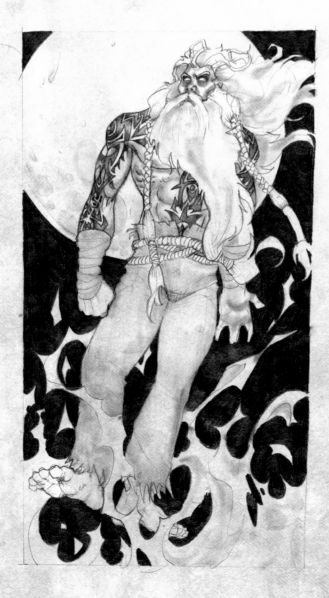

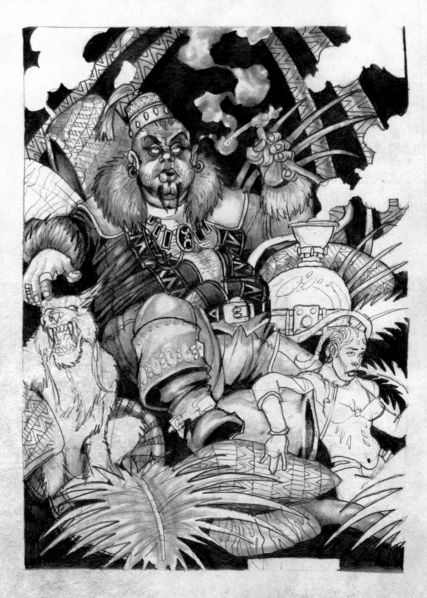

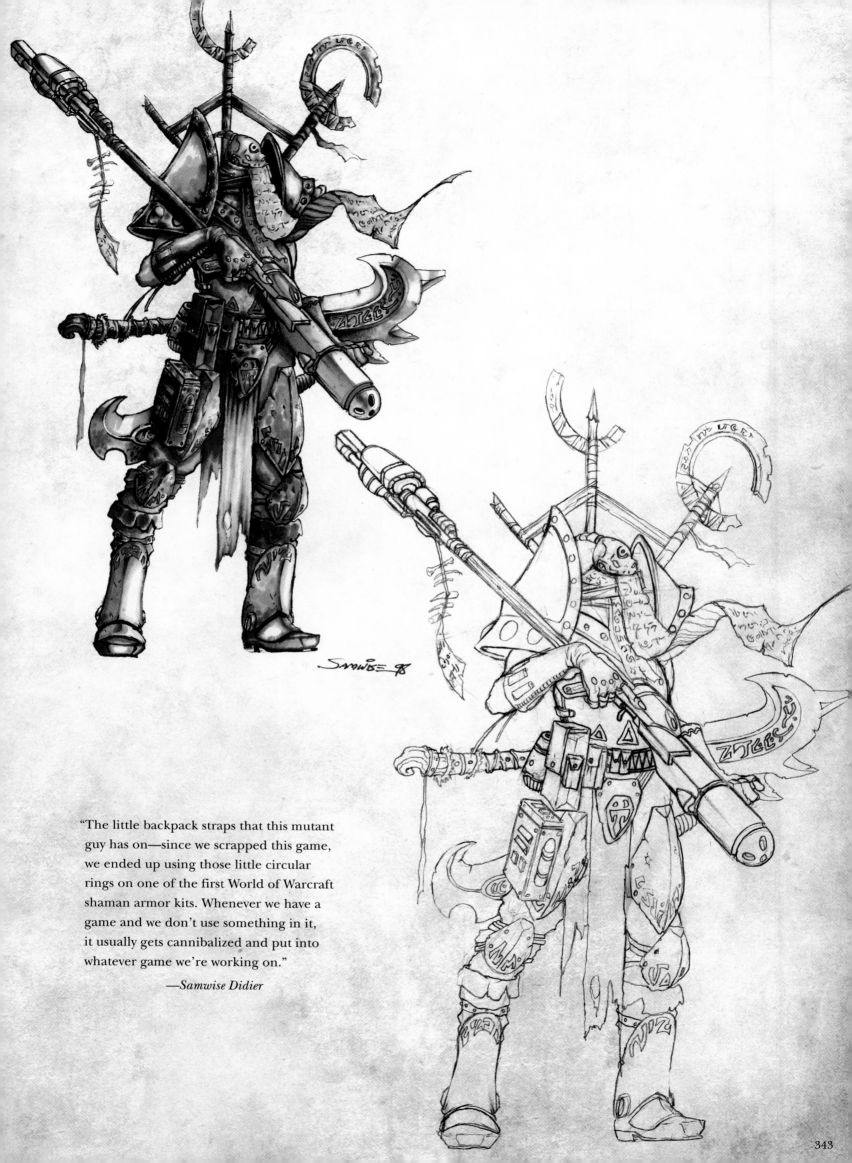

"The little backpack straps that this mutant guy has on—since we scrapped this game, we ended up using those little circular rings on one of the first World of Warcraft shaman armor kits. Whenever we have a game and we don't use something in it, it usually gets cannibalized and put into whatever game we're working on."

—*Samwise Didier*

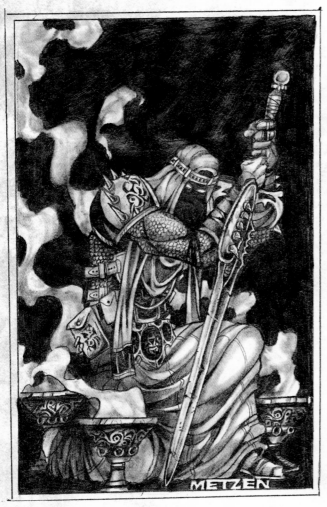

THE INQUISITOR

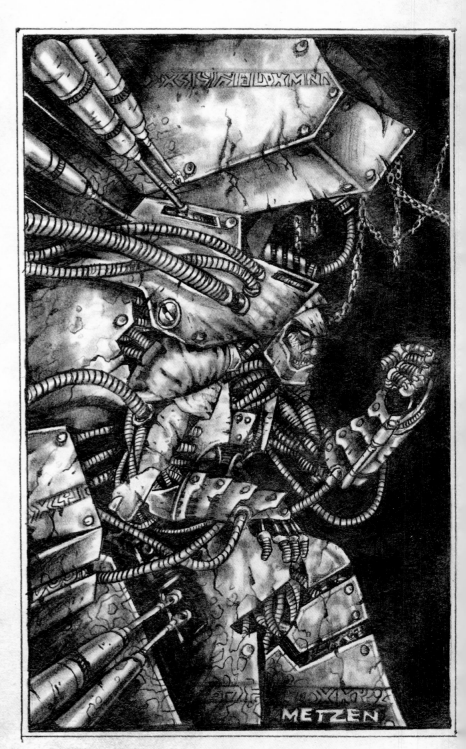

THE MACHINE

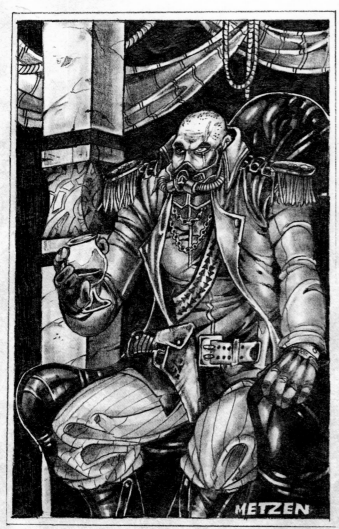

THE GENERAL

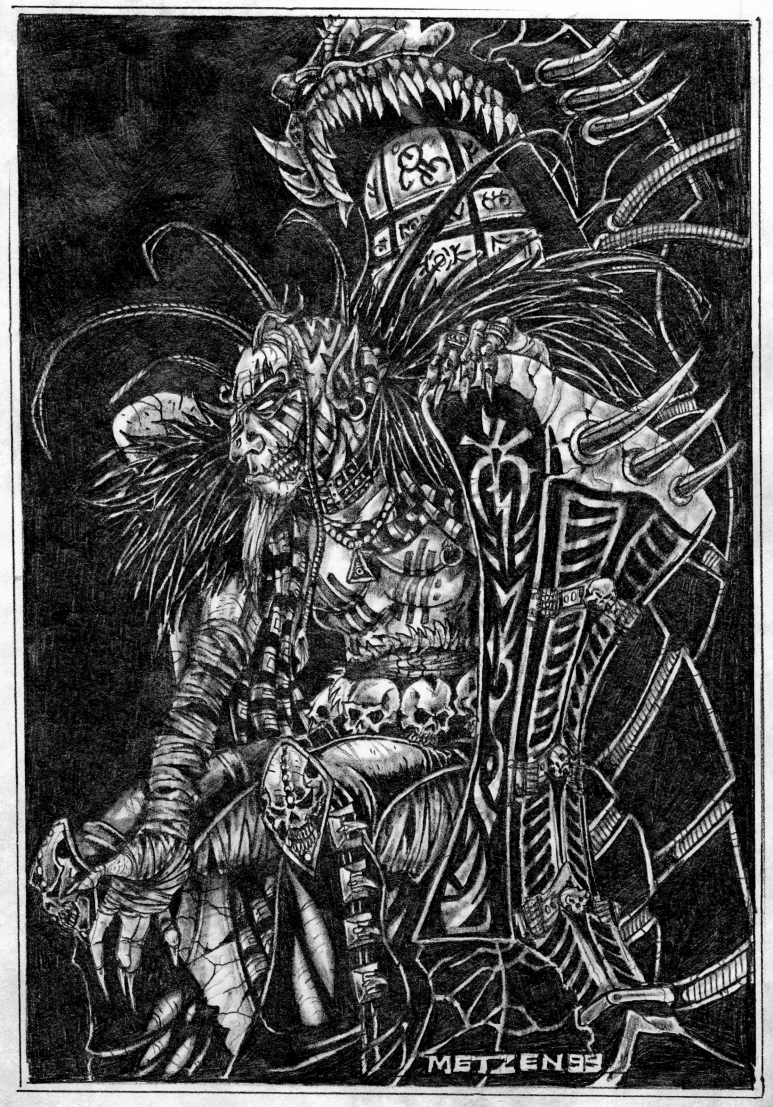

METZEN 99

THE WITCH LORD

BLOODLINES

Bloodlines was a third-person action–RPG that began development in early 1995. It was based in a dark sci-fi setting where rival Sect-Houses of vrykol ("space vampires") fought for dominance over a galactic empire teetering on the brink. *Bloodlines* mixed pop-sci-fi staples like war-mechs, battlecruisers, and droid armies with super-powered vampires bent on mayhem and destruction. The Sect-Houses were ruled by a dynasty of vrykol—each with their own lethal power sets and abilities. The story featured anti-hero Lonn Tiernan—lone survivor of his fallen Sect-House—who eventually brought the corrupt vrykol power-structure crashing down around him. Ultimately, the creative team behind *Bloodlines* was folded into Blizzard's then-new project, *StarCraft* (a move that seemed to work out really well . . .). As a result, *Bloodlines* was never revisited. However, it remains one of the grittier concepts within Blizzard's archives.

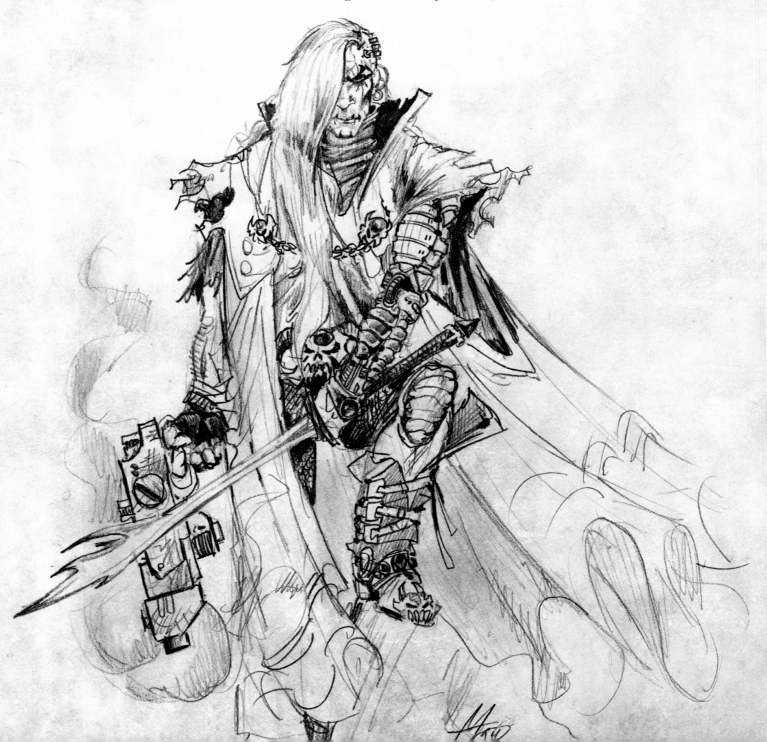

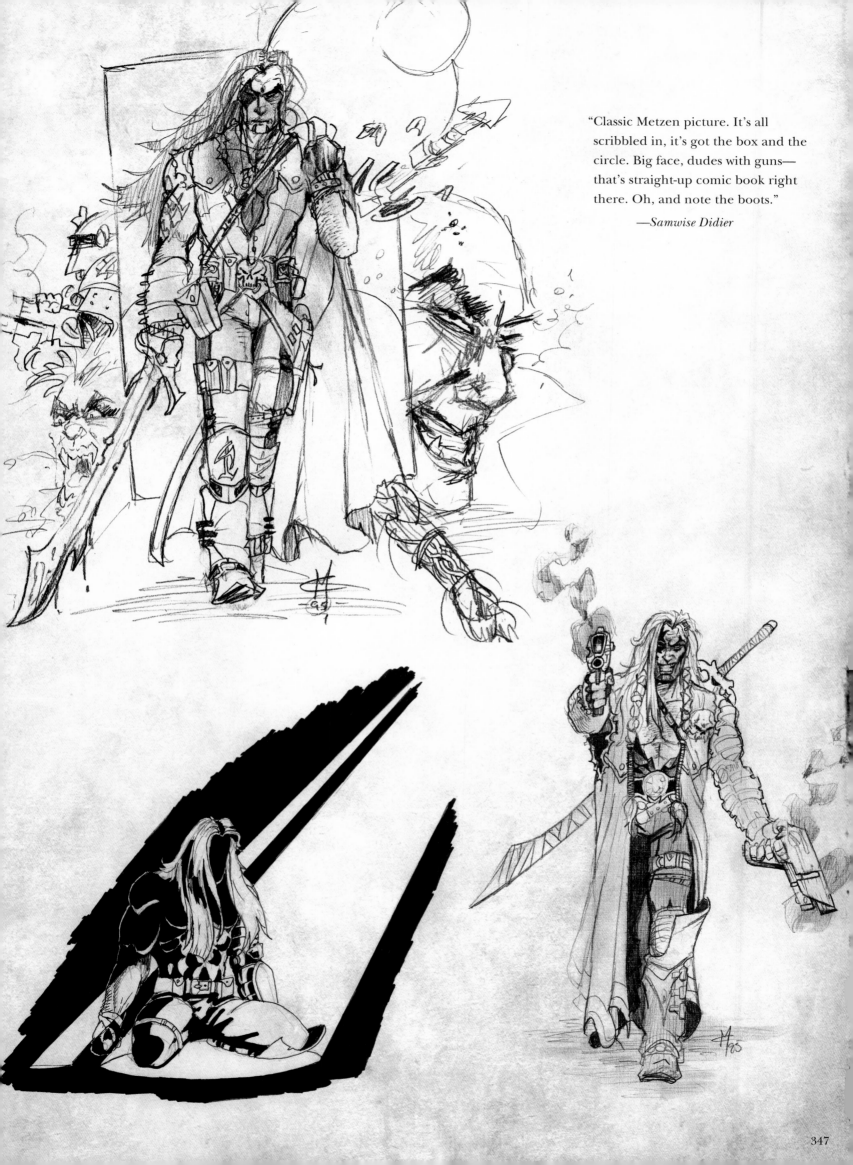

"Classic Metzen picture. It's all scribbled in, it's got the box and the circle. Big face, dudes with guns— that's straight-up comic book right there. Oh, and note the boots."

—*Samwise Didier*

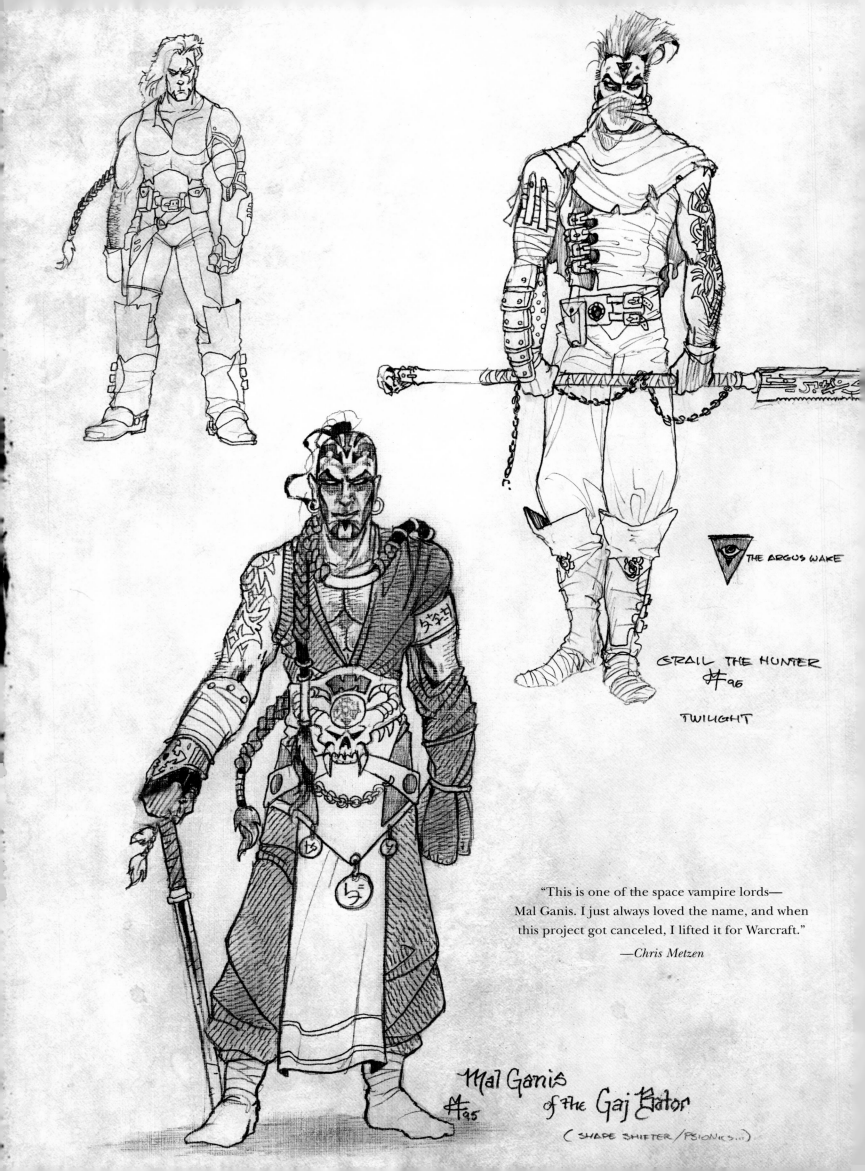

THE ARGUS WAKE

GRAIL THE HUNTER
*96

TWILIGHT

"This is one of the space vampire lords—
Mal Ganis. I just always loved the name, and when
this project got canceled, I lifted it for Warcraft."
—*Chris Metzen*

Mal Ganis
of the Gaj Baton
*95

(SHAPE SHIFTER/PSIONICS...)

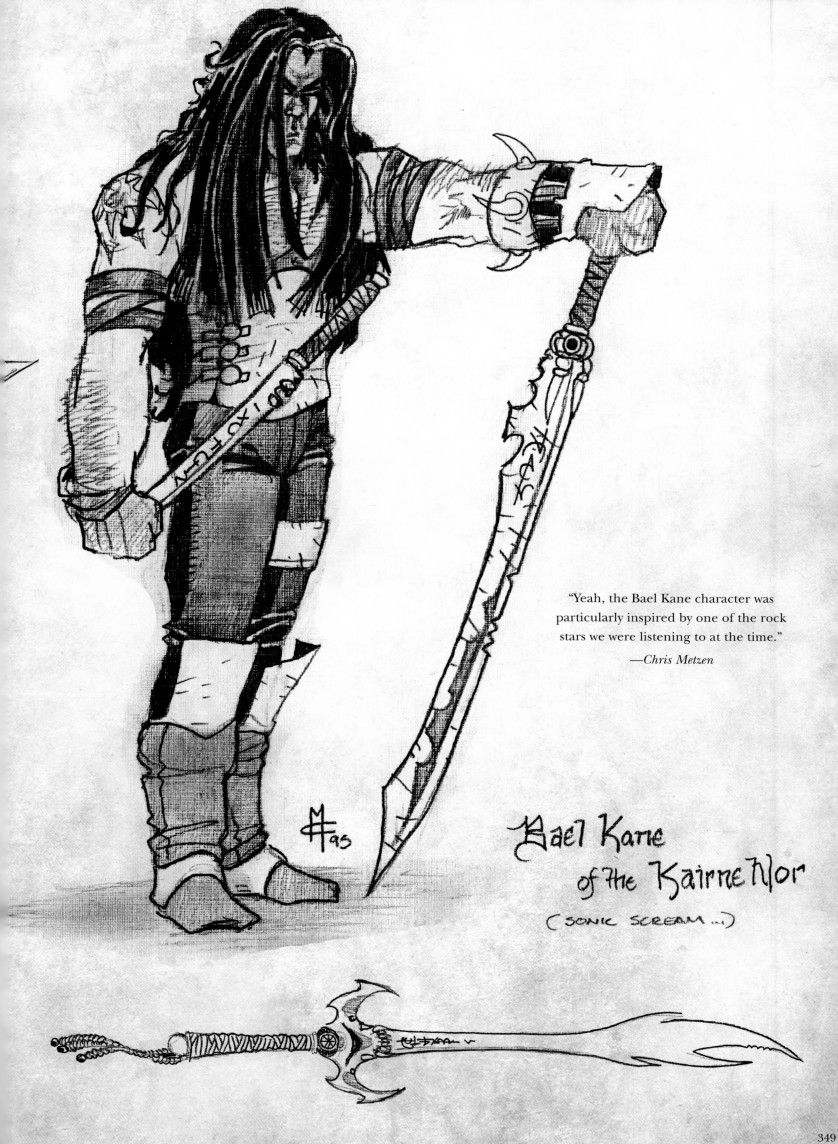

"Yeah, the Bael Kane character was particularly inspired by one of the rock stars we were listening to at the time."
—*Chris Metzen*

Bael Kane of the Kairne Nor
(Sonic Scream ...)

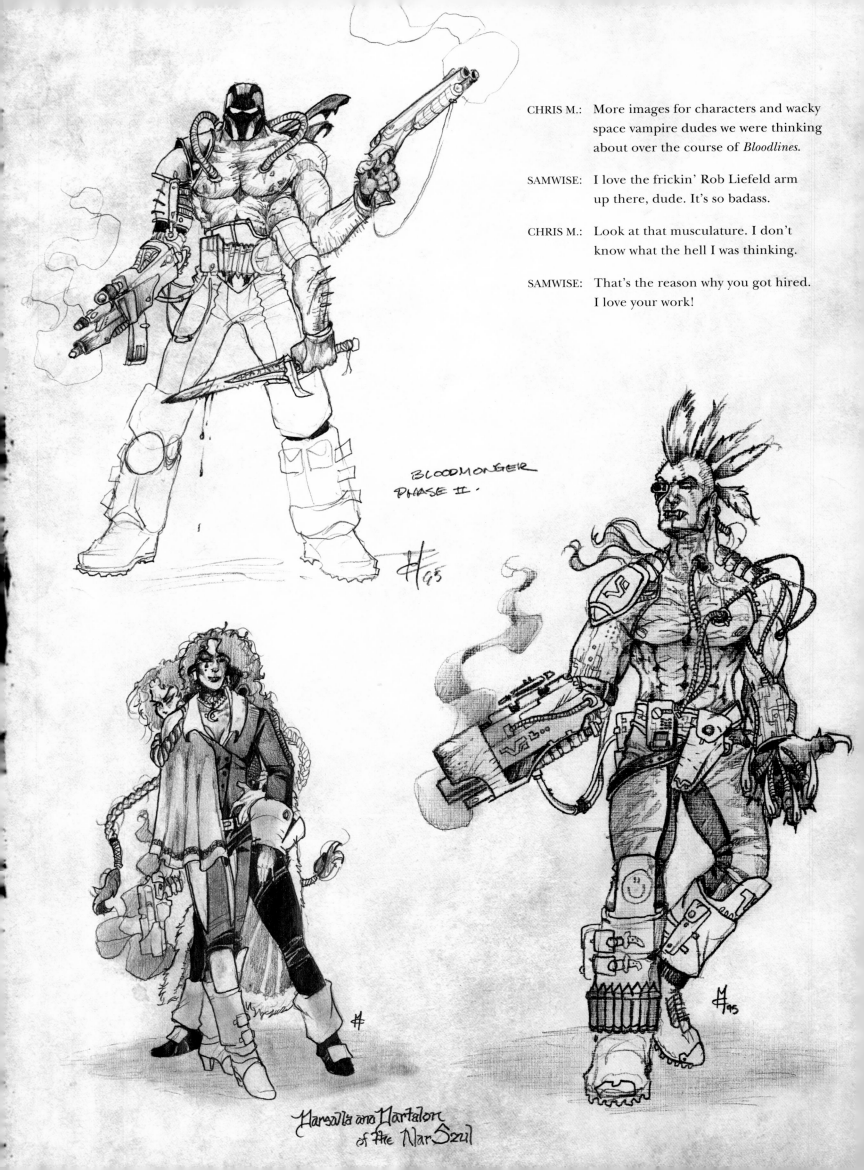

CHRIS M.: More images for characters and wacky space vampire dudes we were thinking about over the course of *Bloodlines*.

SAMWISE: I love the frickin' Rob Liefeld arm up there, dude. It's so badass.

CHRIS M.: Look at that musculature. I don't know what the hell I was thinking.

SAMWISE: That's the reason why you got hired. I love your work!

BLOODMONGER
PHASE II.

Marsalla and Martalon
of the NarSzul

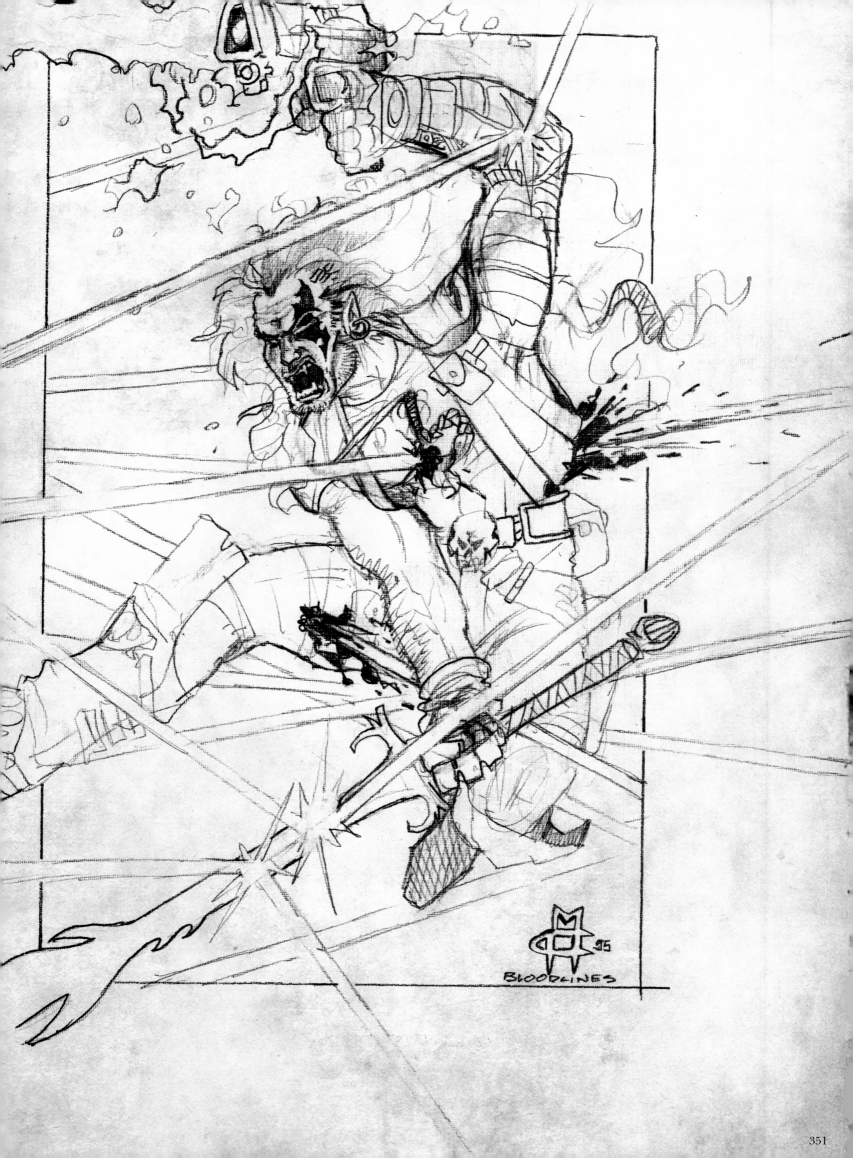

BLOODLINES

DENIZEN

One of the lighter-edged concepts to be developed in the mid-1990s, *Denizen* was a romp 'em, stomp 'em action game that was a strange pairing of games like *Rampage* and *Smash-TV*. The entire point of *Denizen* was to allow players to crash around the game-space as monsters—bringing ruin and mayhem to everything they saw on the screen. The development group created a number of monstrous characters of varying styles. Some were funny and cartoony, while others were starkly rendered. While the project never really got off the ground, it was a great opportunity for Blizzard artists to think outside the RTS box and allow them to craft simplified characters that relied as much on *attitude* as they did on their design functionality.

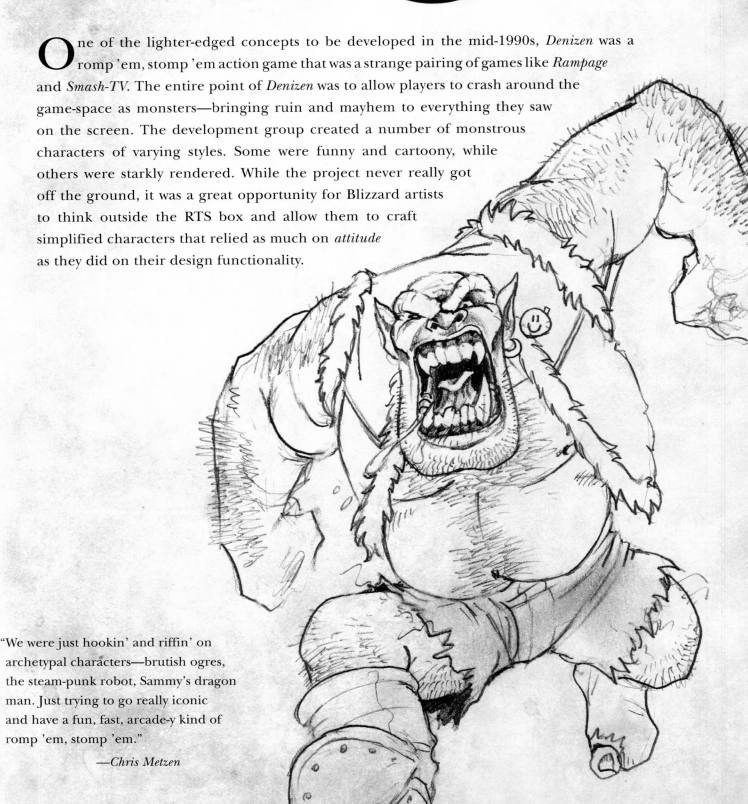

"We were just hookin' and riffin' on archetypal characters—brutish ogres, the steam-punk robot, Sammy's dragon man. Just trying to go really iconic and have a fun, fast, arcade-y kind of romp 'em, stomp 'em."

—*Chris Metzen*

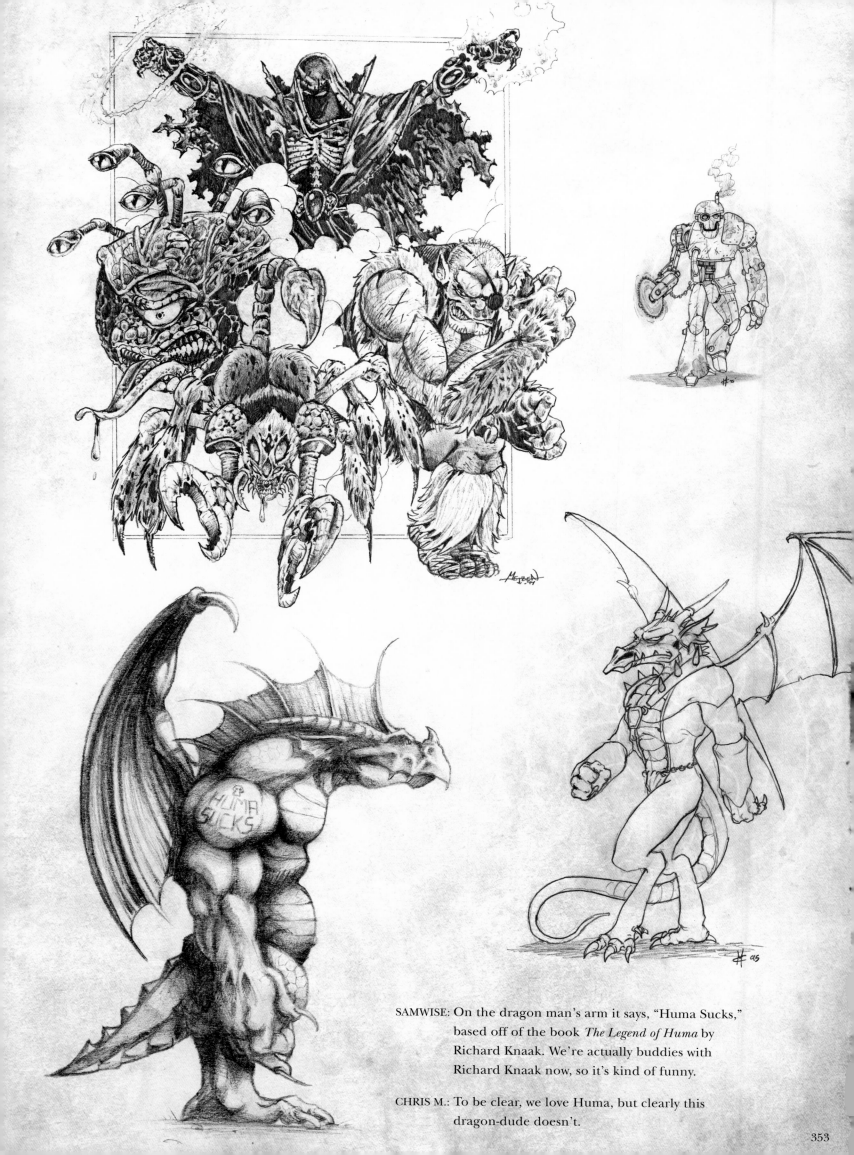

SAMWISE: On the dragon man's arm it says, "Huma Sucks," based off of the book *The Legend of Huma* by Richard Knaak. We're actually buddies with Richard Knaak now, so it's kind of funny.

CHRIS M.: To be clear, we love Huma, but clearly this dragon-dude doesn't.

353

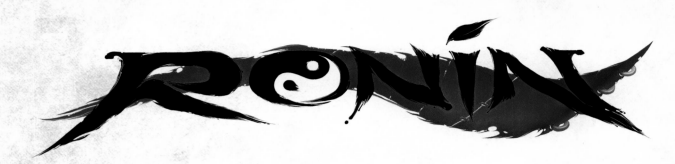

RONIN

I n the mid-1990s, *Ronin* was conceived as nothing more than an RPG set in feudal Japan. We weren't ready to live in the real world yet, even one as captivating as feudal Japan. The art team had been living and breathing *Samurai Showdown* and *Street Fighter* for years, and the idea of *Ronin* evolved because of the influence of those games into a more fantasy-based, non-historical Japanese setting. Following the same format as *Warcraft*, we took traditional mythological creatures from Japan and gave them the ol' Blizzard art pass. Creatures like the ravenous Kappa and the aloof Tengu were worked over and developed, but unfortunately, after about two years, the game got canceled and we stopped production. We were horrible at archiving artwork in the early days, so unless we return to this realm, what you see on these pages is all that will remain of *Ronin*.

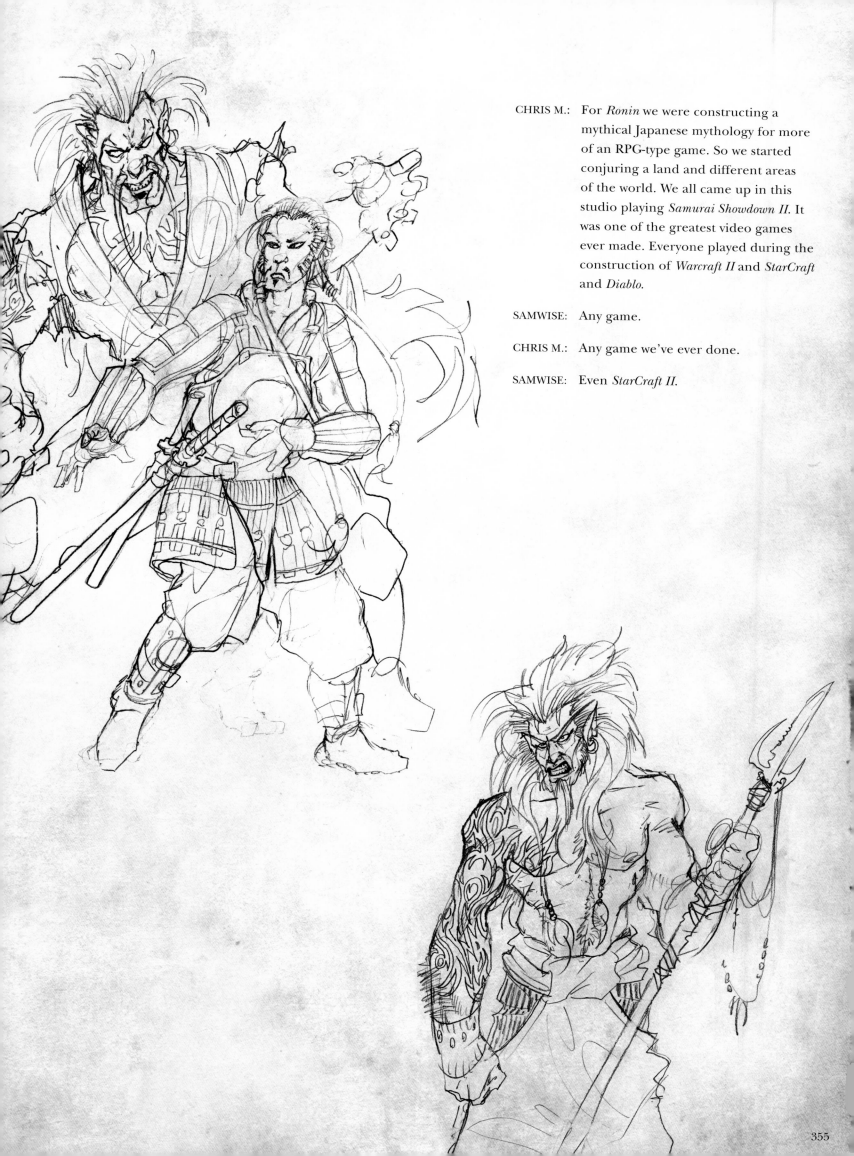

CHRIS M.: For *Ronin* we were constructing a mythical Japanese mythology for more of an RPG-type game. So we started conjuring a land and different areas of the world. We all came up in this studio playing *Samurai Showdown II*. It was one of the greatest video games ever made. Everyone played during the construction of *Warcraft II* and *StarCraft* and *Diablo*.

SAMWISE: Any game.

CHRIS M.: Any game we've ever done.

SAMWISE: Even *StarCraft II*.

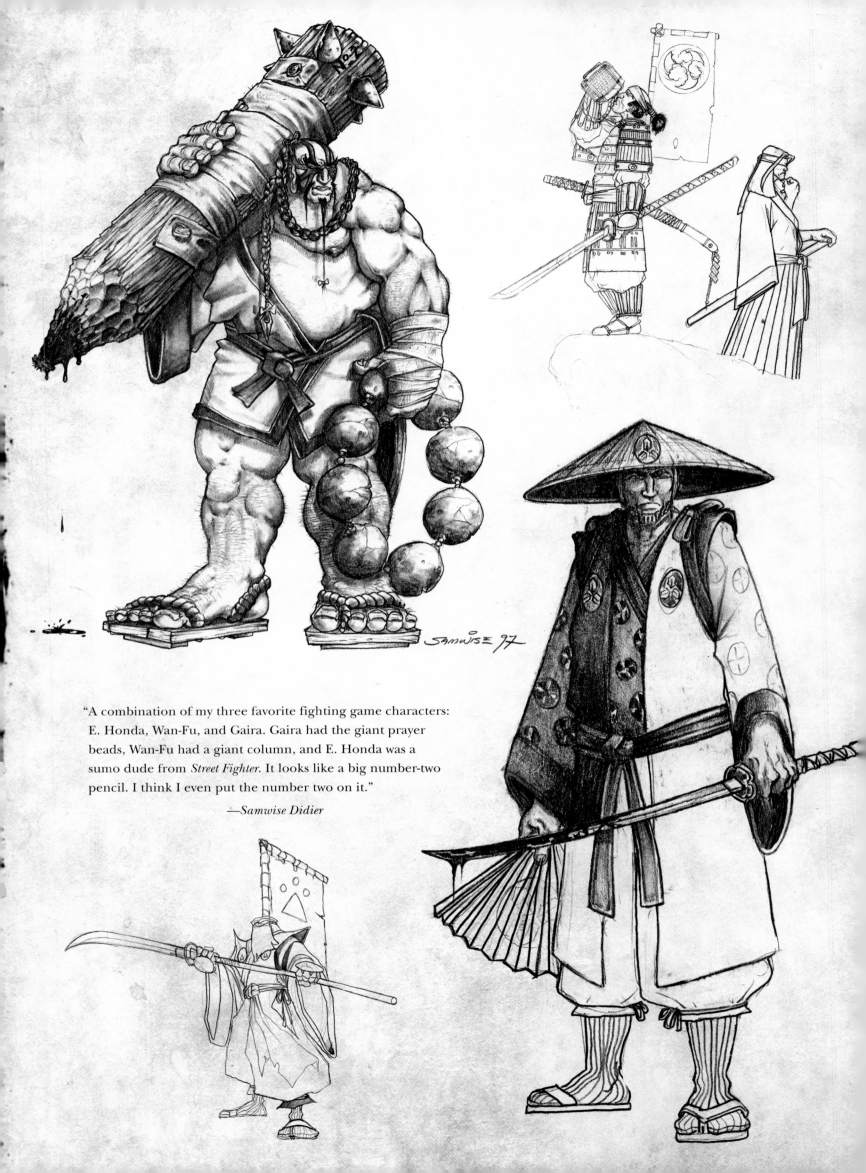

"A combination of my three favorite fighting game characters: E. Honda, Wan-Fu, and Gaira. Gaira had the giant prayer beads, Wan-Fu had a giant column, and E. Honda was a sumo dude from *Street Fighter*. It looks like a big number-two pencil. I think I even put the number two on it."

—*Samwise Didier*

"The raven samurai is one of my favorite
drawings Samwise has ever done."
—Chris Metzen

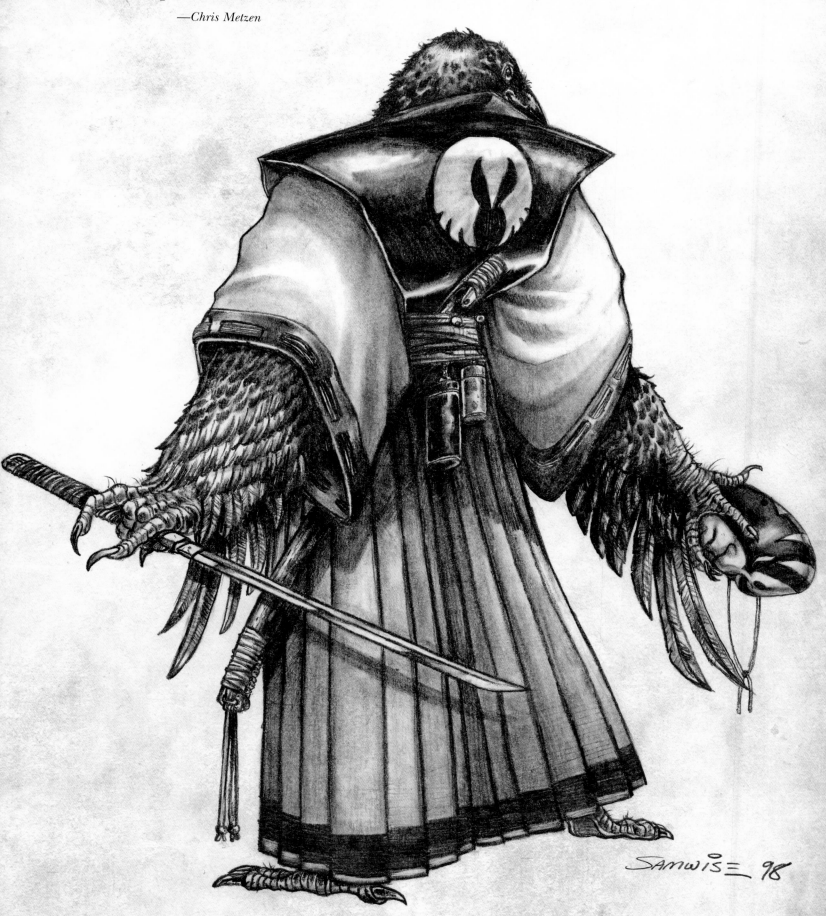

WOOT!

Blizzard Entertainment is known for creating some of the game industry's most memorable characters—night elves and orcs, protoss and zerg, Thrall, Kerrigan . . . and let's not forget big D himself (or herself), Diablo. These are big-time players in the Blizzard world, with rich backgrounds and serious history. But we don't keep it serious all the time; we like to have some fun with our creations, too. This collection of art shows just that—our characters as you've never seen them in their respective game worlds, setting aside old grudges and enjoying some good ol' fashioned holiday festivities. Here you'll find members of the Blizzard family from all of our game universes having fun together and sharing a little bit of seasonal spirit. Isn't that what the holidays are supposed to be about?

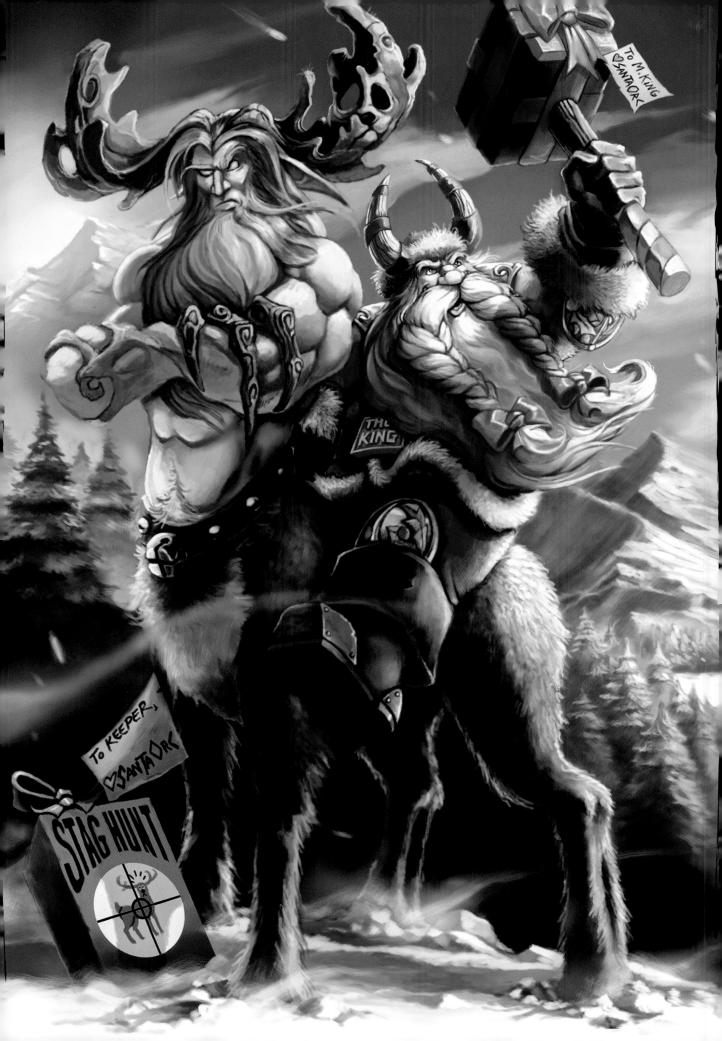

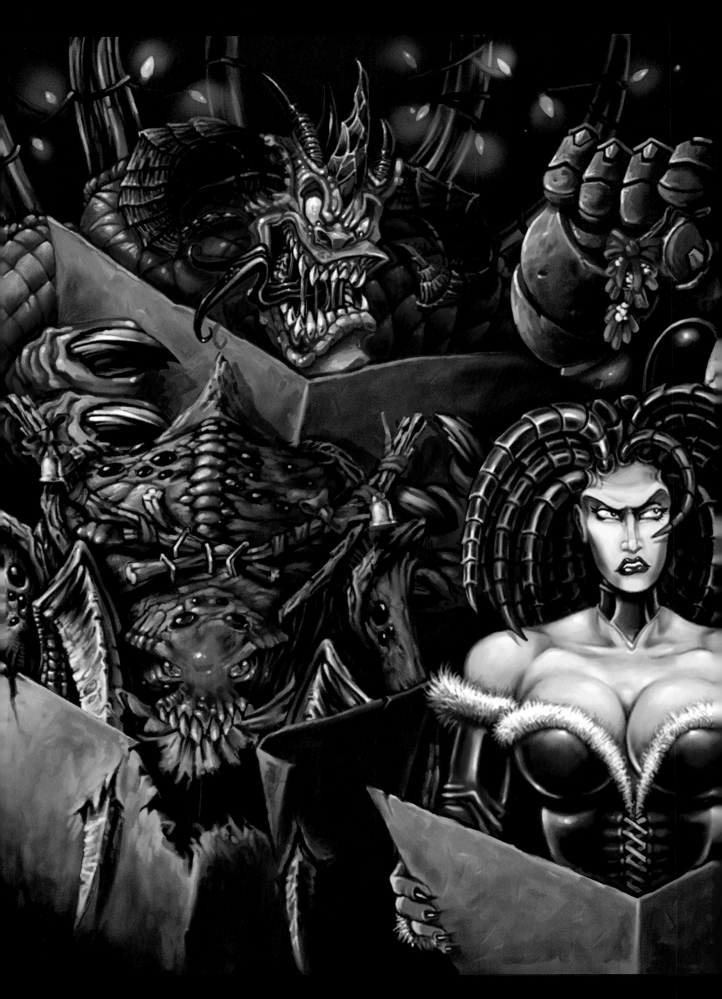

Karaoke Karnage, *1999 holiday card, Samwise Didier*

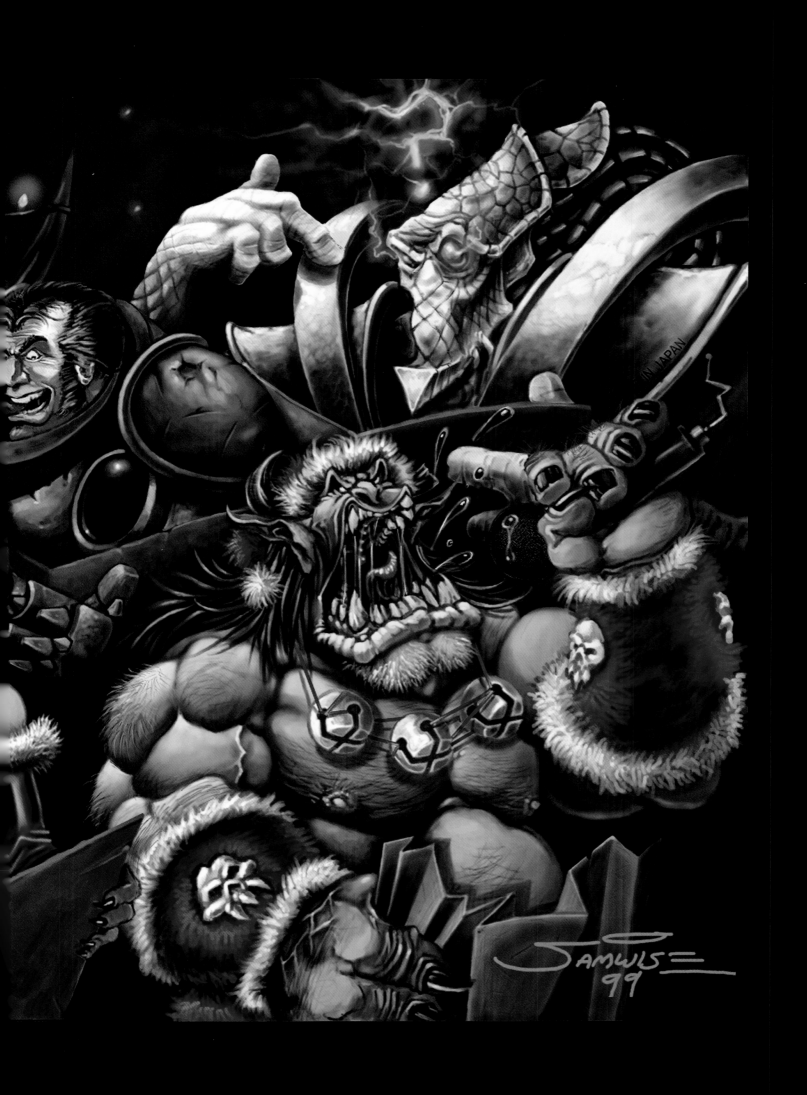

Stocking Stuffer, *1998 holiday card, Samwise Didier*

Old and New Friends, *2003 holiday card, Samwise Didier*

Dinner with Friends, *2002 holiday card, Samwise Didie*

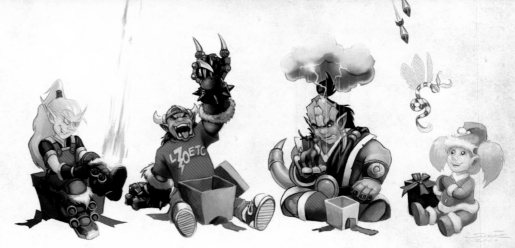

Phat Lootz, *2006 holiday card, Samwise Didier*

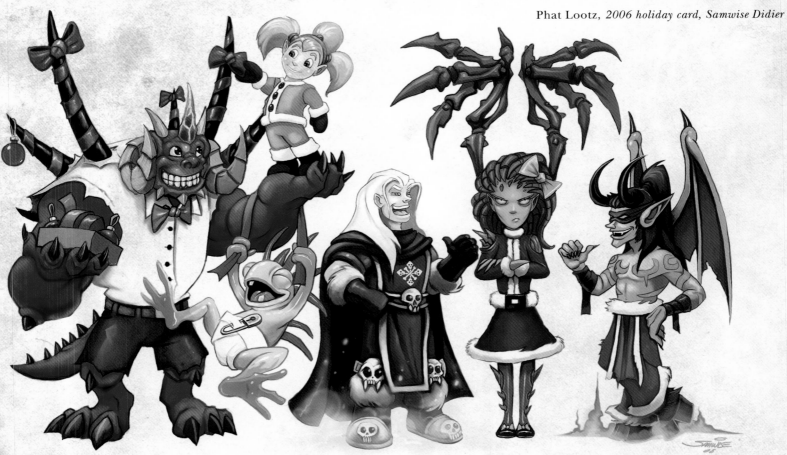

Naughty & Nice, *2008 holiday card, Samwise Didier*

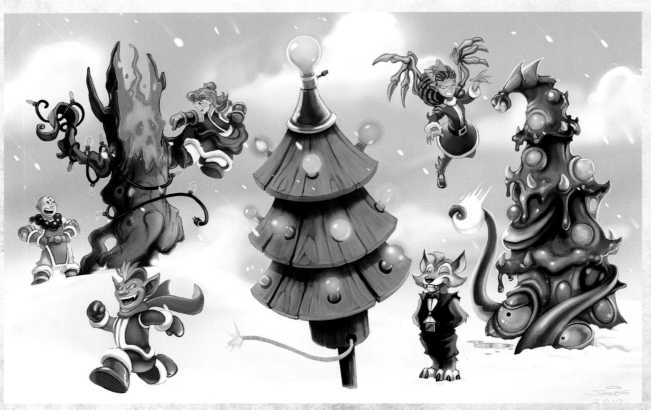

Tree Amigos, *2010 holiday card, Samwise Didier*

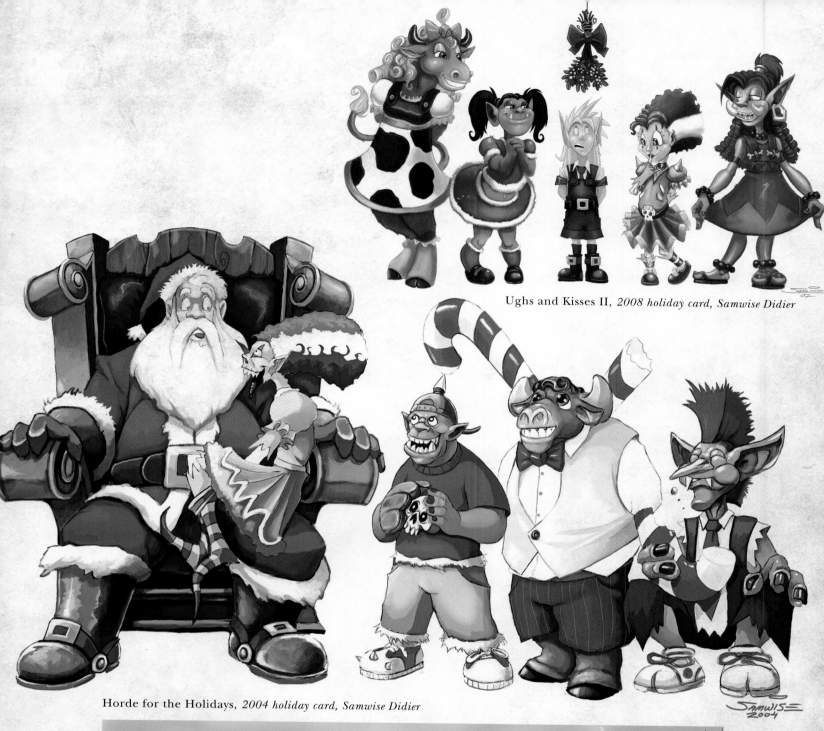

Ughs and Kisses II, *2008 holiday card, Samwise Didier*

Horde for the Holidays, *2004 holiday card, Samwise Didier*

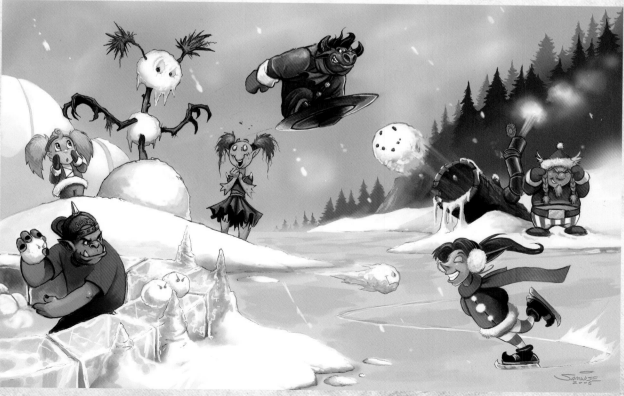

Snow Day, *2005 holiday card, Samwise Didier*

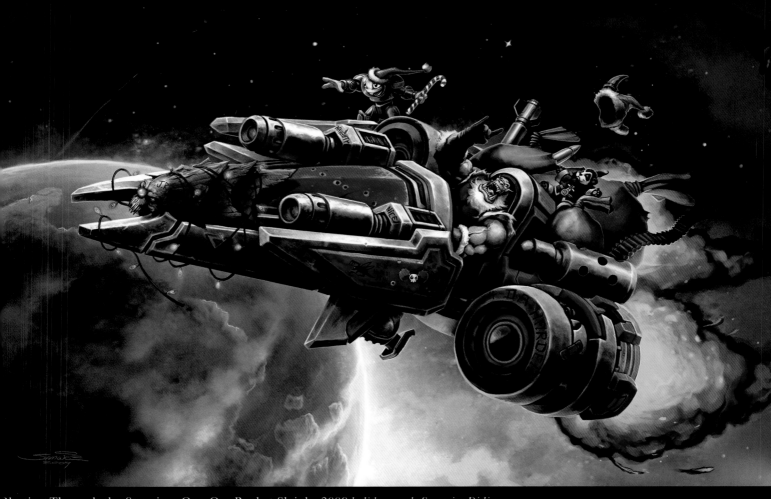

Blasting Through the Stars in a One Orc Rocket Sleigh, *2009 holiday card, Samwise Didier*

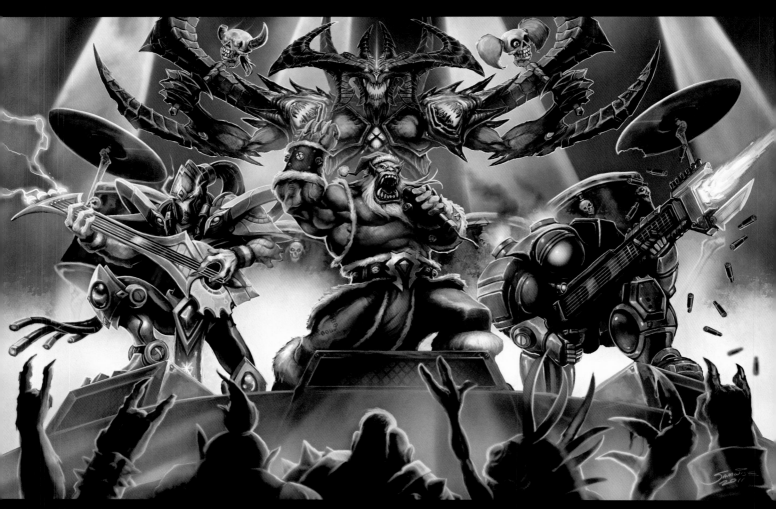

Sleigher, *2011 holiday card, Samwise Didier*

Yer Gonna need a Bigger Chimney

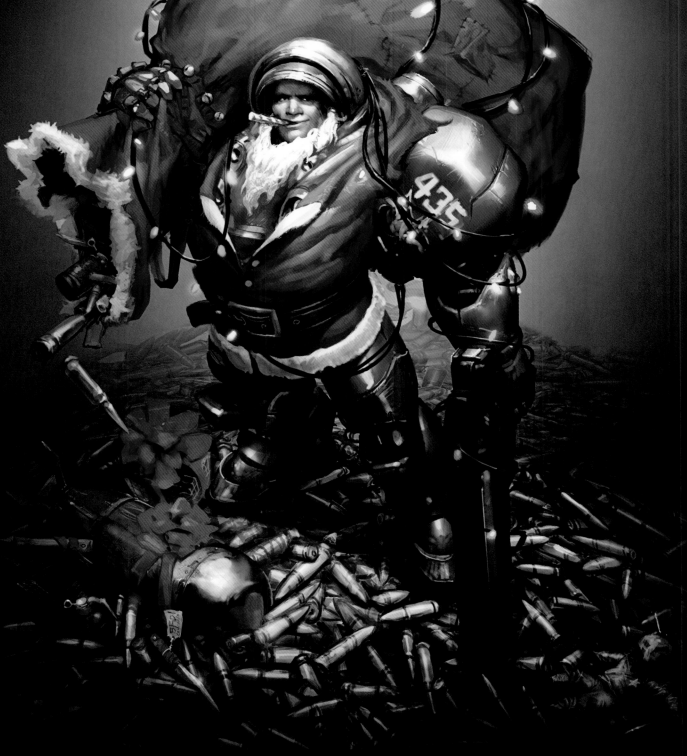

Rainbow Domination, *Peet Cooper*

Ughs and Kisses I, *2003 holiday card - Blizzard North, Michael Dashow*

© 2004 Blizzard Entertainment

Diablo vs. WoW, *Michael Dashow*

Rudolph II, *2004 holiday card - Blizzard North, Michael Dashow*

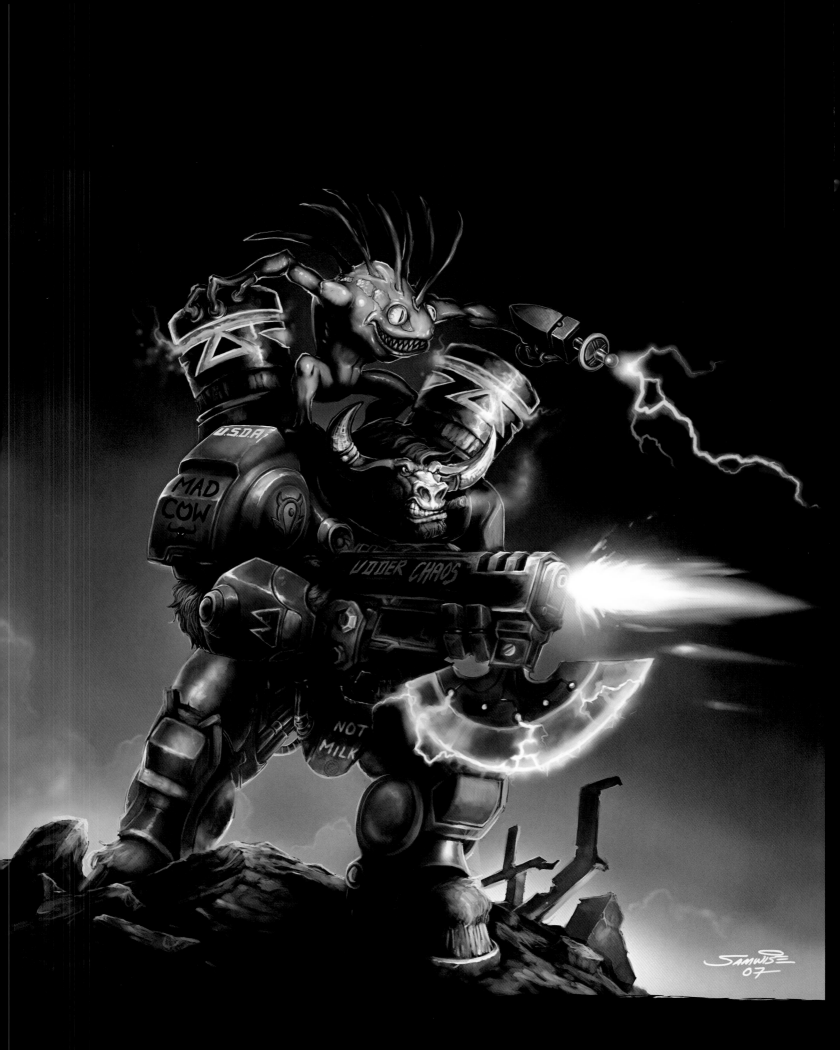

Tauren Space Marine, *2007, Samwise Didier*

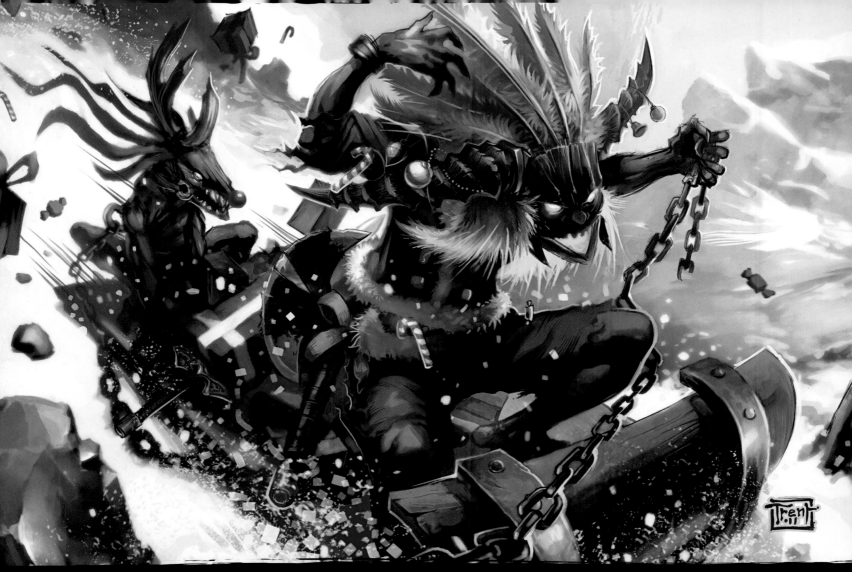

Sleigh Ride, *2011 Diablo holiday card, Trent Kaniuga*

 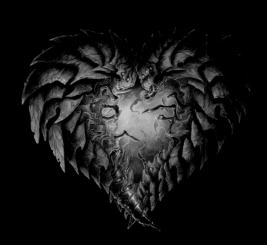

I ♥ SC, 2008, Samwise Didier

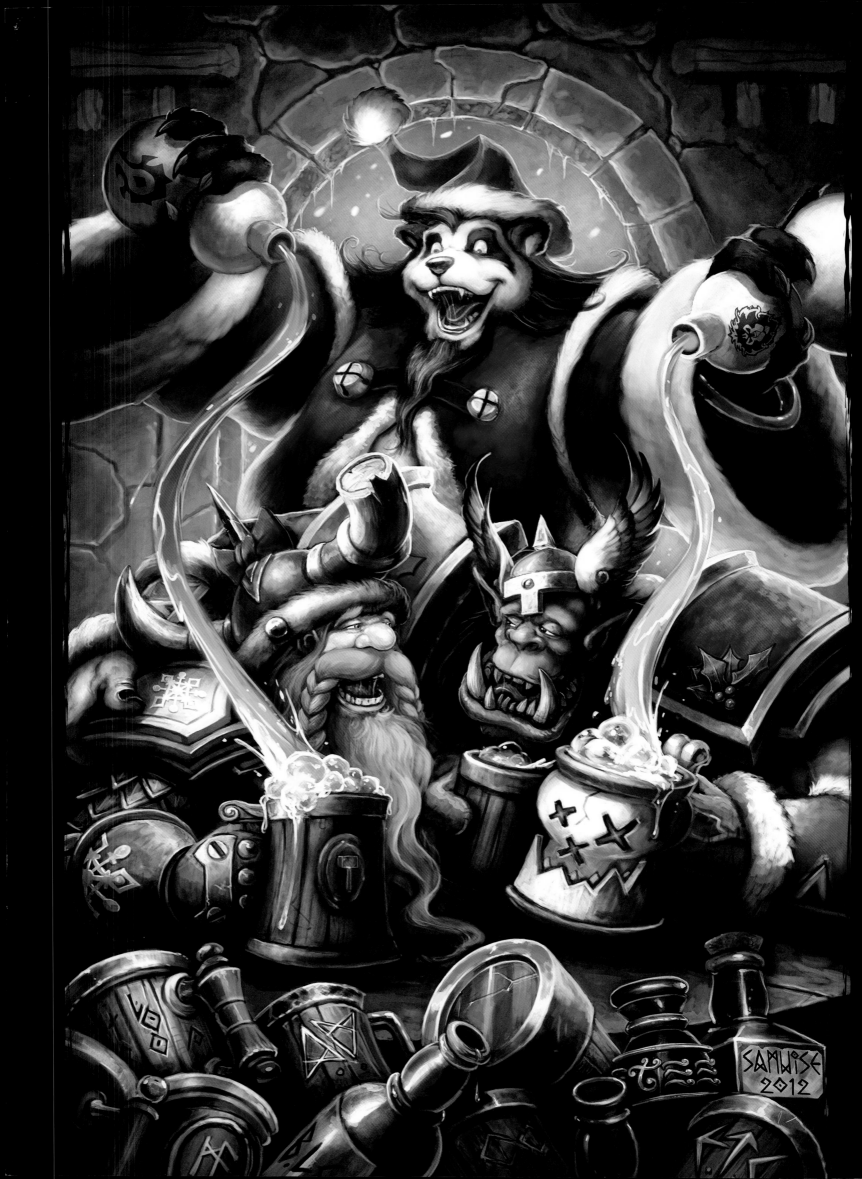

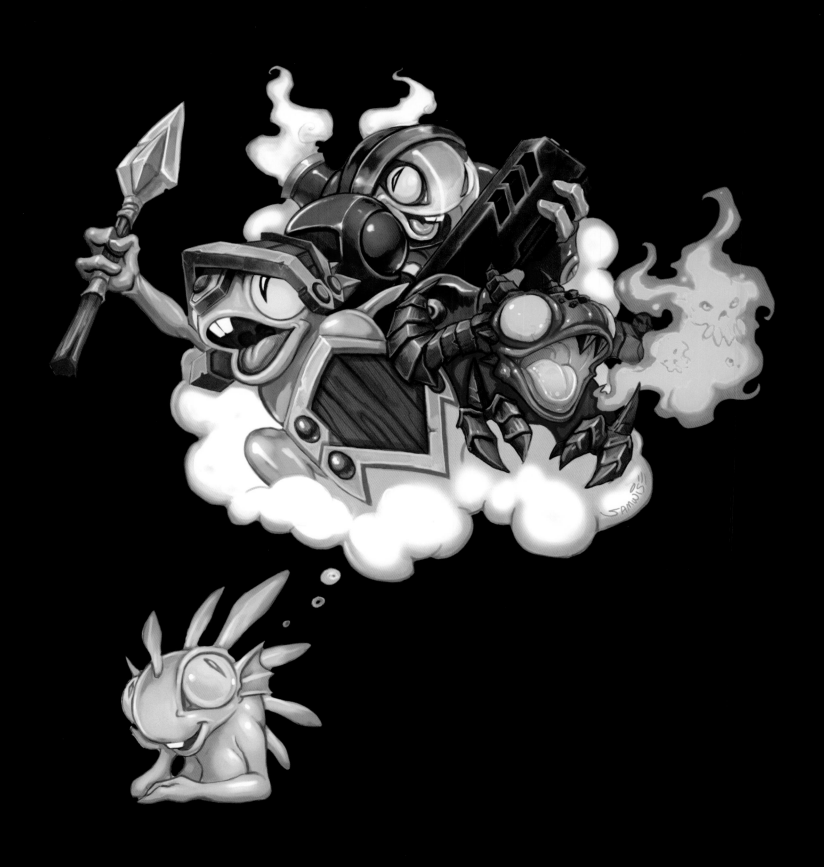

LEFT: Eat, Drink, and Be Hairy, *2012 holiday card, Samwise Didier*

ABOVE: Do Murlocs Dream of Aquatic Sheep? *Samwise Didier*

ARTISTS INDEX

Key: r = right, l = left, t = top, c = center, b = bottom

INSIGHT EDITIONS

PO BOX 3088 SAN RAFAEL, CA 94912

www.insighteditions.com

Library of Congress Cataloging-in-Publication Data available.

ISBN: 978-1-60887-027-1

FIND US ON FACEBOOK:
www.facebook.com/InsightEditions
FOLLOW US ON TWITTER:
@insighteditions

 REPLANTED PAPER

Insight Editions, in association with Roots of Peace, will plant two trees for each tree used in the manufacturing of this book. Roots of Peace is an internationally renowned humanitarian organization dedicated to eradicating land mines worldwide and converting war-torn lands into productive farms and wildlife habitats. Roots of Peace will plant two million fruit and nut trees in Afghanistan and provide farmers there with the skills and support necessary for sustainable land use.

Manufactured in China by Insight Editions

10 9 8 7 6 5 4 3 2 1

www.blizzard.com

BLIZZARD ENTERTAINMENT
ART DIRECTION
Nick Carpenter, Jeff Chamberlain, Samwise Didier, Chris Metzen

BLIZZARD ART COMMENTARY
Nick Carpenter, Samwise Didier, Christian Lichtner, Chris Metzen, Chris Robinson, Josh Tallman, Paul Warzecha

PRODUCTION
Jonathan Berube, Angela Blake, Jeff Chamberlain, Skye Chandler, Phillip Hillenbrand, Kyle Williams

LICENSING
Matthew Beecher, Jerry Chu, George Hsieh

SPECIAL THANKS
Lyndsi Achucarro, Jon Bias, Kat Hunter, David Lomeli

INSIGHT EDITIONS
PUBLISHER—Raoul Goff
ART DIRECTOR—Chrissy Kwasnik
EDITOR—Roxanna Aliaga
ASSOCIATE MANAGING EDITOR—Jan Hughes
PRODUCTION MANAGER—Anna Wan

Additional editorial work by Charles Gerli, Jake Gerli, Jason Smalridge, Jeff Campbell, Andrea Santoro; design support by Spencer Stucky, Martina D'alessandro, Jason Babler, Justin Allen; and production support by Jane Chinn, Binh Matthews, Masar Jonston.

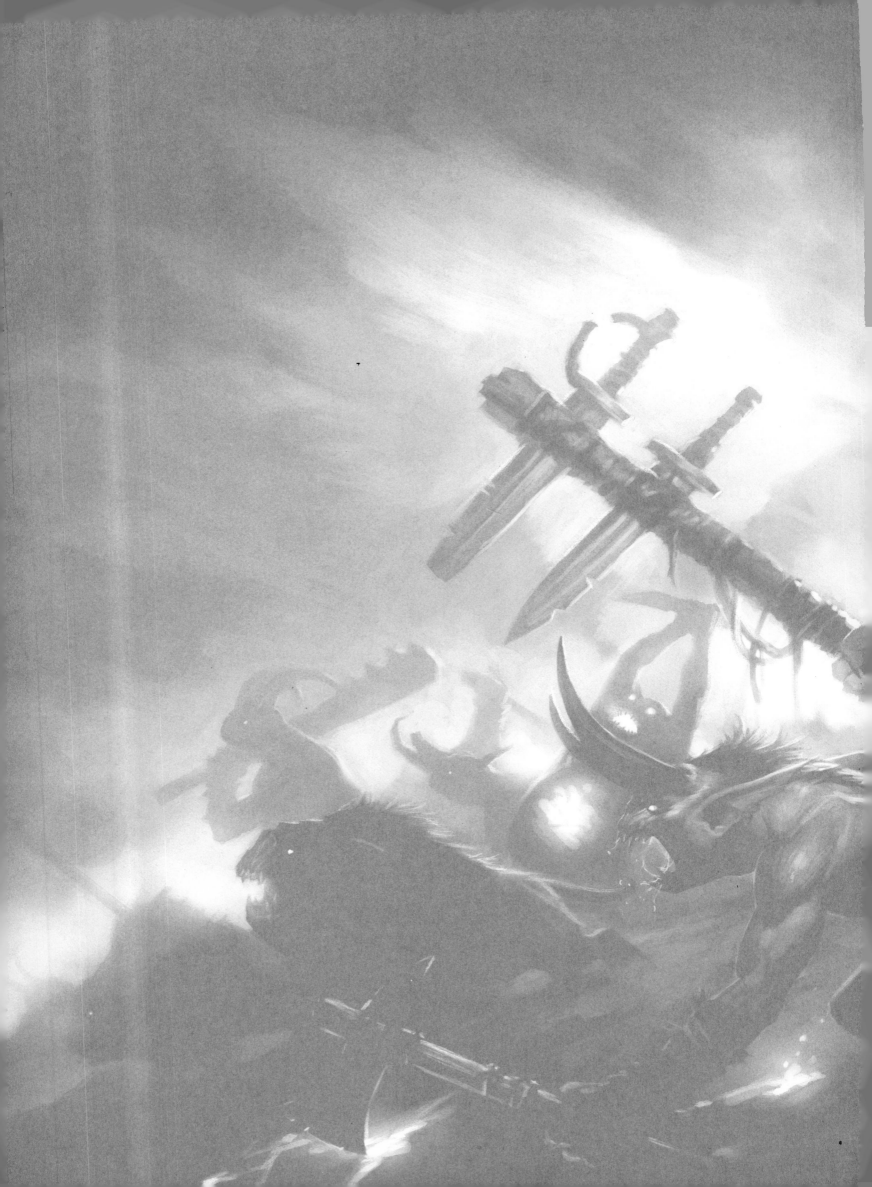